A History of Pain

GLOBAL CHINESE CULTURE

David Der-wei Wang, Editor

Michael Berry
Speaking in Images: Interviews with Contemporary Chinese Filmmakers

Sylvia Li-chun Lin
Representing Atrocity in Taiwan: The 2/28 Incident and White Terror in Fiction and Film

A History of Pain

Trauma in Modern Chinese Literature and Film

Michael Berry

 Columbia University Press
New York

Columbia University Press wishes to express its appreciation for assistance given by the Chiang Ching-kuo Foundation for International Scholarly Exchange and Council for Cultural Affairs in the publication of this series.

Columbia University Press
Publishers Since 1893
New York Chichester, West Sussex

Library of Congress Cataloging-in-Publication Data
Berry, Michael.
A history of pain : trauma in modern Chinese literature and film / Michael Berry.
 p. cm.—(Global Chinese culture)
Includes bibliographical references and index.
ISBN 978-0-231-14162-8 (cloth : alk. paper) — ISBN 978-0-231-51200-8 (electronic)
1. Popular culture—China. 2. Violence in literature. 3. Violence in motion pictures. I. Title. II. Title: Trauma in modern Chinese literature and film. III. Series.

HM621.B52 2008
306.4'809510904—dc22
2007045829
∞

For Suk-Young

CONTENTS

ACKNOWLEDGMENTS

This project marks the culmination of a long journey, and there are numerous individuals who have kindly shared their support, advice, and assistance along the way. Thanks go first and foremost to David Der-wei Wang, whose knowledge, guidance, selflessness, and sensitivity have made me not only a better scholar but also a better person. I am grateful to Perry Link (and a second anonymous reader), who went above and beyond the call of duty providing detailed comments, suggestions, and insights that helped make this a better book. Special thanks to my students and colleagues at the Department of East Asian Languages and Cultural Studies at the University of California, Santa Barbara (UCSB), especially Ron Egan, Sabine Fruhstuck, and John Nathan. I would like to thank the faculty, students, and staff at the Department of East Asian Languages and Cultures at Columbia University, where my research on this topic first began as a doctoral dissertation. Special thanks go to my teachers Richard Pena, Shang Wei, James Schamus, Paul Anderer, Harou Shirane, and Tomi Suzuki, and my classmates I-Hsien Wu, Carlos Rojas, Weijie Song, Xiaojue Wang, Enhua Zhang, John Weinstein, and Mingwei Song. Thanks to Chen Chieh-jen, Dorothy Ko, Zhang Xudong, Ban Wang, Peter Li, Howard Goldblatt, Song Dong, Susan Chan Egan, Wu Hung, Lin Hsiu-mei, Woo Kam-loon, Ye Zhaoyan, Chang Ta-chun, Wang Anyi, Wu He, Robert Chi, Claire Conceison, Shuibo Wang, Paul Barclay, Paul Katz, Chien-hsin Tsai, Hou Hsiao-hsien, Chu Tien-wen, Palm Pictures, Sony Pictures Classics, Rye Field Publishing, and Yushan Publishing. I would like to thank those teachers

who early on touched me with the gift of giving, inspiring me to one day pass on that gift to others, especially Dennis Jensen of Freehold Township High School.

The China Times Cultural Foundation provided support for this project and the Interdisciplinary Humanities Center at UCSB provided valuable leave time to complete revisions. And thanks to the CCK Foundation for generously subsidizing the publication of this book. Portions of this manuscript were presented at conferences and invited lectures at Columbia University, Yale University, UCLA, UCSB, Wellesley College, Harvard University, the Santa Barbara Art Museum, National Chi Nan University, and the AAS Annual Meeting in San Francisco; I would like to thank all those who offered comments, suggestions, and feedback during these presentations, which ultimately helped contribute to the development of this project. Selected portions of this book appeared in different forms in the following publications:

"Cinematic Representations of the Rape of Nanjing" in *East Asia: An International Quarterly* vol. 19, no. 4 (Winter 2001) (Transactions Periodicals Consortium) and in *Japanese War Atrocities: The Search for Justice.* ed. Peter Li (City: Transactions Publishers, 2003).

"Screening 228: From *A City of Sadness* to *A March of Happiness*" in *Taiwan Imagined and Its Reality,* ed. K. C. Tu (Santa Barbara: Center for Taiwan Studies, UCSB, 2005).

"Literary Evidence and Historical Fictions: The Nanjing Massacre in Fiction and Film" in *Canadian Review of East Asian Studies* 1 (2006).

"Revisiting Atrocity: The Nanjing Massacre on Film" (in Japanese) in *China 21* no. 24 (Aichi University Press, 2006).

I would like to express my appreciation to the editors of these books and journals for their feedback and support. Special thanks to everyone at Columbia University Press, especially Milenda Lee, Leslie Kriesel, and Jennifer Crewe.

I would like to thank those close friends who encouraged and supported me during the long writing process: Wen-yi Chang, Jason Tan, Sun-A Jung, Joshua Tanzer, Subryan Virasami, Simon Cheng, Li-Mei Chen, Yanhong Zhu, Zheng Lianjie, Phillip and Michi Ho, Everett Lipman, Don Marolf, and Crystal Martin. I would like to offer my most sincere thanks to my family. I can't express in words how much I appreciate all the love and support my brother and my parents have provided me over the years (special thanks to my father, who read and commented on an early version of the manuscript). Finally, I dedicate this book to Suk-Young Kim, who every day opens up new horizons in my life.

A History of Pain

Introduction

Twentieth-century China represents a time and a place marred by the unrelenting vicissitudes of history and the repeated trauma of violence. Struggling to redefine its position in the world after the harrowing Opium Wars of the mid-nineteenth century and a devastating defeat at the hands of Japan during the Sino-Japanese War of 1894–95, China entered the twentieth century only to face the collapse of its last dynastic empire in 1911. Since then, from May Fourth's violent negation of the past (1919) to the War of Resistance against Japan (1937–45), from the Civil War (1945–49) to the "great leap" into mass famine (1958–60), and from the engineered violence of the Cultural Revolution (1966–76) to the televised bloodbath of Tiananmen (1989), modern China's trajectory has been one of discontinuity, displacement, social unrest, and historical trauma. Heated international disputes and armed conflicts with Japan, the United States, the USSR, and Vietnam have been interspersed with abundant examples of China's own indigenous appetite for class struggle, political movements, and violence. Looking back on China's first modern century, one cannot help but be struck by the level and consistency of brutality, especially those examples of self-inflicted barbarism. Pain has become such a crucial component of our understanding of modern China that Lu Xun's 魯迅 1918 cannibalistic vision now seems just as much a prophecy for the future as it is a commentary on tradition.

In recent years, an increasingly large body of academic monographs has focused on moments of violence in twentieth-century China. Through renewed

examinations of the Rape of Nanjing (Chang 1997; Yamamoto 2000; Yoshida 2006) and the February 28th Incident (Lai, Myers, and Wei 1991; Phillips 2003) and the proliferation of works centering on the Cultural Revolution and June Fourth, these and other events of historical violence have become important components of our understanding of modern China. Gradually, historians, military historians, and social scientists are making an effort to reconstruct lost moments of atrocity, filling in blind spots from which the facts have been suppressed, watered down, or simply erased from official histories, popular memory, and the collective unconscious. Critical appraisals of how these moments of violence and atrocity have been configured in the context of literature, film, and popular culture have been slower to appear. It was not until the early 2000s—as this study was being undertaken—that a series of monographs exploring the ways trauma and violence have been represented in twentieth-century Chinese cultural texts began to open up a series of new critical frameworks for exploring what David Der-wei Wang has characterized as "the monster that is history."

Wang (2004) and such critics as Yomi Braester (2003), Ban Wang (2004), and Xiaobin Yang (2002) have established historical trauma and the manifold responses to that trauma as a central theme in modern Chinese literary and cultural studies. Their works have begun to trace the lineage of imagining violence in modern China and flesh out the means by which writers and filmmakers have confronted the pain of a past seemingly beyond the boundaries of representation. This book continues that investigation. What sets this study apart is its focus on a series of specific historical loci that collectively constitute a temporal, spatial, and fictional mapping of how some of the most traumatic instances of historical atrocity have been imagined in modern China. This project begins with a set of concrete historical events and then, moving toward the present, examines how those historical crises have been continually renewed and re-created *not* in history, but through the lens of literature, film, and popular culture.

This study surveys how historical violence and atrocity have been presented, re-presented, and projected in contemporary Chinese cultural texts and explores what these representations tell us about history, memory, and the shifting status of national identity. What do these cultural portrayals of mass violence contribute to our understanding of ideas of modernity and the nation? How does mass population movement, which is so often intertwined with violence, affect the way we remember, reconfigure, and represent atrocity? What is the relationship between historical atrocity on a national scale and the pain experienced by the individual victims? What is the effectiveness of film and literature as historical testimony? And how do these media allow us to approach the phantom that is "history" in ways that traditional historical scholarship cannot?

This book arises from the premise that fiction, film, and other popular media play an important and fundamental role in shaping popular conceptions and imaginations of history and, in this case, historical atrocity. Inspired by pain and suffering and built out of ruins and ashes, artistic representations of atrocity collectively write their own story, from which arises a new form of "historical" narrative. It is a narrative that comes alive and articulates human experience in ways that traditional historiography is incapable of speaking. It is a history that is constructed, but, then again, the discipline we call "history" is also continually being constructed and deconstructed. The purpose of this study is not to call into question traditional historiography or historical scholarship, which plays an invaluable role in our understanding of the past, but rather to offer that there are also other ways to approach history and resurrect the past.

Just as a new political laxness provided historians at home and abroad with an opportunity to reassess China's violent past, the final decades of the twentieth century saw the opening of a new cultural space for Chinese writers, poets, filmmakers, and artists to probe previously taboo moments in their nation's history. As products of popular culture, many of the texts analyzed here prefigured, echoed, or subverted social, political, and cultural trends, ultimately having a widespread influence often overlooked by historians. In the contemporary world, it is fiction and, to an ever-increasing degree, television, film, and new forms of digital media that reach the largest audience and play a profound role in shaping the public imagination and (mis)conceptions of history—arguably more than any official political propaganda or traditional historical study.

This critical survey of textual and visual portrayals of violence and atrocity in modern China focuses on five specific historical moments. Spanning more than six decades, these primary events are, in chronological order: 1) the Musha Incident (1930); 2) the Rape of Nanjing (1937–38); 3) the February 28th Incident (1947); 4) the Cultural Revolution (1966–76); and 5) the Tiananmen Square Incident (1989). In addition, there is a final, sixth section on the Handover of Hong Kong (1997). Together, these six instances do not—and are not intended to—constitute a comprehensive history of violence in modern China; instead, they subjectively map several important events, each of which played a key role in shaping history and national consciousness through unspeakable violence. The choice to include and exclude particular historical events is also based, to a large degree, upon the existence and availability of textual and visual resources. There is, unfortunately, no shortage of catastrophic incidents in modern China, and this study could easily have expanded to include other examples, such as the aforementioned Boxer Rebellion, the Antirightist Campaign, or the Great Leap Forward. However, each of the six specified incidents is unique in its far-reaching impact, ways it has captured the imagination of different Chinese

artists spanning several generations and altered conceptions of the Chinese nation. There are also various interconnections—including direct historical connections, uncanny cyclical patterns, and allegorical restagings—that further informed the choice of events. Over time and through the process of repeated representation, all of the incidents considered have, on one level, been transformed into cultural symbols, national myths, and historical legends, their meaning and symbolic power often far surpassing their actual place in history.[1] The majority of the texts are culled from a large body of contemporary fiction (novels, novellas, and short stories) and feature-length films and, although most were published between the 1980s and the present, several earlier texts date back as far as the 1930s. Periodically, the study also considers work drawn from a wide array of other media, including poetry, art, popular music, diaries, memoirs, television miniseries, and documentary films. The grouping and juxtaposition of eclectic texts for each chapter is justified by their common focus on a single historical moment. While each respective medium or genre, like the specific historical circumstances against which it was created, may stand as unique, all are united in that, as examples of popular culture, they play a fundamental role in transforming popular conceptions of the historical incident depicted.

Part I highlights three separate historical events that took place during the first half of the twentieth century and unfolded under the shadow of the Sino-Japanese colonial relationship. In colonial Taiwan of the 1930s, the Musha Incident seems to embody the typical anticolonial struggle, displaying both the violent insurgency of the colonized and the brutal suppression by the colonizer. The crackdown on the Musha Incident also served as a precursor to the more widespread violence the Japanese imperial machine would propagate as they advanced their war to bring about a Greater East Asia Co-Prosperity Sphere, in which the Rape of Nanjing became but one example of the immense human toll exacted. The February 28th Incident of 1947 can, on the one hand, be seen as an act of postcolonial violence erupting in the immediate political vacuum left by Japan's surrender. On the other hand, for those Taiwanese who view the Nationalist regime that arrived in 1945 as another imperialist power, the incident becomes yet another form of "colonial" violence. Whether 2/28 is considered an "internal" conflict or the violent remnants—or extension—of Taiwan's colonial past, this key moment on the eve of the Great Divide of 1949 certainly signals a transition to a breed of indigenous, or Chinese-on-Chinese, violence that would largely dominate China during the second half of the twentieth century.

1. For instance, the Nanjing Massacre stands not only for the horrific events of the winter of 1937–38 in Nanjing, but, over time, has also come to stand for all of Japanese aggression in China—and even East Asia—during the war.

Part II shifts from incidents of historical trauma carried out under the flag of imperialist domination or haunted by the specters of a colonial past to self-inflicted trauma, wherein state violence is displayed inwardly in a effort to "discipline and punish" the subjects of a new Chinese nation. The Cultural Revolution is a key example of this new form of historical trauma. Heeding Mao's call to "continue the revolution," countless youths rebelled against their own history, culture, and society only to find themselves the new subjects of state punishment as they were sent to China's frontier land, in which Yunnan was but one destination. In 1989 a popular movement that seemed to carry distant echoes of the Cultural Revolution–era mass rallies reconvened in Tiananmen Square; again, the result was a brutal crackdown during which cries for reform were smothered under the sound of rifle fire, the weight of tanks, and the power of a political iron fist. From the Cultural Revolution to Tiananmen Square, the dark side of modern Chinese history manifested itself in Hong Kong through a culture of fear that weighed heavily as the colony approached its 1997 reunion with mainland China.

The shift from traumatic narratives centered around the shadow of colonialism to those focusing on "indigenous violence" also corresponds to a fundamental change in the way the Chinese state has been imagined and framed. While many of the texts examined in part I take colonial violence as a means for creating, articulating, or strengthening new conceptions of the Chinese nation, with part II comes a new thrust to "unimagine" or escape from the nation, which has now been transformed into a historical monster. During the first half of the twentieth century, as threats of colonialism, imperialist aggression, warlordism, civil war, and natural disasters plagued China, many of the narratives focusing on historical trauma highlighted the drive to create and cement a new modern conception of the "Chinese nation." Throughout the textual journey in part I, this "obsession with China" can be palpably felt, especially in cases such as the Musha Incident, where a conflict between indigenous Taiwanese and Japanese is appropriated as a model of Chinese nationalism and the anti-Japanese spirit. The title of part I, "Centripetal Trauma," borrows the scientific term "centripetal force," which refers to a force traveling from the outside to the center, as a metaphor for the series of traumatic events examined. For although their origins lie on the outside, they often inspire a renewed examination or articulation of the Chinese nation. But what happens after a new Chinese state is established? And how is national discourse reframed or reconsidered when the next atrocities are designed by this new nation? In the wake of the People's Republic of China (PRC)'s own tumultuous "history of pain," the driving force behind cultural representations of trauma shifts from the national imagination to a new "transnational" imagination: when the nation has failed, the only remaining alternative

is a new global vision. Hence, in part II the term "centrifugal trauma" is used to describe a radical shift in the creation of traumatic narratives, which are introduced from within, generated in the center, and projected outward into a new series of global dreams . . . and, sometimes, nightmares.

In part I, with the exception of a few key texts created relatively close to the actual event, most of the texts examined appeared years, often decades, after the event they attempt to revisit. The phenomenon of the belated response, which I argue is in the Chinese context often just as much a symptom of political suppression as of psychological suppression, seems to have undergone a transformation in the final decades of the twentieth century. The floodgates of traumatic purging and representation of the Cultural Revolution broke open in 1977 with the advent of a new form of "scar literature" a mere two years after the end of the movement; in the new media era of cable television, the Tiananmen Square Incident of 1989 inspired an array of cultural responses (almost exclusively from exiles and overseas Chinese communities) that was even more immediate; and by Hong Kong's return in 1997, the representation began to predate the event, or in this case, nonevent. The increased proximity between event and representation since the 1980s has coincided with a mushrooming of belated representations of a wide array of other historical traumas, from the Opium Wars to the Boxer Rebellion and from the Musha Incident to the Rape of Nanjing. This represents a fundamental shift in the ways traumatic experiences are culturally processed and represented in the contemporary age, an era when it seems the array of popular forms (cartoons, fiction, film, television drama, documentary, etc.) reinterpreting and representing historical atrocities has proliferated and been disseminated in ever greater volume, thanks to mechanical and digital reproduction.

In his influential essay, "Discourse in the Novel," Bakhtin described "centripetal" and "centrifugal" as key forces in the formation of what he termed "heteroglossia," the variety of complex conditions that influence the creation of meaning in language. For Bakhtin, every "concrete utterance of a speaking subject serves as a point where centrifugal as well as centripetal forces are brought to bear. The process of centralization and decentralization, of unification and disunification, intersect in the utterance; the utterance not only answers the requirements of its own language as an individualized embodiment of a speech act, but it answers the requirements of heteroglossia as well; it is in fact an active participant in such speech diversity" (Bakhtin 272).

The cultural world, Bakhtin argued, consists of both "centripetal" (or "official") and "centrifugal" (or "unofficial") forces. The former seek to impose order on an essentially heterogeneous and messy world; the latter either

purposefully or *for no particular reason* continually disrupt that order. We stress "for no particular reason" because it is quite common among Bakhtin's admirers, especially Marxists, to misinterpret centrifugal forces as a unified opposition. Bakhtin's point, however, is that although forces of organized opposition sometimes *do* coalesce, centrifugal forces are generally speaking messy and disorganized. (Morson and Emerson 30)

Here, however, "centripetal" and "centrifugal" are not utilized in a linguistic sense, but applied in a wider context to narratives of trauma and historical violence. The centripetal force of trauma begins on the outside and converges in the center, resulting in new "official" or "national" discourses, whereas the centrifugal force originates from this new "national center" and extends outward, unleashing a multitude of destabilizing "unofficial" narratives—a true heteroglossia—that stretch, challenge, and destroy national boundaries. The latter force is akin to what Homi Bhabha (1990) has described as "dissemi-Nation," a process through which "Counter-narratives of the nation that continually evoke and erase its totalizing boundaries—both actual and conceptual—disturb those ideological maneuvers through which 'imagined communities' are given essentialist identities" (300).

While the structure of this study suggests a fundamental shift from "centripetal trauma" to "centrifugal trauma," the interlacing of these forces reveals a relationship much more complex than a crude binary. As Bakhtin has pointed out, centripetal and centrifugal forces exist as an interdependent *yin-yang*, each enmeshed within and simultaneously affecting the other. Thus, while the history of representation charted in these pages reveals macro shifts in discourse, the complexity of these forces can also be seen in various historical and narrative countercurrents in several of the texts selected—for example, in the ways the peripheral "savage land" of the Musha Incident not only inspired new discourses of nationalism but also "decentered" the nation (Japan, China, Taiwan). The 1997 Handover of Hong Kong, while appearing to be a example of Homi Bhabha's "dissemiNation"—as evidenced by the rise of dissident voices in and the massive wave of immigration out of Hong Kong—also had a profound effect on the mainland, so much so that many have argued in its aftermath that Hong Kong actually had a bigger impact on Beijing, rather than the other way around.

Although the events examined in part I took place between 1930 and 1947, the majority of the cultural representations considered are contemporaneous with texts considered in part II, which covers the period 1968 to 1997. What is fascinating is that although most of the works included in each section date from the 1980s to the 2000s, there remains a fairly clear demarcation: the

preponderance of texts from part I have an implicit national agenda (in the case of the Musha Incident and 2/28, these are often articulated in the context of pro-Taiwan independence efforts), while the examples in part II, the trauma does not seem to lead to a reimagination of the nation as much as to a symbolic negation of national boundaries. What might at first appear to be a fixed evolution from historical trauma framed by nationalism to historical trauma representing the failure of the nation is, upon closer scrutiny, revealed as a complex series of patterns of historical appropriation.

Literary History and Historical Fictions

This project begins with a short overview of how strategies for representing violence have transformed over time. The prelude serves as an overture to the chapters that follow by offering readings of a trio of texts from three distinct historical eras, exploring the interconnections between the sites of history and fiction, representation and witnessing, violence and pain. The works explored are Wu Jianren's 吳趼人 *A History of Pain* (*Tongshi* 痛史), a late imperial narrative on dynastic collapse; Lu Xun's "Preface to *A Call to Arms*" ("Nahan zixu" 吶喊自序), a complex and moving essay that recalls the author's life-changing decision to abandon medicine for literature; and Chen Chieh-jen's 陳界仁 installation re-creation of one of China's most brutal tortures in *Lingchi: Echoes of a Historical Photograph* (*Lingchi kao* 凌遲考). The chapter heading is inspired by the title of Wu Jianren's novel but also represents a "history of pain" in the way it traces the transformation and evolution of violence as it has been imagined from traditional literary discourses (*A History of Pain*) and early modernity ("Preface to *A Call to Arms*") to the postmodern era (*Lingchi*). From this exercise in violence abstracted, I move on to tackle a series of specific historical incidents, each indelibly carved into the minds of countless people by way of their barbarism and brutality.

Beginning this exploration of violence in twentieth-century China with the Musha Incident will surely incite questions and, perhaps, even objections due to the very nature of the event. The Musha Incident played out in 1930 (a Second Musha Incident occurred in 1931) as a conflict between the Atayal aboriginal group in Musha, a mountainous region in central Taiwan, and the Japanese—none of the chief players was Han Chinese. Moreover, the place of the incident was not the heartland of China, but Taiwan—an island territory with a long tradition of foreign colonization, which has made it a contested site in terms of both Chinese and Taiwanese national rhetoric and agendas. The inclusion of Musha 1930 as a key entry point into China's modern lineage of violence is in-

tended to further complicate the already complex relationship between Chinese and Taiwanese literary and historical narratives by highlighting the role of aboriginal peoples from Taiwan and their Japanese colonizers. Melissa J. Brown (2004) has used the case of Taiwan to argue that identity is foremost a construct based on social experience over ancestry or cultural ideas, and the discussion of Musha further illustrates the ways ethnic identity and historical memory have been rewritten to serve transforming political agendas. The inclusion of the Musha Incident in a series of what otherwise would be considered exclusively "Chinese" episodes of mass violence is intended *not* to provide any concrete answer to these debates, but to point to the complex set of historical and national forces that go into shaping identity and framing "national" trauma. This opening chapter is intended to not only pose an interesting counterpoint to the other chapters but also prod readers to rethink questions such as: Who is the true keeper of historical memory? At what point can the atrocity experienced by another person become one's own? And how has this brutal moment in colonial history been transformed into a national trauma? Although neither the perpetrators nor the victims of the 1930 Musha Incident fall into categories traditionally considered ethnic "Chinese," literary and visual narratives of the event have been predominantly Chinese.[2] This study is about not just Chinese atrocities but Chinese *narratives* of atrocity, and the Musha Incident provides a fascinating example of how Chinese writers, artists, and filmmakers have appropriated this brutal and disturbing massacre and reintroduced it into a variety of popular narratives.

The Rape of Nanjing was arguably one of the most brutal incidents in modern military history. The massacre was, however, just one page in a long, bloody tale of destruction, ruin, and ashes for the ancient capital. Chapter 2 examines the Nanjing Massacre, a brutal six-week killing spree whose precarious place in history has continued to stain Sino-Japanese relations all the way up to the present. Since 1987, the fiftieth anniversary of the massacre, there have also been several feature-length motion pictures set during the Rape of Nanjing. Three cinematic visions of the atrocity produced between 1987 and 1995 are the focus of a discussion on the different strategies through which national trauma is re-created in the context of pop culture. Turning then to literature, I offer an extended analysis of Ah Long's 阿壠 1939 book of reportage, *Nanjing*, the first Chinese literary work to confront the 1937 massacre, alongside a literary overview that discusses the fifty-year silence on the event and its sudden re-emergence in historiography and cultural discourse in the 1980s. Analyzed are "official"

2. There have also been several Japanese-language stories and novels that have portrayed the Musha Incident.

party-line works by such writers as Zhou Erfu 周而復 and Xu Zhigeng 徐志耕, as well as more daring approaches by contemporary writers like Ye Zhaoyan 葉兆言, whose unconventional novel *Nanjing 1937: A Love Story* (*Yijiusanqinian de aiqing* 一九三七年的愛情) places the massacre in a context never before attempted. Finally, I address the mass relocation of the Nationalist infrastructure to Chongqing on the eve of the massacre—a migration that would be paralleled by Chiang Kai-shek's 蔣介石 politically motivated migration from Chongqing to Taiwan a decade later, and a move that would result in one of the most violent insurrections in the island's history.

A confrontation between a group of government inspectors and a middle-aged Taiwanese cigarette vendor on the evening of February 27, 1947 triggered a series of violent protests that erupted throughout Taiwan. Although repressed for the next four decades by the Nationalist Party, the February 28th Incident remained an unhealed wound for Taiwan throughout its postwar period. The focus of chapter 3 is a series of literary and cinematic texts based on, set against, and dedicated to the February 28th Incident. Since the lifting of martial law in 1987, this formerly taboo subject has become the basis for a proliferation of fiction, documentaries, historical monographs, oral histories, artwork, and monuments. Through close readings and comparative studies of several key literary and visual texts, I probe the different ways the incident has been depicted and reimagined over the course of several decades. From works published in 1947 by Bo Zi 伯子 and Lü Heruo 呂赫若 to contemporary works by writers such as Yang Zhao 楊照 and Wu He 舞鶴, I juxtapose fictional works against cinematic interpretations of the incident by Taiwanese film directors such as Hou Hsiao-hsien 侯孝賢 and Lin Cheng-sheng 林正盛. Hou's 1989 masterpiece, *City of Sadness* (*Beiqing chengshi* 悲情城市), not only confronted the complexly tortured historical memory of the event but also (re)created it in the visual memories of Taiwan and the world.

In chapter 4 I turn my attention to the Cultural Revolution (1966–76), a decade-long political movement that marked the invention of a new form of engineered Orwellian violence in modern Chinese history. No longer is violence dictated by dichotomies of China vs. Japan or mainland Chinese vs. Taiwanese; instead, an indigenous atrocity emerges, one that claimed more lives than both the Rape of Nanjing and the February 28th Incident combined. From "scar literature" (*shanghen wenxue* 傷痕文學) and "search-for-roots literature" (*xungen wenxue* 尋根文學) to the avant-garde, the Cultural Revolution has been a major source of creative inspiration for many contemporary Chinese writers. As comprehensive coverage of the literature of this period would be far beyond the scope of this study, I focus on Yunnan circa 1968 and examine the phenomenon of "educated youths" (*zhiqing* 知青) sent down to

the countryside. Among the writers and filmmakers sent to Yunnan as teenagers are world-renowned Fifth Generation filmmaker Chen Kaige 陳凱歌; writer, painter, and screenwriter Ah Cheng 阿城; best-selling author of *Blood Red Sunset* (*Xuese huanghun* 血色黃昏) Lao Gui 老鬼 (a.k.a. Ma Bo 馬波); and popular writers Wang Shuo 王朔 and Wang Xiaobo 王小波. Here, geographical displacement is not the consequence of or precursor to violence, but a new form of brutality that pervades the physical, psychological, and topological realms. The chapter concludes with a reading of a series of popular television miniseries dating from the 1990s to the 2000s, which extend the sent-down experience from Yunnan to Shanghai and eventually to North America, where the ghosts of the past and legacies of violence make their phantasmagoric return decades later.

On June 4, 1989, more than a decade after the end of the Cultural Revolution, modern China's legacy of violence combined with a déjà vu replaying of May Fourth–era student demonstrations in Tiananmen Square. China, however, had come a long way since 1919; after the lessons in brutality learned during the Cultural Revolution, the 1989 student demonstrations took on a completely new dynamic. The result was a bloody purge televised around the world and a subsequent exodus of students and intellectuals from China. Chapter 5 offers readings of an eclectic series of cultural texts, including novels, short stories, poetry, documentaries, and feature-length films, in order to answer the question of how artists confront atrocity under the shadow of a hegemonic power that suppresses their discourse. Although direct literary representations and portrayals of the massacre were all but impossible in China, the incident did inspire a wave of literature that carries allegorical significance. Veiled depictions of violence, coupled with the Chinese government's downplaying and, to some extent, denial of the massacre, led to what I term an "invisible massacre," wherein a bloody confrontation is rendered invisible, stripped of truth and re-created in rumor, imagination, and allegory. Alongside allegorical fables of violence, the chapter also analyzes a series of novels directly portraying the events of June Fourth written by overseas Chinese writers such as Hong Ying 虹影, whose novel *Summer of Betrayal* (*Beipan zhi xia* 背叛之夏) gives new meaning to the phrase "love and revolution" (*geming jia lianai* 革命加戀愛); Terrence Chang's *Sons of Heaven*, which provides an imaginary historical context for one of the most famous moments of the uprising; and Gu Zhaosen's 顧肇森 short story "Plain Moon" ("Su yue" 素月), which shows how the hands of fate surreptitiously extended from the student leaders in Beijing to an unsuspecting Chinese American garment worker in New York. Occurring less than a decade before Hong Kong's fated return to China, the bloodshed in Beijing also had a particular resonance in the imaginations of many Hong Kong writers and

filmmakers. Portrayals of the massacre can be seen in the fiction of Huang Bi-yun 黃碧雲, among others, and in the films of John Woo 吳宇森, whose Vietnam–Hong Kong epic *Bullet in the Head* (*Diexue jietou* 碟血街頭) was admittedly inspired by Tiananmen, as well as Clara Law's 羅卓瑤 cinematic exploration of cultural identity, *Farewell China* (*Ai zai biexiang de jijie* 愛在別鄉的季節), which also carries the cross of Tiananmen on its back.

The Tiananmen Square incident not only inspired Hong Kong artists' imaginations of the mainland Chinese Other but also raised a multitude of questions, fears, and dire anticipations for their own future. After a century of violence, many instances of which only began to be articulated in literature and film in the 1980s, the fear of violence and atrocity had, by the eve of the 1997 Handover, begun to manifest in a fetishized projection into the future. This phenomenon—which I term "anticipatory trauma"—is explored in a final coda. Anticipatory trauma not only triggered a massive migration of Hong Kong residents to England, Canada, the United States, and other foreign countries but also nurtured a fertile crop of fiction and film imagining Hong Kong's new, apocalyptic post–Handover future—a future that never actually arrived. Examples include such works of fiction as Wong Bok Wan's 黃碧雲 short story "Lost City" ("Shicheng" 失城), John Chan's 陳冠中 *Nothing Happened* (*Shenme dou meiyou fasheng* 甚麼都沒有發生), and Shi Shuqing's 施叔青 *City of the Queen: A Novel of Colonial Hong Kong* (*Xianggang sanbuqu* 香港三部曲). This anticipatory trauma was perhaps demonstrated even more lavishly in the visual realm. Aside from films like the aforementioned *Bullet in the Head* (which was intended to be as much a Handover film as a June Fourth commentary), Fruit Chan's 陳果 powerful vision of personal apocalypse on the eve of the Handover, *Made in Hong Kong* (*Xianggang zhizao* 香港製造); Wong Kar-wai's 王家衛 anti-Handover "story of reunion" *Happy Together* (*Chunguang zaxie* 春光乍洩); and Chinese American director Wayne Wang's 王穎 swan song of colonialism, *Chinese Box,* all serve as visual testament to the coming apocalypse—an atrocity that never was.

As the end of the twentieth century approached, the literary and cinematic imagination of Chinese writers and filmmakers had become so accustomed to the taste of blood that they began to not only re-create atrocities and violence of the past but also project that violence into the future. Anticipatory trauma is evidenced in the profusion of dark visions surrounding Hong Kong's 1997 Handover and in other examples, such as Bao Mi's 保密 best-selling fabrication of a PRC–Republic of China (ROC) war in *Yellow Peril* (*Huang Huo* 黃禍). In these works, new questions are raised about temporality, spatiality, history, and the future. In mapping these uncharitable coordinates of the imagination, have Chinese writers finally found a means of escaping from what C. T. Hsia has

termed "obsession with China," or simply a new means of articulating their obsession? I trace the evolution of violence and atrocity in literature and film through a series of historical sites from the 1930s to the early twenty-first century, and demonstrate the ways these depictions have evolved and how a modern Chinese aesthetic of violence has been created.

This project can be viewed, quite literally, as a "literary history," in that it is about literary and filmic conceptions of history. Many of the works examined challenge our constructions of both literature and history, as well as the relationship between and social functions of the two. Readings of these texts often reveal that the line between history and literature, fact and fiction is much more pliable and mutable than we might assume, often stretching beyond the normal parameters of their respective genres and media. At the same time, however, this study is also very much about literary and film history in the traditional sense. Because many of the incidents examined here have yet to receive comprehensive critical study in the West, when appropriate, I have attempted to frame my discussions and close readings of literary and cinematic texts within a historical context. Throughout this study, extended close readings of key texts are juxtaposed against sections of narrative overview tracing the development of cultural representations of these historical events. Providing background and historical data about the authors and texts places the works in a larger context and traces the lineage and development of the various branches of atrocity literature. Just as the writers and filmmakers considered are attempting to fill the gaps in our understanding of these historical events, I attempt to bridge certain gaps in modern Chinese cultural history and explore the formation of trauma narratives in modern China.

Time in Space

In approaching each of these six specific historical incidents, I devote special attention to their temporal and topological coordinates. The selection of specific loci for each chapter not only brings thematic focus to this study but also, more importantly, allows for a better mapping of this new trajectory of cultural history. To this end, the work of Mikhail Bakhtin has again been helpful, most notably his conception of the chronotope, as outlined in his influential 1938 work, "Forms of Time and Chronotope in the Novel." Bakhtin's use of the term "chronotope" refers to interconnected temporal and spatial junctures that appear specifically in literature. In the words of Bakhtin's intellectual biographers, "a *chronotope* is a way of understanding experience; it is a specific form-shaping ideology for understanding the nature of events and actions" (Morson and Emerson

367). A product of social and linguistic forces, the chronotope is based on the utter interdependence of the time-space continuum in literary texts, which it sees as snapshots of the cultural worlds from which they emerge.

I take the Bakhtinian model of the chronotope as my point of departure, and focus on a particular chronotopic coordinate for each chapter. For the Musha Incident, the focus is Musha, a.k.a. Wushe, the site of the 1930 massacre that has since become enshrined as revolutionary sacred ground in the struggle against imperialist aggression. For the Rape of Nanjing, the space is the former capital of Nanjing in December 1937, the date of that ancient city's most recent cataclysm. The coordinates for the February 28th Incident, Taipei 1947, mark the climax of a violent confrontation whose historical scar is still a cause of social and political controversy and unrest some fifty years later. In the chapter on the Cultural Revolution, the focus is on the harsh, mountainous topological terrain of Yunnan province in southwest China and the group of educated youths sent to this backwater region circa 1968. Although often overlooked, this moment marked what was to become one of the most important chronotopic sites, not only during the Cultural Revolution but also during the ensuing "Cultural Fever" of the 1980s. For the final full-length chapter, the perspective shifts north to the capital of Beijing on June 4, 1989, when the student movement was brutally suppressed in the Tiananmen Square Incident. The book concludes with a twist, the Hong Kong Handover of July 1, 1997, when the former British colony finally saw the end of foreign rule, which had lasted for well over a century. Although the focus of each chapter is primarily upon its respective chronotopic site, the Bakhtinian approach serves as but a platform from which to depart.[3] Such a critical device can prove a powerful tool when analyzing groups of texts that collectively share a single chronotopic coordinate; however, its inherent limitations can also be revealed when the forces of the imagination (and sometimes reality itself) compromise traditional temporal-spatial relationships.

The reimagination of these historical spaces involves stretching the spatial and temporal boundaries of specific chronotopic axes, which are otherwise conceived of as sealed and fixed historical moments. The aim here is not only to revisit "chronotopes of pain"—a series of historical atrocities in modern China that have been traditionally each tied to a specific time and place—but also to

3. One departure from Bakhtin's traditional conception of the chronotope is his employment of the term "as a formally constitutive category of literature; we will not deal with the chronotope in other areas of culture" (Bakhtin, *The Dialogic Imagination*, 84). In this study, film, television, and other examples of visual culture are employed alongside literary texts to provide equally important means of approaching the traumatic events considered.

examine how literary and cinematic renderings of those spaces challenge, expand, and redefine our very conceptions of the temporal and spatial boundaries of historical atrocity. Readings of the group of eclectic texts featured in this study show how atrocity can be pushed into a distant future, to haunt different times and places—sometimes even anticipated and preconceived before the nightmare even begins. Although this study structurally proceeds chronologically from 1930 to 1997, indicating a clear linear historical narrative, violence and the popular imagination of historical pain have been mapped out in much more convoluted, complex, and, sometimes, even cyclical ways. While the sequence of events may be linear, the history of narratives, representations, and historiography has proven convoluted, pliable, and often revisionist—a complex dance performed to the varying rhythm of political change, shifting national agendas, and an ever-evolving search for a historical truth beyond history. Beginning with a set of seemingly fixed historical coordinates, this study actually demonstrates the mutability and malleability of history when examined through the lens of trauma, which prewrites acts of atrocity before they are committed and traces the belated manifestations of those acts into new futures and foreign places.

The six chronotopic spaces—along with the new ways they are expanded through preconception, historical extension, spatial displacement, and belated returns—constitute the physical parameters within which these literary and cinematic mappings of violence take place. As Dominick LaCapra has observed, "there is no such thing as writing trauma itself if only because trauma, while at times related to particular events, cannot be localized in terms of discrete, dated experience. Trauma indicates a shattering break or cesura in experience which has belated effects" (2001:186). However, we should not forget that the other end of our axis lies in the unchartable imagination. The spatial and topographical mappings of violence are actually in many ways superseded by imaginary mappings. The writing of this "history of pain" takes place primarily in a realm of projected and imagined memory—a chronotope of the imagination. In charting this series of incidents of mass atrocity and violence, the true negotiation of history takes place not in reality or fantasy, but in the contested site that lies *between* history and literature, fact and fiction, reality and the imagination. It is only when the phantoms of history and the ghosts of the imagination come together to contest and renegotiate the scars of the past that a new understanding of historical trauma begins to arise.

In addition to issues of atrocity, trauma, and violence, other thematic threads linking the five chronotopes are the interrelated themes of mass human migration, movement, dispersal, and ultimately diaspora. The different ways violence has influenced large-scale population changes in modern Chinese history are

well documented, but seldom explored in a cultural context.[4] The Musha Incident was followed by the mass relocation of all survivors, the Rape of Nanjing was foreshadowed by the full-scale evacuation of the city and the retreat of the KMT government to Chongqing, and the February 28th Incident occurred during the critical transition period of 1945–49, in the midst of the evacuation of Japanese forces and the arrival of the Nationalist cavalry. The movement during the Cultural Revolution to send millions of fervent youths to the countryside was not preceded or followed by mass migration; rather, this spatial (dis)positioning *itself* became one of the chief instruments of a new type of social violence. The June Fourth Tiananmen Square Incident served as the direct impetus for a large diasporic movement among students, intellectuals, and opportunists, who traveled overseas in search of their own transnational dreams. While Hong Kong's return to China in 1997 spurred one of the largest exoduses in the port city's history, it also coincided with a new overflow of Chinese from the PRC into the former colony, creating a two-way dynamic of movement and change. Population movement and the politics of both Chinese nationalism and transnationalism are, in many ways, inextricably interconnected to centripetal and centrifugal forces of historical violence. This examination of literary and cinematic violence also attempts to trace the fascinating ways brutality inspires the Chinese national (and transnational) imagination.

Approaching Atrocity

The title of this project, *A History of Pain,* points to the paired coordinates of event and response, history and representation, violence and trauma. The events examined represent historical atrocities of varying scope and impact, each of which has inspired a vast body of artistic responses. And while the incidents have been frequently linked with trauma, often even referred to as "traumatic events," as Joshua Hirsch has argued, "trauma" can never *be* an event:

> Trauma, first of all, is not a thing, like a letter, that can be delivered. It is not even an event, not even a genocide, which cannot in itself be relayed, but which—perhaps this too is unthinkable—merely happens. Rather, trauma, even before being transmitted, is already utterly bound up with the realm of

4. For more on the Chinese diaspora and issues of contemporary Chinese transnationalism, see Aihwa Ong, *Flexible Citizenship: The Cultural Logics of Transnationality* and Laurence J.C. Ma and Carolyn Carier, *The Chinese Diaspora: Space, Place, Mobility and Identity.*

representation. It is, to be more precise, a crisis of representation. An extreme event is perceived as radically out of joint with one's mental representation of the world that one receives from one's family and culture. The mind goes into shock, becomes incapable of translating the impressions of the event into a coherent mental representation. The impressions remain in the mind, intact and unassimilated. Paradoxically, they neither submit to the normal processes of memory storage and recall, nor, returning uninvited, do they allow the event to be forgotten. (15–16)

Specific acts of mass violence and atrocity serve as the structuring device for this book, but the focus is on the traumatic response, or pain, as manifested in literary, cinematic, and other cultural texts—the sites where this "crisis of representation" is played out. And while many of the works examined were produced by victims of, participants in, or witnesses to the events depicted, the majority were produced by writers, filmmakers, and artists experientially removed— sometimes by several generations—from the history they represent. These are two very different strategies from which to approach history; we should not overlook that difference and the fact that each perspective is also imbued with its own unique, inherent set of problematics of representation.[5] This is where the term "trauma" can be difficult, as depictions of atrocity segue from firsthand accounts of trauma-as-experience to vicarious trauma, or imaginary trauma. Freud and others have written about the important place of fantasies in the construction of traumatic memory, but by "imaginary trauma," I mean not a conflation of traumatic memories and the fantasy component that often becomes intermingled with them, but rather a trauma constructed purely on the textual level, without direct experience or observation. This term aims to highlight a particular form of trauma writing and artistic representation that attempts to retrieve not only the bygone historical event—the atrocity, the injustice, the violence—but also the pain, the trauma experienced as a result. In the context of Holocaust studies, this is what James E. Young has described as "memory of the witness's memory, a vicarious past" (Young 2000:1) and what Marianne Hirsch (1997) has described as "postmemory." Other critics, such as Gary Weissman, arguing for a clearer distinction between firsthand experience and other forms of vicarious memory, have proposed the term "nonwitness" for the latter, stressing that "the experience of

5. Although the focus is on Chinese writers and filmmakers' conceptions of violence, I occasionally contrast native Chinese depictions with works by non-Chinese writers such as R. C. Binstock and Paul West, both of whom have published historical fiction that features the Rape of Nanjing as the historical backdrop; or Nishikawa Mitsuru, who has written on the February 28th Incident.

listening to, reading, or viewing witness testimony is substantially unlike the experience of victimization" (Weissman 20). This is also one of the reasons some critics, like Kalí Tal (1996), have limited their studies to works by actual witnesses or survivors of violence. While there are indeed important distinctions between works produced by these different categories of writers and artists that should be acknowledged, I argue that in the context of popular culture and the creation of a textual body of atrocity literature and cinema, works of imagined trauma are in fact no "less real," or less powerful, in the impact they have on the construction of cultural memory, popular discourse, and the national psyche.

Although this book is structured around a series of large-scale historical events, the conception of "trauma" that emerges is a conflation and, sometimes, synthesis of national and individual trauma. LaCapra (1996) has suggested that psychoanalytic approaches that have traditionally been applied to the individual may be extended to also consider the presence of similar neuroses in the collective structures of society as well as in texts (173–174). One example of this phenomenon can be seen with scar literature, a genre of highly personalized narratives of trauma, pain, and suffering faced during the Cultural Revolution, which became synonymous with the national scar China was trying to heal after a decade of inner turmoil. The intertwining of individual suffering and national pain is highlighted in the prelude, which explores representations of individual torture through which the "body in pain" becomes increasingly symbolic of the national body in pain.

Another interrelated facet of the traumatic imagination that emerges as an important subtheme is the intersection of sexuality and ecstasy with violence and pain. While these encounters are manifested in a great variety of forms—obsession, sadomasochism, vicarious experience of rape, etc.—that indicate the depth and complexity of centrifugal or heteroglossic discourse, I *do not* read these as curious or inappropriate perversions of traumatic history, but rather as important narrative and psychological mechanisms for coping with trauma. In the texts analyzed, sex alternately provides a means of subverting, supplanting, superseding, or serving as a stand-in for various forms of violence. While the specific ways it does so vary widely, the startling frequency with which *eros* and *thanatos* crisscross, complement each other, and sometimes collide points to the conflation of sex and ecstasy with violence and pain as a fundamental aspect of the psychic and cultural imagination of trauma. My exploration of this relationship begins in the prelude with the radical juxtaposition of pleasure and pain seen in various representations of torture, and continues throughout the book in a variety of amalgamations, as seen in various texts that challenge the relationship between pleasure and pain—often with the body itself as the site of negotiation and/or battle.

I have also found several key works in the field of trauma theory to be useful, such as those of Dominick LaCapra (1994, 2001), E. Ann Kaplan (2005), Cathy Caruth (1995, 1996), Susan Sontag (2004), Elaine Scarry (1987, 1994), and Shoshana Felman and Dori Laub (1992); the latter two provide a particularly strong argument regarding the power and limits of testimony. At the same time, I have remained sensitive to the fact that many of these theories and approaches were designed to address the particular traumatic phenomena associated with the Holocaust during World War II. The employment of comparative studies in relation to the Holocaust can be problematic for a variety of reasons. Every incident of mass violence or atrocity is, by its very nature, a distinctive event that deserves to be treated with the utmost sensitivity and solemnity. However, there are certain elements of Western studies of the Holocaust instructive for our understanding several of the Chinese cases considered. These include modes of representation and the controversies surrounding them, issues of denial and repression, and the ways group atrocities can shape national character and be appropriated for state propaganda.

Among the dissimilarities between these types of trauma is the Jewish model of cultural memory, which stands in contrast to how the Chinese have remembered the past. Due to the diasporic nature of the Jewish people, the victims are removed from the locations of atrocity, many of which have long since been converted into ghostlike monuments—places to remember and mourn, but not to live. In the Chinese context, people still live where violence occurred, with little (usually no) reminder of what horrors once took place.[6] Although the site is living, it has paradoxically been erased through a form of "topological denial," a denial of the very site of atrocity, which also signals a denial of victimization, suffering, and history. There exists no place of mourning—except through memories. For generations of Taiwanese, Wushe was known not as the location of the bloody Musha Incident, but as a resort getaway, famous for its hot springs. Tiananmen Square is today a popular tourist destination, a place to fly kites and take pictures of the Mao portrait looming over the gate; all traces of bloodshed have been completely erased. The Monument to the People's Heroes still stands high, but any mourning for the students killed in 1989 must be

6. While there are Holocaust museums all over the world, including at the sites of most former concentration camps, the establishment of museums commemorating these various atrocities in China is a relatively new phenomenon. A museum commemorating the Rape of Nanjing was opened only in the mid-1980s in the western suburbs of the city, far off the beaten path. A February 28th Incident museum was established only in 1997, a full fifty years after the event, and, despite petitions from Ba Jin 巴金 and a host of intellectuals and citizens, there has yet to be any progress on establishing a Cultural Revolution museum in China—not to mention one commemorating the June Fourth Incident, which would be a political impossibility under the current regime. In 1995, Cosmos Book Ltd. in Hong Kong did publish a large two-volume *Cultural Revolution Museum*, a textual museum in lieu of one constructed of bricks and mortar.

done in clandestine silence. Though geographic sites associated with mass vio-
lence have often been ignored, the traumatic memories spawned there do not
dissipate. The denial of physical sites of violence means that more meaning
must be placed on the textual mapping of literary and cinematic works about
atrocity—which often become the sole space left for paying tribute, providing
testimony, remembering, and mourning.

Even more fundamental in the very different approach to memory and trauma
of the Chinese is the fact that, unlike the Jews, who were targeted (primarily, but
not exclusively) by the Germans, much of the violence and atrocity faced by the
Chinese during the second half of the twentieth century was self-inflicted. The
Chinese Civil War, the Cultural Revolution, the White Terror, and the countless
political movements and purges suffered under Mao's regime were all examples
of indigenous violence, which creates a much more complex scenario for address-
ing issues of trauma, depression, and healing—let alone the "larger" ideological
constructs such as nationalism and cultural/political hegemony, which often are
grafted onto and superimposed over historical memory. The scars of war, his-
torical atrocity, and political violence can be difficult to acknowledge and heal,
but that challenge is further compounded when the perpetration of violence
emerges not from a foreign regime or colonizing power but from within.

Despite these differences, we must come to terms with the fact that there are
certain fundamental traits that tie all atrocities together. As contemporary Tai-
wanese novelist Wu He, whose work is discussed in chapters 1 and 3, writes,
"the inherent nature of what a 'massacre' entails is always the same, regardless
of the process or final death toll, for a massacre involves a fundamental betrayal
of life by life itself, it is inhuman, cannibalistic" (Wu He 2003:100). While each
and every example of historical trauma deserve to be examined and considered
as a unique event with its own individual narratives of victimhood, perpe-
tration, and testimony—none of which can be easily framed, compared, or
understood—the horrific nature of atrocity and the human toll it takes involve
similar questions that haunt historical memory, whether of Nanjing, Taipei,
Hiroshima, Auschwitz, or Rwanda. This study is an exploration, or "history,"
of pain in modern China. It is a journey into trauma, suffering, and violence
endured over the course of a century as seen through the eyes of contemporary
writers, filmmakers, and other artists. And, although the majority of the artists
considered are Chinese, as are the victims (and sometimes the perpetrators),
their experiences, sufferings, and imaginations speak to all of humanity, all that
makes us human—and, often, all that makes us inhuman.

Prelude

A HISTORY OF PAIN

> History has been *lingchi*-ed, that is, chopped and severed
> as human bodies. We do not see where we are and what
> was before us. Violence is also gradually internalized, insti-
> tutionalized and hidden. We do not see the violence of
> history or that of the State. We can only imagine it.
>
> —CHEN CHIEH-JEN (JOYCE C. H. LIU 2000)

Wu Jianren's History of Pain

Depictions of violence in Chinese fiction and visual culture are by no means an entirely modern phenomenon. In classic works of late imperial literature, such as *Outlaws of the Marsh* (*Shui hu zhuan* 水滸傳), the chivalric tale of 108 bandits, and *Journey to the West* (*Xi you ji* 西遊記), the fantastic account of a monk, a friar, a pig, and a monkey who travel to India in search of Buddhist scriptures, violence and brutality are not only commonplace but also quite pervasive. Most often, however, such depictions are not of national calamity and trauma but instead are rooted in the violence of the everyday—Wu Song's 武松 visceral slaying of a man-eating tiger, or even the seemingly unending series of bloody battles between the Monkey King Sun Wukong 孫悟空 and a league of supernatural nemeses. The great masterworks of late imperial Chinese fiction all largely steer away from depictions of historical violence. The novel, still relatively new and not yet fully accepted as a legitimate literary form during the Ming, was primarily a genre to be read at leisure and perhaps not ideally suited to take on the burden of depicting the dark side of history and human nature. There was, however, no shortage of horrific historical events, many of which were the subjects of very brutal and often disturbing descriptions in diary, essay, poetry, and historical narrative.

* * *

One of the worst incidents of rape, pillage, murder, and urban desecration in late imperial China occurred in 1645 in the Jiangnan city of Yangzhou 揚州. During the Manchu conquest of China, an army descended south along the Grand Canal in order to suppress Ming loyalists in the former capital of Nanjing. In May the Manchu soldiers reached the city of Yangzhou. Forces loyal to the Ming held out for a week against the Manchu onslaught before the city walls were breached and a brutal ten-day slaughter commenced. The best-known account of the what would later be called the Yangzhou Massacre is a short testament by survivor Wang Xiuchu 王秀楚, "An Account of Ten Days in Yangzhou" ("Yangzhou shiri ji" 揚州十日記). Wang's first-person narrative captures the fear and terror he and his family faced as they struggled to survive amid a sea of senseless killings and brutality:

> Several dozen people were herded like cattle or goats. Any who lagged were flogged or killed outright. The women were bound together at their necks with a heavy rope—strung one to another like pearls. Stumbling with each step, they were covered with mud. Babies lay everywhere on the ground. The organs of those trampled like turf under horses' hooves or people's feet were smeared in the dirt, and the crying of those still alive filled the whole outdoors. Every gutter or pond that we passed was stacked with corpses, pillowing each other's arms and legs. The blood had flowed into the water, and the combination of green and red was producing a spectrum of colors. The canals, too, had been filled to level with dead bodies. (Struve 36)

In the larger scheme of Chinese history, the slaughter in Yangzhou fits into a broader continuum of dynastic rises and falls and the historical trauma that often follows such violent transitions. The Yangzhou Massacre took place during a period of particularly significant dynastic change that pitted Han Chinese ethnic groups against the Manchu; the fall of the Ming represented not only the collapse of a dynasty but also, even more devastating for the Chinese, cultural defeat at the hands of a ethnic minority traditionally viewed as inferior "barbarians." Even at this early stage of modern history, such examples of centripetal trauma played an important role in writers' drive to articulate a new vision of China. This period is also the backdrop for one of the greatest traditional Chinese *kunqu* 崑曲 operas, Kong Shangren's 孔尚任 (1648–1718) *The Peach Blossom Fan* (*Taohua shan* 桃花扇), written several decades after the fall of the Ming in the 1690s.

Set primarily in the ancient capital of Nanjing, *The Peach Blossom Fan* represents an early attempt to position the kind of violence and dynastic upheaval described by Wang Xiuchu in "An Account of Ten Days in Yangzhou" within

the context of popular culture—in this case, *kunqu* drama.[1] Kong's play tells of the love between the young and talented scholar Hou Fangyu 侯方域 and the beautiful courtesan Li Xiangjun 李香君. Their story, however, is something of an impossible romance, as it is interrupted by and juxtaposed with the decline of the Ming dynasty and the advancement of the Manchu army. The story of Hou Fangyu and Li Xiangjun also anticipates numerous tales of lovers struggling against monumental historical catastrophes, employing what would later become a key trope in modern Chinese representations of atrocity. An added hindrance to the lovers' reunion comes in the form of corrupt officials who plot to keep them apart because one of them covets the beautiful Li Xiangjun. The intersection of personal love and national tragedy in *The Peach Blossom Fan* is suggested even in the prop that inspires the play's title—a traditional Chinese fan, which, after being sprayed by the protagonist's blood, is brilliantly transformed by the brush of painter/poet/official Yang Wencong 楊文聰 into a crimson peach blossom. Yang's ingenious beautification of the fan is not simply an intervention in the gift exchange between the two lovers but also a broaching of larger issues of representation, an attempt to transmute trauma into beauty. It also serves as a powerful metaphor for Kong Shangren's play, which, after all, is an attempt to transform the blood of historical cataclysm into transcendent stage art.

A History of Pain also takes the trauma of dynastic collapse as its centerpiece. This classic twenty-seven-chapter novel by the late-Qing writer Wu Jianren (1866–1910) was first serialized between 1903 and 1905 in Liang Qichao's 梁啓超 progressive magazine *New Literature* (*Xin xiaoshuo* 新小說). *A History of Pain* was the author's first work of historical fiction, and it alternates between history and fiction as it explores the shift from the Song to the Yuan dynasty. The author's choice of temporal setting is a clear example of "*jie gu feng jin* 借古諷今," or "borrowing from the past to satirize the present." Like *The Peach Blossom Fan*, Wu Jianren's novel explores themes related to the trauma of historical change; however, *A History of Pain*'s meditation on dynastic collapse shows a heightened sensitivity to both the nature of atrocity and a budding nationalism, two themes that were new to the Chinese novel and often intersect in the author's literary landscape.

Another unique feature of Wu Jianren's novel is its narrative strategy and how it serves the author's larger historical and ideological vision. This is especially evident when compared to the approach adopted by Kong Shangren in

1. In an intratextual reference to Wang Xiuchu's memoir, *The Peach Blossom Fan* even features the Ming General Shi Kefa as an important secondary character, a genuine historical figure whose death is actually witnessed in "Ten Days in Yangzhou."

his play. In *The Peach Blossom Fan* the audience/reader is addressed not only by the characters but also by the Master of Ceremonies, a figure whose direct speeches represent a perspective purportedly detached from the action of the play proper. The Master of Ceremonies actually appears in the play, which lends his commentary an added degree of authenticity, as he is a participant in the history playing out onstage. And though the events portrayed are mere dramatizations, in the narrative approach there is always a unified perspective—even when a "detached" storyteller appears, he is not a stand-in for the author but a witness to history.

A History of Pain takes a very different approach. Writing about Wu's other fiction, Patrick Hanan has noted, "The significant point about Wu Jianren's choice of restricted narration, whether first-person or third-person . . . is that it excludes the authoritative narratorial voice, replacing it with the reflections and judgments of characters who, while not duplicitous, are unreliable because of their ignorance or naiveté" (Hanan 180). But in *A History of Pain*, Wu Jianren uses a very different narrative strategy. Although the third-person narrative freely flows between detached historical accounts and detailed descriptions of the protagonists' actions, throughout the novel, Wu Jianren constantly interrupts by providing first-person (seemingly authorial) commentary on events, actions, and characters. Often set off by parentheses, Wu Jianren's narrative admonishments, exclamations, and observations are interjected throughout the text: "You see, this is the result of betraying your country in order to eke out a meager existence for yourself! Tell me is it not terrible!" (29). Such phrases, not uncommon in traditional Chinese literary narrative, function here as "words of estrangement," elements that clearly distance the author's consciousness from that of his characters and his narrator. More often than not, the presence of the author (and his observations and ruminations) serves a refracted nationalistic agenda, because, although the authorial voice is purportedly commenting on the internal events of the novel, astute readers will quickly see the parallels between the late Song and the late Qing, making Wu Jianren's outraged interpolations not just commentary but a call to arms.

One of the first features to strike readers of *A History of Pain* is the narrative's display of nationalist sentiment. As Patrick Hanan observes, "Wu Jianren is probably the best example of the change to the modern in Chinese literature, if you understand 'modern' as requiring two conditions: a concern on the part of the writer with the national and, more particularly, the cultural crisis that faced China; and an attempt to express that concern by nontraditional literary methods" (Hanan 162). These comments have been echoed by numerous other scholars, including Wu Jianren's translator Shih Shun Liu, who observes that among the prolific writer's body of works, *History of Pain* "was the most patriotic" (Wu

Wo-yao xii). This budding nationalistic consciousness is evident from the very outset of the novel, which begins:

> The earth is divided into five continents, each of which is made up of ten thousand nations. Although in ancient times there was no such conception of "five continents," there has always existed the concept of a nation. And since there have been nations there have been competition and struggles. The strong triumph and the weak meet with defeat. . . . But people of each nation always recognize their mother country; the soil of the country on which you are born shall too decide the country to which your ghost will return after death. No matter how the enemy may rape us or try to win us over, I cannot turn my back on my conscience and forget what is most fundamental by kissing up to the foreigners. No matter how much stronger the enemy may be, they must never destroy my country. And if they are truly bent on destroying this nation, they will do so only if they wipe out every last living breathing person who calls this place home—then, and only then, will they be able to win over what will be a piece of utterly deserted land. (Wu Jianren 1)

It quickly becomes evident that lurking behind nationalistic outcries is a painful past. *A History of Pain* is composed of numerous vignettes centering on a series of actual historical figures prominent during the Song–Yuan transition. The novel opens with an episode not entirely dissimilar to the central action in *The Peach Blossom Fan*, in which two corrupt court officials collude with a greedy eunuch in order to sneak a beautiful young concubine out of the imperial palace so that one of the officials can take her as his wife. Their plot is all the more egregious because it takes place during a time of national calamity—the Mongols are launching a massive onslaught on the Song empire. The officials not only ignore repeated warnings and emergency calls for help from the provincial areas but also go to great lengths to hide the truth from the emperor, further expediting the fall of the dynasty. Descriptions of the emperor as lacking assertive leadership qualities and inundated in a sea of women, drink, and pleasures of the flesh also creates a degree of culpability on his part. The Mongols may be posited as the novel's "villains," but Wu Jianren makes clear that their victory is facilitated by the drunkenness, lust, irresponsibility, and collective selfishness of the Song. Here we see also a parallel to the late Qing, when the excesses of the Dowager Empress's court in the face of imperialist conquest, uprisings, and eventually revolution, were all too transparent. The result of this lack of national consciousness is violence manifested on both individual and national levels. In fact, it could be argued that the rise in depictions of national scourges not only mirrors but in some ways also is inextricably intertwined with

the rise of new conceptions of nationalism in late-Qing China among writers and intellectuals like Wu Jianren.

Throughout *A History of Pain,* the reader witnesses numerous scenes of massacre and violence, such as the following description of Mongol General Zhang Hongfan 張弘範 admonishing his subordinates for not capturing any enemy generals alive before ordering the complete annihilation of an entire city:

> Upon learning that the three Song generals all took their own lives before they could be killed or captured by his troops, he responded with anger: Hongfan was furious and admonished his generals, "Why didn't you bring back one or two alive so I could personally kill them to get my vengeance!" Without any words to respond, the generals stood in silence. Hongfan sent down the order "Massacre the city." Those Tartars had already been brutal and merciless in their raping and pillaging—there was already no crime they had not committed. But now they were given the order to massacre the city! Pity the city of Fancheng; the murder was such that heaven cried and the earth screamed, neither the sun nor the moon shone, bones formed mountains, and blood rushed like a river. [The reader] will be spared detailed descriptions of the miserable scenes that transpired. (You see, this is a horrific situation when another ethnic group vanquishes our own! Tell me is it not terrible!) (26)

This passage features yet another example of the narrative interventions (in parentheses) on the part of the author, who here comments on the violence and implies an underlying ethnic/national consciousness. The enunciation of nationalist agendas also simultaneously highlights the author's own positioning as a late-Qing intellectual writing during a time when the development of a national consciousness was seen as imperative for the salvation of the Chinese nation.

By way of contrast, we can see how Wu Jianren presents the speech of the "upright" Chinese General Zhang Shijie 張世傑 from the Song army, who also uses nationalistic rhetoric to persuade ethnic Chinese soldiers fighting for the Tartars to defect back to the imperial army. Here the connection between ethnic violence and nationalistic sentiment is made even more palpable:

> Zhang Shijie gave a speech to those Chinese [soldiers serving the Mongol army]; he said: "We are all Chinese people, and we are also all subjects of the Song dynasty. It is very possible that your hometowns have already fallen to the Yuan—but this is still China's land and someday it must still be reclaimed. You must know that the Mongols are our enemies; how can you willingly serve our enemies!? (31)

As Zhang Shijie continues his speech, his rhetoric of implied nationalism quickly turns to rhetoric of implied cannibalism when he begins to suggest the consequences of the violence:

> "Although men like Zhang Hongfan, Dong Wenbing 董文炳, and Lu Wen-huan 呂文煥 have completely lost their hearts and conscience, they did so in order to attain high offices and riches. But what benefit are you soldiers getting!? You are simply working yourself to death for them. You must understand the sinister minds of the Mongol Tartars who have pulled you into their ranks to do battle with China. If they win, they will have driven you Chinese to kill other Chinese. And if they should fail, when our army kills you, it too will be Chinese killing Chinese. But all the while it is us brutally slaughtering one another; they want us to wipe out one another's families in order for those damn Tartars to occupy our good land! Those of you willing to serve in the [imperial] army, stay where you are. And those of you not willing, return to your farms. I promise not to force anyone to serve." With those words, everyone was moved to tears. In unison they all agreed to follow the general in his quest to wipe out the enemy, repenting of their former sins. (31–32)

In these passages, Wu Jianren positions the threat of indigenous killing alongside nationalistic sentiment. For Wu, perhaps even more horrific than the massacres and physical violence being perpetrated throughout China during the war between the Song imperial army and the Mongols was the fundamental loss of national identification. Wu's vision, however, is not limited to the battle-field and the large-scale struggle; it is also manifested on an individual scale throughout the text. One example occurs after the aforementioned plot by the Song officials to conceal facts from the emperor (and steal his concubine). After the emperor learns the truth about the Mongol assault, he falls ill from the shock, and the corrupt officials Jia Sidao 賈似道 and Meng Yan 夢炎, in concert with the eunuch Wu Zhong 巫忠, set out to dispel what he has heard as mere "rumors" and track down and punish the person responsible for spreading them. The result is a public execution of an imperial concubine.

> As he thought about it, [Jia Sidao] picked up a copy of *Peking News*. As he opened it up he noticed two red notices posted on the first page. The first one read:
>
> > On decree of the Empress: The Imperial Concubine Wanfei who holds the surname Zhang is charged with fabricating disturbing rumors that resulted in shocking the Emperor on High. This is a terrible crime of the utmost

seriousness. The woman of the surname Zhang is to be stripped of her official name Wanfei and shall be sent to the third penal division to be executed.

Upon reading the edict, Sidao clapped his hands in joy: "Now this really is a good way to release all my pent-up anger! This must be the good news Wu Zhong was talking about; although it is not good news in the traditional sense, it sure is good for me!" (21)

Although this description of an individual execution (and numerous others like it that appear in the text) pales in comparison to the descriptions of the large-scale massacres of Chinese cities during the Song–Yuan transition, the two levels of violence reflect each other, and both signal a similar breed of indigenous killing. When Zhang Shijie describes the war, it is essentially a Chinese-on-Chinese slaughter in the service of the Mongols, and when Wanfei is executed, it is corrupt Chinese officials executing a Chinese in order to serve the greater good of the Mongols. Even more disturbing in the second example is the way the author positions execution and pain alongside entertainment and pleasure. Jia Sidao's gleeful reaction to the execution, in which he no doubt played a major behind-the-scenes role, is a voyeuristic enjoyment of violence (albeit through the mediated forum of a newspaper). The "horrific pleasure" of watching or reading about execution may be but a footnote to the massive dynastic upheaval that pervades *A History of Pain,* but it also serves as a chilling foreshadowing of the body as a site of personal pain, national trauma, and voyeuristic pleasure as it would be further articulated by Lu Xun and Chen Chieh-jen.

Wu Jianren's *A History of Pain* was never finished, and was only posthumously published in single-volume format in 1911—the final year of China's last dynasty. Its incompleteness speaks to the fact that modern China's painful history was only just beginning. Wu Jianren passed away in 1910, so he did not witness the vicissitudes that China would endure in the twentieth century. Instead, a young writer from Shaoxing would prove to have the strongest voice when it came to articulating how this new page in China's history of pain should be written.

Lu Xun and Modern Chinese Literature's Genealogy of Violence

Throughout his corpus of work, Lu Xun (1881–1936) illuminated the dark cultural forces already present in the Chinese tradition. His fictional legacy has influenced subsequent generations of Chinese writers and created a strong tradition of writing trauma in modern Chinese fiction. Lu Xun pioneered a modern

vernacular, as well as a powerful way of identifying and framing what would become key thematic concerns: the city versus the country, tradition versus modernity, the plight of the intellectual, a critique of Chinese historic and cultural traditions, and, of course, violence and "cultural cannibalism," which held a central place in his fictional universe. Violence, cannibalism, and the other dark aspects of Lu Xun's work have been the subject of numerous academic studies;[2] Lu Xun is referenced here not to belabor these points, but to acknowledge the profound impact his work has had on Chinese literature, specifically on atrocity fiction and artistic representations of violence in China. His writings have been inspirational for many of the writers whose works are analyzed in this book, and have been an instructive tool for contextualizing and examining many of the texts considered—especially in terms of their framing of modern China's obsession with violence.

When Lu Xun published the landmark story "Diary of a Madman" ("Kuang-ren riji" 狂人日記) in 1918, he became a pioneer in the modern vernacular movement that would transform Chinese literature and lay the foundation for a long tradition of focusing on violence, barbarism, and cannibalism (both literal and metaphoric) within modern literature.[3] Lu Xun's decision to begin his career in fiction with a dark parable of cannibalism is paralleled by an experience he had years earlier in Japan, which became the impetus for the student to abandon a career in medicine in favor of literature:

I do not know what advanced methods are now used to teach microbiology, but at that time lantern slides were used to show the microbes; and if the lecture ended early, the instructor might show slides of natural scenery or news to fill up the time. This was during the Russo-Japanese War, so there were many war [slides], and I had to join in the clapping and cheering in the lecture hall along with the other students. It was a long time since I had seen any compatriots, but one day I saw a film showing some Chinese, one of whom was bound, while others stood around him. They were all strong fellows but appeared apathetic. According to the commentary, the one with his hands bound was a spy working for the Russians, who was to have his head cut off by the Japanese military as a warning to others, while the Chinese beside him had come to enjoy the spectacle.

2. Among the important English-language studies of Lu Xun, Leo Ou-fan Lee's *Voices from the Iron House: A Study of Lu Xun* and Tsi-an Hsia's *The Gate of Darkness: Studies on the Leftist Literary Movement in China* stand out for their attention to the darker aspects of Lu Xun's fiction.

3. While Lu Xun continues to be regarded in China as the father of modern Chinese literature, David Der-wei Wang has argued for the origins of Chinese literary modernity to be pushed back much earlier, to the mid-nineteenth century. See David Der-wei Wang, *Fin-de-Siècle Splendor: Repressed Modernities of Late Qing Fiction, 1848–1911*.

Before the term was over I had left Tokyo, because after [seeing this slide] I felt that medical science was not so important after all. The people of a weak and backward country, however strong and healthy they may be, can only serve to be made examples of, or to witness such futile spectacles; and it doesn't really matter how many of them die of illness. The most important thing, therefore, was to change their spirit, and since at that time I felt that literature was the best means to this end, I determined to promote a literary movement. (Lu Hsun 1977:2–3)

This decapitation scene has been described by numerous critics such as David Der-wei Wang as the "primal scene" of modern Chinese literary creation. The formation of modern Chinese literature began with an image of violence—a trauma on which rests a multitude of questions concerning memory, modernity, and representations of violence. Rey Chow has discussed the scene in terms of its traumatic underpinnings and also highlights the "modernist shock" that results from the combination of the beheading and the new, technologized visuality implicit in the description, bringing to light the often overlooked relationship between "visuality and power, a relationship that is critical in the postcolonial non-West and that is made unavoidable by the new medium of film" (Chow 6). Built into Lu Xun's primal scene, haunted by the specters of decapitation and cannibalism, are several layers of distance and refracted observation.[4]

Reading Lu Xun's account of the traumatic beheading, we can pinpoint at least five levels of spectatorship bearing witness to the event. The first group of spectators is of course the "apathetic" Chinese shown in the slide, who have "come to enjoy the spectacle." They go on to appear and reappear in Lu Xun's fictional world, ridiculing Kong Yiji in the local wineshop ("Kong Yiji"), sneering at Xianglin's Wife as she is slowly driven out of her mind ("The New Year's Sacrifice"), and gawking at Ah Q during his execution ("The True Story of Ah Q"). Next are the "clapping and cheering" Japanese students, and while Zhou Shuren 周樹人—the young medical student who would later become widely known by his pen name of Lu Xun—sits among them, he is in fact also observing them, commenting on, critiquing, and analyzing their behavior. These three levels of

4. At the same time, we should not forget that "other" primal scene in Lu Xun's oeuvre: the passing of his father in 1896, which was hastened, if not provoked by a lethal combination of traditional Chinese medicinal "cures." The treatments to which Lu Xun's father was subjected included drinking ink and ingesting "drum skin," an alternate version of the traditional Confucian remedy of a son or daughter boiling a slice of their own flesh to feed to a sick parent—one of the highest manifestations of filial piety. This traumatic experience, as recounted in the 1926 essay "Father's Illness" ("Fuqin de bing" 父親的病), played a key role in young Lu Xun's decision to study Western medicine in Japan as a rejection of the feudal superstitious traditions that contributed to his father's death. The slicing of one's flesh can also be read as a microcosm of the *lingchi* 凌遲, the torture to be described the following section.

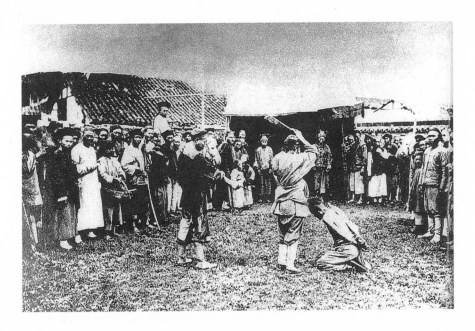

Photograph of a beheading from the late Qing dynasty—an image similar to that purportedly witnessed by Lu Xun in Japan?

spectatorship are in turn digested by a much more mature Lu Xun, writing some twenty years later on his "general's orders" to take up the pen during the height of the May Fourth New Culture Movement. Between these levels of witnessing—the final layer being our own spectatorship of Lu Xun's complex testimony of terror—are many hermeneutical layers and perspectives to navigate through.

Through the matrix of representation laid out in Lu Xun's "Preface to *A Call to Arms*," we cannot help but wonder just where narrator Lu Xun truly stands. As Gao Yuandong 高遠東 has noted, from details like the writer's choice of the Chinese term *jianshang* (鑑賞), here rendered by Yang Hsien-yi and Gladys Yang as "enjoy the spectacle," to describe the original scene, there is a hidden level of narrative betrayal. *Jianshang* is not just "to enjoy," but "to appreciate," as in a fine work of art, a priceless antique, or ancient stone calligraphy rubbings. Its appearance here describing a group of (most likely illiterate) peasants or workers' reaction to a brutal execution not only is out of place but also signals a narrative fissure between the scene described and the values of the cultured Lu Xun. Gao's observation hints at the challenges involved in any attempt at representing violence. Historical distance is often believed to bring clarity, but it can also bring increased complexity and uncertainty. And we must not forget the most fundamental level of witnessing, which has been left out of the equation by both the reader and Lu Xun—that of the executed man. His testimony is

forever lost. All Lu Xun (or we) can do is begin a cycle of continually rewitnessing and reimagining that bygone moment, each time from further and further away, both psychologically and historically, just as Lu Xun himself kept returning to that scene in his later fictional works. In investigating representations of atrocities in modern China, we should not forget the lessons already lurking in Lu Xun's original parable.

Even more instructive is the suggestion by some critics that the scene may not even be the traumatic primal scene it is supposed to have been, but rather another facet of Lu Xun's *fictional* imagination—an ingenious creation myth for a new modern literature and a new modern nation. As David Der-wei Wang observes, "Lu Xun is known to have manufactured or refashioned personal experience for literary purposes. The case of the decapitation suggests that fiction and (private and public) history might have become inextricably confused, at the (textual) beginning of modern Chinese (literary) history" (Wang 2004:21).[5] The suggestion that the iconic moment that supposedly gave rise to Lu Xun's fictional universe was yet another fiction carries potentially devastating consequences for a series of deeply imbedded literary views. But also under examination is the relationship between history and fiction, or, more succinctly, historical atrocities and fictional representations. What does it mean to be a witness to atrocity? And what does it mean to be a witness to an atrocity that never happened—or was never actually witnessed by anyone save the victims?

The trauma that Lu Xun experienced in witnessing (albeit via a projected image) the imminent death of his compatriot and the apathetic look of the crowd of Chinese spectators, coupled with the enthusiastic reception the image received from the Japanese audience, left an indelible psychological scar. Throughout his body of fiction, Lu Xun would constantly revisit that trauma through representations of violence, executions, symbolic cannibalism, and the numbed gaze of onlookers. This pattern of trauma, representation, and re-representation is very much a focus of this study, and very much part of the heritage of literary violence Lu Xun left.

Chen Chieh-jen's *Lingchi* and the Dissection of History

The aforementioned combination of enjoyment/pleasure and torture/pain articulated in Lu Xun's work is not as perverse and contradictory as it might seem when considered as part of China's long tradition of public executions, which

5. It should be noted that Wang is here rearticulating a premise first put forward by Leo Ou-fan Lee in his landmark intellectual biography of Lu Xun, *Voices from the Iron House*, 18.

often served as a highly anticipated form of entertainment for the masses. Besides reinforcing the state's power to discipline and punish and serving as a public example, for many, these displays of violence were indeed spectacles to be enjoyed. Depictions of such events also became common in modern Chinese literature, particularly in the works of Lu Xun and the prolific May Fourth writer Shen Congwen 沈從文 (1902–88), who as a young man would often describe such scenes in both his fiction and his autobiographical writings.[6] But among these public beheadings and other carnage, none created a bigger spectacle and displayed the perverse combination of pleasure and pain than the *lingchi,* or "death by a thousand cuts."

The punishment of *lingchi* can be traced as far back as the Five Dynasties period (907–960) and was not abolished until the last years of the Qing dynasty. This thousand-year tradition was a form of state-sanctioned capital punishment in which the victim would be tied to a pole standing upright, his braided pigtail fastened to the pole so his face was tilted up. The criminal would then be slowly flailed alive, his flesh stripped and his appendages gradually severed. Although the popular imagination often depicts *lingchi* as having been designed to ensure that death would be as prolonged as possible, in many cases, death came swiftly, often with a puncture to the heart soon after the beginning of the procedure. But *lingchi* was also known to sometimes be drawn out, lasting for up to two days, and, according to some, executioners themselves faced punishment if their victims died too quickly. Criminals were often given large amounts of opium as the torture was inflicted, to keep them in a state of semiconscious euphoria. Reconstructing the types of reactions experienced by crowds who gathered to witness the spectacle is a complex task, but from various literary and visual sources, we can imagine a wide range of emotions, from shock and pleasure to fear and awe at this most merciless display of state power. According to some accounts, onlookers would salvage remnants of human organs and flesh from the ground around the execution platform for medicinal uses. Photographic images of the torture also turned up in the early twentieth century, circulating on postcards to feed the macabre side of *chinoiserie* in the West. Such images were no doubt also displayed to enhance Euro-American

6. Among the numerous examples in Shen's work is the short story "The New and the Old" ("Xin yu jiu" 新與舊), a nostalgic look at a headsman whose job is rendered obsolete by "modern and civilized" forms of execution. Another is the semiautobiographical short story "Three Men and a Girl" ("Sange nanren he yige nuren de" 三個男人和一個女人的) (1930), where Shen writes, "When we approached the place of execution, we saw four corpses lying in the field, stripped to the waist and resembling four dead pigs. Many young soldiers were playing about with the bodies, pricking their throats with little bamboo sticks; and there were a few dogs waiting in the distance" (Shen Ts'ung-wen, *The Chinese Earth,* 123).

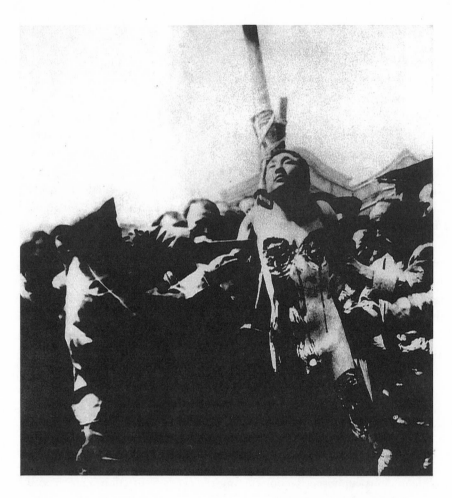

Photographic image from a late-Qing *lingchi*, a brutal torture used to execute criminals.

ethnocentrism by further emphasizing the barbaric and "uncultured" nature of the Chinese.

Among the Westerners who saw these images was the French writer and theorist Georges Bataille (1897–1962). One photograph Bataille came into possession of documented a *lingchi* reported to have occurred on April 10, 1905 in Beijing. The victim was originally identified by photographer Louis Carpeaux as Fou-Tchou-Li [*sic*] (Fuzhuli 幅株哩), a criminal found guilty of murdering Prince Ao-Han-Ouan [*sic*]. According to Georges Dumas and Carpeaux, who reproduced one of the images in his 1923 book *Traité de psychologie,* the original sentence of death by burning was deemed too cruel by the emperor, who

"reduced" the punishment to *lingchi*. Although the circumstances surrounding Fuzhili's crimes as detailed by Carpeaux have been shown by Brook, Bourgon, and Blue (2008:224–225) to be erroneous, the story behind the images has persisted for more than a century. Georges Bataille claims to have first seen the image in 1925, when it was given to him by a psychoanalyst. Bataille attested that "this photograph had a decisive role in my life. I have never stopped being obsessed by this image of pain, at once ecstatic(?) and intolerable. . . . I discerned, in the violence of this image, an infinite capacity for reversal. Through this violence—even today I cannot imagine a more insane, more shocking form—I was so stunned that I reached the point of ecstasy" (Bataille 206). This highly cultured man's enjoyment of the spectacle bears a striking similarity to the "cultured" action of *jianshang* that Lu Xun first attributed to the Chinese spectators in the original image of the execution. Writing about this brutal scene and Bataille's reaction to it, Susan Sontag has observed:

> To contemplate this image, according to Bataille, is both mortification of the feelings and a liberation of tabooed erotic knowledge—a complex response that many people must find hard to credit. For most, the image is simply unbearable: the already armless sacrificial victim of several busy knives, in the terminal stage of being flayed—a photograph, not a painting; a real Marsyas, not a mythic one—and still alive in the picture, with a look on his upturned face as ecstatic as that of any Italian Renaissance Saint Sebastian. As objects of contemplation, images of the atrocious can answer to several different needs. To steel oneself against weakness. To make oneself more numb. To acknowledge the existence of the incorrigible.
>
> Bataille is not saying that he takes pleasure at the sight of this execution. But he is saying that he can imagine extreme suffering as something more than just suffering, as a kind of transfiguration. It is a view of suffering, of the pain of others, that is rooted in religious thinking, which likens pain to sacrifice, sacrifice to exaltation—a view that could not be more alien to a modern sensibility, which regards suffering as something that is a mistake or an accident or a crime. Something to be fixed. Something to be refused. Something that makes one feel powerless. (Sontag 2004:99)

Sontag brings our understanding to another level through her introduction of comparative religious iconography; placed within a Judeo-Christian context, the pain, sacrifice, and martyrdom take on new meaning that points to a kind of transcendence. What is not taken into consideration, however, is the role that opium plays in the act of *lingchi* and in the photograph. If the victim, having been forced to ingest large amounts of liquid opium, is, as he appears to be, in a

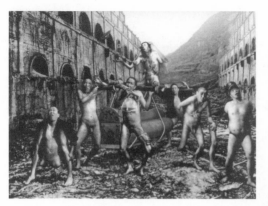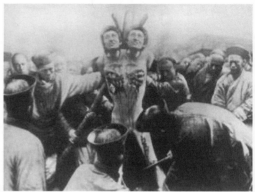

Two images from Chen Chieh-jen's *Revolt in the Soul and Body* series: (left) *A Way Going to an Insane City* (1999); (right) *Geneaology of Self* (1996). Courtesy of the artist.

state of euphoria, then does his body *feel* the pain at all? And if not, where is the pain? Who feels it?

Bataille's writings inspired contemporary Taipei-based artist Chen Chieh-jen to transpose the disturbing images of the *lingchi* into his own body of work and attempt to answer some of these questions. In the process, Chen provided a powerful series of visual metaphors for the relationship between the past and the present, execution and ecstasy, history and representation, the self and the other. Born in 1960 in Taoyuan, Taiwan, Chen Chieh-jen began to gain notice in the 1980s for his performance art staged in Taipei. His public performance pieces and radical reconceptions of the human body pushed the boundaries of artistic freedom in martial law–era Taiwan. In the mid-'90s, with renewed political and technical freedom via computers, Chen began digitally manipulating archival historical photographs. The fruits of this work were first revealed to the artistic community in the shocking *Revolt in the Soul and Body* (*Hunpo baoluan* 魂魄暴亂) series, which featured images of actual criminal executions, including late-Qing public tortures, Nationalist-era executions of communists, and Japanese beheadings of aboriginal Taiwanese. Several of these include the artist himself alternately in the role of victim, torturer, spectator, and often all three. It was through this radical series that Chen began using the *lingchi* as the subject of his work. In 1996, the artist appropriated the very image that had so fascinated Georges Bataille in a work entitled *Geneaology of Self* (*Benshengtu* 本生圖). Through a digital duplication of the victim's head, Chen Chieh-jen further contorted the already grotesque visual document of suffering, prodding his audience to view the spectacle of torture in a new light.

"Violence and ecstasy": (left) Chen Chieh-jen's contemporary restaging of a *lingchi* and (right) close-up of the victim/criminal's opium-induced ecstasy. Courtesy of the artist.

Geneaology of Self marked the beginning of Chen Chieh-jen's long medita-tion on violence, torture, and cruelty in Chinese history and society. He revis-ited these motifs repeatedly through such works as *The Image of an Absent Mind* (*Huanghu tu* 恍惚圖) and *A Way Going to an Insane City* (*Fengdian cheng* 瘋癲城), where Chen inserted himself into his postmodern artistic construction. In 1996's *Portrait of Self-Mutilation* (*Zican tu* 自殘圖), a Republican-era photograph documenting a street execution in Manchuria is haunted by a mutant figure with two torsos, mirror images of each other. One wields the blade of the execu-tioner while the other is being decapitated; Chen's likeness appears on both faces. *A Way Going to an Insane City* also features the image of the artist, marching with an army of his clones carrying a coffin and severed limbs toward an unknown destination. The cannibalistic references are implicit as Chen at-tempts to push Lu Xun's critique of Chinese morality into a new dimension and, in the process, delve into the very heart of physical, psychological, and historical pain. The disturbing power of Chen Chieh-jen's conception of his-tory is felt most forcefully when he steps away from the photographs manipu-lated through his computer and picks up the camera to create his own images.

In 2002 Chen revisited the image of the *lingchi* he had first appropriated for his 1996 work *Genealogy of Self.* This time, however, he expanded his medita-tion on brutality into a penetrating twenty-two-minute, thirty-four-second in-stallation film,[7] which was originally shown in museums on three large screens. *Lingchi: Echoes of a Historical Photograph* revealed a sophisticated dissection of

7. Note: this analysis is based on an alternate twenty-five-minute version of the film, provided by the artist.

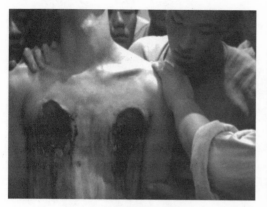

"Shot–reverse shot": (left) Medium shot of the gaping chest wounds and (right) reflections of the victim in the camera's lenses. The lenses not only reflect the victim's facial expression of suffering/ecstasy but also physically reflect the circular wounds carved into his chest. Courtesy of the artist.

torture by painstakingly re-creating the horrific process of torturing a victim by gradually slicing off his flesh. What could easily have turned into a morbid exercise in fetishized, masochistic violence is elevated to a sublime level that not only explores the nature of pain but also questions the philosophical underpinnings involved in witnessing and representing historical violence.

In the film, an anonymous man is silently stripped of his clothing, bound to a pole, and forced to ingest liquid opium before being gradually flayed alive by the executioner. As the torture continues, the perspective continually shifts from the victim to slow, panning portraits of the crowd who have come to witness the spectacle, all of whom gaze in silence, looking numbed, emotionally deadened. Chen Chieh-jen's conception of "the crowd" and their apathetic response to the extremes of bodily torture being carried out before their eyes is, without question, indebted to the primal scene described in Lu Xun's "Preface to *A Call to Arms*." However, Chen's reflection on and re-creation of the nature of pain after nearly eighty years is rooted in a new imagination of historical violence that reframes not only Lu Xunian discourse but also our very understanding of atrocity.

Besides the ominous, looming gazes of the crowds of spectators, Chen introduces a Western photographer and his camera, which adds another layer of historical and artistic reflexivity to the film. The presence of the photographer not only accentuates the action of watching, already implicit in the gazes of the onlookers, but also opens up a rift between the Chinese self being objectified and the Western other who captures the moment in his lens. Similarly, the camera also serves as a time tunnel through which the *lingchi* may travel to our own eyes—to the other group of spectators not seen in the film. This power of the

"The crowd," the numbed, expressionless witnesses from the past (left) and the present (right). Courtesy of the artist.

camera to witness is accentuated by its physical representation in the film. The two photoscopic lenses, which seem to mimic a pair of eyes, not only accentuate its power to witness atrocity but also hint at its power to *inflict* pain. The image of the alternately tortured/ecstatic victim is not just reflected in the camera's eyes; the two lenses also seem to function as a weapon actually boring holes or "shooting" into the victim's chest. This imagery is made explicit during a shot–reverse shot sequence in showing first the gaping holes carved in the victim's chest and immediately afterward, a close-up of the camera. This points not so much to the physical pain of the victim but to the psychological pain of being objectified and put on display, both for the onlookers and for the countless other future witnesses who will gaze through the perspective of the camera. The reflection of the victim's face in the lens hints at the reciprocal relationship between the camera and the victim; the image of pain is now eternally trapped in the camera, to be printed, displayed, and, through mechanical (and now digital) reproduction, continually re-created for future "crowds" of onlookers.

The violence implied in witnessing (and photographing) is highlighted throughout the film in the aforementioned shots of the apathetic witnesses. This series of faces dominates the film, their images inextricably intertwined with the torture being carried out before them. In *Lingchi*, the executioner's cuts to the victim's bound and drugged body are often displaced by the director's cinematic "cuts," replacing the most horrific moments of bodily violence with images of the crowd—their empty, dead gazes foreshadowing the fate of the condemned. During these disturbing sequences, Chen Chieh-jen takes a daring approach to history by intercutting not only the group of male "witnesses" from the time of the execution but also a crowd of contemporary female spectators who also witness the scene.

It is also here in his portrayal of the onlookers that Chen Chieh-jen comes closest to answering the question of just where the pain should be positioned. The stark contrast between the ecstatic transfiguration of the opium-drugged victim and the morose, haunting appearance of the onlookers pushes us away from Lu Xun's condemnation of the crowd as numb, morally vacuous spectators and toward a new interpretation that sees them as the actual victims. Elaine Scarry has discussed the inexpressible nature of bodily pain; here, its articulation is refracted to another. "As physical pain destroys the mental content and language of the person in pain, so it also tends to appropriate and destroy the conceptualization and language of persons who only observe the pain" (Scarry 1985:279). In *Lingchi* Chen suggests that if pain is denied the executed (through his ingestion of mind-altering drugs), it is perhaps deflected to the audience, who become the true carriers of the inflicted violence.

In an artist's statement from one of his exhibitions, Chen provides some insight into the breakdown between these layers of witnessing in his work: "I cannot stop gazing at these photographic images of anonymous people being tortured, executed. It seems that behind these images you can uncover another layer of image and unspoken hidden words. In the trance of gazing at photographic images I was often seeing myself to be a victim, or a persecutor, or a collaborator in the photographs." In this scene, however, Chen goes even further to break down boundaries not only among victims, persecutors, and collaborators but also between the past and the present. *Lingchi* explores the blurring of the subject and the object, the observer and the observed, while delving into the complex layers involved in witnessing. What does it mean to observe the very site of that 1905 atrocity, versus a reproduction staged one hundred years later? Although there are inherent differences, Chen Chieh-jen seems to argue that the perspectives of the viewers and participants in each situation are not entirely dissimilar, and on one level, their pain may be the same. To

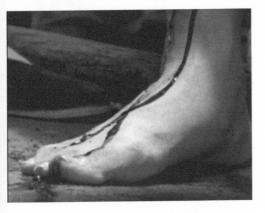

(left) Blood running down the legs of the contemporary spectators; (right) a close-up of blood dripping down the foot of the torture victim; and (center) two streams of blood flowing together to form a puddle. Courtesy of the artist.

illustrate this point, the film employs a series of daring montage sequences demonstrating the complex relationship among the different groups.

In one sequence we see a medium close-up shot of blood running down the legs of the contemporary spectators, which cuts to a close-up of blood running down the foot of the torture victim and onto the ground. In a third shot, a puddle of blood forms on the ground from two streams, implying the union of blood shed by the victim and by the observers gazing at his pain a century later.

The breakdown of past and present, witness and victim is highlighted further when the camera assumes the point of view of the victim himself. Instead of offering the traditional eye-level perspective, the camera takes the position of the chest wound. Gazing out from the two gaping holes, the camera gradually pans from left to right. Through the left-hand side we see the crowd of onlookers in late-Qing garb side by side with the Western photographer capturing the moment on film. As the camera pans to the right, a second set of witnesses is revealed through the right-hand chest cavity, this time the contemporary women gazing back. The women, who are a group of laid-off factory workers, represent the "living history" of pain, casualties of the postindustrial age. The key difference from their earlier appearance is that this time a young man in a uniform is in their midst. As they slowly pull back his shirt to reveal two massive chest wounds, he is identified as a double of the torture victim, a historical ghost returning to haunt the present. Although these sequences break down the divisions between the ways atrocity is witnessed at different times, we should not forget that both groups of witnesses are in fact reconstructions. Chen calls attention not just to the horrific act of the *lingchi* and historical torture but also to the complex process of reconstructing that torture and bearing witness to that reconstruction. As meticulous as Chen Chieh-jen's restaging of history may be, he is also reminding us (often through small details, like the modern hairstyle of the condemned man) that the entire film is, like his earlier digital

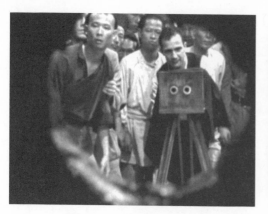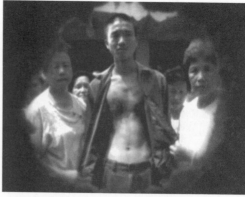

"Traveling to the center of pain": (left) Observers and a Western photographer in late Qing–era costume as seen through the wound in the victim's left chest. The camera pans slowly to the right to reveal (right) observers in modern dress through the hole in his right chest. Courtesy of the artist.

photographs, a manipulation. The variety of perspectives that dominate the viewing of *Lingchi*—spectator, torturer, victim, photographer—all represent imaginary points of view.

Central to Chen Chieh-jen's exercise in historical reconstruction is a more philosophical journey into the heart of violence. The camera peering out through the wounds of the victim not only is an introspective exploration of our voyeuristic fascination with violence but also represents the filmmaker's effort to travel to the epicenter of pain itself. Chen literally voyages into the center of the victim's physical pain, only to transgress the body through a shocking display that ultimately contains a microcosm of twentieth-century Chinese violence, atrocities, and injustices—a "history of pain." The sequence begins with a slow zoom on the victim's chest wounds, gradually dissolving into a fade to black. When the image returns, it is a series of beautifully composed shots of desolate locations and dilapidated buildings, all devoid of human subjects. The rundown buildings and remnants of historical decay are not random sites, but represent some of the chief traumatic places in modern Chinese history: the ruins of Yuanmingyuan 圓明園, the former site in Harbin 哈爾濱 where Unit 731 performed medical experiments on Chinese subjects; the Green Island prison in Taiwan for political prisoners; the former location of RCA's production factory in Zhongli 中壢, Taiwan; and the abandoned shell of a building that was once a women's dormitory at the Lien Fu Garment Factory 聯福製衣廠 in Taoyuan 桃園 (the former employees of such shut-down factories are represented by the women factory workers who appear throughout the film).

Yuanmingyuan is the sole place readily identifiable by audiences viewing the montage sequence. Once revealed, the significance of the first three sites will be clear to most viewers familiar with modern Chinese history—Yuanmingyuan and the Unit 731 building stand as powerful testaments to different forms of imperialist aggression in China, and the Green Island prison represents the Nationalist regime's political repression of its own people. The final two locations represent a different kind of violence. After long-term use of noxious chemicals and materials, the RCA factory in Zhongli contributed to water contamination, environmental damage, and a major outbreak of cancer among employees (more than 1,375 documented cases).[8] The last site, the Lien Fu Garment Factory, once one of the largest textile factories in Taiwan, was suddenly shut down in 1996 with no warning or notice to its thousands of employees, who were left without salary or pensions. The factory closing was a major news story, especially when former workers lay down on railway tracks in protest.[9]

The entire sequence from the camera's "entry" into the wound to its emergence lasts approximately three minutes (13:09–16:09) and reveals that Chen Chieh-jen's interest lies not in reconstructing a single historical incident, but in a much more sophisticated dissection of violence as it is manifested across different historical sites. The part played by Western/external powers in each of the events chosen (i.e., foreign armies' destruction of Yuanmingyuan, the Japanese biological experiments in Harbin) is echoed by the active role the Western camera takes. The montage also traces the historical transmutation of violence from imperialist aggression to political oppression, and ultimately to the brutal economic crimes of global capitalism.

By including these disparate scenes of atrocity and oppression under the same rubric, Chen Chieh-jen also seems to be prodding viewers to consider different forms of violence and injustice. The installation film asks us to compare witnessing the public execution a century ago and standing by and watching transnational corporations wreak unspeakable environmental damage or lay off thousands of uncompensated factory workers so that rich investors can increase their profit margins. Can anyone assert that any of these instances is more or less unjust or horrific than the other? Chen highlights the unspeakable atrocities

8. The scandal surrounding the RCA factory was the subject of a 2002 documentary film by Cai Chonglong 蔡崇隆 and Lu Kaisheng 陸凱聲 entitled *Behind the Miracle* (*Qiji beihou* 奇蹟背後).

9. The factory closure was not a result of bankruptcy or financial loss, but of a decision to redirect funds into a special industrial zone in Thailand where the factory owner runs several enterprises. The owner, Li Mingxiong 李明雄, ran three major factories in Taoyuan, which were closed in 1992, 1994, and 1996. In each case employees—many of whom had been with the factory for more than two decades—were given no severance pay and denied pensions. The incident also inspired Chen's next film project, *The Factory* (*Jia gong chang* 加工廠) (2003), which was shot at the Lien Fu factory site.

committed by Japan during the Sino-Japanese War, represented by the inhumane experiments carried out by Unit 731, but to what extent are those crimes more or less brutal than the widespread environmental destruction, pollution, and disease left behind after the RCA plant's closing? Chen Chieh-jen intentionally conflates different manifestations of injustice, reminding us that violence comes in many forms, atrocity in different scales, challenging attempts to simplify or grant exclusivity to terms like "atrocity" or "holocaust."

It is also through this sequence that the damaged and wounded body transforms into the encasement of the battered and broken state; within this equation lies an attempt to frame a series of incidents, many of which history has silenced, into the performative rite of the *lingchi*. Invisible injustices—like those committed by Unit 731 or the RCA factory in Taiwan—are brought into a performative space wherein they can be displayed and reintegrated into the physical—and national—body. Chen's radical juxtaposition also recalls Foucault's discussion of geneaology and its place between the self and the state, the body and history:

> The body is the inscribed surface of events (traced by language and dissolved by ideas), the locus of a dissociated Self (adopting the illusion of a substantial unity), and a volume in perpetual disintegration. Geneology, as an analysis of descent, is thus situated within the articulation of the body and history. Its task is to expose a body totally imprinted by history and the process of history's destruction of the body. (Foucault 148)

In this context, Chen's Lingchi may be seen as the ultimate geneaological experiment. And while Chen seems to want to allow these histories to speak, the reintegrated sites of violence appear as silent, uncaptioned images that will go unrecognized by most viewers and therefore remain mute, unread pages of this history of pain.

"Vestiges of the past": Three still images of historical sites associated with atrocity, which appear in *Lingchi*. (left) The ruins of Yuanmingyuan; (middle) the location of Unit 731's biological experiments in Harbin; and (right) the former prison on Green Island, Taiwan. Courtesy of the artist.

Toward the end of the film, Chen returns to the bodily wound of the victim a second time. Looking out from the chest cavity, we are provided another glimpse of female factory workers, the contemporary witnesses-cum-victims of violence. But when the camera travels into the wound, the internal view is no longer the series of desolate locations highlighted earlier. Instead we are left with the concluding image of the original 1905 photograph that first fascinated Georges Bataille and from which Chen Chieh-jen extrapolated his disturbing yet brilliant reconstruction. The conclusion of *Lingchi* echoes Bataille's own decision (or that of his editors?) to end his last book, *Tears of Eros,* with that same image of a brutally disfigured remnant of a man. At the same time, the original image also serves as a brutal good-bye to the very practice of "death by a thousand cuts." It is an ironic coincidence that the most famous visual vestige of the cruel *lingchi* would be an image attributed to April 10, 1905—committed to film just fourteen days before the torture that had existed for more than a thousand years would forever disappear. On April 24, 1905, at the behest of the Qing official Shen Jiaben 沈家本 (1840–1913), the practice of *lingchi* or " death by a thousand cuts" was officially abolished in China.

The explosive violence displayed in *Lingchi* is enhanced not only through the cold power of the camera and the levels of history that are folded into the very wounds of the victim but also through a series of cinematic techniques that simultaneously augment the brutality of the images and highlight Chen's own mediating presence as filmmaker. This is done through the use of slow motion; a series of slow fades between shots; the camera's steady, deliberate panning; and the general absence of sound. As a mostly silent film, *Lingchi* heightens viewers' sensitivity to the images, enhancing the brutality of the frames while denying the audience the interpretive devices built into dialogue, music, or even the cries of suffering that might be expected. The lack of an audio track also emphasizes

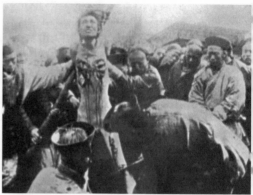

"Gazing into history": (left) The contemporary witnesses as seen a final time through the victim's wound in the penultimate scene and (right) the actual historical photograph of a late-Qing *lingchi* that inspired Chen's work and concludes his film. Courtesy of the artist.

the relationship between the film and the original image that inspired it—photographs are always mute. Silence also serves as a powerful indictment of the nature of history and the merciless way it suppresses the voices of its victims. As the artist Chen Chieh-jen explains in an interview with Amy Huei-Hua Cheng, the victims are always silent:[10]

> The executed is someone who could not escape from being photographed. He could not speak and could not even escape in death. I am not interested in national history. I am interested in the "trancelike" character of historical images because of the uncertainty of the event and the silence of the person being photographed. While looking at the images, we become lost in the maze of images and participants in the maze of images. According to the Daoists, a person has ten different selves. From my experiences growing up during the

10. Standing in contrast to Chen Chieh-jen's silent reconstruction of the *lingchi* is the deafening volume with which the torture has been reimagined in the West. In the late 1980s, composer/producer/saxophonist John Zorn composed a thirty-two-minute piece of music for his avant-garde hard-core fusion ensemble Naked City entitled "Leng Tch'e." The cover image of the original 1992 CD featured the 1905 Bataille photograph, which had inspired the composition and led to major conflict between Zorn and his record label, which objected to its graphic nature. The music is a slow-motion barrage of heavy droning guitar, squealing saxophone, and screaming vocals characterized by music critic Nathan Holaway as "an ambient suite that gradually climaxes to universal catastrophic proportions by the end, providing perfect complement and balance" (*All About Jazz* 11.10.04). In 2001, "Leng Tch'e" was also taken as the name for a new Belgium death metal band, who released a string of CDs with violently charged lyrics and cover art, including *Death by a Thousand Cuts* (2002), *Man Made Predator* (2003), and *Process of Elimination* (2005). The screeching guitars, driving rhythm, and aggressive vocals that mark these Western attempts to revisit *lingchi* can be seen as the direct antithesis of the mute performance of Chen's film. In the case of the band Leng Tch'e, the sensationalist and exploitative quality of the lyrics and cover art point back to the West's original objectification of this "cruel form of Chinese torture" as a spectacle to be exploited and enjoyed.

Cold War and the martial law period, I feel we are in a trance with multiple identities, and while in a trance, we look at ourselves and find that we are in fact the ones being photographed. (Cheng 79)

Chen Chieh-jen's *Lingchi: Echoes of a Historical Photograph* provides a thoughtful commentary on the long history of human violence, torture, and atrocity. The film serves as a powerful metaphor for the simultaneously limited and transcendent power of representation, and as a prelude to the textual journey through modern Chinese atrocity that is embodied in this volume. Beginning with a specific act of violence that occurred in Beijing on April 10, 1905, Chen Chieh-jen pushes our conception of that moment spatially, temporally, and experientially. By grafting images from other locales onto the fabric of his film, juxtaposing witnesses from the late Qing with those from contemporary Taiwan, and playing with the boundaries among witness, victim, and executioner, he stretches, twists, and cuts apart this chronotopic site, revealing a complex prism of violence. The *event* and the *representation* are both staged spectacles—the former is designed to shock, entertain, and warn audiences; the latter, while it will, no doubt, shock some, has a much different primary function: to reflect and contemplate the nature of historical violence and our fascination with it. Although the *lingchi* captured in the photograph is a final trace of a lost form of punishment, it is but a prelude to the history of pain that would dominate twentieth-century China. *Lingchi: Echoes of a Historical Photograph* resonates and disturbs not so much because of the shocking nature of that single bygone event but because it at once reflects and foretells the brutality to follow: Musha 1930, Nanjing 1937, Taipei 1947, Yunnan 1968, Beijing 1989.

The three texts discussed in this chapter represent three distinct ways violence can be portrayed, and also trace how the portrayal of violence has transformed over time. In *A History of Pain,* a fictional text tries to relay the power of historical trauma (albeit projected from another era); Lu Xun's "Preface to *A Call to Arms*" is an essayistic autobiographical text that perhaps belies a deeper fiction. And in *Lingchi,* Chen Chieh-jen presents a fictional vision created from the remnants of a historical photograph. Collectively these works twist and blur the boundaries between history and fiction—boundaries that have grown increasingly mutable—and point to the shifting ways violent imaginations have manifest themselves in premodern to modern and modern to postmodern literature and culture.

Wu Jianren's *History of Pain* is quite clearly configured as a metaphorical parable, utilizing the corruption and lack of national consciousness in the late Song

as an instructive message to readers about the corruption and lack of national identity during the late Qing. However, even though he is dealing with a fictionalized world of metaphor, Wu continually reinforces the legitimacy of the events described—the "truth of the fiction." Although there are two narrative voices—the third-person narrator and the first-person commentator—together they present a single, unified perspective, constantly reinforcing each other. The result is that readers are led to "believe" in the legitimacy of the narrative voice and its power to accurately portray the events witnessed, however disturbing or horrific they may be. With the traumatic beginning of modernity in China comes a crisis, partly a crisis in perspective. Lu Xun's "Preface" requires readers to ask how to witness the execution. From whose eyes do we see it? The reader/viewer is struck with a new awareness of the complexities of observation and narration. The authoritative voice and position appropriated by Wu Jianren and writers of his milieu has given way to a perspective that opens up new space for different interpretations, perspectives, and meanings. The crisis of early modernity is also a product of new technologies (photographic images, projection, film), new global exchanges (such as those that brought Lu Xun to Japan), and the modern dynamics of imperialism and global conquest (i.e., the Russo-Japanese War, during which the decapitation photo was allegedly taken). Although "Preface" is almost always examined as a pure literary work, as Rey Chow has observed, in this "retroactive attempt to verbalize and narrativize a mute visual event" (Chow 1995:7), Lu Xun is already anticipating the kind of radical cinematic intervention Chen Chieh-jen offers more than half a century later.

The narrative bridge to Chen's depiction came from the work of Georges Bataille. But similar to allegations by Leo Ou-fan Lee (1987) and David Der-wei Wang (2004) that Lu Xun's vision of the execution could have been imaginary, Brook, Bourgon, and Blue (2008) have waged a series of persuasive arguments that call into question much of what we know about Bataille's *lingchi* image. Questioning the circumstances surrounding Bataille's first contact with the photo, Brook and his collaborators also show that the image in the photo was *not* Fuzhili but some as yet unidentified victim of *lingchi*, and most explosively, they present serious misgivings about whether Bataille even wrote *Tear of Eros,* or at least the portion about *lingchi*. And so, while two of the most influential texts that attempt to narrativize pain in China and the West (Lu Xun's slide images and Bataille's *lingchi* photos) are presented as part of a culture of visuality and global exchange, both seemingly irrefutable by nature of the photographic testimony each provides, with time, both have been shown to be controversial in their transmission, content, and context. Collectively these works display how even the most deeply ingrained cultural memories of atroc-

ity often conceal greater fictions and warn us that narratives can never become that thing they purport to represent.

The work of Chen Chieh-jen presents yet another perspective on personal atrocity and a new vantage point from which to observe national pain. In his installation film, Chen strips away the divisions between the victims and the witnesses (both old and new) of historical atrocity. Although initially inspired by Bataille, Chen seems to consciously move past earlier narratives of the execution. A "historical photograph" is the starting point, but Chen's approach is anything but historical; he freely admits that the "process of carrying out *lingchi* and the instruments of torture depicted in the film are also rife with scholarly 'inaccuracy'" (Chen 2002). Instead, the artist takes us to a world of parable, traveling to the symbolic center of pain, entering the very wounds of the tortured souls of the past. Chen's journey highlights the various perspectives and levels of pain involved in witnessing and, to some extent, experiencing trauma. At the same time, his highly stylized portrayal of torture—using black and white film, slow motion, voyeuristic panning, impossible temporal scenarios melding scenes from the early twentieth century and from the early twenty-first century—emphasizes the fabricated nature of the atrocity. As visceral, disturbing, and "real" as the violence depicted in *Lingchi* may appear, the fact that it is imaginary is built into the film's self-reflective fabric. As Chen himself states in an interview, "*We do not see the violence of history or that of the State. We can only imagine it.*" The *lingchi* torture now exists only in the small handful of extant still photographs depicting it; the actual event is forever lost, and the voices of the victims are forever silenced. The pain can never be experienced—only imagined. This is the task of Chen Chieh-jen and the other artists, writers, poets, and filmmakers whose works carry the burden of imagining the violence, atrocity, and pain of modern China's past.

PART ONE

Centripetal Trauma

1. Musha 1930

On Sakura Ridge at Musha
Cherry blossoms crimson red
Seem to be crying out for Ichirō and Jirō
Again they bloom

October, 1930
Hanaoka Ichirō and Hanaoka Jirō
The tribal leader Mona Rudao
Resisted the Japanese empire's aggression
Bravely leading a revolt destined to fail
Swallowing their regret in death

Under the wind and the sun
Ichirō and Jirō's freshly spilt blood stained with sorrow and rage
Are like crimson sakura blowing in the wind
Again they bloom in anger

—WU YONGFU (118–119)

Enter the Headhunt

Composed on March 17, 1982, this free-verse poem by Wu Yongfu 巫永福 entitled "The Crimson Sakura of Musha" (*Wushe feiying* 霧社緋櫻) is but one in a long line of attempts to commemorate, reflect upon, and reconstruct the Musha Incident (霧社事件), one of the most violent events in modern Taiwan history. It happened during the height of the colonial period in Taiwan; after more than 35 years under the Japanese flag, virtually all forms of armed resistance had long been suppressed. But that changed one fall morning in Musha 霧社, a small town nestled deep in the mountains of central Taiwan and occupied primarily by aborigine tribes. October 27, 1930 was the date set for the annual track meet to be held at Musha Elementary School. The event turned violent when Mona Rudao 莫那 魯道 (1882–1930) of the Atayal tribe (泰雅族) led approximately 300 tribesmen in an ambush resulting in the deaths of 134 Japanese,

nearly all of those occupying Musha who had gathered that morning to observe the track meet. The Japanese responded with a massive deployment of 1,303 troops and state-of-the-art weaponry, including internationally banned poison gas, even going so far as to recruit other, pro-Japanese tribes to hunt down the perpetrators and suppress the uprising. Among the 6 tribes (originally numbering more than 1,200 people)[1] that took part in the raid on the elementary school, 644 were dead by the end of the Japanese campaign, with nearly half of them taking their own lives, including the leader, Mona Rudao.[2] The vast majority of the surviving Atayal, numbering only 561, were interred in 3 separate detention centers.

Six months later, there came a brutal footnote to this violent suppression when the pro-Japanese Toda subtribe (道澤群) launched a coordinated attack on the detention centers on April 24, 1931. This Second Musha Incident (第二次霧社事件), widely believed by most historians to have been orchestrated by the Japanese, culminated with the near extermination of the Atayal. In the raid, 216 of the detainees were killed, 101 of whom were decapitated by the Toda. The 293 survivors were forcibly exiled from their ancestral homeland of Musha to Chuanzhongdao (川中島, present-day Qingliu, 清流). On October 15 and 16, 1931 all survivors were summoned to Puli to take part in an "Allegiance Ceremony," during which an additional 39 tribesmen suspected of involvement in the original attack on the school were arrested. They were sentenced to 1- to 3-year jail terms, but with the exception of 1 escapee, all died in custody. The harsh crackdown in the wake of the Musha Incident raised questions about the legitimacy of Japanese claims of trying to bring "civilization to the savages." As Anupama Rao and Steven Pierce have noted, when colonial powers appropriate brutality as a means to achieve their goals, the legitimacy of the entire colonial project is called into question:

> If colonialism was about the management of difference—the civilized ruling the uncivilized—the allegedly necessary violence of colonial government threatened to undermine the very distinction that justified it. Disciplining "uncivilized" people through the use of force could often seem the only way to correct their behavior, but this was a problem: Violence also appeared to be the antithesis of civilized government. (Pierce 4)

1. The six tribes that took part in the Musha Incident are the Mahebo (馬赫坡社), Tarowan (塔洛灣社), Boalum (波亞倫社), Suku (斯克社), Hogo (荷歌社), and Rodof (羅多夫社).

2. Of the 644 deaths, Deng Xiangyang (1998:86) states that 85 died in battle, 137 perished in aerial bombings, 34 died as a result of cannon fire, 4 died of illness, 1 was burned, and 87 were decapitated by pro-Japanese tribes. Among the mass suicides, 290 hanged themselves, 2 shot themselves, and 4 killed themselves with swords or knives.

After Musha, this contradiction was deeply felt, and Japan began to reevaluate its entire colonial approach. Both the policy changes enacted in the wake of Musha and the modern weaponry employed first in the crackdown (including poison gas) would prove of critical importance just a year later, when Japan's colonial reach extended to mainland China with the Mukden Incident.

Much has been written about the Musha Incident, especially about Mona Rudao, the mysterious and charismatic Atayal leader of the Mahebo tribe who led the insurrection and, since 1945, has often been hailed as a great hero in Taiwan's struggle against colonialism. Two other figures whose role in the uprising is more ambiguous are Hanaoka Ichirō 花岡一郎 and Hanaoka Jirō 花岡二郎, members of the Atayal tribe who were fostered and educated by the Japanese and praised as "model savages." Originally named Dakkis Nobin 拉奇斯·諾敏 (Ichirō) and Dakkis Nawi 拉奇斯·那威 (Jirō), both were given Japanese names and sent to school in Puli. Eventually Ichirō graduated from a teaching institute in Taizhong—attaining the highest level of education among indigenous people in Taiwan at the time—and returned to Musha, where he worked for the Japanese, overseeing construction projects. Jirō also returned to Musha after graduation and worked as a police officer. Both were married to Atayal women with a similar Japanese background under a new policy to establish "model families" in the tribal mountain areas.

When the Musha Incident broke out, the Japanese initially believed that Ichirō and Jirō had had a role. But in the immediate aftermath of the slaughter, Ichirō and Jirō led all 21 members of their respective families in a mass suicide. Both donned traditional Japanese ceremonial dress; Ichirō committed *seppuku* in the Japanese tradition while Jirō hanged himself from a tree, the traditional Atayal method of suicide. A note was left explaining their decision:

The two Hanaokas
We must take our leave of this world,
The tribespeople have been overworked, which has led to their anger,
We had been imprisoned by our tribespeople and had no recourse.
October 27, the fifth year of Shōwa, 9:00 a.m.
The savages were firmly entrenched in all positions,
The county head and those officials under him all died at the school.[3]
(Deng 1998:84)

3. There have been unsubstantiated allegations that the suicide note was forged by the Japanese authorities after the suicide in an effort to spare the Japanese further shame and redeem honor for the empire.

The deaths of Hanaoka Ichirō and Hanaoka Jirō left more questions than answers. Their chosen methods of ending their lives—*seppuku* and hanging—seem to hint at a cultural schizophrenia: even in death they were haunted by the tensions between loyalty to their Atayal tribe and loyalty to the colonial empire that reared them. And while most contemporary historians in Taiwan do not view Hanaoka Ichirō and Hanaoka Jirō as having played any major role in the uprising, over the past seventy-five years their story has been continually retold in a fashion that situates them alternately as traitors or heroes. The place of Ichirō and Jirō, or Nobin and Nawi, in the historical imagination of the Musha Incident has become emblematic of the complex cultural politics around and the challenges of revisiting this traumatic historical event, which raises deep questions about both national identity and historical narrative.

The Musha Incident (including the Japanese response) has become one of the most contested sites in modern Taiwan history, repeatedly reinterpreted and reframed over time. Even the circumstances that led to the initial uprising have been intensely debated, with contemporary historians tracing the origin to a complex combination of general discontent concerning prejudicial colonial policies, suppression of indigenous cultural rites, exploitation of labor, ill treatment of workers, abandonment of Atayal women by Japanese officers who had married them under the colonial "political marriage" policy, and various other incidents, including a conflict between a Japanese officer and a tribesman at a wedding ceremony just weeks before.[4] Much of the English scholarship on the Musha Incident appeared only in the 2000s, and discussions of the event through literature have been primarily limited to Japanese sources, such as Leo Ching (2001) and Kimberly Kono (2006). While Ching has dealt with the dramatic shift in Japanese colonial policy that led tribes to make the change from mutineers to volunteers as displayed in a variety of literary sources, Kono has focused on a similar cultural division as seen through the lens of Sakaguchi Reiko's 1943 novella *Passionflower* (*Tokeiso*), which traces the identity crisis of a mixed Japanese-aborigine character following the Musha Incident. One exception is David Der-wei Wang (2004), who has offered extended analysis of an important postmodern novel about the incident in the context of literary representations of decapitation in twentieth-century Chinese literature.[5]

4. For more on the "political marriage" policy and its role in the Musha Incident, see Paul D. Barclay's important article on interethnic marriage during this period, "Cultural Brokerage and Interethnic Marriage in Colonial Taiwan: Japanese Subalterns and Their Aborigine Wives, 1895–1930."

5. Literature on the Musha Incident is of course much richer in Chinese-language scholarship. One important study is Lee Wenju's 李文茹"Literature, History, and Gender: On Narrative of the Wushe Event Through a Gender Viewpoint" ("Wenxue, lishi, xingbie: yi xingbie jiaodu tantao wusheshijian wenxue" 文學,歷史,性別: 以性別角度探討霧社事件文學). Like Ching and Kona, Lee focuses primarily on Japanese-language texts.

The aim of this chapter is to present a critical history of how the Musha Incident has been portrayed in *Chinese* literature and popular culture in the decades since the uprising, with special attention to a series of key texts. Over the past seventy-five years, the image of Musha in popular culture has been radically transformed and repeatedly reinvented to serve different political, cultural, and historical agendas. My aim is to examine the Musha Incident through the cultural representations it has inspired, exploring how cultural politics have influenced, and often driven, the writing of national trauma. In a fascinating performance, what was initially a Japanese historical trauma that shook this new colonial power to its core is transformed into a Chinese historical trauma that would be claimed in the postwar period as an example of anticolonial struggle. Simultaneously, a very specific "tribal" uprising is transformed into a "national" uprising. The works discussed not only trace this process but also demonstrate how later generations of Chinese and Taiwanese have reincorporated these indigenous people into the imagined national community. Spanning several decades and different artistic mediums (novels, short stories, poetry, graphic novels, television miniseries, and film screenplays), this chapter traces the evolution of how artists, writers, and filmmakers have imagined Musha and explores what those representations can tell us about historical representation, cultural identity, and the power of political hegemony.

Appropriating Musha: Chinese and Taiwanese Interventions

Through a series of representations of the Musha Incident, Chinese and Taiwanese characters have intervened in the historical narrative of the event. Collectively, these efforts by ethnic Chinese writers, filmmakers, and artists have had a stunning impact on the historical reframing of the Musha Incident in Chinese and Taiwanese terms and its incorporation into a new national anticolonial (or antioccupation) discourse. This section begins with an extended discussion of a 1949 screenplay that laid the groundwork for Chinese and Taiwanese interpretations of the insurrection. I then analyze a series of texts that situate the Musha Incident within a Nationalist-framed anti-Japanese struggle before moving on to nativist works that frame the incident within a larger antioccupation discourse (often including the Nationalist regime as an occupier) in an attempt to use the events of 1930 as a precursor for an indigenous independence movement. The section closes with some of the more iconoclastic Musha narratives, reexamining the Chinese and Taiwanese presence.

Red Across the Land: *Zhang Shenqie's Lost Cinematic Vision*

One of the earliest attempts to position the Musha Incident within the context of popular culture came from the novelist, screenwriter, and activist Zhang Shenqie 張深切 (1904–65). Part of a group of progressive Taiwan intellectuals that included composer Jiang Wenye 江文也, Zhang spent many years on the Chinese mainland and was involved in a series of political and literary organizations. An active critic of Japanese colonial policies, he joined the Association for Taiwan Self-Rule in 1924 in Shanghai and formed the Guangdong Taiwan Revolutionary Youth Group in 1934 before turning to cultural activities, such as editing the journals *The Taiwan-Bungei* (*Taiwan wenyi* 台灣文藝) and *China-Bungei* (*Zhongguo wenyi* 中國文藝). He returned to Taiwan at the end of the War of Resistance in 1945, only to become a target of persecution two years later during the February 28th Incident, when he was accused of communist activities. In the wake of that incident, Zhang wrote *The Sakura of Musha Red Across the Land* (*Wushe yinghua biandi hong* 霧社櫻花遍地紅), a long-form literary film script that was first prepared for the Northwest Film Company (西北影片公司) and serialized in *Spectator* (*Pangguan* 旁觀) in 1949. The screenplay was never produced and only published as a separate volume in 1961 under the shortened title of *Red Across the Land* (*Biandi hong* 遍地紅).

Red Across the Land opens with a sequence that presents a microcosm of the conflict from the perspective of children. A group of Japanese children are playing with swords and air guns; their innocent games turn into a human hunt with the suggestion, "I'm sick of always hunting birds, why don't we hunt the savages! . . . From now on, let's embark on a mission to suppress the savages! Advance!" (66). Treating the indigenous children as beasts to be hunted, the Japanese boys shoot at will, sending the Atayal children scrambling wildly and leaving them screaming and in tears as they are struck by the air guns and fall to the ground.[6] The only one who stands up for them is a single "unarmed Taiwanese child who looks especially refined and lovable" (65). The boy criticizes the Japanese, only to be insulted: "It's none of your business, so shut your mouth, you Manchu slave!" (67). The Japanese children then proceed to beat the boy bloody. The imagined film uses this brutal children's game as a powerful allegory for Japan's relations with its indigenous colonial subjects in Taiwan and a foreshadowing of the Musha Incident in 1930.

Of particular interest is the introduction of the Taiwanese boy, the only character singled out for his "refined and lovable" qualities and the only one

6. There is a clear ironic reversal at play here, as the Atayal, a tribe traditionally known for their head-hunting rites, become the hunted and the Japanese are transformed into the true "savages."

who challenges the bullies. In the end, his efforts prove futile; he "turns over, blood dripping from the corner of his mouth, and stares in hatred at the Japanese children as they run off" (67). But the "Taiwanese" intervention in the Japanese-aborigine conflict is one of the key themes of Zhang Shenqie's reinvention of the Musha Incident, and it is amplified over the course of the narrative.

Moving away from the allegorical game of the opening, the first half of the screenplay is devoted to extended exposition of the tensions brewing between the Japanese colonizers and the local tribesmen, stemming from worker exploitation and abuse, unfair compensation, and the Japanese intermarriage policy, under which Japanese officers marry (and often oppress and abandon) Atayal women. The protagonists include the charismatic leader of the insurrection, Mona Rudao (referred to in the screenplay as Mona Dao 莫那道),[7] and the Japanese-educated Atayal tribesmen Hanaoka Ichirō and Hanaoka Jirō, along with a host of other Japanese and indigenous characters. Zhang Shenqie takes numerous creative liberties in his rendering of the incident; one of the most significant departures is the introduction of the Taiwanese character Zhu Chentong 朱辰同, who, like the Taiwanese boy in the opening sequence, is introduced as a voice of reason to quell the violence and finally joins in the fight alongside his "indigenous brothers."

Some Taiwanese were present in Musha at the time of the massacre, but there is little documentation of any Taiwanese involvement in the planning or execution of the Musha Incident.[8] Zhang Shenqie gives scant background information about Zhu, but his first appearance provides an important glimpse of his political and ethnic alliances.

Zhu was dressed in aborigine clothing, his face was thin, and he seemed to ponder for a moment before speaking. "I have met with Mr. Hualisi and Mr. Shabo several times and am aware of their hatred toward the Japanese and the fact that they are eager to seek revenge. But I hope everyone [realizes] the need to remain calm, you must not take any impetuous actions. The meaning of 'impetuous actions' is to cause trouble for no good reason and end up sacrific-

7. As the Atayal did not traditionally have a written script, various alternate Chinese characters (and spellings when names are romanized) are used throughout various texts about the Musha Incident when proper names of indigenous people and places appear. Hence, in English-language scholarship on the incident, there are several spelling variations of key terms, such as "Atayal," which often appears as "Tayal," or "Seediq," which also appears as "Sediq."

8. A 1934 official Japanese account of the massacre, *Musha jikenshi* does list "plotting by the Taiwanese" as a potential (but unsubstantiated) contributing factor to the uprising. For a full summary of the official report see Leo Ching, *Becoming "Japanese": Colonial Taiwan and the Politics of Identity Formation*, 141–143.

ing your lives, this is what I mean. We should realize that the target we want to take down is not just the local Japanese police here, but all of the Japanese here . . . not only all of the local Japanese [in Musha] but all of the Japanese in Taiwan! We must expel all of the Japanese from Taiwan! Otherwise, please think about what will happen: if we only kill a handful of police officers, they will send even more. If we kill every last Japanese down in the plains, they will only send more soldiers and police from the Japanese mainland. They are many, their weapons are powerful, they have planes, cannons, machine guns, all of which are very formidable. We cannot beat them, we will be killed by them." (88)

This passage stands out for its introduction of a Taiwanese interlocutor who drives the anti-Japanese discourse and plays an instrumental role in the planning of the incident. This not only signals a marked departure from the history of the Musha Incident given by historians and oral accounts but also introduces a distinctly "Taiwanese" presence at a key historical juncture. Zhu is positioned side by side with the aborigines in a show of rhetorical solidarity, accentuated by the repeated emphasis of the pronoun "we"—even though in the actual insurrection, no Han Taiwanese participated.[9] At the same time, Zhu is clearly imagined as the civilized, intellectually superior advisor to the "savages," serving as a strategist and even as a language instructor, as his extensive explanation of the four-character compound *qingju wangdong* 輕舉妄動, or "impetuous actions," shows. What is interesting is that in his effort to "enlighten the savages," Zhu's actions and attitudes, to a certain extent, parallel those of the Japanese colonizers who wanted to "civilize" these minority groups.

As the date set for the uprising draws near, Zhu Chentong not only again provides a "voice of reason" advocating strategy over an excessively emotional reaction but also emphasizes the importance of waiting for the full cooperation of the Taiwanese: "We still haven't connected with the Anti-Japanese Group of Taiwanese Compatriots and acquired all the weapons we need" (130). When this strategy is proven impossible, Zhu nevertheless joins with Mona Rudao and becomes a critical voice in the planning and direction of the insurrection:

Mona glowed with heroic charisma. Capturing the passionate hearts of the masses, he cried out, "Brothers, we have to do it!"

The crowd responded, "Yes!"

Seeing that the situation had been decided, Zhu added, "All right then, let's

9. Not only did no Chinese take part in the Musha Incident, but two Han Chinese dressed in Japanese clothing were actually killed in the when the attacking tribes mistook them for Japanese.

do it! Number one, we must all instill Mona Dao as our commander general."

The crowd responded with shouts of "Long live Mona."

Zhu continued, "Number two, we will send Pituo Shabo to lead the front line, he will lead a small team to cut all the phone lines in Musha!"

Shabo responded by running over and Zhu continued, "Let's take out all the arms and divide them among those who are without weapons."

With a somber tone, Mona ordered, "We act immediately; we kill every Japanese we encounter, we burn the police headquarters, and no one is to lay a hand on any of our Taiwanese compatriots! We will reach Musha by tomorrow morning!" Zhu raised his hands and yelled, "We must all follow the orders of our leader!" Mona: "Notify the other tribes of the uprising! Kill all the Japanese!" (134–135)

This passage positions Zhu in a central place in the uprising, as a key planner, strategist, and orator, side by side with Mona Rudao. Later, as the Japanese soldiers are closing in on the Atayal and Mona Rudao insists on a mass suicide, Zhu's suggestion to temporarily retreat finally wins over Mona and the other men. The emphasis on Zhu's civilized reasoning and strategy over Mona's savage anger and impetuousness is repeated throughout the screenplay, positioning Zhu in the curious role of alternately hailing Mona as the undisputed leader and serving as his intellectual foil. While aiding in this anti-Japanese insurrection, Zhu himself helps groom Mona Rudao into something akin to the "model savage" that the Japanese were trying to foster.

Besides signaling ethnic Chinese cultural and linguistic superiority, the introduction of this Taiwanese protagonist is an important early step in the Taiwanification of the Musha Incident. For Zhu's presence not only unifies the aboriginal native resistance with Taiwanese anti-Japanese sentiments but also reconfigures the incident itself within the context of a new Taiwanese nationalism. By extending the aims of the attack to "expel all of the Japanese from Taiwan," in an effort masterminded by a Han Chinese with strong Taiwanese identification, *Red Across the Land* extends Mona Rudao's tribal consciousness to a new form of national consciousness. This ideological jump is a major shift in the historical positioning of the Musha Incident, a profound reframing of this moment in history. However, through his attempt to retell and popularize the tale of Mona Rudao, Zhang Shenqie actually reinforces the same ethnic stereotypes about indigenous Taiwanese people that the Japanese used to persecute them. The cultural, racial, and linguistic superiority exhibited by Zhu Chentong (and, of course, the Japanese) is echoed even in Zhang Shenqie's preface: "Our mountain compatriots are indeed unenlightened savages (*weiqifa de yeren* 未啓發的野人), but it is precisely because they have yet to be spoiled by the

deceit of civilization that they are so unusually pure and full of the human spirit" (59). This view of the aborigine as simultaneously uncultured and pure in many ways mirrors the perspective of the Japanese. For just as the Japanese colonial project's aim was to incorporate the savages into the Japanese nation, Zhang's (failed) cinematic project tries to reincorporate the savage into Taiwanese (or Chinese?) national discourse.

As a vocal proponent of Taiwan's independence, Zhang Shenqie was most likely attempting to include the Musha Incident in a Taiwanese discourse rather than a larger Chinese national discourse, but in 1949, four years after Taiwan's retrocession, which marked the end of Japanese colonial rule, and two years after the February 28th Incident, when ethnic tensions between newly arrived mainland Chinese and native Taiwanese came to a head, such a position could be problematic. And while the dark, tragic tone, excessive violence (including decapitations, suicides, and bombings), and massive budget needed to stage such large-scale battle sequences may all have been contributing factors that prevented the screenplay from being produced as a film, in the eyes of the Nationalist regime, the single greatest "problem" would have been the chosen subject matter, an uncomfortable topic in the wake of 2/28. In fact, Zhang's screenplay about a sudden rebellion led by oppressed colonial subjects that is quickly and violently put down by a ruthless government may be an attempt to not only explore a brutal episode in Taiwan's colonial history but also provide an allegorical commentary on that more recent insurrection (of which Zhang himself was a victim). Not for many years would Zhang Shenqie's radical reinterpretation of the Musha Incident find resonance within other cultural spheres and Mona Rudao's struggle once again become recontextualized within larger political, historical, and ethnic struggles.

The Musha Incident and the Writing of Nationalism

Not until several decades after the publication of Zhang's screenplay, after a break in diplomatic relations with Japan, did a new critical space begin to open up under the Nationalist regime, finally allowing for renewed literary examinations of Musha. In 1977, two full-length works of reportage literature on the Musha Incident were published in Taiwan: Chen Quchuan's 陳渠川 *The Musha Incident* (*Wushe shijian* 霧社事件) and Li Yongchi's 李永熾 *The Unyielding Mountains: The Musha Incident* (*Buqu de shanyue: Wushe shijian* 不屈的山嶽: 霧社事件). These texts situated the event within a distinctly Chinese discourse, emphasizing its place in a long tradition of anti-imperialist struggle and sacrifice. Li Yongchi's *The Unyielding Mountains* appeared in a series published

by the Modern China Publishing House, "Biographies of Martyrs and Sages" (*xianlie xianxian zhuanji congkan* 先烈先賢傳記叢刊), which placed Mona Rudao's dramatic story among those of such Chinese luminaries as May Fourth intellectual Luo Jialun 羅家倫; Nationalist officials Chen Cheng 陳誠, Zhang Daofan張道藩, and Yu Youren 於右任; and revolutionary martyr Qiu Jin 秋瑾. The narrative voice shifts frequently between long passages of detached historical narrative and anthropological background on Taiwan's indigenous tribes and a more literary approach using dialogue and action. And although the book begins with an overview of the Atayal's religious beliefs, including their creation myth, Li Yongchi is careful to emphasize their "Chinese" roots and cultural ties from the outset:

> In recent years there have been numerous archeological discoveries that have uncovered artifacts of black pottery culture and ancient painted pottery culture throughout Taiwan, proving that there were inhabitants in Taiwan before written history; moreover, their cultural lineage was identical to that of people in mainland China. Therefore, no matter if you take our compatriots from the mountains of Taiwan as descendents of the survivors of the upheaval during the Spring and Autumn period or as early immigrants from other portions of China, in short, they are a part of the Chinese ethnic lineage—this is a fact that lies beyond all question. (1)

Whereas Zhang Shenqie injected his own ethnic Chinese character into history to effectively sinocize the Musha Incident, Li Yongchi simply declares the Atayal (and all other Taiwanese indigenous groups) ethnic Chinese from the beginning, firmly situating Mona Rudao's personal experience within the larger Chinese discourse of historical struggle and martyrdom.

The majority of Li Yongchi's novel serves as a prequel, focusing on the brewing tensions and the meticulous planning in the days leading up to the assault on the elementary school. Only in the final few pages of the novel does Li actually depict the uprising and the massacre. The focus of most of the book is on the complex place of Hanaoka Jirō and, especially, Hanaoka Ichirō in the history of the incident. In his study of Japanese fictional and nonfictional accounts of the Musha Incident, Leo Ching has observed how much of the discourse has been "firmly and continuously based on the dichotomy between 'savagery' and 'civility'" (Ching 140). This in part accounts for the particular attention paid to Hanaoka Ichirō and Hanaoka Jirō, two aborigine men educated by the Japanese and held to be model colonial subjects. They effectively embody the complexities and contradictions involved in the transformation from savagery to civility and in the Japanese colonial project.

The focus on Hanaoka Ichirō, the Japanese-styled "first son" of the aborigine subjects, is startling in that it presents him not as a loyal colonial subject but as a scheming mastermind, meticulously planning each and every aspect of the Musha Incident alongside Mona Rudao. This shift not only emphasizes the indigenous nature of the uprising but also stresses an even greater level of national consciousness and ethnic pride. Although Hanaoka Ichirō and Hanaoka Jirō were educated under the Japanese and employed in official capacities by the colonial system, their allegiances and core identity are shown as still fundamentally aligned with the Atayal and a greater Chinese national consciousness.

In the end, it is actually Ichirō who first proposes the uprising:

"Don't tell me we should just keep putting up with this [exploitation]?" [said Walisi].

Ichirō couldn't help but think back to what Li Xingtai had told him, unequal treatment for different ethnic groups was a fundamental attitude the Japanese invaders held when looking at their colonial subjects. After many days of struggling with his thoughts and soul searching, Hanaoka Ichirō had long since come to a decision. At that moment, he bravely turned to Walisi:

"There is no other option . . . we must fight back!"

As he spoke he looked at Pihuo Walisi's expression. As soon as Walisi heard the words "fight back," a look of excitement appeared on his face.

"That's right! All we can do now is fight back!"

"But in our resistance we must be prepared to die; moreover, we must be willing to sacrifice our entire families. If we are not prepared to make this ultimate sacrifice, we may as well give up now. Secondly, we must plan everything carefully well ahead of time. Only with planning can we carry out a protracted struggle and let the world know why we chose to fight back; otherwise the truth will certainly be twisted and blurred by Japanese propaganda!" (95–96)

Li Yongchi's narrative of this crucial moment includes many important details that historically frame the incident. While the author stops short of inserting a ethnic Chinese character like Zhu Chentong (which is unnecessary if, as the author claims, the indigenous peoples are all part of the Chinese cultural lineage) to help mastermind the attack, Li does invoke the Han character Li Xingtai, an anti-Japanese activist, as the philosophical model inspiring Ichirō to resist. What is interesting is that although Mona Rudao has been traditionally viewed as the "leader" of the uprising, in narratizing the incident there seems a fundamental need to introduce an outsider (i.e., the Taiwanese Zhu Chentong or the Japanese-educated Hanaoka Ichirō) to help. Does this speak to the un-

comfortable nature of making a pure indigenous tribesman a true national hero? Or does it simply reflect a chauvinistic Han perspective that cannot fathom Mona as the sole leader?[10] In *The Unyielding Mountains*, Ichirō not only plans the uprising but also devises the strategy to obtain Japanese weapons, and makes the decision to spare Chinese in the massacre (because they are also exploited victims of the Japanese and their fate is identical to that of the aborigines). In the passage above, it is also interesting that in the moment of conceiving the uprising, Ichirō, the fictional character, is already anticipating the treacherous endeavor of historical writing in the shadow of nationalistic propaganda, for which he has now ironically been appropriated.

For the author, perhaps the biggest challenge in reinterpreting the life of Hanaoka Ichirō was how to reconcile Ichirō's death by *seppuku* while wearing traditional Japanese dress (accompanied by a Japanese suicide note of apology) with the Chinese nationalist agenda that positions him as an anti-Japanese hero. In *The Unyielding Mountains* Li designs an elaborate narrative explanation that repositions what many previously viewed as the ultimate betrayal of the Atayal as the conclusive act of self-sacrifice for the (Chinese) nation. Ichirō explains his motivations to Mona Rudao before his death:

> "If our bodies are discovered on the battlefield, it will certainly mean an end to future educational opportunities for other tribe members. The Japanese will feel that educating 'savages' is a completely meaningless gesture. It will lead to even more hatred for our people and the Japanese will take to genocide and the elimination of our tribe. We all know that this uprising will not drive the Japanese out of Taiwan, we cannot win over them. So we must think about our future generations and leave them with options for the future and the opportunity to continue their educations. Our sacrifice will allow them to be viewed as human beings, and allow them to one day avenge our deaths. And so Jirō and I will choose another path to death and depart a step earlier than the rest of you!" (118–119)

Mona Rudao protests that this decision will stain their name in history and that people will view them as traitors, but Ichirō insists on this higher sacrifice of not only his life but also his honor, in order to preserve the future dignity of

10. A further hint at the uncomfortable nature of claiming Mona Rudao as the sole, or even central, hero of the uprising is the subtitle of Li Yongchi's book, *The Musha Incident*. Each and every title in the Modern China Publishing House's series "Biographies of Martyrs and Sages" features a specific historical figure's name as the subtitle (i.e., Gu Zhenglun, Zhang Daofan). The sole exception is Li Yongchi's volume, which uses the incident rather than the name of Mona Rudao for its title.

his people. Li presents Hanaoka Ichirō's death not so much as an act of ritualis-
tic *seppuku* (although he certainly details Ichirō's murder of his family before
killing himself in graphic detail) but as a manipulated staging for a Japanese
audience. The narrative even describes how Ichirō sheds his traditional Atayal
outfit (which is conveniently blown into a stream and washed away) and dons
a traditional Japanese robe to complete the performance. However, there is an
uncanny doubling at work here. As Ichirō performs his death as a show of loy-
alty to the Japanese nation, Li Yongchi is involved in his own literary perfor-
mance, whereby the same death becomes a display of Chinese patriotism.
Unable to resist the propagandistic impulse to reinterpret history, Li projects a
new nationalistic vision onto Ichirō that proves just as manipulative as the pro-
jection imposed by the Japanese.

The radical historical reinterpretation of Hanaoka Ichirō and Hanaoka Jirō's
actions can also be seen in Chen Quchuan's *The Musha Incident,* which was
published the same year as Li Yongchi's novel. Chen also unambiguously posi-
tions the two "model savages" as "model Chinese nationalists," focusing on
their heroic efforts in fighting the Japanese. The novel even featured a preface
by Ichirō's former Chinese classmate Li Ding 李丁, who declares "Hanaoka
Ichirō's bones are now cold, but I am still deeply moved by this national
anti-Japanese hero who loved his country and loved his compatriots . . . the
manner in which [he] upheld the justice of our people is indeed awe inspiring. I
believe that his heroic achievements will forever be recorded in history for later
generations to reflect on and revisit" (Chen 2–3). The emphasis on the heroism
of the two Hanaokas rewrites their place in history, decentralizing Mona Rudao
and highlighting the "civilized" nature of the uprising. Because of the Hanao-
kas' high social status as the two most educated individuals from their tribe, the
new emphasis on their role helps reposition the Musha Incident as a well-planned
and orchestrated anticolonial movement instead of a "savage" uprising led by a
group of headhunters.

The placement of the Musha Incident within a greater Chinese cultural and
historical tradition in the works on Zhang Shenqie, Li Yongchi, and Chen Qu-
chuan mirrors interpretations of the incident in mainland China. Among the few
publications in China about the uprising, such as 1982's *A Short History of the
Mountain People* (*Gaoshan zu jianshi* 高山族簡史), neither the ethnic connection
of the indigenous tribes to China nor the important role of Han Chinese in the
uprising is ever doubted. As the authors introduce the incident, they position it
within a long history of revolutionary struggle and resistance: "The mountain
people, under the help and influence of the Han Chinese people, became
self-conscious and rose up in the struggle to resist Japanese imperialism—the

most famous example of this was the October 1930 Musha anti-Japanese fight led by the mountain people" (102). Throughout the passages devoted to the Musha Incident, emphasis is consistently placed on the long history, solidarity, and union of Taiwanese indigenous peoples and Han Chinese friends and supporters.

> The Taiwan mountain people are not alone in their anti-Japanese struggle. They frequently fight alongside or receive support from the Han Chinese. This type of pact of brotherhood and friendship over the course of the mountain people's numerous struggles against Japanese imperialism is far from rare. Over the long-term course of mutual struggle, not only have the mountain people and Han Chinese deepened their friendship on the battlefield and ethnic unity, they have created friendly contact through their labor production and everyday lives. Han merchants have often ventured deep into the mountain people's territory, bringing salt, matches, cloth, tools of material production, and other life necessities and production information to trade with the mountain people, having a strong effect on the mountain people's production capabilities. Over the fifty years of Japanese imperialist rule, the struggle has been difficult, the road has been bumpy, but the mountain people and the Han Chinese people's joint struggle to resist has never ceased, all the way up until the victorious end of the War of Resistance. (111)

In narrating the actual October 27 attack, special attention is paid to the fact that Han Chinese were not targeted (although no mention is made of the two Chinese killed during the uprising). The authors use this fact to further "prove" the solidarity of the indigenous and Chinese people:

> As the masses rose up and attacked the elementary school field, completely annihilating the enemy, the mountain people went to great ends to protect the Han Chinese. This action not only proves that in the struggle to resist the foreign invaders, the Han people and the mountain people fought together, it also proves that the mountain people have always resisted the foreign invaders side by side with the Chinese. This type of long-term struggle to resist foreign invaders solidified into a friendship on the battlefield that no imperialist power can ever destroy. (105–106)

In sealing the interconnections and mutual support between the indigenous peoples and the Chinese, *A Short History of the Mountain People* even positions the Musha Incident as key in inciting the combative stance taken by the Chinese during the War of Resistance starting in 1937:

The Musha Uprising allowed the Japanese conquerors an opportunity to get a firsthand taste of the iron fists of the mountain people, which also had a massive effect on inspiring the Chinese people's revolutionary will to combat the Japanese imperialists. At the time, when the Taiwan compatriots and the mainland people in the motherland learned of the Musha uprising they provided incomparable compassion and support for the heroic actions of the mountain people. (106)

While much of the discourse in *A Short History of the Mountain People* is predictable pro-unification propaganda, it is one of the few official mainland Chinese publications to discuss the uprising, so I have quoted at length to present a sense of the multiple angles from which the "Chineseness" of and Chinese impact on the Musha Incident have been highlighted. Although the account is more overtly propagandistic than the literary texts examined, Nationalist and Communist rhetorics concerning the central historical interpretation of the uprising were nearly identical, and were both eerily reminiscent of earlier Japanese colonial strategies and discourses.

In stark contrast to these "Chinese" representations by Li Yongchi and Chen Quchuan and expressed in mainland China is a native Taiwanese framing of the incident. This perspective began with Zhang Shenqie's 1949 screenplay and was developed by two feature films in the 1950s and 1960s as well as later literary portrayals of the Musha Incident by writers such as Zhong Zhaozheng 鐘肇政.

In Taiwan, the lack of attention paid to the Musha Incident following *Red Across the Land* was no doubt heavily influenced by new Cold War power structures that aligned Taiwan and Japan with America against the new communist giant of mainland China. There were, however, several additional attempts to carry on Zhang Shenqie's vision by like-minded Taiwanese intellectuals and filmmakers. These efforts did not emerge from the Nationalist regime's Central Motion Picture Corporation or other "official channels," but rather through the fledgling Taiwanese-language film community, which was primarily privately funded. He Jiming 何基明 (1917–94) directed the first major Taiwanese box office smash, 1956's *Bi Pinggui and Wang Baochuan* (*Bi Pinggui yu Wang Baochuan* 薛平貴與王寶釧), produced by his own Taizhong-based independent film production company, Huaxing 華興. This success opened up a brand new market. Riding the popularity of *Bi Pinggui and Wang Baochuan*, He Jiming leveraged the new profitability of Taiwan dialect films to rally investors around his epic adaptation of the Musha Incident, *Bloodshed on the Green Mountains*

(*Qingshan bixue* 青山碧血).[11] This 1957 film begins with various instances of oppression at the hands of the Japanese, which is brought to a head at a local wedding on October 7, 1930 when a Japanese officer brutally beats an Atayal man after having his pristine white gloves soiled by blood. This proves to be the spark that leads to the uprising, and the film concludes with the slaughter of the 134 Japanese at the elementary school.[12]

Bloodshed on the Green Mountains was the first Taiwanese-language anti-Japanese film produced and was even honored at the Golden Horse Film Festival with the prize for Best Screenplay for Hong Congmin 洪聰敏. The film was a labor of love by He Jiming, who had first gone to Musha during the Japanese occupation period and spent years planning his production. The process of making it was riddled with challenges, as Huang Ren 黃仁 has noted:

> One could say that making a film about the Musha Incident back then was extremely difficult. Transportation alone was a huge hurdle; there were no public roads in the mountains and cars could not get up the mountain, so all of their equipment had to be transported manually by porters. Moreover, up in the mountains they were without proper food supplies; there was no electricity so, naturally, there were no electric lights at night. Thankfully, He Jiming was set on making this film and was not dissuaded by all of these obstacles. The director and his colleagues personally helped with moving all the equipment and everyone on the crew handled multiple tasks, including even the lead actresses; they all worked together to overcome these hardships.
>
> In the end, a crew of just over twenty people went deep into the mountains to shoot. Although He Jiming was able to rise to the occasion when it came to most of the challenges facing him, there were some difficulties that proved too much; these included such resources as planes, cannons, soldiers, explosives,

11. In 1958, He Jiming's Huaxing Company also produced an award-winning but commercially unsuccessfu, film about the 1915 Xilai An Incident 西來庵事件, entitled *Bloody Battle of Ta-pa-ni* (*Xuezhan jiaobanian* 血戰噍吧哖), which further cemented his ideological commitment to Taiwanese nationalism and anti-Japanese discourse, both largely absent from mainstream Nationalist discourse of the day. As Huang Ren, one of the sole scholars to take note of Huaxing's accomplishments, has written: "Most Taiwanese films during that era dealt with everyday themes, but it was under those circumstances that Huaxing was able to produce *Bloodshed on the Green Mountains* and *Bloody Battle of Ta-pa-ni*, these two outstanding films that expressed how the Taiwanese people resisted the Japanese. *Bloodshed on the Green Mountains* was a special case, as it captured the indigenous people's courageous anti-Japanese struggle. In later years no one really paid much attention to this, but it is truly amazing that Huaxing was able to make films from that perspective, producing films without regard to what kind of box office response they would receive" (Film Archives Oral Film History Committee, *Taiyu pian shidai*, 103).

12. Historian Paul D. Barclay has discussed the October 7 incident between Japanese patrolman Yoshimura Katsumi and Tadao Mona in his article, "'Gaining Confidence and Friendship' in Aborigine Country: Diplomacy, Drinking, and Debauchery on Japan's Southern Frontier."

and other items that were impossible to obtain without explicit government support. (Huang Ren 100–101)

Without governmental and military aid, He Jiming was unable to film his planned sequel about the Japanese suppression of the incident. And whether due to practical or political concerns, the fact that the brutal aftermath went unrepresented created a significant absence not only in the body of the film but also in the later history of representation of the incident. In 1965, Hong Xinde 洪信德 released yet another Taiwanese-language film, *Disturbance in Musha* (*Wushe fengyun* 霧社風雲), which extended beyond the uprising and also highlighted the Japanese crackdown. The focus is on Hanaoka Ichirō and Hanaoka Jirō, and the former is taken as the leader of the uprising, a perspective that would be echoed in later literary and visual representations. As Huang Ren (1994:107) has observed, the film also highlighted the sympathy and humanism of the Atayal, who go to great lengths to protect innocent Japanese, in contrast with the colonizers, who order the local hospital *not* to treat injured Atayal. *Bloodshed on the Green Mountains* and *Disturbance in Musha* are often overlooked today, but they stand as important efforts to resurrect the Musha Incident in a distinctly Taiwanese aural context, reclaiming this history for Taiwanese audiences, as Zhang Shenqie had tried to do many years earlier. These two films can also be seen as part of a larger attempt by early Taiwanese filmmakers to articulate a distinctly Taiwanese historical experience against the hegemonic power of government-sponsored Mandarin films and the nostalgic "Chinese" historical vision they relayed.

Best known for such works as 1960's *Dull Ice Flower* (*Lubinghua* 魯冰花) and the landmark *Taiwanese Trilogy* (*Taiwan ren sanbuqu* 台灣人三部曲), which was completed in 1976, Zhong Zhaozheng, an important figure in the Taiwan nativist literary movement, was a frequent contributor to *Taiwan Literature* (*Taiwan wenyi* 台灣文藝), in which many of his major works were first serialized. Zhong's fascination with the Musha Incident actually began while he was growing up under the Japanese occupation.

According to my hazy memories of those days, this is what I remember: Father had the newspaper in his hand and all the "uncles" in the neighborhood stood around talking to no end. The words that I heard most were "guess how many Japanese the savages killed," "even the county head was slaughtered," "nothing escapes the eyes of heaven"; this kind of talk went on for days. Their expressions and tone of voice seemed to be quite excited as they spoke, but left me

with a feeling of terror. All I could think about was the image of a big knife cutting down and dark red blood dripping everywhere as a head rolled down the street like a rock. How could such a terrifying thing happen? And how could Father and the others appear so happy and excited as they spoke of it? I couldn't figure any of this out, but deep in my heart I was left with that feeling of blood-filled terror. (Zhong 7:377)

Zhong's haunting memories already hint at a more complex framing of the Musha Incident that challenges the exuberance of nationalistic celebration with the bloody reality of violence and decapitation. The passage clearly demonstrates the constructed nature of human memory as Zhong "creates" his own very visceral visions while vicariously experiencing this trauma. The metanarrative device of the text is also revealed as the author consciously questions the way this history was first presented to him, through excitement and joy. The dramatic tale of Mona Rudao's uprising would eventually inspire Zhong's two major works on the incident. *The Calamity at Mahebo* (*Maheibo fengyun* 馬黑波風雲), which was first serialized between October 26, 1971 and January 11, 1972, was published in book form in 1973. Exactly a decade later, in 1983, Zhong continued his literary account of the Musha Incident with parts I and II of his Mountain Suite, *Riverisle* (*Chuanzhongdao* 川中島) and *Fires of War* (*Zhanhuo* 戰火), which were intended to become part of a Mountain Trilogy, never finished.

The Calamity at Mahebo firmly positions the Musha Incident as a key historical moment in the birth of a new "Taiwanese" consciousness. Taiwan's changing place in the world was politically embodied by the Republic of China's loss of representation in the United Nations to mainland China in 1972 and by a host of countries breaking international ties in the mid-1970s. The sudden return to the Musha Incident can be seen as an attempt to bring focus back to indigenous Taiwan's history.

Yao Jiawen's 姚嘉文 novel *The Limits and the Gate* (*Wushe renzhiguan* 霧社人止關) further strengthened the Taiwan-centric historical positioning of the incident. Best known for his fourteen-volume historical novel *Taiwan in Seven Colors* (*Taiwan qise ji* 台灣七色記), Yao Jiawen is a veteran writer who spent seven years in prison for his role in the Formosa Incident. With a title referring to the infamous demarcation line in Musha beyond which nonindigenous peoples were warned to proceed only at the risk of never returning, *The Limits and the Gate* follows the love story between a Manchurian man and an Atayal woman in the aftermath of the February 28th Incident. Although the focus is on 2/28, the novel stretches back in time, encapsulating the Lin Shuangwen Incident of 1786, the Musha Incident of 1930, and the Anti-Nationalist

Uprising in Puli in 1947 to reflect on the traumatic history surrounding the area of Musha. By juxtaposing these three historical events, the first anti-Qing, the second anti-Japanese, and the third anti-Nationalist, Yao situates the Musha Incident within a new historical context that unabashedly highlights the historical subjectivity of Taiwan as independent and opposed to outside occupiers, whether they be the Qing, the Japanese, or the Nationalist regime.

Vestiges of Pain: Wu He and Chen Chieh-jen

To date, the most challenging and critically acclaimed work on the Musha Incident is the 1999 novel *Remains of Life* (*Yu sheng* 餘生). Born in 1951 in Tainan, Chen Guocheng 陳國城, who is known exclusively by his pen name, Wu He, or "Dancing Crane," began his creative writing career in 1974 with the publication of his award-winning short story "Peony Autumn" ("Mudan qiu" 牡丹秋). A handful of assorted works of short fiction followed until 1979, when he began a thirteen-year period of reclusion. Wu He left publishing—and mainstream society—behind to delve deep into the tribal societies of Taiwan's aboriginal peoples. He returned to creative writing in the early 1990s with a string of brilliant works of fiction, including the novels *Meditations on Ah Bang and Kalusi* (*Sisuo Abang Kalusi* 思索 阿邦・卡露斯) and *Remains of Life,* both of which were based on his experiences living among the tribes. The latter novel gained critical attention not only for its radical, almost stream-of-consciousness style but also for its literary excavation of the long-forgotten Musha Incident of 1930. Offering a sophisticated and complex exploration of civilization and barbarism that crosses the lines dividing history, reality, and fantasy, *Remains of Life* garnered more than half a dozen major literary prizes and became arguably the single most important novel to emerge in fin-de-siècle Taiwan.

The complete novel attempts a radical departure from traditional narrative approaches by presenting the entire 210 pages without any paragraph breaks and fewer than 20 sentence breaks. As outlined in the author's afterword, there are three main themes that he is exploring: "1) The legitimacy and accuracy behind the 'Musha Incident' as led by Mona Rudao, as well as the 'Second Musha Incident.' 2) The journey of my neighbor Girl. 3) The remains of life that I witnessed and met during my time on the reservation" (251). These themes also represent a secret code for unlocking the novel's structure, with each period (new sentence) representing a thematic shift from one subject to the next. Wu He also creates his own unique language, which combines stream-of-consciousness narrative with attempts to render various kinds of speech, including Taiwanese and Atayal-inflected Mandarin, into Chinese text, often by way of radically reconfig-

ured grammatical constructions. Throughout the novel, Wu He portrays the Atayal-inflected Mandarin through splintered and reversed prose and also relays the variety of linguistic mutations he encounters, from Atayal tribespeople who still speak only Japanese after 50 years of Chinese rule to characters who speak with constant stutters or incomprehensible pronunciation or the elder tribesman whose circular ramblings can barely be deciphered. The linguistic violence Wu He presents raises numerous questions about the Nationalist project to incorporate indigenous peoples into the Chinese or Taiwanese state. Earlier literary texts about the Musha Incident attempted to place the Atayal within the lineage of Chinese history and civilization while widespread policies of sinicization were being carried out in the mountain areas; however, *Remains of Life* reveals that just as the Atayal were losing their own beliefs, culture, and dialect under the pressures of sinicization and modernization, the Chinese culture and language introduced to replace them largely failed to take root. The fractured language throughout the novel can be read as a linguistic scar marking where their own culture was cut off by an ideological idea of "China." But in *Remains of Life* the imagined China (or imagined Taiwan) imposed upon the Atayal has proven violent; instead of transforming them into "good Chinese subjects," it has left them stranded at a crossroads between culture and language. Thus, the novel's radical linguistic strategy serves as a constant reminder of the ways indigenous peoples have struggled to conform to a conception of "China" or "Taiwan" that has consumed and deformed them.

Within the avant-garde literary structure, Wu He's reading of the Musha Incident proves equally iconoclastic. Like Zhong Zhaozheng's *Riverisle,* Wu He's novel does not directly confront the Musha Incident but instead explores the lives of the survivors and their families. As the title implies, *Remains of Life* is a tale of survival and its cost after a catastrophe bordering on genocide. The first-person narrator travels to Chuanzhongdao in the late 1990s and lives there on and off for nearly two years as he investigates what he terms the "contemporary history" of the Musha Incident. This designation refers to the narrator's perspective that there can be no true history independent of our own current historical positioning, which fundamentally shapes our perspectives and interpretations of the past. Given the narrator's self-reflexive reading, it is no surprise that he is equally sensitive to his own intervention in that "contemporary history." Wu He thus becomes a central character in his own novel, continually questioning the historical events that have been collapsed into the "Musha Incident" and acutely aware of the challenges that he faces as an outsider.[13] Among

13. Throughout the book, the first-person narrator is never given a proper name; this mirrors the other characters in the book who are also only known by nicknames, but rarely proper names. Throughout this

the narrative works on Musha surveyed here, the Han intervention has emerged as a common theme, but nowhere is it framed in a more self-conscious light than in *Remains of Life*.

Over the course of his investigation, Wu He encounters an eclectic cast of Atayal characters, including his neighbor Girl 姑娘, a free spirit who has returned to Chuanzhongdao after a failed marriage and a stint as a nightclub bar girl; her little brother Wanderer 飄人, who rides around aimlessly on his motorcycle; Mr. Miyamoto 宮本先生, who clings to the Japanese way of life and samurai ethics; and Shabo 沙波, an Atayal "volunteer" who fought for the Japanese in Southeast Asia. The plight of these characters as they eke out a living on the reservation, which has been left behind by Taiwan's modernization and miraculous economic growth, gradually forms the basis of a new tragic tale. And although these marginalized characters take center stage, seemingly displacing traditional Musha narratives that have focused on Mona Rudao and the Hanaokas, the shadow of those traditional figures is present from the very first page, when Girl makes the whimsical pronouncement, "I'm Mona Rudao's granddaughter" (43). A similar declaration is made later by Old Daya, who claims to be Mona Rudao's grandson (69), displaying the deep connection to the hero of the Atayal people.

Among the other characters that Wu He encounters on the reservation are two Atayal intellectuals educated in Taipei who are given particular attention in the narrative:

> During the course of my investigation into the Musha Incident, I only encountered two people who had a different take on the massacre than other people, both of them were Sedeq tribesmen, both of them were outstanding aboriginal scholars who held degrees from two of the top universities in Taipei, both of them had respect and authority in their tribe, and both were approaching middle age, Bakan, a Sedeq who belonged to the Daya subtribe from Riverisle, believed that history had misunderstood the fundamental meaning of the Musha Incident: "The true nature of the incident lies as a traditional headhunting

section I alternately refer to the narrator as Wu He because the novel is clearly inspired by the author's own experiences in Musha, as evidenced by a 2002 research trip I made to Musha and Chuanzhongdao with Wu He, during which we met several of the "characters" in his novel. However, there is very clearly a literary distance between the characters (including the narrator) and their real-life counterparts. The same may also be said of the literary incarnation of the Musha Incident that appears in the book. Whether by design or mistake, at one point the novel gives a false timeline for the Musha Incident, dating the original uprising on October 27, 1931, a full year after it actually occurred. Whether this is a simple mistake or the author's attempt to create a fictional distance between *his* Musha Incident and that of history, after the publication of *Remains of Life* at least three leading literary critics followed suit and cited 1931 as the year of the actual historical event—an interesting footnote on the ways fiction can write history.

ritual." . . . Danafu of the Sedeq Toda subtribe went even a step further in denying the historical existence of the "Incident," claiming there was only "a large-scale Musha headhunting ritual," coordinated by the clan leader of Mahebo; thus there never existed any such thing as a "Musha Incident" and the common people must learn to forget the "man who led the ritual—Mona Rudao" (Wu 2003:88–89)

Given the importance of Ichirō and Jirō, the two most highly educated Atayal at the time of the incident, it is hard not to read the introduction of Bakan and Danafu, the two most highly educated Atayal under the Chinese education system, as Wu He's attempt to further explore the complex set of cultural and postcolonial policies at work in the formation of this new generation of intellectuals. The ambiguous rendering conflates these figures even more with their historical counterparts when one considers that the fictional characters the narrator encounters are based on actual people Wu He recalled from his days living on the reservation. Wu He is clearly interested in tracing the historical lineage that connects the original incident to the "remains of life" that continue to survive in the shadow of atrocity and exploitation.

For although the novel is set entirely in the late 1990s, the link to the past and the tragic weight it projects into the future are continually highlighted through Wu He's disjunctive narrative. Wu He philosophically frames his work through the "contemporary Musha Incident," inextricably linking historical events and the contemporary context from which we perceive them. The ghosts of the irrevocable past continually creep into the present, as the present is forced to carry the burden of that past. When the local tribe members discuss a scandalous incident involving a single female, Wu He makes the connection to the past implicit:

They dealt with "Sister's matter" through secret talks leading to a decision that would be carried out immediately "Sister's matter" was quite similar to the "incident" that occurred so many years ago; it was only that the content of the strategy and decision were quite different; indeed, the way history passes itself down has its own logic (Wu 1999:89)

Wu He goes even further when he uses this perspective to reevaluate what the Musha Incident actually represented: a traditional headhunt, an anti-Japanese rebellion, or simply an unjust slaughter?

"The contemporary Musha Incident" or "the Musha Incident in contemporary context" . . . is not only the main theme of this novel but also the most

accurate historical perspective; when I first entered the contemporary Musha Incident I already felt that the "injustice of massacre" could face off against the "honor of resistance" and the "headhunt as ritual," possibly overthrowing the legitimacy of the historical Musha Incident (85)

Here Wu He uses contemporary human rights attitudes to openly challenge long-standing assumptions about the history of the Musha Incident. Virtually all historical narratives centering on the event—historiography, fiction, or film—emphasize the honorable or patriotic aspects of what is framed as either an anti-Japanese act of resistance or a traditional Atayal cultural ritual, but Wu He calls the inherent morality of the massacre into question. Although this may not seem like a radical stance from our contemporary perspective, in the long history of writing about Musha, *Remains of Life* is a lone voice questioning this set of interpretations. At the end of the novel, Wu He concludes that the contemporary cannot affirm the legitimacy of the Musha Incident (247). However, delivered by a freelance novelist after two years of personal searching, historical meditation, fieldwork interviews, and strolls along the small paths between the fields and graveyards of Chuanzhongdao, this is far from the final word on a complex page in Taiwan's colonial history.

Another shocking facet of Wu He's contemporary reimagination of Musha is his juxtaposition of his investigation into the incident with a seemingly unbridled sexual imagination. I argue, however, that the almost absurdist sexual component running through the novel does not represent a fantasized or exoticized vision of indigenous people from a conservative Confucian Han perspective. Instead, the emphasis on the body and sex in both language and act throughout *Remains of Life* represents something much more profound and intimately connected to the violent past. In one passage, the narrator begins with a satiric comparison between primitive breasts and civilized breasts before moving on to question his own exclusion of the sexual act from his investigation:

> Why is it that I think of the "contemporary history of the Musha Incident" but never consider the "contemporary history of Musha sexual practices," is it possible that people's sex lives are hidden within the incident, not just superficially, but "contained" in the most deep and primitive way? Considering it like this I return to my original line of thought; I have temporarily conquered my insomnia, I sleep, but still cannot escape "the sex life of the incident," I'll have to wait until the novel's future (90)

Wu He explores the various ways sex and violence intersect, from how sex may have been a driving force behind the headhunt in Atayal culture (228) to the

many contemporary Atayal women who have sought a "better" life for themselves in the cities working as prostitutes. The seemingly pervasive promiscuity, prostitution, alcoholism, and aimlessness that Wu He observes during his time in Chuanzhongdao can be understood as only part of the Musha Incident's post-traumatic legacy. For Wu He, the Musha Incident and the Second Musha Incident of 1931 are not self-contained outbreaks of violence, but touchstone moments in the destruction of the Atayal people's language, culture, traditions, and honor. The ironic historical twist that has changed the Atayal from heroic bearers of the anti-Japanese spirit to disadvantaged remnants flocking to the cities to prostitute themselves or take low-paying construction jobs alongside Southeast Asian laborers makes visible the transformation of colonial violence and oppression into economic violence and capitalist exploitation. As a client who takes Girl back to his room observes, "Your ancestors spilled so much blood on Musha, who could imagine that their grandchildren would be selling themselves in hotel rooms?" (149).

The connection between sex and violence, passion and pain is riddled with complexities in Wu He's reading of the Musha Incident and traditional Atayal headhunting practices. The novel even identifies a complex between the hunter and the "beloved heads" he collects; according to Wu He, this relationship developed from one of terror to one of intimacy, until it eventually became a part of the everyday. The tribal meaning of the headhunt became implicit to all involved, and the decapitated head was not just a trophy of violence but an object of love:

"I decapitate you because I love you, and you will always know there is someone who loved you until death, it was only on that snowy day that you walked over beneath that dying pine tree, you barely resisted, you are dying for love, let us sing and dance until our hearts break all in the name of love, you are one of the few loves in my life, it is you alone I truly understand, so many secrets we share, only you understand my heart, I shall love you all my life even if you should one day end up on the head rack, as I pass by I recognize you immediately, tomorrow I shall bring fresh food and spirits for you, you know that when I hold my wife in my arms, it is you that I think about, it is you that I hold" (161)

While a good portion of this description is to be attributed to Wu He's macabre black humor, such passages belie a deeper connection between *eros* and *thanatos*, pleasure and death. Atayal headhunting rituals represent a passage to manhood for Atayal males, often followed by elaborate carnivalesque celebrations. The linking of gender, sex, and procreation in other headhunting societies has

been the subject of numerous anthropological studies.[14] Here the relationship between the hunter and his "beloved head" speaks of a deep psychological tie between ecstasy and that which lies "beyond the pleasure principle." This explains the numerous passages exploring and questioning the aesthetic beauty the tribesmen see in decapitation. Wu He even goes so far as to trace sex to the very inception of the Atayal practice of headhunting:

> The reason that headhunting became a historical necessity was actually due to "sex" the bloody terror of cutting off someone's head can stimulate sexual desire and that night men and women husbands and wives have wild intercourse; otherwise sex life on the reservation would be as old as the mountains and streams utterly tasteless (228)

But the unbridled sexual imagination running through *Remains of Life* is but one facet of the work's iconoclastic vision, which seems bent on deconstructing traditional views of history, sexuality, literary narration, and even nationalism and the hegemonic power of the state. As David Der-wei Wang has observed, Wu He is a "wounded soul" who comes to Chuanzhongdao only after having been "castrated" by the corrosive power of the Nationalist regime. "In other words, the Musha Incident is treated by [Wu He] as both a historical site and a psychological coordinate where historical violence and personal trauma, however disparate in appearance, are made to elucidate each other's meaning" (Wang 2004:37). As the narrative progresses, it becomes clear that the narrator is another of the damaged remains of life searching for meaning and direction after traumatic upheaval. For the Atayal, the perpetrator is not just the heavy tradition of Japanese colonization, exploitation, and forced assimilation but also the similar politics employed by the Chinese:

> Researching the postwar relationship between the Han Chinese and the indigenous peoples, I predict that the "contemporary" must also question the authority of the Han, their political dominance, cultural intrusion, and natural policy of "complete assimilation" without the slightest self-reflexivity (132)

14. Most such studies focus on headhunting communities in Southeast Asia. Although Taiwan is traditionally considered part of a separate geographic and cultural sphere, DNA tests have linked the indigenous peoples of Taiwan with groups in Southeast Asia. According to the most recent DNA research, Taiwan aborigines are a very different evolutionary branch from Han Chinese. A recent study led by Jonathan S. Friedlaender has indicated that Polynesians and Micronesians are closely related to Taiwan aborigines. For more see Professor Friendlaender's study in the online journal *Public Library of Science Genetics* (www.plogenetics.org). For more on the relationship between headhunting and sexuality in Southeast Asian tribes, see Janet Hoskins, *Headhunting and the Social Imagination in Southeast Asia*, 18–24.

In this sense, Wu He sees himself as another sufferer of this policy of cultural dominance. And while the narrator may occasionally describe himself as a kindred spirit of the Atayal, he remains always conscious of his status as a stranger in a strange land, a outsider searching for shattered pieces of history and remnants of memory in a place of exile. For the sufferings of the Atayal in Chuanzhongdao go far beyond the Musha Incident, the Second Musha Incident, and decades of cultural domination under the Chinese. Through Wu He's narrative other forms of violence creep into our historical field of vision, from Christian missionaries' displacement of traditional Atayal spiritual legends and beliefs to the sale of the younger generation as cheap workers and prostitutes to the erosion of local dialects and traditions by new forms of Chinese and global popular culture, such as Taiwanese variety television shows, karaoke, Chinese pop music, McDonalds, and 7-11s. For many of the "remains" living amid this new set of traumatic circumstances, "the incident" becomes a site of historical amnesia. As one character tells the narrator, "had you not brought it up I would have completely forgotten about the incident." And how could they remember, with the new historical injustices assaulting them?

There are characters such as Mahong Mona 馬紅 莫那, Mona Rudao's eldest daughter, whose story becomes a key entry point for the narrator to understand the historical price of the Musha Incident:

> After the incident Mahong still lived in the "incident," she never forgot or left the "incident" behind, even though all kinds of people used all kinds of words and actions to exhort her and try to get Mahong to lead a normal life, thirty years after the incident, all the way up until her death, not for one second could she leave it behind (153)

The site of Musha 1930 consumed even Mahong's "contemporary history," all the way until her death decades later. The Musha Incident transformed from a nightmare into a reason to live, alternately haunting her and driving her on.

> No one ever asks how the remains of life got on after having been treated, "time" could not cure Mahong Mona, and that is because hers was not a simple sadness; "time" is helpless to cure such deep and complex wounds as hers, but Mahong was happy in her late years, she didn't have the problem of not knowing "how to spend the remains of life," the never-ending wounds injected Mahong's life with the energy to repeatedly attempt to return to "the past," authenticating the site of the incident she had experienced, thus the "incident" fulfilled and completed Mahong Mona's remains of life (179)

Her legacy, however—including a son who miraculously escaped to Latin America and a Latin-Atayal granddaughter fighting for commemoration of the incident from across the sea—marks one of the most fantastic twists in the posthistory of the event.

Remains of Life also stands out for the particular attention it pays to the often overlooked Second Musha Incident, which David Der-wei Wang has rightly observed serves "as the key to demythifying the 'original' incident. As [Wu He] maintains, only through the prism of the redundant second massacre can one understand the complex significance of the first" (Wang 2004:33). With his extended discussions and meditations on the controversial Second Musha Incident, Wu He is able to articulate the myriad contradictions at the heart of what happened and how that history has been mythologized. How can the spirit of the incident be endorsed when headhunting is judged as barbaric? How can the initial incident be read as a purely patriotic, anticolonial movement when it was duplicated a few months later as a cannibalistic bloodfest? And what is the fundamental difference, if any, between the original raid on the Japanese at the elementary school and the second series of raids on the detention center where the Atayal were being held for "protection"? *Remains of Life* goes far beyond any other previous literary treatment, breaking open a historiographical Pandora's box whose contents fundamentally alter our understanding of what happened in 1930 and 1931 in that remote mountain village.

While the original "remains of life" were expelled from Musha to Chuan-zhongdao, seventy years later, at the end of *Remains of Life*, the narrator and Girl, along with a few others, embark on a new spiritual voyage upstream toward Mahebo, Mona Rudao's tribal home in Musha. While the first journey was one of exile from an ancestral homeland to a new settlement named after a city in Japan, the passage at the end of the novel is not just a physical journey but also a symbol of Wu He's historical journey. Beginning with the only physically displayed remnant of the Musha Incident, the diminutive "monument to the remains of life" erected at the foot of a small hill in Chuan-zhongdao, Wu He conducts his historical and imaginary excavation of history, gradually moving closer to the reality of the "contemporary Musha Incident."

Although written nearly seven decades after the Musha Incident, Wu He's *Remains of Life* stands apart from other literary narratives of the event not only for its avant-garde structure and form, attention to the contemporary remnants of the past, and challenges to traditional historical interpretations but also, most of all, for its powerful way of communicating sadness and trauma. The overwhelming number of texts that have positioned the Musha Incident as a glorified struggle against Japanese imperialism have left little room for the trauma and pain lurking behind the incident to speak. With Mona Rudao presented as a

legendary warrior who led his people on a noble mission of resistance and sacrifice later commemorated with statues and coins, the tragic dimensions of Musha have become overshadowed by its mythic retelling. Wu He never once tries to depict or portray the actual events of 1930 and 1931, but his novel provides a most powerful vessel for conveying the trauma of lives fractured by violence and unspeakable loss. From Wanderer's aimless journeys around this place of exile and Mr. Miyamoto's nostalgia for the good old days as a colonial subject to the "grandchildren of Mona Rudao" who now sell their bodies in the cities and the old Atayal man who closes the novel by proclaiming he "lives out the remains of his life in bed without thought or reflection," the multifaceted ways trauma has been reflected and refracted are made glaringly visible. And although Wu He laces his narrative with quirky absurdist humor and nonsensical ramblings, we are left not with laughter but with historical fracture manifested through splintered language, shattered experiences, and fractured remains of life.[15]

An equally iconoclastic reading of the Musha Incident is presented in a digitally manipulated historic photo of the incident by visual artist Chen Chieh-jen.

The image features 101 decapitated heads displayed across the ground with a crowd of hunters sitting proudly in the background. The original image is not, however, from the Musha Incident but from the Second Musha Incident, when the Japanese recruited neighboring tribes to storm the detention centers and slaughter those who had taken part in the insurrection. In the original image the Atayal heads are displayed in the foreground with a squatting Japanese officer in the rear, flanked by the victorious headhunters. In Chen Chieh-jen's reinvention, the artist inserts a bloody and partly dismembered Han Chinese (represented by the artist himself) in the center. This textual intervention reframes the work, not only by literally inserting the "body of China" (or a "Chinese body") between the indigenous subjects and the Japanese but also by introducing a very visceral notion of physical suffering that seems largely absent from both the faces of the hunters and the expressionless heads in the original photo. Chen not only highlights the Chinese presence in the Musha Incident in a highly critical and self-reflexive way but also offers a stinging deconstruction of how the incident has been portrayed in traditional Chinese historiography.

15. Cheng Wen-tang's 鄭文堂 Somewhere Over the Dreamland (Menghuan buluo 夢幻部落) is another example of an attempt to locate the post-traumatic legacy of the Musha Incident in popular culture. The film interweaves the tales of three Atayal trying to navigate through loneliness, alienation, and rootlessness in contemporary Taiwan. Although there are no direct representations or mentions of the Musha Incident, the film is another search for the "remains of life," some seven decades after the insurrection. In fact, several key scenes are indebted to Wu He's Remains of Life, an artistic debt the director emphasized during a 2002 interview.

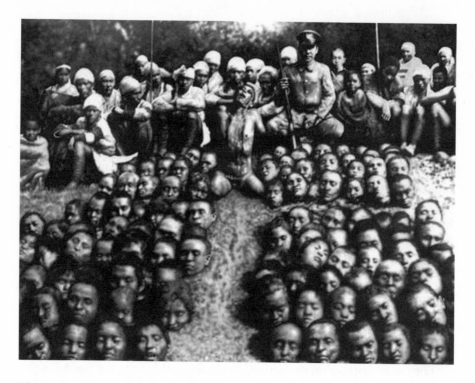

The Musha Incident in Chen Chieh-jen's Revolt in the Body and Soul series. Courtesy of the artist.

Unlike other Chinese and Taiwanese interventions into the Musha Incident, like Zhang Shenqie's insertion of Zhu Chentong, Chen Chieh-jen's violent self-insertion can be read as an allegorical performance of the ways Chinese discourse has intruded into indigenous discourse, in some cases making itself the central object of violence.

Like other pieces in his Revolt in the Body and Soul series, Chen's work on the Musha Incident also highlights a form of self-inflicted or cannibalistic violence. The emphasis is not on the glory of the uprising and the heroism of the indigenous revolt, but on the most complex, morally ambiguous, and, in the eyes of many indigenous people, shameful moment—the Second Musha Incident of 1931, in which the Japanese used a combination or coercion, threats, and promises to recruit other indigenous tribes to headhunt the headhunters. Carried out a full six months after the original insurrection, this belated massacre displayed the darker side of the Japanese policy of "using the savages to control the savages." And unlike the first Musha Incident, which has been positioned largely uncritically in most Chinese discourse as a model of anti-Japanese heroism, the Second Musha Incident points to a much more complex politics of vio-

lence. The result of the April 24, 1931 attack was more akin to Lu Xun's description of a cannibalistic cycle of violence than to any kind of lofty anticolonial struggle. And while both events were very much driven by the colonial situation—the first a reaction against it and the second a result of manipulation by the powers involved—the radically different forms the two incidents took, their close historical proximity, and the fact that both were carried out by different parts of the same ethnic group only further challenges the possibility of any simplistic interpretations of this bloody page in colonial Taiwan history.

Simplifying History? The Musha Incident in Popular Culture

Since the 1990s, the two individuals who have contributed most to the body of existing cultural representations on the incident have been local freelance historian Deng Xiangyang 鄧相揚 (b. 1951) and illustrator Qiu Ruolong 邱若龍 (b. 1965). A practicing medical doctor by training, Deng was raised in the area around Musha and has become a prolific writer on the cultural history of the Musha Incident, publishing a string of energetically researched books, including *Dana Sakura: The True Musha Incident and the Story of Hanaoka Hatsuko* (*Fengzhong feiying: Wushe shijian zhenxiang ji Huagangchuzi de gushi* 風中非櫻: 霧社事件真相及花岡初子的故事), *The Musha Incident* (*Wushe shijian* 霧社事件), and *Layers of Mist, Heavy Clouds: One Atayal Family After the Musha Incident* (*Wucong yunshen: Wushe shijian hou, yige taiya jiating* 霧重雲深: 霧社事件後, 一個泰雅家庭). Trained as an artist, Qiu Ruolong is the author and illustrator of *The Musha Incident: A Manga History of Taiwan Aborigine History* (*Wushe shijian* 霧社事件: 台灣原住民歷史漫畫), a 266-page graphic novel that provides a visceral depiction of the native uprising. In 1998 he directed the first documentary feature film on the incident, *Gaya—The Seediq and the Musha Incident of 1930* (*Gaya—1930 nian de Saideke zu yu Wushe shijian* 嘎雅—1930年的賽德克族與霧社事件).

Since its initial publication in 1990, Qiu Ruolong's *The Musha Incident* has been reprinted by three different publishers in Taiwan and even published in Japanese, becoming one of the most circulated texts on the event. Providing a detailed overview of the exploitative practices of the Japanese and the burgeoning unrest among the natives, Qiu Ruolong devotes the middle sections of his graphic novel to a depiction of the attack on the elementary school, including this rendering of the first decapitation.

Qiu continues with nearly a dozen additional decapitation sequences, never shying away from the brutality of the initial assault. However, all of the Japanese victims portrayed are male military or government officials. This is curious

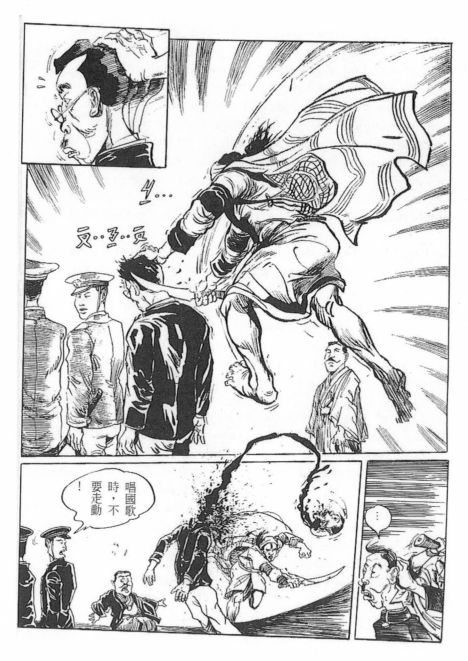

The first decapitation at the elementary school as portrayed by Qiu Ruolong. Image courtesy of Yushan Publishing Company, Taiwan.

because the Atayal did not discriminate in their slaughter, killing Japanese civilians, including numerous women and children, alongside the male officials. This strategy effectively downplays the individuality and humanity of the Japanese killed, transforming them all into living (or dying) incarnations of the Japanese colonial machine.

Qiu further dehumanizes the Japanese by stressing an overt physical "ugliness." Almost always wearing their government-issued uniforms, the Japanese are often drawn with distorted jaw lines, bordering on deformity, and crooked teeth, and usually appear either disproportionately obese or obscenely skinny. Such depictions stand in direct opposition to the image of the Atayal tribespeople, who are drawn with clear, strong lines and handsome features, and dressed in crisp white outfits, unlike the black uniforms of the Japanese officers. Such strong racial stereotypes often lead to radical juxtapositions in the visual rendering of the colonizer and the colonized. Similar approaches are commonly employed in comic books to emphasize the negative traits of a villain and accentuate the positive in the hero. Qiu, however, seems to be striving for a greater degree of historical accuracy, as evidenced by his book's extensive narrative sections, historical figures and maps, footnotes, and appendices. Even the subtitle of the 2004 edition markets the book as *Taiwan's First Investigative Report Manga on the Indigenous People.* Given the racial politics in his representation, however, we must ask if Qiu is actually striving to authenticate his own imaginary re-creation of the incident. One of the main reasons given for the Atayal's uprising has always been the exploitation and unequal treatment suffered by the Japanese, who viewed them as second-class citizens (or perhaps third-class citizens, after the Han). But here, decades later, the artist employs an equally skewed ethnic representation in an effort to, quite literally, invert the injustices suffered.

Also of interest is the fact that the Second Musha Incident is mentioned only in passing at the very end of the text and represented by a rough sketch of the same infamous photograph that Chen Chieh-jen took as inspiration for his own response to the incident. Whereas the initial slaughter is embellished with dozens of pages of blatant violence, in which Japanese are shot, bayoneted, beheaded, and stabbed, the Second Musha Incident is confined to the same visual space it has always occupied—that single disturbing photograph of 101 trophy heads piled up for commemoration. The image, modeled closely on the original photo, also features an extensive textual narration of the event. Qiu's decision to use written text over images further enunciates the uncomfortable place this self-slaughter by the natives inhabits in the historical and cultural legacy of Musha. Whereas the slaughter of the Japanese is an event to be heralded, embellished, and, indeed, celebrated, the cannibalistic slaughter at the three detention centers is a trauma that remains largely outside the realm of representation.

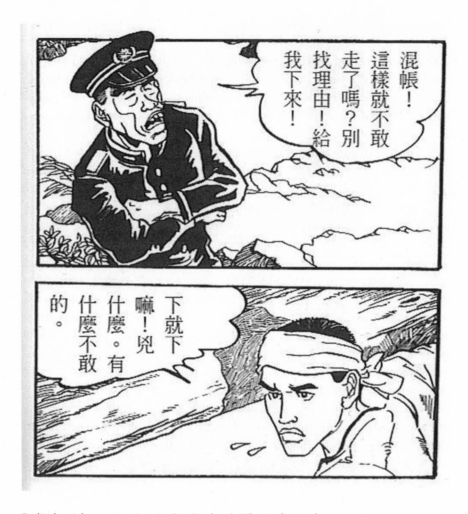

Radical racial representations in Qiu Ruolong's *The Musha Incident*.
Image courtesy of Yushan Publishing Company, Taiwan.

The Second Musha Incident is forever sealed within the confines of the original photograph displaying trophies of violence, which has been passed down as the raw material for writers and artists. Chen Chieh-jen decided to continue a visual dialogue with the raw material; Qiu decided to add a written parallel to a fairly faithful rendition of the original, contextualizing the image in a way that closes it rather than opens it up for further scrutiny and dialogue.

Deng and Qiu have also collaborated on a number of projects aimed at raising awareness of the Musha Incident in Taiwanese popular culture. In 2004, the Council for Cultural Affairs in conjunction with Taiwan Public Television produced a television miniseries based on Deng Xiangyang's book *Dana Sakura: The True Musha Incident and the Story of Hanaoka Hatsuko* about Hanaoka

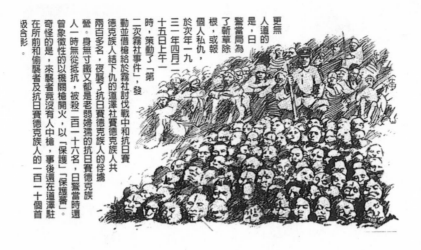

The Second Musha Incident in Qiu Ruolong's *The Musha Incident.*
Image courtesy of Yushan Publishing Company, Taiwan.

Hatsuko 花岡初子, one of his former patients and the widow of Hanaoka Jirō. Qiu Ruolong served as an executive consultant and co-writer for the series, which was directed by Wan Jen 萬仁 (b. 1950), one of the key members of the New Taiwan Cinema movement.

The miniseries, which runs for more than seventeen hours, aired during prime time, reaching a wider Taiwan audience than any previous attempt to popularize this traumatic historical moment. The narrative is framed by a young Chinese history student who travels to Musha and Chuanzhongdao searching for answers about the past. He eventually tracks down Hanaoka Hatsuko, who begins to retell the harrowing story of her life around the time of the Musha Incident. At this point the narrative focalizer shifts and the series slips into a flashback retelling of the story, punctuated by Hanaoka's melancholic voice-over narrative. This narrative begins in 1920, a full decade before the uprising, and explores the formative years of Hanaoka Ichirō and Hanaoka Jirō as they go to school and eventually leave Musha to pursue other educational opportunities in Puli. Their story is intercut with extensive scenes detailing the exploitation of the Atayal people and growing unrest, which result in several failed attempts at rebellion. The narrative then goes on to detail the 1930 uprising, the 1931 Second Musha Incident, and the final purge that took place on October 15, 1931 under the pretext of an "Allegiance Ceremony."

As a prime-time drama, *Dana Sakura* must walk a fine line in the strategies it employs to represent violence. The first Musha Incident is very much the focus, with extensive screen time given to the raid on the elementary school.

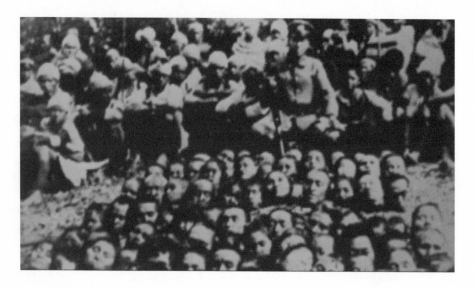

The original photo of the Second Musha Incident headhunt, as reproduced in Wan Jen's *Dana Sakura*.

The act of decapitation, which has for many become the embodiment of the insurrection, is mostly only shown offscreen and followed by displays of the trophies of violence. The portrayal of the Second Musha Incident begins in a similar way, with the Toda descending on the detention camp, and relays a few short sequences of the clash, but then shifts radically. For the first and only time in the series, the camera cuts to a black-and-white photograph. This sudden change once again speaks to a "photographic reality" of brutality and inhumanity that somehow lies beyond the realm of the imagination—and further representation. Wan Jen holds the photograph on screen as Hanaoka's voice-over verbalizes the violence: "After the Second Musha Incident, of the 1,400 people from the six tribes that had risen up against the Japanese, fewer than 300 survived. And for the survivors of this calamity, the shadow of death could never be dispelled."

Like previous literary works by Li Yongchi and Chen Quchuan, *Dana Sakura* remains focused on Hanaoka Ichirō and Hanaoka Jirō. Instead of presenting them as nationalist heroes, however, the series takes a markedly more humanistic approach that highlights their anguish, struggle, and frustration. Although in their dress, speech, and daily life, Ichirō and Jirō seem to be fully Japanized, their Japanese colleagues continue to look down on them as inferior colonial subjects. By the same token, their new position as police officers ostracizes them from other tribe members, who now see them as running dogs for the imperial

powers. As the series progresses, a tug-of-war between duty and loyalty plays out within them, especially in Ichirō, who becomes increasingly tormented as hostile anti-Japanese attitudes grow on the eve of the Musha Incident.

This identity crisis climaxes just before the insurrection during a meeting with Mona Rudao. When Ichirō begs the tribal leader to give up any plans for rebellion, Mona turns the discourse around:

> MONA: Ichirō, Jirō, are you speaking to me now as a Seediq or as a Japanese police officer? Even a wild pig knows to give up when it is surrounded. I am only going to ask the two of you one question: Is that the blood of the Seediq running through your veins?
>
> JIRŌ: But no matter what, you should not take to rebellion. The reservation needs to be built up. Reform takes time, we must do it in steps.
>
> ICHIRŌ: Mona, I won't try to change your mind, but since the tribe has made their decision, Jirō and I must also make our decision.

In *Dana Sakura,* Hanaoka Ichirō and Hanaoka Jirō's eventual decision is essentially a nondecision. They do not report the imminent uprising to the Japanese authorities, but they do not officially join it either. During the October 27 massacre, Ichirō stands amid the violence in a state of flustered confusion, looking for his wife. The brothers' nonaction leaves them in an even more precarious position after the massacre, as the Japanese authorities suspect them of being the chief planners. In the end, torn between the colonial regime that fostered them and the tribal alliances running deep inside, Hanaoka Ichirō and Hanaoka Jirō choose suicide.

Since the death of the two protagonists occurs several episodes before the conclusion of the series, the producers introduce a new character shortly before it. Like the two Hanaokas, Nakayama Kiyoshi 中山清 is a "model savage" educated under the Japanese, who even looked up to Ichirō and Jirō as figures to be emulated while in school. Through Nakayama, *Dana Sakura* is able to effectively continue articulating the same cultural fissure between aborigine and Japanese allegiances. The anguish is made particularly palpable as Nakayama is forced to count the decapitated heads presented by the Toda to the Japanese for monetary rewards during the crackdown.

Another new character introduced to put a new spin on the historical discourse surrounding Musha is the Japanese teacher, Murata *sensei* 村田老師. Murata is introduced early in the narrative as one of the few Japanese characters sympathetic to the plight of the indigenous peoples, and he works to deconstruct stereotypes that present the Japanese as purely exploitative colonizers through

Hanaoka Ichirō and Hanaoka Jirō writing their suicide note in Wan Jen's *Dana Sakura*.

his selfless devotion to the Atayal children. Murata eventually leaves Musha, but he returns years later in the immediate aftermath of the massacre as a journalist, now the voice of international justice to expose the ill deeds of his government, including the use of internationally banned poison gas and summary execution of prisoners without a fair trial. Time and time again, Murata is forcibly expelled from meetings as he shouts protests such as, "The people have the right to know!" In the end, his voice is effectively silenced by threats from the Japanese authorities. In the final moments of the story, however, as he prepares to leave Chuanzhongdao and return to Japan, he offers a final message to the narrator, Hanaoka Hatsuko:

> "Please forgive me. Please forgive the Japanese people for the mistakes we made! Hatsuko, you know that the Japanese do not apologize easily, but for all the hardships your people have been put through and for everything we Japanese have done, I feel the Japanese owe you an apology. I am sorry. And it was I who taught you about Japanese civilization and encouraged you to become Japanese. But Japan was wrong, especially in terms of the role it played in the Second Musha Incident. We committed unforgivable mistakes. We went too far with the Seediq people. I'm so sorry. Now that things have calmed down, I hope that you treasure your life and hold on to bear witness to this Musha Incident."

Murata's statement serves not only as a personal message to his former student but also as a national apology from the Japanese state to the indigenous people who suffered during the brutal crackdown. It encourages the narrator to confront her trauma through testimony, but the message is an imaginary one, written by the Chinese screenwriters to provide a cathartic release for those who suffered and those who claim that suffering as their own.

One of the most fascinating characters in *Dana Sakura* is a Taiwanese, Ruan Wenxiong 阮文雄, who befriends the narrator along with Hanaoka Ichirō and Hanaoka Jirō during their school days in Puli. Ruan is actually a pro-Taiwan independence activist who takes part in political rallies and constantly engages the two Hanaokas in political debate during the early episodes of the series when they are still students. Against the advice of his family, Ruan continues his political activities until warrants are issued for his arrest. He is apprehended and only released to the custodianship of his family after torture and abuse by the Japanese have left him a cripple. Still unwilling to desist, however, Ruan continues attending secret political meetings and is arrested a second and final time, after which he disappears under the political oppression of the Japanese authorities.

Ruan's teachings deeply influence the Hanaokas as they later face their own choice between resisting with their tribesmen and complying with the colonizers, but on a larger scale, Ruan's struggle for Taiwanese autonomy and political freedom parallels that of Mona Rudao, the Seediq from Mahebo, and the other five tribes. This effectively sets up a historical connection between the indigenous uprising and Taiwanese pro-independence activities. But even more interesting is Ruan's place in the framing of the story. At the end of the final episode, the identity of the Han historian who opens the series and travels to Musha and Chuanzhongdao in search of history is finally revealed. His name is Ruan Zhengyi 阮政一, and his great uncle was Ruan Wenxiong, a long-forgotten martyr in Taiwan's struggle for independence. And while Ruan Zhengyi becomes the vessel for Hanaoka Hatsuko's story—belatedly fulfilling her Japanese teacher's request—what Ruan is really looking for is information about his great-uncle's life as he pieces together *his* own family history. Thus while the Musha Incident is central throughout the series, this subtle framing device makes the indigenous rebellion a clue in re-creating a lost chapter in the life of a true "Taiwanese patriot." *Dana Sakura* is not about recentering the Musha Incident as much as reincorporating this contested history into a distinctly "Taiwanese" historical project.

A more surprising collaboration between Deng Xiangyang and Qiu Ruolong was a new book project, *Mona Rudao* (*Mona Ludao* 莫那 魯道), published in December 2006. What was stunning about this second collaboration was the chosen medium—a children's book. Whereas Qiu Ruolong's popular graphic novel was clearly aimed at adults and teenagers, *Mona Rudao* comes in an oversized, large-print form, filled with colorful illustrations and *zhuyin* phonetic markings beside the text. For the account of a bloody uprising where more than a hundred Japanese were slaughtered (many by decapitation) followed by an

even more bloody suppression—and near genocide—of the indigenous rebels that ended with mass suicides, headhunts, bombings, and the use of poison gas, a children's book seems hardly the appropriate medium. Deng (as writer) and Qiu (as illustrator) handle the material deftly, largely avoiding direct depictions of violence surrounding the initial uprising. Instead they provide a series of sterile narratives that position the violence in the most general and opaque terms:

> Under the leadership and careful planning of Mona Rudao, they secretly carried out their plan and chose the most opportune time to wage their fierce war of resistance against the Japanese. (12)

> They raided the police headquarters in each district, stealing their weapons and explosives, finally leading an attack on Musha, where the United Track Meet was being held, where the Japanese suffered great injuries and deaths. (15)

The depiction of the slaughter that follows is more detailed, with more passages listing the weapons employed, more descriptive language (such as "large-scale, bloody massacre"), and even the use of literary devices like onomatopoeia for a more vivid effect:

> The revolt left the Japanese side utterly shaken! But the Japanese government did not reflect on their own actions and instead immediately took to revenge tactics.
> *Weng, weng, weng . . .*
> Planes circled in the air above the mountains.
> *Long, long, long . . .*
> Echoes of cannon explosions ripped through the mountain valley.
> The Japanese mobilized army forces with strong firepower and modern supplies to carry out a large-scale bloody massacre against mountain tribes that had only the most traditional weapons. (16)

Besides certain contradictions (such as the fact that on the previous page, the rebels had just armed themselves with modern Japanese firearms and explosives), the book has a greater flaw: Deng and Qiu's simplification and sanitization of what is in fact an extremely brutal and complex moment in modern Taiwan history. It leaves young readers with a tribute to Mona Rudao that glorifies revolutionary violence and advocates suicide over surrender.

The subtitle of the book, *The Hero on the 20-Yuan Coin* (二十圓硬幣上的英雄) reveals the text's other pedagogical function: educating children about the new

Twenty-*yuan* coin: text reads "The 90th Year of the Republic of China, Mona Rudao."

face adorning their coins. In 2001, the Taiwan government began minting new 20-*yuan* coins with the image of Mona Rudao, placing the indigenous leader alongside other Chinese leaders immortalized on coins—between Chiang Kai-shek (10-*yuan* coin) and Sun Yat-sen 孫中山 (50-*yuan* coin) as a new political icon for Taiwan's future. The appearance of the Mona Rudao coin proves that the reinvention of the Musha Incident signals changes not only in popular culture but also in political culture, also manifested in the construction of a series of new national monuments dedicated to the tribal leader. In 1997, a new life-size statue of Mona Rudao was erected in Musha, on a hill overlooking the elementary school and close to where his remains were eventually interred. And in 2003 construction was completed on a new commemorative hall in Chuanzhongdao, where the survivors were exiled after the Japanese crackdown.

Although there were a handful of important texts about the Musha Incident produced intermittently from 1949 until the early 1980s, the proliferation of

popular cultural texts revisiting the tragic events of 1930 did not really occur until the late 1990s. And unlike traumatic representations of the February 28th Incident, which seemed to spontaneously explode after the lifting of martial law in 1987, attempts to portray the Musha Incident seem more closely linked with the change in political leadership from the pro-mainland Nationalist party to the pro-independence Democratic Progressive Party (DPP) in 2000 (a process actually begun by former president Lee Teng-hui 李登輝 in 1996). In the construction of a new set of Taiwan-centric historical narratives to support the new political line, a new Taiwanese historical subjectivity that could stand separate from the mainland Chinese master narratives of cultural unity began to emerge. The culture, history, and traditions of Taiwan's indigenous peoples suddenly became important components in the DPP's cultural policies. And Mona Rudao and the Musha Incident emerged as central figures in that new national imaginary.

Starting with Zhang Shenqie's unsuccessful effort to make the tragic story into a film in 1949, representations of the Musha Incident have been marked with an inherent visuality. As Allen Feldman has noted, "Visual appropriation, because it is always pregnant with the potential for violence, has become a metonym for dominance over others: power lies in the totalizing engorged gaze over the politically prone body, and subjugation is encoded as exposure to this penetration" (Feldman 428). This is especially true of the remolding of the Musha Incident since the late 1990s. From Wan Jen's television miniseries to Qiu Ruolong's graphic novel and documentary film, the bloody signifiers of this "anticolonial" headhunt have become a particularly powerful metaphor for a new militant political discourse. In 2004 yet another attempt to position the Musha Incident in visual culture came with Wei Desheng's 魏德聖 *Seediq Bale* (*Saideke Balai* 賽德克 巴萊). Best known for his work as assistant director on the Taiwan supernatural thriller *Double Vision* (*Shuangtong* 雙瞳), Wei invested more than two million NT to produce a five-minute trailer for a planned epic film about the incident. But in a strange replay of the situation with *Blood Across the Land* more than fifty years earlier, Wei never raised sufficient funds for production and instead had to settle for publication of his vision as a novel (adapted from the original screenplay).[16] Zhang Shenqie's and Wei Desheng's respective attempts at filming Musha speak not only to the drive to portray the incident visually but also to the challenges associated with such representation.

16. Wei Desheng appears to still plan to adapt his screenplay for film and has set up an extensive Web site, www.seediqbale.com, which provides extensive details on the Musha Incident, the film, and even information for investors.

Although for Zhang and Wei, the chief challenges were primarily political and economic, these unrealized cinematic visions can be seen as a metaphor for the difficulties associated with re-creating traumatic narratives.

Another curious aspect of the visual imagination of the Musha Incident is the particularly strong imagery of the sakura. The name "Musha Incident" is the description that came out of the Japanese military headquarters on Taiwan on October 30, just three days after the insurrection, and the iconography associated with the event has also taken on a distinctly Japanese tone, especially in the appropriation of the sakura, or Japanese cherry blossom, as a key signifier. From Zhang Shenqie's screenplay, which was originally titled *The Sakura of Musha Red Across the Land*, and Wu Yongfu's poem "The Crimson Sakura of Musha," which includes imagery of the sakura as an emblem of Hanaoka Ichirō and Hanaoka Jirō's untimely sacrifice, to Deng Xiangyang's *Dana Sakura*, the cherry blossom has come to stand for the heroic sacrifice of the Atayal who died, many still in their youth. The flower has deep cultural connotations in Japan, where it is viewed as a symbol of ephemeral beauty. And while the tree is found throughout Asia, its associations with Japan are so strong that in Korea many sakura were removed after the colonial period as an unwanted reminder of the Japanese presence. In the context of the Musha Incident, however, this symbol has been repeatedly conjured as *the* embodiment of the violent insurrection. In the cultural iconography of the Musha Incident, the sakura seems to have the same contradictory status as the Japanese-educated Atayal intellectuals Hanaoka Ichirō and Hanaoka Jirō, both distinctly "Japanese" and appropriated by Chinese writers as markers of this "anti-Japanese" massacre.

Heavy Metal Headhunt: ChthoniC and the Colonization of Historical Memory

One of the most unusual reinventions of the Musha Incident came not via literature, film, graphic novels, or television, but in the form of a epic concept album by the Taiwan progressive heavy metal band ChthoniC (閃靈). Formed in 1995, ChthoniC is a hybrid of East and West that combines screaming electric guitars with traditional Chinese instruments such as *erhu*. In live performances, the band utilizes stage props and makeup that seem equally indebted to the American hard rock band Kiss and traditional Peking opera. Over the course of their career, ChthoniC's members have made their political stance clear through their lyrics and musical activism, such as the 2002 compilation *Anti-China Taiwan Live* (反中國併吞) and the 2006 concert event they organized, "2/28 Say

Yes to Taiwan," which have helped foster a new form of Taiwanese nationalism among younger generations of Taiwanese listeners. In stark opposition to the apolitical love songs that dominate Taiwan pop music, ChthoniC have pioneered a new genre of gothic orchestral metal and an unprecedented level of political engagement.

Three years in the making, the original Chinese edition of *Seediq Bale* (賽德克 巴萊) was released in 2005. The album chronicles the uprising ("Bloody Gaya Fulfilled" 大出草), the Japanese crackdown ("The Gods Weep" 泣神), the mass suicide ("Exultant Suicide" 虹橋赴), and the exile to Chuanzhongdao ("Banished Into Death" 川中島之禁). The lyrics, rendered in elegant classical Chinese with phrases of Japanese and native dialects intertwined, become almost incomprehensible as they are screamed over a cacophony of electric guitars and double-bass drums that seem to vent the anger and violence of the incident.

Breaths cut off, as their heads fall	附鼻息 隨影游離
Shades formed as shadows shorten	貼身形 斷生斬首
Hunting knives hew down	番刀刈落
Harvesting deaths	竹箭飛悚
Woods shroud warrior attacks	動 林木藏殘影
Gun smoke marks their hurried passing	硝煙 匯山河怒集
Breeze sweeps away sadness	槍 被風掃秋息
Clearing the road to fiery hell	揭揚 恨燃煉獄
War cries signaling the cleansing of enemies	喝 雪怨快意
Headless bodies	讎敵 魂奔魄悸
Litter the ground	首落遍地 駐所血洗[17]

Through such passages, lyricist and singer Freddy Lin not only hints at a primordial naturalistic vision, wherein the environment works in concert with the Seediq warriors, but also aestheticizes the original violence. Rendering it in classically influenced poetic form is key in ChthoniC's reconfiguration of the Musha Incident. Through this process, the violence is further abstracted and given a new textual framing that emphasizes its place in a classical lineage of historical narrative.

17. This set of lyrics is not a direct translation, but rather a sample from "Bloody Gaya Fulfilled," the English version (left) and the original Chinese version (right).

虹橋依存

潢首之番 主唱．二胡：Freddy

Image stills from ChthoniC's music video of "Quasi Putrefaction."

The music videos the band has produced to promote their album further complicate the cultural politics at play. The video for "Quasi Putrefaction" (半屍 橫氣山林), a song that traces the aftermath of the mass suicide and the Atayal souls' journey to the netherworld, intercuts footage of the band in full stage makeup with dramatic re-creations of the massacre (images borrowed from Wei Desheng's film pilot). The juxtaposition of the tattooed Atayal warriors with the elaborately made-up band members creates an interesting performative dialogue in which primitive tribal rites collide with a contemporary gothic subculture. As the music video comes to a climax, the dead warrior finally stands proudly before the rainbow bridge—the mythical pathway to the sacred tree, where the Atayal believe they can join the spirits of their ancestors. But instead of being transported there, the viewer is visually transported to a live concert performance of ChthoniC, where an aerial crane shot descends on the band performing their own musical interpretation of the headhunt. Are ChthoniC (which, ironically, comes from the Greek term for "earthbound") positioning themselves as the spiritual ancestors, or perhaps torchbearers, of the Atayal spirit?

Rebellion and nonconformity have always been central themes of rock and roll (and later heavy metal), and the Musha Incident, a historical insurrection that takes rebellion to shocking new levels, is an ideal embodiment of those attitudes. The Second Musha Incident, however, is replaced by traditional tribal myths. In repositioning the Musha Incident within the gothic culture of black metal (a primarily European subgenre of heavy metal known for extremely fast tempos, complex composition structures, and a penchant for occult themes), ChthoniC emphasizes (and also exploits) the violence already inherent in this legendary uprising, with special attention to the Atayal's legends and religious beliefs. Notably absent from *Seediq Bale* are Hanaoka Ichirō and Hanaoka Jirō, two figures who have proved so crucial to earlier representations of the incident. ChthoniC is clearly not interested in these individuals whose role in the Musha

Incident is ambiguous at best; instead the band places renewed emphasis on Mona Rudao, who makes his grand appearance at the end of the opening song: "Birth prophesied, destined for sublimity / The seal is broken, the way is cleared, Mona comes." Their version of the tale presents him as a semidivine warrior leader sent to rid his people of the Japanese scourge. The "coming of Mona" seems to refer to the coming of Jesus, a parallel pushed even further in the music video for "Progeny of Rmdax Tasting" (岩木之子), where the band performs before a looming cross, equating Mona Rudao's death with Jesus' crucifixion, a new vision of the uprising reemphasizes traditional Atayal folk beliefs and Christian symbolism alongside the undisputed position of Mona Rudao. All ethnic and historical ambiguities (such as the two Hanaokas and the Second Musha Incident) are removed, since they would only detract from this mythic framing. As Kalí Tal has observed, mythologization "works by reducing a traumatic event to a set of standardized narratives (twice- and thrice-told tales come to represent 'the story' of the trauma) turning it from a frightening and uncontrollable event into a contained and controllable narrative" (Tal 6). ChthoniC's mythologization can also be read as an attempt to return the Musha Incident to its indigenous roots. The Atayal had an oral tradition, a "culture whose practical mode revolves around passing down myths, legends, and folk stories through the generations, through which its unique cultural form and meanings are passed down as well" (Xie Zhaozhen 120). So while ChthoniC's retelling may appear as a crude simplification that overlooks key historical aspects of the incident, on another level it restores the mythic dimension so fundamental to traditional Atayal oral culture. Through this new narrative, ChthoniC presents a curious doubling of traditional indigenous myths with a new national myth promoting a breed of Taiwanese nationalism. Mona Rudao is a hero reborn in the struggle to stand up against both the Japanese colonial forces of the past and the growing Chinese hegemonic shadow looming in the future.

Perhaps the most unexpected development is that after decades of attempts to position the Musha Incident in popular culture, including a graphic novel, a children's book, four film projects, a television miniseries, and numerous novels and memoirs, the single most influential cultural text on an international scale was a theatrically staged heavy metal opera. In 2006, the ChthoniC concept album on the Musha Incident was remixed and repackaged with English lyrics for international release. The new version of *Seediq Bale* was widely reviewed in Europe, America, and Japan, and in 2007 ChthoniC took its epic tale of Mona Rudao on the road, performing in Europe and Japan and landing a coveted spot on tour with veteran heavy metal artist Ozzy Osborne, where they per-

formed *Seediq Bale* for hundreds of thousands of people in seventeen U.S. cities. The anti-Japanese headhunt resurrected as a musical stage show to provide mass entertainment and catharsis for an audience of thousands, primarily teen-age American boys, may be the most surprising twist in the aftermath of the Musha Incident, but it is the latest chapter in a complex history of representation continually rewritten to serve different political, historical, and cultural agendas.[18]

Three quarters of a century later, many questions still linger about the Musha Incident. Whereas cultural discourse has often positioned the incident in black-and-white terms, depending on what political discourse happened to be in fashion, the reality is much more complex. It begins with the original historical forces that led to the uprising and the Japanese response, but goes on to raise questions of ethnic and national identity, the ways cultural and political power structures have appropriated historical trauma for political ends, and the problem of representing historical pain.

Just what makes the Musha Incident a "Chinese" or "Taiwanese" trauma? As a conflict that played out primarily between indigenous tribespeople and Japanese colonizers, the Musha Incident pushes the very boundaries of national discourse, resulting in a curious recentering of indigenous figures traditionally viewed as the most marginalized group in the already peripheral territory of Taiwan. This prompts a rethinking of our very notion of ethnic and national borders. Just who are the keepers of historical memory? To what extent can violence committed upon or by "the other" be reconstituted into national narratives? What are the ethical implications of reenacting historical trauma to serve national agendas?[19] And in this complex historical context, where there exists a cyclical layering of victimization (via exploitation and colonization), violence

18. Those who question the impact of ChthoniC's popular intervention into the history of the Musha Incident need look no further than the words of Taiwan President Chen Shui-bian, who personally presented the band with the award for "Best Rock Group" at the 14th Annual Golden Melody Awards. During his introduction, Chen commented, "Ah Bian firmly believes that music is much more powerful and moving than the words of any politician." As lead singer and lyricist Freddy Lin accepted the award, he emphasized his thanks to the "mother country of Taiwan" (祖國台灣).

19. This is not to imply that all cultural texts on Musha set out to use the incident as a simple tool of political propaganda. Some of the works discussed appear to have much more altruistic aims, attempting to rectify history and bring a form of literary justice to an atrocity that has often been misunderstood. In the process, however, many of these texts have, consciously or unconsciously, injected a very clear set of political and ethnic perspectives that often work in concert with ideologies of Chinese and Taiwanese nationalism.

(the Musha Incident), and further victimization (the Second Musha Incident), what constitutes historical trauma? The brutality of the Musha Incident and the Second Musha Incident are plain to see: beheadings, betrayals, *seppuku*, mass hangings, poison gas, and a culture of terror that would haunt the few survivors for years to come. The numerous texts produced on the Musha Incident include heroism, glorious displays of sacrifice and martyrdom, and the articulation of a new national spirit. But where is the trauma? And where is the voice of the Atayal?

In traditional Atayal culture, headhunting is not associated with pain and trauma, but rather is a central rite of passage for young males. Only by presenting a human head to the tribe does a boy become a man, a process commemorated by a facial tattoo. Before the Japanese forcibly curtailed the practice of headhunting in Taiwan, only Atayal men with facial tattoos were allowed to marry.[20] And only men who had successfully gone through this rite could wear and play a special set of hand-woven clothing and musical instruments. After a head has been taken (usually from a another tribe), an elaborate series of rites are performed, including dancing, music, and celebration, a process through which the spirit of the hunted actually returns to protect the warrior who killed him. The facial tattoos made after the hunt, formed by repeated trauma to the skin that leaves permanent scars, become, quite literally, scars commemorating violence. The Japanese prohibition against headhunting, which resulted in an entire generation of Atayal males who were relegated to a state of perpetual adolescence and psychological inferiority, can be seen as an important factor that, combined with exploitation, mistreatment, and other abuses, contributed to the explosion of violence on October 27. And while the Musha Incident should not be looked at purely as a traditional headhunt fueled by years of policies that emasculated the male tribe members, the tribal politics and traditions of thousands of years must be considered alongside arguments that inject "the nation" and "anticolonialism" into this complex historical moment.

Just as ethnic and national identity has become a source of contention, Musha, the very site of the massacre, has become a contested, or perhaps more appropriately, erased historical space. Overnight, it was radically transformed from a "model village," which the Japanese held up as a functioning example of their successful colonial policies, to the site of the largest insurrection in the history of Japan's colonization of Taiwan. Eventually, Musha would be known almost exclusively as a mountain resort of quaint teahouses and soothing hot springs. The

20. Facial tattoos are also an important symbol of coming of age for women, who win their right to be tattooed after mastering traditional weaving techniques.

survivors of the Atayal tribe were exiled from their ancestral homeland of Musha to Chuanzhongdao, a small village in the mountains that shares its name with the Japanese city of Kawanakajima, site of five famous battles between 1553 and 1564. The physical removal of the survivors from their ancestral home and the site of violence was a clear attempt to rewrite history and can also be seen as a form of "topological denial," whereby the very place where violence occurred is wiped clean. In the engineered remapping of Musha, exile and cartological renaming (Chuanzhongdao was eventually renamed Qingliu) served as powerful tools to refute not only what took place but also where it happened.

In many of the Chinese representations of the Musha Incident, the traumatic aspects (as most powerfully embodied by the Second Musha Incident) have been downplayed in favor of a celebratory stance that positions the death of the Atayal warriors as an act of martyrdom for the Chinese or Taiwanese nation. Surveying the history of cultural representations of the incident, which has become a grand heroic narrative, one cannot help noticing the absence of indigenous voices. There have been some attempts to reinsert native perspectives into the historical discourse, many in the form of visual culture to counter the lack of written representation. One is the aforementioned work by Chen Chieh-jen, where he positions himself in the center, experiencing violence and reclaiming a place for the silent aborigines. But the overwhelming majority of works on the incident are by ethnic Chinese; those by Atayal or other indigenous people have been few.[21]

A very clear set of historical and cultural reasons partly explains the lack of representations by indigenous peoples: language (most aborigine languages and dialects do not have a written script), education (opportunities for which were often denied), and the traditional priority of oral transmission over written history in indigenous culture. There are also deeper reasons, including a fundamentally different cultural system for remembering history and commemorating trauma. While both the Chinese and the Japanese position headhunting as a barbaric ritual filled with primitivism and exoticism (which has helped fuel the large number of especially visual representations of the incident), for the Atayal the headhunt was a fundamental part of their religious and cultural life, fully integrated into tribal society. But there is another, more obvious explanation for

21. There have been a handful of short stories by Atayal writers, such as Yubas Naogih's "Out of the Brush" (which deals with Atayal headhunting during the occupation period, but not directly with the Musha Incident), included in English translation in John and Ying-tsih Balcom's edited anthology *Indigenous Writers of Taiwan: An Anthology of Stories, Essays, and Poems.* The majority of works offering the Atayal perspective on the Musha Incident are oral histories, such as Ahwei Hebaha's 阿威赫拔哈 *Ahwei Hebaha's Testimony on the Musha Incident* (*Ahwei Hebaha de Wushe shijian zhengyan* 阿威赫拔哈的霧社事件證言) and Kumu Tapas's 姑目 苔芭絲 *Tribal Memories: An Oral History of the Musha Incident* (*Buluo jiyi: Wushe shijian de koushu lishi* 部落記憶: 霧社事件的口述歷史). The latter title offers a distinctly Christian perspective, framing the oral history within a religious narrative of suffering and redemption.

the lack of a strong indigenous cultural response to the incident. With the almost complete extermination of the Japanese in Musha during the first Musha Incident and the subsequent mass suicides and slaughter of the Atayal, very few survivors were left on either side. Of the indigenous tribes that did survive and have some understanding of the incident, the largest group were the pro-Japanese Toda subtribe, who led the attack on the detention centers. But given the ways the Second Musha Incident has been downplayed, negated, or simply written out of history, Toda voices have been largely absent.

The substantive silence that surrounds indigenous representations can even be seen in several of the novels and films by Chinese writers, and it speaks of the radical disharmony present in historical narratives of the incident. At the beginning of Wan Jen's television miniseries *Dana Sakura*, the young Chinese history student from the plains who comes to Musha to learn about the events of 1930 immediately runs into resistance and silence when he attempts to interview natives. The first person he approaches, an elderly man with facial tattoos who admits to having beheaded three people in headhunt rituals during his youth, turns hostile when the outsider asks about the Musha Incident and Mona Rudao. With a look of pained violation, the elder admonishes him for poking his nose into matters he does not understand. Eventually, he drives the young man off, even threatening him, "You're going to lose your head if you go around asking about that!" The protagonist seems to fare better with a middle-aged Atayal woman working in a local shop, but when he asks about the Musha Incident, she also instantly turns away from him, declaring, "I don't know anything about that! I can't say anything about the Musha Incident."

The curious resistance on the part of Atayal tribe members to speak about what is purportedly a point of great national pride is also seen in several of the more reflective representations. When the narrator in Wu He's masterful novel *Remains of Life* asks a young Atayal girl about the incident, she responds with a mocking tone:

> "There are so few of us aborigines, what is there here worth researching?" She had obviously been drinking, yet even so, from her soft tone it was clear that she was not joking. "First go do some research on yourselves, you Han Chinese are the ones deserving of some real research. . . . Do your research on the great Chinese race, then when you're bored you can mosey on up to the mountains to see how little savages like us carve out a life for ourselves among you great Chinese" She turned around and ordered someone to kill a chicken, saying that a cute guy from the plains had to research her, dinner was on her (Wu He 2003:95)

你幹嘛不懂還要問　　　　　　　我不知道這個

"What's wrong with you? Asking around when you don't understand a thing!" replies the elderly Atayal warrior to the Han visitor (left); "I don't know anything about that!" says a middle-aged Atayal woman, turning away.

Her sharp words are fueled by both sarcasm and a deep subjectification, her people having been exploited for decades—first for labor, land, and as conscripts under the Japanese and later as cheap construction labor, sex workers, and political tools under the Chinese. Now it seems that even their historical memory is being taken. When the narrator continues his inquiry with a senior tribal elder, he receives a similar response.

"I came here to see the remains of life left over after the Musha Incident, but first I must understand the contemporary Musha Incident," The woman translated what I said to the tribal elder, the elder nodded repeatedly as he took another drink with me, the woman told me that the elder sitting before me was regarded as the most precious member of the tribe, countless people researching tribal history and especially the Musha Incident had interviewed him, When the Incident occurred he was a fourth grade elementary school student—and he was there at the schoolyard when the massacre took place. "The Musha Incident is history, it's all in the past; as to the actual details about what happened, the elder has already told others everything he knows," the woman's husband continued, "If you want to understand the contemporary Musha Incident, then that's another matter altogether," That's right, I said, the contemporary Musha Incident is how I evaluate history through a contemporary perspective—there is no such thing as "historical history," in actuality all that ever exists is "contemporary history," The woman interrupted me to say that it was a rare occasion for the elder to be there (who knows where Girl and those young men ran off to), while the chicken soup was still hot, it wouldn't hurt to ask the elder to say a few words, "Originally you invited me over for flying squirrel stew," The elder sat up straight, "It's a good thing that we have

the nutrition of the chicken soup to keep us strong, otherwise how could we speak of the intestine-cutting incident that occurred in my homeland of Musha?" The woman explained that most everyone in Musha had their head cut off in the incident, although the old man survived, at the time he was in so much pain that he felt as if his intestines were cut, he ridicules himself because even today at the age of eighty-four his intestines have yet to mend, when he is asleep at night his intestines crawl out and wriggle their way up the mountain path to the old schoolyard, "I don't want to talk anymore about the details surrounding the incident or what caused it, after sixty or seventy years all the information there is to find has already been collected and organized as good as it could ever be," The old man only understood his native tribal tongue and Japanese; he spoke in Japanese, his tone of voice was calm and flat, The woman's husband interpreted for the majority of the discussion while the woman spent most of the time with her cheek leaning on her hand as she gazed out at the western sky, (Wu 2003:96–97)

The native responses to the Musha Incident revealed in *Dana Sakura, The Remains of Life,* and numerous other texts reveal a fundamental block when it comes to confronting the violence of the past. Unlike the iconic passage in Lu Xun's "New Year's Sacrifice," where the victim of trauma compulsively retells her story until it becomes a cliché that first entertains, then only annoys the audience, the victims of the Musha Incident seem always unwilling to speak.[22] Their response is a mixture of shame, anger, and violation, and it is instead the audience of outsiders that compulsively inquires, seeking answers and imagining their own versions of this trauma.

During such moments, the deep contradictions within the history of representation of the Musha Incident become visible. Like the silent victim in *Lingchi,* whose voice is eternally silenced, what about those Atayal victims? For all the literature on the Musha Incident, very little has attempted to truly explore the voices of the victims, both the Atayal and the Japanese killed in the initial uprising. With the exception of Wu He's *Remains of Life,* Chinese and Taiwanese cultural discourse has almost never examined the deaths of the 134 Japanese—the ruling assumption in Taiwan being that *all* Japanese, even children and those born after the colonial period, are stained by this original sin of colonial exploitation. There have been numerous textual attempts to give voice

22. In Lu Xun's famous story "New Year's Sacrifice" (*Zhu fu* 祝福), Xianglin Sao, unable to recover from the trauma of losing her only son to a wolf, continually repeats the story of his tragic end. Although she initially wins the sympathy of the townspeople, over time, the repeated narrative earns her only mockery, scorn, and alienation.

to the Japanese historical trauma suffered from this shocking blow to their co-
lonial empire, but the voice of the native has remained conspicuously absent.[23]
This is a fissure not just between history and memory but also between the in-
digenous and the outsiders, the self and the other, silence and representation,
and, certainly, the colonized and the colonizer. The colonization, however, is a
colonization of memories. Native traumas left unspoken have been repeatedly
appropriated by Chinese and Taiwanese and written, drawn, filmed, and tele-
vised back into history. And like all forms of colonization, which are purport-
edly carried out with the "lofty" goal of bringing civilization to the savages, this
cultural colonization is carried out (often with the best intentions) by articulat-
ing a history that the natives are unwilling or unable to recount for themselves.
Lurking behind these representations, however, is a larger historical power play
wherein commemoration of indigenous injustices becomes a tool for furthering
Chinese or Taiwanese political agendas.

Taken in front of the tomb of Mona Rudao, which stands on a hill overlook-
ing the Musha Elementary School, this photo serves as a testament to the poli-
tics, ethnicity, and history constantly at play in the Musha Incident. On the
right stands Awi Dakis, also known by his Japanese name Hanaoka Hatsuo
花岡初男, the son of Hanaoka Jirō. Decades later, the son Jirō never met seems
to have finally reconciled the cultural conflicts that plagued his father by creat-
ing an entirely new cultural and ethnic identity. After the 1945 retrocession, Awi
Dakis was given a new name, Gao Guanghua 高光華, or "Glorious China."
Standing beside Gao Guanghua, who is dressed in Western-style clothing typi-
cal of most Chinese, is Taiwanese President Chen Shui-bian, wearing tradi-
tional Atayal dress. While Chen assumes the identity of the Atayal,
appropriating the Musha Incident to enunciate a historical and cultural tradi-
tion rooted in indigenous Taiwan culture, Gao Guanghua and most of the rest
of Taiwan's indigenous population have been folded into the hegemonic power
of Chinese and Taiwanese culture. One can only wonder what Mona Rudao
would think, gazing out from beyond his grave, of this radical performance:
just as the "savages" have been tamed, seamlessly homogenized into mainstream
Han culture, the Taiwanese have claimed the most "savage" example of their
culture—the Musha Incident—as an articulation of a new national vision.[24]

23. In recent years there have been a handful of publications providing firsthand accounts of the upris-
ing from the Atayal perspective, but almost none has processed these stories in the context of fiction, film,
or other creative media. Moreover, several have been published as oral history, dictated and recorded but
then still processed and published by Chinese editors and publishers.

24. For more on the dramatic transformation of indigenous dress over time, see Henrietta Harrison's
"Clothing and Power on the Periphery of Empire: The Costumes of the Indigenous People of Taiwan."

President Chen Shui-bian (left) and Gao Guanghua (right) at the tomb of Mona Rudao.
Image courtesy of Yushan Publishing Company, Taiwan.

At the beginning of the twenty-first century, as Chiang Kai-shek and the old political icons from the past were being torn down,[25] the Musha Incident was revisited as a source of a new Taiwanese identity and its ghosts resurrected in a new decapitation fantasy. More than seventy-five years after his death, the "savage headhunter" Mona Rudao has been erected as a new icon for Taiwan's future. And just as the headhunt represented a rite of passage into adulthood for

25. In February 2007, Chen Shui-bian's Democratic Progressive Party passed a motion to remove numerous statues and effigies of Chiang Kai-shek from parks, historic sites, and public spaces. Chiang Kai-shek Memorial Hall was also renamed Democracy Memorial Hall.

Atayal males, commemorated by a tattoo across the face, the Musha Incident has been transformed into a signifier of Taiwan's own passage from colonial slavery to a "modern" national consciousness inspired by the bravery of the most "primitive" tribal inhabitants and commemorated by the scars of historical trauma.

2. Nanjing 1937

The year 1937 is but a cloud of mist passing before my eyes.
My gaze is caught lingering on this particular era of the past,
but, as a writer, I find myself unable to truly understand
that history that historians call history. All I see are
shattered pieces and broken fragments, and a handful
of melancholic stories destined to come to naught,
all quietly playing out upon the grand stage of history.

—YE ZHAOYAN (1996:5)

Mapping the Site

Nanjing, the southernmost of China's capital cities, stands out not only for its rich cultural heritage and as a thriving urban and economic center but also for repeatedly being the site of acts of destruction and desecration. Between the gorgeous vistas of the Purple Mountain and the gleaming shores of the Yangtze, on which Nanjing is situated, are hidden countless stories of unspeakable violence and barbarism. Perhaps more than any other Chinese capital, the city formally known as Jinling 金陵 has been riddled by dynastic failure, violent political suppressions, natural disasters, and atrocity throughout its history.

Nanjing's status as capital was sporadic, frequently interrupted by the collapse of ruling dynasties, all of which seemed destined to be short-lived. All told, the city served as capital of China during ten distinct historical periods—from the Kingdom of Wu (222–280), when it first took center stage in the political arena, until the Republican era (1911–37), when it became the stronghold of the Nationalist regime. The city's first major devastation was in 589, when the first emperor of the Sui dynasty (580–618) leveled all architectural structures and sites associated with the former Chen dynasty (557–589). Barry Till, author of the historical guide to the city's material culture, *In Search of Old Nanking,* described the destruction as absolute: "all important buildings inside the city walls [were destroyed] and then everything [had] to be ploughed under. Thus all the beautiful palaces, gardens and temples were razed to the

ground and absolutely no trace was left of the former beauty of the city" (Till 1984:ix–x). The Sui was only the beginning of a cyclical pattern of nightmarish destruction that would plague Nanjing throughout its dynastic history.

Even the pinnacle of Nanjing's splendor during the Six Dynasties period (317–589) proved to be ephemeral. In less than three centuries, Nanjing hosted the Eastern Wu and Eastern Jin, followed by the Song, Qi, Liang, and Chen dynasties of the Southern Dynasties Period (420–589). None lasted more than a hundred years and several were as short as twenty or thirty years. Like the fleeting glory of the individual Six Dynasties' regimes, Nanjing's later imperial grandeur would be short-lived. The last Chinese monarchy, the Ming (1368–1644), was established in Nanjing, but after only thirty years, the dynastic seat and imperial throne were moved north to Beijing in 1398 by the second Ming emperor, Zhu Yunwen 朱允炆 (reign title: Jianwen 建文). The Taiping Heavenly Kingdom (during the Qing dynasty, China's final dynastic cycle) and the Republic of China (during the first half of the twentieth century) saw similar patterns wherein the city-as-capital's widespread cultural, political, and economic development was halted by utter devastation and tragedy.

The Taiping Rebellion stands as one of the darkest moments of Nanjing's history, not so much for the insurrection itself, which left the people of the city largely unharmed, but for the bloody suppression of the Taipings by the Qing court. The cataclysm that ended the Taiping Heavenly Kingdom lasted more than three months, resulting in the deaths of thousands. One witness documented the destruction of the city shortly after the collapse of the movement:

Now I have come to Nanking. All I see are the evidence and atmosphere of devastation everywhere. According to the local people, while the Hairy Rebels [Taipings] occupied the city they never burned any buildings or slaughtered any people and the populace was as comfortable and peaceful as ever. . . . But when the Hsiang Army seized the city, they killed everybody they saw and burned every house they saw. All women and all wealth were taken away by the Hsiang Army and Nanking will forever be poor. (Jen 1973:534)

With the suppression of the Taipings in 1856, Nanjing lost its status as capital and the city once again fell under the jurisdiction of the Qing court in Beijing.

Shortly after the Republican victory half a century later, on January 12, 1912, Nanjing was again declared the capital under Dr. Sun Yat-sen as provisional president. Once again, the city's primacy proved fleeting when power was ceded to the warlord Yuan Shikai 袁世凱, who immediately moved the capital back to Beijing, where it would remain for the next fifteen years. In 1927, Chiang Kai-shek took steps to reconsolidate the power of the Nationalist regime

and restored Nanjing to its former place as capital. A decade later, the city would be in virtual ruins. Just over eighty years after the Taiping massacre, Nanjing was again the setting for mass looting, burning, destruction, murder, and rape.

In Nanjing's long and often dark history, the Rape of Nanjing stands out as perhaps the most disturbingly violent and controversial event. The atrocities committed during the Nanjing Massacre make it not only one of the most horrid and tragic moments of twentieth-century Chinese history but also an incident that may well be remembered as "among the most brutal in modern warfare."[1] Air raids of the Chinese capital began as early as August 1937, and after a fierce battle in Shanghai, where the Japanese army met with unanticipated resistance, they slowly made their way westward along the Yangtze toward Nanjing. On December 13, 1937, the Japanese army entered Nanjing, beginning a 6-week bloodbath in which an estimated 300,000 Chinese citizens were killed.[2] Although a number of Western publications on China discussed the massacre, it was not until the mid-1990s that the events of that winter began to attract renewed interest, as seen in the publication of numerous academic monograghs. At the same time, the massacre was, primarily for political reasons, consistently underplayed in China. Not until the mid-1980s did the Nanjing Massacre suddenly, via a changing PRC political agenda, began to reenter the Chinese consciousness; a handful of literary depictions emerged and films about the Rape of Nanjing appeared in theaters and classrooms throughout China.[3] According to Takashi Yoshida (2006:154–164), it was during this period that China began a project of "nationalizing memory of the Nanjing Massacre" through new directives aimed at strengthening patriotic education.

The mid-1980s also saw the establishment of the first state-sponsored museum commemorating the atrocities committed in Nanjing, as well as a virtual flood of monographs and historical publications. The purpose of the vast majority of these Chinese-language publications is to provide "evidence," through photographs, wartime diaries, witness testimonials, and documentary footage, that the massacre actually occurred. This thrust to prove the existence of the

1. *New York Times,* December 12, 1996.

2. Official PRC historiography has placed the number of deaths at around 300,000 (some even take this number as conservative and place the total closer to 450,000). Some Japanese revisionists claim that as few as 5,000 died; others claim the entire incident was a fabrication. Most Western scholars have accepted the 300,000 death toll, although some, such as America's highest-profile China historian, Jonathan Spence, place the number of deaths at 50,000. The discrepancy has led to much controversy among historians, politicians, and the public.

3. Screenings of government-approved documentaries on the Nanjing Massacre were, like many other propaganda-laden films and documentaries in the PRC, often made a compulsory part of schoolchildren's education, especially in Nanjing.

atrocities and lend legitimacy to the victims' voices has dominated Chinese discourses on the massacre and shaped the way it has been remembered. A sample list of some Chinese-language books aptly demonstrates the fixation on presenting testimony and evidence: *A Collection of Testimonies by Survivors of the Rape of Nanjing Committed by the Invading Japanese Army, A Collection of Testimonies by Foreigners About the Rape of Nanjing Committed by the Invading Japanese Army, The Rape of Nanjing: An Undeniable History in Photographs.* The drive to "prove" the legitimacy, authenticity, and scope of the atrocities not only was expressed in oral histories and historical monographs but also played a central role in cinematic representations.

Since the 1997 publication of Iris Chang's *The Rape of Nanking,* which met with unprecedented acclaim, controversy, and, of course, commercial success in international publishing markets, the Nanjing Massacre has inspired renewed interest among foreign academics and a new wave of critical inquiry. The United States alone has produced a small library of mostly academic works focusing on various aspects of the massacre. A selection includes: Timothy Brook's *Documents on the Nanjing Massacre,* Honda Katsuichi's *The Nanjing Massacre: A Japanese Journalist Confronts Japan's National Shame,* Masahiro Yamamoto's *Nanking: Anatomy of an Atrocity,* and Zhang Kaiyuan's *Eyewitnesses to Massacre,* all of which were published in the years between 1999 and 2001.

Iris Chang, Vera Schwarcz, and others have drawn (often controversial and sometimes disputed) comparisons between the Holocaust of World War II and the atrocities committed in Nanjing during 1937–38.[4] Although there are undeniable similarities deserving further study and exploration, one area where stark and dramatic discrepancies exist is the way atrocity has been remembered and depicted in the respective cultures. This is clearest in the quantity (and often quality) of narrative fiction and film concerning the two events. In the last half century, the body of work reflecting or set against the Holocaust has reached truly epic proportions. The number of novels and narrative films alone (not to mention other academic and artistic studies and portrayals) has grown exponentially, announcing the genuine arrival of Holocaust film and literature as distinct and powerful genres in their own right. The sheer volume has demanded

4. The controversial subtitle of Chang's work is "The Forgotten Holocaust of World War II." Schwarcz is the author of *Bridge Across Broken Time: Chinese and Jewish Cultural Memory,* which offers a comparative exploration of the Holocaust and the Nanjing Massacre. In 2005 General Raymond David and Judge Dan Winn published an account of Japanese atrocities in China in order to validate the U.S. decision to drop two atomic bombs on Japan. In *The Super Holocaust (in China),* Davis and Winn argue that "This extermination of Jews in Germany, and countries occupied by Germany, from 1938 to 1945 has always been considered and referred to as 'The Holocaust.' . . . With valid records of China and others showing that the Japanese murdered more than 30,000,000 Chinese, we should not hesitate to call the China atrocities a *Superholocaust*" (1–2).

numerous full-length studies, including Annette Insdorf's influential study of film and the Holocaust, *Indelible Shadows: Film and the Holocaust*, and several works on literature, notably James E. Young's *Writing and Rewriting the Holocaust* and Lawrence L. Langer's *The Holocaust and the Literary Imagination*.

In comparison, creative attempts to represent the Nanjing Massacre have been so few as to have gone almost unnoticed. Over the nearly seventy years since the massacre, fewer than a dozen novels reflecting the Nanjing atrocities have been published, several by foreign authors. Filmic representations were virtually nonexistent during the first five decades following the massacre, but between 1987 and 1995 numerous documentaries and three feature films were produced; two additional features appeared during the following decade, and four new major works were produced in 2007–08.[5] Although products of popular culture, these texts have had a huge impact on the formation of the collective cultural memory of the Nanjing Massacre. Backed by new channels of commercial distribution, marketing, and promotion, which often work in concert with state agencies who see the pedagogical uses of these texts, these novels and films are able to reach far greater audiences than academic and historical works. Memories, perceptions, and impressions of atrocity are often shaped not by the actual events of history but rather by how those events are represented, re-created, reconstructed, and, in some cases, deconstructed through the lens of popular culture.

This chapter examines how the Nanjing Massacre has been remembered, reconstructed, and revisited in the context of narrative fiction and film. Besides providing an overview of some of the most important literary and cinematic texts concerning the Rape of Nanjing, I will demonstrate how these texts expand and challenge our traditional conceptions of fiction, film, and their social functions. At the same time, I probe the line between literature and history, fact and fiction through texts that stretch beyond the normal limits of their respective genres and media, ultimately raising questions regarding just where literature becomes history, history becomes literature, memory ends, and the imagination begins. What do literature and film tell us about history—or an atrocity like the Rape of Nanjing—that historical research and documentaries cannot?

5. Among the 2007–08 productions are Bill Guttentag and Dan Sturman's documentary *Nanking* (*Nanjing* 南京); Roger Spottiswoode's film about a British journalist who witnesses the Nanjing Massacre, *The Children of Huang Shi* (*Huangshi de haizi* 黃史的孩子); William J. MacDonald (writer/producer) and Simon West's (director) Sino-U.S.-British co-production *Purple Mountain*; Andrei Konchalovsky's *The Forbidden City*, based on Stephen Becker's novel *The Last Mandarin*, which traces the hunt for Japanese war criminals in the aftermath of the massacre; Sixth Generation director Lu Chuan's 陸川 epic *Nanking Nanking* (*Nanjing nanjing* 南京, 南京); and Hong Kong director Stanley Tong's 唐季禮 US$40 million project *The Diary*, about foreign nationals who provide testimony of the massacre through diaries, photos, and film.

I begin by giving equal attention to three narrative films that confront the massacre: *Massacre in Nanjing*; *Black Sun: The Nanjing Massacre*; and *Don't Cry, Nanking*. This section examines the fascinatingly similar and alternately contradictory strategies of representation employed in the films and explores the images of atrocity they respectively (and collectively) convey. The third section of the chapter begins with an overview of the body of both Chinese- and English-language historical fiction set during the incident, then goes on to offer extended discussions of Ah Long's 阿壠 *Nanjing* (南京) and Ye Zhaoyan's *Nanjing 1937: A Love Story*. Besides being the first Chinese work of fiction set against the 1937 atrocities, *Nanjing* stands out for the author's unique literary techniques, complex interpretation of history, and scathing critiques of not only the Japanese but also the Chinese. Nanjing-based writer Ye Zhaoyan's *Nanjing 1937: A Love Story* is among the most subversive, intricate, and powerful novels to deal with the massacre. My reading teases out the encyclopedic dimensions of the work and explores how Ye contextualizes his own historical melancholia. The chapter concludes with a discussion of Raymond Tu's 杜國威 *May & August* (*Wuyue he Bayue* 五月和八月) and Zheng Fangnan's 鄭方南 *Qixia Temple 1937* (*Qixiasi 1937* 棲霞寺 1937), a pair of films from the 2000s that reframe our understanding of how atrocities are re-presented, as well as the radical contemporary politics shaping the perception and reception of such texts. The collective of writers and filmmakers whose works are analyzed offer new perspectives and strategies for imagining terror, fantasizing history, and mapping atrocity.

Three Cinematic Visions of Nanjing 1937: Luo Guanqun, T. F. Mou, and Wu Ziniu

Much of the body of film on the Nanjing Massacre has been produced in the documentary mode. The vast majority of works have been PRC productions, such as *The Massacre of Nanjing—The Surviving Witnesses* (*Nanjing datusha— Xingcunzhe de jianzheng* 南京大屠殺- 倖存者的見證), *The Rape of Nanjing* (*Nanjing datusha* 南京大屠殺), *Actual Record of the Nanjing Massacre* (*Nanjing datusha shizheng* 南京大屠殺實證), and the multivolume *Eyewitness to History* (*Lishi de jianzheng* 歷史的見證). In these documentaries, as in the aforementioned historical works on the massacre, the emphasis is on proof. The documentaries all present extended testimonials from survivors juxtaposed with black-and-white photographs and documentary film footage. They also pay close attention to the death toll. Common sense says that the Chinese people

would like the number to be as low as possible. However, fueled by Japanese extremists who consistently deny the existence of a massacre or downplay the human losses, a discourse has emerged wherein participants go to great lengths to *increase* the Chinese death toll and "prove" its accuracy.

Nowhere is this tendency more visible than in the aforementioned documentaries, all of which begin with an epigraph dedicating the film to the 300,000 victims of the Nanjing Massacre. The death toll is highlighted through repeated shots of the number 300,000 carved in stone at the entrance to the Nanjing Massacre museum, and some documentaries even go as far as tallying the corpses buried in the various mass graves throughout Nanjing. Proof, however, comes in many forms, and these films also employ an array of other tactics, including extended testimonial interviews and displays of the bodies themselves as the ultimate "physical evidence." In the Chinese-made Nanjing documentaries, physical scars are continually displayed by a number of survivors (most notably Li Xiuying 李秀英, Tang Shunshan 唐順山, and Xia Shuqin 夏淑琴, who appear in virtually all of the films). Thus bodily scars are symbolically transformed into the historical scars of modern China—and Nanjing 1937. This repeated narrative and corporeal display of atrocity walks a fine line between commemoration and a tragic rehashing of Lu Xun's tale of Xianglin's Wife. The filmmakers also seem not to perceive that, by repeatedly featuring the same handful of photogenic survivors and their stories (and bodies), their films not only become dangerously close to the narrative of Xianglin's wife but also risk compromising their central argument. After all, if the population of Nanjing at the time of the massacre was approximately 600,000, as several documentaries estimate, and 300,000 were massacred, why are only the same handful of stories repeatedly retold and the same groups of survivors constantly featured?

This is not to call the 300,000 death toll into question per se, but rather to address the flawed strategies employed by many of the documentary filmmakers. The documentaries are also riddled with inaccuracies. For example, in *The Nanjing Massacre*, it is stated by the narrator that Reverend John Magee's documentary footage "played a decisive role during the 1946 International Military Tribunal for the Far East," but the footage was never shown during the tribunal.[6]

The documentaries produced in the West, Peter Wang's *Magee's Testament* and Christine Choy 崔明慧 and Nancy Tong's 湯美如 *In the Name of the Emperor*, have managed to avoid many of these pitfalls. *Magee's Testament* is a

6. Rev. John Magee did testify before the tribunal and did bring his film footage with him; however, it was never shown before the court, a decision that mystified Magee and many others. See David Magee's discussion of this incident in *Magee's Testament*.

thirty-five-minute documentary built around the film footage taken clandestinely by American missionary Reverend John Magee, one of the few Westerners who stayed in Nanjing during the massacre. Rev. Magee also played a key role in the establishment of the International Safety Zone. Featuring extensive excerpts from interviews with Magee's son, the documentary effectively frames the indelible footage within a moving, personal family narrative. *In the Name of the Emperor* is more ambitious in its attempt to present a comprehensive historical portrait of the Nanjing Massacre, especially the complex multiplicity of issues and controversies still surrounding the incident in Japan. Featuring interviews with textbook editors, former comfort women, survivors, former soldiers, and scholars from China, Japan, and abroad, Nancy Tong and Academy Award nominee Christine Choy use their film to address issues including historical reparations for victims and comfort women, Japanese denial, the death toll debates, textbook controversies, and contemporary attitudes about the massacre in Japan. In scope and presentation, their work stands out as the strongest documentary offering on the subject to date.[7]

The black-and-white images of brutalized Chinese children taken by John Magee (and other footage filmed by the Japanese themselves, obtained after the Allied victory) have become ingrained in the Chinese collective unconscious through their continual reuse in a series of pedagogical documentaries. Arguably, the trio of dramatic features produced between 1987 and 1995 have reached the widest Chinese audience. Like the documentaries, these films attempt to address history itself, as well as the market. Here the burden of testimony clashes with the burden of commerce, as art and economy, politics and propaganda combine to create complex and challenging versions of what is perhaps the most notorious "rape" of the twentieth century.

Through a close reading of PRC director Luo Guanqun's 羅冠群 1987 film *Massacre in Nanjing* (*Tucheng xuezheng* 屠城血證), Hong Kong–based director T. F. Mou's 牟敦芾 docudrama *Black Sun: The Nanjing Massacre* (*Hei taiyang: Nanjing datusha* 黑太陽: 南京大屠殺), and PRC director Wu Ziniu's 吳子牛 1995 release *Don't Cry, Nanking* (*Nanjing 1937* 南京一九三七), I will survey the narrative, formal, and technical aspects of each, highlighting the different, and at times startlingly similar, ways the Rape of Nanjing has been conceived on the Chinese silver screen and relived in the eyes of countless moviegoers.

7. Neuropsychologist Rhawn Joseph, Ph.D. has also directed a seventy-seven-minute documentary on the massacre entitled *Rape of Nanking: China and Japan at War, Japanese Atrocities in Asia*, a low-budget film appropriating footage from Magee and other sources. The film is available on Joseph's Web site, Brain-Mind.com. In 2004 the Canadian 4 Square Productions, in conjunction with Jiangsu Television Station, produced a forty-six-minute documentary on the massacre entitled *Scarred by History: Nanjing Nightmare* (*Nanjing emeng* 南京惡夢).

Massacre in Nanjing: *Authenticating History*

PRC film critic Zhang Xuan 張煊 (1996:102) has noted three distinct ways film-makers have approached (or proposed to approach) the Rape of Nanjing: 1) from the perspective of the Tokyo War Crimes Tribunal; 2) from the perspective of the foreigners in the International Safety Zone; and 3) from the perspective of an average Nanjing family. Luo Guanqun's film *Massacre in Nanjing,* the first major motion picture to depict the event, falls somewhere between the second and third categories. In terms of narrative and structure, the film owes a deep artistic debt to the Xin Jin 謝晉 model of melodrama,[8] a mid-1980s cinematic form that has been described as dwelling "excessively on innocent victims' traumatic experiences of political persecution so as to invoke in the viewer an acute sense of injustice as well as a profound feeling of sympathy" (Zhang and Xiao 1998:241). *Massacre in Nanjing,* however, fails to fully escape the pre-1976 PRC cinematic tradition of socialist realist aesthetics, especially those of (political) martyrdom. Co-produced by the Fujian Film Studio and the Nanjing Film Studio, the film was awarded the 1987–88 Ministry of Film and Broadcasting award for outstanding picture and the 1991 Tokyo World Peace Film Festival award for best drama, which was surprising, given the sensitivity of the subject matter in Japan.

Beginning on December 13, 1937, the first day of the massacre, Luo's film follows the lives of a group of individuals and their respective fates. At the center of the story are Dr. Zhan Tao 展濤 (Zhai Naishe 翟乃社) and his love interest Bai Yan 白燕 (Shen Danping 沈丹萍); Fan Changle 范長樂, a photographer who develops photos for the Japanese in a desperate attempt to save himself and his family; Katie, the daughter of an American doctor who stays behind to aid the wounded; a battalion of Chinese soldiers; a second-rate sing-song girl and her corrupt lover/manager; a Japanese lieutenant named Li Yuan 笠原 (played by popular film and miniseries star Chen Daoming 陳道明); and his former lover Liu Jingjing 柳晶晶 (Wu Lijie 吳莉婕). This group of characters, makes up a microcosm of Chinese society in the 1930s—an ensemble approach that is startlingly similar to the "group film" model prevalent in the late '40s. And, although they all come from different social and economic classes, during the chaos of the massacre, these very different individuals cross paths in a tragic, yet markedly patriotic way.

8. Renowned director of such classics as *The Red Detachment of Women, Hibiscus Town,* and *The Opium War,* Xie Jin has long planned to make a film about the Rape of Nanjing. His initial idea was to focus on the Tokyo War Crimes Tribunal; however, in recent years, he has instead talked about tackling a film based on the diary of John Rabe, a German member of the Nazi Party who played a key role in the Nanjing International Safety Zone.

The main plot line, which brings them all together, involves Dr. Zhan's efforts to recover photos of Japanese soldiers committing atrocities that Fan Changle developed, in order to provide proof of the massacre.[9] In this sense, the plot itself contains the film's driving political message—that the Rape of Nanjing *did* in fact occur. Although this might seem self-evident to many Western viewers, in the face of Japanese denial, much of the Chinese discourse on the Rape of Nanjing focuses on trying to "prove" it. As Susan Sontag has noted, "To photographic corroboration of the atrocities committed by one's own side, the standard response is that the pictures are a fabrication and that no such atrocity ever took place, or, those were the bodies the other side had brought in trucks from the city morgue and placed about the street, or that, yes, it happened and it was the other side who did it, to themselves" (Sontag 2003:11). The true tragedy of the film is that just as the characters struggle to prove that the massacre actually happened, so *Massacre in Nanjing*, which was released on the fiftieth anniversary of the tragedy, is still struggling with the same issues—only now the film itself replaces the photographs as the chosen vehicle. At the same time, this (cinematic) representation of a (photographic) representation adds an extra layer of distance to our understanding of the massacre.

Roland Barthes and Walter Benjamin have written about the power of photos as a testimonial to death. Perhaps even more poignant are Sontag's writings where she emphasizes the relationship between photography and death as well as how to photograph people is "to violate them" (Sontag 1973:14). In the context of the Nanjing Massacre, that "violation" is taken to an obscene new level, well beyond the context to which Sontag originally referred. Over the course of the quest to retrieve Fan Changle's photos in *Massacre in Nanjing*, four major characters die, including Mr. Fan, Liu Jingjing, the sing-song girl, and, eventually, Dr. Zhan. However, because of the subplot of "recovering the photos,"

9. Although this incident is significantly dramatized and politicized in the film (as evidenced by Fan Changle's initial motivations for retrieving the photos and his subsequent martyrdom), it is a fictionalization of an actual event that occurred during, or perhaps in the aftermath of, the Nanjing Massacre. The incident is based on the story of Luo Jin 羅瑾, who developed atrocity photos, saved a duplicate set, and made them into a small booklet, and Wu Xuan 吳璇, who later discovered the booklet and took action to guard and preserve it. The story is retold in several sources, notably the documentary film *The Massacre of Nanjing—The Surviving Witnesses,* which features extensive interview footage with both Luo and Wu. Daqing Yang also makes reference to the story: "a Chinese clerk working in the shop secretly made an extra set of prints, which were hidden until the end of the war and then admitted as evidence no. 1 at the Nanjing Tribunal" (Fogel, ed., *The Nanjing Massacre in History and Historiography,* 146). The most comprehensive discussion of the photos appears in a doctoral dissertation by Robert Yee-sin Chi, *Picture Perfect: Narrating Public Memory in Twentieth-Century China* (Harvard, 2001), which features the original photos preserved by Luo and Wu in an appendix. Fascinatingly, the Luo Jin photos, which serve as the inspiration for the film, are not the ones that appear at the end of *Massacre in Nanjing.*

these victims become symbols of all the victims of the massacre, inscribed with new meaning by their transformation into martyrs. Dr. Zhan and Liu Jingjing in particular are portrayed throughout the film as Lei Feng-esque moral heroes, ever pure and upright, as displayed by Dr. Zhan's berating Mr. Fan for selling out to the Japanese (even if it was to save his pregnant wife's life) and Liu's outright refusal of Li Yuan's advances (even though she once loved him). The perfect moral altruism positions Zhan and Liu as holdovers from an earlier mode of cultural propaganda. This not-so-subtle injection of revolutionary, socialist realist discourse links the film with the tradition of pre-1978 PRC film but simultaneously pushes it even further away from the brutal reality of the Rape of Nanjing.

In one fascinating scene that both proves Liu's purity and brings in the photo motif, Li Yuan, during his reunion with Liu Jingjing (she is, in fact, his prisoner), admits that he has loved her ever since their time together in Manchuria. He proves his love by mentioning a treasured photo of the two of them: "I've carried it with me for six whole years." He brings out the photo to show Liu, but she does not accept his affections. During this key moment, Liu's back faces the camera—a symbolic denial of Li's advances—and the photo is never actually shown on screen. This memento is the direct antithesis of the atrocity photos, around which the plot revolves; moreover, never actually showing it (the proof) negates the relationship, thus metaphorically negating Sino-Japanese love/friendship.

Throughout *Massacre in Nanjing* there is also a series of scenes that work to manufacture an alternative body of photographic evidence standing in direct contrast to the atrocity photos. The story behind the production of those photos is told during an impassioned monologue by a Japanese commander on board a warship after he sees a Japanese newspaper report of a killing contest:

> Our brave soldiers in Nanjing have written the most glorious page in our imperial history [with their deeds]. These images display the power of the imperial army to the Chinese [*zhina ren*], but how can the newspapers openly print photos like this?! Who knows what kind of talk photos like this will generate back home?! What will happen to the name of our great nation? We need to let the world know that what we have brought the Nanjing people is peace and safety! The government has sent me here especially for this very purpose!

The contest referred to is a historically accurate incident, and the newspaper report actually fits into the temporal scheme of the film, as several reports were

Li Yuan gazing at the photo, which Liu Jingjing now rejects.

originally published on November 30, December 4, and December 6, 1937. "*Tokyo nichi nichi shinbun* carried reports of a 'killing contest' between two second lieutenants, who were trying to outdo each other in obliterating the Chinese enemy" (Yoshida 16). In an effort to "rewrite history," the Japanese commander's mission is not only to suppress such violent images but also to produce a new set of images that document the "peace and safety" brought to the Chinese people by the benevolent Japanese imperial army. This leads the general to stage a series of wartime photo ops in which Chinese prisoners of war are forced to smile for the camera and wave the Japanese flag. In each of these scenes, such as when Chinese children are given candies by Japanese geisha or when a group of prisoners are sent to a teahouse, where they are to pretend to enjoy a performance of Chinese opera with a group of top Japanese officials, Luo Guanqun highlights the contrived nature of the photo sessions with the dejected expressions of and gunpoint threats to these new subjects of the Japanese empire. Like the "photographic evidence" of Li Yuan and Liu Jingjing's love, the resulting photos are never displayed—the ultimate denial of their power, agency, and authenticity. The foregrounding of this war of historical images emphasizes that *Massacre in Nanjing* is about not just history, but how historical memory is created and contested through "photographic evidence."

Even the film's Chinese title, *Tucheng xuezheng*, a literal translation of which would read something like "Bloody Evidence in the Massacred City," hints at the underlying intent behind, or rather, transparent in, the film's narrative. The

key word here is the final character in the title, *zheng* 證, "authentication, proof, testimony, or evidence," which points to the series of black-and-white photos and also to the film itself as a means of proof against the Japanese denial of the event. To enhance the authenticity of the history that his film portrays, Luo Guanqun uses an array of cinematic techniques. The most blatant is black-and-white documentary footage from the 1930s in the opening sequence—very different from the main body of the work. By bracketing his film with a 45-second montage of archival footage of Japanese bombers, followed by a nearly 2-minute segment where the opening credits are run against a backdrop of fire, the director is trying to draw the audience into *his* vision of war-torn Nanjing and convince them of its authenticity. The effect is enhanced by ending the opening credits with the transitional title "December 13, 1937" in red and immediately cutting to Luo's staged version of 1937 Nanjing, complete with burning buildings and refugees flooding the streets—the implied result of the actual bombing footage just shown.

As the film progresses, Luo Guanqun creates a series of highly dramatic juxtapositions of images to highlight the cruelty of the invading Japanese army. The first occurs approximately 13 minutes into the film when a line of wounded, unarmed soldiers are summarily executed against a wall outside the gate of Chaotian Palace 朝天宮 in western Nanjing. Luo deploys a virtual arsenal of cinematic techniques as the soldiers are being gunned down: slow motion, removal of all sound and background music to highlight the images, periodic stills, and random insertions of ghostly black-and-white negative snapshots (the images that Fan Changle will later develop?).

The massacre at Chaotian Palace is further emphasized through Eisensteinian methods borrowed from the 1925 classic *The Battleship Potemkin.* By placing the execution on the skewed temple steps, Luo Guanqun draws a cinematic parallel with the iconic massacre on the Odessa Steps. Film critic Marilyn Fabe's reading of the Odessa Steps scene in the Eisenstein film pinpoints the ways the sequence highlights the victimization and helplessness of the murdered and the spatial imbalance of the staircase heightens the cinematic tension, all details further developed by Luo Guanqun in *Massacre in Nanjing.* Fabe's analysis could just as well describe Luo Guanqun's scene:

> Eisenstein's idea of staging a massacre on the Odessa Steps was truly inspired. While being caught in the line of fire is bad enough, the stuff of nightmare, the last place one would want to be if this were actually to happen would be on a lengthy flight of stairs. Steps are always a precarious place to be under any circumstances, because they threaten us with loss of balance. Much of the action at the beginning of the Odessa Steps sequence

The Japanese photographer in *Massacre in Nanjing* (left) and the ghostly negative stills superimposed over the screen as he "shoots the victims" (right).

involves images of people losing their balance, tripping, and falling as they desperately try to flee the gunfireEisenstein intensifies the spectator's horror (and fascination) at witnessing this spectacle by focusing on the very people who would have the most difficulty escaping from danger on stairs. Thus the first person we see fleeing is a man without legs. We watch him desperately thrusting himself down the stairs supported only by his arms. Soon after, a one-legged man on crutches appears, who negotiates the steps with even more difficulty than the legless man. In quick succession, interspersed with long shots of the crowds of people fleeing en masse, we see a woman with a sick child, a group of elderly men and women, and, toward the end of the sequence, and most pathetically of all, a young mother who has somehow found herself stranded on the steps with an infant in an unwieldy baby carriage. She is horribly caught between the murderous soldiers above and the endless flight of steps below. (Fabe 25)

In the massacre at the Chaotian Palace, one of the most violent and disturbing sequences in the film, it appears that many of the central tropes are inspired just as much by cinematic history as by actual history.

The director enhances the aura of persecution through standard tropes of victimization, such as the decision to show all of the captured Chinese soldiers wounded (virtually every one is wrapped in bloodied bandages) and to include the sound of a crying child, the ultimate symbol of innocence. At the end of the scene appears the image of a traditional stone lion—a symbolic rendering of China herself—bathed in blood as the baby's cries are silenced by a single gunshot. The setting on the large staircase, the presence of wounded and even legless victims, and the helpless baby caught in the crossfire—all the major aspects of the production design and structure create a microcosm of the Odessa Steps sequence. Luo, however, goes one step further by juxtaposing this scene with the sinister laughter of gloating Japanese soldiers.

A legless wounded soldier (left) and a wounded soldier being pushed down the steps at Chaotian Palace (right).

Later in the film, this method of juxtaposing radically different images to produce an emotional effect in the viewer is repeatedly reused. Smiling geisha girls hand out candy to dejected Chinese children (with bayonets pointed at them); Li Yuan's execution of a Chinese prisoner is immediately followed by the image of a holy cross; sounds of gunfire and tortured screams are matched with biblical murals and Jesus on the crucifix; and a baby is bayoneted as its horrified mother looks on amid the exaggerated evil snickering of Japanese soldiers. Although powerful when used sparingly, Luo Guanqun's flurry of extreme audio-visual juxtapositions brings the relationship between physical pain and sadistic pleasure to obscene new levels.

Only toward the end of the film, after Dr. Zhan has sacrificed himself delivering the all-important photographs to the American girl Katie, are they finally shown on camera. Their necessary guardian is neither the Chinese victim nor the Japanese perpetrator but the detached witness of the West, an invented character. The filmmaker places confidence in the West's identity as a neutral and objective party and even grants the West the exclusive power to gaze upon atrocity. Perhaps this is an attempt to rationalize China's own historical amnesia regarding the Nanjing Massacre, but it simultaneously undercuts the director's own effort to provide cinematic testimony. As Katie flips through the images, the viewer sees that they are the most recognizable collection of photographic images associated with the Rape of Nanjing. This group of black-and-white photos finalizes the bracketing or framing of the film that began with the black-and-white film of Japanese bombers.

The bracketing device presents Luo Guanqun's film as a conscious attempt to reconstruct or fill in the blanks between these two concrete, documented historical junctures. This bracketing is further enhanced by the recurrence of another number in bold red print (the first being the date "December 13, 1937," which immediately followed the opening credits). This number is not a date but

Framing film with documentary in *Massacre in Nanjing*. The opening image of Japanese fighter planes (left) and one of the final images of Katie thumbing through the "evidence" as she leaves China aboard a steamer (right).

a death toll—300,000. As the figure, etched in large, blood-red numerals, lingers on the screen, an offscreen narrator declares: "Let us always remember this number." However, the memory did not linger long. The sharpest irony of the film did not occur until June 4, 1989, just over a year after its cinematic release, when there would be a new search for "bloody evidence in the massacred city."

Black Sun: *Two Faces of a Violent Docudrama*

Seven years after the release of *Massacre in Nanjing*, two other Chinese-language feature films dealing with the atrocities appeared. *Black Sun: The Nanjing Massacre* and *Don't Cry, Nanking*[10] were both released in 1995 to correspond with the fiftieth anniversary of the Allied victory over fascism (which marked the conclusion of China's eight-year War of Resistance). This in itself gives both films a political slant, further enhanced by the fact that each was openly marketed as a visual commemoration of the event.[11]

However, the first of these two films never got a chance at cinematic life as a work of propaganda or commemoration. Although partly funded by a well-known Beijing-based government organization and filmed on location in

10. *Don't Cry, Nanking* is just one of the many titles used for the film, which was marketed under different titles in different regions. In Chinese, it is known as *Nanjing datusha, Nanjing 1937* and *Bie ku le, Nanjing*. In English, the film is known as *Nanking 1937; Don't Cry, Nanjing;* and *Don't Cry, Nanking* (there is, arguably, some political significance behind the use of "Nanking" in some regions and "Nanjing" in others). Oddly, even the film credits change significantly in different prints. For instance, Hong Weijian was credited as the sole screenwriter when the film was screened in Taiwan, whereas a team of several co-writers was credited in the PRC cut.

11. This is the same in the case of Luo Guanqun's *Massacre in Nanjing*, which, as mentioned earlier, was released to correspond with the fiftieth anniversary of the massacre itself.

Nanjing, Hong Kong–based producer and director T. F. Mou's *Black Sun* never made it past the PRC censors, which limited it to a short run in Hong Kong and a handful of international screenings.[12]

Rising to prominence in the late 1970s, T. F. Mou (b. 1939) became known for a series of controversial films, such as the 1977 erotic drama *Dreams of Eroticism* (*Honglou chunmeng* 紅樓春夢); the 1980 exploration of the cruel tortures faced by illegal immigrants, *Lost Souls* (*Da she* 打蛇); and a brutally violent adaptation of martial arts novelist Jin Yong's 金庸 classic *A Deadly Secret* (*Liancheng jue* 連城訣) (1980). However, he is perhaps best known for his disturbing look at Japanese wartime medical, biological, and virus-infection experiments on living Chinese subjects in *Men Behind the Sun* (*Hei taiyang 731* 黑太陽 *731*), the first film ever to receive a Category III rating, the Hong Kong equivalent of NC-17. To capture the terror and violence of the Rape of Nanjing, Mou re-creates some of the most horrid incidents. Combining the bullets and blood of John Woo with Chang Cheh's 張徹 penchant for swords and severed limbs, Mou brings the blood and violence of Hong Kong martial arts and action cinema (without the martial arts or action) directly into his Sino-Japanese docudrama. With intentionally weak characterization, no recognizable stars, and no tangible plot line, *Black Sun* serves as a detached witness to the massacre as it chronologically follows the events from December 11 to Christmas Eve, 1937. Over the course of this fifteen-day bloodbath, Mou's camera witnesses a monk being castrated, numerous beheadings, cannibalism, people buried or burned alive, multiple firing squad–style executions, a child boiled alive, a woman disemboweled (and the subsequent removal of her intestines by a bayonet), dogs gnawing on human corpses, and the rape of a preadolescent girl. Although Mou prefaces his film with a dedication to "all war victims to commemorate the 50th anniversary of the successful conclusion of the Campaign of Resistance," his vulgar and contrived portrayals of violence often make the movie seem more like an exploitative horror flick than a solemn memorial.

In his groundbreaking study of exploitation films from 1919 to 1959, Eric Schaefer (1999:254) defines atrocity films as "essentially about death and disfigurement; their spectacle centered on violent, 'inhuman' behavior such as war, massacre, mutilation, and other grisly topics." He describes the function

12. The film was most likely banned because of its overly violent content (especially in the wake of Tiananmen) and to avoid straining current Sino-Japanese political and economic relations. *Black Sun's* Hong Kong theatrical run lasted from July 7 to July 21, 1995, grossing HK$902,488. It was screened in New York and Palo Alto on December 13 and 16, 1995, respectively, with the director present as part of a series of events organized by the Alliance in Memory of Victims of the Nanjing Massacre in commemoration of the fiftieth anniversary of the end of World War II.

of these films as "primarily to repulse with images of violence, carnage, or bloody ritual" (285). In this context, we can read *Black Sun* as a contemporary reinvention of the atrocity film. The film re-creates a carnival-like spectacle of "grisly topics" such as dismemberment, torture, and rape, freely mixing documentary newsreel footage with dramatic re-enactments in a style almost identical to Schaefer's description of early American atrocity films such as *Hitler's Reign of Terror* (1934) and *The Love Life of Adolph Hitler* (1948). The depictions of blood and gore in *Black Sun* become a double-edged sword—turning away a more serious audience while attracting a new one by way of inherent sensationalism.

The exploitative element of the film is enhanced by the "nonportrayal" of the victims. Although history itself takes center stage in *Black Sun,* the failure to build an emotional link between *any* of the Chinese characters and the audience makes much of that history appear cold and dehumanized. Most of the Chinese do not even have names, whereas when each major Japanese character first appears, there is a momentary freeze frame and the character's name and official position appear in subtitles. This occurs eleven times during the course of the film; all characters named are Japanese (except for one enigmatic case, an American from the International Safety Zone who is also identified this way). The director's strategy in attaching real names to the Japanese characters is undoubtedly to hold the perpetrators accountable. However, by naming and focusing most of his attention on them (the vast majority of the dialogue is among Japanese officials), Mou tends to silence the voices, identities, and ultimately the humanity of the victims—the very group to which his film is dedicated.

Although *Black Sun* lacks the melodramatic components of *Massacre in Nanjing,* it does bear a series of uncanny similarities to its cinematic predecessor. The most startling, in the opening scene, sets up an unavoidable parallelism between Mou's and Luo's films. *Massacre in Nanjing* opens with a forty-five-second montage of documentary footage immediately followed by the credits run against a background of fire. *Black Sun* also opens with just under one minute of vintage documentary footage—some of which actually repeats the footage used in *Massacre in Nanjing*—followed by a close-up of yet another flame image—this time a candle.[13] The structural similarities between

13. Other similarities between the two films include the focus on the International Safety Zone, the presence of a Japanese character who sympathizes with the Chinese (Li Yuan in *Massacre in Nanjing* and Takayama Kenshi in *Black Sun*), the attention to photographers, and the punishmentlike death of Chinese collaborators who appease Japan.

the films' opening sequences are so striking that they seem more than a mere coincidence.

What distinguishes the first two minutes of *Black Sun* from *Massacre in Nanjing* is a voice-over narration. The objective, unseen narrative voice combined with the black-and-white film clips makes the first moments of Mou's film virtually indistinguishable from a documentary. Also, unlike *Massacre in Nanjing*, in which documentary footage is used only in the opening scene, *Black Sun* is laced with vintage photos and film clips throughout. There are at least nineteen different scenes where T. F. Mou augments his staged dramatic footage with actual photos and film of the Rape of Nanjing. Just under half of these (eight) are accompanied by the same documentaryesque voice-over narration. The most startling of these interruptions occurs about eight minutes from the end of the film where, for the first time, the documentary-style narration actually *spills over* from the black-and-white archival footage into the color footage of the film proper. At this moment, the two bodies of film (the documentary and Mou's drama) are linked not only spatially and contextually but also narratively. The historical stakes are raised and the lines are blurred between documentary and fiction, staged reenactment and actual history.

Black Sun also, in what are without question some of the film's most fascinating moments, meticulously tries to re-stage specific historical events.[14] Filmed on location in Nanjing, many of the re-creations were done at the actual locations where the atrocities occurred. The most powerful scene happens thirty minutes into the movie, when a Japanese soldier executes an elderly Chinese monk. Just as the monk drops to his knees and the soldier draws his gun, the frame freezes. Then, corresponding with the sound of a gunshot, the staged image is replaced with the actual photo upon which the scene is based. Underlying T. F. Mou's painstaking reenactments of these fleeting moments of historical tragedy is the same obsession with bearing witness and proving the truth of the Rape of Nanjing that we see in *Massacre in Nanjing*. Through scenes like this, the structure of the film, which initially appears quite random, becomes apparent: *Black Sun* is actually built around the series of black-and-white photos and archival documentary footage that appear throughout. Whereas *Massacre in Nanjing* brackets itself with these images, *Black Sun* weaves them into its cinematic body, further blurring the line between photographic evidence and cinematic re-creation.

14. *Black Sun* was also marketed as a documentary of sorts. The cover of the videocassette features an actual photograph from the 1937 massacre (rather than a movie still) and only the cast list makes the video distinguishable from a documentary.

Black Sun's reenactment of history (left), immediately followed by a freeze frame of an actual historical photograph (right).

Like Luo Guanqun's film, *Black Sun* uses the presence of photos and cameras within the reenactments to stress the validity of the version of history the director is fighting to convey. T. F. Mou's extensive appropriation of archival film footage and photographic images is, however, not without problems. Aside from footage taken by the American missionary John Magee and a handful of other exceptions, the vast majority of all extant visual records of the massacre were produced by the Japanese, the perpetrators of the violence. Needless to say, the motivations behind their production of the images were very different from those of contemporary filmmakers like Mou, who have appropriated these visions some sixty years after the event. Holocaust survivor and Nobel Prize–winning writer Elie Wiesel addresses this very issue in his short introduction to *Indelible Shadows*. His criticism on the usage of documentary footage is relevant here:

> For the most part the images derive from enemy sources. The victim had neither cameras nor film. To amuse themselves, or to bring souvenirs back to their families, or to serve Goebbel's propaganda, the killers filmed sequences in one ghetto or another, in one camp or another: The use of the faked, truncated images makes it difficult to omit the poisonous message that motivated them . . . will the viewer continue to remember that these films were made by the killers to show the downfall and the baseness of their so-called subhuman victims? (Insdorf 1989:xii)

Although, as Wiesel concludes, "we [nevertheless] can't do without these images, which, in their truthful context, assume a primordial importance for the eventual comprehension of the concentration camps' existence" (xii) (or of the Nanjing Massacre as historical fact), we cannot easily escape the

problem at hand. Ultimately, the perspective of horror and pity assumed by the viewer observing images of atrocity is not far away from the gaze of the executioner.

The many faces of *Black Sun*—docudrama, gorefest, exploitative atrocity film, historical tragedy, pseudo-documentary, cinematic commemoration, war epic—create a challenging pastiche of sounds and images. The film has a double life as a serious historical docudrama (no doubt the filmmaker's original intention) and as a cult film with a following among fans of B horror movies. These two self-contradictory and seemingly irreconcilable identities are evidenced in the market availability of the film.

Black Sun can be obtained through the Alliance in Memory of Victims of the Nanjing Massacre (AMVNM), a nonprofit organization based in New York, for a donation of $75. AMVNM also distributes the film in a boxed set entitled *Can Japan Say No to the Truth?*, therein marketing it as an educational lobbying tool of sorts. In this context, *Black Sun* is presented as "evidence" of the massacre (along with the two other straightforward documentaries in the boxed set). However, the film is also widely available on the Internet from horror film distributors, who sell it alongside such titles as *Cannibal Apocalypse: Vietnam Vets Eating Flesh, Model Massacre,* and *Caligula Reincarnated as Hitler* and describe it as "Very horrific! People are tortured and killed in ways that you never knew existed."[15] In 2003 *Black Sun* finally saw an official U.S. DVD release by Unearthed Films, a distribution company run by a group of self-described "hard-core cult film enthusiasts" who have set their sights "on rare underground horror films, lost animated gems and psychotic action films."[16]

The complexity, poignancy, irony, and, to some extent, blasphemy of T. F. Mou's *Black Sun* displays how an attempt at a serious historical documentary uses the cinematic aesthetics of a shock-infused carnival of gore. The radically divergent modes of appropriation and communities of consumption associated with the film bear out Susan Sontag's observation on photography (even more appropriate because T. F. Mou highlights the power of the image and the role of the photographer): "The photographer's intentions do not determine the meaning of the photograph, which will have its own career, blown by the whims and loyalties of the diverse communities that have use for it" (Sontag 2003:39).

15. This description was taken from a 2002 online auction of *Black Sun: The Nanking Massacre* (http://cgi.ebay.com/aw-cgi/eBayISAPI.dll?ViewItem&item=524499876).

16. Description is cited from the company description found on Unearthed Films' Web site: http://www.unearthedfilms.com.

Don't Cry, Nanking: *International Melodrama*

Fifth Generation director Wu Ziniu's (1953) *Don't Cry, Nanking* won the largest viewership among the films examined here. It was shown across China and also had a coveted theatrical run in Taiwan.[17] Although *Don't Cry, Nanking* was released in 1995, the same year as *Black Sun,* Wu's approach couldn't be more different from T. F. Mou's. In fact, when asked to describe his film, Wu Ziniu seemed to direct his response at the kind of violent aesthetics and cold, historical reconstruction undertaken by Mou, while addressing Luo Guanqun's obsession with authenticity:

> I hope to make a sincere, dignified, and solemn melodrama. I began to realize the difficulty in choosing an angle [from which to approach the material] back last May when I first began to brainstorm. If I try to present a cinematic record of what actually happened, [the film] will come off too bloody and violent. Then again, using my film as a means to confirm the authenticity of the event is also not what I am interested in—that's work to be left to the historians.
>
> The Rape of Nanjing is China's national shame; the Chinese people there were slaughtered without even putting up any kind of resistance. Because of this, it is extremely difficult to find the proper angle; simply filming images of desperation and desolation will be nothing more than a kind of vulgar exhibition. So I have decided to focus on the human element and stick with a more humanistic approach. (Jiao 1998:184)

> Nakedly exposing blood and violence, as far as I'm concerned, is nothing more than selling out for money and a betrayal of one's conscience. (185)

This conscious break from the internal aesthetics, historical perspectives, obsession with authenticity, and portrayal of violence in the previous two films is only the beginning of the differences between Wu Ziniu's film and the others. Wu Ziniu is the biggest name of the three directors, and he had the luxury of a much larger production budget than theirs thanks to Taiwanese funding, making *Don't Cry, Nanking* the most expensive Nanjing Massacre film at the time of its production. More than 9,000 extras were used (some of whom were actual survivors of the massacre[18]) and the final cost exceeded 25 million *yuan*

17. The Chinese government did, however, pull the film from the Venice film festival. (According to Wu Ziniu's biographer, Zhang Xuan, the decision was made by the Taiwan-based Long Shong Production Co. for financial reasons.)

18. This fact bears an eerie resemblance to the famous Ming play, the *Peach Blossom Fan,* which was also

(roughly US$3.25 million, more than twice the initial budget). The Nanjing municipal government also gave the crew virtually unprecedented liberties by allowing them to film on location at several Ming dynasty historic sites.

The cast and crew of *Don't Cry, Nanking* are a veritable who's who ensemble. The film was produced by Hong Kong–Hollywood superstar action director John Woo (who coordinated most production efforts from Hollywood), was beautifully scored by American-based composer Tan Dun 譚盾 (of *Crouching Tiger, Hidden Dragon* fame, who also scored the aforementioned documentary *In the Name of the Emperor*), and starred Taiwanese pop singer/actress Rene Liu 劉若英 and 1970s romance idol Qin Han 秦漢, along with a supporting cast from China, Japan, and Taiwan. The screenwriting team included the PRC best-selling *zhiqing* writer Liang Xiaosheng 梁曉聲 and Hong Kong–based screenwriter Hong Weijian 洪維健 (Tsui Hark's 徐克 longtime collaborator). This international creative team brought the work a higher profile and a wider audience than the previous two films and achieved a level of depth and reflexivity unmatched by earlier cinematic depictions of the massacre.[19]

The main story line revolves around Cheng Xian 成賢 (Qin Han), a doctor working in Shanghai, who returns to his hometown of Nanjing with his family as refugees on the eve of the infamous massacre. A widower, Cheng Xian has remarried a Japanese woman named Rieko 理惠子 (Saotome Ai 早已女愛), who is pregnant with their child. Rieko, like Cheng, also has a child from a previous marriage, and the film explores the family's struggle to stay together and retain their dignity amid the ensuing Rape of Nanjing.

Unlike the Sino-Japanese romance portrayed in *Massacre in Nanjing*, which is all but refuted (and eventually ends with the Japanese lieutenant Li Yuan executing his former Chinese lover), the love story between Cheng Xian and Rieko forms the basis not only for the story but also for the optimistic worldview and humanistic quality that Wu Ziniu works to convey. Although the previous two films both include Japanese characters who take a somewhat sympathetic stance toward China, *Don't Cry, Nanking* develops this to the point that a Japanese character actually shares the same fate as the Chinese. The in-

set in Nanjing. In the play, the storyteller who introduces the work notes how he (who actually took part in the events portrayed) notices himself in a small role in a play produced several decades after the event.

19. The producers of *Don't Cry, Nanking* went to great lengths to bring together a superstar cast and crew and market the film as a serious historical drama. Not unlike *Black Sun*, Wu Ziniu's film took on a double life in the Asian film market. Thanks primarily to Asian bootleggers, *Don't Cry, Nanking* appeared throughout Asia (often under various alternate titles) with black-and-white atrocity photos replacing the original cover art, which featured color stills of stars Rene Liu and Qin Han. Obviously in some regions (especially where Taiwan actors are not well known), atrocity is more marketable than star power.

nocent, naïve, almost angelic light in which Rieko is portrayed works against the tendency to universally vilify the Japanese. Details such as this enable the film to function as a general denouncement of war and the brutality of which humans are capable.

The complications of guilt are further developed with the supporting character Ishimatsu 石松 (Jiang Guobin 江國斌), a Taiwanese draftee sent by the Japanese to China, where he serves as a military cook. Ishimatsu's presence marks an attempt on the part of the director (or more likely, the Taiwanese investors?) to address the complex and precarious position of Taiwan in the Second Sino-Japanese War. Although he is forced into service for the Japanese, Ishimatsu's allegiance remains with greater China, as is demonstrated by his willingness to sacrifice himself so that Cheng Xian can escape. From a political perspective, Ishimatsu's martyrdom is not only a symbolic act of atonement but also a patriotic reappraisal of Taiwan's role in the war. Ishimatsu's presence in the film (and that of the array of Taiwanese actors who dominate the lead roles) seems to be a direct result of influence exerted by the Taiwan-based production company (Long Shong International Co. Ltd.). Even the most subtle reference to Taiwan is markedly absent from the previous two films, but here we are presented with a concrete example of how politics, the market, and international investment shape, complicate, and perhaps even compromise the cinematic presentation of history.

Wu Ziniu includes a number of subtle, yet carefully thought out symbolic gestures, such as the example of Ishimatsu's death. "Cheng Xian's profession being that of a physician is naturally symbolic," as is "the new life Rieko is pregnant with, which symbolizes the once good relationship between these two nations . . . [equally symbolic is the scene wherein Japanese soldiers] kick her pregnant stomach" (Jiao 1998:185). Another brilliant moment of symbolic imagery occurs as Liu Shuqin 劉書琴 (Rene Liu) is teaching her students the famous poem "Evening Thoughts" ("Ye si" 夜思). Its inclusion carries strong resonance because the scene takes place in a refugee camp; separation from home is one of the poem's key themes. The interruption of the lesson by a Japanese air raid represents the interrupted education of countless children during the eight-year War of Resistance and, because Li Bai's 李白 poem is often read as the quintessence of Chinese culture, the destruction of the Chinese cultural and historical heritage.

Although heavy symbolism is also present in *Massacre in Nanjing* (Zhan Tao was also a doctor) and *Black Sun* (the John Woo-like juxtaposition of Christ images with violence and death), neither reaches the level of subtlety or complexity expressed by Wu Ziniu. While *Don't Cry, Nanking* tries to use the

Ishimatsu releasing Cheng Xian in *Don't Cry, Nanking.*

Rape of Nanjing as a springboard to address larger issues, T. F. Mou's and Luo Guanqun's films never seem to get past trying to prove that the incident happened. This can also be seen in the timeline that each film follows. While both *Massacre in Nanjing* and *Black Sun* are temporally trapped in the actual massacre (both beginning and ending amid a flood of seemingly never-ending violence), *Don't Cry, Nanking* actually begins *before* the arrival of the Japanese army. This allows for a level of character development absent in the earlier films and a more complex portrayal of the city struggling to continue functioning through the growing chaos. For instance, we witness the sudden influx of refugees (the protagonists among them) into the seemingly impregnable capital city on the eve of the massacre. This slightly wider historical perspective also allows for a more complex and introspective look at the forces at work leading up to the Rape of Nanjing.

Even in its spoken language, *Don't Cry, Nanking* presents a much broader and more genuine representation of the linguistic heteroglossia of wartime Nanjing. In Luo Guanqun's *Massacre in Nanjing*, all dialogue, whether spoken by Chinese, Japanese, or American characters, was dubbed into perfect Mandarin; although far from accurate, it was at least consistent. *Black Sun* was also dubbed into Mandarin (including lines spoken by Japanese, Germans, and Americans); however, special effort was made to dub all lines spoken by Westerners into a choppy, almost pidgin Chinese, while all Chinese and Japanese

characters speak standard Mandarin.[20] Wu Ziniu's film achieves, by far, the highest degree of linguistic accuracy (barring the fact that several of the actors have trouble entirely covering up their Taiwanese accents). For the majority of the movie Chinese actors speak Chinese, Japanese speak Japanese, Westerners speak English (or pidgin Chinese), and interpreters actually interpret into two different languages.

The only flaw in this linguistic diversity, a crippling one, occurs in the dialogue scenes between Cheng Xian and his Japanese wife, Rieko. It is made obvious that Rieko and Cheng understand only a smattering of each other's languages, yet they repeatedly carry on long conversations with Cheng speaking Chinese and his wife answering in Japanese. Although Rieko tries to compensate by throwing out occasional lines of broken Chinese, the contrived nature of their exchanges repeatedly compromises the illusion of a real relationship. As they are the main characters, this carries larger implications for the film as a whole. As elaboration of dialogue is one of the key components of the melodramatic form, the linguistically closed world in which Cheng Xian and Reiko live is a significant drawback. Wu Ziniu's melodramatic vision ultimately lies contingent upon his viewers making a "leap of faith" to accept the illusion of genuine communication between the main characters.

Don't Cry, Nanking marked the culmination of a decade-long cinematic meditation on war by Wu Ziniu (and the beginning of a five-year hiatus from filmmaking). Since his 1984 feature, *Secret Decree* (*Diexue heigu* 碟血黑谷), Wu Ziniu has directed more than half a dozen war films, including *Evening Bell* (*Wan zhong* 晚鐘), *Joyous Heroes* (*Huanle Yingxiong* 歡樂英雄), *Between the Living and the Dead* (*Yinyang jie* 陰陽界), and the banned Vietnam War epic *The Dove Tree* (*Gezi shu* 鴿子樹).[21] At the time of its release, *Don't Cry, Nanking* was hailed by critics, audiences, and government censure boards (although Wu Ziniu was eventually forced to make some alterations), and it stands among Wu Ziniu's strongest cinematic contributions. As an exploration and contemplation of wartime atrocities, it presents, unquestionably, a more complex and introspective vision than Luo Guanqun's and T. F. Mou's films; unfortunately, it does not rise

20. This is especially ludicrous when the Chinese interpreter, who is collaborating with the Japanese, translates the Japanese general's orders to the Chinese crowds in Mandarin.

21. The film also marks an interesting point in the political transformation of Wu as a filmmaker from his early controversial war films, like the aforementioned *The Dove Tree*, which Deng Xiaoping 鄧小平 is said to have personally criticized (Jiao, *Fengyun jihui: Yu dangdai Zhongguo dianying duihua*, 173), to 1999's *National Anthem* (*Guoge* 國歌), a film that, according to Hong Kong–based film critic Paul Fonoroff, qualifies as nothing more than "creative propaganda." (See Fonoroff's review in the November 1, 1999 edition of the *South China Morning Post*.) In this context, *Nanjing 1937* marks a middle ground in Wu's oeuvre.

to the aesthetic, visual, and narrative standards set by Wu's classmates, Zhang Yimou 張藝謀, Chen Kaige, and Tian Zhuangzhuang 田壯壯.

The three films analyzed in this section work in very different ways, but they share a surprising number of similarities, including the incorporation of the International Safety Zone as a major part of the narrative and the attempt to offset Japanese war crimes with the presence of "good-hearted" Japanese characters. Other recurring images include a single weeping Chinese child after a mass execution, a pregnant woman being kicked in the stomach (in two of the films), and the concluding image of children escaping into the night (also in two of the films). And just as the first image seen when visiting the Nanjing Massacre Museum on the western outskirts of the city is a massive "300,000" carved into stone at the museum entrance, all three films end with subtitles stating the 300,000 death toll (*Black Sun* actually breaks the numbers down in an attempt to prove the validity of this controversial tally). On this level, all three films—individually and collectively—function as cinematic memorials working to etch the (still debated) death toll into the collective memory of the audience—and at the same time, into history.

Luo Guanqun's noble effort to cinematically redress the atrocities committed during the Rape of Nanjing deserves credit for being the first to face the burden of history, at a time when it was not terribly popular to do so. In order to bring his vision of the massacre to a large Chinese audience, he appropriates the popular form of the melodrama. However, using his film as a blatant vehicle to "prove" or "authenticate" the event itself brings Luo a new set of problematic consequences. The film borrows from the formal strategies of the melodrama, a genre often "characterized by sensationalism, emotional intensity, hyperbole, strong action, violence, rhetorical excesses, moral polarity, brutal villainy and its ultimate elimination and the triumph of good" (Dissanayake 1993:1). However, by utilizing the sensationalism and extravagance of emotion (along with other cinematic conventions, such as the "group film" model) as a means to portray and authenticate the massacre, the film falls into an internal trap. In the end, Luo Guanqun fails to address the implications of using a highly stylized, dramatic, and inevitably convoluted form to bear objective testimony to actual history. After all, can a dramatic feature film ever *prove* anything?

Black Sun avoids this issue by circumventing the melodramatic structure in an attempt to bear detached witness to the events as they actually unfolded. However, Luo Guanqun's lack of plot, structure, and character identification (let alone development), combined with his bloody aesthetics of violence, create a

new problematic—demonstrated, most poignantly, by the two conflicting, contradictory, and (one would think) mutually exclusive ways the film has been appropriated by the market. From gory shock cinema to pedagogical propaganda, viewers have two very different readings of this very disturbing text. Any cinematic portrayal of the Nanjing Massacre is bound to be unsettling, due to the nature of the subject matter. But *Black Sun* is doubly disturbing, owing to the exploitative strategies it employs to present historical atrocity as a blood-and-guts spectacle for entertainment, under the pretext of commemoration.

Although Wu Ziniu has tried to escape the issue of authenticity dealt with by Luo Guanqun's and T. F. Mou's bloody tactics, the subject matter makes this difficult. Wu has stated that his film was not intended to be a vulgar or bloody exhibition of the Rape of Nanjing, but, like the other two movies, it is a very violent depiction of the incident. The scene of the Japanese raid and subsequent gang rapes of Chinese women (including Rene Liu's character, Liu Shuqin) in the International Safety Zone stands as one of the most violent and disturbing moments in the history of Chinese cinema. Even if the representations of violence in *Massacre in Nanjing* and *Don't Cry, Nanking* never reach the level of those in *Black Sun,* which leave viewers likely to laugh in disbelief or simply walk out of the theater in disgust,[22] they are both much more effective. This is due to an increased sense of empathy on the part of the viewer because the characters are more developed. At the same time, although Wu consciously tries to avoid the issue of authentication, the screenplay for his film features the subtitle "historical record" (*lishi jishi* 歷史紀實). And, like the other filmmakers, he cannot forego a final gesture of proof, the 300,000 death toll shown at the end of film—itself the ultimate gesture of authentication.

Luo Guanqun, T. F. Mou, and Wu Ziniu each attempt to pay homage to the victims of the Rape of Nanjing through films released on symbolic anniversaries.[23] However, their works all compromise the subject matter to varying degrees. *Massacre in Nanjing*'s politically charged melodramatic form and aesthetics of authenticity and martyrdom, *Black Sun*'s faceless victims and exploitative docudrama violence, and *Don't Cry, Nanking*'s mass-market strategies and contrived Sino-Japanese romance illustrate the various problems associated with cinematic portrayals of atrocity. At the same time, it is precisely by attempting to represent the unrepresentable that the films—individually and

22. As Wu Ziniu did after sitting through the first ten minutes of *Black Sun.* Interview with Wu Ziniu, November 2000.

23. Wu Ziniu's film was not only released in the summer of 1995 to correspond with the fiftieth anniversary of the end of World War II, but actually started filming on December 13, 1994, the anniversary of the date the massacre began. By incorporating these two anniversaries into its shooting and release schedule, the film itself functions as a work of commemorative symbolism.

collectively— open up a new dialogue with the past and provide new trajectories for approaching history. Ultimately, however, none has been able to fully escape the shadow of Japanese denial and, to a lesser extent, the fear that representing Japan in an overly negative light will result in the film being banned (as was the case with *Black Sun*). It has been observed how denial and "doubt of other persons . . . amplifies the suffering of those already in pain" (Scarry 7). One of the greatest tragedies of the Rape of Nanjing is that, even seven decades after the fact, the Chinese cinematic memory of the massacre continues to be dictated by Japan's denial.[24]

Writing the Nanjing Massacre: Ah Long and Ye Zhaoyan

Turning from the cinematic imagination to the literary imagination, this section provides an overview of historical fiction portraying the Nanjing Massacre before moving on to an extended analysis of Ah Long's *Nanjing* and Ye Zhaoyan's *Nanjing 1937: A Love Story*. Owing largely to the chaotic political climate following the massacre and the ensuing civil war, there was very little fiction produced about the Nanjing Massacre before 1949. After the great divide between the Nationalists on Taiwan and the Communists on the mainland and in the three and a half decades since, Cold War politics and each region's struggles to modernize have consistently made literary portrayals of the massacre a low priority or a political impossibility. Except for a small number of early works written during the War of Resistance, the literary history of the Nanjing Massacre is marked largely by silence until the sudden reemergence of the incident in political and literary discourses in the 1980s.

Among the first novels chronicling the Rape of Nanjing during that decade was veteran author Zhou Erfu's (b. 1914) epic *The Fall of Nanjing* (*Nanjing de xianluo* 南京的陷落). Author of such classic CCP-endorsed works as *Doctor Norman Bethune* (*Baiqiuen daifu* 白求恩大夫) and *Morning in Shanghai* (*Shanghai de zaochen* 上海的早晨), Zhou chose *The Fall of Nanjing* as the inaugural

24. Iris Chang has well documented the Japanese tradition of denying the occurrence of the Nanjing Massacre. Citing such incidents as politician Ishihara Shintaro's now infamous 1990 *Playboy* interview, Chang goes so far as to interpret Japan's denial as a "second rape" (Chang, *The Rape of Nanjing*, 199–214). Not surprisingly, Chang's book was also "denied" by Japanese revisionists, as evidenced by the revisionist Web site *The Rape of Nanking: Looking for Truths in the Sea of Wartime Propaganda* (http://www.jiyuu-shikan.org/nanjing/). The site not only goes to great lengths to challenge the accuracy of and discredit Chang's work but even resorts to revengelike tactics by including exposé essays on "Cannibalism in Chinese History" and "Chinese Execution Methods." The concerted effort to deny the massacre has continued with the 2000 publication (and mass distribution) of Tanaka Masaaki's book, *What Really Happened in Nanking: The Refutation of a Common Myth*.

volume in his monumental series *A Portrait of Ten Thousand Miles Along the Great Wall of China* (*Changcheng wanli tu* 長城萬里圖).[25] The novel was initially conceived during the War of Resistance, but Zhou did not complete the first draft until decades later, in 1982, and it took several more years for the novel to appear in print. In 1987 *The Fall of Nanjing* was finally published to coincide with the fiftieth anniversary of the massacre and serve as a symbolic literary commemoration, a tactic also employed for the film *Massacre in Nanjing*. The novel approaches the massacre from a macrohistorical perspective, exploring the events through the eyes of leaders and key figures in the political and military hierarchy including Zhou Enlai 周恩來, Chiang Kai-shek, Wang Jingwei 汪精衛, and Matsui Iwane 松井石根. This grand historical narrative is interspersed with descriptions of common folk and soldiers. The focus, however, is not on the massacre itself but on the Japanese breach of the city; the novel stops short of a full description of the brutal atrocities committed afterward.

Another multivolume historical epic, Wang Huo's 王火 (b. 1924) *People and War* (*Zhanzheng he ren* 戰爭和人), a literary chronicle of the War of Resistance, also prominently features the Nanjing Massacre. Written over the course of a decade and published in three volumes between 1987 and 1992 (and later reprinted as a set under the current title in 1993), *People and War* spans the ten-year period from December 1936 to March 1946, with the eight-year War of Resistance as its focal point. The Rape of Nanjing figures prominently in the first volume, to which the author devotes the chapter "Ah! A Downpour of Blood and a Stench Fills the Air of Nanjing" ("Ah! Xueyu xingfeng Nanjing cheng" 阿!血雨腥風南京城). Although connected with the earlier narrative, this chapter also stands alone as a separate vignette tracing the lives of a group of individuals and their respective fates as the Japanese army occupies the city. Instead of the political chess masters who take center stage in *The Fall of Nanjing*, they are common citizens, including a housewife, a soldier, and an old gardener, all struggling to maintain their dignity and survive after the occupation. The chapter concludes with a gesture of patriotic violence and martyrdom when the gardener Liu Sanbao brutally decapitates a sleeping Japanese soldier before being murdered by the enemy soldiers in retaliation.

In addition to such fictional accounts of the Nanjing Massacre, there have been several works of reportage that, while purporting to be the results of

25. Other volumes in the series include *The Yangtze Rages On* (*Changjiang haizai benteng* 長江還在奔騰) (1988), *Countercurrents and Undercurrents* (*Niliu he anliu* 逆流和暗流) (1989), *Before Dawn on the Pacific* (*Taipingyang de fuxiao* 太平洋的拂曉) (1991), *The Darkness Before Dawn* (*Liming qian de yese* 黎明前的夜色) (1993), and *Chongqing in Mist* (*Wu Chongqing* 霧重慶) (1995), all published by the Renmin wenxue chubanshe.

stringent historical research, contain embellishments and literary techniques that point more toward historical fiction. One is Sun Zhaiwei's 孫宅魏 *1937 Nanjing Elegy: Record of Atrocities Committed by the Japanese Army* (*Yijiusanqi Nanjing beige: rijun tusha lu* 一九三七南京悲歌:日軍屠殺錄). Sun, a member of the Jiangsu Province Academy of Social Sciences and a prominent scholar on the Nanjing Massacre, presents his work as based on "historical records . . . accurate and reliable" and even recommends the content "be used for educational and research purposes" (Sun Zhaiwei 1995:xi). The book's embellished narrative passages and fictionalized dialogue, however, point to a different strategy of representation. Passages such as this one from section 49 of chapter 3, "Ripping out a Fetus with a Bayonet" ("Yong cidao tiaochu taier" 用刺刀挑出胎兒), amply illustrate a narrative closer to fiction than "historical research":

> "Any pretty girls here?" four Japanese soldiers screamed as they rushed into the room.
>
> "No, no there aren't . . ." The old woman's voice trembled. She anxiously stared at the two tightly shut doors. Oh, how she hoped that those plain wooden doors could work as a magical incantation to keep the enemies sealed off on the outside.
>
> But indeed, wood is wood, and it lacks any magical power. A Japanese soldier wildly kicked open the door to her daughter-in-law's room. Seeing the frightened pregnant woman trembling in the corner, he began to yell with wild excitement.
>
> "Ha, ha! So there is a pretty girl after all!"
>
> With that, the soldier, who was no better than an animal, pushed the pregnant woman down on the bed as if he was a starving wolf. He ripped off her jacket and removed her pants. The pregnant woman's protruding stomach and lower body were left completely naked and exposed. (341–342)

The brutal climax of this episode is already made clear in the title; such bloody scenes raise a new set of problems caused not only by the strategies of representation employed but also by the way these *literary* methods are passed off as *historical* ones. With direct dialogue; descriptions of sounds, timbres, even tones of voice; and ruminations on the inner psychological workings of often nameless "historical figures," the text seems suspiciously distant from nonfiction. But is Sun merely narrating actual historical events in a "popular" format (as he claims in his preface)? Or is he, by presenting a fundamentally fictional narrative as a historical document worthy of pedagogical and research uses, transforming fiction

into fact?[26] The example of Sun Zhaiwei, who also coauthored a second book on the Rape of Nanjing with the same approach as the first, raises the question of just what about the novel format leads even a respected historian to employ its formal and narrative devices for his supposed historical work. In other words, what can literature tell us about history that traditional historical approaches fail to convey? Is Sun simply attempting to gain a larger popular readership, or does fiction provide a human element lacking in the representative figures and cold data of traditional historical approaches?

In the mid-1990s (several years before the publication of Iris Chang's landmark book), the Nanjing Massacre began to simultaneously capture the literary imagination of two American-based writers, R. C. Binstock and Paul West, who produced full-length novels inspired by the massacre, both published to critical acclaim in 1995. R. C. Binstock's *The Tree of Heaven* is the unconventional love story of Kuroda, a Japanese officer temporarily in charge of a provincial garrison town outside Nanjing, and Li, a Chinese woman he takes under his protection after saving her from being gang-raped by several of his subordinates. A botanist and professor by training, Kuroda is a far cry from his bloodthirsty and sex-crazed comrades. Li, one-quarter Japanese by birth and semifluent in the language, is single after having been abandoned by her Chinese husband, making her an equally atypical and complex character. Told in twenty-four chapters, with odd-numbered chapters narrated by Kuroda and even chapters told in the voice of Li, the novel is a highly dramatic literary achievement, a gripping portrait of love, hate, desire, and loathing in wartime China.

Although *The Tree of Heaven* actually takes place in 1938 during the aftermath of the massacre, the atrocities committed in Nanjing continue to haunt the memory of the protagonists and guide the story. It is the mass rapes that seem to weigh heaviest, and as the novel comes to a climax, the memories prove overwhelming for Li:

> *Twenty thousand. Thirty thousand.* My head was spinning, my knees were weak. Even I was overwhelmed. I walked as quickly as I could and as I went I kept hearing it: *Twenty thousand, thirty thousand. Little girls and aged women.* Mothers with babies nursing, mothers with six children behind them, college

26. Another similar, but less extreme example is *Lest We Forget: Nanjing Massacre, 1937,* by veteran author of party-sponsored reportage literature Xu Zhigeng. Although closer to a straight historical narrative than *1937 Nanjing Elegy,* in addressing a wider audience, Xu's award-winning book also employs a host of highly literary tactics, including extensive dialogues, which compromise the historical value of his work. Neither book contains bibliographies, footnotes, or references to back up the writers' respective claims of accuracy.

graduates, prostitutes, shop clerks, students at the missionary schools. Women nine months pregnant. Rich women, poor women, pretty women, plain. Trapped by three soldiers, chased by half a dozen, assaulted by ten or twenty or thirty and left for dead. Mutilated, stabbed or just used and discarded. The playthings of fifty thousand men. (Binstock 1995:209)

After the death of Kuroda at the hands of Chinese rebels, Li's ruminations on the mass rapes consume her. She is given a chance to escape but chooses to turn back and symbolically offer her body to the Japanese soldiers pursuing her. In this moving and disturbing climax, Binstock offers one of the most powerful and unsettling depictions of the Rape of Nanjing, set months later amid a flurry of violent desire, twisted redemption, and, perhaps, pathological curiosity.

In *The Tent of Orange Mist,* Paul West, British-born and American-based author of more than fifteen novels, including *Rat Man of Paris* and *Love's Mansion,* offers a different Sino-Japanese romance during the Sino-Japanese War. West follows the story of Scald Ibis, who, after the death of her family and the destruction of her home, is forced to prostitute herself to survive. Over the course of the novel, Scald undergoes a dramatic transformation from innocent young girl to sexual slave to elegant geisha. Along the way, we meet Colonel Hayashi, the Japanese official who shapes her fate, as well as her father, Hong, whose sudden reappearance after being believed dead adds a layer of dramatic tension and pushes the plot in new directions.

In 2005, a full decade after Binstock's and West's Nanjing novels, the Nanjing Massacre reappeared in two more English-language novels, Shouhua Qi's *When the Purple Mountain Burns* and Mo Hayder's *The Devil of Nanking.* Western Connecticut State University professor Shouhua Qi's debut novel owes a debt to epic Chinese novels about the massacre published two decades earlier, for its narrative focus upon actual historical figures. It was, however, more visibly inspired by the recent string of English-language historical monographs such as *American Goddess at the Rape of Nanking: The Courage of Minnie Vautrin* and *The Good Man of Nanking: The Diaries of John Rabe*; the novel takes Vautrin, Rabe, and other key Western figures such as Dr. Robert Wilson as its chief subjects. The title comes from the adage, "When Purple Mountain burns, Nanjing shall be lost." The novel spans one week in December 1937 as the massacre begins. *When the Purple Mountain Burns* claims to be "the first [novel] that deals with the hellish tragedy directly" to "enable readers to feel what it is like to be there, to live through it with the main characters."[27] Whereas Qi at-

27. Quoted from a description of the novel written by the author and posted on the Web site http://www.southernct.edu/conference/csufrc/details/19.htm.

tempts to re-create the historical site of Nanjing 1937 and the historical figures associated with the massacre, English writer Mo Hayder, best known for her novels *Birdman* and *The Treatment*, published her own fictional exploration of the massacre, *The Devil of Nanking* (first published in the UK in 2004 under the original title *Tokyo*). Into an account of the historical events, the daring novel intercuts the first-person narrative of Grey, an Englishwoman in her early twenties who comes to Tokyo in search of a rare 16-mm reel of film depicting Japanese atrocities described in a series of 1937 diary entries by Shi Congming, a survivor and witness. Shi, now an elderly professor at Todai University in Tokyo, is not only the supposed possessor of this film but also the holder of an even more disturbing secret that is revealed amid mounting suspense. With the Nanjing Massacre as a springboard, this contemporary thriller uses a rich palette of characters including *yakuza* gangsters, Russian hostess girls, and a club owner who idolizes Marilyn Monroe to go beyond wartime memory and explore a range of issues including mental illness, the loss of a child, and the specter of guilt.

The Devil of Nanking also explores trauma on several levels, venturing past the Nanjing atrocities to self-mutilation and sadomasochism, *yakuza* disembowelment rituals, and medicinal cannibalism. The novel's fascination with these different levels of violence is illustrated in the obsessions driving Grey and her love interest, Jason. Grey's attraction to Nanjing's dark past is driven by her personal trauma involving a violent self-performed C-section to deliver (and ultimately kill) her own child, while Jason's attraction to Grey is driven by a different type of obsession. With a taste for exploitation violence as embodied in such films as *Faces of Death,* Jason finds the ultimate fulfillment of his mutilation fetish in Grey's physical scars. The startling juxtaposition and intertwining of these two seemingly exclusive modes of violence recall the two contradictory receptions of T. F. Mou's film *Black Sun*, and chart the varied and often perverse ways human fascination with and curiosity about violence are displayed. Although Hayder goes furthest to resituate the massacre in a contemporary fictional universe by placing it within the plot of a mystery thriller (the first Nanjing Massacre novel to do so), the burden of proof still looms large. The mysterious 16-mm film, whose contents are only "displayed" to the reader at the novel's climax, is not just a literary McGuffin to set the story in motion; it is the narrative engine that frames the novel and inspires the main characters' actions. The importance of the preserved black-and-white moving images also places this unique novel within the same tradition as *Massacre in Nanjing*, which also featured a Western woman's quest for "proof" of the massacre in order to testify to the world about what really happened. At the end of *The Devil of Nanking,* Grey finally views the horrific footage from Nanjing and,

after carefully packaging it in bubble wrap, sends it to the U.S. Department of Justice. Nearly twenty years after Katie smuggled photos out of China in *Massacre in Nanjing,* the urge to prove what happened is just as powerful, and the West is still the mediator.

From the grand historical narratives of Zhou Erfu and Wang Huo to the decadent imaginations of Binstock and West, these novels offer a survey of how the Nanjing Massacre has been reconceived and reconceptualized more than fifty years after the atrocity. However, one of the most fascinating pages of literary history concerning the massacre is still the first. Ah Long's *Nanjing* was the earliest full-length narrative about the massacre. The novel was long suppressed, and since its belated publication in the 1980s, has gone largely unnoticed. In order to better understand how the massacre was perceived and imagined by writers during the war, I return to Ah Long's poetics of violence.

Writing Atrocity Between New Culture and New Life: Ah Long's Nanjing

Born into a poor Hangzhou family in 1907, Chen Shoumei 陳守梅 was primarily self-educated. Having come of age with the Republican revolution, Chen looked to Lu Xun as his primary model and turned to literature in an effort to resist Japan and expose the dark side of Chinese society. He began writing poetry as a youth and published under several pen names throughout his career: S. M., Chen Yimen 陳亦門, Chen Shengmen 陳聖門, and Ah Long 阿壟, which he later used most often. Ah Long was a member of the tenth graduating class of the prestigious Central Military Academy and was sent to the front lines shortly after graduation in 1937. He was wounded during the historic Songhu battle 淞滬戰爭 in Shanghai and, while still recovering from severe head injuries, published what is considered the first collection of reportage literature about the War of Resistance, *The First Strike* (*Di yi ji* 第一擊), which included "Fighting Breaks Out in Zhabei" ("Zhabei da qilai le" 閘北打起來了) and "From Attack to Defense" ("Cong gongji dao fangyu" 從攻擊到防禦). Ah Long first went to the communist stronghold of Yan'an 延安 in 1939; however, he was sent to Xi'an 西安 for medical treatment after injuring his eye during field training. It was during this second period of recovery that Ah Long put aside just over two months to compose a full-length novel about the events in the Nationalist capital of Nanjing after the arrival of the Japanese army.

Completed in October 1939, only two years after the events it depicts, *Nanjing* was the first Chinese literary work to attempt to narrate the atrocities of the

Nanjing Massacre.[28] Although the manuscript was awarded the Chinese National Arts and Literature Anti-Japanese Committee's prize for best novel, it was only published posthumously in 1987—almost a half century after it was written and a full twenty years after the author's death.

The reasons for this belated publication are as complex as the author's background and the historical milieu in which he lived. Although the delay was partly caused by the chaotic state of publishing during the War of Resistance, *Nanjing* was said to have been initially rejected for publication on the grounds that it was "too realistic" (Ah Long 4), a label that refers to both its explicit portrayal of violence and its exposure of the Nationalist regime's shortcomings. Ah Long revised the novel in 1940, only to have it rejected a second time. During the ensuing social upheaval of the decade, from the War of Resistance to the Civil War, the fate of *Nanjing* must have been put on hold, as the author was serving under the KMT as a tactical instructor while working as a mole for the Communists, secretly supplying military secrets to high-profile Communist agents such as Song Qingling 宋慶齡 and Hu Feng 胡風.

Traditionally considered a key member of the "Hu Feng Clique,"[29] Ah Long was never a party member and began to face harsh criticism as early as 1950, when two of his theoretical writings were attacked in the party mouthpiece, *The People's Daily* (*Renmin ribao* 人民日報).[30] Criticism began to build, and when his 60,000-character theoretical work on poetry, *Poetry and Reality* (*Shi yu xianshi* 詩與現實), was published later that year, an editorial book review in the *Guangming Daily* (*Guangming ribao* 光明日報) bore the scathing title,

28. It should be noted that although Ah Long's novel was the first Chinese-language work of fiction to depict the massacre, it was preceded in Japan in 1938 by Tatsuzo Ishikawa's *Living Soldiers* (*Ikiteiru Heitai/Weisi de bing* 未死的兵). A short work based on interviews with Japanese soldiers, *Living Soldiers* describes atrocities committed between the Battle of Shanghai and the Nanjing Massacre. The story was initially published in the magazine *Chuo Koron* on February 17, 1938; however, it was almost immediately banned, and the author and his publisher were indicted on charges of slandering the Imperial Army. Ah Long was familiar with *Living Soldiers* and refers to it in the afterword of his novel.

29. The Hu Feng Clique 胡風集團 was a group of writers associated with the poet, literary theorist, and translator Hu Feng (1902–85), who was a protégé of Lu Xun. It included such notable literary figures as novelists Lu Ling 路翎 and Lu Yuan 綠原 and poets Ai Qing 艾青 and Ah Long. In June 1954, Hu Feng and those writers closely associated with him, labeled the "counter-revolutionary Hu Feng Clique," were persecuted, imprisoned, and sent to labor camps for their literary views, which were at odds with those of Mao Zedong as laid out in his 1943 Yan'an Forum on Arts and Literature. Hu Feng and other surviving members were rehabilitated in 1979 after the Cultural Revolution.

30. These attacks stemmed from Ah Long's alleged fundamental misinterpretation of Marxist theory/Maoist thought and his flawed view of the role of politics in literature in his articles "On Tendencies" (*Lun qingxiangxing* 論傾向性) and "A Brief Discussion of Positive and Negative Characters" (*Luelun zhengmian renwu yu fanmian renwu* 略論正面人物與反面人物). For a more detailed account of these criticisms and their aftermath, see Lin Xi 林希, *Baise huajie* 白色花劫, 82–93.

"A Complete Waste" ("Wanquan shi langfei" 完全是浪費). Criticism and at-
tacks continued until 1955 when Ah Long was accused of being second in com-
mand of the "counter-revolutionary Hu Feng Clique" and put in prison, where
he would spend the last twelve years of his life. The original manuscript of *Nan-
jing* was rediscovered during the relatively relaxed political climate of the early
to mid-1980s, and Ah Long's novel was finally made available to the public.
After undergoing some "necessary"[31] revisions and being refitted with the new
title *Nanjing Bloody Sacrifice* (*Nanjing xueji* 南京血祭), *Nanjing* was finally
published in 1987, to commemorate the fifty-year anniversary of the Marco
Polo Bridge Incident, the military skirmish that marked the outbreak of the
Second Sino-Japanese War.[32]

Nanjing is difficult to categorize. Straddling the boundary between fiction
and reportage, the book is also heavily indebted to the author's dual back-
ground as both a poet and a military man. This ambiguity of genre is addressed
by Lu Yuan in his preface as well as by the author himself when he writes:

> It is difficult for me to say whether the book is a work of reportage or fiction.
>
> The book contains true stories [from Nanjing], then there were actual
> stories that were transplanted from other sources, as well as partly true stories.
> These aspects resemble reportage fiction.
>
> However, there are also fictional stories in the book. Because of the diffi-
> culty in collecting materials for the novel, the true stories always serve as an
> outline, but never anything more than that. I thus had no choice but to add
> color, give them flesh and blood, and add a layer of imagination. This aspect
> resembles fiction.
>
> I dare not look at it as reportage, but nor do I dare label it as fiction. (Ah
> Long 1987:227)

He then goes on to further complicate matters by referring to his frequent use
of military terminology as having the effect of making the book into a virtual
army "drill manual." At the very least, the long, detailed descriptions of war
strategy and historical facts, combined with a general lack of heroes or even

31. Lin Xi 林, *Baise huajie* 白色花劫 , 4. According to Lu Yuan, these were merely stylistic changes
(*wenzi jiagong* 文字加工); however, it is impossible to determine to what extent, if at all, they went beyond
syntax and just how invasive the revisions were. The author never read the proofs or had the opportunity to
approve the only published version of the novel.

32. The politics of commemoration are not only present in the publication of the novel but also written
into the work itself. Ah Long marks the date of completion at the end of each chapter, and for two of the
chapters, he features an inscription marking the significance of the date; chapter 4 was completed on Sep-
tember 18, the eighth anniversary of the 9/18 Mukden Incident, and chapter 8 was completed on October
10, 1939, National Day, and after an 81-plane enemy air raid.

main characters, point away from traditional conceptions of narrative fiction. However, the contrived nature of the author's tireless moralizing, high-minded slogans, and ornately poetic language constantly reminds us that *Nanjing* is anything but a work of reportage. Ah Long therefore should be credited not only for being the first to write of the Nanjing Massacre but also for actually imagining a new literary genre, a poetics of violence. To what degree the unprecedented brutality of the subject matter demanded a new language and literary form and to what extent Ah Long's experiment was successful is addressed in the following analysis.

Ah Long's work may be the first novel depicting the Nanjing Massacre, but strictly speaking, *Nanjing* is a prequel to that event. It begins in November 1937 (amid air bombings on the eve of the Japanese attack) and takes the military battle to defend the capital as its narrative core. Seemingly endless accounts of violence and brutality are included, in the context of the Nationalist army's struggle to defend the city. The infamous massacre of hundreds of thousands—and the estimated tens of thousands of rapes that would later become synonymous with the Rape of Nanjing—all take place *after* the events depicted in Ah Long's novel.

Although the narrative is linear, *Nanjing* is populated by a wide spectrum of nonrecurring characters, whose fleeting appearances create a jarring, disorienting effect. The general absence of any recognizable main characters is very similar to the narrative approach of Luo Guanqun's *Massacre in Nanjing,* in which a single story is told through the perspectives of different characters of varying social classes. This is especially true in the first chapters, which present people from various walks of life, age groups, and occupations. However, as the novel progresses and becomes increasingly focused on the impending war, civilians are summarily dropped from the narrative and soldiers and various military men become the actors. Perhaps the true protagonist of the novel is Nanjing itself. Indeed, the only continuous element in the narrative is the city, whose history, architecture, scenic places, and, of course, destruction at the hands of the Japanese are described in detail throughout.[33]

The opening paragraph of the novel provides a sense of Ah Long's sensibilities and approach:

First lieutenant platoon leader of the signal corps, Yan Long 嚴龍 is in the middle of brushing his teeth. White liquid foams from the edges of his mouth

33. For a detailed plot summary of each chapter, see Ken Sekine's article "A Verbose Silence in 1939 Chongqing: Why Ah Long's *Nanjing* Could Not Be Published," available online at the Modern Chinese Literature and Culture resource center (http://mclc.osu.edu/rc/pubs/sekine/htm).

like juice from a pierced berry and drips one drop after another onto the patterned bricks' light red shadows beside his feet. It appears as if he has been rudely awakened by someone; the softness of his face and the light in the room create a heavy and grim mood that does not seem to match. His waist is gracefully, slightly bent and his thin silk shirt slightly trembles as if blowing in a light breeze. An orderly walks past him, opens the window, and instantly crisp sunlight and fresh air fill the room. The three apples on the table are so red they look like they are smiling; they have an oily shine, casting a hazy shadow. Farther off are two packs of "Platinum Dragon" cigarettes; a copy of *Autobiography of a Prostitute* is left open on the table. A bottle with a long thin neck is set atop an old yellowing opera ticket; it is an expensive glass bottle; a ray of light shines through from one side, while inside is Paris perfume that is as green as spring grass, and there is an emerald pen carelessly left in the corner. Suddenly someone screams outside. Alarmed, he immediately stands up, hurriedly picks up the glass of water the orderly had given him from the table, and after washing out his mouth, "Bong!"

He throws his toothbrush into the water basin, wipes his mouth, and taking short, hurried steps in his pair of flower-embroidered slippers, he raises the *portiere* and scurries outside. People are running around everywhere. (1)

Immediately, several of the key formal and stylistic elements of the novel are in place. Ah Long displays his poetically embellished literary sensibilities in his descriptive use of language: "The three apples on the table are so red they look like they are smiling; they have an oily shine, casting a hazy shadow." And, although the above scene takes place well before the massacre and even the outbreak of fighting, already the author is beginning to inject violent imagery into his novel. Beginning with the "pierced berry" and its white foam dripping onto the ground and culminating with the screaming, spitting into the basin, and utter chaos outside, the reader is virtually inundated with symbolic disturbances and disorder that set the stage for the ensuing violence of battle. The "Bong" that concludes the first paragraph also foreshadows the author's employment of sound devices when describing screams, bombings, gunfire, and an assortment of other aural interventions.

Ah Long's fascination with sound, which virtually inundates the novel, is something seldom seen in the canon of modern Chinese literature and most likely stems from the author's dual background as a poet and a soldier. Ah Long had an innate sensitivity to rhyme as well as the inherent aural resonance and rhetorical power of poetry. And having seen battle, he was all too familiar with the horrific sounds of war—the screeching blare of air-raid sirens, the deafening blasts of rapid-fire machine guns, and the explosive jolts of enemy bombings.

His use of sounds may also have been influenced by sound cinema, a new technology that was all the rage in cosmopolitan Chinese cities (and was even the aforementioned character Yan Long's favorite pastime).

Ah Long employs this attention to acoustic resonance in several creative ways, often combining his poetically inspired references to sound and aural metaphors with crude onomatopoeia. The following passage is one of many excellent examples.

> An enemy [soldier] exposed half of his head from behind a rock. And at that moment, Guan Xiaotao's 關小陶 Fujian-inflected orders again sounded out loud and clear through the open air of Purple Mountain; the sound of rifles and machine guns all at once erupted.
> "Pai!—"
> "Ka! Ka, ka, ka! . . ."
> "Pai!—Pai!—"
> Shots also broke out from other places. The entire Purple Mountain let out an angry roar: the roar of the small pine forest, the massive clumsy roar of the mountain rocks, the roar of the valley wind; even the fiber-shaped altocumulus clouds in the sky let out their angry howl. (152)

In this short passage, the author employs three distinct aural strategies, descriptive (Guan Xiaotao's accent), direct onomatopoeia (the gunfire), and metaphoric (the mountain roar). And to a significant extent, onomatopoeic exclamations actually take the place of character dialogue. We know that Guan Xiaotao calls out some orders, but the words he actually utters are not nearly as important as the gunshots they trigger. For Ah Long, the language of war and descriptions of violence are composed not of words but of gunfire, explosions, shouts, groans, cries, and desperate screams. Even more than Ah Long's experience as a poet and as a soldier, this attention to sounds and aural signifiers beyond the scope of normal language indicates the fundamental inability of speech to convey the horror he is attempting to represent. Elaine Scarry best articulates this linguistic breakdown: "To witness the moment when pain causes a reversion to the pre-language of cries and groans is to witness the destruction of language; but conversely, to be present when a person moves up out of that pre-language and projects the facts of sentience into speech is almost to have been permitted to be present at the birth of language itself" (Scarry 6).

The novel's structural looseness, absence of identifiable protagonists, and extensive use of sound all seem to mirror the chaotic nature of battle. Although these techniques are not terribly successful in a literary context, they do capture the cacophony of violence that characterizes war—and especially the Nanjing

Massacre, which was marked by a breakdown of central command, a wide array of nameless soldiers and citizens, and the incessant sounds of violence. More surprising than the unconventional form, however, is the content. For although the events of the novel transpire on the eve of the Rape of Nanjing, it is not the author's descriptions of Japanese atrocities that stand out. Instead, the most interesting and problematic moments of *Nanjing* are his portrayals of his compatriots.

Throughout the novel, there are virtually no direct descriptions of Japanese soldiers or characters, who are consistently referred to simply as "the enemy." The Chinese characters, however, are another matter. Already with the introduction of the opening character, Yan Long, a petty bourgeois with an affinity for Nanjing movie houses and an abhorrent fear of—and disgust for—war, Ah Long weaves a layer of criticism into his portrayal of the Chinese military forces and citizenry. These unfavorable descriptions are gradually developed with the introduction of more characters, and *Nanjing* is transformed into a forum for introspective and often scathing criticism of the Chinese national character.

Part of the author's strategy to this end is his attention to the Nationalists' Scorched-Earth Policy on the eve of the massacre. This was a strategic tactic adopted to prevent useful resources from falling into the hands of the advancing enemy forces. Although often overlooked by contemporary historians (especially in China), the Scorched-Earth Policy had a widespread impact. In fact, one reporter from *The New York Times* estimated the damage by these incidents of "Chinese military incendiarism" at $20 to $30 million.[34] Ah Long is perhaps the only Chinese author to highlight the detrimental effects of this policy and its implications in a larger cultural context.

In chapter 2, in one of the novel's numerous vignettes, the character Zeng Guangrong 曾廣榮 is introduced. Zeng is a second lieutenant in the military police who is assigned to persuade three small rural households—an old lady, a private tutor, and a widow—to abandon their homes and evacuate as part of the Scorched-Earth Policy. The people are unwilling to leave, and the widow offers an impassioned condemnation of the policy:

> Let the Japanese come! Let them come! Let us die at the hands of the Japanese! Why do you have keep coming here every day to force us? . . . No matter how hard you insist on making things for us, we will keep on living. You have driven everyone away and there are no customers left to buy my sweet potatoes; now you want to burn my house down and force us to leave. You're not even

34. Masato Kajimoto has a brief discussion of the policy in his *Online Documentary: The Nanjing Atrocities*, where he quotes Frank Tillman Durdin's January 9, 1938 article in *The New York Times*.

leaving us a way out! We'll have died by your hands before the Japs even get here! (51)

Later, when Zeng is trying to persuade the neighboring old lady, who is too terrified to even open the door, he attempts to console her with, "The Chinese army won't eat the Chinese people" (56). The cannibalistic references, which point back to the author's literary model, Lu Xun, couldn't be more explicit. While describing the impending destruction of the capital and the imminent rape and murder of thousands by the Japanese, Ah Long attempts the unthinkable—suggesting to his readers that the true enemy is not the Japanese but rather the enemy within.

Although the above examples from the Scorched-Earth Policy end without bloodshed (Zeng eventually breaks down and patriotically gives the widow money out of his own pocket to finance her move), other characters in the novel do not fare as well. Early on, we are presented with an elderly woman trying to escape the terror of an air raid with only her grandson and a small bag of valuables. She has difficulty walking, and an impatient Chinese soldier is described as refraining from hitting her with the butt of his rifle only because she is so old. Finally, unable to go on carrying both her grandson and the bag, she decides to throw the bag into a shallow well and come back for it when the danger has passed. What she tosses into the well, however, is not her bag but her grandson! When she realizes what she has done and begins to scream in horror, a Chinese soldier warns her, "There are [enemy] planes above us! You make another move and I'll beat you to death!" before raising his rifle and knocking her down with the butt. Here, amid the chaos of war, is a double vision of symbolic cannibalism: the old woman not only fails to protect but even murders her grandson and a Chinese soldier again fails to protect and even assaults (perhaps murdering) the citizens he is sworn to guard.

But nowhere is Ah Long's cultural criticism more sharp, scathing, and ironic than in the case of Zhong Yulong 鐘玉龍. A Buddhist vegetarian with feminine characteristics who is mockingly described as having an aversion to war, Zhong is impotent to aid a bombing casualty moaning for help because of his fear of blood. The author passes literary judgment , seeming to see Zhong as an accomplice to the crime in a passage where Lu Xun's metaphor of Chinese cultural cannibalism is raised to a perverse new level:

Something soft flew into Zhong Yulong's mouth, lodging itself in his throat, almost choking him. "What's this?—" He was still clearly conscious. He coughed it out, like the phlegm he purged from his system every morning. He spit it into his right hand and, under the hazy shadows, leaned over to look.

The thing looked like a mouthful of an over-ripe peach that had been bitten off by someone. Bright, bright red and seeping with juice. He took a closer look—it was a piece of meat! As if he had touched a scorpion, he instantly shook his hand in disgust; his hand retracted in horror as if it had committed some terrible sin. Immediately, he began to vomit; a surging strength welled up in his stomach as a foul smell violently forced its way out like a bull in heat. It was as if his pockets were turned upside down to empty out all the dirty things inside him. His eyes stared in disbelief, his meaty cheeks and lips sticking out. He let out a terrible scream; he faced the heavens and, as if interrogating a disloyal friend, said:

"I, I—I never—killed—a single—a single ant, not even an ant! I never— never ate—a single bite of pork,—a single crucian carp,—I, I—but today I ate, ate, ate human flesh! Human flesh! Human—flesh!—(30)

Immediately after this episode, Zhong Yulong lets out a final shriek of terror before going insane and running madly down the bombed-out streets of Nanjing. Cannibalism and madness, the two dark tenants of Lu Xun's canonical treatise "Diary of a Madman," are here articulated in the most certain terms, even in a disturbingly literal way. Through such passages, Ah Long cements his indebtedness to the father of modern Chinese literature. However, because of the context he chooses for his cultural criticism, he also creates a new set of problematics.

At issue is the perceived "appropriateness" of raising such questions amid a national war effort to resist Japan, which was still going on when Ah Long wrote his novel in 1939. There have been various hypotheses about the postponement of *Nanjing*'s publication; chief among them stands an explanation by Ken Sekine, the Japanese translator of Ah Long's novel, who offers an extensive and thoughtful rumination on the factors behind the novel's belated appearance in print.

> During 1939–1940, the period when Ah Long submitted *Nanjing* to *Resistance Literature*, neither the Communist Party nor the Nationalist Party had come up with an official account of the massacre. There was a lack of information, as well as a lack of basic consensus about human rights. Above all, the leaders of these two parties were busy promoting a strong image of the united front's military force and its fighting spirit or its great 'Chinese national consciousness,' so they were probably reluctant to inform the Chinese people about what had really happened in their former capital city, Nanjing. From these factors, we may suppose that leftist intellectuals were encouraged to shy away from this theme and eventually they avoided writing about Nanjing Massacre of their

own volition, at least until the Communist Party defined the political signifi-
cance of the tragedy. (Sekine 2004)

I would argue, however, that in the minds of publishers and censors, the central
flaw of *Nanjing* is its problematic—almost schizophrenic—message, which
walks a tightrope between the idealism of the New Culture Movement and the
politics of the New Life Movement, a set of policies enacted in 1934 to promote
Confucian social ethics and the militaristic values of fascist Germany and Italy.
It is very probable that, in addition to the reasons cited earlier, another more
fundamental cause was simply the impossibility of reconciling critical May
Fourth rhetoric of cultural cannibalism with the literary and cultural policies in
place between the New Life Movement and the War of Resistance. Ah Long,
however, hints at even further contradictions when he offsets his Lu Xunian
references (and occasional blatant displays) with multiple examples of un-
abashed patriotic rhetoric, which he often uses to redeem characters shown to
have "cannibalistic tendencies" like Zeng Guangrong, who, after initially
threatening citizens, ultimately selflessly helps them. How are readers to recon-
cile these cannibalistic visions of the Chinese with the redemptive rhetoric of
patriotism, nationalism, and heroism?

This contradiction hints at a deeper struggle beneath the author's larger
militaristic literary vision. Traditionally, historians and public opinion have
judged the Japanese atrocities committed in Nanjing harshly—at least in part
because of the long-held belief that no major military battle was fought. In-
stead, the Japanese soldiers turned against civilians and unarmed prisoners of
war. Commander Tang Shengzhi 唐生智, who had volunteered to stand by to
the bitter end, abandoned Nanjing with his soldiers on the eve of the attack,
thereby handing the city over to the Japanese on a silver platter. Although Ah
Long remains highly critical of Tang, to whom he refers only by the veiled epi-
thet, "the man from Hunan,"[35] and an often disparaging view of Chinese sol-
diers, the novel is essentially a record of the battle to protect the city. This
revision of traditional views of the massacre opens up a new set of problems
seldom explored, not simply because *Nanjing* is alternately both patriotic and
highly critical of the Chinese but also because Ah Long's depiction of the mili-
tary battle, although patriotic in spirit, runs the risk of lessening the perceived
severity of the massacre and adding fuel to Japanese revisionist arguments.

Ah Long's patriotic rhetoric reaches its climax only in the epilogue, which
includes a description of the valiant Chinese victory over the Japanese at Wuhu

35. Ah Long cannot help but also level satiric references to Tang's alleged megalomania in making such
statements as, "Nanjing is—*Mine!*" (*Nanjing xueji* 87).

蕪湖, a prefecture famous for its rice markets in Anhui 安徽 province. In this final, impassioned ode to resistance, Ah Long's poetics of patriotism and violence meet with his politics of redemption in a powerful climax:

> There were twenty thousand of them!
> They were China's famous "Iron Army!" Gradually coming together, they formed a bloody battalion of resisters.
> They were like a flooded river after the snow has melted, they were like a typhoon rising up from the south, they were like a wildfire spreading through the dried December leaves, they were like a group of wild animals rushing out of their gates, rushing toward Wuhu. (211)
> "Kill! . . ."
> "Kill! . . ."
> "Run your asses out of here! Takes yourselves out of our China! . . ."
> The Chinese soldiers rushed down the streets killing; they killed them in the hills, they killed them on the shores.
> Those responsible for the massacres got what was coming to them.
> The brigade reassembled and with their general riding on a white horse, the people shouted with happiness and ran down the streets.
> December 20, the Chinese army took Wuhu. (215)

The battle of Wuhu stands out as one of the great Chinese victories of the War of Resistance; however, whereas in 1939, it represented faith in the Chinese military and fervent hope for a Chinese victory, today it seems a wry, melancholic footnote to an eight-year struggle during which the Chinese people were subjugated to the Japanese war machine. From our perspective, Ah Long's conclusion, not with the brutal display of rapes and murders in the Nanjing Massacre but with the Nationalist victory at Wuhu feels tacked on, even though at the time of writing the events at Wuhu may have signaled a genuine optimism.

Whereas Wuhu provides the obligatory optimism of "national defense literature," or *guofang wenxue* 國防文學, a more powerful alternate ending appears at the end of the last chapter, in the sole portrait (vague as it may be) of a Japanese soldier. As they are referred to throughout the novel simply as "the enemy," we are never given anything close to a humanistic portrait—let alone a human portrait—of the Japanese. Only at the conclusion of the novel proper, just before Ah Long's epilogue, is there a somewhat enigmatic portrait of a Japanese that presents a fleeting glimmer of hope. Or does it? The confusing and contradictory symbols and emotions mark the complex and contradictory sentiments throughout the novel—and in war itself.

The Japanese approached him but didn't hit him; nor did he raise his gun. Instead he squatted down and drew a circle on the ground with his finger. Walking away, [the Japanese] gazed at him and, as he raised his right hand to the nape of his neck to make a decapitating motion, teardrops welled up in his eyes. Not knowing why, that Japanese began to cry. (207)

Perhaps the biggest irony of Ah Long's life was that, after surviving one of the most vicious battles of the War of Resistance and spending much of his literary career documenting the crimes and injustices committed by the Japanese, he would face the greatest persecution and violence at the hands of his compatriots. In the end, he would succumb not to the Japanese enemy but, as his fiction seemed to predict, to the cannibalistic enemy within. On March 21, 1967, during the height of the Cultural Revolution, the man born Chen Shoumei died alone in a Chinese prison of bone tuberculosis, a victim of the modern Chinese literary inquisition. His ashes were buried in an unmarked grave—a final act of sympathy by the investigator assigned to his case, who was supposed to destroy them.

Romancing Atrocity: Ye Zhaoyan's Nanjing 1937: A Love Story

One of the most fascinating depictions of the Nanjing Massacre in fiction is Ye Zhaoyan's 1996 novel, *Nanjing 1937: A Love Story.* Since his appearance on the literary scene in the early 1980s,[36] Ye Zhaoyan (b. 1957) has established himself as one of contemporary China's most creative, daring, and imaginative writers. His body of work is difficult to categorize due to his chameleonlike versatility and tireless experimentation with different literary forms and genres, from the tradition of *The Scholars* (*Rulin waishi* 儒林外史) (c. 1750) to the legacy of Qian Zhongshu 錢鐘書, from May Fourth to Mandarin Ducks, from *roman à clef* to postmodernist collage, and from hard-boiled detective fiction to the avant-garde. The addictive story lines and stunning visuality of his work have won the Nanjing-based writer a loyal readership in Chinese-speaking communities and led to foreign translations and film adaptations.[37] Ye Zhaoyan has been actively

36. Ye Zhaoyan's first published short stories appeared in 1980, but he did not begin to gain wide recognition until his 1988 work, *Tale of the Date Tree* (*Zaoshu de gushi* 枣樹的故事).

37. One case in point is Ye's 1994 novel, *Flower Shadows* (*Hua Ying* 花影), which was adapted by Fifth Generation director Chen Kaige (along with Wang Anyi 王安憶, who cowrote the screenplay) for his 1995 motion picture, *Temptress Moon* (*Fengyue* 風月). The following year the novel was translated into French under the title *La Jeune Maitresse* (Paris: Philippe Picquier, 1996). Film rights for *Nanjing 1937: A Love Story* have, likewise, been purchased by actor/director Jiang Wen.

involved in a larger project of rewriting and reimagining the Mandarin Duck and Butterfly tradition, a popular romantic literary genre that flourished in Republican China.[38] His fascination with this form is perhaps best demonstrated by his masterpiece *Evening Moor on the Qinhuai*,[39] a collection of historical novellas set in Republican-era Nanjing.

One key to Ye Zhaoyan's attachment to preliberation China is the literary family from which he hails. Ye's father, Ye Zhicheng 葉至誠 (1926–92), was a noted writer, as was his grandfather, Ye Shengtao 葉聖陶 (1894–1988), who was also an influential educator and editor; among his best known works is the 1928 classic *Ni Huanzhi* (倪換之),[40] one of the first full-length modern vernacular novels.[41] Ye Zhaoyan is also one of the few contemporary Chinese writers to hold a graduate degree in Chinese literature, having earned his M.A. from Nanjing University in 1986, writing his thesis on one of the crowning achievements of preliberation literature, Qian Zhongshu's *Fortress Besieged* (*Wei cheng* 圍城).[42] After graduation, Ye worked as an editor for the Jiangsu Arts and Literature Publishing House. In 1991, he left publishing to pursue writing full time; he has since produced an astounding thirty books, including a seven-volume set of collected works.

First published in 1996, *Nanjing 1937: A Love Story* is perhaps Ye Zhaoyan's most ambitious project to date. Individually embodying the genre-crossing complexity that characterizes so much of his body of work, the novel also expresses Ye's nostalgic passion for writing missing pages from Republican China's past. Starting with its title, the novel is a literal contradiction in terms. On the eve of the 1937 Rape of Nanjing, one of the most horrid moments in modern Chinese history, how could there be such a thing as love or romance? In this contemporary take on the Mandarin Duck and Butterfly novel, traditional

38. Tragic romances are just one fictional genre that falls under the umbrella of Mandarin Duck fiction. Others include scandal fiction, detective stories, and chivalrous martial arts tales. For more on Mandarin Duck and Butterfly literature, see Perry Link's influential study, *Mandarin Ducks and Butterflies: Popular Fiction in Early Twentieth-Century Chinese Cities*.

39. The four award-winning novellas that make up *Evening Moor on the Qinhuai* (*Ye bo Qinhuai* 夜泊秦淮) were serialized in three PRC literary journals between 1987 and 1990 before being collected in a single volume in 1991.

40. *Ni Huanzhi* was translated by A. C. Barnes as *Schoolmaster Ni Huan-chih*.

41. The Ye family can now claim four generations of published writers. In 2001, Ye Zhaoyan's then seventeen-year-old daughter published her first book, a collection of essays on America.

42. *Fortress Besieged* was first serialized in *Literary Renaissance* and appeared in book form in 1947. The work is generally considered the last great literary masterpiece of the preliberation era. It is a satirical novel that traces the romantic and professional misadventures of Fang Hongjian, who, after several years of study abroad, returns to China, bogus degree in hand, to teach at a provincial university. An English edition translated by Jeanne Kelly and Nathan K. Mao appeared in 1979 (Bloomington: Indiana University Press).

dichotomies of love and war are juxtaposed (and sometimes blurred), creating a unique literary vision where history is romanticized and love is militarized.

The backdrop is a sweeping, comprehensive vision of Republican China just before the outbreak of the War of Resistance. The novel functions as a chronological encyclopedia of Nanjing's final prewar year as capital, a virtual "who's who" of Republican China, an encyclopedia of textual styles and forms, and a minicatalogue of modern (and to a lesser extent, premodern) Chinese literary references. The underlying complexity of this often overlooked novel merges the historical, cultural, and literary burdens of a bygone era, creating a new form of popular literature.

Nanjing 1937: A Love Story spins a multilayered narrative in which the epic fall of Nanjing to the Japanese is juxtaposed with the hero's romantic endeavors and misadventures. While still a teenager, Ding Wenyu 丁問漁, the only son of a powerful Shanghai banker, falls head over heels for a young married woman, Ren Yuchan 任雨嬋, and is sent abroad by his father as a cure for his lovesickness. Some seventeen years later, Ding returns to China, only to fall even harder for Yuchan's younger sister, the stunning Ren Yuyuan 任雨媛—on her wedding day.

The novel begins on January 1, 1937, the day of Yuyuan's wedding to a star fighter pilot, Yu Kerun 余克潤. Carried away by the beauty of the bride, Ding Wenyu, now an unhappily married college professor, begins a preposterous letter-writing campaign to win Yuyuan's heart. Gradually, through a series of uncanny, almost inconceivable events, true feelings of love actually do begin to develop between Ding and Yuyuan—but only as the Japanese forces are about to enter the capital to commence one of the most brutal bloodbaths in twentieth-century military history. At this moment, national history and personal history, war and love, sacrifice and redemption all come together in one masterfully tragic literary stroke.

The alternative narrative line of the novel, running against the "love story" highlighted above, is the "war story"—an extensive series of passages describing the social and political state of the capital, which serves as a prelude to the massacre. As the novel progresses, the two stories are playfully juxtaposed. Descriptions of the turbulent and complex social and political changes in the capital take on epic proportions as Ye romanticizes the prewar splendor of the city by chronicling its economic development (such as booms in real estate and construction) and rapidly changing topography. Here is one excellent example of how Ye describes the disorienting nature of the urban landscape in transformation:

This development craze caused Shanxi Road and Yihe Road to intersect where they never did before; moreover, they crisscrossed and curved in a most

unconventional manner. In the end the neighborhood around the intersection became as confusing and chaotic as a labyrinth. There were many people who would get dizzy and be driven to the end of their tether when they went there. Owing to the fact that most people came and went in automobiles, when the owners of these homes had to occasionally set out on foot, they sometimes found that after only a few blocks, they already couldn't find their own front door! (Ye 1996:98–99)

Ye Zhaoyan's topological imagination captures Nanjing's lightning-quick growth and its disorienting effect on the city's residents (which could equally describe Nanjing in the late 1990s) and also enhances the splendor and "Wild West" sense of opportunity in the budding capital at a time when virtually anything was possible.[43] Simultaneously, the attention given to this rampant expansion and development creates a sense of melancholy. Ye's construction of his imagined hometown, a city of memory, is prefaced by the reader's knowledge that all progress and expansion will be halted by the massacre, which will begin before year's end. The author's romantic vision of the thriving capital city is matched with passages in which militaristic terminology is appropriated to describe romantic episodes:

He [Ding Wenyu] continuously sought out different types of women, and once he *achieved his target*, he would immediately *initiate his next campaign*. He was like a *general* who endured a *hundred battles*, *charging forward* amid a sea of women, time after time facing setbacks, time after time losing face for all to see. Even though he usually came off as *the glorious victor in his battles*, his soul had already long been covered with scars. (31)

By running from the *battlefield defeated*, it was as if she [Yuyuan] was guilty of some wrongdoing. (144)

Qu Manli's 曲蔓麗 *first offensive* against Yu Kerun was pressing him to divorce his wife. (348)

She [Qu Manli] began her little talk as if she were *launching an attack*. (350)

43. Ding Wenyu is unable to navigate through this new topological framework. His disorientation as an outsider from Shanghai is increased by the rapid changes to the cityscape through widespread construction and development; hence his reliance on the rickshaw coolie Monk to navigate for him. This alienation from his topological environment is mirrored by his ignorance of the political reality in which he lives, even though he is constantly surrounded by some of the most important political figures of the era.

Ding Wenyu decided to *strengthen his romantic offensive* on Yuyuan. (407) (my italics)

Such militaristic descriptions of romance and interpersonal relationships saturate the novel. This technique works parallel to the romantization of history discussed earlier, while forging an uncanny and, at times, highly ironic narrative link between personal history and national history. Seemingly oblivious to the grand narrative of history, Ding Wenyu lives in a romantic world of his own creation. Only through the third-person narrator's war-tinged metaphors describing Ding's romantic pursuits is a direct parallel drawn between the advancing Japanese army and his romantic advances on Ren Yuyuan (who, ironically, is half Japanese).[44]

The irony of Ding Wenyu's relative imperviousness to the history unfolding before his eyes is further highlighted by the novel's encyclopedic scope, which can be divided into four subcategories, the first being a chronological timeline. The narrative proper begins on January 1, 1937 and, progressing chronologically, culminates on December 13 of the same year, the very day the Japanese army enters the capital.[45] As the story develops, Ye Zhaoyan goes to great lengths to detail virtually every major political and military development that transpires during that year, including the 1937 Lushan Conference, the New Life Movement, the fall of Shanghai, and the Nationalist retreat to Chongqing. At the same time, Ye does not overlook "unofficial" history and includes popular (and sometimes petty) cultural events and even tabloid gossip: descriptions of a Children's Day Speech Contest, popular controversy over Spring Festival stage performances, and the "enlisted man marathon." By placing key events in the *official* history of the era side by side with *unofficial* history and giving equal attention to both, Ye Zhaoyan creates a new, almost postmodern conception of cultural and historical time.

44. In his landmark study of Mandarin Duck and Butterfly fiction, Perry Link comments on the links between romantic passion and nationalistic passion as a theme often seen in the genre. "His heroic, or *ying-hsiung* passion parallels the passion of his romantic, or *erh-nü* attachments. A young man's patriotic love and his pure love for a young woman are more than just similar. They are, in fact, two forms of what is fundamentally the same pure *ch'ing*, which a given individual will possess in one form if and only if he also possesses it in the other" (77). In this context, Ye Zhaoyan's juxtaposition of individual romantic passion and militaristic national passion can be seen as an conscious attempt to revisit and reconceptualize this tropic theme of the genre. While both Ding Wenyu and Monk (whom I shall later argue functions as his double), are ever lost in their *ernü* attachments, both seem exiled from the heroic world. At the same time, however, both characters do explicitly exercise fantasies about "dying for their country"—and in the end they do, but only in the most tongue-in-cheek fashion.

45. Although the narrative progresses along a linear trajectory, many of the events in Ding Wenyu's early life, including his affair with Yuyuan's older sister when he was seventeen, are fleshed out via an extended flashback sequence early in the novel. These flashbacks also conveniently serve as a tool to fill in many key details and events in pre–War of Resistance Sino-Japanese relations.

Within both the chronological historical timeline (official and unofficial) and the primary "love story" narrative, the reader is introduced to scores of cultural, military, and political superstars of the era. These cameo appearances make up the novel's second encyclopedic function as a virtual who's who of Republican celebrities. All told, there are more than seventy-five cameos and, although the majority are off screen, a significant number of these historical celebrities enter into the main line of narrative or actually *interact* with Ding Wenyu. The protagonist alternately has drinks with Zhu De 朱德, is offered a job by Soong Mayling 宋美齡, and translates for Tang Shengzhi. Besides political figures, the novel features references to a host of cultural, literary, and intellectual stars such as writer Eileen Chang 張愛玲, playwright Tian Han 田漢, opera star Mei Lanfang 梅蘭方, actress Lan Ping 藍萍 (a.k.a. Jiang Qing 江青), and the renowned intellectual Dr. Hu Shi 胡適. This works to strengthen the novel as a document of (pop) cultural history as much as the official military and political historical discourse mentioned earlier.[46]

Textually, the novel also functions as a compendium of genres and forms. In addition to the two main narrative lines, Ye Zhaoyan embellishes the narrative with a wide variety of literature: letters, diary entries, newspaper headlines, tabloid reports, song lyrics, newspaper advertisements, playbill coming attractions, divorce announcements, etc. This literary pastiche is also postmodernist in its often ironic references to—and metafictional rewriting of—several key works in the canon of modern Chinese fiction.

These rewrites also shed light on the novel's two seemingly contradictory and mutually exclusive narrative lines.[47] On the eve of what historians would later deem the "Rape of Nanjing," in a time and place inextricably connected with horrific images of violence and war, love and romance survive and even flourish. One explanation for this lies in the tradition of fictional romance set in times of national calamity. *Nanjing 1937* inevitably invites comparisons to earlier works in the Chinese literary tradition, from the Qing drama *The Peach Blossom Fan*, also set in Nanjing, which depicted an impossible love against the fall of the Ming dynasty, to Eileen Chang's modern classic, "Love in a Fallen

46. Some may argue that the scope of this "who's who" compendium seems contrived (especially when foreigners such as Picasso, Yeats, Hemingway, and Borges make appearances). The cameos, however, are a necessary ingredient for Ye to achieve his historicity. As he is a "star professor" at one of China's top universities and comes from a wealthy and influential family, it is not unreasonable or "unrealistic" that Ding Wenyu should come in frequent contact with the celebrities of his day. At the same time, Ye Zhaoyan's slightly detached narrative leaves room for a satiric and surreal reading of many of Ding Wenyu's celebrity encounters.

47. A more literal translation of the book's title, *Yijiusanqi nian de aiqing,* would read "The Romance of 1937."

City" ("Qingcheng zhi lian" 傾城之戀) (1943), both of which have left their marks on Ye's novel.

This brings us to the final and, perhaps, most intriguing aspect of the novel's construction—as a sweeping, multilevel compendium of Chinese literary references. The literary genre Ye Zhaoyan takes as his model is the Mandarin Duck and Butterfly school (*yuanyang hudie pai* 鴛鴦蝴蝶派), a popular fictional discourse that flourished during the first half of the twentieth century and is best exemplified by such writers as Zhang Henshui 張恨水. Originally published in a popular literary magazine, as were many of the early Mandarin Duck and Butterfly works, *Nanjing 1937: A Love Story* is a conscious effort on the part of the author to carry on this literary genre.

The broad definition of the Mandarin Duck and Butterfly school technically includes everything from romance novels and detective fiction (*zhentan xiaoshuo* 偵探小說) to knight-errant martial arts fantasies (*wuxia xiaoshuo* 武俠小說) and scandal fiction (*heimu xiaoshuo* 黑幕小說), while a narrower use of the term refers exclusively to romantic "love stories." All references here are to the genre's narrower definition, which can be divided into the two subcategories of *yanqing xiaoshuo* 艷情小說 (言情小說), romance novels that generally have happy endings, and *aiqing xiaoshuo* 哀情小說, melancholic love novels that often end in tragedy.[48] One stock aspect of the former, *yanqing xiaoshuo* strain is the standard conclusion, "marital harmony symbolized by paired ducks or butterflies" (McDougall 1997:83). Although this description does not apply to the entire genre—notable exceptions include Zhang Henshui's classic novel *Fate in Tears and Laughter* (*Tixiao yinyuan* 啼笑因緣)—it does hold true for much of the *yanqing* fiction of the tradition. Even though Ye Zhaoyan follows this obligatory standard with the surprise, speedy union[49] between Ding Wenyu and Ren Yuyuan, the novel's last page reminds us that, living in the postmodern age, Ye has not only a very different set of literary and aesthetic strategies than his romantic predecessors but also a new conception of historical tragedy.

Although Ye Zhaoyan's novel is formulated very much in the yanqing mode, the line between it and the melancholic aiqing tradition is not entirely clear, making the work a hybrid of the two styles. Ye remains unrestrained by anxiety of influence and gives his project a postmodern literary construction, freely ap-

48. See Link, *Mandarin Ducks and Butterflies*, 62-63 and Chow, *Woman and Chinese Modernity*, 36.

49. The rapid-fire consummation (and almost immediate separation) of Ding Wenyu and Ren Yuyuan's relationship is also reminiscent of Kong Shangren's *kunqu* play *The Peach Blossom Fan*. In the play, after a long and torturous separation, the protagonists Li Xiangjun and Hou Fangyu finally come together in a lightning-fast reunion, only to immediately take Daoist vows and be separated again.

propriating themes from four of the century's most influential Chinese literary works: Eileen Chang's "Love in a Fallen City" ("Qingcheng zhi lian" 傾城之戀), Lao She's 老舍 *Rickshaw* (*Luotuo xiangzi* 駱駝祥子), Zhang Henshui's *Deep in the Night* (*Ye shen chen* 夜深沉), and, most strikingly, Qian Zhongshu's masterpiece, *Fortress Besieged*.[50] This comprehensive pastiche or minihistory of Republican-era literary styles is one of the most intriguing innovations of the novel and highlights its subtle complexity and "literary historiography."

Although her fiction is marked by a dark, decadent, and highly personal literary vision, Eileen Chang actually began her literary career by appropriating the popular Mandarin Duck and Butterfly formula and published her first series of stories in some of the leading Butterfly magazines of the 1940s.[51] Starting with the title of Chang's 1944 short story, "Love in a Fallen City" (which Ye Zhaoyan could have simply borrowed for his own work), the parallel between these fictional works is immediately apparent. There is the common plot of a love affair in a city that is about to fall to the Japanese, which functions as the narrative hub. However, this similarity is arguably secondary to Eileen Chang's decadently informed aesthetics of romance and semidetached narrative style, aesthetic and stylistic values that have informed Ye Zhaoyan's own fin-de-siècle tale of love in a fallen city.

Ye Zhaoyan also owes a debt to Lao She's most famous novel, *Rickshaw*, from which he gained inspiration for one of the secondary figures in his novel, the rickshaw puller (and keeper of Ding Wenyu's amorous secrets), Monk. Commonalties between Monk and Lao She's Camel go far beyond their choice of livelihood. Like Camel, who "lost both his parents" while still a child, Monk is an orphan; both characters lack a true identity and are known only by generic nicknames, symbolic of their low place on the social ladder. Both Camel and Monk eventually become the prey of a much older woman who uses deceit to win their affections. For Camel, this older woman is the infamous Huniu 虎妞; her counterpart in Ye Zhaoyan's novel is the cunning and flirtatious Mrs. Zhang. Each of these characters lives in a traditional walled compound with a number of other families, within which each meets his eventual true love in the form of a young girl. However, here comes Ye Zhaoyan's decadent twist: while Camel's

50. Looked at chronologically, these works trace out an interesting minihistory or chronology of preliberation literature, from the socially conscious *jingpai* fiction of Lao She to the classic popular novels of Zhang Henshui. We are presented with not only two major writers of the period but also representative works from the two major schools that dominated literary debates of the 1920s and '30s. Eileen Chang serves as an example of the later, decadent strain of Mandarin Duck and Butterfly fiction circa the early 1940s, and Qian Zhongshu provides the crowning literary achievement of the pre-1949 era, as well as a very different conception of "popular fiction."

51. For more on Chang's early career and her connection with the Mandarin Duck and Butterfly school, see Lee, *Shanghai Modern*, 267–269.

true love interest is the "prostitute with the heart of gold," Fuzi 小福子 (who eventually kills herself out of desperation), Monk's love interest is Mrs. Zhang's daughter, Little Moon, who dies by Monk's hand in what is the most violent scene in the novel.[52]

The parallels between Camel (whose incarnations in film, in literature, and on the stage have transformed him into an encoded icon) and Monk are too numerous to be coincidental. Instead, Ye Zhaoyan consciously conjures up a decadent and postmodern re-creation of Lao She's eternal hero in the form of a petty sidekick to accompany the novel's true hero (or antihero) Ding Wenyu on his amorous adventures and help him navigate the Nanjing pleasure quarters. Monk's disappearance from the narrative in the middle of the novel may lead some readers to conclude that he is merely an example of what Brian McHale has described as a "cancelled character," discarded after fulfilling his textual function; however, there is another layer of identity lurking beneath Monk's surface. The fevered compulsion and obsession he feels about Little Moon serves as a vulgar double to the equally obsessive (but comparatively "cultured") fixation that draws Ding Wenyu to Yuyuan. While Ding expresses overzealous passion and inappropriate affections through the culturally respected and time-honored tradition of the letter, Monk (who is most certainly illiterate) resorts to violence. However, in both cases the underlying drive is the same abnormally obsessive, pent-up desire. Ding's and Monk's identities as doubles are sealed in the final scene, when they are reunited and together in death.

Ye Zhaoyan is not the first writer to have gained literary inspiration from Lao She's classic novel. Decades before, one of the most prolific purveyors and representative authors of Mandarin Duck and Butterfly fiction, Zhang Henshui, offered his own version of Camel's tragic tale in his classic novel *Deep in the Night*. It shares the same plot parallels with *Rickshaw*, and even the main characters' names, Ding Er*he* 丁二和 and Yang *Yue*rong 楊月榮, each have a Chinese character in common with the names of Ye's parallel protagonists, *He*shang 和尚 (Monk) and Xiao *Yue* 小月 (Little Moon). At the conclusion of *Deep in the Night*, Ding Erhe, in a drunken rage, seeks to avenge the injustices done to him through violence. With a butcher's knife concealed under his clothes, he comes close to taking his revenge when he suddenly remembers his sick mother in the hospital, who needs his care, and abandons the plot. Not until several

52. The murder and rape of Little Moon was inspired by an actual event that Ye Zhaoyan read about in the newspaper and appropriated for his novel. This is reminiscent of Taiwanese writer Li Ang's 李昂 inspiration for her controversial best-selling novel *The Butcher's Wife* (*Sha fu* 殺夫) and the literary experiments of Chang Ta-chun 張大春, who also freely integrates actual news stories into his novels, especially in the case of *The Grand Liar* (*Da shuohuang jia* 大說謊家).

decades later, when Monk (who, being an orphan, is unrestrained by filial obligations) climbs into Little Moon's attic bedroom with a claw hammer concealed under his jacket, is the deferred act of violence finally carried out.

Finally, we come to Qian Zhongshu's preliberation masterpiece, *Fortress Besieged*, a novel that had profound influence on Ye Zhaoyan's work[53] and can even be said to be the intertextual skeleton key for entering Ye's conception of 1937 Nanjing. Ye even goes so far as to quote—almost verbatim—a line from *Fortress Besieged*'s famous opening page. Qian's original reads: "Later everyone agreed the unusual heat was a portent of troops and arms, for it was the twenty-sixth year of the Republic (1937)" (Qian 1979:1), while Ye Zhaoyan's literary tip of the hat reads: "The summer of 1937 was especially hot. The entire city was like a huge sweltering oven—everyone said that this was a portent of troops and arms; it was going to be a year of crisis" (Ye 1996:259). The intertextual similarities, however, go far beyond quotations and time frame. In both works, the protagonist is a Chinese foreign student returning from abroad on the eve of the war with Japan. Neither Fang Hongjian 方鴻漸, the hero of *Fortress Besieged*, nor Ding Wenyu is able to obtain a foreign diploma (the former purchases a mock diploma from a nonexistent American university, while the latter sees no point in even earning one). Fang and Ding both hail from Shanghai and both enter academia after their return to China. But while Fang takes a post teaching at Sanlü daxue 三呂大學, a backwater provincial college, the well-connected Ding heads straight for the capital and one of the country's most prestigious universities.

Although Ding Wenyu is spatially positioned in the center of China (in the capital) and surrounded by the grand narrative of history (which comes to him in the form of dinner conversations, loudspeaker announcements, and even direct contact with leading politicians of the day), he, like Fang Hongjian, is seemingly conscious only of his own romantic pursuits. The protagonists' obliviousness to the "call of the times" is illustrated best in the classic lecture scene where Fang Hongjian gives a talk on "the influence of Western civilization on China," which he boils down to the introduction of opium and syphilis. In a dialogic rejoinder written half a decade later, Ye Zhaoyan has his protagonist, Ding Wenyu, deliver a lecture entitled "A Comparison of Chinese and Western Prostitution Traditions." While Fang Hongjian's lecture succeeds only in embarrassing him, Ding's meets with wild applause and even breaks all records

53. Ye Zhaoyan not only wrote his 1986 M.A. thesis on the novel but even today continues to be fascinated by Qian Zhongshu's brilliant portrayal of petty intellectuals during the War of Resistance. In the 2000.4 issue of *Harvest* (*Shouhuo* 收穫), Ye published the essay "Laughter in the Fortress Besieged" ("Weicheng li de xiaosheng" 圍城裡的笑聲).

for university lecture series attendance. The lecture also works to cement the intertextual bond between the two writers, serving as a subtle, tongue-in-cheek display of Ye Zhaoyan's romantic, satiric, and, ultimately, decadent aesthetics. With Ding Wenyu's apparent imperviousness to time and history amid the virtual inundation of historical and military narratives of which he is the center, Ye Zhaoyan reaches a level of irony never matched in *Fortress Besieged.*

Besides creating formal and biographical similarities between the two protagonists, Ye Zhaoyan offers a new interpretation of the allegorical meaning of Qian's work, which is, perhaps, best summarized by Qian's wife, writer Yang Jiang:

> Those trapped in a fortress besieged long to escape,
> Those outside want to charge in.
> Such is one's marriage, and one's career,
> Such is the way of most human desires. (Zhang Wenjiang 1993:57)

This life philosophy is echoed by Ye Zhaoyan when he writes, "Ding Wenyu seemed to realize that there is never a time when man can ever feel truly satisfied—this eternal craving seems to be what makes us human" (Ye 1996:276). However, Ye Zhaoyan's brilliance is not fully revealed until the end of the novel, when the Japanese army descends on the capital city. It is at this tragic moment, as the curtain of history falls, that Qian Zhongshu's "besieged city" is lifted from the allegorical to the literal level and the reader realizes that Ye Zhaoyan has constructed a true "fortress besieged."

For Ye Zhaoyan, nostalgia functions on two different levels: it is an act of elegiac mourning for the long-forgotten final days of old Nanjing, an era of both grandeur and decadence, *and* a nostalgic gesture of remembering (and re-creating) Republican-era literary texts and traditions. A Nanjing native long fascinated with both his hometown and the Nationalist period, Ye Zhaoyan has combined his two passions in such works as *Evening Moor on the Qinhuai* and *Old Nanjing* (*Lao Nanjing* 老南京). Although *Nanjing 1937: A Love Story* began as an attempt to face the Rape of Nanjing, the result was a sweeping, elegiac romance that captures the ancient capital's final hour of glory.

Ye Zhaoyan's literary and historical vision is marked by complexity and a penchant for the unexpected. Indeed, his strategies of representation could not be more different than those in previous works of historical fiction set during the Rape of Nanjing, such as Ah Long's *Nanjing* or Zhou Erfu's *The Fall of Nanjing.* Though the indelible December tragedy constantly lurks just beyond the horizon of his novel, Ye Zhaoyan's repeated descriptions of the grandeur of the budding metropolis—its booming real estate market, rapid development,

flourishing economy, and political dynamism—all remind us of its lost splendor, bearing testament to a side of Nanjing's past often obscured in the shadow of calamity.

Popular culture of the day also plays a key role in *Nanjing 1937*. The meticulous attention paid to everything from cultural pastimes like mahjong to cultural icons like Mei Yanfang helps deconstruct the grand and sublime discourses that have dominated so many historical and even literary representations of the era. Ye's Nanjing is a world where notions of popular culture are (re)inscribed onto—and sometimes in place of—more traditional historical narratives. Monumental figures like Zhou Enlai and Deng Xiaoping are only minor characters who appear fleetingly on the streets of Paris. Chinese fighter pilots are remembered not for their heroic deeds in the air but rather for their superstitious bedside manners.

Likewise, with the exception of two minor Japanese characters who express typically nationalist sentiments in support of the war effort, even the traditional "villains" of the Nanjing Massacre—the Japanese people themselves—are portrayed in a very unorthodox manner. The female protagonist Ren Yuyuan is half Japanese, yet works as a confidential secretary in the *Chinese* army headquarters. The only significant full Japanese character, Lady Miyako 美京子夫人, not only fails to represent Japanese cultural and political hegemony and the dream of a Greater East Asia but embodies the exact opposite: "Lady Miyako became an out-and-out Chinese wife. . . . The entire family overlooked the fact that she was Japanese and even Miyako herself practically forgot about her native country. She never wore a kimono, and she even forgot how to cook Japanese food" (Ye 2002:29). Even the Rape of Nanjing, the purported subject of the novel, is subverted—the novel ends just as it begins. However, Ye's inability to depict the massacre at year's end should not be seen as a failure to face a bloodstained past but instead as a passionate attempt to remember what was lost.

That is not to say that Ye Zhaoyan does not raise a different set of questions to ponder. Although he shies away from graphic illustrations of the Rape of Nanjing, he does not exercise the same restraint when depicting acts of violence committed by Chinese characters upon their compatriots. The aforementioned example of murder and necrophilia committed by Monk upon Little Moon is the most vivid and brutal example and deserves to be quoted at length.

> Before Little Moon had a chance to realize what was happening, Monk raised his claw hammer and hit her with three consecutive blows on the back of the head. With her arms wrapped around her head, Little Moon's body fell to the ground. Afraid that she would scream, Monk rushed over to gag her mouth

with his hand. Once things got to this point, Monk started to get bold. He noticed that Little Moon's eyes seemed to be open but had a faint, dead look. He released his hand from her mouth and, seeing that she didn't make a sound, told her: "I though you were a tough cookie. Well, you don't look so tough now!" Little Moon didn't have the slightest reaction and Monk, feeling that he still hadn't gotten even with her, began to grumble to himself: "What are you gonna do if I want to have my way with you, huh?" What happened next he had already thought about for a long time. In his dreams he had already acted it out step by step, innumerable times. He carefully pulled off one of her pant legs, undid his own pants, and slid them down to his knees. At this critical moment he discovered that he had completely lost control of himself and couldn't help what he was doing. He realized that he didn't even really want to do it. For a moment everything was quiet, but suddenly the blind old lady called from downstairs. Monk became even more panicky. He tried to contain himself, but he lost control and that dirty fluid spurted out of him onto the floor. In a fluster Monk scooped it up off the floor with his finger and, in a desperate attempt to mend the fold even after his sheep had gotten out, wiped it on Little Moon's vagina. It was at that moment that he discovered that there was a pool of blood seeping from Little Moon's head. The blood was spreading out on the floor like a red snake slithering forward, dripping down through the cracks in the floor. The blood dripped downstairs onto the blind woman's face. The old woman wiped it with her hand, placed it under her nose to smell it, and began to scream in terror. (172–173)

Monk's act of cold-blooded murder constitutes the novel's single most significant subplot and also presents a darker, alternate trajectory for obsession, the same passionate affliction that consumes the protagonist Ding Wenyu. This crime of passion, culminating in a twisted postmortem rape, ironically turns out to be the only sexual violation in a novel meant to be set during the most notorious "rape" of the century—the Rape of Nanjing. Although this murder arrives suddenly in the narrative, it comes after two subtle elements of foreshadowing. The first occurs fairly early on and features an argument between Monk and his middle-aged lover (Little Moon's mother), Mrs. Zhang. The second, which occurs in flashback, features Ding Wenyu witnessing Monk, who has been conscripted for obligatory civilian military training, bayoneting target dummies. The author's attention to this training hints at the hidden potential for violence within Monk, but, more significantly, points to the indoctrinating power of the state in inspiring violence.

The second key example of indigenous violence further develops this theme when Chinese soldiers open fire on their compatriots.

The retreating troops were already out of control; stubbornly arguing that they never even heard of any "plan for breaking through the enemy encirclement," they insisted on being let through. The sentries at the gate refused to let anyone by. The arguing went back and forth until both sides opened fire.

Several soldiers in the crowd were killed; the others started cursing out of indignation, but they still couldn't get any closer to the port. (336)

This scene transpires just before the novel's climax, as routed soldiers attempting to flee Nanjing by crossing the Yangtze River—the sole means of escape—before the Japanese arrive are gunned down by Chinese sentries ordered to guard the port. Such incidents seem to foreshadow (or rather, having been written in 1996, recall) the ensuing sixty years of violence carried out by the Chinese against their own people.

Thus, the most vicious and cold-blooded acts portrayed in a novel set in 1937 Nanjing are not committed by (or even against) the Japanese, but rather by Chinese *against* Chinese. Ye's understated criticism points back, however subtly, to a Lu Xunian critique of the Chinese national character. But unlike Ah Long, Ye Zhaoyan is not one for moralizing, and *Nanjing 1937*'s complex combination of satire and sentimentality leads many readers onto a tightrope between loving and loathing his characters. And while Ah Long's 1939 references to symbolic cannibalism and indigenous violence turned out to be tragically prophetic, Ye Zhaoyan's 1996 literary injection of Chinese–Chinese violence can be read as a mere footnote to a century of violent political movements, state insurrections, purges, and atrocities at the hands of their own people.

In Ye Zhaoyan's 1937 Nanjing, there is a fine line between love and obsession, satire and sentimentally, comedy and tragedy, splendor and decadence, history and allegory. These themes intersect and blend, creating a sophisticated and stirring fictional pastiche. The year 1937 saw not only the fall of the ancient capital of Nanjing but also the pinnacle of its development; Ye Zhaoyan captures both. Although the novel concludes on the day the massacre begins, the reader knows all too well how the story ends. Ye Zhaoyan may not understand "that history that historians call history," but he leaves us with precisely its melancholic power and unbearable weight.

Facts and Fictions: From *Qixia Temple 1937* to *May & August*

The multiplicity of literary voices and cinematic visions discussed so far alternately reinforce and deconstruct established historical discourses and strategies of interpretation. Collectively, they constitute a fairly comprehensive sample of

the various representations of the Nanjing Massacre in popular culture. From a comparative perspective, one of the most fascinating aspects of these texts is the striking number of uncanny similarities among them. The fact that no fewer than five of these works (*Massacre in Nanjing; Don't Cry, Nanking; Tree of Heaven; The Tent of Orange Mist;* and *Nanjing 1937: A Love Story*) feature interracial romantic relationships between Chinese and Japanese characters is both fascinating and problematic. In most cases the male figure in the relationship is Japanese and the woman is Chinese, symbolizing a masculine and assertive identity for Japan and a passive and feminine one for China. In *Don't Cry, Nanking*, the sexual-political power structure is symbolically reversed and negated through the director's humanistic approach and the climactic birth of the interracial child. The motif is further complicated in *The Tree of Heaven* and *Nanjing 1937*, where the female protagonists, Li and Yuyuan, are both products of a mixed-blood relationship.[54]

The portrayal of Sino-Japanese romance while the two countries are locked in a life-and-death struggle seems to suggest a humanistic optimism where love triumphs over tragedy. Such a conclusion, however, is both too simplistic and naïve. None of the stories ends very optimistically, and it is questionable whether "true love" plays a role at all. In the case of Ding Wenyu in *Nanjing 1937*, obsession may be stronger than love; although passionately complex feelings (which could be construed as love) arise in the female protagonists of *The Tree of Heaven* and *The Tent of Orange Mist*, they are still prisoners of war, and it is the Japanese hegemonic control of China that defines their sadomasochistic relationships—not love (even if at times it may seem otherwise).

Proof or testimony, *jianzheng,* is a weighty theme in the artistic discourse of the Nanjing Massacre. From documentary films like *The Massacre of Nanjing—The Surviving Witnesses* and *Eyewitness to History* to feature films like *Massacre in Nanjing* and *Black Sun*, the seemingly irrepressible urge to return to the scene of the atrocity to "witness" and "testify" to the horrors has become not only a recurring trope bu, arguably the defining strategy. Further evidence is that in 2004, students from Hong Kong Polytechnic Institute developed the first Interactive Situation Simulation Software computer game about

54. The fact that both Li and Yuyuan suffer from a biological "flaw" that leads to abandonment by their respective husbands is yet another intertextual coincidence. In *Nanjing 1937: A Love Story*, Yuyuan lacks pubic hair (a trait inherited from her Japanese mother) and, as a result, is ostracized and abandoned by her superstitious husband, who believes her defect will bring him bad luck. In *The Tree of Heaven*, Li does not have monthly periods and is thus thought incapable of bearing children. As a result, her husband abandons her for another woman. In an ironic anecdote, Li eventually gets pregnant by her Japanese lover, Kuroda. And although both Kuroda and the fetus die, we learn that it was not Li who was sterile after all—it was her Chinese husband.

the massacre. Presented as "edutainment," the video game brings visual representations of the Nanjing atrocities into the twenty-first century through interactive means unavailable to previous literary or even cinematic representations. The title of the game is most telling: Eyewitness—Nanjing Massacre. The player does not assume the role of a victim or a perpetrator; instead, he or she becomes a cameraman whose objective is to "shoot" the atrocities playing out before his or her eyes.

The ultimate display of evidence, however, came with the 2005 release of Gao Qunshu's 高群書 The Tokyo Trial (Dongjing shenpan 東京審判). Although Gao's film is a courtroom drama reenacting the trial for war crimes committed during both World War II and the Sino-Japanese conflict, the Nanjing Massacre occupies a central position, which can be seen as a natural development of the filmic proof discourse begun with Massacre in Nanjing. Whereas the action in Luo Guanqun's film revolves around preventing the evidence from falling back into Japanese hands, The Tokyo Trial centers on the International Military Tribunal for the Far East, from May 3, 1946 to November 12, 1948—the definitive exhibit of proof.

Another connection among several of the literary texts is their apparent inability to directly confront the massacre as an event in and of itself. The two literary texts examined at length, Ah Long's Nanjing and Ye Zhaoyan's Nanjing 1937: A Love Story, are both prequels, and R. C. Binstock offers a sequel of sorts in his novel The Tree of Heaven. While much PRC historiography on the massacre has focused on repeatedly revisiting the site of trauma through witness testimonials and the exposure of physical and emotional scars, much of the fiction uses a very different strategy of representation and commemoration. The inability or unwillingness to "write atrocity" and the alternative focus on events preceding and/or following the massacre is, ironically, perhaps the greatest "testament" to the unspeakable horrors committed.

Ah Long and Ye Zhaoyan also both use the Rape of Nanjing as a backdrop for a critique of the Chinese people's cannibalistic tendencies. Echoing the prophetic words of Lu Xun's "madman," these descriptions, which pervade Nanjing and, to a lesser degree, Nanjing 1937: A Love Story, present an unfortunate prelude to a century of violence committed by the Chinese people against their own compatriots. And although both Ah Long and Ye weave a self-critical discourse into their respective novels, both remain very much concerned with Nanjing and the Chinese nation. As a work of "national defense literature" that retains its optimism even in the face of unspeakable atrocities, Ah Long's novel points to salvation for the nation through military strength and autonomy. By the same token, at the heart of Ye Zhaoyan's novel lies the drive to rebuild literary traditions, the city of Nanjing, and the glory of a nation on the eve of

Promotional image for the interactive computer game Eyewitness—Nanjing Massacre.

destruction. From this perspective, both novels have quite a bit in common with traditional nationalistic representations of the Nanjing Massacre by state-sponsored writers like Zhou Erfu, Wang Huo, and Xu Zhigeng. Although the massacre was intended to be a step in the establishment of Japan's Greater East Asia Co-Prosperity Sphere, the novels and films it inspired led to a rei-magination of the Chinese state. The power of this centripetal trauma became especially evident in the 1980s, as the Nanjing Massacre became central in China's renewed post–Cultural Revolution policy of patriotic education.

Seven decades after the massacre, its images and depictions still haunt us, and the ghosts of its victims—some still living—still roam. One case in point is Shiro Azuma 東史朗 (1912–2006), a former soldier once stationed in Nan-jing and now spending his final years facing guilt while waging his own per-sonal war against both the demons of his past and his country's denial (not to mention countless death threats from Japanese fundamentalists). Shiro Azuma's voice first came to the attention of the public in 1987 when he published his war diaries from Nanjing, which contained extensive descriptions of atrocities com-mitted by him and his platoon. In 1995, Shiro's story was dramatized in a three-episode miniseries directed by Wang Jianjun 王建軍 and Zhang Yiran 張毅然. In *The Bullet-Ridden Silver Dollar* (*Dai dankong de yinyuan* 帶彈孔的銀圓), an elderly Japanese man travels to China under the pretext of hiring a

Chinese film director, but his real motivation is to visit the atrocity museum dedicated to the victims of the Nanjing Massacre.[55] Shiro's personal journey of admission and repentance has figured prominently in the Chinese national quest to authenticate the injustices committed; it was even adapted in 2002 into a comic book/graphic novel entitled *Shiro Azuma Begs for Forgiveness* (*Dong Shilang xiezui* 東史朗謝罪). Shiro and the ghosts of the Nanjing Massacre also make a cameo of sorts in Lillian Lee's 李碧華 fascinating literary pastiche of reportage, biography, and fiction, *The Red String* (*Yanhua sanyue* 煙花三月). This moving book, published in 2000, tells of the impossible reunion of two long-lost lovers—a former comfort woman and a former prisoner of the Chinese gulag. Although the female protagonist was not in Nanjing, the shadow of the massacre looms darkly over the story, which culminates in a series of actual letters exchanged between the author, Lillian Lee, and Shiro Azuma. Reprinted in full, they add a darker dimension to this already tragic tale of lives sacrificed. The Nanjing Massacre has proved to be a physical and psychological scar that, after sixty-five years, is not healed and continues to trigger recurring nightmares and belated tragedies.

In the new millennium, the Nanjing Massacre returned to the silver screen again in *May & August* (2002) and *Qixia Temple 1937* (2005). Both films extended the emphasis on evidence in new directions, partly through appropriation of narrative tropes from Holocaust literature and film in an attempt to reach a wider audience. Released on December 13, 2005, the sixty-eighth anniversary of the massacre, *Qixia Temple 1937* takes place at the famous monastery located on the northeastern outskirts of Nanjing on the bank of the Yangtze River, and portrays the epic story of a Buddhist monk who opens his monastery to refugees. Acting against the advice of his fellow monks, many of whom fear accepting refugees will only incite the wrath of the Japanese and bring about the destruction of the historic temple, Master Jiran 寂然法師 (Zhang Xinhua 張新華) provides safe haven for city dwellers trying to escape the violence. As the flood of refugees into Qixia Temple swells to more than 20,000 people, Master Jiran struggles to maintain a strained agreement with the Japanese to protect the sanctity of the temple and the safety of its occupants. *Qixia Temple 1937* was produced by Zhang Ruiping 張瑞平 in conjunction with Master Chuanzhen 傳真法師, a Buddhist monk, who also co-wrote the screenplay with director Zheng Fangnan. Eight other monks served as Buddhist advisors during the production, and the story was inspired by "real people and real events" that took place in Qixia Temple during the Nanjing Massacre. Because of the

55. For more on the miniseries, see Robert Yee-sin Chi, *Picture Perfect: Narrating Public Memory in Twentieth-Century China*, 103, where I first learned of this television feature produced by Nanjing TV.

thematic similarities with Spielberg's 1993 Holocaust film *Schindler's List*—one man working against all odds to preserve the lives of thousands amid unthinkable violence—*Qixia Temple 1937* was widely marketed as the "Chinese *Schindler's List* that will sweep the Oscars."[56] The film's heroic depiction of Master Jiran marks a major break with the way monks (and religion) have been conceived in most popular culture, especially works about the Sino-Japanese War. The film attempts to reconcile the ascetic views of Buddhism with anti-Japanese nationalistic rhetoric. The conflation of Buddhist compassion and Nationalist indoctrination is illustrated in such scenes as when Master Jiran goes against the advice of the other monks to admit a contingent of three high-ranking Nationalist officers, including General Liao Wenxiang 廖文湘, into the temple along with the other refugees. In response to the objection, "No matter what, we cannot take in any soldiers!" Master Jiran responds, "They are Chinese too, are they not?" Master Jiran's selfless compassion for sufferers, faith in Buddhism, and overt devotion to his country make for a psychological portrait far less interesting, complex, or convincing than that of Oskar Schindler.[57]

General Liao Wenxiang and Su Ping 蘇萍 (Meng Yu 夢雨), a student at Ginling College 金陵大學, are two players in the film's most substantive subplot. It begins when Mr. Martin (Ismael Amideo), a Universal Studios documentary filmmaker, arrives at Qixia Temple to shoot footage of refugees. In the days following his visit, Mr. Martin records a series of horrific atrocity scenes with his camera before he too becomes a victim of the Japanese atrocities. (Martin can also be read as a fictionalized rendering of Reverend John Magee, the American who took some of the most graphic film footage of the massacre's victims in the Drum Tower Hospital.) Just before his death, Mr. Martin passes a roll of film to his interpreter, Su Ping, who smuggles the "evidence" into Qixia Temple, the one place she knows it will be safe. Eventually, Su Ping also falls victim to the Japanese, but not before passing the film to Master Benchang 本昌法師, who brings it back to the temple. Not until the climax of the film do

56. This description was used on both the cover of the Chinese DVD edition and publicity posters. Traditionally, it is the story of German national and Nazi Party member John Rabe, who has been described as "Nanjing's Schindler." Rabe, a portrayal of whom also appears in *Qixia Temple 1937* in a cameo, served as the chairman of the International Committee for the Nanjing Safety Zone and personally hid hundreds of Chinese in his garden during the massacre. It is an interesting form of national(istic) politics that has reconfigured "Nanjing's Schindler" as a Chinese, while relegating Rabe to a minor supporting role.

57. Although the monks are generally portrayed in a positive light, there are several notable exceptions in the monks who oppose taking in refugees, especially soldiers. Master Zhihai 志海法師, the most vocal opponent of Master Jiran's policies, is eventually killed by the Japanese. Another key signpost in reading the film's perspective on the Buddhist–Nationalist continuum is at the end of the film, when the young monk Master Benchang 本昌法師, abandons his holy robes to join the Nationalist Army to fight the Japanese.

Shooting atrocity: Mr. Martin capturing Japanese atrocities on film in *Qixia Temple 1937*.

we learn that it is ultimately General Liao Wenxiang who smuggles the film out of the temple and out of Nanjing—to be screened for the international community in Shanghai.

The heart of *Qixia Temple 1937* is actually this epic attempt to preserve the "bloody evidence" captured on Mr. Martin's film reel. While Master Jiran struggles to feed, clothe, and protect the 24,000 refugees, the real struggle is to preserve what the film's publicity poster refers to as "the steel evidence of the massacre" (*tu cheng tie zheng* 屠城鐵證). This rearticulates the strategy of the very first film about the Nanjing Massacre, 1987's *Massacre in Nanjing* (*Tu cheng xue zheng* 屠城血證), which also highlighted a dramatic quest to preserve evidence. Both films trace the complex journey of photographic or filmic evidence from person to person and the human sacrifice and martyrdom that facilitates it. Surprisingly, however, *Qixia Temple 1937* goes even further in strengthening the rhetoric of nationalism and the politics of proof than its predecessor—what was earlier called "bloody evidence" is now "steel evidence."

The "evidence" in *Qixia Temple 1937*, produced by an American filmmaker, stands in stark contrast to the set of photos taken by Japanese soldiers to commemorate and glorify their violent deeds in *Massacre in Nanjing*. This change allows for a way out of the conundrum articulated by Elie Wiesel regarding enemy-produced images of atrocity. The proof no longer comes from the perspective of the executioner, but through the compassionate and "objective" eyes of the West. At the same time, having an American produce the images reverses the pattern of transference in *Massacre in Nanjing*, where the American

Katie stood at the other end. The symbolic distributor of the images has become the producer (an ironic twist, given Martin's identity as an employee of Universal Studios and *Qixia Temple 1937*'s fixation with Hollywood via *Schindler's List* and the Academy Awards). The fact that the medium has shifted from photography to film is also significant: the fragmentary series of still photos is now crystallized and contextualized by the power of *moving images*—surely a more convincing form of evidence in the filmmaker's eyes. Its importance is highlighted not only visually but also through narrative and dialogue, which continually emphasize the importance of the sacred reel. When Mr. Martin first begins taking the footage, he remarks to his interpreter, Su Ping, about the importance of the images he is capturing: "It's a real massacre. I want to show the world what is really happening here!" This rhetoric is later developed into a stilted monologue by Su Ping as places the film into the hands of Master Jiran:

> "I'm Su Ping, don't you remember me? A few days ago I came here to the temple with an American photographer named Mr. Martin, who shot film at the temple. . . . I've come here for your help . . . I've brought a very important film that I need to get smuggled out of here immediately. . . . Mr. Martin shot lots of scenes of Chinese killed by the Japanese army in Nanjing. There is a very good chance that these images could serve as proof of the Japanese atrocities that have been perpetrated. Mr. Martin has already been killed by the Japanese military police. I think the film must be sent out of here to the concession district in Shanghai and then transmitted as soon as possible into the hands of the International Peace Society."

Su Ping's statement can be read as a form of proleptic speech, in which she not only immediately recognizes the future importance of the film but even predicts the future time and place of its screening—which will eventually signal the ultimate closure for the film, and ideally for the victims of the atrocity.

In *Massacre in Nanjing,* closure comes with Katie's display of the series of photos to the camera at the end of the film. In *Qixia Temple 1937,* this final exhibition of the evidence is taken to a new level. Instead of simply alluding to the fact that the film will one day play an important role in attesting to the war crimes committed by the Japanese, *Qixia Temple 1937* also delivers a symbolic admission of guilt and shame by the Japanese. Besides the 24,000 citizens, the most important refugees that the Qixia Temple protected were General Liao Wenxiang and the film itself. In the penultimate scene, we are told that Liao (with the help of Master Jiran) has made it out of Nanjing and taken the film to Shanghai, where screenings were held for the international

community. The news comes to the audience through the Japanese ambassador in the film:

> Ambassador: Commanding officer, your men are a bunch of worthless idiots!
> They can't even catch a defeated general [Liao Wenxiang]!
> Attendant: Mr. Ambassador, telegram from the Foreign Ministry.
> Ambassador: What is it about?
> Attendant: A documentary film shot by an American named Martin has been
> playing in Shanghai in the foreign concessions of the United States, Britain,
> France, and the Soviet Union. Most of the scenes in the film showed images of
> Japanese soldiers shooting and killing Nanjing civilians and prisoners of war.

And here, Zheng Fangnan cannot help but insert a Japanese self-commentary on the empire's crimes from none other than the ambassador—both the literal and the symbolic representative of Japan:

> Ambassador: The Japanese cut off millions of Chinese heads. But from this
> point forward there will be no place for Japan to ever again raise its head in
> the records of human history.

The ambassador's statement represents an attempt to provide closure for those who suffered at Japan's hands during the war and those who have vicariously suffered during the aftermath of the war. But given that the history of the Nanjing Massacre has been consistently downplayed and denied by Japanese politicians and historians, one cannot help but wonder whether this final sentiment is merely a case of wishful thinking on the part of the Chinese filmmakers—a wry reaction that gives the film an even more tragic note.

Unfortunately, *Qixia Temple 1937* has wrapped itself up in a vicious circle of facts and fictions. The film clearly aims at "strengthening the evidence" of *Massacre in Nanjing*—from photos to film and from Japanese denial to admission of guilt—in order to provide an irrefutable record of the atrocities. But the "fictional evidence" *Qixia Temple 1937* provides actually takes the audience further away from any sort of cathartic experience. Moreover, injecting this filmic "evidence" with more overt patriotic rhetoric than any previous Nanjing Massacre film creates a vulgarization that, once again, attempts to commemorate this human tragedy within a network of national agendas and a tradition of already flawed cinematic tributes.

Even more startling is the case of *May & August*, which has raised an extraordinary controversy and places earlier discussions of representations of the Nanjing

Massacre in a new perspective. The film was written and directed by one of Hong Kong's most prolific screenwriters, Raymond Tu, in his second directorial effort; it stars Cecilia Yip 葉童 as a mother struggling to survive and save her two daughters amid the massacre. *May & August* differs from earlier representations in that it is essentially a moving entertainment drama about one family's will to survive tragedy. The events of Nanjing 1937 merely serve as the backdrop.[58] The narrative traces the story of the two young girls, May and August, who survive by hiding in a secret attic (if *Qixia Temple 1937*'s model is *Schindler's List*, *May & August*'s is *The Diary of Anne Frank*) and eventually escape to Zhenjiang 鎮江 after their parents are killed by the Japanese. Most major acts of brutality occur off screen—the emphasis here is on not death, but life. Instead of opening with documentary footage of the war, *May & August* begins with impressionistic pencil sketches of Nanjing. This marks a shift from an urge to "prove" history through actual photos and evidence to a desire to "portray" the scars of the past through a more symbolic vision. The purpose of *May & August* is *not* historical censure but psychological catharsis. As the film progresses, it becomes apparent that the sketches utilized during the titles sequence are from a collection of works by a preadolescent boy orphaned by the massacre, who befriends May and August. The images are meant to represent a personal means of grappling with the unspeakable pain, sorrow, and loss caused by atrocity. Further evidence of this shift from the physical to the psychological is Raymond Tu's decision not to include large quantities of documentary footage, photographic evidence. For the first time, a film about the Nanjing Massacre seems to have escaped from the burden of history and slipped past the shadows of Japanese denial. Looks, however, can be deceiving.

May & August was scheduled to have its premiere on December 13, 2002 at the Nanjing Massacre Museum as part of the commemorative events scheduled for the sixty-fifth anniversary of the event. Just days before, however, Zhu Chengshan 朱成山, the PRC's most prominent Nanjing Massacre historian and curator of the museum, held a press conference denying *May & August* the right to be screened at the museum and even went so far as to recommend that the film, which had already been approved by the Chinese Film Bureau, be banned throughout the country. Zhu's criticisms, which set off much controversy, did

58. The director, Raymond Tu, has stated in an interview with dayoo.com that the film was originally conceived as a testament to one family's extraordinary will to persevere in a time of war, and it was only much later that Taiwanese film director Hsu Hsiao-ming (Xu Xiaoming), who is credited with the original story, suggested the Nanjing Massacre as the actual historical backdrop. (See http://dailynews.dayoo.com/content/2002-12/09/content_872542.htm for the complete interview.)

not focus on the film's story, acting, production values, or portrayal of violence, but were directed primarily at erroneous closing titles and a series of "unconscionable" historical inaccuracies.

Chief among these inaccuracies were casualty figures that appeared at the end of the film, just before the closing credits. These figures, which were removed before commercial release of the film as a direct result of the controversy, originally stated the number of casualties of the Nanjing Massacre as 300,000, the number of rapes as 20,000, and the total number of Chinese killed or injured during the eight-year War of Resistance as 31,000,000. Zhu protested that the accurate death toll for the Nanjing Massacre should be "More than 300,000" or "Over 300,000," but *not* 300,000. He also stated that the number of women raped should, likewise, be listed as "More than 20,000" and the total number of Chinese killed or injured during the course of the war should be 35,000,000. Zhu Chengshan also raised a number of other criticisms concerning historical inaccuracies in the film itself, from the appearance of green leaves in winter and children bathing in the December waters of the Yangtze to references to bodies being burned to ash and historical events presented in reverse chronological order.[59]

The ultimate irony is that *May & August*, a mass-market story about perseverance and the will to survive, the first film that clearly was not trying to be a historical docudrama about the Rape of Nanjing—let alone "prove" that the massacre happened—could not escape the burden of proof and the weight of history. The critics seemed unable to see the film as anything *but* "history." Zhu Chengshan even went so far as to declare that its release would provide "evidence" that Japanese extremists could use to deny the very existence of the Nanjing Massacre! In the cases of *Massacre in Nanjing* and *Black Sun*, feature dramas took on the qualities of documentary—or even evidence—but here, an innocent "entertainment film" never intended to be "read" as history was not only forced to shoulder that burden but also actually granted the power (by one of China's foremost historians) to rewrite history.

We should not forget that even history is but a representation of bygone, irretrievable events. And with this in mind, perhaps we should ask where historian Zhu Chengshan gets his data. According to Zhu, the "More than 20,000" figure for the number of women raped during the Nanjing Massacre is based on

59. Zhu Chengshan argues that green leaves in winter and children bathing in the Yangtze in December are both impossibilities. He also states that the Japanese army did not have the patience to burn bodies to ash, which is a very time-consuming process, and instead simply buried them in mass graves or dumped them into the river. Another criticism was leveled at the plot construction of the children fleeing to Zhenjiang 鎮江 after their parents were murdered in Nanjing—a historical impossibility since Zhenjiang actually fell to the Japanese *before* Nanjing.

Detail from original poster advertising *May & August* with the caption, "The first Nanjing Massacre film to expose the rape and murder of Chinese women."

the 1945 International Military Tribunal for the Far East about which many questions of reliability have been raised due to the then-prominent Cold War politics and the way the United States in particular pushed for an expedient conclusion.[60] The 35,000,000 figure, however, is, according to Zhu, based on a figure given during a speech made on May 9, 1995 by Jiang Zemin 江澤民 in Moscow. Suddenly, it seems that presidential speechwriters are the keepers of history.

The controversy surrounding *May & August* articulates most clearly one of the key themes running through several of the literary and cinematic texts on the Nanjing Massacre—the very fine line between literature and history, facts and fictions. In *Massacre in Nanjing, Black Sun,* and, to a much lesser extent, *Don't Cry, Nanking,* full-length feature dramatic films try not only to serve as

60. The same trial gave the total death toll of the Nanjing Massacre as approximately 200,000. Perhaps we should rhetorically ask Zhu Chengshan why he does not appropriate this number as well.

historical representations but also to re-present history and *prove* that it occurred. Instead of the signifiers (films) pointing to an unapproachable, unspeakable, and forever lost signified (the event), they have been taken as the signified itself, and fictions have begun functioning as facts.

Likewise, Ah Long and Ye Zhaoyan attempt to write history and, in the end, produce works much closer to fiction (or perhaps a hybrid of the two). Ah Long said of *Nanjing* that he "dare not look at it as reportage, but nor do I dare label it as fiction" (Ah Long 1987:227). And Ye Zhaoyan, in his afterword to *Nanjing 1937: A Love Story,* stated, "I planned to write a novel about war but ended up writing a rather unorthodox love story" (Ye 2002:342). Once again, the lines between fiction and history are challenged and bent.

Nowhere is the tightrope between fact and fiction, history and literature, memory and the imagination thinner than in Sun Zhaiwei's *1937 Nanjing Elegy: Record of Atrocities Committed by the Japanese Army,* where history becomes fiction, and Raymond Tu's *May & August,* where fiction is forced to carry the burden of (and become?) history. Although these texts compromise our traditional conceptions of literature and history and their respective parameters, they also expand our understanding of those genres and their possibilities. The ways these divisions consistently blur perhaps points to the shortcomings of traditional dichotomies between "literature" and "history" and reinforces the inherent need to continually revisit the moment of atrocity—a moment eternally lost and approachable not through history, literature, reportage, film, or documentary, but rather through a complex combination of them all. In the case of the Rape of Nanjing, it is only through an intricate series of literary and historical trajectories that intersect and intertwine that the elusive specter of history comes alive.

3. Taipei 1947

"The power of history will sweep everything up into its
vortex." . . . "Aren't you afraid that you would be terribly
bored just sitting there with your arms crossed in indiffer-
ence? I feel bad for you, because you are completely helpless
in the face of history. Even if your beliefs make you willing
to try and exert any power in one direction or another,
others will not necessarily trust you—moreover, they
will most likely suspect you of being a spy. When you
look at it this way, you are truly an orphan."

—WU ZHUOLIU (1995:211–212)

Memories Forgotten

Although responsibility for the atrocities committed in Nanjing between De-
cember 1937 and the early months of 1938 lies with the Japanese, in the eyes of
some, the Nationalist forces also carry a burden of guilt for a flawed resistance
strategy and the massive military and governmental evacuation of the capital. It
could be argued that the heavy casualties suffered in Nanjing were in part due
to the absence of any significant Nationalist military presence to defend, lead,
or even negotiate on behalf of the Chinese citizenry.[1] The degree of culpability
the Nationalist regime should face is repeatedly alluded to in several of the
more controversial representations of the Nanjing Massacre, such as those by
Ah Long and Ye Zhaoyan, both of whom highlighted indigenous Chinese–
Chinese violence over Japanese-inflicted atrocities.

Exactly ten years later, again facing defeat, this time at the hands of the Chi-
nese Communist forces, the Nationalist regime initiated yet another mass

1. Some critics and historians argue that one contributing factor explaining the large scale of the atroci-
ties committed by the Japanese in Nanjing and throughout China had to do with the reality of Chinese
nonresistance and large numbers of Chinese surrenders. According to the moral code of Japanese soldiers,
suicide was preferred over surrender; thus, when Chinese soldiers surrendered, or, in many cases, failed
even to resist, they were often looked upon as less than human by their enemies.

migration—this time to Taiwan. Suddenly, a decade after the Nanjing Massacre, the tables were turned and the Chinese were taking over what had been Japanese territory.[2] History, however, works in strange ways: on February 28, 1947, amid the power vacuum left by the Japanese and the new conflicts arising between the local Taiwanese population and the newly arrived mainlanders and Nationalist military forces, another tragedy would be born—one that has haunted the island up until the present day.

Much of the cultural friction that eventually led to violence had already been hinted at several years earlier by Xinzhu 新竹 native Wu Zhuoliu 吳濁流. Often considered the father of Taiwanese literature, Wu Zhuoliu (1900–1976) worked as a reporter in Nanjing during the Japanese wartime occupation. His book *Random Thoughts on Nanjing* (*Nanjing zagan* 南京雜感) was based on his time in the ancient capital and is only too clear about the terrible atrocities committed there during the war. Wu's masterpiece, 1945's *The Orphan of Asia* (*Yaxiya de gu'er* 亞西亞的孤兒), stands as a seminal work set in prewar Taiwan. The novel became a cornerstone in the canon of Taiwanese literature and provided a powerful metaphor for Taiwan's predicament in the modern world. The concept of the island as the "orphan of Asia" resonated even more on the eve of the February 28th Incident, as it became increasingly clear that, even under Chinese rule, Taiwanese people would in many way, remain second-class citizens.

After an initial mood of celebration, Taiwanese citizens were quickly disillusioned by their corrupt Nationalist "liberators." The military contingent that landed in Taiwan paradoxically appeared to be even less "modern" than the Japanese colonizers. At the same time, the new mainland Chinese presence, which consisted largely of government and military personnel, tended to perceive the Taiwanese as ungrateful sell-outs to Japan, particularly after the eight-year War of Resistance, during which many Taiwanese were sent to the mainland to fight alongside the Japanese. Many Nationalists believed that China had suffered incalculable human losses (including the 300,000 victims of the Nanjing Massacre) in part so that Taiwan could finally be returned to the motherland. But the Taiwanese not only failed to appreciate their new "compatriots'" sacrifice but also expressed great discontent, appearing almost nostalgic for the "good old days" of Japanese rule.

There were several layers of misunderstanding and miscommunication between the native Taiwan population and the newly arrived "rulers" that con-

2. Taiwan was ceded to Japan in 1895 following the Sino-Japanese War of 1894–95. The island territory remained a colony of Japan until 1945, when it was returned to China following Japan's defeat in World War II.

tributed to the conflict. Tensions built around a multitude of issues ranging from linguistic incomprehensibility and intolerance (Taiwanese spoke primarily Japanese and Taiwanese, while the mainlanders spoke Mandarin), corruption, and widespread failure to employ Taiwanese in positions of power, all of which reinforced native feelings that they were being "*re*colonized" rather than "*de*colonized." Just when the "orphan of Asia" thought that her mother(land) had come calling, Formosa found herself orphaned again.

If the Nanjing Massacre was the ultimate symbol of wartime Japanese atrocities, could the February 28th Incident—on the level of the national subconscious—be the ultimate form of vengeance, a grand incarnation of Ah Q's spiritual victory complex (*jingshen shengli fa* 精神勝利法)? Since China was unable to continue the War of Resistance against Japan, were the former colonial subjects of Japan in Taiwan the next best thing? These questions are meant neither to blame Japan nor to absolve China's Nationalist forces—assigning guilt and responsibility for such large-scale historical atrocities is a complex process—but rather to highlight the complex ways the tumultuous eight-year War of Resistance profoundly affected how the February 28th Incident, or "2/28," as it is popularly referred to in Taiwan, played out. The incident could even be viewed as a post-traumatic reaction to the shock of war; in the end, however, this violent explosion fueled in part by unresolved anger toward Japan turned into an implosion, a brutal crackdown on the Taiwanese the mainlanders were supposed to be liberating.

The complex tensions came to a head in the early spring of 1947, in a major uprising that broke out in the aftermath of a police investigation of contraband cigarettes. The events surrounding the investigation have been well documented in the landmark study by Lai, Myers, and Wei:

> At 11:00 a.m. on Thursday, February 27, 1947, the Taipei City Monopoly Bureau received a secret report that a boat near the little port of Tamsui [Danshui] was carrying some fifty boxes of illegal matches and cigarettes. Even such a small shipment could elicit a major police effort, and in fact the Bureau immediately dispatched six investigators and four uniformed policemen to the scene. When the team arrived, it found only five boxes of cigarettes. Later, the Bureau received another secret report that the missing contraband was being sold at the T'ien-ma [Tianma] Tea Store on T'ai-p'ing [Taiping] Street in Taipei (now called Yen-p'ing [Yanping] North Road). Smugglers were known to frequent the T'ai-p'ing [Taiping] Street area, so the investigative team drove there, ate an early supper at the Hsiao-hsiang-yuan [Xiaoxiangyuan] Restaurant on T'ai-p'ing Street, and then, probably sometime between 7:30 and 8:00 p.m., went to the store, only to discover that the dealers had fled.

The investigators then saw a forty-year-old widow, Lin Chiang-mai [Lin Jiangmai], selling what they thought were contraband cigarettes. Not even a solitary peddler could escape the attention of officials, and the team demanded that she hand the contraband over. The widow Lin replied, "If you confiscate everything, I will not be able to eat. At least let me have my money and the cigarettes provided by the Monopoly Bureau." When the investigators refused, Lin grabbed hold of one of them, who reacted by hitting her on the head with the butt of his pistol, producing a bleeding gash. Lin's daughter began to cry, and some of the crowd that had now gathered began to taunt the team, screaming, "You unreasonable *a-shan,* you evil pigs, return her cigarettes!" One of the investigators, Fu Hsueh-t'ung [Fu Xuetong], tried to flee. He took out his pistol, brandished it, and then fired, hitting a bystander named Ch'en Wen-hsi [Chen Wenxi], who was reported to be the brother of a major hoodlum. Ch'en later died. The investigators managed to escape, but the angry crowd burned their abandoned vehicle and then went to the nearby police station to demand that the investigator who had fired the pistol be summarily executed. (Lai 1991:102–103)[3]

This was the spark that would ignite islandwide protest, violence, and political persecution. Taiwanese protesters flocked together in support of the victims, Lin Jiangmai 林江邁 and Chen Wenxi 陳文溪, descending on the Taipei Police Bureau and converging on the editorial offices of the *Taiwan New Life Daily* (*Taiwan xinsheng bao* 台灣新生報) later that evening, where they demanded press coverage of the incident.

The voices of the protesters grew stronger over the course of the ensuing days, resulting in large-scale public protests, anti-Chinese demonstrations, and violence, including the fatal beating of two officials from the Monopoly Bureau on February 28. The impassioned protest of the beating of Lin Jiangmai and death of Chen Wenxi at the hands of the inspectors had transformed into a full-fledged social movement. After fifty-one years of Japanese colonization, many Taiwanese were disappointed—finally realizing that their Chinese repatriation was just another form of colonization. Issues including unequal employment opportunities for Taiwanese, rampant inflation, ubiquitous corruption, and the political and cultural hegemony of the Nationalist Party created ten-

3. *A Tragic Beginning: The Taiwan Uprising of February 28, 1947* by Lai Tse-Han, Ramon H. Myers, and Wei Wou is a seminal study on this important historical incident. Although there has been extensive material published on the February 28 Incident in Taiwan, this was the first and, for many years, remained the sole full-length study of 2/28 in the English language. *Between Assimilation and Independence: The Taiwanese Encounter Nationalist China, 1945–1950* by Steven Phillips, which also dealt extensively with the February 28th Incident, was published in 2003.

sion between the Taiwanese and the mainlanders that reached the boiling point on February 28, 1947.

The incident also spread beyond Taipei, the site of the initial confrontation and the Nationalist power seat, quickly proliferating in a series of uprisings against the Nationalist regime, voicing cries for self-government and Taiwan independence. These were not simple acts of civil disobedience or peaceful marches but involved forced takeover of government offices and radio stations throughout the island, as well as frequent and random beatings and murders of mainlanders. From Jilong 基隆 to Jiayi 嘉義 and from Taipei 台北 to Tainan 台南, the violence was widespread, with major insurrections in Taizhong 台中, where female Communist leader Xie Xuehong 謝雪紅 spearheaded a massive armed assault on the city, and Gaoxiong 高雄, where intense fighting between armed activists and Nationalist soldiers carried on for several days in early March.

The Nationalist response was swift, but many of the measures taken were to leave indelible scars on the Taiwanese national psyche and carry consequences that would still be felt decades later. Governor-General Chen Yi 陳儀 declared martial law on Friday, February 28, and on the following day, a Resolution Committee (*chuli weiyuan hui* 處理委員會) consisting of Taiwanese politicians and citizens was established to mediate with Chen's regime and present a list of the government's demands in response to the incident. Although the Resolution Committee made some initial progress and martial law was lifted on March 2, two days after it was first instituted, public anger continued to rise. Antimainlander violence continued, and many Taiwanese were making demands much more extreme than those of the Resolution Committee. Chaos escalated; according to some estimates, approximately 1,000 mainlanders were killed, wounded, or missing during the immediate aftermath of the incident. Talks with the Resolution Committee began to break down, and on March 5, Chiang Kai-shek made the decision to send the army's Twenty-First Division, under the direction of General Liu Yuqing 劉雨卿, to Taiwan. A decade after the Nationalist forces pulled out of Nanjing on the eve of one massacre, Chiang Kai-shek sent them to Taiwan, where they ended up starting another.

On March 7, the Resolution Committee introduced several propositions, such as putting the Taiwanese in charge of their own army and navy, that incited Chen Yi's anger, officially ending all talks. At dusk on March 8, 1947, the Twenty-First Division troops entered Taiwan from both Jilong in the north and Gaoxiong in the south. The following day, one week after it had been lifted, martial law was reinstated, the Twenty-First Division reached Taipei, and a bloody military crackdown began. Chen Yi officially proclaimed the Resolution Committee an illegal organization and many members were secretly rounded up and executed. Untold numbers of Taiwan's most outstanding citizens, including

intellectuals, professors, artists, politicians, school principals, doctors, and businessmen—many of whom had no direct involvement with the February 28th Incident—were murdered in the crackdown. The death toll of the 2/28 incident remains unknown, with estimates ranging from the thousands to the tens of thousands, and is still a point of contention.

The significance of the Nanjing Massacre and the February 28th Incident in their respective cultural contexts comes down, in part, to their respective *chronotopic* coordinates of time and space, history and geography. Whereas the Nanjing Massacre was but one in a chain of tumultuous historical events, including the Land Reform movement, the Antirightist Campaign, the Great Leap Forward, and the Cultural Revolution on the mainland, February 28th was arguably *the* defining incident in Taiwan's modern history and the direct catalyst for the White Terror, a long period of political repression and human rights violations taking place under the smokescreen of martial law that began with the Twenty-First Division's crackdown and continued to shroud the island in darkness for decades.

Writing 2/28: The Fictional Legacy of the February Uprising

The history of writing the February 28th Incident parallels that of writings on the Nanjing Massacre, in that a small handful of works were published soon after the actual incident and then literary output virtually ceased. In both cases, only after a "historical blackout" that lasted for several decades did public narration of the respective atrocities return as a key form of artistic expression, in the 1980s. Although the reasons for the long silence and the sudden resurgence of each respective incident decades later were politically motivated, in Taiwan the political blacklisting of the February 28th Incident stretched far beyond literature, and during the height of the White Terror even the mention of the numbers "2/28" could carry severe consequences.[4] It seems only natural, then, that when the ban was finally lifted there was a virtual explosion of discourse, and today the number of literary works on February 28th far surpasses those on the Nanjing Massacre. As few critical works on February 28th fiction are available in English,[5] this section offers a critical overview of the history of fictional

4. In the introduction to his anthology of February 28th fiction, Lin Shuangbu cites one such example, where a schoolteacher consciously or unconsciously utters the three numbers during a class. See Lin Shuangbu 林雙不, *Ere r ba Taiwan xiaoshuo xuan,* iv–vi.

5. While there has been much published in English on Hou Hsiao-hsien's groundbreaking February 28th film *City of Sadness,* discussions of February 28th fiction are few. Two notable exceptions are Robert Yee-sin Chi, *Picture Perfect: Narrating Public Memory in Twentieth-Century China* (Ph. D. diss., Harvard

representations of the incident and provides close readings and analysis of several of the key texts. This examination attempts to map the formation of 2/28's literary canon of violence and trace a lineage of cultural memory and political suppression, drawn with the scars of history.

"Prewriting" 2/28: Lü Heruo, Qiu Pingtian, and Bo Zi's Early Literary Accounts

Some of the very first works of fiction bearing a connection to the February 28th Incident were written before the actual event. Just as the impact and repercussions of the incident extended far beyond the date in question, the impetus for the conflict lay in events that had taken place much earlier. These early writings reflect the larger cultural conflicts, portraying the tensions brewing between native Taiwanese and the newly arrived Nationalist contingent. Among the handful foreshadowing the incident is a short story entitled "Winter Night" ("Dongye" 冬夜), which was published on February 5, 1947 in *Taiwan Culture* (*Taiwan wenhua* 台灣文化). The author, Lü Heruo (1914–1951), stands with Lai He 賴和 and Wu Zhuoliu, as one of the key figures of early modern Taiwan literature. Lü Heruo is best known for his 1935 masterpiece, "The Oxcart" ("Niuche" 牛車, or "Gyûsha" in Japanese).

"Winter Night" is the story of Caifeng 彩鳳, a Taiwanese woman whose husband, Lin Muhuo 林木火, was conscripted by the Japanese and sent to Southeast Asia, where he disappeared; he is officially assumed dead. After four years of constant waiting, Caifeng is forced into marriage with Guo Qianming 郭欽明, a mainlander who proclaims his "love of his dear Taiwan compatriots who have been abused by the Japanese." But he expresses his love for Caifeng by giving her syphilis, then abandoning her on the grounds that *she* gave it to him. With nowhere to go and forced to repay the 30,000 *yuan* dowry that Guo gave

University, 2001), which, although it does not assess 2/28 fiction, does discuss both 2/28 film and several key works inspired by the White Terror; and Yomi Braester, *Witness Against History: Literature, Film, and Public Discourse in Twentieth-Century China* (Stanford: Stanford University Press, 2003), which also discusses not 2/28, but rather two important short stories written in the shadow of the White Terror, Liu Daren's 劉大任 "Azaleas Cry Out Blood" ("Dujuan ti xue" 杜鵑啼血) and Chen Yingzhen's 陳映真 "Mountain Path" ("Shan lu" 山路). More recently, the Spring 2004 and Fall 2005 issues of *Modern Chinese Literature and Culture* featured two important articles on 2/28 fiction, Sylvia Li-chun Lin's "Two Texts to a Story: White Terror in Taiwan" (vol. 16, no. 1) and Margaret Hillenbrand's "Trauma and the Politics of Identity: Form and Function in Narratives of the February 28th Incident" (vol. 17, no. 2). In 2007 came the first full-length monograph on 2/28 in the cultural sphere, Sylvia Li-chun Lin's *Representing Atrocity in Taiwan: The 2/28 Incident and White Terror in Fiction and Film* (New York: Columbia University Press). Collectively these works represent the emergence of 2/28 literature as a concern among literary scholars.

her family, Caifeng becomes a prostitute. She meets Spring Dog (Guochun) 狗春,[6] a Taiwanese man who has just returned from the Philippines, where her first husband was stationed. But during one of Spring Dog's evening visits, gunshots ring out nearby and a new tragedy starts to take form.

With "Winter Night," Lü Heruo captures the sense of dual victimization felt by so many Taiwanese on the eve of the uprising. After losing her husband at the hands of the Japanese, Caifeng finally begins to trust again—only to have her trust betrayed and her life destroyed by her supposed savior. The allegorical dimensions of the story relating to Taiwan's relationship with Japan and the mainland are all too explicit, and further enhanced with highly symbolic elements, ranging from the characters' names to Caifeng's disease. The latter is especially telling because the Nationalists appropriated and exploited Taiwan's economic and natural resources in order to support their war with the Communists, only to later turn around and commit terrible atrocities against the Taiwanese people. And the gunshots at the end of the story signal a new armed conflict between the Nationalist police and the native Taiwanese—the birth of the February 28th uprising.

The absent or missing father figure is a recurring theme in modern Taiwan literary texts, such as Wang Wen-hsing's 王文興 modernist classic *Family Catastrophe* (*Jia bian* 家變); however, it has a particular relevance in the canon of February 28th fiction. From the missing husband in "Winter Night" to the missing brother in *City of Sadness* to the missing father in "Investigation: A Narrative" and many of the 2/28-related works that follow, the absence of male figures and the ongoing trauma their disappearances trigger is a key motif. Ironically, Lü Heruo himself would become yet another missing figure: "Winter Night," his prequel, may have served as his last written testament to Nationalist violence, but his mysterious disappearance and death in the wake of the February 28th Incident are his ultimate testament . . . a testament of silence.[7]

In the same issue of *Taiwan Culture* as "Winter Night" was a short work by an unidentified author publishing under the pen name Qiu Pingtian 丘平田.[8] "The Rural Defense Brigade" ("Nongcun ziwei dui" 農村自衛隊) only ten pages long, is a vivid portrait of 1947 Taiwan that is disturbingly powerful and prophetic. "The Rural Defense Brigade" is the story of an urban working man

6. *Chun*, or "spring" can also carry an sexual connotation, which here implies the amorous encounters between Caifeng and Gouchun, whose name could also be rendered as something akin to "Dog in Heat."

7. Kang-I Sun Chang has written about the fate of Lü Heruo in an unpublished article, "What Happened to Lu Heruo (1914–1951) After the February 28 Incident?" presented at the conference "Taiwan and Its Contexts," Yale University, 2007.

8. Some scholars have argued that the identity of Qiu Pingtian may be Su Xin 蘇新 (1907–1981), a prominent intellectual and a key figure in the Taiwan Communist Party.

who rushes back to his country hometown on the eve of the Chinese New Year after receiving an urgent letter from his uncle. Upon arriving, the protagonist discovers his kin living in abject poverty, two of his nieces dead from smallpox, and a nephew presumed dead after being sent to mainland China by the Nationalists to fight against the Communists (once again, the motif of the missing male figure). But the protagonist also finds deep-rooted discontent among the country people. When commenting on the lack of smallpox inoculations, which led to the death of his two granddaughters, the uncle remarks, "What's all this talk about inoculations? Once they recovered Taiwan, they recovered everything else in the process; all the bad practices, including all the thieves and idlers, priests and fortune-tellers and, especially, those experts of so-called 'Chinese medicine'" (Lin Shuangbu 1989:23). In the end, the countrymen's solution is to establish a rural defense brigade, to take up arms and protect themselves.

Lurking between the lines of Qiu Pingtian's story is deeply rooted discontent and strong cultural criticism: "'That's right, we have been slaves all our lives, it is enough already. We are no longer willing to let our children and grandchildren be their slaves!'" (27–28). Here, the words of the uncle remind us of the Republican revolution and Lu Xun's famous statement, "Before the revolution we were slaves, and now we are the slaves of former slaves." The reference is further developed in the next line: "Humph! Compatriots killing their compatriots, what's the point! We are brave against one another but cringe at the outside, that's the special trademark of the Chinese race! Ever since ancient times, that's how it's always been!" (28).

It is at this point that the uncle's criticisms begin to echo even more strongly Lu Xun's classic critique of the Chinese national character. In "The Rural Defense Brigade," Qiu Pingtian locates the growing conflict between Taiwanese and mainlanders *not* in the postcolonial context of 1947 but in the larger historical context of Chinese "cannibalism." He also employs another key motif from Lu Xun's works: the dialogic relationship between the country and the city, displayed in such classic stories as "My Old Home" ("Guxiang" 故鄉) and "At the Wineshop" ("Zai jiulou shang" 在酒樓上). In this sense, Qiu Pingtian has created a true homage to Lu Xun, echoing the great writer's aesthetics of desolation through a melancholic voyage back to the ontological homeland. The difference is that when the protagonist-cum-narrator finally leaves the backward countryside to return to the city, he finds the brutal reality there just as bad.

In the story's disturbing conclusion, the protagonist returns to his new home in the urban center of Taipei, only to find his house ransacked and burglarized. Although he reacts in a nonchalant manner, commenting on how even poor thieves need to have a little money for the new year, he remarks, "Deep down I

felt so sad. I was silent for a long time, thinking only of the 'rural defense brigade' that Uncle told me about yesterday" (Lin Shuangbu 1989:30). Suddenly, the dichotomy between the city and the country is broken down. Social unrest knows no boundaries, and the city man becomes a victim of the same crime to which his kin in the country are constantly subjected. The narrator's final prophetic sentiment is expressed in silence, but it affected readers with the power of a call to arms—just three weeks after this story was published, a new grassroots "defense brigade" took form in Taipei. The results are still being felt today.

Because they predate the incident, neither story can qualify as an example of February 28th fiction in the truest sense of the term. However, because of their subject matter and close proximity to the actual events, both works provide a new perspective on the social tensions already building to full eruption,[9] a rare glimpse of the historical forces and cultural conflicts that helped create the tragedy.

In May 1947, just over two months later, another unknown writer published what can most certainly be considered the first work of fiction to directly portray the February 28th Incident. "Blood and Hatred on the Island of Taiwan" ("Taiwan daoshang xue he hen" 台灣島上血與恨), written under the pen name Bo Zi, describes the incident through the story of young Taiwanese worker. Like "The Rural Defense Brigade," Bo Zi's work invokes the spirit of Lu Xun, not with a prophetic look at what was to come but with a satiric testimony to violence. When the story opens in 1947, 24-year-old Chen Fusheng 陳福生, a factory worker for 5 or 6 years, has already been unemployed for a full year—ever since the arrival of the Nationalist Army in Taipei. With the help of his aunt's boyfriend, Wu Chengfu 吳誠夫, Chen finally gets a job as a watchman at the Monopoly Bureau warehouse. On the eve of the incident, however, he loses his job after he approves doctored paperwork (which, as an illiterate, he cannot read), unknowingly aiding in the theft of 120 crates of goods. After being fired, Chen Fusheng spends his time meandering through the Taipei streets, often frequenting the Rose Teahouse (Meigui chashi 玫瑰茶室), where he quells his depression with ale. But soon the actions of his former employer, the Taipei Monopoly Bureau, trigger an explosion of protest, revolt, and violence—and even Chen Fusheng cannot escape.

9. These relatively obscure stories only began to receive attention after appearing in an anthology of February 28th fiction edited by Lin Shuangbu, who deemed both stories important works. "The Rural Defense Brigade" was later also included in Xu Junya's 許俊雅 updated anthology, *A Spring of Silence: A Selection of February 28th Fiction* (*Wuyu de chuntian: Er er ba xiaoshuo xuan* 無語的春天: 二二八小說選).

Although the story is openly anti-Nationalist and contains numerous de-
rogatory references to the newly arrived mainlanders, the protagonist is also not
portrayed in a very favorable light. Chen Fusheng's name literally means "born
unto good fortune," but that fortune seems to have ceased with Japan's with-
drawal from Taiwan. Caught between the remnants of Japanese colonial life to
which he clings while struggling to adapt to the ever-changing political reality
around him, Chen Fusheng is not a hero or even an everyman. Instead, he is
illiterate, clumsy, and politically backward. In picking up his pen to create the
first work delving into the February 28th Incident, Bo Zi seems to have looked
back to one of the first iconic literary characters in modern China—the ulti-
mate antihero, Ah Q. Although the portrayal of Chen Fusheng is not as sharply
satiric as Lu Xun's description of his most infamous protagonist, there are
numerous connections between the two characters. Inept at simple tasks and
awkward in his surroundings, Chen at one point, "tramples over broken glass"
and moments later is "almost knocked over by people pushing" (40–41). Later,
when he visits his favorite drinking spot, the Rose Teahouse, he makes a comic
entrance but ends up the source of derision: "He found himself a place to sit on
a soda bottle crate, but sitting his ass down on an empty bottle, he immediately
jumped to his feet and the glass bottle smashed to the ground. Everyone broke
out in giggles and laughter" (42). This scene evokes Ah Q's ridicule at the local
wineshop and the ridicule faced by Lu Xun's other antihero, Kong Yiji 孔乙己.
The location is of pivotal importance in much of Lu Xun's fiction, and a wine-
shop (specifically, Tianma's Teahouse on Yanping Road) is also a crucial place
in the history of the February 28th Incident.

But there are even further connections, as evidenced in the penultimate
scene in "The True Story of Ah Q" ("Ah Q Zhengzhuan" 阿 Q 正傳). Ah Q's
illiteracy paves the way for his execution, and Chen Fusheng's inability to deci-
pher the Chinese characters on an order form ultimately seals his fate. And
then, of course, there are the equally complex historical settings of the respec-
tive stories, tumultuous revolutions where nothing is clear-cut or black and
white. Just as in "The True Story of Ah Q," where characters seem to constantly
change sides, in "Blood and Hatred on the Island of Taiwan," the boyfriend,
Wu Chengfu, has close connections with the Monopoly Bureau (he is respon-
sible for getting Chen the job there), yet goes on to play a key role in the revolu-
tion (which is directed specifically *against* the Monopoly Bureau). And Chen
Fusheng, like Ah Q, is caught up in a revolution not of his making . . . and not
even of his understanding. However, toward the end of the novel, Chen
Fusheng, who is portrayed in a more endearing light than Ah Q, seems to shed
his passivity and take a proactive role in the movement. In the end, though, Chen

Fusheng and Ah Q share the same fate, both becoming revolutionary scapegoats—and victims of history.[10]

Because of its unique place as the first short story written about the February 28th Incident after the actual events, the description of the incident is of particular interest.

"The Monopoly Bureau has beaten to death an old woman!"

"Were they arresting cigarette vendors?"

"On Yanping Road! Right there on Yanping Road!"

Fusheng was stunned. His old aunt had a cigarette stand very close to Yanping Road. He immediately began running east along the East Gate rail line toward Yanping Road.

There were people everywhere, screaming, yelling. He was racing toward Yanping Road when, just as he passed the Railroad Administrative Office, he suddenly heard a series of gunshots and a crowd of people rushed away like a tide surging onto shore. But the people behind him continued pushing forward with their shoulders and the screams and cries grew louder. There seemed to be a fight going on before him, and people yelled to charge forward. It was not at all difficult for Fusheng to make his way to the center of where all the activity was. A crowd was surrounding a few investigators who could not escape and beating them. Fusheng mistakenly stepped on a dead body—he recognized him as a cigarette vendor named Chen. But he couldn't figure out how he could be lying there with his mouth open and a strange, twisted look frozen on his face. Not far from there an old woman was lying on the ground, sprawled out over loose cigarettes that lay scattered. Her gray hair was covered with blood. He knelt down, and it was only after he reached out to support her sunken face, which was still oozing blood, that he realized it wasn't his old aunt. In a loud voice, he kept trying to ask the woman her name, but after he'd called out to her for a while a cloud of black gasoline smoke overtook him, filling his throat and making him nauseated. While the crowd had the investigators surrounded and were on the attack, a Monopoly Bureau truck was burning in flames.

10. Although Bo Zi's story is infused with much anger and negative sentiment toward the mainland, it is not at all improbable for him to have looked to Lu Xun as a literary model. Lu Xun had a strong impact on Taiwanese intellectuals under the Japanese, especially in the years immediately following Taiwan's retrocession to the mainland. For a more detailed account of Lu Xun's influence on Taiwan literature, see Zhongdao Lilang, ed., *New Taiwan Literature and Lu Xun*(), which features separate accounts of Lu Xun's impact and reception in Taiwan during different historical periods. See also the chapter by Ruan Taoyuan 阮桃園, "When the Native Meets Ah Q" ("Dang yuanxiangren yushang Ah Q" 當原鄉人遇上阿 Q), in Chinese Department of Donghai University, ed., *Historical Experience in Taiwan Literature* (*Taiwan wenxue zhong de lishi jingyan* 台灣文學中的歷史經驗); and "Lu Xun in Taiwan" ("Lu Xun zai Taiwan" 魯迅在台灣) in Chen Fangming 陳方明, *In Search of a Canon* (*Dianfan de zhuiqiu* 典範的追求), 305–339.

"The military police are coming!"

"Who cares! Just because they are officials doesn't mean they can slaughter us like this!"

"Arrest the killers! The police are going to arrest the murderers!"

"Don't the police care?"

Several thousand people crowded around the police station, shouting deep into the night before finally dispersing with the anger still clinging inside them.

First thing the next morning, Fusheng headed out the door. He went down by Taiping Ding, where people had organized in throngs. They were angry, cursing, blindly pacing back and forth. Drums were pounding like thunder and gongs were sounding one after another. Some people's hands were already clenching rocks and sticks, and the crowd grew larger and larger. As soon as they laid eyes on a mainlander they would gaze at him with anger and the passerby would quickly slip away, bearing with him the curses that followed from behind; he dared not look back.

All of the stores were closed; posters written in black dripping ink were everywhere, as were Japanese flyers, which appeared all over the walls. What was written, and what everyone was saying, was:

"All 600,000 Taiwanese must stand up and unite!"

"Converge on the Monopoly Bureau to petition!"

"Execute the murderers!"

"Let the pig-headed officials pay with their lives!"

The crowd was so enormous that the streets were almost split open. They placed the dead bodies on a pushcart, and following them were thousands, tens of thousands of people. There were idlers, the old and the young; there was an entire brigade of students wearing their black school uniforms; there were even women wearing large straw hats . . . they were the full body of the Taiwan people—they were a flood of anger. (38–40)

This passage provides, to the best of our knowledge, the first literary narrative of the February 28th Incident. Although the text carries great importance as a literary document, we should be circumspect in reading Bo Zi's portrayal as an accurate *historical* document. For instance, although the incident did begin over a search for contraband cigarettes and someone with the surname Chen (Chen Wenxi) was killed in the ensuing conflict, he was not a cigarette vendor but an innocent bystander allegedly struck down by a stray bullet. Lin Jiangmai, the woman initially struck with the butt of a gun by one of the inspectors, was not an "old" woman but middle-aged. Although these may seem like relatively minor details, in both cases the author's interpretation works to

further heighten the sense of victimization of the Taiwanese and of human agency and intent on the part of the Monopoly Bureau. It is more reprehensible to beat an old lady than a middle-aged woman, and it is a much more serious crime to intentionally execute a cigarette vendor for a minor offense than to accidentally kill someone with a stray bullet. Bo Zi's subtle revisions to history can be partly attributed to the abundance of rumors about the event and the lack of credible reports; however, they can also point to the problematic role literature plays in this context. Was Bo Zi out to objectively record history or incite it?

Bo Zi also presents chilling accounts of retributive attacks on mainland Chinese. The disturbing manner in which the violence is portrayed is complicated by the narrative politics of the story, making the reader wonder if Bo Zi applauds the violence or is appalled by it:

> At the station, a crowd of people pulled a man out from a Taiwanese's home. When he emerged, his neat blue suit was already torn into a ragged cloth; his face was a deathly pale as he kept stuttering that he was a Taiwanese—until a big, fierce guy started interrogating him in Japanese. He didn't understand, his legs collapsed beneath him as he knelt down, but the big guy kicked him to the ground, quickly followed by the crowd, who descended upon him with kicks and clubs. They beat him until he was a ball of battered blood and flesh. On another street a low-level government worker wearing glasses ran for dear life down the street, his hands holding his bloody head. Following close behind and not letting him go were a group of children, taunting and beating him as he ran. Fusheng clapped his hands when saw them, yelling:
> "Yeah! Great! Great!" (45)

Also unclear in this passage is what Chen Fusheng's enthusiasm is meant to symbolize. His evolution from political ignorance to political activism seems to hint at the emergence of a newfound nationalism. Amid the chaos, Chen Fusheng clearly rejects his new "Chinese" identity (represented by the mainlanders), but he is unable to sufficiently define another identity for himself as "Taiwanese." Instead, he is forced to revert to the only identity he knows, that of a Japanese, or rather, a Japanese subject, as is exemplified in several passages, such as his singing of Japanese songs. "Blood and Hatred on the Island of Taiwan" portrays not only Taiwan in crisis, but, even more vividly, identity in crisis.

Looking back on the tragic tale of Ah Q, who is simultaneously both slave and revolutionary and dies a scapegoat for ideals he neither believes in nor comprehends, we are better able to understand the predicament of Chen Fusheng and his contemporaries. These early literary accounts of the February

28th Incident speak to the clash of cultures, ideologies, and histories and also testify to individual identities in conflict, confusion, and crisis. However, these works are but the first chapter in what would become a long tradition of remembering and writing violence. Some atrocities do not simply fade away but expand and grow through time. The tragedy of February 28th was only beginning.

Silent Cries: Wu Zhuoliu, Chen Yingzhen, and the Burden of History

"Blood and Hatred on the Island of Taiwan" stands out not only for being the first work of its kind but also, under the shadow of the White Terror, for proving to be the last for a long time. Although most literary discourse on 2/28 ceased shortly after the incident, a small group of writers dared to speak out during the most repressive era of Nationalist rule. These writers and their works represent a missing page in the history of 2/28 as well as modern Chinese literary history, through which we can begin to understand the true extent of the event's violent heritage.

In 1967, after two decades of silence about the February 28th Incident, veteran writer Wu Zhuoliu completed his classic *The Fig Tree* (*Wuhuaguo* 無花果). With the final chapter of this stirring autobiography, "Before and After the February 28th Incident" ("Er er ba shijian ji qi qianhou" 二二八事件及其前後), rendered as "Massacre" in Duncan Hunter's translation, Wu Zhuoliu became one of the sole voices brave enough to broach this taboo historical event during the politically oppressive 1960s. First serialized in three 1968 issues of *Taiwan Literature* (*Taiwan wenyi* 台灣文藝), which Wu edited, *The Fig Tree* was published in book form in 1970, when it was immediately banned. Although copies circulated underground, it was not until the late 1980s, long after the author's death, that the bold humanism of *The Fig Tree* was finally resurrected and saved from literary obscurity.

Although Wu Zhuoliu still believed in the power of literature even after witnessing the catastrophic February 28th Incident (as shown through his continued support of the arts through *Taiwan Literature*), he found it impossible to write any more fiction or poetry. Like Adorno, who once wrote, "To write poetry after Auschwitz is barbaric" (Adorno 1973:362), Wu turned away from creative writing, focusing instead on his editorial work and his memoirs, of which *The Fig Tree* is the most powerful. But it is also a telling sign that, although the book was written in 1967, its narrative ends twenty years earlier, with the February 28th Incident of 1947—for Wu Zhuoliu, it was not only poetry that ceased after that date, but life itself.

The portrayal of February 28th presented in *The Fig Tree* was one of the few non-state sanctioned narratives that existed, albeit in very limited form, during the long Nationalist-sponsored historical blackout. Wu's account is also valuable for its rich and thorough contextualization, a long historical narrative of the author's own life and modern Taiwan's long road toward its "glorious return" to the mainland and the terrible tragedy that would follow. In addition, as a journalist, Wu provides a somewhat less biased perspective on the incident and draws on extensive journalistic sources, information, and connections that place him in a more privileged position to tell the story. Even as Wu prepares to describe the actual events, he is careful to reference the greater social factors at work:

> Prices were going up and public order was rapidly deteriorating. Public property was vandalized and people were even helping themselves to panes of glass from school buildings or removing rails from the sugar refineries' permanent way. But the chaotic conditions were caused by more than just stealing. According to Qiu Nantai's book, *Ling hai wei biao*, some of the troops stationed in Taiwan were replacements from the mainland, new recruits who had no rigorous military training. Taiwan was a new experience for them; they had gone wild and committed many outrageous acts. As a result they were despised by the citizens and transformed into targets of popular hatred. It would not be inaccurate to say that conditions were exactly as Qiu describes them.
>
> In the middle of February the price of rice went up two or three times a day as news spread that 500,000 tons of sugar, which was the guarantee of the Taiwan currency, and thousands of tons of coal were being shipped to Shanghai. That was one explanation at least—the other was that profiteers were stockpiling the stuff. But whatever the reason, from one day to the next rice all but disappeared from the shops. There was a wave of protests from the townspeople, and their grievances to the mayor. It was in this angry atmosphere that an event of momentous impact suddenly occurred. (Wu Zhuoliu 1993:236–237)

Although Wu's censure of the Chen Yi government is clear, so is his sensitivity to the losses incurred on both sides; he points out that "in Taipei alone 33 government employees had been killed and 866 injured." But he is also quick to remind us that "the number of dead and injured among the general population, and the extent of their losses, was certainly much, much greater and should go down in the record as an indelible stain on the history of those times" (241). Most disturbing in Wu's account than the images of dead bodies littering the streets and alleys in the immediate aftermath of the conflict are his subtle de-

scriptions of intellectuals who simply "disappeared," never to be heard from again, in the government's subsequent crackdown.

After so many years of neglect, Wu Zhuoliu and his 2/28 narrative posthumously reclaimed their place in the canon of modern Chinese fiction. Wu's work, however, continues to be a point of contention in the battle for history, as is made even more evident by his last major book, 1975's *The Taiwanese Forsythia* (*Taiwan lianqiao* 台灣連翹). As the late critic Helmut Martin points out, this memoir "was again written in Japanese for fear of KMT reprisals, and only intended for publication in a more open future. Wu picks up the themes of *The Fig Tree*, fleshing them out and making more explicit what he could only hint at, or not even mention at all, in the 1967 book" (xiii). Martin goes on to explain Wu's further violation of an unspoken taboo concerning the role of *banshan ren* 半山人, a term alternately used to describe people originally from Taiwan who had temporarily moved to mainland China during the Japanese occupation or individuals of mixed Taiwanese and Chinese blood:

> This group of landowners, officials, and merchants, who had either been with Chiang Kai-shek in Chungking or had lived in the Japanese-occupied areas of China during the war, returned to the island in 1945, in the wake of the KMT takeover, as powerful henchmen of the Generalissimo. Detested as rapacious and power-hungry parvenus, they had, unlike other members of the local intelligentsia or upper class, the advantage of speaking fluent Mandarin. Wu makes it clear that he sees them as lackeys of the new rulers of Taiwan, briefing Chiang's mainlanders, who spoke neither Japanese, the former official language, nor the Taiwanese dialects, on the local conditions and, in some cases, providing names for the blacklist that had served as the basis for the organized killing of intellectuals in the aftermath of February 1947. So sensitive was this issue that even in 1993, the premier, Lian Zhan, whose father, himself a *banshan*, had been active in the transition years, became very abusive when the topic resurfaced—so much so in fact that the [. . .] Taiwan branch of P.E.N., backed up by the opposition in parliament, felt forced to launch a counterattack to defend Wu's work against groundless accusations by leading establishment politicians that it had no literary, or other merit. (xiv–xv)

The irony of this example testifies to the power that literature can carry in the political realm and to what extent the February 28th Incident remains a source of controversy and contention. But Wu Zhuoliu was only too clear about the tragedy and irony that imbue history. As he wrote at the end of *The Fig Tree*, "[2/28] was a manifestation of the evil ways of an obscene, feudal bureaucracy, a

tragedy caused by men who thought human beings were no better than ants. Many died as meaninglessly as Ah Q had died" (1993:261).

Chen Yingzhen (b. 1937) first read Lu Xun's famous story in a literary anthology while still a youth in Taiwan. Chen would later frequently be compared with the iconic May Fourth writer, as many of the themes in his work echo Lu Xun's critical spirit.[11] Chen's work is also another example of literary resistance against the Nationalist control of history and historical narrative. For several decades, Chen has been prominent on the Taiwan literary scene for his sensitivity to the social plight of those around him and his unwavering commitment to his political ideals, for which he sacrificed seven years in prison (a period he has described as his own "cultural revolution"). In his 1960 short story "The Country Village Teacher" ("Xiangcun lai de jiaoshi" 鄉村來的教師), Chen took a different approach to the February 28th Incident and narrating the violent legacy of modern Chinese history.

In this disturbing story, Wu Jinxiang 吳錦翔, conscripted by the Japanese and long assumed to have died in Southeast Asia, suddenly returns to his mountain village in Taiwan. His homecoming is startling because it happens in 1946, a full year after the war's end and Taiwan's return to the mainland. Wu is assigned to run the local elementary school, where he instructs seventeen students, and begins to find solace in a nostalgic longing for China and the sentiment that, after so many years of war, peace has finally come. Eventually, however, the ghosts of the past and the horrific memories of what he experienced in Borneo begin to catch up with Wu Jinxiang. Less than five years after his return to his quiet mountain village, his body is discovered by his mother:

> From his thin outstretched hands blood flowed, forming a great pool. The wounds of his severed veins were perfectly clean. Jaggedly sliced muscle tissue appeared white, almost lucent, like fresh swordfish meat. His eyes were wide open and staring. His upper teeth were clamped tightly into his lower lip, their whiteness vividly contrasting with the dark disarray of his curling whiskers and hair. His face was the bloodless white of tallow. His countenance expressed an unimaginably profound skepticism. (Miller 1986:48–49)

Two and a half months earlier, as the village prepared to send a young man off to the army, a drunken Wu Jinxiang had revealed that he had eaten human flesh during his time in Borneo. The story quickly spread throughout the

11. For comparisons between Lu Xun and Chen Yingzhen and arguments tracing the influence of Lu on Chen, see Sung-sheng Yvonne Chang, *Modernism and the Nativist Resistance: Contemporary Chinese Fiction from Taiwan*, 164, 166–167 and Lucian Miller, *Exiles at Home*, 4, 23.

mountain village, as did a haunting paranoia, until Wu made the decision to take his own life. Once again, the echoes of Lu Xun are evident, especially in Chen's description of the village people after Wu's dark secret is revealed: "wherever he went he would be met with strange glances, students talking, women whispering behind his back, the children in class staring transfixed with eyes like corpses. He could not stop sweating. The skulls of the children appeared so thin and fragile. Their alien looks reminded him of the terrified gleam in the eyes of the native girls in Borneo" (48). The passage bears a startling resemblance to Lu Xun's "Diary of a Madman," where an "awakened madman" is convinced that those around him are cannibals waiting to consume his flesh. Here Chen Yingzhen presents an ironic twist in which the "cannibal" is consumed, driven to insanity and suicide by the vicious stories and rumors about his tortured past.

Another key to reading the story (and understanding Wu's suicide) is not the literal cannibalism of human flesh but the even more powerful, metaphoric cannibalism of history. When Wu Jinxiang first returns to Taiwan, he continually repeats the phrase, "Peace has come." However, peace does not last long:

> The next year at the beginning of spring, the upheaval within Taiwan and the turmoil on the mainland spread to Wu's isolated mountain village. Fresh excitement flowed into the simple village society, where the people so loved to gossip. Everyone chattered about what was going on, or declaimed loudly and inflated the news. At this point teacher Wu became aware of a disturbance within himself, and also of other obscure emotions. (43)

The "upheaval within Taiwan" is a naked reference to the February 28th Incident, while the "turmoil on the mainland" points to the Chinese Civil War, which would soon result in a large-scale Nationalist retreat to Taiwan. Only with this change does Wu begin to be aware of the conflict building within him. As Wu's own student is sent off to war, beginning another cannibalistic nightmare, the biting irony and cyclic cruelty of history prove too much for the country teacher to bear. In the shadow of 2/28, Wu Jinxiang takes his own life and Chen Yingzhen takes on the burden of history, writing a bold new page in China's struggle against the demons of the past.

To better understand the silent cries of Wu Zhuoliu, Chen Yingzhen, and the unknown number of other writers who continued to confront 2/28 and the political violence of the Nationalist Party, even during the height of the White Terror, it is useful to consider the work of a PRC critic examining a similar phenomenon across the Taiwan Strait. In a fascinating 1999 essay entitled, "Our Drawer: An Attempted Examination of Invisible Writing in Contemporary

Chinese Literary History (1949–1979)," Shanghai-based literary critic Chen Sihe 陳思和 described the practice of "*qianzai xiezuo*," (潛在寫作) "latent" or "underground" writing, which is here rendered as "invisible writing."[12] Also referred to as "drawer literature," it designates unpublished writings "kept in the drawer," left outside the discourse of literary history, and published only much later. As Chen clarifies, invisible writing "is limited to works in which publication was not a consideration at the time of writing, or works written despite the fact that the author knew that publication was impossible" (Chen Sihe 2001:61).

This partly describes the literary activities of Wu Zhuoliu and, to a lesser extent, Chen Yingzhen, both of whom were very conscious that much of their writing was unpublishable (and that it would most certainly be banned if it were published), yet persevered even during the darkest political era in modern Taiwan history. The cross-strait activity of invisible writing also speaks to the ironic fact that even at the height of the ideological war between "Free China" and "Red China," writers in both places were fighting their own personal war against literary censorship, oppressive politics, and history.[13] Wu Zhuoliu and Chen Yingzhen are among the rare examples of writers who fought against all odds and at all costs (including a lengthy prison term for Chen) for their work and their beliefs. Invisible writing reminds us that there are yet more stories about the February 28th Incident waiting to be written, and perhaps still some waiting to be discovered.

Crucifying the Innocent: Li Qiao, Lin Shuangbu, and the Rebirth of Political Fiction

Although numerous writers, such as essayist Bo Yang 柏楊 (a.k.a. Guo Yidong 郭衣洞) and historian-cum-cultural critic Li Ao 李敖, went to great lengths in testing the literary limits and pushing the political boundaries under martial law in Taiwan, and writers like Chen Yingzhen and Wu Zhuoliu dared broach the subject of 2/28, the consequences were often severe. In 1960, the daring periodical *Free China* (*Ziyou Zhongguo* 自由中國) was shut down and its editors, including Fu Zheng 傅正 and Lei Zhen 雷震, were imprisoned. The following

12. See "Women de chouti: Shi lun dangdai wenxue shi (1949–1976) de qianzai xiezuo" 我們的抽屜:試論當代文學史 (1949–1976) 的潛在寫作 in Chen Sihe, *On Tigers and Rabbits* (*Tan hu tan tu* 談虎談兔), 61–80.

13. An additional example of "invisible writing" is Ah Long's *Nanjing*, which was discussed in chapter 1. Although written in the 1930s, the novel was not officially published until 1987.

year, Li Wanju 李萬居, head of *Public Opinion* (*Gonglun bao* 共論報), was also arrested. In 1968, eight years after "The Country Village Teacher" was published, Chen Yingzhen was imprisoned on charges of inciting rebellion. In 1969, Bo Yang, who would later gain much fame and arouse much controversy with *The Ugly Chinaman* (*Chouluo de Zhongguoren* 醜陋的中國人), was sent to the notorious home of political prisoners, Green Island, allegedly for translating and publishing a controversial installment of Popeye the Sailor Man. And these were just a few of the more high-profile victims of a new kind of literary inquisition, which also targeted such writers as Ye Shitao 葉石濤, Shi Mingzheng 施明正, Li Ao, and Ke Qihua 柯旗化.

Only in the early 1980s, after the death of Chiang Kai-shek (1887–1975), did a thaw begin and literary depictions of the February 28th Incident finally surface. One of the first writers to revisit the atrocities of 1947 was Li Qiao 李喬. A native of Miaoli 苗栗, Taiwan, Li Qiao (pen name of Li Nengqi 李能棋) was born in 1934 to a Hakka family and worked for most of his life as a middle school teacher, while pursuing a prolific career as a writer on the side. Li has been publishing fiction for over forty years, including such novels as *The Spring of Blue Rosy Clouds* (*Lan caixia de chuntian* 藍彩霞的春天) and the classic trilogy *Wintry Night* (*Hanye sanbuqu* 寒夜三部曲),[14] which was written between 1975 and 1980. In the 1982 premier issue of *Literary World* (*Wenxuejie* 文學界), Li published "Fiction" ("Xiaoshuo" 小說), which, betraying its title, became one of the first literary works in many years to face the "reality" of what occurred thirty-five years earlier around the time of the February 28th Incident. The story received much critical acclaim and was reprinted in several anthologies; its very publication signaled a transition to a more relaxed political climate.

"Fiction" is a challenging work that begins with an exploration not of history but rather of literature.

> To my young friends: You ask, "What is fiction?" This is a question that is very difficult to answer, but it is also very simple.
>
> My own personal opinion is that a chaotic mess all thrown together with a bunch of nonsense is what you call fiction. Because fiction is written about the affairs of people, and people. . . . What? You don't believe me? Okay then, why don't you try out the story of Zeng Yuanwang for size? (Li Qiao 1989:233)

Only after this short dialogue with the reader does the narrative proper begin, exploring the bitter experiences of a political fugitive named Zeng Yuanwang

14. An abridged version of the trilogy is available in English translation. See Li Qiao, *Wintry Night*.

曾淵旺, a name homonymic with "unjustly accused." As the protagonist in one of the early landmark works of 2/28 political fiction, Zeng is not the political hero or champion of Taiwanese patriotism that we might expect. Instead, he is a middle-aged father of several grown children who works in a tea factory. It is the early days of Nationalist rule in Taiwan and Zeng, whose family once owned many tea fields, now finds himself a mere worker. He takes part in a local protest march, which apparently corresponds to the February 28th Incident. It ends with a local official being pushed to the ground and, although Zeng had no role in the minor conflict, he somehow becomes a political outlaw. The center of this short novella focuses on the main character's life as a fugitive, living in the barn of a distant cousin.

Although the story seems simple enough, Li Qiao's structure is deceptively complex. The narrative proper is divided into six sections, each labeled with a different date: "March 13, That Year," "March 13, This Year," "April 28, That Year," "April 27, This Year," and so forth. This sets up a pattern of repetition whereby events are told and retold in slightly different ways, bridging the past and the present. The disjointed narrative structure parallels the increasingly schizophrenic psychological state of the protagonist, whose self-imposed solitude in the barn begins to drive him mad. The disintegration of Zeng's psyche is displayed first through stream-of-consciousness ramblings:

> I confess my crime—what crime? I don't know, but since the investigator said I was guilty I suppose I must be guilty, and if I'm guilty I must be punished, but I'm afraid of the investigator's punishment do I just punish myself here I don't want to counterplea I don't want to refute I just want to admit guilt like a good boy and see if they will forgive me stop investigating me stop trying to arrest me over time everything will gradually be forgotten. (255)

But over time everything is not forgotten, and Zeng's schizophrenia only gets worse:

> That's right, I'm a criminal, a criminal guilty of terrible crimes, I carry guilt and must face up to my crime, my participation in the demonstration was a crime, it was rebellion, it was a treason, I should be sent to prison and locked away, and after receiving judgment I should be sentenced to death—No, No! Execution too severe, don't I have the opportunity to repent? And execution will really hurt I don't want that—so, it is best if I don't get caught, I will serve out my sentence here in this dilapidated cowshed! I shall sentence myself and carry out the punishment myself, the principle and result should be the same. He thought. (266)

This disturbing passage points to the power of the state to convince even an innocent man that he is "guilty"—in his delusional mindset. Zeng even comes close to endorsing the belief that his crimes are punishable by death. (His "crimes" are also enough to convince his cousin, who eventually divulges his location to the authorities.) In a larger context, Zeng Yuanwang's schizophrenia is a metaphor for the cultural schizophrenia symptomatic of living within a historical fissure—a predicament in which many characters (like Chen Fusheng) found themselves during 1947. "Fiction" is about the February 28th Incident, but more important, it is, once again, about the crisis of identity that the incident represented.[15]

Li Qiao revisited many of the themes first touched upon in "Fiction" with his 1984 novella, *Record of Taimu Mountain* (*Taimu shan ji* 泰姆山記).[16] In this second, more complex story, Li Qiao incorporates mythic elements of aboriginal culture into the tale of a political fugitive forced into hiding in the wake of the February 28th Incident. After living in seclusion for four months in Xizhi 汐止, Yu Shiji 余石基 decides to find a safer haven. With the help of his aboriginal friend, Wo Xing 窩興, Yu escapes from Taipei and, after a long cat-and-mouse chase eluding investigators aboard a series of trains and buses, eventually arrives at an aborigine reservation near Ahli Mountain 阿里山. There, Wo Xing's cousin, Falu Wayong 法路瓦勇, leads him to the sacred Taimu Mountain. Yu's pursuers catch up with him, and it is there on Taimu Mountain that the protagonist finds salvation and, ultimately, death.

However, things are not quite what they seem in *Record of Taimu Mountain*, which continues the exploration of identity begun in Li's earlier 2/28 story. Yu Shiji, is actually not a political activist or revolutionary leader but a mild-mannered music teacher, who had studied classical violin in Japan. However, after the February 28th Incident, he mysteriously becomes a target of the Nationalist authorities, another innocent victim of the White Terror. One reason may be his relationship with Wo Xing, who, as is later revealed, orchestrated the attack on the Jiayi Airport during the incident.[17] But as the story

15. Another crisis that Li's story undertook to explore was the dichotomy between history and fiction, a question that Li Qiao would continue to pursue, along with the February 28th Incident, in his 1995 novel *Burying Injustice: 1947: Burying Injustice,* which is discussed in the final section of this chapter.

16. Also published under the alternate title *Taimu Mountain* (*Taimu shan* 泰姆山).

17. The incident that occurred at the Jiayi Airport is of great significance in the history of the February 28th Incident. On March 3, a brigade of protesters took over a weapons warehouse where they confiscated Nationalist weapons and armed themselves heavily. The resistance took over much of the city and launched a major attack on Nationalist forces at the airport. On March 12, large numbers of Nationalist soldiers were flown in and what was probably the largest massacre of the February 28th Incident ensued. Historian Yang Yidan 楊逸舟 has noted that the conflict in Jiayi marked "the largest and most devastatingly brutal battle of the entire uprising" (*Er er ba minbian* 143). See the discussion of Yang Zhao's fiction later in this chapter.

progresses, both Wo Xing and Yu Shiji are shown to have several conflicting names and identities, which open up a complex web of altered identities, mistaken identities, and identity crises between the two characters.

Wo Xing, who served as a second lieutenant under the Japanese, renounces his Japanese surname, Yukawa (Tangchuan) 湯川, as he tells Yu Shiji (to whom he refers as "Shitou" 石頭, or "Stone"): "Shitou: Don't be like that. Me, Wo Xing, just a stupid second lieutenant, a murderer who has killed with knives and guns; but that was before. Tangchuan is dead, from now on, and for all eternity I will never kill another man, I am Wo Xing!" (Li Qiao 280). Interestingly, after stripping off the label of Japanese colonialism and adopting a new, sinicized name, Wo Xing consistently refers to himself not by his Japanese or even Chinese name but by his reappropriated, distinctly aboriginal name—Wo Xing. When he leads the attack on the airport, he does so not as a disconcerted pro-Japanese or even as a native *bensheng ren* 本省人 activist, but as an aborigine.

Wo Xing and his cousin, Falu Wanyong, both carry the scars of colonialism and cultural hegemony, as evidenced by their multiple names and even their speech, which is a strange mixture of awkward, Taiwanese-inflected Chinese, spoken with a heavy native accent, and Japanese. Even after telling Yu Shiji about his decision to renounce his "Japanese" identity in favor of his "native" identity, Wo Xing quickly follows up by saying: "Shitou, you big Stone! Do you take me, Wo Xing, for a 'savage' that you can just kill?! Humph!" (280). Here, Wo Xing makes clear that, although he has reappropriated his aboriginal identity, it is not the stereotypical native as savage but a new, empowered conception: native Taiwanese as cultured rulers of their own fate.

Yu Shiji is caught in a similar identity crisis, which eventually takes on a distinctly historical context. Yu, who also speaks a mixture of Chinese, Taiwanese, and Japanese, also goes by several names throughout the story. He is referred to as "Stone" by Wo Xing and makes up a false name when registering at a small hotel. But it is not until the inspectors catch up with him at Taimu Mountain that the power of identity becomes dangerously evident. While Yu is convinced that he is a wrongly accused victim of the post–2/28 crackdown, he is, in fact, simply the victim of a case of mistaken identity. The investigators pursuing him are actually after Lin Shuangwen 林雙聞, another one of the leaders of the uprising in Jiayi. Yu Shiji, however, mistakenly believes they are looking for Lin Shuangwen 林爽文. While the former Lin Shuangwen refers to one of the masterminds of what was perhaps the bloodiest episode of the February 28th Incident, the latter Lin Shuangwen (?–1788) refers to the leader of one of the most violent rebellions in early Taiwan history. His 1786 campaign "be-

gan in [Dali] near [Taizhong] as an attempt to overthrow the Qing administration and reinstate the Ming. As they moved north, Lin's followers carried out wanton destruction, murder and looting as underlying ethnic hatreds gushed forth. [. . .] Eventually Hakka, Ch'uan-chou Fujianese and aborigine volunteers joined with government troops to defeat Lin's band" (Roy 2003:22). With more than 10,000 supporters at its height, Lin's uprising was the largest peasant revolt in Taiwan history, and took an especially heavy toll on what is today Zhanghua 彰化 and—Jiayi. Here, Li Qiao skillfully inscribes one historical atrocity onto another. At the same topographical site, a duplicity of violence is created and Yu Shiji, the unsuspecting protagonist, carries the dual identities of both revolutionary leaders.

As the inspectors pursue Yu Shiji, he continually proclaims his innocence, explaining that they have the wrong man. But when they ask just who he is, Yu responds, "I'm . . . Yu Qingfang! You don't know me" (Li Qiao 1989:309). But readers know Yu Qingfang, another figure of pivotal importance in modern Taiwan history. Yu Qingfang 余清芳 (1879–1916) was the leader of the 1915 Xilai An Incident 西來庵事件, also known alternately as the Ta-pa-ni Incident 噍吧哖事件 and the Yu Qingfang Incident 玉清芳事件, a large-scale, religiously inspired anti-Japanese uprising that culminated with an armed attack on a Japanese police headquarters building. The Japanese suppressed the uprising with mass executions and the alleged massacre of more than 1,000 in a village that helped conceal the rebels.[18] The hero, like Yu Shiji, escaped into the mountains, but was eventually captured by the Japanese and executed.

Projected onto Yu Shiji are the identities of *three* rebel leaders and folk heroes from three different ages. From the Lin Shuangwen Incident of 1786 to the Xilai An Incident of 1915 to the February 28th Incident of 1947, Li Qiao maps out a history of patriotism, rebellion, and suppression, all at a single site and embodied in one fictional character. All the leaders were driven to rebel by a patriotic rejection of outside rule, but each case ended with a brutal crackdown, a massacre, and the death of the leader. Through this subtle layering, *Record of Taimu Mountain* once again demonstrates the tragically cyclical nature of history. And, although we know that Yu Shiji is not any of these three leaders, he carries their burdens, their sadness and their failures—the original sins of Taiwan's past.

18. According to some accounts, the death toll was more than 3,000; however, the actual number of victims of the Xilai An Incident remains unknown. For more, see Paul Katz's monogragh, *When the Valleys Turned Blood Red: The Ta-pa-ni Incident in Colonial Taiwan.*

Li Qiao's meditation on identity is further complicated by the fact that the character Yu Shiji was largely inspired by the actual biographical details of writer Lü Heruo and the tales of his disappearance, related to a political incident in which he was involved, and mysterious death in the aftermath of 2/28. Lü Heruo, whose original name was Lü Shidui 呂石堆, allegedly died after being bitten by a poisonous snake, the same fate met by Yu Shiji.[19] In his exploration of the February 28th Incident, Li Qiao went back to the source of its literary heritage. Li Qiao's story also marks a return to history itself and the original homeland lying beyond the conflicts among Chinese, Japanese, and Taiwanese, serving as a reminder that although the February 28th Incident in large part represented a political and ideological war between "mainlanders" and "Taiwanese" over the fate of Formosa, the only "true Taiwanese" are the aboriginal peoples of the island, who have, unfortunately, been written out of much of history.

For Li Qiao, resolution lies in a mythic journey to the land of Taiwan's aboriginal peoples and the mystical Taimu Mountain, a place where the past meets the present and history meets legend. On the holy mountain that "can move" and is "wife to the sun," Yu Shiji hopes to find solace, protection, and forgiveness for his sins:

> In the past I have sinned—of course, my crimes are not those that "they" have
> assigned to me. I have been ignorant, arrogant, selfish, thankless, I have not
> cared about where I come from, nor have I done my best for my compatriots.
> I am weak and have not done what I should have; instead I just tried to protect
> this dirty and despicable shell of flesh of mine. I am only dragging out my
> shameful existence by coming here. I don't have the right to receive protection
> or be given safe haven. (304–305)

Yu Shiji's monologue about his "sins" echoes that of Zeng Yuanwang in "Fiction," but Yu's "crimes" are not those of political deviance—they are the original sins of history. And Yu is punished, but not by the gun of his pursuer. Taimu Mountain's rejection comes in the form of a fatal bite by a poisonous snake. Li Qiao thus transforms the tragic tale of a persecuted artist into a larger-than-life allegory of sacrifice and redemption. Like Lin Shuangwen, Yu Qingfang, Lin Shuangwen, and Lü Heruo, who also died by a serpent's bite, Yu Shiji enacts a new chapter in Taiwan's history of political martyrdom that retraces the lineage of rebellion, political violence, and Taiwan's pain.

19. Lü Heruo was a native of Fengyuantanzi, Taiwan, which is also the hometown of Yu Shiji in *Record of Taimu Mountain*.

Li Qiao's initial foray into what had been no man's land on the literary map opened the way for a major breakthrough the following year. On July 16, 1983, Lin Shuangbu's 林雙不 "A Brief Chronology of Huang Su's Life" ("Huang Su xiao biannian" 黃素小編年) ran in the evening edition of one of Taiwan's major newspapers, the *Independence Evening Post* (*Zili wanbao* 自立晚報). Lin Shuangbu, or "Double Negative Lin," is the pen name of Huang Yande 黃燕德 (b. 1950),[20] author of such novels as *Friday Showdown* (*Juezhan xingqi wu* 決戰星期五) and *The Great Buddha Is Without Attachment* (*Da fo wu lian* 大佛無戀), along with numerous short stories. A teacher for most of his life, Lin was a major voice in the nativist camp who wrote extensively about the Taiwan countryside and later published numerous stories about campus life. "A Brief Chronology of Huang Su's Life" traces the story of Huang Su 黃素, a young, vibrant nineteen-year-old girl full of elation and excitement about her coming marriage to Wang Jinhai 王金海. On a spring morning in 1947, as her wedding draws near, Huang Su and her mother get dressed up and go to town to purchase items for her new married life, among them a good-quality knife. Just as their day in town begins to wind down, a crowd of Taiwanese with clubs chasing a group of mainlanders rushes by, and Huang Su gets swept up. By the time the chaos and commotion have passed, Huang Su is lying on the ground, covered in blood—and beneath her is a dead body. She is immediately arrested for murder. Then, one day in early 1948, the triangular-faced investigator visits her in her cell to announce, "Proof of your guilt has been displayed and you have been sentenced to death." Huang is brought before a firing squad and is just about to be killed when an eleventh-hour stay is granted and she is released. The news, however, comes too late—Huang has already gone insane.

Huang Su returns home incontinent and mad, continuously uttering, "I don't want to be shot! I don't want to be shot!" However, it not just Huang Su who has suffered:

> It was late spring when Huang Su returned to her small village. There to welcome her was a family that had been transformed. Four months after Huang Su disappeared, her father took ill and had been bedridden ever since. As her mother gradually began to get news about what had happened to her daughter, it proved too much to bear—she had a stroke and remained paralyzed in bed. The smiles that once lit up the faces of her three sisters-in-law had all disappeared; it seemed as if even the ducks and geese had ceased their quacking. (Lin Shuangbu 1992:70)

20. Lin Shuangbu also published extensively under the pen name Bi Zhu 碧竹.

Eventually, Wang Jinhai's family comes to formally break off their engagement, and Huang ends up confined to the small lumber shack beside the pigsty. Unable to control her bowel movements, uttering incoherent ramblings and living next to pigs, Huang Su is transformed into an animal. Nowhere else had the dehumanizing effects of 2/28 political oppression been displayed in such disturbing and literal terms. Part of the reason Lin Shuangbu's portrayal of Huang is so unsettling is that the violence and mistreatment are dealt to her not only by the hand of the state but also by society. Although the state initiates the attack on Huang Su, it is society, through stigmatization and a psychology of shame and fear, that finishes the job. The author pushes her tragedy into the future:

> Winter 1959, Huang Su's mother suddenly extended her legs as she bid farewell to this world. After that, her three sisters-in-law gradually began to stop taking care of Huang Su. Huang Su would often run away, but no one was ever concerned about finding her: it would always be a good-hearted neighbor who would bring her back. She was incontinent, did not know how to get dressed or comb her hair, and, gradually, she became a dirty and small old madwoman. The children in the village were not afraid of her; on the contrary, they would throw stones and curse her. (67)

Finally, in the summer of 1967—exactly twenty years after her arrest— thirty-nine-year-old Huang Su leaves home again. After getting kicked off several trains for not having a ticket, she ends up walking north along the tracks, toward Taipei, the place where all her nightmares began. But Huang Su's return to the source of violence is never completed:

> Suddenly she heard the anxious sound of the steam whistle and the deafening rumble of the steel tracks coming from behind her.
> Huang Su turned to look. The train was coming straight at her.
> Huang Su stood in the middle of the bridge; she didn't move a muscle. (67–68)

Owing to its wide distribution in a major newspaper, Lin's story was the first piece on the February 28th Incident that many people had ever read. The story also stands out for its historical reflection, which both portrays the incident and, more important, sketches the lineage of trauma and tragedy sparked by it. Lin displays the widespread social ramifications of the February 28th Incident and the ways it affected entire families and all of society over time. Huang Su's involvement comes down to nothing more than being in the wrong place at the

wrong time, but sometimes fate weighs heavily. The February 28th Incident also weighs heavily on Lin Shuangbu, who, after the publication of "A Brief Chronology of Huang Su's Life," became a high-profile activist, editing books on the subject and delivering lectures advocating a full government redress of the incident, including the payment of reparations to victims and the establishment of a commemorative museum.[21]

Together with Li Qiao's "Fiction" and *Record of Taimu Mountain*, "A Brief Chronology of Huang Su's Life" continued the literary exploration of innocent victims of Taiwan's post–2/28 political witch hunt.[22] Although Li Qiao's protagonists are hunted because of their political background, neither is a true revolutionary or political hero in any sense of the word; they are punished simply for voicing their discontent and political persuasion. Lin Shuangbu's daring story, however, paints the hunted criminals of February 28th as mere victims of circumstance, not perpetrators of any real crimes. Both writers expand readers' conceptions of atrocity, Li Qiao by placing 2/28 in a much larger historical context that points back to a long tradition of failed revolutions and tragic martyrdom, and Lin Shuangbu by displaying not only the results of state violence but also the even more devastating effects of social stigmatization faced by former political prisoners, even innocent ones. Together, Li Qiao and Lin Shuangbu tested the limits of political fiction in the early 1980s, and through the wide distribution of their work, succeeded in opening the floodgates for a new social and cultural discourse on Taiwan's dark past.

Reconstructing History: An Overview of 2/28 Fiction in the Post–Martial Law Era

Although Li Qiao, Lin Shuangbu, and others had already begun to stretch the limits in the mid-1980s, it was not until 1987, when martial law was lifted by the

21. After years of controversy, the Taipei 2/28 Memorial Museum (Taibei ererba jinianguan 台北二二八紀念館) was finally established in 1997, inside the former location of New Park (Xin gongyuan 新公園), which is now known as Peace Park (*Er er ba heping jinian gongyuan* 二二八和平紀念公園), renamed in memory of 2/28. See http://228.culture.gov.tw/.

22. Although "A Brief Chronology of Huang Su's Life" was Lin Shuangbu's only published story directly about the February 28th Incident, the conflict between mainlanders and Taiwanese is a frequent and recurring theme in many of his works, such as the novel *The Great Buddha Is Without Attachment*, where a "mainlander" university president mistreats "Taiwanese" professors, and the short story "The Trumpeter" ("Xiao laba shou" 小喇叭手), where conflicts arise between Taiwanese students and their mainlander teachers. Placed in a historical perspective, all of these conflicts symbolize an extension of the cultural fallout of the February 28th Incident.

then ailing Chiang Ching-kuo 蔣經國 (1910–88), that the old taboos were shattered and the Taiwan literary world found itself on the verge of a new era. This new freedom allowed novelists to revisit previously forbidden history and inspired a new generation of writers and a new surge of fiction confronting everything from Taiwanese independence and political corruption to past human rights abuses and the victims of the White Terror. For the first time, the island province that had long been deemed "Free China" was actually creeping toward freedom—at least in literature. One of the most important phases of this literary renaissance was the powerful emergence of February 28th fiction, revisiting and reflecting on the uprising of 1947.

Like "scar literature"—tragic tales of victimization endured during the Cultural Revolution, which had flourished several years earlier on the mainland—the discourse of 2/28 fiction exploded with an outpouring of emotion, anger, and sadness. After so many years, however, the fictional representations of the February 28th Incident that emerged had an introspective depth and reflective quality missing in many of the early scar stories from the mainland. Also unlike scar literature, which spoke to its readers due to very close historical proximity to the events it described, February 28th fiction revisited the painful memories of Taiwan's past after four decades of silence and created new memories for younger generations either too young to remember or born after the tragedy. After 1987, millions of Taiwanese had to effectively be reintroduced to a national calamity that for decades could only be whispered about in hushed tones or had been forgotten. As if to make up for lost time, 2/28 reemerged and began to pervade virtually every aspect of society—from history and politics to art and literature.

Literature proved particularly powerful in resurrecting the February 28th Incident in post–martial law Taiwan. The wide array of new novels and short stories offered a new perspective on the events of 1947 and their profound impact on the fate of this island nation. And, although Taipei was the undeniable epicenter of the February 28th Incident, just as that event was caused by forces of mass population redistribution, its repercussions spread far beyond the capital city and were felt throughout Taiwan. This is evident in the curious fact that the majority of 2/28 literature is actually set outside Taipei, in such places as Taizhong, Tainan, Jiayi, and even the distant mountain areas of Taiwan's aboriginal people.

Although the February 28th Incident has failed to capture the international literary imagination to the same degree as the Rape of Nanjing (as can be seen by the number of translations of Chinese works and the string of English novels on the subject), it has paradoxically been the inspiration for a significantly larger body of Chinese-language fiction than that prompted by the Nanjing

atrocity, including several works by overseas Chinese. In the mid-1980s, following the work of Li Qiao and Lin Shuangbu, a series of stories by such writers as Guo Songfen 郭松棻, Stella Lee (Li Yu 李渝), and Yang Zhao began to appear, creating a vibrant new literary discourse on February 28th. New York-based Chinese writer Guo Songfen (1938–2005) published the powerful novella *Imprint of the Moon* (*Yue yin* 月印) in 1984. Set just after the war, it tells of Tiemin 鐵敏, an intellectual who befriends a group of leftists from the mainland shortly after recovering from a bout of tuberculosis. At the heart of the story, however, is his wife, Wenhui 文惠, who makes a report to the police that, in the aftermath of 2/28, leads to the immediate arrest and execution of her husband and his "comrades." With delicately constructed prose and beautiful language, Guo's novella is a fascinating meditation on nationalism and national myths and a sensitive account of 2/28 from the perspective of a woman who must live with the wages of her guilt and the destruction of her dreams.[23]

Just two years later, Guo's wife, NYU professor, art scholar, and writer Stella Lee (b. 1944), published her own masterful account of the February 28th Incident. Lee's short story, "The Night Zither" ("Ye qin" 夜琴), is an intricately designed portrait of memory and tragedy, about a young woman from the mainland who arrives in Taiwan to start anew. After experiencing a lifetime of war, first with the Japanese and then with the Communists, she thinks that at last the fighting is over, only to find herself caught in the upheaval of 2/28. She is saved by a kind Taiwanese woman who shields her from the violence, but her husband is not so lucky. "The Night Zither" is one of the few early 2/28 writings to highlight the victimization of mainlanders. Lee's delicate portrayal is underlined by a humanism that prods us to look past traditional rivalries and dichotomies. *Imprint of the Moon* and "The Night Zither" are two of the most fascinating and penetrating accounts of the February 28th Incident to be published to date. Writing in New York some forty years after the incident, Guo and Lee evince a sensitivity informed by their distance from the incident and, undoubtedly, by their own revolutionary experience as key proponents of the overseas Diaoyu tai Movement 釣魚台運動.[24]

Another attempt to approach the February atrocity from abroad is Japanese writer Nishikawa Mitsuru's (Xichuan Man 西川滿) (1908–1999) 1990 short story "Eiren's Fan—An Elegy on the February 28th Incident" ("Huilian de

23. Guo Songfen partly revisited 2/28 again with his 1997 story "The Stars Shine Tonight" ("Jinye xingguang canlan" 今夜星光燦爛), about one of the key figures in the incident, Governor-General Chen Yi.

24. Although seemingly unrelated to the 2/28 incident, the controversy over the Diaoyu tai Islands on one level echoes many of the issues at the heart of the incident. Not only are the players the same (Taiwan, China, and Japan), so are the driving issues of nationalism and sovereignty, not to mention the shadow of Japanese colonial rule of Taiwan.

shanzi" 惠蓮的扇子). Although born in Kakamatsu, Aizu, Japan, Nishikawa had a long association with Taiwan and spent his formative years there, from the age of three until the end of the war, when he was thirty-six years old. The short story is told in the first person from the perspective of Yuji, a Japanese living in Taiwan and in love with a Taiwanese girl named Eiren. Yuji's love, however, is unrequited because Eiren's parents disapprove of her marrying a Japanese. Instead, she marries Zheng Zhongming, who is killed in the February 28th Incident. One year later, Eiren follows her husband to the grave, executed after a failed assassination attempt on Chen Yi, whom she blames for her husband's death. "Eiren's Fan" is a moving reminiscence of Yuji's friendship with Zhongming and Eiren and a disturbing portrait of the uprising.

Although the story provides a complete narrative of the confrontation outside Tianma's Teahouse, recounting the beating of Lin Jiangmai and the death of Chen Wenxi, part of Nishikawa's project is to present the conflicts leading up to the massacre:

A common saying of the time tells it most plainly: "The dog is gone and the hog has come." The dog of Japan may have bitten at times, but he still protected our lives and property. The hog that has come from the mainland devours anything and everything, including the fertilizer. (Nishikawa 2003:62)

Nishikawa Mitsuru also uses his account of the incident to explore national identity from a uniquely Japanese perspective. Much has been written about the Japanization of Taiwanese during the colonial period, but what about the "Taiwanization" of Japanese like Nishikawa who were raised in colonial Taiwan? Through descriptions of Yuji's rejection by Eiren's family (in favor of a Japanese-educated Taiwanese, no less), Nishikawa reminds us that ethnocentrism and racism can work in both directions. He also demonstrates the seemingly inescapable "master-slave" dynamic in relationships between Taiwanese and Japanese both before and after the war. The author's sensitivity to issues of ethnicity, race, and nationalism is clear throughout "Eiren's Fan." Nishikawa explores national identity from the perspective of language and education, and even in terms of the impact clothing has on his characters' self-perception and acceptance in society. And in addition to the unique Japanese perspective, he also introduces a Frenchman, whose interpretation of the incident, while simplistic, forces readers to think of it in a new light: "This is a conflict between the Japanese way of life and the Chinese way of life" (60). While numerous fictional works alternately position 2/28 as either a Chinese trauma or a Taiwanese trauma, Nishikawa Mitsuru is one of the first to explore the voice of the *Japanese* trauma, and the crisis of identity it triggered.

While overseas writers opened up new perspectives on Taiwan's violent past, the true renaissance was occurring at home in Taiwan. Younger-generation writers born after the incident, like Yang Zhao and Lin Wenyi 林文義, began incorporating magic realism and postmodern approaches into their literary interpretations of history. Yang's 1987 stories "Fireworks" ("Yan hua" 煙花) and "Dark Souls" ("Anhun" 黯魂), both of which are discussed in the final section of this chapter, and Lin's series of 1988 stories like "Night of the Generals" ("Jiangjun zhi ye" 將軍之夜) provided fascinatingly fresh views of the incident and its legacy of terror, as did writers like Lin Shenjing 林深靖, who published multiple 2/28 stories in the years immediately following the thaw, including 1987's "Three Brothers of Xizhuang" ("Xizhuang san jieyi" 西庄三結義), which directly portrayed the uprising. Other contributions included Chen Lei's 陳雷 1988 short story "Hundred Family Spring" ("Baijia chun" 百家春) and veteran writer, literary critic, and pioneer of nativist literature Ye Shitao's own elegy in 1989, "The Wall" ("Qiang" 牆).

The combination of renewed freedom after the lifting of martial law and the events just months before in Beijing during the June Fourth Tiananmen massacre seemed to inspire a new generation of writers to look introspectively back upon their own dark heritage of violence. Besides an ever-increasing body of short stories and novellas, 1989 saw the publication of the first full-length novel to directly confront the February 28th Incident, Chen Ye's 陳燁 *Muddy River* (*Ni he* 泥河). As critic Zhu Shuangyi 朱雙一 has observed, *Muddy River* "goes to great lengths in revealing the profound long-term impact it has had. Writing decades after the incident about today [1989], the novel reveals not only the collapse and destruction of a large family, but how the dark shadow of the incident nightmarishly hangs on decades later, enveloping the lives of everyone in the family" (Zhu Shuangyi 96–97).

The following year, the literary critic, poet, and writer Lin Yaode 林燿德 (1962–1996) published his own take on the incident, *1947 Formosa Lily* (*Yijiu si qi gaosha baihe* 一九四七高砂百合). Lin's 1990 novel remains one of the most fascinating examinations of 2/28, for both its unorthodox approach to the incident itself and for its bold postmodern construction. Like Li Qiao's *Record of Taimu Mountain*, *1947 Formosa Lily* looks at February 28th through the lens of aboriginal culture; however, Lin Yaode goes much further in his exploration, which takes an Atayal tribe member as the narrative center of the story. Although the novel does not directly portray the 2/28 incident, the temporal window in which the novel is set is precisely the afternoon and evening hours of February 27, 1947—when the events on Yanping Road were unfolding. Lin displaces the historic violence and its national mythology by creating his own mythic counternarrative, interweaving tales of Taiwan's native mountain headhunters with

stories of Japanese colonizers, Western missionaries, and Chinese military men. In this sophisticated novel, ritual and religion combine to form a new historical vision that attempts to deconstruct the myth of 2/28 as *the* formative moment in Taiwan's modern heritage. Lin Yaode reintroduces lost voices and perspectives from Taiwan's past and shows how, even at the very moment that the defining national calamity was happening, alternate histories were also being written. *1947 Formosa Lily* bears testament to the great literary talent of Lin Yaode, hinting at how much potential was lost with his early passing.

In the 1990s, veteran writers Dongfang Bai 東方白 and Zhong Zhaozheng both published important epic novels, often referred to as "great river novels" (*dahe xiaoshuo* 大河小說), sweeping narratives covering most of modern Taiwan history that addressed 2/28 as a key moment. Dongfang's *Sand Beneath the Waves* (*Langtaosha* 浪濤沙) and Zhong's *Angry Tide* (*Nu tao* 怒濤), each the product of more than ten years of research and writing, resituated the incident in a macrohistory, once again displaying its far-reaching effects. Other established writers like Li Qiao, Xiao Lihong 蕭麗紅, and Li Ang also tackled 2/28, the latter, after more than twenty years on the literary scene, devoted much of her first full-length novel, 1991's *The Strange Garden* (*Mi yuan* 迷園), to the incident. Historical violence also attracted first-time authors, like Wu Fengqiu 吳豐秋, whose award-winning 1996 novel *The Sun Shines First Behind the Mountain* (*Houshan ri xianzhao* 後山日先照) stretches from the colonial period to Taiwan's return to China and from the February 28th Incident to the White Terror. Set in the coastal city of Hualian 花蓮, it inspired a twenty-hour television adaptation by award-winning television director Li Yuefeng 李岳峰.

The astounding body of literature produced between 1987 and the present constitutes a new category of February 28th atrocity fiction. The volume of works published, their diversity, and the variety of literary approaches, from modernism to postmodernism and from realism to magic realism, include many vibrant literary voices who collectively have made 2/28 fiction one of the most vital and important literary discourses of the 1980s and '90s. As the end of the century drew near, the February 28th Incident proved to be *the* crucial juncture in modern Taiwan history from which they could reevaluate the past and look toward the future. After four decades of lies, falsehoods, and cover-ups, history itself was called into question. In her 1997 collection, *Revelations on Banned Books* (*Jinshu qishilu* 禁書啓示錄), writer and critic Ping Lu 平路 describes the problematic nature of history:

> The truth is the part that is never written down. Therefore, history is destined to always be a canon that is never passed down. And the history people read about is filled with inaccurate records. The point of this is to make people

believe that they belong to a place they do not belong to, and that they possess an autonomy that they do not really possess. (Ping Lu 1997:169)

Fiction then becomes a tool to re-create history by reinstating personal narratives and reinserting a multiplicity of perspectives denied by traditional historical narratives. The abundance of recent historical fiction about the February 28th Incident constitutes a new "creation myth" for Taiwan, a historical legend rooted in a crisis of identity and a heritage of violence. These literary reenactments of 2/28 weave a complex web of memory and imagination that reconstructs historical pain. The heteroglossia of voices fighting to re-create 2/28, however, extended far beyond the literary realm. In 1989, the incident would capture the cinematic imagination of audiences throughout Taiwan—and the world.

Screening 2/28: From a *City of Sadness* to a *March of Happiness*

Although the February 28th Incident left an indelible scar on the collective memory in Taiwan and continues to be a highly charged and controversial subject in the academic and political realms, to date, only two feature films have attempted to reconstruct and reconfigure the 1947 tragedy in the context of popular culture. Produced a decade apart, Hou Hsiao-hsien's *City of Sadness* (1989) and Lin Cheng-sheng's *March of Happiness* (1999) use very different strategies of representation. The former film adopts an attitude of distance and meditative observation, while the latter travels to the heart of the matter to revisit the actual primal moment at which the historical nightmare of February 28th began. In this section, I offer readings of both films and explore how one of the most pivotal events in modern Taiwan has been re-imagined on the silver screen.

Although but two feature-length dramatic productions deal directly with the events of February 28th, that incident has had a deceptively profound impact on—and presence in—contemporary Taiwan film. February 28, 1947 marked the beginning of the terrible incident; it was also the prelude to forty years of martial law and political oppression during the White Terror. Although beyond the scope of this study, the ever-increasing body of film devoted to the state violence committed under the smokescreen of the White Terror should also be considered an extension of the tragic events of February 28th. Among the films that fall into this category are Edward Yang's 楊德昌 1991 four-hour opus *A Brighter Summer Day* (*Kuling jie shaonian sharen shijian* 牯嶺街少年殺人事件) and Wang Zhongzheng 王重政 and Hong Weijian's 洪維健 2001 epic

Forgotten or Forgiven (*Tian gong jin* 天公金). Set in the 1960s, *A Brighter Summer Day* focuses on the life of Xiao Si 小四 and his middle school classmates as his father faces incessant interrogations and persecution under the regime. *Forgotten or Forgiven* traces the aftereffects of the Nationalist Party's political oppression decades later, concluding with the epitaph, "Historical scars may be forgiven, but never forgotten."

However, the watershed year for White Terror cinema in Taiwan was 1995, which saw the premiere of Hsu Hsiao-ming's 徐小明 *Heartbreak Island* (*Qu nian dongtian* 去年冬天) and New Taiwan Cinema pioneer Wan Jen's *Super Citizen Ko* (*Chaoji da guomin* 超級大國民). *Heartbreak Island* is a stirring adaptation of Dong Nian's 冬年 novel of the same title about the victims of Gaoxiong's Formosa Incident (美麗島事件), which occurred in the wake of a failed prodemocracy demonstration in December 1979. *Super Citizen Ko* explores the guilt one former political prisoner must face. Imprisoned for taking part in a "political reading group," Xu Yisheng 許毅生 inadvertently divulges harmful information about his friend, Chen Zhengyi 陳正一, who is eventually sentenced to death. After a sixteen-year prison term and more than a decade of self-imposed isolation in a retirement home, Xu embarks on a moving voyage to confront his past and find the grave of his old friend. The most high-profile White Terror film of the year was Hou Hsiao-hsien's *Good Men Good Women* (*Haonan haonu* 好男好女), the final chapter in Hou's Taiwan Trilogy. Annie Shizuka Inoh 伊能靜 plays a contemporary actress preparing for a film about the White Terror. The film is among Hou's most structurally complex works, intercutting three different stories from three different eras into a powerful meditation about how to re-create Taiwan's past.

That all of these films appeared in 1995, just months before Taiwan's first full democratic election, was no coincidence. During this time of heated political debate and contention, past incidents like February 28th and the White Terror took on renewed meanings not only as historical tragedies but also as political tools to manipulate votes and serve election agendas.[25] This is one of the great tragic ironies—after five decades of political persecution, the victims unjustly sacrificed for one political agenda have been appropriated for another. Yet this phenomenon is a powerful testament to the ways traumatic memories of bygone

25. One example I personally witnessed was during a commemorative rally on February 28, 1996 in New Park (now renamed Peace Park in commemoration of 2/28), where survivors and family members of victims ended extended, emotional, teary testimonials about political persecution with, "So, be sure to vote for Peng Mingmin 彭明敏."

historical injustices are used in the process of constituting a new nation and new nationalistic perspectives.

Articulating Pain in a City of [Unspeakable] Sadness

For over thirty years, Hou Hsiao-hsien (b. 1947) has been defining and redefining Taiwanese cinema. From his pioneering work in the early 1980s, when he played a key role in the New Taiwan Cinema movement with such classic films as *A Time to Live, a Time to Die* (*Tongnian wangshi* 童年往事) and *Dust in the Wind* (*Lianlian fengchen* 戀戀風塵), to his landmark Taiwan Trilogy of the late '80s and early '90s, to more recent efforts such as *Flowers of Shanghai* (*Haishang hua* 海上花), *Millennium Mambo* (*Qianxi manbo* 千禧曼波), and *Three Times* (*Zuihao de shiguang* 最好的時光), Hou has consistently displayed a distinct and powerful cinematic vision. With his signature long takes, drive for realism, and passion for Taiwan's history, Hou's work visualizes an imagined past marked by a detached longing and a distanced passion. Working with a core group of frequent collaborators, including screenwriter Chu T'ien-wen 朱天文, editor Liao Ching-song 廖慶松, sound designer Tu Du-che 杜篤之, cinematographer Mark Li Ping-bing 李屏賓, and actors such as Jack Kao 高捷, Hou has set a new standard for Taiwan cinema and influenced a new generation of local directors, including Hsu Hsiao-ming and Chang Tso-chi 張作驥.[26]

Produced in 1989 by Hou's own 3-H Films in conjunction with ERA International, *City of Sadness* was Hou's most ambitious film and the first installment of what would later be referred to as his Taiwan Trilogy. The film was revolutionary for several reasons. It was the first Taiwan film to be shot with sync-sound and, at 158 minutes, it was the director's longest film. And it was the first Taiwanese film to take home a top award at a major international film festival—the Golden Lion at the 46th Venice International Film Festival. The film truly stood out, however, because of its portrayal of the politically sensitive and ever-controversial February 28th Incident. Released less then two years after the lifting of martial law in Taiwan, *City of Sadness* was

26. Hou Hsiao-hsien produced Hsu Hsiao-ming's 1992 film *Dust of Angels* (*Shaonian an le* 少年吔, 安啦). Its uncanny stylistic similarities to Hou films like *Good-bye South, Good-bye* have inspired rumors that Hou was the true creative force behind the film. Chang Tso-chi was the assistant director on *City of Sadness*, and his feature films *Ah Chung* (*Zhong zai* 忠仔), *Darkness and Light* (*Heian zhi guang* 黑暗之光,) and *The Best of Times* (*Meili shiguang* 美麗時光) are all indebted to the Hou cinematic model. The same can also be said of screenwriter and sometime Hou Hsiao-hsien collaborator Wu Nien-jen's 吳念真 directorial debut *A Borrowed Life* (*Dousang* 多桑), which was also produced by Hou.

the first motion picture to address the atrocities of 1947 and was surrounded by controversy.

Areas of contention concerned everything from the film's international honors at Berlin and elsewhere to its failure to win the 1989 Golden Horse for Best Picture at home in Taiwan,[27] as well as Hou's portrayal of women[28] and the chosen politics and strategies of historical representation (or rather, nonrepresentation). However, the focus of the debate was Hou's portrayal of the February 28th Incident. The once-taboo historical backdrop of *City of Sadness* elevated the film to an almost mythic level. It was *the* cultural event in Taiwan during the late 1980s, and its release had great historical, sociological, and political implications.

Reflecting on the origins of the film, Hou Hsiao-hsien remarked:

During the early days of New Taiwan Cinema, everyone was making films about our background growing up and the Taiwan experience. The entire process came a full decade after literary works reflected similar themes. The subject matter of *City of Sadness* was a political taboo in Taiwan, so it came even later, a full decade later in 1989. Chiang Ching-kuo passed away, martial law was lifted, and the times changed. Suddenly a new space opened up, creating the possibility to film subjects that were once off limits. Even before martial law was lifted, I heard all kinds of stories about the past and read an assortment of political novels, like those of Ch'en Ying-chen. That perked my interest to start digging up all kinds of materials about the White Terror and the February 28th Incident. The timing was perfect; originally I hadn't intended to make a film about the February 28th Incident, but rather, a motion picture about the aftermath of the incident. I wanted to make a film about the lives of the next generation, who were living in the shadow of the February 28th Incident. That would have been more dramatic in nature, but because martial law was lifted, we decided to

27. Best Picture at the 1989 Golden Horse Awards was instead awarded to Stanley Kwan's 關錦鵬 *Full Moon in New York* (*Ren zai niuyue* 人在紐約, a.k.a. *Sange nüren de gushi* 三個女人的故事). Even Kwan himself seemed to feel the award should have gone to Hou and featured a "tribute" to him in his next film, *Hold You Tight* (*Yu kuaile yu duoluo* 愈快了愈墮落), by displaying a *City of Sadness* poster in the bedroom of the male protagonist.

28. The controversy concerning the film's portrayal of women as historically invisible or sealed outside the discourse of grand history was first raised by Li Ang, who described *City of Sadness* as "A film without women," arguing that, "Although the film's narrator is a woman, the entire perspective adopted is that of the male." This perspective was later expanded by several critics, including Mi Zuo 迷走, in the essay, "Are Women Unable to Enter History? On Female Characters in *City of Sadness*" ("Nüren wufa jinru lishi? Tan *Beiqing chengshi* zhong de nüxing juese" 女人無法進入歷史? 談悲情城市中的女性角色), in Mi Zuo and Liang Xinhua 梁新華, *Xin dianying zhi si*, 135–140.

confront the incident itself and made *City of Sadness*. So it really all came down to timing. (Berry 2005:253–254)

When the film was finally completed, it was not a cinematic portrait of those living in the aftermath of February 28th, but it did not actually confront and center upon the incident in and of itself. Instead, it took a much more sophisticated approach by tracing the events between Emperor Hirohito's surrender and Taiwan's retrocession from 1945 to 1949, when the Communists took the mainland, transforming Taiwan into the sole stronghold for Chiang Kai-shek's Nationalist regime. *City of Sadness* is a cinematic meditation on cultural transition and conflict during a five-year historical vacuum, at the heart of which lies the tragic events of February 1947.[29]

The primary action revolves around the family of Lin Ah-lu 林阿祿, the elderly patriarch and a powerful local leader, and his sons, Lin Wenxiong 林文雄 (Lin Wen-heung), the eldest, who runs the local "Little Shanghai Restaurant"; Lin Wenliang 林文良 (Lin Wen-leung), the third son, who returns from the war in mainland China shell-shocked and mentally impaired; and the fourth son, Lin Wenqing 林文清 (Lin Wen-ching), a deaf-mute photographer who runs a studio in a nearby town. An additional sibling, the second-born Lin Wensen 林文森 (Lin Wen-sung), a local doctor, does not appear and is assumed a casualty of Japan's war in Asia. *City of Sadness* serves as a testament to a once proud and powerful family's decline and collapse as they struggle to navigate the ever-changing political terrain of Taiwan in the late 1940s. The sole male member left intact at the end is the frail and all but helpless patriarch, Lin Ah-lu.

The title of the film already points to the complexity of this rich and challenging work. The "city" referred to in *City of Sadness* refers to multiple signifiers, including Jiufen 九份, the small, picturesque mining town where Lin Wenqing runs his photo studio and much of the action takes place, and Badouzi 八斗子, the coastal port town where the Lin family lives. Both seem equally qualified as spatial coordinates of "sadness." However, the true "city"—Taipei—is the offscreen and invisible site of sadness and violence. It is where Chen Yi's radio broadcasts about the insurrection, which slip periodically

29. During a 2001 interview, Hou Hsiao-hsien made the following comment about the February 28th Incident in relation to *City of Sadness*: "The February 28th Incident in and of itself is already a very complicated incident. But our perspective is very clear. The February 28th Incident has its own set of inherent historical impetuses, causes which are extremely difficult to depict clearly on film. What would be the purpose of depicting these causes, especially when so many others have already done that quite clearly in written form? So I only used the incident as a backdrop, to create an atmosphere for the film" (Berry, *Speaking in Images,* 327).

into the cinematic narrative, originate. And it is the capital from which the waves of atrocity extend. Because of the film's release date just a few months after the Tiananmen Square massacre, many audiences chose to allegorically read the city spoken of in the title as Beijing, even though production on *City of Sadness* was completed before the now-historic Beijing Spring of 1989.[30] When asked about the significance of the title, however, Hou Hsiao-hsien provided a different reading: "The 'city' in *City of Sadness* is actually Taiwan itself. 'City of Sadness' is the name of an old Taiwanese song, there is also an old Taiwanese film of the same name, also called *City of Sadness*.[31] But that film has absolutely no connection with politics, it is a romance film" (254).

Here the chronotopic site of Taipei 1947, imbued with violence and social unrest, is expanded not just to Jiufen and Badouzi, but to the entire island of Taiwan—just as events occurring in Taipei during February and early March quickly expanded and spread to virtually every major urban center. Hou's comments hint at the allegorical power of the film, which far surpasses the personal tragedies endured by the members of the Lin family.[32]

In a larger context, the film is an attempt to articulate a historical pathos and address unspoken pain. After four decades of silence on the February 28th Incident and the White Terror, *City of Sadness* came loaded with expectations of clarifications, justice, and closure. The film, however, attempted to express what is ultimately beyond words—the experience of cultural suppression, dislocation and disconnection, and the weight of historical rupture, violence, and pain.

Early in the film, in a scene that takes place in the local hospital (one of the key locales, with a symbolic presence), a group of hospital employees are engaged in a Mandarin Chinese language class, in preparation for treating pa-

30. There have been arguments that the Silver Bear and the film's strong box office record were partly due to critics' and audiences' desire to support a Chinese film about historical injustices from "Free China" in the wake of the Tiananmen atrocities. The producers were keenly aware of this and exploited the similarities with promotional slogans such as "The Taiwan Massacre" and "Taiwan's Tiananmen Square Incident" when *City of Sadness* was screened internationally. For more on the promotion of the film and its different treatment in Taiwan and abroad, see Lin Zhuoshui, "February 28th's Dark Shadow and *City of Sadness*" ("*Beiqing chengshi* de er erba yinying" 悲情城市的二二八陰影), Mi Zuo and Liang Xinhua, *Xin dianying zhi si*, 100–107.

31. *Beiqing chengshi* 悲情城市 is a 1964 black-and-white Taiwanese-language feature film directed by Lin Fudi 林福地 and starring Jin Mei 金玫, Zhou You 周遊, and Yang Ming 陽明. The film depicts the trials and tribulations of Yu Qin 玉琴 (Jade Zither) who, after being sent to prison and subsequently working as nightclub singer, eventually dies, then is resurrected and reunited with her lover Wen De 文德.

32. Hou's reference to the 1964 film *City of Sadness* also brings in *film* history, reminding us that Hou's film was groundbreaking in terms of content and cinematic form. The title pays tribute to the tradition of popular Taiwanese-language film, of which the original *City of Sadness* was very much a part, and symbolically mourns the loss of that cinema under Nationalist-enforced cultural hegemony. Taiwanese-language film and nativist culture were to some extent additional victims of the White Terror.

tients from the mainland. Similar crash courses in Mandarin Chinese were quite pervasive between 1945 and 1949, during which time Taiwan saw a massive influx of mainland immigrants and refugees. The class itself hints at the changing linguistic, cultural, and even political terrain of Taiwan. However, of equal importance are the words actually being said:

"headache" (lit. head pain)	頭痛,
"stomachache" (lit. stomach pain)	肚子痛,
"Where does it hurt?" (lit. Where is your pain?)	你那裡痛啊?

The irony is obvious: on the eve of a movement that would result in the brutal suppression of Taiwanese citizens, a group of doctors and nurses (itself highly symbolic) speak Taiwanese-inflected Mandarin, the language of the liberator-cum-oppressor, in order to reach out to (and diagnose the pain of) their future terrorizers. Beyond the irony, however, lies sadness. "Where is your pain?" is the very question prompting Hou and his collaborators' cinematic gesture. *City of Sadness* attempts to articulate the physical, national, and historical pain of February 28th and the traumatic transition from colonial rule under Japan to retrocession to China. However, just as the doctors are speaking a foreign tongue to diagnose the pain of mainlanders from far away, Hou Hsiao-hsien employs a new cinematic language, marked by a distinct visual vocabulary and syntax, in hope of remembering that which has been repressed, retrieving and articulating a brutality that cannot be spoken.

The politics of silence and violence are displayed most masterfully by the fourth son of the Lin family, Lin Wenqing, played by Hong Kong actor Tong Leung Chiu Wai 梁朝偉 (best known for his work with director Wong Kar-wai 王家衛 and his starring role in Zhang Yimou's 2002 martial arts blockbuster *Hero [(Yingxiong* 英雄*)])*. The character of Wenqing was dramatically adapted (due to Leung's inability to speak Taiwanese) and cast as a deaf-mute.[33] What was initially a creative limitation became one of the most powerful aspects of the film; Wenqing's disability worked on a highly symbolic level. As Hou Hsiao-hsien has stated, "knowing your limitations is really the greatest freedom an artist can have" (251). In *City of Sadness*, Lin Wenqing's world of silence "speaks" to the ways the February 28th Incident was all but written out of official

33. An earlier abandoned scenario called for Leung to play a Hong Kong man traveling to Taiwan in the wake of the February uprising in search of a relative.

你那裡痛啊？⋯⋯

Teaching Mandarin to the hospital staff in *City of Sadness:* "Where does it hurt?"

histories before 1987, and also to the impossibility of ever truly retrieving that event and all that was lost through it.[34]

Equally symbolic is Wenqing's profession as a photographer, a natural enough career choice for a deaf-mute that carries another layer of symbolic meaning. Wenqing is chosen to record on film the vestiges of atrocity. This positioning of Wenqing as the voice of history is made more explicit in one of the most frequently cited segments of the film, the *"Lorelei"* scene, where a group of intellectuals (including a reporter and several teachers) converse in the Japanese-style dining room while Wenqing and his love interest, Hinomi 吳寬美, play a German recording of *Lorelei* in the adjoining room. The intellectuals are discussing the implications of the Nationalist mismanagement of Taiwan:

LIN HONGLONG 林宏隆: In the end it is the people that suffer. We need to be brave and stand up for ourselves. If the Nationalists let Chen Yi keep at it

34. The protagonist's silence once again points back to Hou Hsiao-hsien's interest in cinema and film history, notably silent film. Wenqing's status as a deaf-mute brings a renewed focus to visual aesthetics. This "silent film" tribute is further enhanced by black-and-white intertitles, which serve as Wenqing's sole means of communication and establish him as one of the key narrators of the film.

like he's been doing, as I see it, sooner or later Taiwan is going to be in major trouble.

Lao He, Taiwan is heading for some big problems.

At this moment, the visual focus shifts from the men around the table to Hinomi and Wenqing in the adjoining room. The conversation among the teachers continues: "Get your pen ready, when the time comes you'll be the witness!" The term used is *jianzheng* 見證, to "see" (*jian* 見), and "authenticate" (*zheng* 證), which can mean to "witness" or "testify," a term that is also key in the rhetoric of the Nanjing Massacre. Here, the esteemed place of the witness who testifies to history is given to Lao He 老何 (He Yongkang 何永康), the mainland Chinese reporter. Played by noted author and cultural personality Chang Ta-chun 張大春 in a cameo, Lao He is the sole recurring character who speaks Mandarin Chinese throughout the film. His position as a mainlander among the Taiwanese community of intellectuals provides him with a unique, objective (or at least distanced) perspective on history. However, as Lao He is half-jokingly delegated the responsibility to record and preserve history, Hou Hsiao-hsien surreptitiously grants the honor to another.

Under the strict press censorship enforced under martial law, Lao He's pen would prove all but useless. Instead, the frame shifts to Lin Wenqing, who has his back to the camera as he puts a phonograph record on for Hiromi. Just as he turns around to face the camera, we hear the last line of dialogue from the adjoining room: "Come on, let's toast to the witness!"

Here, however ironically, Lin Wenqing is visually positioned as the true witness—but as a deaf-mute, all he can do is *jian*, or see the brutality of history, while remaining impotent to *zheng*, testify or transmit the secrets locked behind his eyes.[35] In the penultimate scene of the film, after he and his family decide to abandon their efforts to run away, Wenqing turns to his camera and takes a photo with his wife and son. His only solace is found not in documenting history or the tumultuous events of his age, but in preserving a final vestige of his family. The portrait is the antithesis of the large group photo of the Lin clan taken outside Little Shanghai Restaurant at the beginning of the film. All that is left is the small nuclear family, but even that will not survive. In the next scene, we are told that Wenqing has been arrested.

35. This reading of Lin Wenqing as the principal historical "witness" is, naturally, also influenced by his positioning as the central focalizer, Tony Leung's identity as the biggest star in the film, and the fact that the film effectively ends with his arrest. Other readings of the crucial scene could present equally powerful arguments for Hinomi as witness (or "co-witness"), due not only to her central positioning in the same shot but also to her series of letters/diary entries/voice-over narrative sequences, which are among the film's key narrative devices.

來，來，敬見證

Lin Wenqing as witness to history in *City of Sadness*.

Lin Wenqing is unable to fulfill his role as the witness to history, just as *City of Sadness* is helpless to reenact the events of February 28th. However, this may be precisely what both Lin Wenqing's life and the film are actually about—the fragmentation of historical memory and the limitations of representation. In *City of Sadness,* pain, atrocity, and sadness are all mitigated by the politics of nonrepresentation and silence.

Much has also been written about the inability of the film's female characters to either participate in or retell historical narrative. As Berenice Reynaud and other critics have pointed out, although the film's perspective comes through the shared narrative duties of Wenqing, Ah Xue 阿雪, and Hinomi, the latter two are subordinate voices that serve primarily to articulate the experience of male characters.[36] The silence of female characters is perhaps best demonstrated in a scene that takes place during the crackdown after the events of February 28th, where Ah Xue and Hinomi are discussing one of the victims:

36. See Mi Zuo, "Are Women Unable to Enter History? On Female Characters in *City of Sadness*" (Mi Zuo and Liang Xinhua, *Xin dianying zhi si,* 135–140) and the section "A Film Carried by the Voices of Two Women" (Reynaud, *A City of Sadness,* 65–71). Reynaud has also astutely pointed out that "*Hinomi rarely speaks in sync*" (69). Hinomi is simultaneously both witness and participant; however, only in her former role is she endowed with a voice.

HINOMI: When did the shop close up?

AH XUE: During those days when everything was so chaotic. So many people died. They went several times to ransack the neighbor's house. Dad's friend Mr. Xu was also arrested. . . .

WOMAN: Ah Xue!!

This is one of the sole instances where female characters describe events related to the February 28th Incident. However, just as Ah Xue's narrative begins, it is cut off. Whereas Wenqing's silence is inherent and non-negotiable due to his handicap, Ah Xue and Hinomi's silence is enforced—imposed by society. Ah Xue, on the verge of broaching the taboo, is instantly put in her proper place by an older matriarchal figure. Her right to articulate history is denied and the fate of Mr. Xu becomes forever suspended in mystery, like that of so many victims of KMT political persecution.[37]

City of Sadness consistently denies the viewer a comprehensive narrative account of the Lin family and the history through which they live and die. Instead, the film weaves a complex tapestry composed of a vast ensemble of characters, a rich linguistic heteroglossia, intertitles, flashbacks, and frequent gaps in narrative space. These narrative gaps and moments of historical blackout prove the most powerful means of conveying pain and sadness. A similar strategy is also employed in representations of violence, which are often indirect, carried out offscreen, implied, obscured by darkness, or shot from a distant perspective.

This aesthetics of violence uses trademark long takes and extreme long shots, a combination that brings a cold detachment to some of Hou's most brutal screen moments. Nowhere is this strategy more evident than in *City of Sadness*. Although violence is predominant in several of his other films, such as *Goodbye South, Goodbye*, here Hou Hsiao-hsien presents a fully developed meditation on violence that goes beyond the physical, pointing to a more pervasive brutality that extends toward the realms of culture, politics, and ideology.

Hou Hsiao-hsien's aesthetics of violence and strategies of nonrepresentation combine to form a visual poem ruled by distance, silence, and absence. This is chiefly evidenced by the film's concrete avoidance of Taipei (and any other cities generally associated with mass insurrection) and choice of Jiufen and Badouzi,

37. Although much has been written about the suppression of the female voice in *City of Sadness*, it should be noted that the silence imposed cuts across gender, generational, and class lines. For example, when Hinoe 吳寬榮 returns home after the incident, his father immediately slaps him at the first mention of what has transpired. During the February 28th Incident and the subsequent White Terror, it was not *only* women's voices that were suppressed.

two sites generally not associated with the February 28th Incident, as the primary settings. However, when violence does creep into the film's narrative, it is almost always viewed from afar—or not viewed at all. One example takes place in the beginning of the aforementioned scene where Wenqing is symbolically identified as the witness. The conversation among the intellectuals gives the first concrete reference to mainland–Taiwanese conflict, which actually foreshadows the February 28th Incident:

> "Mainland police killed a cigarette seller the other day. Did you know?"
> "Yes, I heard. The locals were furious about it."
> "The whole street was very tense. Things almost exploded. The cigarettes were smuggled in by some big official."
> "Bribery gets anything in."
> "They go after the small fry but leave the big shots alone."

The description and details may sound stunningly similar to the February 28th Incident, but what is actually being addressed is a little-known event that occurred on December 10, 1946 in Jilong, where a young boy was beaten to death for selling contraband cigarettes. The killing incited a small local riot, but no arrests were made in the youngster's death. Hinoe and the other intellectuals' discussion works as a foreshadowing device for the conflicts to follow and introduces present conflicts between mainlanders and Taiwanese, and more specifically, between local cigarette vendors and state monopoly inspectors. What is interesting in terms of the cinematic representation is that as the Jilong death is being discussed, the opening shot is not of the intellectuals but of serene mountain scenery. In *City of Sadness* not only violence, but even *discussions* of violence are spatially displaced. And just as the Jilong incident foreshadows the events that will occur two and a half months later in Taipei, this visual displacement establishes a cinematic strategy whereby violence is refracted and dislocated in the film's narrative.

One of the most stunning examples of this displacement corresponds with the death of the proud and seemingly invincible first son, Lin Wenxiong, at the hands of mainlanders from Shanghai. Ironically, his death is the result not of the KMT's post–2/28 crackdown on native Taiwanese elite but of his interference in and opposition to his family's involvement in the drug trade. Hou Hsiao-hsien seems to be reminding us of the dynamics and complexities of violence during this tumultuous era—conflicts come in many forms, and the stereotypical dichotomies often invoked during discussions of 2/28 are but one aspect of a very complex cultural landscape. The brutal slaying of Lin Wenxiong is brilliantly intercut with yet another gorgeous shot of Taiwan's moun-

tain landscape, a solitary bird gliding across the frame. Such insertions hint at the sublime while opening up a an abstracted cinematic space that functions as a site of meditation and mourning for audiences to reflect upon the violence they have just witnessed.

Other examples of displaced violence include several powerful scenes during Wenqing's imprisonment. His cellmate is called out by guards, and moments later, as Wenqing stares out of the cell with a melancholy, numb expression, we hear the jarring sound of rifle shots, signaling the death of his cellmate. The violence is never seen—only heard—but even those sounds are displaced through the audience's knowledge that Wenqing cannot hear them. When Wenqing is finally released from prison, he visits the family of his deceased cellmate to deliver a letter written in blood—a final vestige of his life and a final testament to an atrocity silenced. One of the most violent moments in the film—and the only sequence to directly portray the 2/28 incident—occurs when a group of Taiwanese chase down and beat mainlanders near a railroad. A group of three Taiwanese repeatedly beat a defenseless fallen man with clubs, but once again the violence is obscured by distance (shown in a long shot) and space (the victim is lying on the ground and obscured by other objects). Even more telling is the way the violence is obscured by memory; this is one of less than a half dozen flashback sequences that occur as Wenqing recounts the violence to Hinomi. It is never revealed to the viewer whether these fleeting images of violence are an objective portrayal of "what happened," a visualization of Wenqing's memory, or the projected imagination of Hinomi as she reads Wenqing's notes.

Later in the film, the capture and execution of Hinoe are never directly portrayed, and neither is the final arrest of Wenqing. In *City of Sadness,* violence is indirect, played out offscreen on a much larger historical canvas and thus, by implication, much more brutal and disturbing. This dislocation also mirrors Lin Wenqing's inability to speak and the silence of history it represents. *City of Sadness* is a challenging film because of its nonlinear structure, linguistic diversity, cultural complexity, vast array of characters, and, most of all, its historical complexity. The film uses distance to view the darkness of the past and silence to articulate unspeakable pain.

A March of Happiness *in the Shadow of February Sadness*

Almost a full decade after *City of Sadness* made its controversial debut, director Lin Cheng-sheng (b. 1959), who got his start with a trio of inspired documentary films, decided to revisit the February 28th Incident for his fourth dramatic

feature, 1999's *March of Happiness* (*Tianma chafang* 天馬茶坊). Given the unprecedented commercial success of Hou Hsiao-hsien's epic in Taiwan and the seemingly unquenchable thirst for information on the February 28th Incident throughout the 1990s, it is curious that the incident did not inspire other cinematic representations. This is, however, less related to feared controversy or an anxiety of influence in the wake of Hou's film than to the loss of local Taiwan film audiences in the 1990s to Hollywood and Hong Kong (and to a lesser extent Japanese and Korean) productions.

The seeds of Lin Cheng-sheng's belated second installment to the cinematic legacy of the February 28th Incident were actually sown quite early and owe an uncanny debt to *City of Sadness*. In the late 1980s, Lin and his then wife, Ke Shuqing 柯淑卿,[38] had only one short eight-millimeter production under their belt and had temporarily retreated from city life to run a fruit farm on Pear Mountain, Taiwan. During this time, the couple learned of an exciting new feature film in preproduction by one of their favorite directors. The director was Hou Hsiao-hsien, the film was *City of Sadness,* and Lin and Ke decided to apply for jobs. After initial meetings with assistant director Huang Jianhe 黃健和,[39] everything seemed to be in place for Ke to handle continuity and Lin to serve as camera assistant. Although ultimately unable to become a part of Hou's masterpiece, Lin and Ke had already begun to explore the creating their own cinematic representation of the February 28th Incident, taking a very different approach than that of Hou Hsiao-hsien. Nearly ten years later, Lin Cheng-sheng and Ke Shuqing finally had the opportunity to revisit 2/28 and, in the process, transform "sadness" into "happiness."[40]

The historical setting of *March of Happiness* spans just over two years, from 1945, before the Japanese unconditional surrender, to February 28, 1947, the day of the uprising. This structure creates an atmosphere of tragedy unfolding as the events gradually move toward that fateful day. It bears an uncanny resemblance to *Nanjing 1937: A Love Story,* Ye Zhaoyan's prequel to the Nanjing Mas-

38. Ke Shuqing and Lin Cheng-sheng met in 1984, when they were classmates in a film program, and married in 1987. Ke has been Lin's most faithful creative partner, serving in the capacity of producer and/or screenwriter for virtually all of his documentary and feature film productions. Lin has also served as producer for Ke Shuqing's directorial efforts, such as 1998's Minshi 民視 television production *Qingshui Shen huijia* 清水嬸回家.

39. A second assistant director, Chang Tso-chi, would later become a noted director in his own right with such films as *Ah Chung, Darkness and Light,* and *The Best of Times.*

40. Lin Cheng-sheng writes about his early involvement in *City of Sadness* in the last section of his autobiography, where he talks about his terrible disappointment at being left out of the production. Running their fruit farm, Lin and Ke were still awaiting a telephone call from Huang Jianhe when they read a newspaper article announcing the commencement of filming. See Lin Zhengsheng, *Weilai, yizhilai yizhilai,* 365–368.

sacre, which also ends on the day that violence breaks out. *March of Happiness* functions as a cinematic prequel to the February uprising and, like *Nanjing 1937*, is at heart a love story. The film stars Lim Giong 林強, a musician, composer, and star of such films as *The Puppetmaster* and *Good Men Good Women*, as Ah Jin 阿進, a young, romantic, guitar-toting idealist active in the new theater movement of the 1940s. In 1945, Ah Jin falls in love with Ah Yu 阿玉 (Hsiao Shu-shen 蕭淑慎), a member of the same drama troupe and the daughter of the local "Fishball King," Hailong Wang 海龍王. Wang, however, is trying to arrange a marriage between his daughter and Xie Renchang 謝仁昌, the son of an important doctor. The film traces the trials and tribulations of the young couple as they struggle to overcome traditional social conventions and escape from the arranged marriage planned for Ah Yu. These events play out against the historical backdrop of Japan's surrender, the evacuation of all Japanese citizens, and the new tensions brought on by the arrival of the Nationalists, which culminate in the February 28th Incident.

A key subplot of the film is the story of the New Drama Group (*xin jutuan* 新劇團), the performance troupe of which Ah Jin and Ah Yu are members. The group and its political inclinations, choice of repertoire, performance aesthetics, and pressures faced reflect and respond to the rapidly changing sociopolitical terrain of Taiwan in the late 1940s. From colonial pressures to present Japanicized productions, to celebratory performances marking the island territory's "return" to China, to Nationalist censure for failing to conduct performances in Mandarin, the fate of the troupe mirrors Taiwan society's transition from resignation under the Japanese to postwar celebration and ultimately to increasing discontent under the Nationalists. Yan Tianma 詹天馬, a member of the troupe and also its chief patron, plays a key role—albeit often behind the scenes—in most of the film's central action. Portrayed by Leon Tai 戴立忍, one of contemporary Taiwan cinema's most prolific actors and a talented director in his own right, Yan Tianma appears both onstage and backstage, guiding the New Drama Group's survival, transformation, and fate. As cultural liaison, Yan negotiates and navigates through the upper echelons of Japanese society and the Nationalist military bureaucracy to win support for the group and protect their artistic vision from censorship and cultural hegemony, which he accomplishes with varying results.

The role of Yan Tianma provides the structural glue that holds the various elements of the film together. In many ways, the character is reminiscent of Yang Wencong, the painter-poet-official in the classic Qing drama *The Peach Blossom Fan*, who is perennially playing all sides and bringing characters and plot lines together, although Yan lacks Yang's deceptiveness. Yan Tianma does bring the film its chief location, the teahouse he runs, which bears his name:

Staging violence in *March of Happiness:* (left) The new drama troupe performing a Taiwanese play; (right) After a Japanese officer arrives, the stage is quickly changed and the lead actress changes costumes and immediately begins singing in Japanese.

Tianma chafang, or Tianma's Teahouse. It is a unique intersection for a broad sample of Taiwan's social strata circa the late 1940s: Japanese intellectuals and spies, Taiwanese artists and revolutionaries, and even Nationalist military officers and local cigarette peddlers. The back room of the teahouse doubles as the headquarters and rehearsal space for the New Drama Group, while the front public area serves as the site of romance and revolution, all served over tea. It is where poets and intellectuals meet, it is where Ah Jin and Ah Yu fall in love . . . and it is where Xie Renchang tries in vain to win Ah Yu's heart. The teahouse is also the site of nostalgia for a Japanese former customer who visits before his repatriation to Japan. The visit turns tragic when his arrival sparks a fatal confrontation with a short-tempered Nationalist official. The nostalgic Japanese is murdered in cold blood by the official in a residual act of violence from the Sino-Japanese War.

Lin Cheng-sheng uses the social, cultural, economic, and even linguistic changes that occur around the teahouse and its customers to provide a microcosm of Taiwan society and convey its dramatic transformation during the late '40s. He conveys the complexity, richness, and sadness of this utter redesign of the social fabric with compassion—although not without a melodramatic bent. However, Lin's poetics of history and historical canvas are much more complex than they may appear on the surface. Tianma's Teahouse is not just the central location in the film but also a key location in twentieth-century Taiwan history. The real Tianma's Teahouse (referred to in the earlier quote by Lai, Meyers, and Wou as the T'ien-ma Tea Store) was where the six investigators from the Taipei City Monopoly Bureau met on the evening of February 27, 1947 to investigate a report of contraband cigarettes being sold. Coming up empty-handed, they spotted a

forty-year-old cigarette peddler whom they suspected of selling illegal cigarettes. The confrontation that ensued after they tried to confiscate the peddler's goods served as the prelude to tragedy and four decades of political persecution.

March of Happiness, whose original Chinese title, *Tianma chafang*, highlights the spatial importance of the teahouse, marks a symbolic return to the ontological site of terror, where the wounds inflicted would leave deep scars in modern Taiwan history. The film superimposes fictional voices and identities upon the faceless and nameless historical players who shaped and were shaped by the collision of politics, culture, history, and fate around Tianma's Teahouse in the last days of February 1947. Unlike *City of Sadness*, which adopts a contemplative viewpoint dominated by spatial and temporal distance, *March of Happiness* delves directly into the trauma of history through its fictionalized reconstruction of this chronotopic space.

Although Lin Cheng-sheng attempts to face the past head on, his "confrontation with history" is mediated by his imagination, and the vision of Taipei 1947 he creates is ultimately as much fiction as history. This is evident in the film's climatic portrayal of the key events of the incident, which are laden with temporal inconsistencies regarding the actual timeline of events that occurred on February 27 and 28, 1947. (The historical conflict between Lin Jiangmai and the Monopoly Bureau officials occurred on February 27, 1947, but it is moved to February 28 in the film, no doubt to further strengthen the power of the iconic date.)

In the film, Hailong Wang has chosen that same fateful February day for a ceremony to celebrate his daughter's engagement and marriage to the doctor's son.[41] It is also on the evening of February 28th that Ah Jin and Ah Yu plan to run away together. They look to escape not to southern Taiwan or Japan but rather to the "motherland" of mainland China on the eve of "liberation." The introduction of the mainland also serves as a subtle reference to leftist interpretations of 2/28, which read the uprising as a proletariat revolution masterminded by the CCP. Ah Jin, the consummate actor, is both the romantic patriot on the Taiwan stage—devoted lover, protector (and accomplice?) to his first love, a Japanese spy who was carrying out covert missions in Shanghai when she was killed; and a Communist youth returning to the "homeland" to take part in the construction of the new nation. However, Ah Jin is never able to realize his

41. Critic Shelly Kraicer has commented on how Ah Yu's forced betrothal to Xie Renchang can be read as an allegory of the incident itself. Kracier's critical reading describes the naked parallel: "Ah Yu is betrothed to a man she doesn't love. Her father tries to force the marriage, and picks February 28th for its realization. Yu refuses the forced marriage, and tries to elope, but Taiwan's catastrophe conspires to prevent her from following her heart . . . [the film] all too obviously juxtaposes the theme of resistance to forced marriage (and resistance to patriarchy) with the story of the struggles of the native Taiwanese against the mainlanders who fled there from the Communist revolution" (Kraicer, Review of *March of Happiness*).

我們是專賣局的

The seeds of atrocity: the cigarette vendor outside Tianma's Teahouse as the inspectors from the Monopoly Bureau arrive.

dreams. His death is foreshadowed by the hot-tempered Nationalist officer's summary execution of the Japanese man after their meeting at the teahouse. It is the same officer who, in a fit of rage and desperation, fires a warning shot from the theater stage, killing Ah Jin, who is up in the rafters. Ah Jin dies as he lived, onstage in a final sacrifice for his nation. Meanwhile, Ah Yu, left waiting at the dock for their escape to the mainland, is visited by the ghost of Ah Jin. His phantasmagoric return represents the lovers' belated reunion as well as the reemergence of the specters of history, which, after decades of silence, have finally made their cinematic return.[42]

In Hou Hsiao-hsien's modern classic *City of Sadness* and Lin Cheng-sheng's reappraisal of the incident in *March of Happiness*, two very different strategies of representation are employed. From the sidelines to the center, from silence to speech, and from historical refraction to historical reflection, Hou and Lin

42. Ah Jin's reappearance should also be considered along with other spectral returns in contemporary Taiwan film, such as Chang Tso-chi's *Darkness and Light* and *The Best of Times*, both made around the same time as *March of Happiness*.

provide two powerful visions of a painful past. One final link and difference between the films is the two directors' use of the stage. Stage drama—itself a potent metaphor for representation and the restaging of history—is highly symbolic and powerful in both films. In the previously discussed "*Lorelei*" scene from *City of Sadness,* a moving reminiscence about Wenqing's childhood love of traditional Chinese opera is relayed to Hiromi. A fall from a tree left him deaf and mute, effectively ending any hope of a life on the stage. Of course, he later channels his love for theater into another form of artistic representation—photography. But the (historical) stage in *City of Sadness* is sealed, and "representation" is an impossibility beyond the reach of the characters. Except for a fleeting flashback of children mimicking opera performers in class and playing around an outside performance space, the stage where histories are passed down does not appear; it has been destroyed. *March of Happiness* takes an alternative approach wherein the stage is literally and figuratively at the center. The film both opens and closes with action centered around two stage performances, and the main characters are all actors in the drama troupe associated with Tianma's Teahouse—the place where the violence began. The film is about representation, but even more powerfully, *March of Happiness* is about voyaging to the very heart of atrocity, with the characters playing challenging dual roles in art and in life, onstage and in history. This is most obvious when, at the end of the film, the rash Nationalist officer barges into the theater and murders the idealistic protagonist Ah Jin. The drama stage doubles the historical stage, and both are positioned at the center. A full decade after *City of Sadness* reimagined history from the periphery, *March of Happiness* places that history at center stage—both literally and figuratively. However, in this move from Hou's strategy of distance to Lin's urge to display, something is lost. The literalization of history with which Lin Cheng-sheng's narrative is fueled (and the often forced manner in which he superimposes this history onto his cinematic stage) ironically fails to achieve the historical impact of *City of Sadness.* Perhaps the sound of silence still provides the ultimate testimony to those elusive specters of the past.

Rewriting 2/28: Old Obsessions and New Investigations

Ah Jin's afterlife appearance on the dock on the evening of February 28 marks the spectral fulfillment of a promise to Ah Yu and also hints at the unaddressed pain of 2/28's countless innocent victims. Returning to the scene of violence has become something of an obsession among several contemporary Taiwan-based

writers. Over the past fifteen years, a group of authors have written and rewritten the February 28th massacre, not only "writing" but also almost compulsively "rewriting" history in what has become a major trend in contemporary literary representations of the incident. What do these rewrites tell us about literature, history, and the traumatic impulse to continually reimagine historical pain? This section features an overview of several writers who have repeatedly revisited 2/28 in their fiction, with special emphasis on the work of Yang Zhao, whose trio of intricately crafted stories about the incident gives vital voice to the lasting guilt and the repercussions of historical trauma. In the final section, I will offer an extended reading of a penetrating and disturbing short story by Wu He, arguably the single most important figure on the Taiwan literary scene at the turn of the millennium. Wu He offers a deconstructivist "investigation," where a literary narrative about a spectral disappearance—not a spectral return—offers a new perspective on both 2/28 and history, memory, and violence.

Revisiting Atrocity: A New Twist on an Old Obsession

In 1961, C. T. Hsia published the first edition of what would become his representative work, *A History of Modern Chinese Fiction*. This landmark study provided the first comprehensive English-language narrative of modern Chinese literature and rewrote literary history by restoring such writers as Shen Congwen, Qian Zhongshu, and Eileen Chang to the canon. Another achievement of the work was an essay added to the appendix, outlining Hsia's conception of a term that he coined, "obsession with China," described as an "obsessive concern with China as a nation afflicted with a spiritual disease and therefore unable to strengthen itself or change its set ways of inhumanity" (Hsia 1999:533–534). Hsia observed this to be one of the key themes in the "modern" phase of Chinese literature. He initially used the work of writers such as Lao She, Shen Congwen, and Lu Xun to flesh out his theory, but later revisited his own ideas with a Taiwan twist, examining obsession with China in the works of three Taiwan-based writers who were born on the mainland—Kenneth Hsien-yung Pai 白先勇, Jiang Gui 姜貴, and Yu Guangzhong 余光中.

In Taiwan's post–martial law era, amid a renewed examination of the island's complex past, C. T. Hsia's "obsession with China" began to take on a whole new meaning. No longer was the object of geographic/cultural/historical longing so clearly "China." While many remained obsessed with the "motherland," the very nature of the locale was now a point of contention—there was suddenly also room to obsess over Taiwan, or even Japan. The symbolic locus

where these three geographic/cultural/historical spaces intersect is also a coordinate of inhumanity, national shame, and violence—February 28, 1947.[43] The February 28th Incident became the ultimate site onto which all types of national and ideological obsessions were projected. Perhaps the most visible manifestation of this phenomenon, which is also one of the most fascinating aspects of the 2/28 literary tradition, is contemporary Taiwan writers' obsession with writing and rewriting the incident, over and over again.

Li Qiao was one of the first writers to broach the subject, publishing two short stories even before the lifting of martial law in the early to mid-1980s.[44] However, after those initial flirtations with violence (neither of his stories truly dealt with the incident head on), Li Qiao revisited 2/28 more than a full decade later. In 1995, he published a major 1,200-page work in two volumes, *Burying Injustice: 1947: Burying Injustice* (*Maiyuan: 1947: Maiyuan* 埋冤: 1947: 埋冤). The massive project was completely self-financed; Li Qiao personally oversaw the printing, distribution, and sales. After a decade of research and more than a hundred interviews with survivors, Li Qiao spent more than a year struggling with the dichotomies between literature and history before deciding to divide his novel into two segments, *Burying Injustice 1947* (*Maiyuan 1947* 埋冤 1947) and *Burying Injustice, Burying Injustice* (*Maiyuan, maiyuan* 埋冤 埋冤): "the first volume staying close to the reality of history, but with a fictional plot running through; while the second volume was aiming at pure literature, but without sacrificing historical accuracy" (Li Qiao 1996:16–17). Both sound quite similar to what we normally refer to as "historical fiction." However, in the process of historicizing fiction and fictionalizing history, Li Qiao has further blurred the line between the genres while writing a new chapter in the history of February 28th fiction.

Another contemporary writer who has continually revisited February 28th is Li Ang (b. 1952). She decided to write a literary biography of the controversial 2/28 heroine Xie Xuehong and ended up publishing two books on this central

43. In this context, national shame operates on several levels. There was obviously much shame felt on the part of the Japanese and Japanese loyalists after their empire's defeat, which forced Japan to cede Taiwan back to China. For many pro-Chinese Taiwanese, there was an inherent shame in the fact that their "mainland compatriots" treated them no better than they had been treated under the Japanese colonizers. And for mainland Chinese, who had fought bitterly against Japan for eight long years, it must have been very difficult to suddenly befriend a territory whose people had been thoroughly Japanicized after five decades of Japanese rule.

44. Although the February 28th Incident plays a very important role in Li Qiao's fiction, it is but one aspect of a larger project of writing modern Taiwan history through literature. Li has published numerous works of historical fiction, several of which deal with other large-scale atrocities. One such example is his earlier work of fiction *The Sworn Brothers of Xilai An* (*Jie yi xilai an* 結義西來庵), set against the 1915 anti-Japanese uprising referred to as the Xilai An Incident.

figure of the uprising. In 2000, Li Ang simultaneously released her novel *Auto-biography: A Novel* (*Zizhuan no xiaoshuo* 自傳の小說) and a companion travel-ogue, *A Drifting Journey* (*Piaoliu zhi lu* 漂流之旅), which documented her own journey walking in the historical footsteps of Xie. Broaching sensitive and taboo subject matter was not something new for Li Ang, who has long since earned a reputation as one of the most iconoclastic literary figures in Taiwan.

Inspired by literary critic Chen Fangming's 1991 biography of Xie Xuehong, *Autobiography: A Novel* is among Li's most ambitious projects, undertaken over a ten-year period and intricately weaving together elements of biography and history with literature and fiction. Like Li Qiao before her, Li Ang was very conscious of the ways she was transgressing traditional distinctions between literary genres. In her introduction, she writes:

> If this is an "autobiography" then how can it be a "novel"? And how can an "autobiography" be composed by someone else besides the subject? And how can a "novel" become an "autobiography"? Just whose autobiography is this? And whose novel?
>
> After almost a decade of writing, I have written a novel and travelogue that are more than 400,000 words.
>
> When writing these two books, I was naturally very ambitious and had a very large plan. I'm just afraid that those individuals who enjoy "looking for the seat with their name on it" will come out of the woodwork again to "create something out of nothing" or "look for their seat," which will lead to a bunch of controversy that has absolutely nothing to do with my work; so I am especially taking the time to mention this here. (Li Ang 1999:9)

Li Ang was not only rewriting Chen Fangming's meticulously researched biography of Xie but also as her travelogue reveals, actually used the experience to retrace Xie's past and integrate Xie's life into her own. Li Ang's personal February 28th voyage actually began with her 1990 novel, *The Strange Garden*. Seven years later, amid a swarm of controversy surrounding her novella *Every-one Sticks Theirs Into the Beigang Incense Burner* (*Beigang xianglu renren cha* 北港香爐人人插), about another well-known female political figure, Li Ang published *Bloody Sacrifice of the Made-up Face* (*Caizhuang xueji* 彩妝血祭), which again delved into the dark world of 2/28.

Chen Ye (b. 1957) is another writer who has long walked the thin line be-tween politics and literature. Chen played an important role in feminist writer and political candidate Shi Jiqing's 施寄青 1996 bid for the ROC presidency and coauthored a handful of mass market fiction titles, such as *Women Rule the Nation* (*Nüren zhiguo* 女人治國), which was released to coincide with Shi's

campaign. Although other works had broached the subject earlier, Chen Ye's 1990 *Muddy River* is generally credited as the first full-length novel about the February 28th Incident. In an interview with critic Qiu Guifen 邱貴芬, Chen Ye pointed out that with *Muddy River,* she

> did not aim at an investigation of political issues, but rather an investigation of the deepest reaches of my mother's memories. Just what was it she was afraid of? She had the typical symptoms of those who survived the trauma of the February 28th Incident. I am extremely curious about what went on in the deepest reaches of her memory, and I'm sure that our war is still not finished, and I'm sure it never will be, at least not in my lifetime. (Qiu Guifen 1998:182–183)

Some twelve years later, Chen Ye revisited the recesses of her mother's memory and the trauma of February 28th again with *A Tale from Chikan* (*Lieai zhenhua* 烈愛真華) (2002), which was not only a return to Chen's past but also a reconfiguration of Taiwan's past.

One of the most fascinating attempts to write and rewrite February 28th comes from Yang Zhao (b. 1963). For Yang, literature and politics seem to be a family tradition. His father dabbled in both worlds and, besides his large body of political fiction, Yang has written articles in *The Journalist* (*Xin xinwen* 新新聞), Taiwan's leading weekly political news magazine, and done guest spots on a variety of cable television talk shows, establishing himself as a high-profile political commentator. A graduate of Taiwan University and a former doctoral candidate in history at Harvard University, Yang began writing in the early 1980s and has published an impressive array of novels, short fiction, prose, and critical essays. Among his best-known works of fiction are the novels *Great Love* (*Da ai* 大愛) and *A Dark Alley on an Enchanting Night* (*An xiang mi ye* 暗巷迷夜), both of which emphasize his own enchantment with the dark side of Taiwan's political past.

Three standout works are the stories "Fireworks," "Dark Souls," and "1989," all of which deal directly with the February 28th Incident. First published in 1987, "Fireworks" is a powerful and intricately woven tale of two lonely individuals who come together nearly twenty years after the February 28th Incident—their loneliness dictated by the tragic events of 1947. Jin Hongzao 金鴻藻 is a middle-aged widower at a research institute who investigates the strange phenomenon of a group of red flowers that sprout up around the grave of a certain Wang Heshun 王和順. Wang's daughter pays regular visits to her father's grave, and gradually the two establish an uncanny bond. Jin was once a close friend of the girl's father, and they both lost loved ones in the February 28th Incident—Jin's wife was killed by rioting Taiwanese after taking refuge in

a local police station and Wang Heshun was murdered by government authorities during the aftermath.

The subtlety and layered meanings of Yang's fiction are evident even in the story's title. *Yanhua*, which most commonly means "fireworks," here takes on several other meanings. *Yan* referring to smoke and *hua* to flowers, the term literally means "smoke flowers," hinting at Jin Hongzao's research on flowers that grow amid the terrible pollution and smog in the cemetery. *Yan*, however, is the same character used for cigarettes—and the February 28th Incident began with a conflict between citizens and the Monopoly Bureau over illegal cigarettes. Thus, the two themes of the story are laid out immediately.

An additional layer of the story comes from yet another reading of the title, which traditionally can also refer to a prostitute or streetwalker—the occupation of Wang Heshun's daughter. The girl's profession is not so much a matter of choice as one of circumstances, and even points back to the deep-rooted hatred between her Taiwanese family and mainland Chinese. After the death of her father at the hands of the Nationalists, the girl's family took an uncompromising antimainland stance and adamantly refused to allow her engagement to her true love, a mainlander. Instead, Yang Zhao tells us with great irony,

> As the girl cried she mumbled through her tears. He couldn't quite understand everything that had happened. All he knew was that two years before, the girl had met a mainland boy. Before long several relatives and members of the older generation all came to her home; they were terribly angry. How could Wang Heshun's daughter possibly marry a mainlander? Her uncle Ah Guan was especially angry and his voice of opposition was especially strong. How could Heshun's daughter marry a mainlander? The incident led her mother to have a stroke.
>
> "I can't marry a mainlander." Facing him, she revealed a strange and seductive smile. "But I can sleep with foreigners." (Yang Zhao 1993:197–198)

Although it is out of respect for the memory and ideals of Wang Heshun that her family refuses to recognize or approve of his daughter's relationship with her boyfriend, Wang was actually a moderate fighting for greater understanding and cooperation between mainlanders and Taiwanese—as displayed by his close friendship with the mainlander Jin Hongzao. That cooperation and understanding are belatedly realized in the relationship between Jin and Wang's daughter, whose paths cross at a cemetery, not unlike the well-known climax of Lu Xun's classic story "Medicine" ("Yao" 藥), in which two mothers meet at the cemetery where their sons, who died for very different causes, are buried. Like "Medicine," which concludes with the enigmatic flight of a sole crow toward

the horizon, an image that has generated much controversy among critics, "Fireworks" presents a relatively ambiguous ending. Yang Zhao creates what is one of the most optimistic portraits in 2/28 literature—an image of true understanding, empathy, and growth as mainlanders and Taiwanese collectively overcome their history. However, this ray of hope comes into a society where the politics of guilt and victimization weigh heavy, and for many (including the girl's entire family), it is impossible to move past the shadow of 2/28.

In the end, Yang Zhao never truly fulfills the promise of hope. Instead, he fulfills the promise of history. After an intimate encounter with his deceased friend's daughter,[45] Jin feels a renewed optimism, which gives him the courage to take part in a political meeting. Soon he is arrested for crimes against his country and dies in prison. Almost immediately after Jin Hongzao assumes the role of the girl's surrogate father, fate brings him down the very same road as Wang Heshun, yet another victim of the February 28th Incident. But Yang Zhao still expresses optimism, in the form of the triumph of humanity and the hope that political idealism still exists, even in the heart of "white" darkness.

Written during the same stretch of time as "Fireworks," "Dark Souls" continues Yang Zhao's exploration of February 28th, only this time the starting point of the story is pushed forward from the 1950s to the late 1980s.[46] This carefully conceived story combines history, legend, and the supernatural in a way that is surprising, powerful, and disturbing. During the last years of his life, Yan Jinshu 顏金樹 finds himself struggling with his newly discovered power to foresee others' deaths. The supernatural power is a curse of sorts inherited by the male members of the Yan family, ever since a wandering ancestor made a pact with a group of spirits, murdering an entire clan of aborigines in order to keep his side of the bargain. The story spans three generations, from the patriarch, referred to simply as "Father," to his son, Yan Jinshu, down to the grandson, Yan Rixing 顏日興. Toward the end of his life, Father, who is assumed insane by his family, has a vision of a terrible massacre by the Japanese and sends Yan Jinshu to mainland China, out of harm's way. Yan is taken prisoner by the Japanese and incarcerated with six other Taiwanese, but released unharmed. Only toward the end of his own life, when Yan Jinshu inherits the supernatural family power, does everything his father experienced suddenly become clear.

45. As a prostitute, the girl seems to view sexual contact as the sole means of attaining true intimacy with Jin Hongzao; however, Jin stops short of physically consummating their relationship and instead becomes the father figure of which she has been deprived since childhood.

46. "Dark Souls" was written exactly forty years after the 2/28 incident, in February 1987, one month before the composition of "Fireworks." Both stories first appeared in the *China Times* in September 1987 amid a flood of highly politically charged fiction published immediately after the lifting of martial law.

"Dark Souls" is the first 2/28 story to break the tradition of realism, which has dominated virtually all of the incident's literary discourse, and flirt with the supernatural, reaching beyond the bounds of history and into the realm of legend. Although the February 28th connection is not immediately apparent, it is eventually revealed that Father's aforementioned vision was about not a Japanese slaughter, but a Chinese one:

> "I don't know what will happen in the future. I just know that of these young people around me, more than half will be shot and murdered. I can't see who it is pulling the trigger; they are wearing a kind of uniform that I have never seen before; it must be a military uniform. As my friends die I see from their faces that they are still quite young. It must be a terrible turmoil that would lead to the death of so many Taiwanese. These are respected people being tied up and left for dead in the barren fields; there are corpses left beside the creek and in the ditch near our home, where congealed clumps of dark red blood float in the morning. It must be a terrible atrocity. Eventually people won't be able to take it anymore and will take on the Japanese. Those people they were fighting must be from the imperial army." (210–211)

The curse limits Father's visions to the actual occurrence of death, omitting the context and surrounding details. Years later, Yan Jinshu realizes that the vision that was meant to save his life from the Japanese was actually a prediction of a Chinese massacre.

In a short narrative that spans many decades of modern China's tumultuous history (even referring to early conflicts between aborigines and Chinese settlers and the 1915 Xilai An Incident), the February 28th Incident casts the longest shadow. Yan Jinshu and his six Taiwanese compatriots survive their imprisonment, but in the postwar era, none fares very well—Chen Maosheng 陳茂生 takes his own life, Lu Jiangshan 盧江山 is found hanging from a tree, Li Chaohan 李朝漢 ends up a victim of the Cultural Revolution, and Wang Tianding 王添丁 dies in the events foreseen by Father—the February 28th Incident. When Yan Jinshu finally inherits his father's ability to predict death, it is not the demise of his own children and family that disturbs him most, but rather the vision of Wang Tianding's death (for which Yan also bears a portion of the guilt). Now he understands the burden his father carried, the curse haunting the male members of his family, and the curse haunting modern Taiwan history.

In the twilight of his life, however, Yan Jinshu decides to battle the specters of history:

After searching for a long time, sixty-five-year-old Yan Jinshu finally realized that, for a person like himself, the most pleasure he could get would be from—reading history books. During those almost two years, he learned about so many secrets; secrets about people that had never been mentioned, and probably never will be mentioned, in the history books. He learned the true details surrounding the death of all of those historical figures. He learned of so many lies recorded in history. (222)

Locked away in a room full of books, Yan Jinshu can isolate himself in a world of the past, avoiding the disturbing future visions of the deaths of his friends and family members. History becomes both his escape and his prison, as he is forced to bear the stories of countless deaths and countless secrets of the past. But when he sees a vision of his only son, Yan Rixing, dying from an apparent heart attack, he—and history—both finally find their liberation. Yan's release stems not from the fact that his son dies of natural causes rather than as another tumultuous political purge or movement, but from the fact that his son has seemingly finally escaped the burden of history: "Ha, ha! It is sure a good thing that he figured out that [martial arts novels] are probably much more interesting than books about history, [Yan Jinshu] thought; each generation of the Yan family seems to learn how to better cope with this punishment we have been dealt" (223). For "dark souls" weighed down by the secrets, lies, and incessant death that litter the history books, fiction is the only way out.

For Yang Zhao also, fiction is the way out, circumventing the maze of "history" while providing a new path to approach history and the atrocities along its course. With "Dark Souls," Yang Zhao transforms allegory into history and history into allegory, at the heart of which lies an original sin, analogous to Taiwan's status as the orphan of Asia. As critic Xu Junya points out, "'Dark Souls' is not directly about 2/28, but the story situates 2/28 as a fundamental site in a national history of pain and, thus, comes to function as a historical testament." The story's depth comes from its "bridging the atrocities Taiwan has experienced with the concept of original sin in the Taiwanese people's development; revealing a deep consciousness of repentance" (Xu Junya 2003:20).

Yang Zhao's first February 28th stories were written and published in 1987, the fortieth anniversary of the incident and the year martial law was finally lifted. Sixteen years later, he revisited the incident with the short story "1989" ("Yi jiu ba jiu" 一九八九), published in the September 2003 inaugural issue of *Ink Literary Monthly*. The title brings to mind images of the June 4 Tiananmen massacre, but at the heart of "1989" lies the tragic incident of 1947.

The story is told in a natural and convincing first-person voice that belies the complexity of Yang's earlier stories and reads more like a memoir than a work of fiction (even though it is very clear from the details that the narrator is *not* Yang). The story takes place in the summer of 1989, when the narrator is a college sophomore studying in Taipei. He has an ex-girlfriend who follows him around and waits outside his dormitory, hoping for a sign that their relationship can be revived. The girl's waiting continues until, one day, the narrator's ninety-year-old grandfather comes to Taipei from Jiayi to admonish his grandson for missing another family get-together. Making a hurried departure, the grandfather and ex-girlfriend leave together, boarding the same public bus—and the narrator never sees the girl again. Driven by guilt and curiosity, the narrator makes a surprise visit to Jiayi to see his grandfather who, for the first time, shows him an old family photo album.

As the pages in the album turn, the narrative voice gradually shifts and the grandfather takes over, retelling the events of his life. At the heart of his past is his longtime friendship with Ah Shezai 阿舍仔 and his second wife, Bo Zi 博子. Ah Shezai was a rebel with strong anti-Japanese beliefs, which led to frequent conflicts with his pro-Japanese father. Yang Zhao uses the differing political philosophies of father and son to heighten the irony of the Nationalists' contradictory policies concerning Taiwan citizens in the wake of retrocession:

Ah Shezai and his father, toward the end of the Japanese colonial period, the old embraced Japan while the young rejected Japan. Time after time, Ah Shezai was arrested for taking part in all kinds of political movements and each time was imprisoned for 29 days—on two occasions even Bo Zi was sent to prison with him. But who would have guessed what would happen in the end? With the end of the war Ah Shezai was ecstatic and embraced the motherland with open arms—before long, however, both father and son—one in Tainan, one in Jiayi—were arrested and accused as traitors to China. The official disdainfully listened as Ah Shezai described how he had worked with the Union for Autonomy, before biting back, "So you guys begged the Japanese to give you election rights; what's the difference between that and being a lousy traitor dog that wags its tail for the master?"

As Ah Shezai tried to explain the patriotic character of the Union for Autonomy, the official crudely spit on the floor, cursing, "You have the nerve to make being a traitor sound like such a glorious thing? If you really resisted Japan, wouldn't the Japs have put a bullet in your head and killed you? Who ever heard of them locking someone up for a few days and then letting them go? Do you think the Japanese are that stupid? This proves you are a traitor! The only reason they let you go after a few days in the slammer is because you

were still of use to them; and to think, you still have the gall to even mention this!" (Yang Zhao 2003:224–225)

As in "Dark Souls," the characters survive the oppression of Japanese rule only to become victims under the new Chinese regime, and again little distinction is made between Taiwanese who are pro-Japanese or anti-Japanese—in the eyes of the Nationalists, they are all traitors. And Ah Shezai's fate is tied to what once again is the narrative hub of the story—the February 28th Incident.

> Grandfather suddenly cast a sidelong glance at me and asked, "By now you know what '2/28' is, right?" I felt a bit guilty because of the way he was staring at me and nodded my head. "I know a little bit, there has been a lot in the newspapers about it lately."
> Grandfather replied, "Just as long as you know. Ah Shezai died during 2/28." (225)

After taking part in a local committee following the incident—identical to the committee that Wang Heshun joins in "Dark Souls"—Ah Shezai is killed. His remains are never recovered; all that that is left of his body is "blood; chunks of congealed blood." Here again Yang Zhao imbues his story with intertextual echoes from sixteen years before.

But Ah Shezai is not the only casualty. After disappearing for several years, Ah Shezai's second wife, Bo Zi, suddenly reappears, and Grandfather accompanies her to Taipei to witness Chen Yi's execution. Although they never see the execution (which is moved to a sealed location at the last minute), political desire gives rise to sexual desire and Grandfather finds himself uncontrollably drawn to his dear friend's widow. Their relationship is never consummated, and they return to Jiayi. Bo Zi, who is eventually revealed to be an active member of the Communist Party, is later arrested and executed. As in "Fireworks," repressed sexual desire is somehow intricately intertwined with political repression, and it is only in the late 1980s that Grandfather is finally able to address both (speaking to his twenty-year-old grandson, which makes for one of the most moving but also most contrived passages in the text). In the summer of 1989, Grandfather's pathos and sealed memories are triggered by the other atrocity that lurks just outside the narrative, the Tiananmen Square massacre. During this last summer of Grandfather's life, he continues his travels around Taiwan, fighting his own personal battle in the name of historical justice:

> With great seriousness Grandfather told me: "That's Jiayi, poor Jiayi. During the 2/28 Incident more people were killed in Jiayi than any other place.

However, of those killed, there weren't any of those celebrities known all over the island, so no one cares!" Grandfather went on to tell me that during those two years there were many vigils in memory of the 2/28 Incident and he went to every single one he heard about. It didn't matter where it was, he would always go. But he would often return full of anger and in a terrible mood. That was because during those rallies where thousands turned out, he always couldn't help but say, "There were more people killed in Jiayi than anywhere, how come you don't talk about what happened in Jiayi?" But no one ever listened. (226)

The only audience Grandfather has is his grandson, and his story is mediated by both words and images. The narrative is structured around the family photo album, which Grandfather started keeping after 1947 and in which he collects pictures from regular family reunions that he organizes. There are only two photos of Ah Shezai remaining, as Grandfather burned the others in order to destroy any evidence that might incriminate him. The missing remains and destroyed photos of both Ah Shezai and Bo Zi signal a destruction of memory and a historical erasure against which Grandfather struggles. He battles with the past through his photographs, which provide proof of his—and his family's—survival against history. Just as Lin Wenqing in *City of Sadness* has only that final, melancholy family portrait to leave as testament against history, Grandfather has only his pictures . . . and his memories.

The reason the narrator's ex-girlfriend stopped coming after her contact with Grandfather (which is what prompted the narrator to travel to his grandfather's home in Jiayi in the first place) is never revealed to either the narrator or the reader. But that is because Yang Zhao's 2003 story is not about 1989, when the story is set, but about 1947. Yang Zhao is interested in not only rewriting 2/28 but also revisiting the very site of his previous stories, even describing identical scenes and imagery. Through his trio of 2/28 stories, Yang Zhao has created a disturbing fictional world where the dead victims lie scattered in unmarked graves and their ghosts continue to haunt the survivors. In "1989," Grandfather dies, but he has already, in the final months of his life, passed his nightmares on to his grandson, who will undoubtedly carry them along with his own traumatic memories of what happened in his own lifetime during that fateful summer.

After more than five decades, the traumatic memory of the February 28th Incident continues to haunt the living with a profound impact on the historical and literary imagination of contemporary Taiwan. Yang Zhao, Li Qiao, Li Ang, and

Chen Ye are just some of the writers to have repeatedly returned to 2/28 as a source of literary inspiration (as well as national and/or personal catharsis). Lin Wenyi, Qiu Yonghan 邱永漢, and Ye Shitao have also all published multiple works of fiction depicting or taking place during the February 28th Incident.[47] But what does this obsession with atrocity say about history, trauma, and identity? What draws writers back to that early spring day in 1947, to repeatedly write and rewrite that moment of lost history?

The February 28th Incident represents the primal scene in the formation of Taiwan's national identity. For native Taiwanese and mainlanders alike it is, as critic Xu Junya has described it, the island's "original sin." But even today, that political and national identity remains inherently "indefinable." The conflicting roles and futures for Taiwan, from renegade province to independent state and from free China to free Taiwan, are constantly in fluctuation, contention, and uncertainty. The phenomenon of rewriting 2/28 is undoubtedly tied, first and foremost, to the horrific events of sixty years ago and the brutal suppression of any representations, whether in catharsis or censure. However, 2/28 also embodies the same conflicts and controversies that exert major influence on contemporary Taiwan and have become increasingly evident under the presidencies of Lee Teng-hui and Chen Shui-bian.

Although the events in Nanjing 1937 were also largely shrouded in silence for half a century, resulting in an explosion of fiction in the late 1980s, the number of such representations still pales in comparison to the volume of literature about the February 28th Incident that one (relatively small) province has produced during roughly the same period of time.[48] I argue that this imbalance indicates not the relative severity or horrific nature of the atrocities but the very specific contemporary political realities and cultural implications of each.

47. Author of more than twenty volumes of essays and fiction, Lin Wenyi (b. 1953) published three 2/28 stories between 1989 and 1998, including "The Lowest Level of Wind and Snow" ("Fengxue de diceng" 風雪的地層), "Night of the Generals" ("Jiangjun zhi ye" 將軍之夜), and "Grandpa, the Sea Is Rising!" ("Ah Gong, Hai zhang luo!" 阿公, 海囉!). Qiu Yonghan published a series of stories about 2/28 in Japan in the 1950s, including "Muddy Stream" ("Zhuoshui xi" 濁水溪), "Hong Kong" ("Xianggang" 香港), and "The Inspector" ("Jiancha guan" 檢察官). Ye Shitao (b. 1925), one of the most important contemporary nativist writers, has published numerous works of fiction and nonfiction on the 2/28 incident. In 1949 he published the novella, "Mazu in March" ("Sanyue de Mazu" 三月的馬祖), which he followed up four decades later with a string of stories, including 1989's "The Wall" and 1990's "Red Shoes" ("Hong xiezi" 紅鞋子); the latter was one in a series of stories about Jian Ahtao, A Taiwan Man, Jian Ahtao. Between 1987 and 1997, Guo Songfen (1938–2005), whose work was briefly considered earlier, also published multiple works of fiction on the incident, including "Snowblind" ("Xuemang" 雪盲), "Mother Running" ("Benpao de muqin" 奔跑的母親), and "Tonight the Stars Are Shining."

48. The vast majority of 2/28 fiction appeared after 1987's lifting of martial law in Taiwan. That was, coincidentally, the same year that the PRC began producing large amounts of fiction about the Nanjing Massacre, in commemoration of the fiftieth anniversary of the atrocity.

Whereas strategies of remembering and representing the Rape of Nanjing can have a strong impact on Sino–Japanese relations and, in a larger context, the articulation of a new Chinese nationalism, the 2/28 incident carries profound implications for the very sovereignty of Taiwan and its future as a state or province. In the contemporary political world, Taiwan is still very much the "orphan of Asia,"[49] and as much as the proliferation of 2/28 literature reflects the traumatic nature of the past, it also expresses an uncertainty regarding Taiwan's future.

"De-Writing" 2/28: Wu He's Investigation, Narration, and Refutation

Six decades after the events of 1947 and twenty years since the cultural explosion following the lifting of martial law, which opened the door for many of the works discussed in this chapter, the February 28th Incident has continued to be a central topic for cultural debate in contemporary Taiwan, and to some extent has become a symbolic polarizing force in the current political arena, where mainland and native Taiwan agendas do battle. In the cultural area, which is often injected with a heavy dose of politics, February 28th has inspired a seemingly endless series of rewrites as well as refutations. One case in point is the work of Wu He, who, with a single short story, challenged us to rethink February 28th, providing a powerful argument that acts of atrocity are not sealed away in chronotopic spaces of the past but rather spread out into new spatial and temporal domains. Wu He explores the act of writing violence and, through his brilliant (but unorthodox) linguistic mutations, also displays a new mode of violent writing. His daring deconstruction of the event forces readers to revisit their conceptions of history, memory, and violence.

First published in 1993 in the influential periodical *Literary Taiwan* (*Wenxue Taiwan* 文學台灣), a literary journal with a long tradition of promoting native Taiwanese literature, "Investigation: A Narrative" (*Diaocha: xushu* 調查:敘述) has since been widely anthologized and has appeared in two of Wu He's collections, 1995's *Excavating Bones* (*Shi gu* 拾骨) and the 2001 Rye Field reprint *Sadness* (*Beishang* 悲傷). At a mere seventeen pages, the short story is slight in length but remarkable in terms of its power, complexity, historical breadth, and ways of challenging both "historical investigation" and "literary narrative." "Investigation: A Narrative" chronicles a visit by two investigators to the home of

49. As evidenced by the ever-increasing number of countries that have broken relations with the ROC on Taiwan in order to establish relations with the PRC on the mainland, as well as Taiwan's ongoing bid for representation in the United Nations, which has been consistently defeated.

one of the many victims of the February 28th Incident, the manager of a local Asian candy factory who disappeared decades earlier.

The two investigators interview the victim's son, and through their dialogue and the son's reminiscences, both the investigation and the narrative are built. The details surrounding the father's February 28th disappearance are gradually revealed, only to be challenged, undermined, and ultimately refuted. Expectations are built as memories, rumors, and stories of assumed significance are introduced, then proved all but irrelevant to the father's case. The same tactic is also employed when introducing the father's former acquaintances, such as a mysterious candy manufacturer from Shanghai who initially seems to become the focus of the investigation (he also disappeared during the February 28th Incident) and a supposed mistress the father kept. In the end, all roads lead to nowhere; information that the father is alive in a mental institution turns out to be false, and even when the mother gets a lead that her long-lost husband has been found, it turns out to be a scam, setting her up to be the victim in a robbery and brutal rape. Only toward the end of this labyrinthine story and after decades of searching for the lost father does the son finally make the penultimate revelation: "On her deathbed, Mother finally revealed a secret she kept with her all those years: one hundred and fifty-six days after Father was arrested, they sent over a photo of Father's dead body lying in the mud after he had been executed" (Wu He 1995:106–107). This is, however, quickly refuted by the investigators, who identify the story about the photo as a widely circulated anecdote about a boatman's son.

Underlying the work are the two complementary lines of narrative and investigation; alternately they build the story, but together they also deconstruct it. As already made clear from the plot summary, the "narrative" continually undermines and contradicts itself. For instance, early on, when it is mentioned that the father served on the Resolution Committee representing the local candy industry, the son almost instantly points out that "when I happened to come across some files, I realized that my father's name wasn't ever listed among the committee members' names" (92). Such details allude to the dark history of 2/28, after which members of the Resolution Committee were soon victimized by the White Terror, but they also have significant bearing on the reliability of memory and, in a larger sense, the reliability of narrative and history. Wu He adopts a similar strategy when outlining and undermining the "investigation," as in the opening paragraph of the story:

Two self-professed investigators from the "Investigative Working Group Into the Incident" came knocking on our door. The first thing they said: "This is an age of peace, the dark shadows of the past can all be laid out in the sun to

dry. As for tears—that is if you have any tears left—you are now allowed to let them out and cry out in the open. 'Apologies—Rehabilitation' are some of the actions that may be adopted; let us all learn and grow from the painful scars of history." "Pain, pain, pain," the myna bird beside the window repeated. That investigator had probably enunciated "painful" a bit too much. "Pain, pain, pain." My wife brought over some tea and there was a moment of silence amid the fragrance of the fresh-brewed tea. (91)

Even in the first line of the story, when the two visitors are described as "self-professed investigators," the narrator fails to give the reader the benefit of the doubt that they are bona fide. Nothing is taken at face value. There are no certainties, and no one is to be believed.

This rich passage also shows Wu He's black humor in the form of the investigators' opening remarks, the melancholic mockery of which can be felt both within and outside of the text. The humor comes in both the investigator's cliché-ridden opening speech and his Japanese-accented Mandarin (which is lost in the above translation). The old inspector's highly identifiable inflection recurs throughout the story, providing humor but also repeatedly reminding readers that this "inspector" no longer embodies the repressive values and cultural hegemony of the mainlander-dominated Nationalist regime. A final sting of mockery comes in the form of the myna bird, who echoes a single word from the inspector's speech—"pain (tong 痛)." Behind this blind repetition is a melancholic cry that cuts through the sea of stories and lies, memories and fabrications. The details about the father's disappearance may be unclear, but then again, according to Wu He, the true story of the February 28th Incident and its victims, living and dead, may very well be irretrievably lost amid a maze of horrid nightmares and broken memories. The dead do not speak, and "Investigation: A Narrative" speaks to the impossibility of ever truly knowing "what happened." Investigation leads to dead ends; narration leads in circles. Beyond apologies, blame, rehabilitation, and revenge, all we are left with is that single recurring word that haunts the text and the memory of February 28th—"pain, pain, pain."

Pain and historical atrocity have indeed long been a focus of Wu He's fiction. In his 1999 novel, *Remains of Life*, he offered an expansive meditation on the origins and legitimacy of mass violence, and,, even in "Investigation: A Narrative," he references yet another atrocity—the Nanjing Massacre:

During my sophomore year of high school I had a history teacher from Nanjing who told us the grim details of the massacre that occurred there, describing all kinds of terrible ways that [the Japanese] killed people there.

My hands and limbs grew cold and numb as I listened, and I wondered what kinds of tortures my father faced before he died. It was also this same history teacher who, when mentioning that "incident" that occurred right here in Taiwan, concluded with the judgment, "It is nothing compared to [what happened in Nanjing], there is absolutely no reason that people should make such a big deal about it." He wanted us to always to remember the hatred our nation [held toward the Japanese] and not to make such a big deal about our own little problems we have among ourselves. Often, I would ride my bicycle toward Kunshen and sit atop the pillbox of the American GIs' ocean bathhouse and amid the blazing red silence of the setting sun, I could almost forget about my father. (104)

Here the memory of the Nanjing Massacre is incited by the teacher as a means of putting the February 28th Incident in "proper perspective"; however, in the process, he demonstrates the power of cultural hegemony to delegitimize historical horror. The teacher from Nanjing, who wields dual authority as both a mainlander and a history teacher, effectively writes off the February 28th Incident; it is an internal incident of little consequence compared to those crimes perpetrated by the Japanese or other foreign powers. He disallows the narrator to have his nightmare and deal with his pain. The history teacher has failed to learn from the pain Japan's denial of war atrocities has created for its Chinese victims and continues the circle of denial. What he does not realize is that sometimes self-inflicted wounds are the most painful.

Wu He seemed to offer a belated response to such comments in *The Remains of Life*:

As for the extended killing of thirty-eight others by the remains of life of Musha and Riverisle, from our contemporary perspective this is truly a "tasteless" slaughter where the numbers barely add up to anything, They not only pale in comparison to the Nazi death camps of World War II, but they are dwarfed by the massacres that would occur seventeen years later during Taiwan's own February 28th Incident (and this does not include the following decade of purges carried out against the remains of life), Even so, every time I delve into this page of history my heart and soul shudder—that is because the inherent nature of what a "massacre" entails is always the same, regardless of the process or final death toll, for a massacre involves a fundamental betrayal of life by life itself, its inhuman, cannibalistic, and empty nature has the power to give birth in humans to the ultimate suspicion—history always harshly denounces those who incite massacre, (Wu He 2003:100)

Wu He's narrative of atrocity surpasses the Musha Incident, the Nanjing Massacre, and even the February 28th Incident with a keen understanding that there is no historical pain without personal pain. Wu He also reminds us that the horrors of history are not confined to the past and historical scars left open do not heal but instead cause new wounds. This is illustrated most tragically in the case of the narrator's mother, wife of the missing candy manufacturer. After years of searching for her lost husband, she finally receives a ray of hope in the form of a "man in a khaki Zhongshan tunic who slipped into the family store and mysteriously introduced himself as a member of a secret organization that had recently acquired information pertaining to Father's disappearance" (Wu He 1995:104). The man asks the mother to accompany him to identify the missing person and bring along all of her jewelry and savings. However, instead of being reunited with her lost husband, the mother becomes the victim of yet another tragedy: "In the rear courtyard of the Butterfly Dream Garden, he robbed and raped my mother. Upon finishing, he grabbed hold of a stick and used it to jab into Mother's vagina, rubbing her until her skin was chafed bloody and raw" (104). Here Wu He pushes the limits of violence and brutality and thus also pushes the atrocities of the February 28th Incident decades into the future. At the ironic location of Ming loyalist Zheng Chenggong's 鄭成功 former garden, the latest page about the February 28th Incident is written. However, like the history teacher who tried to negate the tragic dimensions of the incident, the old investigator stops short of attributing the mother's victimization to 2/28: "He expressed great pain and sympathy over what Mother went through, however, he stressed the fact that he definitely did not feel that that this 'rape' had even the slightest connection to this very serious 'incident' that we are here today discussing" (105). History repeats itself not just in terms of the tragedy but also in terms of the tragic denial of tragedy.

Although the beginning of the story offers a temporary solace in the form of the investigator who works to mend the wounds of the past through reconciliation, apologies, and rehabilitation, Wu He eventually reveals that these abstractions are not so easily achieved. Only through this investigator, who is not only native Taiwanese but also Japanese-educated, is the narrator able to reclaim his identity as the victim, which had been stolen by the political machine of the Nationalist Party and the invisible power of "Chinese cultural hegemony." However, as we see in the case of the mother's rape and the decades of mental torture she and her son have endured in the wake of the father's disappearance, victimization and accountability have limits even in the eyes of the newly sympathetic Nationalist regime. It is only after decades of uncertainty and the utter breakdown of dichotomies such as the colonizer versus the colonized, the ruler

versus the subject, and the mainlander versus the native[50] that the fatherless narrator can "cry if you have tears left to cry." However, after more than four decades of repression and denial, further enhanced by the fragility of human memory and the state's rape of that memory, what tears remain? Perhaps all that is left is the echoing sound of those haunting words, "pain, pain, pain."

50. Naturally these dichotomies do, to some extent, still exist; however, what is being referenced here is the fundamental shift in the nature of the Nationalist Party since the age of Lee Teng-hui in the 1990s, a change that has been pushed further since Chen Shui-bian's presidency in the new millennium. Wu He highlights this by blatantly making one of the "investigators," a representative of the government, a native Taiwanese (educated under the Japanese).

PART TWO

Centrifugal Trauma

4. Yunnan 1968

> Only much later did I realize that life is a slow process of
> being hammered. People grow old day after day, their desire
> disappears little by little, and finally they become like those
> hammered bulls. However, that idea never crossed my mind
> on my twenty-first birthday. I thought I would always be
> lively and strong, and that nothing could beat me.
>
> —WANG XIAOBO (2007:66)

An Education in Violence

Of all the atrocities that China witnessed during the twentieth century, the Great
Proletarian Cultural Revolution is unique for its length, divergent forms of pain
inflicted (including torture, imprisonment, public humiliation, psychological tor-
ture, and forced relocation), and the complex ways "culture" was both a target
and a means to wage political warfare. Just as "old" forms of culture were being
singled out, other forms of culture (such as model operas, films, and literature)
were being appropriated for political ends. Seventeen years after the "liberation" of
China, Mao Zedong 毛澤東 (1893–1976) decided it was time to "continue the
revolution" and consolidate power by purging contending elements within the
party itself. The Cultural Revolution would be the aging chairman's last great po-
litical movement. He mobilized millions of school-age children to join the ranks of
the Red Guards, who "made revolution" through struggle sessions, raids on homes,
class warfare, and destruction of the "four olds"—old thoughts, old culture, old
customs, and old habits. Eventually schools shut down completely and Red Guards
traversed the country during "the Great Linking Up" (*da chuanlian* 大串聯), a
policy that allowed them to travel free by train and bus in order to further spread
the revolutionary flames that were already beginning to rage out of control.[1]

1. For more on the Great Linking Up, see Jin Yucheng's 金字澄 excellent edited volume on the movement,
My Great Linking Up: Floating in the Red Sea (*Wo de da chuanlian: Piaobo zai hong haiyang* 我的大串聯:
漂泊在紅海洋).

Workers, soldiers, and peasants were elevated to new heights as local government leaders, "rightists," former landlords, those with connections abroad or to the Nationalist government, and especially intellectuals suffered terribly. Writers Lao She (1899–1966) and Zhao Shuli 趙樹理 (1906–70), filmmakers Cai Chusheng 蔡楚生 (1906–68) and Zheng Junli 鄭君里 (1911–69), architect Liang Sicheng 梁思成 (1901–72), champion athlete Rong Guotuan 容國團 (1937–68), General Zhang Xuesi 張學思 (1916–70), and even the "model worker" Shi Fuxiang 時傳祥 (1915–75) are but a few who were persecuted to death during this dark era.[2] Heads of state and party leaders such as Liu Shaoqi 劉少奇, Deng Xiaoping, Peng Zhen 彭真, and eventually even Mao's right-hand man, Lin Biao 林彪, were purged from their posts, imprisoned, or even killed. They were replaced by a new inner circle of leaders loyal to Mao and his wife, Jiang Qing, such as the so-called "Gang of Four" and the head of the Chinese intelligence agency, Kang Sheng 康生.

After the Red Guards' power grew out of control and guerrilla-style warfare broke out between different factions, Mao was forced to call in the military to quell the escalating chaos, which had already engulfed the entire nation. The Cultural Revolution entered a new phase and the former Red Guards were stripped of their power and "sent down" to the countryside for "reeducation."

Spanning an entire decade—from 1966 to 1976—the widespread violence, persecution, and injustices during the Cultural Revolution have been the subject of a seemingly endless flood of dramatic, literary, and cinematic works inspired and often haunted by the memory of the Cultural Revolution. The body of artistic representation directly connected with this period far surpasses the literature produced on any other single atrocity in modern Chinese history— perhaps appropriately so, given that the movement's origin is linked to a dramatic play. Deputy mayor of Beijing and Ming historian Wu Han's 吳晗 (1909–69) *Hai Rui Dismissed from Office* (*Hai Rui ba guan* 海瑞罷官), a historical drama about an upright Ming official who dared criticize the emperor, was read as a commentary on Mao's dismissal of veteran General Peng Dehuai 彭德懷 after he dared criticize the chairman's policies regarding the disastrous Great Leap Forward. Mao Zedong launched a nationwide campaign against Wu's play and in the process unleashed a political maelstrom that would not be quelled for a full decade. The Cultural Revolution had begun, and it was intricately tied to an earlier representation of history. Just as atrocity often inspires artistic representation, it can sometimes work the other way around. There were more fundamental

2. For a more comprehensive list of the human losses suffered during the Cultural Revolution, see Wang Youqin's 王友琴 *Victims of the Cultural Revolution: An Investigative Account of Persecution, Imprisonment and Murder* (*Wenge shounanzhe: Guanyu pohai, jianjinyushalu de xunfang shilu* 文革受難者:關於迫害, 監禁與殺戮的尋訪實錄).

causes of the Cultural Revolution (dissatisfaction with party leaders, power struggles in the top echelons of the CCP leadership, Mao's attempt to consolidate power and strengthen his leadership after the Great Leap Forward), but literary, dramatic, and other cultural texts played a key role, albeit often as components of larger political agendas.

In the wake of Mao's death in 1976, the fall of the Gang of Four, and the reversal of Cultural Revolution policies, including official redress of countless cases of wrongful persecution, the Cultural Revolution suddenly became the focus of a new series of diaries, memoirs, histories, and works of fiction that grew into a robust genre during the 1980s, and an unavoidable subject for virtually all contemporary mainland writers. Beginning with Liu Xinwu's 劉心武 1977 short story "Class Counselor" ("Ban zhuren" 班主任), an explosive new wave of fiction depicting the horrors of the Cultural Revolution took over the PRC literary scene. This new movement, which soon became known as "*shanghen wenxue*" 傷痕文學 or "scar literature," after Lu Xinhua's 盧新華 1978 short story "Scar" ("Shanghen" 傷痕),[3] provided a cathartic release of the pain, sorrow, anger, and disillusionment that so many people felt. Gradually, the bold exposé of physical and emotional wounds gave way to a new phase deemed "*fan si wenxue*" 反思文學 or "reflection literature," which injected a deeper level of philosophical reflection into the literary discourse. Out of "reflection literature" came what is arguably the most mature and nuanced stage of Cultural Revolution literature, "*xungen wenxue*" 尋根文學, which has been referred to in English scholarship as "search-for-roots" or "root-seeking" literature. Best represented by such writers as Ah Cheng and Han Shaogong 韓少功, root-seeking literature used the Cultural Revolution, in particular the experience of sent-down educated youths, to explore modern China's cultural heritage. The genre thrived in the mid- to late '80s before giving way to new literary forms in the '90s, such as the new Chinese avant-garde and new forms of commercial literature (represented, respectively, by such writers as Yu Hua 余華 and Liang Xiaosheng), which continued to take the Cultural Revolution as an important concern.

A defining aspect of the Cultural Revolution experience is physical displacement. Mass population movement has played a key role in atrocities and in the politics that make them possible. For millions of young people, the Great Linking Up, which began in August 1966, brought a renewed geographic understanding of their country, which would open up new avenues for imagining the physical parameters of the state, the boundaries between the country and the city, and the spatial dimension of making revolution. Even in times of war,

3. Lu Xinhua's story "Scar" has also been translated as "The Wounded" by Bennett Lee in Lu Xinhua, Lin Xinwu, et al., *The Wounded*.

famine, and environmental calamity, China had seldom witnessed population movement of the scale and scope it did in 1966. For the first time, the entirety of China took on a new mobility as the majority of the country's teenage population simultaneously visited the "holiest" sites in Red China—from Yan'an, the cradle of Chinese Communism, to Shaoshan 韶山, Mao's hometown. But the preferred destination for these revolutionary pilgrimages was Beijing, where Mao Zedong personally received millions of youths who had taken part in the Great Linking Up in Tiananmen Square. However, the Great Linking Up of 1966 was but a prequel to an even greater population dispersal. Just two years later, in 1968, the movement from provincial areas toward the capital would be reversed as youths from the cities were sent down to the countryside in a project that would cause countless tragedies. This time, the movement would not be entirely voluntary, the sites would not be as glamorous, and there would be no ride home—at least not until nearly a decade later.

A full-scale overview and analysis of the large body of literary work inspired by, commemorating, and portraying the widespread atrocities committed during that tumultuous decade is far beyond the scope of this study.[4] Instead, I will examine the Cultural Revolution through the particular example of literature concerning educated youths in Yunnan 雲南 during the late 1960s. Perhaps the most fascinating aspect of this diverse genre is the geographic dislocation of such youths during the second stage of the Cultural Revolution. "*Zhi qing*" 知青 (an abbreviated form of *zhishi qingnian* 知識青年), or "educated youths," refers primarily to urban young people with a middle school education or above who were sent down to rural or mountainous regions to be reeducated by peasants. Young middle and high school students, many former Red Guards, were sent to China's harshest and most remote locales, including Tibet, Xinjiang, and Inner Mongolia. "*Zhiqing wenxue*" 知青文學, or "educated youth literature" is one of the richest genres in contemporary China, "carrying over through such phases as 'Scar Literature,' 'Reform Literature,' 'Search-for Roots,' the 'Misty Poets' and 'Neo-Realism'" (Yang Jian 2002:319).

4. More comprehensive full-length studies of Cultural Revolution literature include Xu Zidong 許子東, *In Order to Forget the Collective Memory: Reading 50 Cultural Revolution Novels* (*Wei le wangque de jiti jiyi: Jiedu 50 pian wenge xiaoshuo* 爲了忘卻的集體記憶: 解讀 50 篇文革小說) and Lan Yang, *Chinese Fiction of the Cultural Revolution*. On the subgenre of *zhiqing* literature, the most definitive Chinese-language work is Yang Jian 楊建, *A Literary History of China's Educated Youths* (*Zhongguo zhiqing wenxue shi* 中國知青文學史). Zuoya Cao, a former *zhiqing* herself, has authored the single most exhaustive survey of educated youth in English, *Out of the Crucible: Literary Works About the Rusticated Youth*, which features readings and analysis of more than fifty texts divided into nine thematic categories. Laifong Leung has also published an excellent collection of interviews with *zhiqing* writers entitled *Morning Sun: Interviews with Chinese Writers of the Lost Generation*.

In the late 1960s in China's remote, beautiful southwest, mass population movement would once again play a pivotal role in a new breed of violence. Unlike in Nanjing and Taipei, where atrocity and violence were in part the direct result of large-scale population movement (in a massive military campaign and in postwar population redistribution), in Yunnan and countless other locations during the Cultural Revolution, population movement itself would become the vehicle for a new form of state-engineered violence.

This chapter examines literary and cinematic works dealing specifically with the experience of educated youths sent to southwest China during the Cultural Revolution and the chronotope of Yunnan 1968. The phenomenon of educated youth being sent down to the countryside has a long history in the PRC, spanning from 1955 all the way until 1981. Although several of the works examined here are set after 1968, that year is significant because it was when rustification of urban youths was first carried out en masse, as an obligatory part of state policy, especially after Mao Zedong's December 22, 1968 instructive spelling out the necessity for such reeducation. Yunnan is the spatial coordinate because it was far removed from the political maelstroms taking place in Beijing, Shanghai, and other major cities and one of the most important topological sites in the formation of an entire generation of young men and women, many of whom became the premiere writers and filmmakers of the 1980s.

Yunnan is a unique locale in China, with harsh mountains and subtropical jungles. It is home to more than two dozen ethnic minorities, including the Yi 彝, Dai 傣, Hani 哈尼, and Jingpo 景頗 peoples. The rugged terrain, large non-Han Chinese population, and difficult-to-reach location, nestled between the Chinese provinces of Tibet 西藏, Sichuan 四川, Guizhou 貴州, and Guangxi 廣西 on the east and north and Vietnam, Laos, and Myanmar on the south and west, have historically positioned Yunnan as a marginal site. As it exists on the periphery of the Chinese empire, its Southeast Asian connection is often stressed by anthropologists and linguists, who have argued to define the province's identity as "Southeast Asian."[5] But Yunnan's marginalization is even more pronounced in the Chinese political realm. Traditionally the region had been considered inhabited by "barbarians" operating outside the rule of the Chinese empire, and it was best known as the place of exile for countless scholars

5. I am here referring specifically to a 2003 Association of Asian Studies panel, "Yunnan as Southeast Asia," in which H. Parker James and Bin Yang (Northeastern University), Laichen Sun (National University of Singapore), and David Bello (Southern Connecticut State University) charted the Southeast Asian connection to Yunnan in the realms of trade, language, and ethnicity.

and officials, who frequently voiced their disillusionment and laments in a rich record of essays and poetry.[6]

Yunnan again became a place of exile in 1968, but this time the mythical borderland of mountainous terrain, rubber tree forests, and exotic minorities would double as the place of "education." The unlikely area suddenly became a chief pedagogical site in Mao's China. For many urban youths, their education was imposed by the state; however, for some it was voluntary. To shed light on the reasons so many *zhiqing* were willing to make the arduous journey from the relative comfort of urban living to the backwater rainforest regions of western Yunnan, I cite the example of Li Zhenjiang 李鎮江. During the rustification movement, he was one of a small group of several dozen educated youth who achieved a small degree of celebrity for their selfless behavior and model actions. Li first traveled from Beijing to Yunnan in 1967 during the Great Linking Up. Very moved by the experience, she returned to Beijing to spearhead a campaign to recruit other young people to join her in returning to open up harsh and exotic Xishuangbanna 西雙版納. On November 27, 1967, Li and fifty-five other recent middle school graduates presented a report to Premier Zhou Enlai entitled "Capital Red Guard Soldiers Open Up Yunnan's Border Region."

> We are Beijing middle school Red Guards; we are determined to follow Chairman Mao's instructions and walk the road unified together with the worker and peasant masses; we are determined to travel to the frontier region of Yunnan to partake in the three great revolutionary movements.
>
> We have already chosen the road to revolution and we are determined to walk that road to the very end. Late last year and this October we embarked on two trips to the Yunnan border region to conduct investigations and make local contacts.
>
> After several months of hands-on investigation and personal experience we have come to a deep understanding about the phenomenal prospects the border regions of Yunnan show in terms of future development; this is especially so in the case of one of the four major industries—plastic production—which is in even greater need of individuals armed with Mao Zedong Thought in order to carry out development. We swear to Chairman Mao, the party, the people, and all the veteran revolutionaries: In order to strengthen national defense, protect our mother country, defeat American imperialism, and earn respect for the

6. Yunnan also serves as the backdrop for countless mythological tales, ghost stories, and legends. For a sampling of some of the traditional stories associated with Yunnan, see Lucien Miller, *South of the Clouds: Tales from Yunnan.*

Chinese people and all the people of the world, we are willing to travel to the frontier regions of Yunnan to serve as foot soldiers of agricultural development and donate our energy to our nation's rubber industry.

We are already fully prepared in terms of our organization, thought, and all other areas. With but a single order from the central government, we will race to the battlefield! Please send us down an order! Once again we request you send us the order! (Liu Xiaomeng 1995:774)

Although from our contemporary perspective its rhetoric may appear exaggerated, even surreal, the document accurately represents the passion, excitement, and optimism of many educated youths as they began their life-changing journey in the late '60s. The letter is important not only for the insights it provides into the psychology of Red Guards/educated youths but also as a historical document marking the beginning of one of the largest redistributions of human labor into Yunnan. Li Zhenjiang and his comrades were sent to Yunnan on February 8, 1968, and essays, poems, and articles about their journey (including the above-quoted letter) were printed in newspapers throughout China's major cities as a model to be followed. As Liu Xiaomeng 劉小萌 notes, "not long after Li's arrival at the Yunnan frontier, approximately 100,000 passionate educated youths took part in the newly formed production and development military units in Yunnan. They came from Beijing, Shanghai, Kunming, Chengdu, Chongqing, and other large-midsized cities throughout China to write a new chapter in the history of opening up Yunnan" (776).

The story of Li Zhenjiang may have marked the glorious beginning of the Cultural Revolution–era educated youth movement in Yunnan, but what happened after the *zhiqing* arrived is a very different tale. The accounts of rape, malnutrition, disease, exploitation, and death faced by thousands of educated youth in Yunnan were never given the kind of media embellishment enjoyed by Li Zhenjiang's letter to Zhou Enlai—in fact, many of the horrors encountered in the rubber forests of Yunnan would remain buried for more than a decade. What had been awaiting these youths in Yunnan was not the revolutionary dreams they had hoped for but a new form of collective exile.

For many of that generation, such as Lao Gui, who wrote of his experience in *Blood Red Sunset* and *Blood and Iron* (*Xue yu tie* 血與鐵), Yunnan represented the site of an education of the body. Amid the difficult natural environment and the fascist military culture, enhanced by collectivism and "work farms," for Lao Gui (and his fictionalized alter ego, Lin Hu 林胡) the only motivation left was idolatry of Chinese war heroes and the urge to perfect the body through labor. Paralleling the remaking of the physical body was the reformation (and often desecration) of the physical environment, as the youths embarked on mass projects

to transform the jungles and mountains, including burning forests (to clear room for "useful cultivatable land") and mass planting of rubber trees. Rubber production had been the government's primary method of developing Yunnan since 1955, when 4,000 people were transferred there to work on 9 military farms. This production model reached its pinnacle during the Cultural Revolution when *zhiqing* were deployed to what had become a complex system of 4 divisions, 23 regiments, 116 camps, and 1038 companies.[7] The results not only fell short of the original lofty production goals but also often proved devastating to both the environment and the bodies of the *zhiqing*. The burning of forests in pristine areas like Xishuangbanna resulted in a massive loss of wildlife habitat and widespread landslides when trees and vegetation were no longer in place to keep soil intact. According to cultural critic Meng Fanhua 孟繁華, "By the 1980s, 90 to 100 percent of the rubber trees planted by educated youths in Yunnan had perished, their death heartlessly attesting to the absurdity of this empty movement" (Yang Jian 2002:435). For other youths, Yunnan represented a different kind of physical education, a sexual awakening spurred on by contact with less repressed ethnic minorities, as displayed in Zhang Nuanxin's 張暖忻 *Sacrificed Youth* (*Qingchun ji* 青春祭) and through a carnivalesque absurdity in Wang Xiaobo's *The Golden Age*. And in many of the works considered here, Yunnan represents the geographic coordinates of a historical and psychological fracture that, on several levels, mirrors the schism between the cities from which the educated youths came and the countryside in which they found themselves trapped.

The diversity of these texts and their divergent strategies emphasize that of all the atrocities considered in this study, the Cultural Revolution—especially the rustification of the educated youths—is the only one that has inspired memories of trauma and pain alongside often equally powerful feelings of nostalgia and passion. Since the 1990s, many educated youth writers and filmmakers have wrested their Cultural Revolution experience from the clutches of scar literature and teary-eyed testimony to resituate it in a new context of sentimental nostalgia, manifested in educated youth theme restaurants, class reunions with other sent-down youths, and memoirs that revisit that once-in-a-lifetime experience. This conflation of the traumatic with the nostalgic is part of what makes the educated youth experience unique and complex, but to what degree is the nostalgic rendering of that era merely a new means of creating a post-traumatic narrative? This chapter demonstrates how Yunnan, circa 1968, is one of the most important points of departure from which to construct—and deconstruct—the horrors of the educated youth experience during the Cultural Revolution and explores the myriad ways that experience has been reconfigured.

7. For more statistics on the labor distribution on the Yunnan *zhiqing* farms, see Liu Xiaomeng et al., *Encyclopedia of the Chinese Educated Youth,* 359.

Wang Xiaobo's Golden Age of the Cultural Revolution

Yunnan has become one of the most important fictional locations within the literature of the Cultural Revolution. It is frequently revisited by numerous contemporary writers, most of whom were directly shaped by their own experience there, including Zhang Manling 張蔓菱, Ye Xin 葉辛, Deng Xian 鄧賢, Ah Cheng, and Dai Sijie 戴思杰. Zhang Manling is a woman writer who was among the first to write about the educated youth experience in Yunnan; Ye Xin, based in Shanghai, is one of the best-known "educated youth novelists"; Deng Xian is the author of the best-selling *Dream of the Chinese Urban Youth* (*Zhongguo zhiqing meng* 中國知青夢); Ah Cheng is a brilliant writer, artist, and screenwriter, best known for his collection *Three Kings*; and Dai Sijie is the author of the international best-seller *Balzac and the Little Chinese Seamstress*. Even Wang Shuo, one of the most popular writers of the late 1980s–early 1990s and pioneer of "*pizi wenxue*" 痞子文學, or "hooligan literature," spent several years in Yunnan during the Cultural Revolution. And there are writers such as Zhu Lin 竹林 who never went to Yunnan as educated youths, yet have felt compelled to project their own Cultural Revolution explorations onto the idyllic landscape "south of the clouds," a key site in the corpus of educated youth literature.[8] Throughout the '80s and '90s, these and other writers, including Lao Gui and Huang Yao 黃堯, collectively created a rich fictional tapestry. But the most surprising, subversive, and sexually charged work to emerge from this literary tradition was unquestionably that of Wang Xiaobo.

Wang Xiaobo (1952–97) was one of the most important writers of the mid- to late 1990s in China, becoming a cultural phenomenon after his untimely death at the age of forty-four. Wang had a rich and diverse background and spent time as an educated youth and laborer in Yunnan and Shandong. He worked in an instrument factory before earning a degree in trade economics from People's University in 1982. After two years as an instructor at his alma mater, Wang went to America, where he earned an M.A. in East Asian Studies at the University of Pittsburgh. Returning to China in 1988, Wang held teaching posts in sociology and accounting until 1992, at which point he became a full-time freelance writer.

Wang Xiaobo is credited with several firsts. He was the first PRC writer to twice win Taiwan's prestigious Unitas Literary Award for outstanding novella. He coauthored (with his sociologist wife, Li Yinhe 李銀河) the first serious study of homosexuality in China, entitled *Their World* (*Tamen de shijie* 他們的世界).

8. One example pointed out by Richard King in his special issue of *Renditions* is Zhu Lin's *The Sobbing Lancang River* ("There and Back Again: The Chinese 'Urban Youth' Generation" 37).

And he was the first Chinese screenwriter to win a best screenplay award at a major international film festival; the film, Zhang Yuan's 張元 *East Palace, West Palace* (*Donggong, xigong* 東宮西宮), was also the first gay film in China. Many of Wang's major works were first published after his death from a heart attack. He became a best-selling author and widely debated cultural figure, inspiring such memorial books as *Romantic Warrior—Remembering Wang Xiaobo* (*Langman qishi—Jiyi Wang Xiaobo* 浪漫騎士: 記憶王小波) and *No Longer Silent* (*Buzai chenmo* 不再沉默).

Wang was also a talented essayist whose sensitive, sharp, and highly perceptive collections, such as *My Spiritual Garden* (*Wo de jingshen jiayuan* 我的精神家園) and *The Silent Majority* (*Chenmo de daduoshu* 沉默的大多數), won him almost as many readers as his fiction. But he is best known for his novels, particularly his trilogy, *The Golden Age* (*Huangjin shidai* 黃金時代), *The Silver Age* (*Baiyin shidai* 白銀時代), and *The Copper Age* (*Qingtong shidai* 青銅時代). Wang's fiction is marked by black humor, absurdist rhetoric, and a continued concern for the plight of the intellectual, whether he writes about the Tang dynasty, the Cultural Revolution, or a science fiction future.

The Golden Age's existential absurdity effectively deconstructs traditional narratives of the Cultural Revolution. The novella tells the deceptively simple tale of Wang Er 王二, an educated youth from Beijing, who has a series of sexual trysts with Chen Qingyang 陳清楊, a doctor from Shanghai who is also sent down to Yunnan during the Cultural Revolution. Accused of having an illicit affair by local party leaders, Wang and Chen pragmatically decide that since they are already suffering for these alleged crimes, they may as well commit them. Thus they embark on what they deem their "great friendship," a cycle of sex, self-criticisms, and public denouncements. Another portion of the narrative takes place in the 1990s and chronicles the lovers' reunion twenty years later in Beijing. As the story progresses, the intercutting between the 1960s and the 1990s becomes increasingly frequent. It represents not only the historical fissure between two eras but also the gulf between two locales, the country and the city, another key theme.

At the heart of *The Golden Age* is Wang and Chen's experience of being uprooted from the two largest urban centers of China, Beijing and Shanghai, and sent to the harsh mountainous region of Yunnan. The rupture between the city and the country is highlighted in numerous passages: "It just so happened that at the time a relief delegation from Beijing was coming to investigate how the city students were treated in the countryside, especially whether any been tied up, beaten, or forced to marry locals" (Wang Xiaobo 2007:76). Wang Xiaobo presents what was for many an experience inextricably linked with violence and trauma as

a carnivalesque orgy of absurdity and sex—Wang Er's own personal "golden age." Very far removed from the communist utopia imagined by Mao Zedong, it is instead an individualist utopia framed by solitude in the barren Yunnan mountains. And rather than an ideological liberation from bourgeois thoughts and bad elements, it represents a sexual liberation: a few days after Wang Er's twenty-first birthday, he loses his virginity to Chen Qingyang. But well before that, Wang had already aptly displayed his sexual—and especially phallic—fixations.

Throughout the text, there are countless references to (and long descriptions of) intercourse and sexual organs. The explicit sexual references (one of the primary reasons the novella's mainland Chinese publication was delayed) made *The Golden Age* the most daring PRC literary representation of sex since Jia Pingwa's 賈平凹 1993 novel *The Abandoned Capital* (*Feidu* 廢都). The focus of Wang's sexual imagination, however, seems to be images of the protagonist's penis, which, throughout the work, plays a role as perverse as it is pervasive. The following four passages represent but a small sampling:

> She laughed hard for a while and said she couldn't bear the sight of that thing on my body. It looked silly and shameless, and whenever she saw him, she just couldn't help getting angry. . . . My little Buddha still stuck out, glittering in the moonlight as if wrapped in plastic. I was a little offended by what she said and she realized that too. So to make peace, she softened her tone and said, "Anyway, he is breathtakingly ugly—don't you agree?"
>
> Standing there like an angry cobra, the thing was indeed homely. (Wang Xiaobo 2007:71–72)

> Then there was this little Buddha of mine, stiff and straight, and that was something I couldn't invent either. (78)

> My penis was like a skinned rabbit, red, shiny, and a foot long, frankly erect. Panicked, Chen Qingyang immediately screamed. (78)

> After a while I pulled my little Buddha out and ejaculated onto the field. She looked back at this with a surprised and fearful expression. I told her that it would fertilize the land. (101)

Throughout the novella, Wang repeatedly offers long passages highlighting, exaggerating, and glorifying all aspects of the phallic in his characters' lives. At times, such as during Wang Er's interactions with the two Jingpo boys, the phallic even infiltrates language:

I shouted at them, "You pricks [*jiba* 雞巴], where're the fish?"

The older one said, "It was all that prick [*jiba*] Le Long's fault! He sat on the dam all the time, so the dam fucking [*jiba*] collapsed."

Le Long roared back, "Wang Er, the fucking [*jiba*] dam you built wasn't strong enough!"

I said, "That's bullshit! I built the dam with sod. What prick [*jiba*] has the nerve to say it wasn't enough?" (67)

In this short passage, the Chinese slang term for penis (here translated as "prick" when used as a noun and "fucking" when used as an adjective), appears no less than five times. The infiltration and adornment of phallic words represents a subversion of language itself—a language which, during the Cultural Revolution, had been thoroughly monopolized by quotes from Chairman Mao and politicized discourse. As the foremost historian on the educated youth movement, Liu Xiaomeng, has observed, "The Cultural Revolution advocated an almost Islamic prohibition on desire; the 'erotic' and 'sexual' became the greatest taboo in language and speech. It was a time when everyone was singing songs based on Mao's quotations, studying the Little Red Book, bowing to the image of Chairman Mao every day where they would 'ask for instructions in the morning and report back in the evening,' and continually wiping out any private thoughts" (Liu Xiaomeng 1999:303). But here Maoist political discourse is radically remodeled into a new form of sexual discourse. In the above passage, which records a conversation between the protagonist Wang Er and two minority boys, a more liberal (and potent) conception of sexuality is also projected onto the local tribes vis-à-vis the Han Chinese.

Phallic representation in *The Golden Age* also comes in the form of metaphor, most commonly a gun fascination displayed most clearly in the following passage, where Wang Er describes his decision to purchase a shotgun.

She couldn't do it unless she was in the right mood; having sex wouldn't put her in a good mood. Of course, after her deception she felt guilty. That was why she gave me 200 *yuan*. I thought since she might have trouble spending the 200 *yuan*, I wouldn't mind helping her. So I brought the money with me to Jingkan and bought a double-barreled shotgun for myself. (84)

The passage makes the gun a direct surrogate for the phallus, which has been denied by Chen's refusal to have sex. The 200-*yuan* double-barreled shotgun subsequently becomes almost as important to Wang Er as his own sex organ. He even laments its loss after he finally returns to Beijing. But what lies behind

Wang Er's phallic fixation, with all its linguistic perversion and martial projections? And, more important, what does this fixation tell us about violence during the Cultural Revolution?

The emphasis on the phallic throughout *The Golden Age* operates as a mechanism for assuaging an implicit fear of castration. This fear central to Freudian psychoanalytic theory often needs to be teased out through metaphors and psychological symbolism, but here it is explicitly articulated early on:

> I was present every time they castrated the bulls. Ordinary bulls could just be cut with a knife. But for extremely wild ones, you have to employ the art of hammer-smashing, which is to cut open their scrotums, take out the balls, and then use a wooden hammer to pulverize them. From then on these altered bulls know nothing but grazing and working. No need to tie them down if you want to kill them. Our team leader, the one who always wielded the hammer, had no doubts that surgery of this kind would also work on humans. He would shout at us all the time: "You young bulls! You need a good hammering to make you behave." In his way of thinking, this red, stiff, foot-long thing on my body was the incarnation of evil. (66)

Soon after this description, Wang goes even further in drawing his parallel between the bull and himself: "Only much later did I realize that life is a slow process of being hammered. People grow old day after day; their desire disappears little by little and finally they become like those hammered bulls" (66). Through this and other examples, the author not only displays the horror of castration that haunts Wang Er but also hints at how the Cultural Revolution has stripped so many people of their humanity in the same way that castration strips from bulls their very nature. The repetition of phallic-centered imagery, symbolism, and even language can be seen as an effort to resist this castration complex through overcompensation.

This phallic dimension of Wang Xiaobo's narrative brings to mind Derrida's concept of the "phallogocentric," which has been defined as a "conflation of *phallocentric* ('phallus-centered') and *logocentric* ('word-centered'; epistemologically, 'truth-centered')" (Cuddon 1992:704) and addresses the dual fixation on both the phallus and language through which a male attempts to exert sexual and social power and influence. The term only takes on its full meaning when both components are present. Throughout *The Golden Age*, Wang Xiaobo also displays an equally obsessive interest in language, logic, and truth. The concept of the phallogocentric is thus perfect to describe the dual and often layered fixation Wang Er/Wang Xiaobo demonstrates toward language and the body, truth and sex, the political and the phallic.

Wang Xiaobo's conception and use of logic and language in *The Golden Age* are as unique, creative, and startling as his sexual imagination. Throughout the work, there is repeated and consistent absurdist logic, black humor, and an ironic search for the historical truth behind "what really happened" through deduction, investigation, and linguistic deconstruction. In many of these passages, Wang first poses a logical conundrum, then offers a systematic analysis, and finally provides a solution—or more often, shows the impossibility of a solution. When Wang Er is first accused of having an affair with Chen Qingyang, he analyzes it this way:

> I told her that we would have to prove two things before our innocence could be established:
>
> 1. Chen Qingyang was a virgin.
> 2. Castrated at birth, I was unable to have sex.
>
> These two things would be hard to prove, so we couldn't prove our innocence. I preferred to prove our guilt. (Wang Xiaobo 2007:65)

Here and in the following passage, the concept of the phallogocentric is further developed because the author layers the sexual/phallic dimensions with the focus on language/truth. After the illicit affair is discovered, the lovers are arrested and forced to provide written confessions of their crimes. In this passage, Wang Xiaobo describes the absurdist process through which Wang Er divulges the details:

> Finally we were taken into custody and forced to write confessions for a long time. At first I wrote the following: Chen Qingyang and I have an indecent relationship. That was all. But it came down from above that what I wrote was too simple, and they asked me to start over. Later on I wrote that Chen Qingyang and I had an indecent relationship, and that I had screwed her many times and she liked being screwed by me. This time the opinions from above said it needed more detail. So I added detail: the fortieth time that we made illegal love, the location was the thatched hut I secretly built on the mountain. It was either the fifteenth day or the sixteenth by the lunar calendar—whatever the date, the moon shone brightly. Chen Qingyang sat on the bamboo bed, her body gleaming in the moonlight shining through the door. I stood on the ground, and she locked her legs around my waist. We chatted for a while. I told her that her breasts were not just full but also shapely; her navel not only round, but shallow too. All of this was very good. She said, "Really? I had no

idea." After a while the moonlight moved away. I lit a cigarette, but she took it from me after I finished half of it, taking several drags. She pinched my nose, for the locals believed that a virgin's nose would be very hard and a man dying of too much sex would have a soft nose. On some of these occasions she lazed on the bed, leaning against a bamboo wall; other times she held me like a koala bear, blowing warm breath on my face. At last the moonlight shone through the window opposite the door and we were separate by then. However, I wrote these confessions not for the military deputy—he was no longer our military deputy, having been discharged from the army and gone back home. It didn't matter whether he was our military deputy or not, we had to write confessions about our errors anyway. (82–83)

During a time when confessions were forced and often resulted in terrifying consequences, Wang Xiaobo offers a comic version wherein the confessions serve as a sexual and creative release for the writer and a voyeuristic experience for the readers, who repeatedly crave more details. Just as the confessions become literary entertainment, so the struggle sessions that follow them take on a heightened sense of performance, yet another radical departure from the usual extreme violence. Even the struggle sessions where the couple is tied up and humiliated before angry (and lustful) audiences leave Chen Qingyang sexually excited and become simply a sadomasochistic form of foreplay for the lovers.

Wang Xiaobo's novel subverts all the main tenets and practices of the Cultural Revolution. From being sent down to the countryside and undergoing re-education to writing political self-confessions and taking part in struggle sessions, everything is reimagined and reconstructed in a carnal utopia. The Cultural Revolution is the site of sexual education, erotic confessions, sadomasochistic (sexual) struggle sessions, and an ever-present phallic fixation. Wang's inversion of the everyday, recontextualized through his phallogocentric imagination, also brings to mind the work of Bakhtin, in which the carnival represents "a boundless world of humorous forms and manifestations opposed to the official and serious tone of medieval ecclesiastical and feudal culture" (Bakhtin 1968:4) and state culture and ideology are at once parallel and radically subverted. Wang Xiaobo's carnivalistic universe of sexual excess and absurdity in many ways parallels and mirrors the equally surreal world of Cultural Revolution–era China.

In this carnivalesque reimagination of history, the sexual is reinserted into the political and a "cultural revolution" is transformed into a "sexual revolution." But one should not be too quick to read The Golden Age as a full-fledged subversion of the Cultural Revolution's violence, which is replaced by sex. Behind the novel's black humor and wanton eroticism is a dystopian nightmare. From the characters' perspective, the carnal emphasis can be a place of refuge

from everyday violence, and from a critical vantage point, sex can even become an allegory for violence. Just as a castration complex lurks behind Wang Er's phallic fixation, a larger demon lurks behind Wang Xiaobo's *The Golden Age*. Although Wang Xiaobo has written about the autobiographical dimensions of the work, within the story itself there are countless fissures between reality and fantasy. Perhaps one of the strongest examples is toward the climax: Wang writes, "After Chen Qingyang told me this, the train roared away. I never saw her again" (Wang Xiaobo 2007:117), but the intercut narrative already has them reunited in the 1990s. The way the author raises doubts about the validity of the parallel narrative reflects the absurdist logic that runs throughout the text and calls into question the story itself. Immediately, the reader loses faith in the narrator and his fantastic conception of the Cultural Revolution.

The reality is that, although Wang Er's *raison d'être* seems to be his resistance of the castration complex through exaggerated sexual exploits and descriptions of them, he is already politically and ideologically castrated by the hegemonic power of the Cultural Revolution. All that is left is fantasy. The result is a phallogocentric carnival of the absurd and a place where political violence is at once subverted and ever-present—for only through Wang Xiaobo's complete deconstruction of the Cultural Revolution is its inescapable shadow made visible. Three decades later, after scars, reflection, and a search for roots, what is left is wry, perverse laughter at the absurdity and futility of the project to "reeducate the educated youths." The sex and laughter mask the tragic results of Mao's project to "continue the revolution," which resulted in a generation losing both their education and their youth.

Cultural Refractions: Ah Cheng from Fiction to Film

Yunnan has also been a critical site in the rich and ever-growing corpus of Cultural Revolution visual culture, continually revisited by contemporary Chinese television and film directors. One of the standout works in the tradition, created in 1987, is *Sacrificed Youth*, adapted from a story by educated youth writer Zhang Manling and directed by Fourth Generation director Zhang Nuanxin (1940–95), a 1962 graduate of the Beijing Film Academy known for her bold aesthetic vision and subtle psychological studies in such films as *Good Morning, Beijing* (*Beijing, Ni zao* 北京, 你早). *Sacrificed Youth* is about the transformation of Li Chun 李純 (Li Fengxu 李鳳緒), a young girl from Beijing, as an educated youth among a Dai minority tribe in Xishuangbanna, deep in southwest Yunnan. Li Chun undergoes a sensual awakening to the natural world around her and her own budding sexuality as she begins to wear Dai outfits,

swim naked with local women, and explore her attraction to two men, a fellow *zhiqing* and a local Dai. As Jerome Silbergeld has observed, *Sacrificed Youth* "is perhaps the leading example of a film in which youth looks back on the ruinous ways of the Cultural Revolution to conclude (rightly or otherwise) that only from the arrogance of the dominant Han culture could such destructiveness erupt and that the real lessons of life were to be learned from China's peaceful ethnic minorities" (Silbergeld 1999:81). The film also employs a documentary-style approach, with stunning cinematography and one of the most affecting voice-overs in contemporary Chinese cinema that allows the viewer to enter Li Chun's world, experiencing her awakening, liberation, and eventual disillusionment.

In the early 2000s, more than twenty years after the last educated youths had returned to the cities, the cinematic landscape of Cultural Revolution–era Yunnan continued to extend, thanks to four new feature films. The first pair, *The Little Chinese Seamstress* and *The Foliage* (*Mei ren cao* 美人草), were both about educated youths caught in love triangles and both, coincidentally, starred Liu Ye 劉燁. *The Little Chinese Seamstress* (2003) was directed by French-based writer and director Dai Sijie, adapted from his own best-selling novel *Balzac and the Little Chinese Seamstress*. The film actually continues Dai Sijie's 1989 feature film exploration of the Cultural Revolution, *China, My Sorrow*, a tragic comedy about a group of Shanghainese sent to a reeducation camp in the countryside. *The Little Chinese Seamstress* follows Ma and Luo, two educated youths sent to a remote mountain region for reeducation, as they pursue the granddaughter of a local seamstress and forge their own inner spiritual world of Mozart and Balzac while resisting the harsh environment around them. Thanks to the popularity of the original novel, the film's all-star cast (which, besides Liu Ye, included Zhou Xun 周迅 and Wang Hongwei 王宏偉), and honors at the Golden Globe Awards and the Cannes film festival, *The Little Chinese Seamstress* has powerfully brought the unique tragedy of the educated youths to the world.

In 2004, Lü Yue 呂樂, one of the Fifth Generation's standout cinematographers, who shot several features for Chen Kaige and Tian Zhuangzhuang, made *The Foliage,* his first commercial release as a director after his *Mr. Zhao* (*Zhao xiansheng* 趙先生) was banned in 1998. Set in a small Yunnan village in 1974, *The Foliage* traces the story of Ye Xingyu 葉星雨 (Shu Qi 舒淇), a woman caught between two men on the eve of the great exodus of educated youths from Yunnan. The film bears witness to the violent factional conflict among different groups of educated youths and portrays the environmental devastation caused by the cutting and burning of forests. Like *Sacrificed Youth*, which concludes with Li Chun's return to the ravaged remains of the Dai village, *The Foliage* closes with an epilogue wherein the female protagonist returns to the

place of her "sacrificed youth" years later and encounters her lost love.[9] Just months after the release of *The Foliage,* writer-turned-director Zhu Wen's 朱文 2004 award-winning sophomore directorial effort *South of the Clouds* (*Yun de nan fang* 雲的南方), which also explored the plight of youths sent to Yunnan during the 1960s for reeducation, was released.

Collectively, these works have firmly situated the experience of educated youths in Yunnan as a key site along the visual trajectory extending from the Cultural Revolution. The fact that so many of the films project the tale into the future is also most telling about our imagination of that particular world. For so many of these youths, memories of the past continue to influence their lives. At the end of *Sacrificed Youth,* Li Chun returns to Xishuangbanna to find the mountain village destroyed by a mudslide, just as in *The Little Chinese Seamstress,* the violin player Ma's return from France is prompted by news of the impending disappearance of the mountain village under the rising waters of the Three Gorges Dam. The youths return to discover that not only is the past irretrievable, its very site has been forever destroyed. The past can only be reclaimed in the fictional realm, and the multiple cinematic adaptations of Ah Cheng's fiction have done the most to make the plight of the Yunnan *zhiqing* an indelible part of our popular imagination of the Cultural Revolution.

King of Chess and a Tale of Two Chinas

Born Zhong Ahcheng 鐘阿城 in 1949, Ah Cheng was raised in Beijing and spent time as an educated youth in Shanxi, Inner Mongolia, and Yunnan. After returning to Beijing in 1979, Ah Cheng established himself as a painter through his groundbreaking work with the Stars Collective, a group of artists who were the first to make a concerted effort to challenge the dominant socialist-realist aesthetic in the aftermath of the Cultural Revolution. Throughout the 1980s, Ah Cheng also established himself as a critic, essayist, screenwriter, and fiction writer. Although not prolific, he has developed a uniquely powerful literary style, which relies on an economy of language and an unadorned elegance indebted to such writers as Shen Congwen and Wang Zengqi 汪曾棋. Ah Cheng has written extensively about Yunnan, where he spent several years in both

9. *First Love* (*Chu lian* 初戀), the original novel by Shi Xiaoke 石小克 upon which the film was based, has a much darker ending. Instead of the lovers reuniting, Ye Xingyu dies of cancer shortly after her husband's passing from SARS.

Kunming and Xishuangbanna, in several short volumes, including *A Land for Life, a Land for Love* (*Piandi fengliu* 遍地風流), a collection of short impressionist fiction written during the Cultural Revolution but only published decades later during the 1990s.

Ah Cheng is in demand as a screenwriter and has worked with such directors as Xie Jin, Stanley Kwan, Tian Zhuangzhuang, Hou Hsiao-hsien, and even King Hu 胡金銓. Given his long association with the film industry, it seems appropriate that Ah Cheng's own works also made the successful transition to the big screen. His best-known collection of fiction, published in the West under the title *Three Kings,* has inspired three major motion pictures. This section examines the literary world of Ah Cheng as it has been reimagined on screen, beginning with *King of the Children* (*Haizi wang* 孩子王) and paying special attention to Yim Ho 嚴浩 and Tsui Hark's feature film version of *King of Chess* (*Qi wang* 棋王). I hope to show how one of the single most influential literary works of the 1980s has been transformed into images, and what that process says about the visual record of *zhiqing* violence transmitted through popular culture.

The first and most critically acclaimed cinematic adaptation of Ah Cheng's fiction was *King of the Children* (1987), directed by Chen Kaige. When the film was released, two other unrelated productions of *King of Chess* were under way in China and Taiwan. Unlike those, which both became commercially oriented, *King of the Children* held to a very different approach, extending the aesthetic first pioneered by Chen Kaige in 1984 in *Yellow Earth* (*Huang tudi* 黃土地), with brutally realistic depictions of the difficult lives of peasants, bold symbolism, powerful imagery, and a new conception of revolutionary history. *King of the Children* was an art film dominated by a stunning *mis-en-scène* and reflective philosophical probing. It tells a simple, yet powerful story about an educated youth sent to Yunnan for reeducation. Lao Gan 老桿 is laboring on a farm along with his fellow *zhiqing* when he is transferred to a local elementary school a few mountains away to teach the Chinese language. Soon after arriving, Lao Gan is surprised to find that the area is so impoverished that the students do not even have textbooks and are forced to copy lessons from the blackboard. This pales in comparison to his eventual realization that the students are simply copying and memorizing their lessons without understanding the meaning of the Chinese characters. Lao Gan eventually decides to do away with the textbook altogether and teach the students the actual meanings of the characters, using them to inspire creative thinking. However, he is removed from his teaching post for refusing to use the state-mandated textbook and sent back to his work brigade. Structured

like a classic Greek tragedy, the novella explores the hegemonic control and political brutality so deeply embedded in the state and delves into the more subtle modes of indoctrination hidden within culture and the Chinese language itself.

Born in 1952, Chen Kaige was from a prominent Beijing film family. Like Ah Cheng, as a teenager he answered Mao's call for China's youth to stand up and revolt and was eventually sent down to the countryside. Chen spent eight years as an educated youth in Yunnan province and returned to Beijing in 1975. After the Cultural Revolution, he was admitted to the now-legendary 1982 graduating class of the Beijing Film Academy, a group that would later become known as the Fifth Generation. Chen worked on a handful of films as an assistant director before joining his former classmates Zhang Yimou and He Qun 何群 at the Guangxi Film Studio to produce what would eventually become *Yellow Earth*. With *King of the Children*, Chen Kaige transformed Ah Cheng's novella into a new form of visual poetry that pushed the story in new directions and continued Chen's own innovation and experimentation, continually rebelling against cinematic norms and audience expectations.

King of the Children has elicited much debate and discussion within China and the overseas sinological community. The film has been the subject of extended studies by such leading Chinese film scholars as Xudong Zhang (1997), Tony Rayns (1989), Jerome Silbergeld (1999), Rey Chow (1995), and Chen Mo (1998). One of the central tropes that several of these critics have identified is an almost schizophrenic fracture that haunts the film on many levels, from the spatial to the historical and from the psychological to the cultural. In Rey Chow's influential reading of *King of the Children,* she begins by addressing the discontinuities between the literary and filmic versions before moving on the trope of copying and reproduction and other forms of visual fragmentation, such as the now iconic shot of Lao Gan's fractured image reflected in a broken mirror.

Lao Gan (Xie Yuan) fractured (center) between nature (left) and culture (right).

Xudong Zhang, who characterized the film as about a "youth forging his way through political chaos and cultural wilderness" (Zhang 1997:288), first identifies a historical split between the present and the past (283), then discusses the fracture in Lao Gan's identity:

> Lao Gan's identity as a teacher is split from the very beginning, as his image is presented on the screen in a flattened deep shot of two "portraits" of the instructor: Lao Gan before the class lecturing, captured in a midrange frame; and a caricature of him on the blackboard with "This is Lao Gan" beside it, of which he remains unaware while lecturing, apparently drawn by the pupils now sitting quietly in front of him. Throughout the film, conventional or traditional pedagogy stands as the radical opposite of the educational revolution Lao Gan and his students are engaged in; and traditional pedagogy is seen to be subverted by the engagement. Thus the double image of the teacher prefigures the double consciousness of Lao Gan in his role as a teacher. (287–288)

The multiple layers of fracturing in *King of the Children* are a powerful indicator of the violence endured by the educated youth during the Cultural Revolution. The deep fissures present in the novella also speak to the historical and psychological trauma of that dark era, but the symbolic layers at work in Chen's film anticipated an even more radical display of cultural, historical, geopolitical, and even textual fracture in *King of Chess*.

Upon its initial publication in 1984, *King of Chess* almost single-handedly set off a new literary and cultural debate, becoming the central work in the root-seeking movement, which would sweep China from the mid-'80s until the eve of the Tiananmen Square uprising in 1989. The story of Wang Yisheng 王一生, an educated youth with an unquenchable hunger for food and the art of chess,

marked a major departure from fiction by other contemporary writers set during the Cultural Revolution. Ah Cheng shied away from moralizing and historical condemnation, offering instead a story of one man's will to preserve his dignity, values, and humanism amid the political maelstrom. At the same time, Ah Cheng used the Chinese language in a refreshing new way and revived ideals and imagery often conceived of as the quintessence of Chinese culture—Daoist philosophy, Confucian rites, and of course, traditional Chinese chess. If *King of the Children* is modeled after Greek tragedy, *King of Chess* is in many ways indebted to the structure of traditional *wuxia* fiction, as it features many of the tropes of the genre, including the concealed hero, operating in concert with his own "way"; a *jianghu* 江湖, or martial society, of other players who live by their own codes; and the final chivalric showdown between the protagonist and an array of opponents, including a reclusive elder master. Ah Cheng created a new form of cultural hero to battle the political absurdity that reigned during the Cultural Revolution—in stark contrast to the discourse of victimization that dominated scar literature.

The novella became a best-seller in China as well as Hong Kong, Taiwan (where it was among the first post–1987 literary sensations from the PRC), and overseas. Critic Gang Yue has written about the novella's warm reception in Chinese-speaking communities around the world and its transnational voyage to publication and popularity (Yue 1999:201–202), but the work traveled even farther and took on a heightened sense of trans-China hybridity once adapted for the silver screen. Just a few years after its publication, two major feature films based on the work were in production. Under the direction of the Xi'an Film Studio, Teng Wenji 騰文驥 (b. 1944), a 1968 graduate of the Beijing Film Academy who has directed almost two dozen films, collaborated with noted writer Zhang Xinxin 張辛欣 on adapting a screenplay based on *King of Chess*. Ah Cheng had previously collaborated with Teng as a screenwriter on his earlier films—1985's *The Star* (*Da mingxing* 大明星) and 1987's *Let the World Fill with Love* (*Rang shijie chongman ai* 讓世界充滿愛). Teng's 1988 adaptation, which starred Xie Yuan 謝圓 as Wang Yisheng, remained remarkably faithful to the original novel. In order to bring the film to feature length, Teng inserted several additional scenes, but he stuck close to the original dialogue and went to great lengths in re-creating the milieu of China during the 1960s.

In contrast, the second film version of *King of Chess* proved to be quite a departure, taking numerous dramatic liberties. In 1988, as Chen Kaige's adaptation of *King of the Children* was finishing the international festival circuit and Teng Wenji's PRC version of *King of Chess* was under way in Xishuang-

banna, the second adaptation was being shot across the Taiwan Strait. Instead of one director, it had two. The film was to be produced by the legendary pioneer of the Hong Kong New Wave, Tsui Hark (b. 1950), and directed by Yim Ho (b. 1952), a Hong Kong director who has shot numerous films on the mainland, including *Homecoming* (*Sishui liunian* 似水流年) and *The Day the Sun Turned Cold* (*Meiyou taiyang de rizi* 沒有太陽的日子). Yim Ho codirected and cowrote the screenplay (with Tony Leung 梁家輝) and also costarred—as none other than Ah Cheng (an appropriate role for the "author" behind the film). The division of labor gradually led to personality conflicts between Tsui and Yim, as the latter recounts:

> I spent a hell of a lot of time, energy, and effort turning the two books into one script, and somehow in the middle of it, Tsui Hark, who was the producer of the film, got paranoid. . . . At that time I think he was not too organized and the film was taken out of my hands, so only those parts of the film in which I actually appear are shot by me. And the other parts were shot by Tsui Hark. It's all in the past now. (Wood 1998:154)

Due to creative differences between the two directors, shooting and postproduction dragged on and the film was not commercially released until 1992, more than three years after the principal shooting had been completed. Eventually, Tsui Hark took over and completed the final cut. But even more startling than the creative division behind the film was the structural division within it. *King of Chess* was not only helmed by two directors but also adapted from two different novels. It was only partly based on Ah Cheng's Cultural Revolution–era story; the other half came from a short novel of the same title by Taiwanese American writer Chang Hsi-kuo 張系國 (b. 1944), a professor of computer science who is better known as the "father of science fiction" in Taiwan. Set in contemporary Taipei and focusing on a eleven-year-old chess prodigy who can see the future, Chang's 1978 novel portrays a fast-paced commercial society that seemingly could not be further removed from the 1960s China in Ah Cheng's fiction.

In *King of Chess,* however, Yim Ho and Tsui Hark took the novel approach of linking these disparate literary worlds, building a visual bridge between Cultural Revolution–era China and 1980s Taiwan. The cinematic "reunification" is announced from the opening sequence, in which archival documentary footage of the Cultural Revolution is re-edited and set against the contemporary pop-rock anthem "Comrade Lover" ("Airen tongzhi" 愛人同志) by Taiwanese singer-songwriter Lo Ta-yu 羅大佑. The lyrics, which juxtapose typical pop

The transformation of the historical and spatial in *King of Chess*: Mao Zedong's motorcade parading down the Avenue of Eternal Peace in Beijing (upper left) segues to the Chiang Kai-shek Memorial in Taipei (upper right).

verses with the political terminology of the PRC, at once reference the images and create an ironic subtext against which to read them.

Whenever I close my eyes I think of you	每一次閉上眼睛就想到了你
You are like a beautiful slogan that won't go away	你像一句美麗的口號揮不去
In this world of criticisms and struggle	在這批判鬥爭的世界裡
Everyone must learn to protect themselves	每個人都要學習保護自己
Let me believe in your sincerity Comrade Lover	讓我相信你的忠貞 愛人同志

In Lo's ironic lyrics, the political and the personal collide as the private longings denied in socialist China are reinserted into a individualist rock and roll vision laden with the keywords of communism. As the theme winds down, the viewer is gradually transported from the politicized world of Cultural Revolution parades along the Avenue of Eternal Peace in Beijing to the economically charged world of contemporary Taipei.

This transition indicates the parallel transformation of the spatial and the historical, serving as an establishing shot of the two disparate worlds in which the film(s) will unfold. In the panels, "Red China," embodied by Mao Zedong's motorcade, dramatically changes to "Free China," embodied by the memorial hall of Mao's former nemesis, Chiang Kai-shek. And in the following series of shots, the economic might of contemporary Taiwan rises up from, or is superimposed over, the politicized site of the memorial. The chief signifiers of contemporary Taipei are not the landmarks of communism but those of capitalism.

The skillfully cut opening sequence illustrates the radical dissimilarities between 1960s China and contemporary Taipei while hinting at the eerily similar methods by which each society appropriates and sublimates icons, slogans, and social behavior. From politically charged rallies to the bustle of commerce and shopping, from the image of Mao to the supermodel, and from slogans urging "attack capitalist thought" to signposts encouraging consumption, the sequence delineates the ideological, historical, and social discontinuity between the two places. Yet the film visually conflates the seemingly fixed spatial/temporal positioning of the sites.

Tsui and Yim's ingenious opening sequence also introduces a bold social critique that equates the radical political culture of 1960s China with the radical capitalist culture of 1980s Taipei. As the film progresses, it becomes apparent that on one level, the fast-paced business world of contemporary Taipei is no less vicious than politically fanatical Cultural Revolution China. This is even more evident when Wang Shengfang 王聖方, the chess prodigy of the Taiwan segment, is introduced. Although he is the "king of chess," Wang is continually used as a pawn: exploited to predict stock market information; forced to appear on television to boost ratings and a talk-show host's failing career; kidnapped and ultimately killed trying to save a young girl.

The Taipei segments present a critical portrait of capitalistic society, but no less critical than those portions adapted from Ah Cheng's novella set in mainland China. Gang Yue has pointed out in his discussion of Ah Cheng's story, "*The Chess King* arose when the term *culture* became a catchword displacing the official term *ideology*" (Gang Yue 209), and it would not be an exaggeration to argue that the story played a crucial role in that displacement. However, although one of the key features of the original novella is the deconstruction of the ideological bent of victimization and political censure, the film reinserts these elements into the text.

In the original novella, Wang Yisheng arrives for the climactic chess tournament a few days late, missing the first round of competition. In order to get Wang into the finals, and to secure a transfer for himself, another educated youth who goes by the nickname Tall Balls 脚卵 bribes a local official with a Ming dynasty chess set. The loss of the family heirloom is subtly understated, a small sacrifice in a time of calamity. In the film, however, a much more dramatic and violent plot twist is inserted. Instead of innocently arriving late and missing a registration deadline, Wang Yisheng is arrested for using a portion of a big-character poster as toilet paper (a plot twist lifted from elsewhere in Ah Cheng's fiction). Tall Balls (portrayed by Taiwan film and stage veteran Jin Shijie 金世傑) approaches the local cadre with the sole purpose of effecting Wang's release; he doesn't offer the chess set, the official asks about it. This rewrite

is typical of Tsui and Yim's film in its addition of another layer of brutality, complete with absurd arrests and overt corruption. When Wang is finally released but refuses to take part in the official tournament, even though Tall Balls has already sacrificed his treasured chess set to ensure his release and participation, he incites the anger of none other than Ah Cheng (portrayed by director Yim Ho), who proceeds to beat his friend.

Throughout the film, consistent sarcasm about the Maoist fervor of the era is only thinly concealed in the actors' expressions. This strategy is an attempt to delegitimize the historical legacy of the Cultural Revolution, an effort already carried out en masse throughout China, and to delegitimize the idea that people within China actually believed in Maoist principles during the Cultural Revolution, which is a much more tenuous proposition. In addition, *King of Chess* introduces a series of highly symbolic images that emphasize the violent suppression carried out during that era. Religion was, without doubt, one of the many targets; however, nowhere within Ah Cheng's novella is religion—especially Christianity—explicitly singled out. But in *King of Chess,* the crucifix belonging to Tall Balls becomes a central prop given numerous close-ups, often implying the suppression of organized religion.

In one scene, a Red Guard notices Tall Balls clutching his crucifix in desperation, but failing to see the religious emblem, instead attacks the educated youths playing chess for their feudal bourgeois sensibilities. This scene not

The symbols of communism and capitalism in *King of Chess*: crowds (left), icons (middle), and slogans (right).

only introduces the implicit threat against religion but also prominently features the figure of the wicked Red Guard (silently smirked at by other characters, further highlighting the sarcasm toward Maoism) and subtly criticizes chess—all elements that never appear in the original literary work. Ideological symbolism is further injected into *King of Chess* during Wang Yisheng's climactic blind chess game, which he carries out simultaneously with nine opponents. During the final moves of Wang's game with his last opponent, a window is suddenly opened, sending a white ray of sunlight into the dark room. In this moment of epiphany, Wang Yisheng proves victorious. However, when the window is opened, a highly symbolic hole is simultaneously opened in a larger-than-life image of Mao Zedong's head painted on the outside of the building. The chess king's victory and will to survive, implicit in Ah Cheng's novella, are here directly linked to the defeat and subversion of Mao.

In *King of Chess,* Ah Cheng looked back to China's cultural heritage as an escape from both the darkness of the Cultural Revolution and the cultural climate of the 1980s that had contextualized that era via the politics of victimization. But in Tsui Hark and Yim Ho's cinematic adaptation, the violence of the Cultural Revolution is reinserted, and instead of pointing toward China's cultural past as a new way out, the narrative shifts to a capitalist future filled with a new set of pitfalls, equally difficult for the artist to navigate.

The two chess kings: Wang Yisheng (Tony Leung), who reflects China (left), and Wang Sheng-fang (Wang Shengfang), who mirrors Taiwan (right).

On one level the dichotomy between the two chess kings is a further development of a split already present in Ah Cheng's original story, as has been noted by critic Jing Wang (and also discussed earlier in reference to *King of the Children*):

> Those who accuse [Ah] Cheng of glorifying the Dao fall short of grasping that the dramatic pathos of the tale's central metaphor, the mock-heroic battle of the chess king with his rival, lies not in the fictional enactment of the Dao of chess, but in the symbolic battle of life-and-death that took place *within* the chess king Wang Yisheng himself—the turbulent confrontation of his finite self with his transcendental self embodied in his maddening pursuit of the ultimate truth of chess. This clash of Wang Yisheng's empirical self—a mundane existence confined in a social reality he is powerless to transform—with his transcendental subjectivity, which aspires after infinite freedom in the spiritual realm, unmistakably subverts the Chineseness that underlies a tale about the art of chess. I emphasize that the drama and trauma of the confrontation between Wang Yisheng's two selves, which nearly consumes our hero at the end of the story (he sinks into a physical coma), bespeak aesthetics of the modern. More specifically, the confrontation highlights the contest between the old and the new regime, a familiar scenario that modernity never fails to trigger. (Wang Jing 1996:185)

In *King of Chess,* however, "the drama and trauma" play out not just between Wang Yisheng's two selves but also between two chess kings, two historical milieus, two geopolitical realities, and two stories.

Besides the common title, the only narrative device tying the otherwise un-related stories together is the character Cheng Ling 程凌, a Hong Kong mar-

The subversive "opening of Mao's head" during the climactic moment of *King of Chess* (left); Ah Cheng, portrayed by director Yim Ho, beating Wang Yisheng (Tony Leung) (right).

keting man who comes to Taipei and discovers Wang Shengfang for the Taiwan television show *Whiz Kids* 神童世界. The eleven-year-old boy triggers Cheng's memories of twenty years earlier, when he traveled from Hong Kong to mainland China to visit his cousin Tall Balls. It was during that (historically unlikely) trip that he met another "chess king," Wang Yisheng. Portrayed by veteran Hong Kong actor-filmmaker John Sham 岑建勳, Cheng serves as a go-between for the two locales of China and Taiwan, reinforcing the traditional Cold War–era role that Hong Kong faithfully performed. Cheng Ling's position also mirrors the role of Tsui Hark and Yim Ho, two Hong Kong filmmakers bringing together Taiwan and the mainland in a grand cinematic gesture of unification.[10]

At the end of *King of Chess*, in one of the most moving moments of the film, Wang Yisheng suddenly appears in full Cultural Revolution–era regalia on the streets of contemporary Taipei. The "chess idiot" who looks toward the past meets Wang Shengfang, the "whiz kid" who can see into the future, and they walk off hand in hand toward an unknown destination. The two protagonists come together against a dark background devoid of any spatial identifiers, and the chronotopic spaces in which each lived disappear. Reading the ending as a political allegory seems to look beyond the violence of the past and the exploitation of the present to an optimistic future where the two chess kings—and, symbolically, the two Chinas—are reunited. However, we should not forget that it is only through death and a dark spectral return that Wang Yisheng and

10. The symbolic unification of China, Taiwan, and Hong Kong is further represented by the film's credits, which include directors Tsui Hark and Yim Ho (Hong Kong), writer Ah Cheng (China), executive producer Hou Hsiao-hsien (Taiwan), musician Lo Ta-yu (Taiwan), and actors Tony Leung and John Sham (Hong Kong). The film was shot alternately in Taiwan and Hong Kong.

The two chess kings united in death at the end of *King of Chess.*

Wang Shengfang can finally be together.[11] And it is only through a drive to "unimagine" China—via Hong Kong and ending in Taiwan—the trauma of the Cultural Revolution is reconfigured.

Serialized Returns: Back to Shanghai and Off to "Haiwai"

In 1979, 13 years after the launching of the Cultural Revolution and more than a decade after Mao called upon urban youths to "go up to the mountains and down to the countryside," there were still large numbers of educated youths who had yet to return home. As many as 200,000 were being rusticated each year during the late 1970s, and it was not until disgruntled youths began demonstrating and organizing protests that the government finally began to belatedly grant them the right to return home. The mass protests in which they wrote letters in blood demanding to be allowed to leave have been widely documented in literature, such as Deng Xian's best-selling work of reportage, *Dream of the Chinese Urban Youth,* and Guo Xiaodong's 郭小東 novel, *The Zhiqing Tribe of China* (*Zhongguo zhiqing buluo* 中國知青部落), which was also made into a popular television miniseries.[12] Deng's work set out to provide a detailed account of the

11. The fact that Wang Yisheng seems not to have aged and is still wearing his army-style uniform when he appears at the end of *King of Chess* implies that he died during his time in the countryside after the chess tournament, a fact never alluded to in the original story.

12. The eight-episode miniseries *The Zhiqing Tribe of China* was directed by Yuan Jun 袁軍; Guo Xiaodong,

events leading up to the Yunnan exodus, which began when a *zhiqing* woman and her child died during a botched baby delivery and escalated into mass protests throughout the province. Guo takes the same incident as its starting point but mingles his account with fiction. Moreover, Guo's fascinating narrative strategy juxtaposes stories about the rusticated youth during their time in Yunnan with descriptions of their lives back in the cities more than a decade later. These works, along with writings about similar exoduses in other parts of China, such as Liang Xiaosheng's best-selling novel *Tonight the Snowstorm Descends* (*Jinye you baofengxue* 今夜有暴風雪), bear testament to the educated youths' desperate desire to escape the place responsible for their pain . . . and their pasts.[13]

Memories are often hard to escape. The terrors endured by the youths, which included denial of formal education, separation from their families, hard physical labor, malnutrition, and often, more direct forms of physical and/or sexual abuse, proved to be indelible experiences that would haunt them for years to come. These ghosts not only refused to die but in some cases have been continually resurrected, inspiring a circle of violent repetition.

Repetition of violence has emerged in trauma studies as an important trait of many survivors. As Cathy Caruth has observed:

> The survival of trauma is not the fortunate passage beyond a violent event, a passage that is accidentally interrupted by reminders of it, but rather the endless *inherent necessity* of repetition, which ultimately may lead to destruction. The examples of repetition compulsion that Freud offers— the patient repeating painful events in analysis, the woman condemned repeatedly to marry men who die, the soldier Tancred in Tasso's poem wounding his beloved again—all seem to point to the necessity by which consciousness, once faced with the possibility of its death, can do nothing but repeat the destructive event over and over again. Indeed, these examples suggest that the shape of individual lives, the history of the traumatized individual, is nothing other than the determined repetition of the event of destruction. (62–63)

The full toll of atrocity and violent experience is not exacted at the moment of violation, but often in its psychic and experiential replays at a time and place far

author of the original novel, served as a planner. The series was quite popular upon its release in 1998, which corresponded to the thirtieth anniversary of the *shang shan xia xiang* (rustification) movement.

13. For more on the motif of exodus and the escape of educated youths in *Dream of the Chinese Urban Youth*, *The Zhiqing Tribe of China*, and *Tonight the Snowstorm Descends*, see Zuoya Cao, *Out of the Crucible: Literary Works about the Rusticated Youth*, 185–194.

removed from the original trauma. This section examines the repetition of violence in a landmark work inspired by the experience of educated youths in Yunnan, but set many years later in locations from Shanghai to "*haiwai*" 海外, or overseas, as former educated youths venture back to the Chinese metropolis and then on to new horizons overseas. There are numerous works where this repetition is manifested in a desire to revisit the actual physical site of atrocity, such as Huang Yao's disturbing postmodern novel *Without Order* (*Wu xu* 無序). But there is also a different, almost phantasmagoric return of memories as ghosts that come looking for those who abandoned them. This type of repetition is dramatized in several television miniseries that focus on a psychological return, manifested in a very different form of physical movement—not back to the site of atrocity, but farther away, from Yunnan to Shanghai and from Shanghai to North America. *The Wages of Sin*, the 1993 novel by Ye Xin on which these series were based, bears witness to a traumatic experience that stays with the victims, defying limitations of time, space, and history. Nightmares recur and the scars of the educated youth from Yunnan not only refuse to heal but also reopen decades later, creating a new series of belated tragedies and projected traumas.

Duplicitous Voyage: The Wages of Sin

In 1979, the central government finally passed a motion to allow all unmarried educated youths to return to their hometowns and regain their original residence cards. For many educated youths, however, the situation was complicated by children they had had, often out of wedlock, during their time in the countryside. The choice to return home often meant abandoning their own children. One of the many vignettes included in Deng Xian's best-selling work, *Dream of the Chinese Urban Youth,* illustrates the conundrum faced by married educated youths in the late 1970s as they decided whether to remain in Yunnan, where they had lived for almost a decade, or return to the urban centers from which they came. Deng recounts the story of a certain Miss Li who takes in a child abandoned by an educated youth couple just before their return to the city, inspiring a wave of child abandonment:

> The good-hearted Miss Li spoke up, volunteering to act as foster mother. She bought babies' bottles and milk with her own wages, and hung brightly colored diapers out to dry in the station dormitory. By the next day, news of the abandoned child was all over the station, and streams of people came over

to express their sympathy and to praise Miss Li for her high principles and virtue.

The following day three more abandoned babies were discovered in the waiting room and the open square outside the station, one dangerously ill with a high fever. . . .

According to incomplete statistics, during the 1979 return of the urban youth to the cities, the city of Kunming alone took in almost 100 abandoned infants, the highest total for a single day being 11.

This figure does not include babies left in bus stations, docks, and public squares in the suburbs of Kunming. (King 1998:103–104)

In an ironic response to Lu Xun's famous quixotic wish to "save the children," just as China was entering a new age of reform and openness, untold numbers of educated youths abandoned their children in a desperate effort to save themselves. But what became of the Yunnan orphans described by Deng Xian? And how did leaving their children behind affect the former educated youths? In his 1993 novel *The Wages of Sin,* Ye Xin attempted to answer these questions and, in the process, extended the tragic tale of the educated youths twenty years into the future.

Ye Xin was born in 1949 and sent down to the countryside near Guizhou in 1969; he spent more than a decade there. A native of Shanghai, Ye began writing about the educated youth experience in the early 1980s, publishing *Wasted Years* (*Cuotuo suiyue* 蹉跎歲月), a novel filled with a nostalgic yearning for youth, in 1982. However, by the time he completed *The Wages of Sin* a decade later, Ye's conception of that experience and understanding of its long-term impact had changed dramatically. As critic Yang Jian writes, "There is a huge difference between *Wasted Years* and *The Wages of Sin;* the former is informed by romanticism while the latter portrays the common world of the everyday. After more than a decade since his first novel, it is already very difficult to find any traces in *The Wages of Sin* of the author's former nostalgic idealism" (Yang Jian 432). In the ten years between the two works, Ye Xin had begun to explore the fate of the children left behind by the educated youths. In the 1985 novel *On the Awakened Earth* (*Zai xinglai de tudi shang* 在醒來的土地上), Zheng Xuan 鄭璇, a female educated youth, must choose between her local peasant husband (and their child) and the male educated youth she truly loves. In 1988's *Variations on Love* (*Ai de bianzuo* 愛的變奏), educated youth Jiao Nan 矯楠 abandons his lover along with their child so that he can return to Shanghai, and in the short story "The Visit" ("Baifang" 拜訪), educated youths who have become parents have to

deal with the consequences of their actions. With 1992's *The Wages of Sin*, Ye finally crossed the border between these former educated youths' experiences and the shadow of violence that projected from their pasts into the lives of their children.

The Wages of Sin struck a chord with readers throughout China, becoming one of the best-selling novels of the 1990s and one of the most important works of educated youth fiction. Like *Wasted Years,* which had been adapted into an award-winning television series a decade earlier, *The Wages of Sin* made the successful transition to television. In 1993, Ye Xin wrote the script for the twenty-episode series, which was directed by Huang Shuqin 黃蜀芹, director of *Woman, Demon, Human* (*Ren, gui, qing* 人鬼情) and the popular television series *Fortress Besieged.* When the series premiered on January 9, 1995, it set a new ratings record, capturing an astonishing 42.7 percent of the television audience. It also helped revive the popularity of the novel, which was reprinted several times in 1995 and broke several book sales records.

Set in the early 1990s, *The Wages of Sin* traces the journey of five teenagers from the countryside to the metropolis of Shanghai. Although their trip seems far removed from the mass movement that swept China twenty years earlier, there are direct parallels with the movement of educated youths to the countryside in 1968. Shen Meixia 沈美霞, Lu Xiaofeng 盧曉峰, An Yonghui 安永輝, Sheng Tianhua 盛天華, and Liang Sifan 梁思凡 are all children who were abandoned by their educated youth parents more than a decade earlier and who have now come from Yunnan seeking out the mothers and fathers they never knew. For the former educated youths, the arrival of their forgotten children revives traumatic memories and creates a new series of tragedies.

The story begins when Shen Ruochen 沈若尘, a magazine editor, receives a letter from Xie Jiayu 謝家雨, a fellow former educated youth who decided to stay behind in Yunnan. The letter says that Shen's ex-wife, Wei Qiuyue 韋秋月, has died of a brain tumor and his now-orphaned fourteen-year-old daughter, Shen Meixia, is coming to Shanghai to look for him. Jiayu's letter represents the first sign of the coming storm, juxtaposed with a more upbeat narrative describing the blithe life Jiayu now enjoys.

> I'm still here at the old international trade firm; it seems I'll spend my whole life here in Xishuangbanna. Without realizing it, I seem to have lived up to the old saying, "dedicate your youth, dedicate your life, dedicate your life, and dedicate your descendents." My situation may not compare with yours, brother, but I'm at least able to live a carefree life. (Ye Xin 1996:5)

While Shen Ruochen and the others who fought to return to Shanghai now must face the consequences of their actions, Jiayu has accepted his fate and been rewarded with stability and a peaceful life. This can be read as Ye Xin's ironic commentary on fate, but it also hints at his idealistic yearnings for the rural utopia of the past.

Once Shen Meixia and the other four teenagers arrive in Shanghai, locating their parents amid the maze of skyscrapers and labyrinthine *longtang* alleyways is only the first hurdle. Their trials, however, are dictated not by the harshness of nature and the brutality of politics, but by a new breed of social problems afflicting postsocialist China. As Lu Xiaofeng's grandfather observes, "Of course, it is great that these kids have the chance to come to Shanghai to find their real parents, but their arrival is like throwing a grenade into the window of their home. Things are going to get ugly." Meixia must face the malicious teasing and jealousy of her half-brother, who has been spoiled under the one-child policy, while her arrival threatens to destroy her father's second marriage. Unlike the other children, who were products of mixed (peasant–educated youth) relationships, An Yonghui was the son of two educated youths who both abandoned him to return to Shanghai. When he arrives in the city fifteen years later, he must face a dual rejection by both parents, who are now separated and caught up in their own decadent lives of corruption, sex, and money. Lu Xiaofeng discovers that his long-lost father has been imprisoned for a crime he didn't commit. Sheng Tianhua's mother initially refuses to see him and only takes him in after an exhaustive process of searching and pleading., But soon Tianhua is overwhelmed by the decadent urban web of sex, violence, money, and drugs. While Liang Sifan seems to fare better than the other teenagers and is actually taken in by his birth father, in the end, he must pay the highest price for this reunion. Just as many of his father's classmates sacrificed themselves a generation earlier, Sifan becomes a belated victim when he is hit by a motorcycle—a tragedy foreshadowed when his father warns him of the dangers of riding a bicycle in the big city.[14]

Once again, tragedy is built into the discrepancies between the city and the country. The two locations of Yunnan and Shanghai become the sources of calamity, Yunnan for the educated youths and Shanghai for their children. In both the novel and the miniseries, frequent flashbacks from contemporary Shanghai to Cultural Revolution–era Yunnan inextricably link the two locales

14. In the novel, Liang Sifan dies as a result of his injuries, but in the miniseries he is wheelchair-bound and his birth father and his wife bear the responsibility of taking care of him, making Sifan the only one of the five children to remain in Shanghai.

Huang Shuqin's *The Wages of Sin:* the children arrive in Shanghai (left); Shen Ruochen and Shen Meixia reunited (right).

through the narrative structure. Ye Xin explores the discontinuity between them in the afterword to his novel:

> It was not only this story that attracted me, but it was the topographical site where the story plays out: Xishuangbanna. Oh, what an incomparably splendid land this is! Compared with the customs and habits of Shanghai, it is like another world. Shanghai has a sea climate, Xishuangbanna is a mountain climate with both dry and rainy seasons; Shanghai is known throughout the world for its high population and crowded living conditions, but all the people in Xishuangbanna live in bamboo homes surrounded by spacious courtyards; Shanghai is a city of tall buildings and narrow alleys, but in Xishuangbanna all one sees are green mountains and water; Shanghai's Huangpu River and Xishuangbanna's Lancang River couldn't be more different; Shanghai is known as a major metropolis of the Orient, second only to Beijing as the center of politics, economics, culture, finance, and trade, whereas Xishuangbanna is an oasis in a desert, a rich land with no winter. It has been called the plains region of the mountain kingdom, the land of the peacocks, the kingdom of the elephants; it has so many unfathomably mysterious natural preserves and precious rain forests; Shanghainese are often described as being clever but not lofty, smart but not open-minded, but the tribal peoples of Xishuangbanna are modest and amiable, warm, soft, and beautiful. No matter if it be in real life or in the movies, their image always leaves people with endless room to fantasize—the contrast is too strong, the differences are simply too great. (458–459)

Decades earlier, the Chinese Communist Party called upon the "countryside to surround the cities" (*xiangcun baowei chengshi* 鄉村包圍城市), in an effort to break down class differences and bring about a socialist utopia. The movement to send educated youths "up to the mountains and down to the countryside" (*shangshan xiaxiang* 上山下鄉) was another aspect of this project that would rusticate urban teenagers by "surrounding them" with the countryside. As Ye Xin describes, however, the differences between Yunnan and Shanghai, the country and the city, are too pervasive and far-reaching to be bridged. For the former educated youths, the land of Xishuangbanna is the site of recurring nightmares, until their unwanted children from the countryside finally return to surround the city. And with this voyage, so too their rural nightmares of exile make a belated return.

The action depicted in *The Wages of Sin* represents not only the delayed consequences of the past but also a repetition of that past. The parents in the story must face the long-suppressed consequences of their past actions, but these have also surreptitiously unleashed a new series of tragedies upon their children. Between the ages of fourteen and sixteen, the children are actually the same ages as their parents were when they went to Yunnan. The educated youth set out for the countryside filled with idealism, hope, and revolutionary fervor, but received an education in bitterness and violence and were not able to return home for years. Two decades later, their children make a similar journey from Xishuangbanna, filled with optimism and the yearning to be reunited with their parents. The reunion, however, takes place at the experiential rather than the emotional level, and the children face a similar set of disappointments and challenges at the end of their travels. Like their parents, they discover heartbreak, disillusionment, and tragedy before returning home.

Prime-Time Soap Opera as Post-traumatic Narrative?
Midnight Sunlight

Whereas *The Wages of Sin* traced the traumatic journey of five children and their parents from Yunnan to Shanghai and back again, *Midnight Sunlight* (*Wuye yangguang* 午夜陽光) extends the travels of former Yunnan-educated youths even farther, from the metropolis of Shanghai to Vancouver, Canada, where several characters go to work, study, and live. Produced a full decade after Huang Shuqin's epic miniseries, *Midnight Sunlight* was the third installment in television director Zhang Xiaoguang's 張曉光 "Sunlight Trilogy," which also included *Meter of Sunlight* (*Yimi yangguang* 一米陽光) and

Standing by the Sunlight (*Shouhou yangguang* 守候陽光). This 2005 miniseries is set primarily in Shanghai, and traces the convoluted love story of two people whose families each hide dark secrets that throw the future of their relationship into question.

The series opens in the early 1990s when Xia Qingyou 夏清优 (Luo Shanshan 羅珊珊), a sophomore in high school, is sent to Shanghai to live with her "uncle," Xia Yingtai 夏英泰 (Wang Shikui 王詩槐), and his family after her father's death in a car accident. Although Xia Yingtai is introduced as Qingyou's biological uncle, it will eventually be revealed that their relationship is much more complex. Her arrival causes a series of disturbances to the Xia household: her aunt complains; her younger cousin, Xia Shanshan 夏珊珊 (Ke Lan 柯藍), grows jealous; and her older cousin, Xia Jidong 夏繼棟 (Guo Xiaodong 郭小東), develops a secret crush on her. But Qingyou has eyes only for her classmate, Yu Youhe 於佑和 (Zhong Hanliang 鐘漢良), and they begin a fairy-tale romance built on idealistic promises and romantic stories, such as the tale of "midnight sunlight" for which the series is named. The romance is brought to an abrupt halt, however, when their relationship is discovered; Yu's mother yanks her son from school and they immigrate to Canada, where she had gone to study after the Cultural Revolution.

The narrative picks up a full decade later in Shanghai. Xia Qingyou is now an airline stewardess, her cousin Xia Jidong is a doctor, and Xia Shanshan is an executive in a multinational firm working under an aggressive young Chinese Canadian manager—who turns out to be none other than Yu Youhe. Thus begins a series of reunions, romances, and episodes of unrequited love all built upon a fragile chain of secrets from the past. Qingyou must now vie with both her cousin and Yu Youhe's Chinese Canadian fiancée to win back the heart of her first love, while also fighting off the advances of another Chinese returnee from Canada and her own cousin, Xia Jidong, who is finally coming to terms with the suppressed love he feels for her. With an array of narrative twists and turns and a roller-coaster romance between Xia Qingyou and Yu Youhe in which they break up and reconcile more than half a dozen times, *Midnight Sunlight* pushes Zhang Xiaoguang's formula of tears and excess to new melodramatic heights. The series is a typical example of the popular genre of "teen idol dramas" ("*qingchun ouxiang ju*" 青春偶像劇), which became a cultural craze in the wake of 2001's *Meteor Garden* (*Liuxing huayuan* 流星花園). The genre usually features beautiful young women and handsome young men in saccharine tales of love and loss that appeal to teenage and young adult viewers throughout East Asia and overseas Chinese-speaking

communities. These audiences clearly identify with the idealized romances of the younger protagonists, and for them, the backstory about the Cultural Revolution that plays out offscreen is nothing more than a convenient plot convention. That backstory, which is only fully revealed in installment fourteen of the twenty-one-episode series, undoubtedly looms larger in the eyes of older audiences: middle-aged housewives constitute another large segment of the viewing audience.

Zhang Xiaoguang's drama also owes a particular debt to the novels, films, and long-running television miniseries of Qiong Yao 瓊瑤. From the melancholy love story and the latent incestual desires of the characters (often masked by family secrets) to an escapist vision of the privileged and a forbidden romance that brings families to the verge of breakdown, virtually all the key narrative elements of the Qiong Yao model are followed. As Miriam Lang has observed, "Her novels of the 1960s are mostly set in the period of civil war and the flight of the Nationalists to Taiwan, and they often feature dislocated families, strained circumstances, and loneliness. . . . Qiong Yao's writings have often been called "morbid" (*you bingtai*), perhaps because in many of her novels the central romantic liaison is socially questionable (relationships between teacher and student, guardian and ward, brother-in-law and sister-in-law)" (Lang 516–517). Another pattern in the work of Qiong Yao is the way past secrets kept by parents hinder the lives of their children decades later; in *Midnight Sunlight* these secrets are tied directly to what happened more than thirty years ago in Yunnan.

As the narrative progresses, Yu Youhe breaks up with his Chinese Canadian fiancée in order to reunite with Xia Qingyou—his long-lost high school sweetheart. When Yu Youhe's mother, Yu Meiqing 於美清 (Zhao Jing 趙靜), discovers that her son is engaged to the same girl she whisked him away from a full decade earlier when they first moved to Canada, she immediately forbids him to take the relationship any further. Initially, she presents a series of banal explanations for her opposition to her son's union, but eventually, in a stirring monologue, she reveals the truth:

I originally thought I could cut myself off from the past by bringing you abroad, but now I realize that I must face it. As soon as I graduated from high school more than thirty years ago, I happened to be swept up in the rustification movement. I was sent to Yunnan. I thought I would end up spending the rest of my life there . . . I ended up living there, working there . . . and setting up a family. There were many educated youths there who ended up getting married and having children. Because my mother

came from a family of intellectuals and had overseas connections, we were deemed most seriously in need of reform. We were looked down on by everyone, and every time new jobs were allocated, I was always ordered to do the most difficult tasks. They worked me harder than anyone else, forcing me to wake up earlier and work later than the others, and I was fed worse any of them. I couldn't stand it anymore. I contemplated . . . I contemplated just ending it all by drowning myself in a river. I never imagined that someone would save me.

That someone was none other than Xia Yingtai, with whom Yu Meiqing had a secret affair in Yunnan when they were both sent down. The relationship lasted only until Xia Yingtai returned to Shanghai, leaving behind Yu, who ended up marrying his brother. As the narrative progresses, the ties between the Xias and the Yus becomes increasingly complex, as Yu Meiqing reveals that she was already pregnant with Xia Yingtai's child—Yu Youhe—when he abandoned her to go back to Shanghai. Later Yu Meiqing had a second child, a daughter, Xia Qingyou, whom she then abandoned for an opportunity to return to Shanghai with her son. And while this revelation initially breaks up Xia Qingyou and Yu Youhe, who suddenly learn that their affair is an incestuous relationship between half-siblings, that too is eventually refuted when a letter reveals that the real Xia Qingyou died in infancy and the present Xia Qingyou is a girl of the same age adopted by her father so her mother (Yu Meiqing) would never know. Yu Youhe and Xia Qingyou are, in fact, not related by blood. The lovers' union is rendered possible . . . only now they must face the biggest challenge of them all, Yu's bout with a rare form of cancer.

The plot is indeed convoluted, as in so many teen idol dramas. My aim here is to demonstrate that virtually all the endless trials and tribulations that the children and their parents endure throughout the twenty-one episodes of *Midnight Sunlight* have their roots in what happened in Yunnan during the Cultural Revolution. The harsh circumstances of that era forced both Xia Yingtai and Yu Meiqing to make a series of difficult decisions, the repercussions of which would be felt thirty years later by their children. The desperate desire to return to Shanghai drove Xia to abandon his pregnant lover; later, that same desire would drive Yu to abandon her husband (Xia Yingtai's brother) and her daughter (who would die shortly thereafter, only to be "replaced" by Yu Qingyou, the adoptee). Although the rain forests and rubber farms of Yunnan never once appear on screen in *Midnight Sunlight*, it remains central to understanding the characters' woes; whether in Shanghai or Vancouver, the shadow of Yunnan is

The siblings/lovers Xia Qingyou and Yu Youhe reunited after he undergoes a bone marrow transplant.

ever-present. Beyond the seemingly superficial and contrived narrative conventions of this miniseries lurks a more serious attempt to articulate a post-traumatic pain that finally comes raging out.

Historical trauma hidden within the world of escapist soap operas is also a staple of many of the works of Qiong Yao. The source of much of the heartbreak and tears that flood through Qiong Yao's fictional world is the historical fissure of 1949 and the tragedies of countless friends, families, and lovers torn apart during the Great Divide. For Qiong Yao, who was born in 1938, the defining historical trauma of her generation was the Chinese Civil War (1945–49), which pitted families against one another, Chinese against Chinese, and eventually resulted in a violent rift. In Qiong Yao's stories, families and lovers are separated, some remaining on the mainland, others immigrating to Taiwan, Hong Kong, or even overseas, and then reunite decades later, often under tragic circumstances. While Qiong Yao is often criticized for her low-brow, sensationalistic, and melodramatic bents, no other writer/filmmaker of her generation has gone further in positioning the national divide of 1949 within the context of popular culture.

Behind the heartbreak of lost love lies a much greater heartbreak of a lost nation, fractured politically, economically, and culturally.

Although *Midnight Sunlight* suffers from many of the same overly melodramatic pitfalls as Qiong Yao's works, it also unveils a greater historical trauma hidden beneath the surface. In her major works written and produced during the 1970s, the Great Divide loomed large; a generation later, a new historical trauma has been pinpointed as carrying equally devastating repercussions. For so many in China it is Yunnan, or, more generally, the rustification movement of 1968–78 that marks the defining fissure of their lives. In *Midnight Sunlight* it causes not only a crisis of history but also a crisis of identity. As the complex past of the young lovers' parents is slowly revealed, most of the principal characters suffer an irrevocable loss of identity. Having been raised single-handedly by her father, Xia Qingyou must go through the painful process of learning that she is adopted. Her lover, Yu Youhe, must come to terms with the fact that his father is actually Xia Yingtai. Xia Jidong is forced to confront the fact that he now has a half-brother he never knew and that he has spent his life repressing love for his cousin due to a taboo on incest, when she was actually adopted all along.

Once the dust has settled and everyone seems to have finally come to terms with their new families, identities, and lives, the star-crossed lovers, Xia Qingyou and Yu Youhe, finally stand at the altar in a Vancouver church to take their wedding vows. Everything seems in place for the obligatory happy ending, but when Yu Youhe suddenly collapses, losing his battle with cancer and bringing the series to a heartbreaking conclusion, we are reminded that not all traumas can be overcome.

The series of identity crises that arise in *Midnight Sunlight* and *The Wages of Sin* all play out in the urban jungle of Shanghai in the 1990s and into the first decade of the new millennium, far removed in time and space from the educated youth experience in Yunnan, but they mark a powerful manifestation of that post-traumatic memory—or perhaps, post-traumatic amnesia. For educated youth fiction and film writers like Ah Cheng and Wang Xiaobo, the sent-down experience signaled a fissure between the city and the country, the self and the other, reality and fantasy, dreams and nightmares. The repression and forced amnesia of that experience; the torture suffered there; and in some cases, the children begotten there are repeatedly reconstituted into new nightmares to haunt a new generation.

The tragic tale of the Yunnan educated youths has also served as backdrop for numerous other television miniseries, including *The Zhiqing Tribe of China*,

which intercuts narratives about mass exodus from Yunnan in the late 1970s and the lives of the former educated youths in the cities years later. In 2002 Guo Daqun 郭大群 directed a nineteen-episode miniseries entitled *Fatal Promise* (*Zhiming de chengnuo* 致命的承諾), which also extended the traumatic memories of Yunnan into the future. Two educated youths from Shanghai, Lin Fang 林放 and Lu Jing 陸靜, cross the border from Yunnan into Burma to escape a wave of violence and become entangled in the shady world of the jade trade between China and Burma. Spanning more than two decades, *Fatal Promise* delivers a brutal testament to the post-traumatic legacy of the rustification movement for both the former educated youths and their children, who, like the second generation in *Midnight Sunlight,* also end up in incestuous relationships as a result of their parent's secrets. At the end of the series, when the child of two former educated youths is paralyzed after being hit by a car, he is sent to a new destination for medical treatment and final salvation—America. From Yunnan to Burma, Burma back to Shanghai, and Shanghai to America, the convoluted journey of the educated youths and their children speaks to the global dimensions of past violence.

Yet another television miniseries that set out to confront the belated effects of Yunnan on educated youths was Shen Tao's 沈濤 twenty-six-episode *Dangerous Trip* (*Toudu* 偷渡).[15] Produced by the same team that created the 1993 television hit *A Beijinger in New York* (*Beijing ren zai niuyue* 北京人在紐約), including screenwriter Cao Guilin 曹桂林 and actress Wang Ji 王姬, *Dangerous Trip* is the story of Han Xinxin 韓欣欣, a former educated youth, who, after the death of her boyfriend in Yunnan, eventually immigrates to the United States by marrying a Chinese American. When her husband is killed by the San Francisco Chinese triads, Han steps into the Chinese underworld to avenge his death. Known in the Sanyi Society as Sister Lin 林姐, Han works her way up until she becomes a triad leader, overseeing a large, multinational human smuggling operation. For Han, the fissures between China and the United States, her past and her present, her purity and her decline are all intricately linked to her dark past in Yunnan. The schizophrenic break is her renouncement of her former identity as she assumed the new name of Sister Lin. At the climactic conclusion of the series, Han, wanted by both the Chinese and U.S. governments, finally returns to Xishuangbanna and shoots herself in the head. But is this a convenient escape from her current trouble with the law or a post-traumatic return to the origin of her nightmares?

15. *Dangerous Trip* has also been distributed under the alternate Chinese title *Weixian lucheng* 危險旅程.

The (often transnational) repetition of violence in these serialized dramas points to one of the most fascinating and disturbing dimensions of post-traumatic cultural memory. In *The Wages of Sin* the journey of the former educated youths is duplicated by their forgotten children more than a decade later, unleashing a new set of tragedies. Similar upheavals result when suppressed memories, relationships, and pasts are revealed in *Midnight Sunlight*, throwing the children of the Yunnan educated youths into a web of incest and resentment. And while the plot details may be driven by a melodramatic notion of cruel fate, the collective message of these miniseries, which project a unified vision of tragedy, violence belatedly manifested, and transnational longing, is something more. In *Midnight Sunlight* Yu Meiqing's escape from Shanghai to Vancouver may have consciously been driven by a desire to save her son. This could be fate, or it could be what Caruth might refer to as an "inherent necessity" for destructive repetition. As LaCapra has observed:

> Acting out is related to repetition, and even the repetition compulsion—the tendency to repeat something compulsively. This is very clear in the case of people who undergo a trauma. They have a tendency to relive the past, to be haunted by ghosts or even to exist in the present as if one were still fully in the past, with no distance from it. (LaCapra 142–143)

In *Dangerous Trip*, this unconscious need to duplicate destructive experiences drives Han Xinxin to America. After the great escape from the jungles of Yunnan, she must battle for survival in the concrete jungle of San Francisco. This secondary traumatic experience is a very different type of historical pain, demonstrating the complex post-traumatic aftereffects of unspoken secrets of the past.

The Chinese term for being sent down to the countryside during the Cultural Revolution, *chadui* 插隊 or "joining a rural production team," was adapted in the 1980s to *yang chadui* 洋插隊 or "joining a western production team," as a colloquial way to refer to studying or working abroad, which was often viewed (or imagined) as a similar testing experience. From Yunnan back to Shanghai, and from Shanghai to *haiwai*, post-traumatic nightmares recur, in Burma, San Francisco, Vancouver, and beyond. The same transnational framing can also be seen in other feature films and literature about the educated youth experience, such as Dai's *Balzac and the Little Chinese Seamstress,* which features the protagonist Ma several decades later, now a concert violinist in France, reflecting on his time in Yunnan. Indeed, many of the writers and filmmakers whose works examine this subject—including Wang Xiaobo, Ah

Cheng, Lao Gui, Cao Guilin, and Dai Sijie—immigrated or spent extended time abroad in the 1980s and '90s. And while this international framing of the educated youth trauma represents a physical escape, it tells of the ultimate psychological escape from the past and the nation. But as this series of television miniseries demonstrates, sometimes escape is only another form of traumatic repetition.

5. Beijing 1989

> When history is calamity, she thought, perhaps poems could
> only be splinters of words, for traumas destroy normality.
>
> —HONG YING (1997:47)

Imaginary Massacre

Contrary to the spirit of its name, the "Gate of Heavenly Peace," Tiananmen Square has witnessed much unrest, protest, and violence over the course of the twentieth century—from the May Fourth advocacy of New Culture to Mao Zedong's proclamation of New China and from the mass rallies of the Cultural Revolution to the mass mourning of lost leaders. Events in this open square in the center of Beijing, just outside the gates of the Forbidden City, have played a decisive role in defining many of the key cultural and political movements of the twentieth century. But none has captured the imagination of the world in such a dramatic and immediate way as the June Fourth Massacre of 1989.

As leading contemporary Chinese art historian Wu Hung has pointed out in *Remaking Beijing,* Tiananmen had a long tradition as a site for public trials, tortures, and executions throughout the Ming and Qing dynasties, including the horrific *lingchi* or "death by a thousand cuts,"a violent spectacle once inextricably connected with the site. After the fall of the Qing, the blood red of Tiananmen's past was replaced with the revolutionary red of Mao's New China, but as Wu Hung observes, with the death of Mao and the end of the Cultural Revolution, "the colourful puppet shows ended; the Square once again became associated with outlaws, the accused and death. Suddenly the submerged dark side of the Square jumped back out. The age-old memory of Tiananmen Square as a place of public abuse and humiliation was refreshed, challenging the official myth surrounding it"

(Wu Hung 2005:36). The end of a long decade of disunity, chaos, and violence also surreptitiously marked the return of Tiananmen Square's long-suppressed identity as the location of execution and death. The dark side of Tiananmen, however, would not be fully revealed until thirteen years later, in 1989, a year that for many Chinese would be indelibly stained with images of killing.

Beginning in the late 1970s and continuing throughout the 1980s, China carried out widespread economic reforms, opening itself to the outside world for international trade and cultural exchange. Within a decade, China had undergone a remarkable transformation from a nation ravaged by decades of failed socialist policies and political upheaval to a growing economic giant on the path to becoming a superpower. But amid phenomenal changes in virtually every aspect of the economy, society, and culture, one component that remained surprisingly stable was the structure of the Chinese Communist Party and the political system that still ruled the nation with an iron fist. The stagnant nature of this system gave rise to different factions among the CCP's top leadership, and tensions gradually mounted between figures like Deng Xiaoping and Li Peng 李鵬 (b. 1928) and more liberal, reform-minded figures like Zhao Ziyang 趙紫陽 (1919–2005) and Hu Yaobang 胡耀邦 (1915–89). Hu Yaobang had been purged from his position as Secretary General in 1987 after purportedly supporting student demonstrations the previous year. Because of his sympathy for that student movement, Hu's sudden death on April 15, 1989 proved to be the watershed moment that brought tensions within the party and within the nation to the boiling point.

Mourners convened in Tiananmen Square in the heart of Beijing to lay wreaths and flowers and commemorate Hu in a highly symbolic show of support for the reformist ideas he embodied. Suddenly years of disillusionment, frustration, and anger toward the government found an outlet for expression. The protests were at first startlingly similar to the 1976 Tiananmen Incident, prompted by the death of Zhou Enlai. However, China's remarkable transformation and her changing place in the world ensured that the new protest would be different. Beginning as a student rally, it quickly gained the popular support of workers, intellectuals, government employees, and countless ordinary citizens. Lasting 6 long weeks, during which time the square was almost continually occupied by tens of thousands of protesters, the incident took on global dimensions as the international media arrived to capture all the dramatic events as they unfolded. In the weeks leading up to the crackdown, the world witnessed the impassioned speeches of the student leaders, the erection of a towering "Goddess of Democracy," the defiling of Mao's portrait with black paint, and group hunger strikes in a makeshift camp in the middle of the square. All provided a strong testament to the protesters' desire for tangible political reforms and inspired hope in the hearts of people throughout China, as similar movements began in other major cities. But the hope proved fleeting and the will of

the people too weak to stand up to the power of guns and tanks. At a May 18 meeting between student leaders and Premier Li Peng, any chance for true negotiation was drowned beneath the antagonism, hostility, and uncooperative attitude from both sides. The mood of desperation only increased with the purging of Zhao Ziyang, which effectively quelled the last voice in the party's top leadership sympathetic to the students. Zhao made his final public appearance on May 19, and martial law was imposed two days later. The movement in the square seemed unhindered, but the hardliners had already triumphed and the gears were in motion to crush the popular protest. At 1:00 a.m. on June 4, crack military divisions began making their way toward Tiananmen, taking the square by 6:00 a.m. An unknown number of students, soldiers, and innocent bystanders were killed during the crackdown; the original death toll was estimated at 2,600 by the Chinese Red Cross. More conservative reports place the number around 200. The actual death toll may never be known, but what is certain is that the bloody incident has had deep and lasting effects on the Chinese psyche and the international community.

The combination of China's relatively lax climate concerning foreign media in 1989, the proliferation of international 24-hour cable news networks like CNN,[1] and the timing of the incident so close to a historic state visit by Mikhail Gorbachev gave the student protests unparalleled and unprecedented international coverage. Most of the major events leading up to the crackdown played out in real time on televisions across the globe, and millions shared in the joys and sorrows of the students. But even with numerous eyewitness reports, photos, and even videotape, the leadership completely denied the existence of any "massacre." Instead, they summarily rounded up dissenters and protesters and suppressed any reference to the event in the media, press, and print publications, effectively writing the Tiananmen Square Massacre of 1989 out of any official or state-sanctioned history. June Fourth was transformed into an "invisible massacre," a phantom existing only in the memory of those who experienced or witnessed it. The square itself became the ultimate site of topological denial as it superficially seemed to return to "normal" overnight—the physical scars of trauma removed, Tiananmen again played host to curious sightseers and carefree kites.

According to official reports published by the government, the events of June Fourth did not represent a "massacre" but rather an incident, disturbance, or turmoil.[2] "The turmoil was not a chance occurrence. It was a political turmoil in-

1. Several foreign networks like CNN and CBS were asked to cease live transmissions from Beijing on May 20.

2. The two most-cited government publications stating the official PRC line on the incident are Various authors, *Student Demonstrations, Disturbances, Riots* (*Xuechao, dongluan, baoluan* 學潮, 動亂, 暴亂) and Li

cited by a very small number of political careerists after a few years of plotting and scheming" (Li Jiang 1993:3). The government went on to accuse media organizations of creating a fictitious "massacre." An editorial published in *The Liberation Daily* stated that "foreign propaganda organs such as the 'Voice of America' and other Western media, as well as a number of newspapers and magazines in Taiwan and Hong Kong, unscrupulously churned out slanderous rumors of the 'massacre of Tiananmen' in an attempt to mislead the public, stimulate the 'indignation' of the people who were ignorant of the truth, and fan irrational fanaticism among the masses" (He 1996:223). According to early government reports, not a single protester, soldier, or bystander was killed in the square during the military clear-out in the early morning hours of June 4. There was no mention of the hundreds killed in the streets surrounding the square. The government later conceded that "according to reliable statistics, more than 3,000 civilians were wounded and over 200, including 36 college students, were killed" (Li Jiang 1993:5). At the same time, official reports of military losses were much more severe than such a tally would seem to indicate: "Over 1,280 vehicles were burned or damaged in the rebellion, including over 1,000 military trucks, more than 60 armored cars, over 30 police cars, over 120 public buses and trolley buses, and over 70 motor vehicles of other kinds. More than 6,000 martial law officers and soldiers were injured and scores of them killed" (Li Jiang 1993:5). In the eyes of the government, if there had been any semblance of a massacre on the morning of June 4, then the principal victims were not the student demonstrators but the valiant PLA soldiers trying to "restore peace and quell the disturbance."

On the few occasions that images of violence were employed, it was to heighten the victimization of the PLA. The way images can be appropriated and radically recontextualized by different media sources can be seen in the example of one of the most violent and disturbing ones from the massacre. On June 3, as violence was escalating, a soldier was beaten to death, burned, and strung up, his body dressed up in a military hat and sunglasses and eventually disemboweled. Photos of this morbid scene were published in several major news outlets.

The following image was printed in the Taiwan pro–student movement book, *Tiananmen 1989* (*Tiananmen yijiubajiu* 天安門一九八九). Notice the presence of several slogans on the side of the bus beside the hanging corpse of the soldier Liu Guogeng 劉國庚. The slogans read, HE KILLED FOUR PEOPLE! MURDERER! THE PEOPLE MUST WIN! RETURN THE BLOOD DEBT! The caption run alongside the

Jiang, *The Truth About the Beijing Turmoil* (*Beijing fengbo jishi* 北京風波紀實). A selected number of English-language publications, such as *Beijing Turmoil: More Than Meets the Eye* by Che Muqi, were aimed at making the government's case to an international readership.

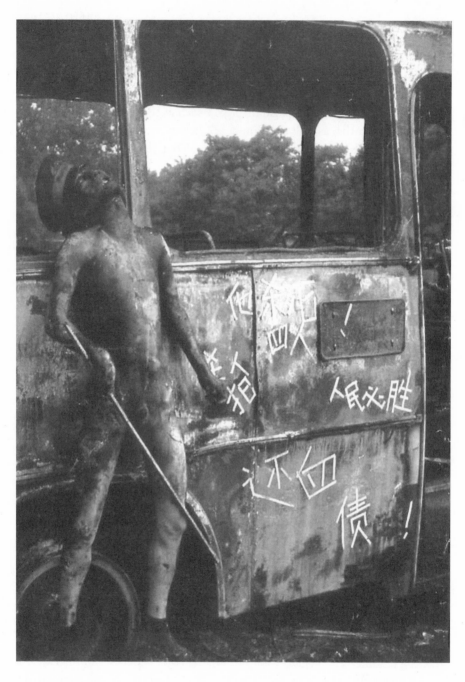

An image of Liu Guogeng's tortured body from the Taiwan media.

image read: "The New Lei Feng: A communist soldier is strung up and burned to death by the people. Beside his body someone wrote, 'He killed four people!' The Chinese communists later used the media to praise him as a 'people's hero'" (176). The sarcastic tone of the Taiwan caption may be inappropriate and represents a rather radical form of historical reinterpretation, but it stands in stark contrast to an alternate framing of the same event in PRC media.

The alternate image that appeared in one of the few PRC-published accounts of the massacre, *The Truth About the Beijing Turmoil* (*Beijing fengbo jishi* 北京風波紀實), featured a full two-page spread devoted to the same horrific scene and a total of four images of the murdered man. Besides a slightly different angle and framing, the chief difference in the latter version is the removal of the graffiti statement about Liu's own alleged crimes. Alongside the image ran the following caption:

On the evening of June 3, when Liu Guogeng, an officer of a certain unit
of the martial law enforcement troops, and a driver got near the Telegram
Building, a group of rioters turned upon them ferociously. Bricks, bottles, and
iron sticks rained on their heads and chests. The driver was knocked uncon-
scious there and then. Liu Guogeng was first beaten to death by some thugs,
then his body was burned and strung on a bus. Afterward, his body was
disemboweled by a savage rioter. (61)

The caption replaces the accusatory text that appeared *within* the photo in the Taiwan version, which attempted to present the violence committed against Liu as a form of "justice" in response to his own crimes. Through this alternate lens, the publisher (or photographer?) whitewashes or crops out all accusatory graffiti and mourns Liu as a "national martyr whose spirit will never die." The series of photographs of Liu Guogeng stand not only as a brutal testament to the violence of 1989 but also as a powerful witness to the ways historical narra-tives of atrocity can be (re)written and revised. The PRC image stands out for the significant absence of the words that contextualize and frame it. This com-ponent of the photo—and of so many other images, stories, and narratives about June Fourth—points to how the government edits and stages events in ways agreeable to party politics and national history.

It is not uncommon for certain historical details to be called into ques-tion, but what happens when the most fundamental components of history are doubted, defied, and negated? Although much of the drama unfolding in Tiananmen Square during May and June 1989 played out for the world to see, in China the June Fourth Incident very quickly became invisible. The blood-stained bricks in Tiananmen Square were replaced. Students and

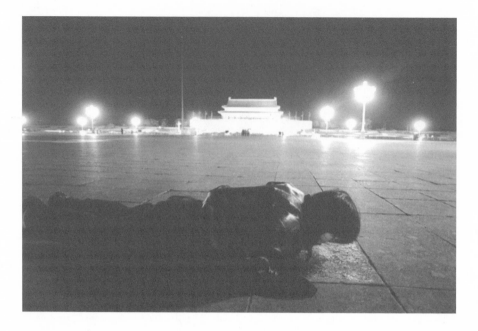

Song Dong, *Breathing Part 1.* Image courtesy of Song Dong

protesters who had cried for freedom quickly disappeared, fleeing abroad, being sent to prison, or simply remaining silent. Many of the victims' families dared not even come forward to claim the bodies of their loved ones. The Tiananmen Massacre of 1989 seemed destined to disappear from popular memory. It seemed that, like the Rape of Nanjing or the February 28th Incident, June Fourth would only reemerge decades later after a regime change—and perhaps only then would the Chinese people rediscover this tragic page in history.

The denial of the massacre inspired a series of strong (if not veiled) responses from several members of Beijing's avant-garde performance art community, who used their work to comment on the failed student movement. One came from Beijing native Song Dong's 宋冬 (b. 1966) 1996 performance piece, *Breathing Part 1* (*Haqi* 哈汽). Song Dong prostrated himself in the center of Tiananmen Square on New Year's Eve and breathed onto the ground for forty minutes, until the moisture from his breath created a thin sheet of ice beneath his mouth.

Song's project can be read as a metaphor for the June Fourth event itself: the physical effort of breathing represents the toils of the student protests and the thin sheet of ice stands for what the movement achieved; for both, what is left behind is ephemeral. Indeed, by the morning after Song Dong's performance any trace of his breath had vanished. Song's *Breathing* is not an exercise in futility but a bold and dark commentary on the toils and sacrifice of the people in the name of the nation (or democracy). In the end, not only is nothing left for them, but under the hegemonic power of the state, their very efforts may be erased.

Another powerful visual metaphor for the disappearance of history and the invisibility of brutality is an image taken from Beijing-based artist Li Wei's 李暐 (b. 1970) iconoclastic *Mirroring* (Jingzi 鏡子) series. Li's seemingly computer-manipulated photographic work *Mirroring: Tiananmen Square* presents, quite literally, the disembodiment of the historical subject in the shadow of the historical site. Li Wei reminds us that, just as the benevolent face of Mao Zedong still looms over Tiananmen and his body lies in its crystal coffin in the center of the square, the site is haunted by the disembodied specters of atrocity. The work is actually not computer manipulated but, as the series title connotates, the result of the artist wearing a specially designed mirror (with a hole cut out for his head) around his neck. Wu Hung has further linked the formal device Li uses to carry out his performance art to traditional Chinese torture. "With his head stuck through the hole, he looks like a criminal in premodern China sentenced to wear a wooden cangue around the neck. The difference is that Li Wei's cangue is reflective and turns everything in front of him into mirror images" (Wu Hung 2005:218). On the surface, everything looks normal in Beijing and everyday life goes on without any hint of the past bloodshed, which is rendered visible only through mirrored reflections. Li Wei's mirror thus serves as the ultimate metaphor for the power of mimesis to "reflect" and simultaneously "reverse" that which cannot be seen on the surface. This reversal also happens through an inversion of the historical site and the disembodied victim. Upon initial viewing, the "floating head" seems to represent the *imaginary* ghosts of the June Fourth victims haunting the *real* space of Tiananmen Square. In reality, however, the ghostly head is the only "real" object in the piece—the tidy square, which reveals no trace of the violence committed there, turns out to be the illusion, a mere reflection. This inversion of the real speaks to the power of Li Wei's work to render the "imaginary massacre" corporeal again. The irony is further heightened by the design of Beijing, with Tiananmen Square situated at the cosmological and topographical heart. Suddenly, the physical embodiment of the nation is transformed into the backdrop for a

Li *Wei, Mirroring: Tiananmen Square.* Reprinted with permission from Wu Hung, *Between Past and Future*

spectral disembodiment of history. In a new twist on Lu Xun's decapitation fixation, *Mirroring: Tiananmen Square* presents a disturbing vision, not of de-capitation but, rather, of de-embodiment. Li Wei reconceptualizes the challenges of reconstructing places and reimagining incidents that have been forcibly forgotten.

Although historical studies about (and artistic works representing) the massacre are still strictly prohibited in China, June Fourth's literary heritage has thrived from Hong Kong to Taiwan, American to Australia, and England to the Internet. And in some cases, June Fourth has even surreptitiously made its way back to Beijing. This chapter examines the 1989 Tiananmen Massacre through the work of several novelists and filmmakers who take on the challenge of depicting an "imaginary massacre" and reconstituting suppressed atrocity. June Fourth led to an exodus of intellectuals from China, and in addition to numerous student leaders and protesters, thousands of others took advantage of the political climate to emigrate and acquire foreign citizenship. The changing meaning of "China" and the mushrooming of Chinese communities abroad, have opened up new opportunities for writers to revisit the Beijing Massacre in ways that would be unthinkable in China. From the distance of New York, London—or, in some risky cases, even in Beijing; from the sexual revolutions of Hong Ying and Beijing Comrade 北京同志 and the dark visions of Emily Tang 唐曉白, Stanley Kwan, and Lou Ye 婁燁 to the diasporic imaginings of massacre by such writers as Terrence Chang and Gu Zhaosen, June Fourth continues to be restaged, reenacted, and remembered.

Sexing Tiananmen: Hong Ying and Beijing Comrade

The Beijing spring of 1989 was marked by idyllic dreams of democracy linked to a modern lineage of rebellion, which would ultimately be shrouded by the violence of reality. Images of student hunger strikers, the lone nameless hero who held back a line of tanks, Chai Ling's 柴玲 tearful pleas to the Western media, and militiamen marching into the square in the early morning of June Fourth have come to dominate the popular memory. But spring 1989 was also a time of love and romance. One of the most famous romantic events took place on Sunday, May 21 in the square itself, when student leader Li Lu 李祿 from Nanjing University married his girlfriend, Zhao Min 趙敏, a fellow student from Nanjing. "In my life I've experienced everything but sex and marriage," Li Lu declared. "I may die at any time. I owe myself this pleasure" (Thomas 1991:248). So, under the recommendation of the chief commander of the students' Tiananmen Square Committee, Chai Ling, and with an "official marriage

certificate" issued by fellow student leader Wuer Kaixi 吾爾開希, Li Lu and Zhao Min were married and spent their "honeymoon" in a small tent, which also served as a makeshift nuptial chamber, in the center of Tiananmen Square amid a sea of student protesters.

Just two weeks before the tanks rolled into the square and the student movement was crushed, the old tradition of "revolution plus love" was being redefined one more time. Although Li and Zhao's legendary romance didn't last (Li Lu escaped to America shortly after the massacre to earn a law degree at Columbia University and never saw Zhao again), many more dramatic stories about love and revolution and sex and violence played out on the stage of Tiananmen Square. This section examines two novels written in the 1990s that "continue the (sexual) revolution" by exploring the landmark student movement from the perspective of sexuality and romance. Hong Ying and the anonymous author known only by the pen name Beijing Comrade—both PRC writers who immigrated to the West after 1989—together place the two pillars of commercial culture—sex and violence—in a brand-new context and display how the politics of the state can influence the politics of the body.

Between the Body Politic and the Body Poetic: Hong Ying's Summer of Betrayal

Born in 1962 into a sailor's family in Chongqing, Hong Ying is the prolific author of more than half a dozen novels and numerous volumes of short stories and essays. She began writing in 1980 and first published her poetry in 1983, gradually making her name with a powerful and highly original poetic voice. She studied at the Lu Xun Writers' Academy in Beijing and Fudan University in Shanghai before moving to London in 1991 to pursue further studies. In 1992, Hong Ying published the first of a string of novels, including *Summer of Betrayal, Daughter of the River* (*Ji'e de nüer* 飢餓的女兒), *K: The Art of Love* (*K*) and *Peacock Cries* (*Kongque de jiaohan* 孔雀的叫喊), which have won critical praise and made her one of the most widely translated Chinese writers in the West. Hong's work has also made her one of the most controversial writers in China. Her 1999 novel *K: The Art of Love*, a fictionalization of a 1930s love affair between Ling Shuhua 凌淑華 and Julian Bell, was at the heart of a major literary scandal and lawsuit brought by Ling's daughter.[3] Scandals, however, come

3. In 2003, Hong and her husband Henry Zhao found themselves involved in another scandal, this time involving a contemporary writer, Bei La 貝拉.

and go; after initially being "eternally banned" from PRC publication by Chinese courts, *K* was revised, retitled, and published in China under the title *British Lover* (*Yingguo qingren* 英國情人).

Although translated into more than ten languages, Hong Ying's first novel, *Summer of Betrayal,* remains banned in China more than fifteen years after its initial 1992 publication in Taiwan. Set during the 1989 Tiananmen crackdown, *Summer of Betrayal* proves that, in contemporary China, politics is still much more sensitive than sex. In what was the first published full-length work of Chinese-language fiction on Tiananmen, Hong Ying tackles both. Beginning in the immediate aftermath of the June massacre and extending over a two-month period, *Summer of Betrayal* is divided into four chapters, which are arranged by date: June 4, June 14, July 14, and August 2. The novel traces the fate of a female student, Liu Ying, and her circle of intellectual, artist, and reporter friends after the crackdown. In the early morning hours of June 4, Liu Ying escapes from the square covered in the blood of victims and haunted by the images of maimed bodies. She flees to the apartment of her boyfriend, Chen Yu, only to find him in bed with another woman—his wife, whom he is in the process of divorcing. The dual political betrayal by her government and personal/sexual betrayal by her lover sends Liu Ying down a dark path of self-discovery and self-destruction involving deception, sexual experimentation, and a friend's suicide.

Like much of Hong's fiction, *Summer of Betrayal* highlights a playful flirtatiousness between fact and fiction, (auto)biography and the imagination. Echoing aspects of Hong Ying's own life, Liu Ying hails from a riverside town in Sichuan and comes to Beijing to study. But, even more important, she is also a poet, and poetry becomes a major theme in the novel. In the shadow of the Tiananmen crackdown, amid the stifling political suppression under martial law, the veiled and riddling language of poetry is one of the few safe ways to express oneself. Liu's poetry, with its twisted grammar and disjointed structure, seems to be her last weapon against a world violently closing in upon her. Through her poetry, Liu becomes a witness to history:

What I want is for this whole world to become a sheet of blackness
That can be rolled up
The way this century's tears
Have been collected in my pupils. (Hong Ying 1997:58)

On that dark morning of June 4, 1989, Liu Ying bears witness to another great tragedy of the twentieth century. Vehicles explode into flames, blood splatters

on her light-blue skirt, and carnage is strewn on the streets surrounding Tiananmen:

> Unprepared, she abruptly caught sight of a body lying in a strange position on the sloping ground. One eye was bulging out like a small round ball; the other eye was squashed to a slit. Dark-red blood looked as though it had been deliberately spattered on the man's white undershirt, his blue underpants, his graying hair and beard. White brain matter mixed with blood seemed to be oozing onto the ground. (7)

In the dark post–Tiananmen summer, however, Liu Ying's ability to use her poetry to articulate her experience, hopes, and fears becomes increasingly tenuous. And as a poet, Liu Ying is struck to the core of her very identity by the impotence of language.

In a society that has gone from light to dark virtually overnight, where idealistic professors, students, artists, and reporters who danced for freedom in the square now rat one another out to avoid being hunted themselves, everything begins to change. In one passage Li Jiangjiang, who takes Liu Ying in after her break with Chen Yu, brings home a pile of flyers and newspapers laden with government propaganda about the "disturbance" in the days following the crackdown, which provokes Liu Ying's disgust. Li thinks they will be interesting to look back on one day. So quickly, tragedy is transformed into a cute commodity and the power of political hegemony takes full root. Just a month later, Liu Ying finds herself saying: "Since the disturbance, my periods haven't been normal." Instinctively she claps a hand over her mouth, then says, "How could I have used the word *disturbance*?" (101).

Here, the term "disturbance" connotes an endorsement of the government line that June 4 was not a "massacre" or even an "incident," just a small social "disturbance" incited by hooligans and dregs of society. Under the relentless power of the state, even the poet, with her heightened sensitivity to language, loses power over her own words. This marks the beginning of the death of poetry and the demise of the artist. At the same time, the passage's reference to the disruption of Liu Ying's menstrual cycle makes tangible the connection between the political and the physical.

It is actually soon after the crackdown that Liu Ying begins to feel herself losing control of her poetic language. After composing a four-line verse in the room of her new lover, Li Jiangjiang, Liu throws down her pencil in frustration. "Writing used to be the most natural thing in her life. Now the words wouldn't come together: her notebook was filled with fragments of disjointed sentences"

(46–47). Later, during a visit to the studio of painter Qi Jun, where Liu Ying paints her naked skin and uses her body to paint a large picture, she comes to the realization—ironically, through verse—that her poetry has been rendered powerless:

> But everything that I narrate
> seems to have lost its meaning.
> From the hand you put on me
> I know
> that the sky is still dark. (127)

Liu Ying's frustration with her creative outlet continues to build until it becomes clear that "Poetry's time was over. She knew that. Her poetic style, with its complex metaphors and suggestiveness, expressed as vast, unspeakable wound, a voluntary withdrawal, a reluctance to converse with actuality. . . . Being a professional poet in China was nothing but a dream" (139).

Tying into extracts of Liu Ying's poetry that run throughout the text, tracing the gradual destruction of the artist under the increasingly stifling power of state ideology, is the parallel discourse of popular music. From the introduction of Teresa Teng 鄧麗君 into China in the late 1970s to the rock anthems of Cui Jian 崔健 in the mid-'80s, popular music played a key role in the liberalization of China's social and cultural milieu leading up to Tiananmen. The lyrics sung and cited throughout *Summer of Betrayal* are important not only for their cultural power but also because of their connection to poetry—after all, what are song lyrics but poetry set to music? The popular lyrics serve as a counterpoint to the excerpts from Liu Ying's poetry, creating a literary dance between music and words.

But just as Liu Ying's ability to write fails in the wake of Tiananmen, signaling the death of the poet and the death of society's conscience, there is a parallel devolution of popular music. The first reference to it occurs on page 16, when a group of female demonstrators waiting in line for the bathroom sing a verse from the 1980s pop song "Follow Your Feelings" by Su Rui 蘇芮: "Follow your feelings, hold tight to the hand of the dream." The lyrics about hope, dreams, and optimism for the future hint at a new, emerging individualism. The author even points out the importance of such songs by mentioning how "happy" they are in contrast to revolutionary anthems like "March of the Volunteers" or "Blood-Dyed Grace." Other songs appear periodically throughout the narrative in key moments of the characters' lives, such as the picturesque song about a beautiful river that lies completely outside the reality of the sewage-laden waterway

beside which Liu Ying lived as a child. However, by the end of the novel, after the Tiananmen tragedy, widespread arrests, and even the suicide of one character, the '80s songs of individualism and optimism, like Liu Ying's poetry, seem to have no place. Instead, the revolutionary anthem is reborn:

> The sun is most crimson,
> Chairman Mao is most kind,
> Your glorious thought forever
> On my soul will shine.
> Higher than the sky is your munificence,
> Deeper than the ocean is your benevolence,
> The sun in our hearts will never go down.
> You are our savior, our shining star. (150–151)

The singing of Mao's revolutionary anthem "The East Is Red" after Tiananmen, at a going-away party for Li Jiangjiang, an intellectual bound for foreign study in Germany, creates an ironic twist so sharp it is almost palpable. The reintroduction of the song represents the triumph of the state and also hints at a new form of nostalgia for the true paternal figure of revolutionary China— Mao—and criticizes the man he brought down on several occasions, Deng Xiaoping, who approved the use of force on June Fourth. But whether the singing of Mao's anthem signals the victory of the state or simply a new form of sublimated political struggle session, it marks a devolution to an earlier era where the state ruled and the individual was all but crushed under the party's hegemonic weight.

The tie between music and poetry is revealed most clearly soon after the going-away party when, for the first time, someone plays a tape of Liu Ying's poetry—set to music. Suddenly the two parallel lines of poetry and music collide. The music is composed by Yan Heituo, who also simultaneously reveals Liu Ying's work of body art, which he has transformed into a masterpiece. While Liu Ying seems proud of her artwork, she seems alienated by her poetry set to music. Although "her poem gained new meanings, hard to capture on a sheet of paper, the tenderness of her original work had been diluted" (Hong Ying 156–157). Liu Ying has an epiphany-like realization that the only meaning that can be found is through the corporeal self. At the farewell party, she stands before the body art on display, strips naked, and begins a wild sexual orgy where she has intercourse with Yan Heituo—a physical manifestation of the symbolic union between her words and his music.

The unbridled sexual acts that conclude *Summer of Betrayal* actually mark an important stage in Liu Ying's transformation and transition from poetry to

sex. As much as Hong Ying's novel is about words, it is also about the body. As Liu Ying struggles with the seeming powerlessness of her poetry, she finds a new kind of power or autonomy through sexuality. As the state infringes upon her personal space, making art all but impossible, the only resource she can turn to is the physical. After her betrayal by her live-in boyfriend, Chen Yu, Liu Ying is taken in by Chen's friend, Li Jiangjiang. They sleep together and Liu takes temporary refuge with Li; however, she soon discovers that he too has betrayed her—his taking her in was planned by Chen Yu. This dual betrayal, coupled with the previous betrayal of her government (not to mention the multitude of informants betraying their friends and colleagues), sends Liu Ying on a journey of sexual exploration in which her body becomes her medium of self-expression. After her relationship with Li Jiangjiang, Liu experiments with masturbation, female bonding with Hua Hua and Shao Liuliu, watching Western pornographic videotapes, and ultimately, the orgy at Qi Jun's apartment.

The transition from poetry to the body is perhaps best displayed through Liu Ying's painting at Qi Jun's studio. Smearing red and black paint on her skin and committing the imprint of her naked body to paper, Liu has found a new form of artistic expression that ironically coincides with her loss of faith in her own poetry. The revelation of the painting at the farewell party serves as the catalyst for her public sexual tryst with Yan Heituo, and it is amid her physical ecstasy that Liu Ying herself becomes a work of art, "the art of sex, its lyrics" (176). And in this climactic moment, Liu Ying's poetry is fully displaced by her body. During a time when everything, including even words, is controlled and dictated by the state, the individual is slowly stripped of all her cultured resources of defense, rebellion, and speech until all that is left is the biological self. In the end, sex is her only weapon.

Virtual Sex and Invisible Politics: Beijing Comrade's Lan Yu

Although Hong Ying's novel was translated into numerous Western languages, the sole Chinese-language edition of *Summer of Betrayal* was published in Taiwan, meaning the work had little opportunity to influence readers in the PRC. But in the late 1990s, the Internet revolution began to take over China's urban centers and crept gradually throughout the nation. One of the unforeseen consequences was the birth of a vibrant online literary culture. The Internet allowed writers and readers new forums for expression, discussion, and debate, helping to usher in what was arguably the most open era since the Tiananmen crackdown. Online writers took advantage of the medium's fast-paced nature

and lack of restrictions[4] to forge a daring voice for a new generation. The group of bold new Internet authors would eventually include such sensational figures as reporter-turned-sex icon Muzi Mei 木子美, who made herself a national celebrity in 2003 through a series of autobiographical pieces about her trysts with a variety of men, including a Chinese rock star. But one of the earliest and most dramatic success stories of the virtual Chinese literary world was that of Beijing Comrade.

Frustrated with the poor quality of most Internet fiction, a Chinese student in New York decided to try her own hand at the new medium in the late '90s. She wrote under the pen name Beijing Comrade (Beijing tongzhi 北京同志), borrowing a term infused with both proletariat political connotations and the homoerotic imagination—"comrade" or "*tongzhi*" 同志, the most typical form of address in socialist China, has since the mid-'90s been appropriated by lesbian and gay communities as a synonym for "queer." Thus, in the very name of the author are the two parallel themes of the novel: state politics and homoerotic desire. *Tongzhi* has become a term that simultaneously references both the homogeneous and the homoerotic, the political and the personal, inextricably tied together. Of course, superimposed on both sets of connotations is Beijing, the capital of China and the setting of the novel, which originally appeared under the title *Autumn in Beijing* (*Beijing zhi qiu* 北京之秋), then was renamed *Beijing Story* (*Beijing gushi* 北京故事) and finally republished in book form as *Lan Yu*.[5] The novel's combination of explicit homoerotic situations with a sentimental love story made it an immediate sensation, and its appeal was enhanced by an award-winning 2002 film adaptation by one of Hong Kong's top directors (discussed in the following section) and foreign translations, which helped transform *Lan Yu* into possibly the most successful work of Chinese Web literature until the time of its release.

Framed by a present-day narrative that reflects on the period between the mid-'80s and the early '90s, *Lan Yu* traces narrator Chen Handong's 陳捍東 tragic love for a young architectural student in contemporary Beijing. As the

4. That is not to say that Chinese Internet sites have become a true model of free expression, unconfined by censorship. While some topics are easier to publish online due to relatively lax editorial standards compared to traditional print media (not to mention bloggers, who serve as their own editors), the government, in concert with U.S.-based computer giants like Microsoft and Google, has developed new technology to clamp down on articles and bloggers that tread politically sensitive territory. This includes "Internet filtering" software that effectively blacklists sites and Web pages with controversial political or sexual content and prohibits searches of certain keywords, like "Wei Jingsheng" and "June Fourth."

5. *Beijing Story* first appeared in the late 1990s on a Beijing-based literary Web site and was circulated and reprinted on numerous other PRC sites, including www.shuku.net, www.netbig.com, and www.havebook.com. The first published book edition appeared in Taiwan under the revised title *Lan Yu,* to be promoted in conjunction with Stanley Kwan's film adaptation.

narrative proper opens, Handong is a successful twenty-seven-year-old head of a trade company taking full advantage of China's new openness, in terms of both business and sex. Handong is bisexual and engages in frequent affairs with a variety of young men and women, often introduced by his colleague and friend, Liu Zheng 劉征. It is Liu who brings Handong a young college student named Lan Yu 藍宇. Handong seduces the virgin student, and what begins as a one-night stand grows into a complex relationship that challenges both characters' conceptions of sexuality, commitment, and love. Over the course of their tumultuous relationship they experience threats, affairs, a failed marriage, arrests, and even the June Fourth Massacre, which has a prominent place in the novel. Finally, their relationship is shattered by the tragic death of Lan Yu in a car accident.

Lan Yu also highlights a fascinating relationship between sex and money, a connection that the author cements from the very first page:

> After graduating from college I took a large sum of money to set up my own trade company. The company engaged in all kinds of business—as long as there was money to be made, we were willing to give it a try. Except for dealing in human trade or selling arms, we had our hand in virtually everything else, from clothing and food to all kinds of everyday items—there was nothing we didn't have a piece of. During those years business with Eastern Europe was especially hot. Relying on my old man's connections and my own business instincts, the company's assets reached a million RMB in just five years. I was twenty-seven years old. I never thought of marriage; I didn't even have a steady sexual partner. The reason I use the term "sexual partner" is because it includes both men and women. (Beijing tongzhi 2001:4–5)

Here the connection between upward economic mobility and increased sexual opportunities is rendered transparent. Later the narrator recounts, "Everything that was happening with Lan Yu was starting to annoy me, but everything with the business was really driving me crazy" (60). Through such passages, Beijing Comrade further establishes the power relationships between sex and money and inextricably links them. *Lan Yu* gradually interweaves the characters' material and sexual desires in a complex web of exchange and symbolic ownership. This begins after Handong leaves behind money for Lan Yu after their first night together and builds as Handong later buys his lover a shopping bag full of Japanese clothing and, eventually, a home on the outskirts of Beijing. Indeed, as the novel progresses, the symbolic tie between the bank note and the body becomes increasingly evident, even to the characters themselves.

This is most clear in Lan Yu's aversion to being "bought" by Handong. We later learn that his resistance to being prostituted (both literally and figuratively) stems from a deep-rooted belief inherited from his late mother: "She left behind a long letter; it was for [Lan Yu]—and his father. She despised money. She said that money has the power to make people cold, selfish, and uncaring. She said that for her the most precious thing was genuine feelings; she would rather have a shard of shattered jade than a brick left intact" (71). This final message has a powerful impact on Lan Yu, but an ironic one too; he tells Handong, "Since my mother's death, no one has cared for me like you" (73). Though Handong is positioned as Lan Yu's new emotional rock, such passages actually hint at the emotional desert that Lan Yu occupies—after all, contrary to his mother's advice, he has entered a relationship based (at least initially) on sex and money.

During a time characterized by a fascination with liberal Western political ideas and a resistance to state ideology, corruption, and nepotism, the novel instead presents a world of liberal business ideas and a resistance to traditional conceptions of sexuality and gender relations, and of the body. But beyond sex and money lies the shadow of politics. Not only is Chen Handong the son of a government cadre, his very name, Handong or "Protect (*han* 捍) Mao Ze*dong* thought" recalls a dark era of political fanaticism and state violence. However, that violence is not simply relegated to a page from history—it is alive and well and manifested in the heart of China, Tiananmen Square. Lan Yu, who is a college student at the time of the 1989 Tiananmen Square massacre, participates in the student protests and witnesses the government crackdown, an event that becomes the narrative hub of the novel.

The author gives the reader several telltale signs of the coming unrest, but none so revealing as the death of Chen Handong's father. The sudden passing of the veteran revolutionary, who just days before had reprimanded his son for "not being honest at work," is a powerful foreshadowing of the imminent disaster and a sign of the failure of the old regime. Soon after his death, Beijing is caught up in a storm of protest and revolution, at the heart of which is Lan Yu, one of the countless young students swept up in the idealism, hope, and revolutionary fervor of that spring. *Lan Yu* features an entire chapter depicting the June Fourth crackdown, which becomes a catalyst bringing Lan Yu and Chen Handong's relationship to another level. In this passage, Beijing Comrade depicts the lovers' reunion in the aftermath of the massacre, after Chen Handong has been tirelessly searching for Lan Yu.

From far away someone approached me, half running—it was Lan Yu. I could feel it was him before he was even clearly in sight.

His white shirt was covered with blood; there were even traces of blood on his face. I was scared speechless.

"They are fascists! Animals!" He cursed in anger.

"What happened to you?" I was utterly stupefied.

"I'm okay." He looked at his clothes. "It's someone else's blood!"

Hearing that, I started to feel dizzy.

He walked all the way back from Northriver, and kept describing everything that had happened.

"When the first shot was fired, everyone started running away. I got down on the ground and when the shooting stopped, I noticed that someone in front of me wasn't moving. I went to help him, but when I touched him my hand was covered with blood . . . there was a girl beside me and I wanted to pull her away, but she was so terrified that she couldn't move. At that moment more shots rang out and I covered her with my body to protect her. . . ."

As Lan Yu spoke, a series of bloody images appeared in my mind. I looked at him and found it so hard to imagine proper, cultured, and passionate Lan Yu trying to protect someone amid that sea of bullets.

Although I had been up all night anxious about Lan Yu, now that he was back we were too excited to sleep.

"I thought I would die, and never see you again," he said as he lay in my arms.

"Humph! See how selfish you are! I almost went to the Front Gate of Tiananmen Square to find you! If you didn't get killed, I probably would have died looking for you!"

"You really care . . . care about me that much?" The way he uttered "care" was very soft, as if he was embarrassed to say it out loud.

"I hate you! I want to kill you!" (82–83)

The scene effectively conveys the deep bond between the lovers but simultaneously hints at the irony behind their relationship. Lan Yu is the idyllic rebel freedom fighter and Chen Handong is the corrupt businessman—the very embodiment of everything students like Lan Yu were protesting—corruption, waste, nepotism, and an outdated political regime (personified by Chen's father). Throughout the novel, Lan Yu struggles to remains honest and frugal, taking public buses instead of taxicabs and rejecting Handong's offers of money or career advancement through connections. Handong, however, consistently pushes Lan Yu toward money, materialism, and individuality. The struggle between the two characters on one level duplicates the struggle between the old and the new, the conservatives and the reform-minded that was happening on China's political stage. But ironically, the reform-minded student protester Lan Yu is actually

much more traditional, conservative, and "communist" than Chen Hangdong, who advocates unbridled freedom in both business and relationships.

In the end, this contradiction takes a tragic form. Handong's playfully sarcastic response to Lan Yu's expression of affection just after the massacre—"I hate you! I want to kill you!"—proves prophetic. Throughout the novel, the author repeatedly highlights Lan Yu's stubborn insistence on taking public buses, the preferred form of transportation of the "masses." On the other hand, Handong, as a member of the new elite, continuously reprimands Lan Yu for not taking taxis. There is clear political and ideological symbolism equating socialism with Lan Yu's buses and capitalism with Handong's taxis and private cars. Only toward the end of the novel is the true power of this disparity revealed, when Lan Yu begins to listen to Handong's prodding. On one fateful morning after waking up late for work, Lan Yu decides to take a cab. The cab is involved in an accident in which Lan Yu is killed. Lan Yu's struggle against so much of what Chen Handong stands for takes on new meaning as he dies not amid the violence of Tiananmen Square but years later, amid the rampant development overtaking China. Implied sacrifice for *democratic* freedom is transmuted, devolving into a random consequence of taking advantage of new forms of *capitalist* freedom. But was this not precisely the unspoken deal that the Chinese leadership made with its people in the wake of the crackdown, trading the people's political agency for new economic mobility and capitalist freedoms?

The setting of Beijing is prominent in the novel's narrative and also appears in both the original book title and the pen name of the author. This perhaps represents a projected longing for home on the part of the expatriate writer (accompanying her self-projection onto another gender and sexuality), but the emphasis on the city also suggests a topographical desire that mirrors the sexual desire running through the text. This mirroring is further enhanced by the well-known fact that the urban design of the ancient capital of Beijing is actually a blueprint of the body, especially in reference to the Forbidden City, which lies at the heart, looming over Tiananmen. Just as the term "comrade" or "*tongzhi*" has been hijacked to take on a new meaning that obscures and supersedes the original meaning, *Lan Yu*'s trajectory of desire overwrites its political subtext.

The tragic nature of Lan Yu's death is heightened by the reader's knowledge that Handong has since married and immigrated to Vancouver. Like Lu Xun's classic story, "Diary of a Madman," which begins with a section explaining that the madman has recovered and taken an official post, *Lan Yu* is framed by the facts of Handong's later life. Although the novel boldly attempts to break through homosexual stereotypes and provide hope for gay men to be embraced by society, it is actually a tale of the betrayal of the body

itself. In the wake of tragedy, Chen Handong denies both his physical body through a rejection of his bisexuality and the political body through his departure from Beijing, the very physiological-political heart of China. Once again, the body and the nation are mirrored, their denial equally thorough and equally tragic.

Whereas *Summer of Betrayal* utilizes the Tiananmen Square Massacre as a springboard to a destructive sexual journey, *Lan Yu* uses the incident as the key moment of commitment between Lan Yu and his lover. *Summer of Betrayal* and *Lan Yu* thus offer two distinct examples of using body politics to battle state politics. In the wake of June Fourth, both the political body of the Chinese nation and the physical body it reflects are shattered.

In *Summer of Betrayal* Liu Ying uses her body to resist the powers that be, but even amid her final ecstasy, the state lurks close by—the very men with whom she has sex are sons of veteran party members. Before her arrest, Liu Ying gives up an opportunity to go abroad with Li Jiangjiang. She chooses to become a martyr, fighting the absurdity of society with her body. In contrast, the writers Hong Ying and Beijing Comrade stand in direct opposition to their characters—both choose a different course of action, moving abroad and forging a new corporeal utopia through words.

Fleeting Images: Tiananmen Square on (and off) Screen

As the first Chinese atrocity to have played out in real time on television sets across the globe, the Tiananmen Square Massacre has been more closely linked with the visual image in popular memory than any other incident of mass violence in modern China. By the late 1980s, the infiltration of cable (and later digital) media into everyday life had transformed the way people perceive, understand, and "witness" violence. This marks a fundamental shift in historical experience. As Susan Sontag has observed, "battles and massacres filmed as they unfold have been a routine ingredient of the ceaseless flow of domestic, small-screen entertainment. Creating a particular perch for a particular conflict in the consciousness of viewers exposed to dramas from everywhere requires the daily diffusion and rediffusion of snippets of footage about the conflict. The understanding of war among people who have not experienced war is now chiefly a product of the impact of these images" (Sontag 2003:21). In the spring of 1989, an arsenal of cameras and video cameras descended upon Beijing, intending to capture the historic Sino-Soviet summit but ultimately bearing witness to a

grassroots protest movement that shook the very foundation of the Chinese Communist Party. Zhou He, author of a full-length study exploring the role of the media in the Tiananmen Square events, writes:

> We are unlikely to forget the images of the 1989 spring in China; the huge ocean of human beings and banners in Tiananmen Square demanding democracy and freedom, the crude but lofty Goddess of Democracy, the shadows of armed troops shooting at people against the background of blazing fire, and the lone man blocking a column of incoming tanks with nothing else but his own body. (He 1996:1)

These are the most iconic images of June Fourth, continually replayed and re-produced during the height of the movement and in the wake of the crack-down. Their place in the mass memory canon of June Fourth speaks to how photographs and moving pictures have come to dictate the ways we remember specific historical events—and even perceive them in the first place.

> Something becomes real—to those who are elsewhere, following it as "news"—by being photographed. But a catastrophe that is experienced will often seem eerily like its representation. The attack on the World Trade Center on September 11, 2001, was described as "unreal," "surreal," "like a movie," in many of the first accounts of those who escaped from the towers or watched from nearby. (After four decades of big-budget Hollywood disaster films, "It felt like a movie" seems to have displaced the way survivors of a catastrophe used to express the short-term unassimilability of what they had gone through: "It felt like a dream.") (Sontag 2003:21–22)

By the end of the twentieth century, the ways people imagine, contextualize, and conceive of violence and war had become increasingly dictated by television, film, and the mass media. In the case of Tiananmen, this cinematic dimension is perhaps best summed up by filmmaker and former Tiananmen activist Kevin Feng Ke, who recounted (however ironically) to *The New York Times*: "Soldiers were pouring out from the Museum of Revolutionary History, from the Gate of Heavenly Peace. This would be a great movie, I was thinking that at the time" (Wong 2000).

Indeed, the Tiananmen Square Massacre has inspired numerous explorations through documentary and narrative film. This section examines how June Fourth and its aftermath have been rendered onscreen. Beginning with an overview of the body of documentary film works on June Fourth, I go on to discuss how the incident has been positioned in contemporary Chinese narra-

tive cinema. From documentation to disappearance, Beijing 1989 has been transformed from the most visible of atrocities in modern China to the most elusive and misunderstood.

Documenting June Fourth: From Sunless Days *to* Sunrise Over Tiananmen

The first major attempt to provide an in-depth examination of the June Fourth massacre through documentary film came in 1990 with Shu Kei's 舒琪 90-minute *Sunless Days* (*Meiyou taiyang de rizi* 沒有太陽的日子). A prolific and influential film critic in Hong Kong, Shu Kei is also a well-established producer and director of such features as *Hu-Du-Men* (*Hudumen* 虎度門). *Sunless Days* stands out for its novel narrative structure, which begins in Beijing with the 1989 turmoil but quickly branches out to Hong Kong and beyond. The film offers a uniquely Hong Kong perspective on the massacre and hints at the fear and angst it triggered in light of the former British colony's impending handover to PRC control, a theme that will be explored in more detail in the coda to this study. The narrative arc of the film is much looser than that of subsequent documentaries about June Fourth, incorporating archival footage from a variety of sources and a series of interviews with both celebrities and individuals close to the filmmaker. While these elements are not always entirely complementary, they succeed in painting a rich and diverse portrait of just how far-reaching the effects of June Fourth were.

For most people around the world, June Fourth was a tragedy sealed in and around Tiananmen Square, which became the site *and* the symbol of the atrocity. *Sunless Days* examines the broader consequences of the event, stretching the temporal and spatial boundaries of June Fourth by probing how the incident affected individuals as diverse as a Chinese American dramatist living in Canada; a Hong Kong doctor working in Australia; Taiwanese director Hou Hsiao-hsien, who is interviewed in Venice; and mainland Chinese poet Duo Duo 多多, who is interviewed in London. Through Shu Kei's conversations and journeys, the connections between disaster and diaspora are fleshed out and it becomes clear how monumental June Fourth was for Chinese families in Hong Kong and across the globe. Through an extended segment on *City of Sadness*, which was completed just two months before the 1989 crackdown, the documentary draws parallels between June Fourth and earlier acts of violence in modern Chinese history. In the interview with Hou Hsiao-hsien, the veteran director provides a stunning meditation on violence in Chinese culture:

After the Tiananmen Square Incident, you realize that you can't run away from it. What I mean by this is that you can't face what happened there in mainland China with anger and hatred. The structure of power and the way they are wrapped in internal struggle have all been like that for a long time; it is actually a very traditional aspect of Chinese culture. The Communist Party has strengthened these elements so that what happened [in Tiananmen] is not so simple. It is as if the Chinese people are unable to free themselves from these dire straits. (Shu Kei 1990)

Hou's comments reveal a fatalistic vision of both June Fourth and the whole of Chinese history as an "iron house" from which the Chinese people really cannot escape.

Another strength of *Sunless Days* is its use of various forms of artistic representation to mediate the violence and upheaval of June Fourth. Unlike other documentaries, which rely heavily on archival footage of the events in question, this film focuses on how artists have confronted those events. *Sunless Days* begins with a selection from an elegiac work of modern dance, "Today Is June 8, 1989, 4:00 p.m." by renowned Taiwanese choreographer and founder of the Cloud Gate Theater, Lin Hwai-min 林懷民, and concludes with the rock anthem "Runaway" by Cui Jian, the father of Chinese rock and roll and one of the key cultural forces behind the student protests. In between, the film features a variety of other artistic representations and means of commemorating atrocity, such as poetry by Wang Dan 王丹 and paintings by Duo Duo. Arguably, however, the single most powerful work, featured in an extended segment, is the construction of the Hong Kong Goddess of Democracy.

On May 30 in Tiananmen Square, students from the Central Academy of Fine Arts erected a 28-foot-tall white figure inspired by the Statue of Liberty. Although it stood for only five days before it was crushed on June 4, it remained one of the most indelible images of the 1989 student movement. The symbolic statue, defiantly facing Mao's portrait over Tiananmen Gate, became a rallying point of the protests and a major source of media interest in the West, where it seemed the ultimate embodiment of "freedom" and "democracy." Two weeks after the destruction of the icon, a new Goddess of Democracy was erected on June 18 in Hong Kong. *Sunless Days* documents the destruction of the original goddess and the abandonment of the Hong Kong remake, along with the story of how a documentary short about the making of the second statue, produced by more than 30 Hong Kong filmmakers, including Shu Kei, was rejected by every single commercial theater in the city. We witness the destruction of not only the goddess and its clone, but even the filmic representation of the clone.

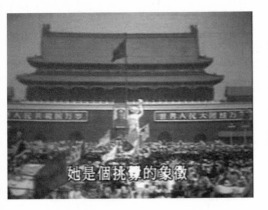

Two images of the Goddess of Democracy from *Sunless Days:* standing defiantly before Mao's portrait in Tiananmen Square (left) and being re-created in Hong Kong after the original was toppled (right).

This is a testament to both the power and the powerlessness of representation: only through *Sunless Days*—a level of representation removed once more—is the tragedy of the statue's fall finally preserved.

In 1994, Michael Apted, the director of such films as *Coal Miner's Daughter* and *Gorillas in the Mist,* teamed up with producer-actress (and wife of British pop star Sting) Trudie Styler to produce a high-profile reexamination of the massacre. *Moving the Mountain (Yi shan* 移山) was a big-budget, feature-length documentary that combined interviews with student leaders and archival footage of the movement with dramatic re-creations shot on location in Taiwan. Besides Apted and Styler, the film featured a score by Liu Sola 劉索拉 and Bill Laswell and candid interviews with an assortment of cultural and political celebrities, including Hong Kong film producer/actor John Sham (star of *King of Chess*), dissident Wei Jingsheng 魏京生, and student leaders Wang Dan, Chai Ling, and Wuer Kaixi. However, the narrative clearly revolved around student leader Li Lu, whose autobiography, *Moving the Mountain: My Life in China,* was the inspiration for the film.

The approach of the filmmakers is clear in their exclusive choice of interview subjects who are either student leaders or sympathetic to their cause. Among the interviewees, the most outspoken critic of the students, and a mild one at that, is ironically Wei Jingsheng, the "father of Chinese democracy." At no point are the deaths of Chinese soldiers, which are so much highlighted in government propaganda, even mentioned (and no images of them are shown). Rather than an objective documentary, *Moving the Mountain* is more like a bio-pic that uses the inner circle of student leaders as the principal subjects,

with the focalizer being Li Lu. Unfortunately, what was meant as a sensitive, humanistic portrayal of the massacre suffers from its unflinching bias, and perhaps even more from its projection of an idealized notion of heroism onto Li and the mythic dimension that frames his journey.

Moving the Mountain records the events of the June Fourth democracy movement and places them within the context of Li Lu's life. The film begins in Tiananmen but quickly retraces some of the most traumatic moments in the preceding twenty years, from the Cultural Revolution to the Tangshan earthquake to the Democracy Wall. These events, especially the Tangshan earthquake of 1976—the most deadly earthquake of the twentieth century, which claimed more than 240,000 lives—take on a larger-than-life quality as they describe the dark road China has walked and lead into the mythicized journey of Li Lu, a native of Tangshan who survived the earthquake as a child. The earthquake is often cited as predicting the death of Mao and his loss of the "mandate of heaven," but here it is used as a key formative moment in the making of a future student leader. According to the documentary, it was amid the rubble and ruins of Tangshan that Li Lu first laid eyes on idyllic images of the West, and he dreamed that he had been "carried by an angel to a new place where people smiled, with pigeons, and beautiful buildings."

Li Lu's journey is portrayed against the sweeping backdrop of events like the Tangshan earthquake and the Cultural Revolution, through which he is identified as one whom "history has chosen." The epic quality is accentuated by Li's emotional voice-over and documentary footage of him delivering powerful oratory defenses of freedom and democracy at places like Oxford. The mythic dimension is further embellished by references to fantastic legends, such as the almost dreamlike story of Li's childhood encounter with a small lizard, the parable about the foolish old man who tries to move a mountain (from which the film draws its title), and even the mysterious tale of Li Lu's escape to the West.[6] All of these elements make *Moving the Mountain* a larger-than-life portrait highlighting one man's transformation through an epic Jungian heroic arc. Toward the end of the film, the featured student leaders each reveal their goals for the future: Chai Ling is working as a lobbyist in Washington, Wuer Kaixi is a radio host, and Wang Chaohua is lecturing in Chinese at UCLA. But Li Lu is preparing to be, once again, "summoned by history." He is the most charismatic of the June Fourth leaders, but in *Moving*

6. During a 1994 lecture at Rutgers University around the time of the film's release, Li Lu went even further in dramatizing his mysterious journey abroad. He described contemplating suicide by jumping into the ocean during a voyage aboard a small boat when the voice of his long-deceased grandfather suddenly spoke, encouraging him to persevere, go to America, and get an education at Columbia University (!).

the Mountain his charisma verges on arrogance and, at times, megalomania, traits that have helped make him one of the most controversial and frequently attacked figures of the movement.[7] Among the articles criticizing Li Lu was an insightful piece originally published in the New York-based Chinese-language dissident magazine *Beijing Spring* (*Beijing zhi chun* 北京之春), "A Few Reservations About *Moving the Mountain*" ("Guanyu *Yi shan* de jidian zhiyi" 關於 移山的一點質疑). The essay points out several inaccuracies and inconsistencies in *Moving the Mountain* regarding the democratic election of student leaders, the hunger strike, the beginning of martial law, and the final moments in the square before the massacre. "A Few Reservations" makes clear that the mythic hero's journey around which *Moving the Mountain* is structured is much less damaging than the factual inaccuracies upon which *Mountain* is built.

The author of the article was in a unique position to judge the accuracy and objectivity of Apted's film because she had spent the previous several years making her own documentary about the Tiananmen Square massacre. Carma Hinton, daughter of China expert William Hinton, the author of *Fanshen*, is the director of more than half a dozen documentary films on China, all produced by her Boston-based Long Bow Company. In 1995, just months after the release of *Moving the Mountain*, Hinton and her husband and codirector Richard Gordon completed what would be the most widely distributed and highly acclaimed documentary on Tiananmen, *The Gate of Heavenly Peace*. This penetrating three-hour film went to the greatest lengths in its quest for objectivity and also drew the most heated criticism. Ironically, *The Gate of Heavenly Peace* was attacked by both the Chinese government, which publicly protested its selection at several international festivals, including the New York Film Festival,[8] and top Chinese student leaders, including Chai Ling, who viciously assailed the film in the Chinese press. This critical reception demonstrates how far the filmmakers went in pursuing the most even-handed, no-holds-barred, historically accurate account based on materials available at the time of production.

Although *The Gate of Heavenly Peace* never saw theatrical release, an edited version was shown on the award-winning PBS series *Frontline*, winning the

7. Charles Wilbanks's "No More Heroes," *Asiaweek* (July 10, 1998) and Patrick E. Tyler's "Six Years Later, Survivors Clash Anew on Tactics," *The New York Times* (April 30, 1995), are but two of the many articles critical of Li and his film.

8. In the case of the New York Film Festival, which would not pull *The Gate of Heavenly Peace* from the program, the Chinese government refused to allow Zhang Yimou to attend for the New York premiere of his film *Shanghai Triad* (*Yao a yao a yaodao waipo qiao* 搖啊搖啊搖到外婆橋), which was featured on opening night.

film the widest audience of any Tiananmen documentary. The film attempted to reach out ideologically by including the sometimes divergent voices of a broad array of students, teachers, intellectuals, officials, workers, and witnesses like Wang Dan, Feng Congde, Dai Qing, and Han Dongfang.[9] Equally impressive, the filmmakers reached out historically to trace modern China's history of student protest and revolution that has played out in Tiananmen Square. From the 1919 demonstrations at the height of the New Culture Movement to the 1949 Communist march on the square, *The Gate of Heavenly Peace* examines the genealogy of the site itself, including the construction of the modern version of the square in the mid-1950s and the mass rallies during the Cultural Revolution. Dispelling the superficial sound bite coverage featured in the international media and the highly romanticized *Moving the Mountain*, Hinton and Gordon's film presents a picture of Tiananmen much more complex, nuanced, and fully rooted in a long historical tradition of violence and revolution.

Perhaps the most fascinating documentary exploration of Tiananmen Square is Canadian-based artist/filmmaker Shui-Bo Wang's 王水泊 *Sunrise Over Tiananmen* (*Tiananmen shang taiyang sheng* 天安門上太陽升). Nominated in 1998 for an Academy Award for best short documentary film, the film provides a penetrating vision of Tiananmen through a deceptively simple personal narrative about growing up under the shadow of history. Wang, born on September 11, 1960, documents all the tumultuous events of modern Chinese history, from the mass famine of the Great Leap Forward during which he was born to the Cultural Revolution and Tiananmen Square, with side trips to fill in earlier pages in history such as the Long March, the Second Sino-Japanese War, and Mao's "liberation" of China. Wang's historical contextualization is quite different from that of *The Gate of Heavenly Peace*, because of his unique visualization of history and his highly personal narrative, which cuts through the macro-history against which it unfolds.

Rather than the standard combination of documentary and archival film footage, *Sunrise Over Tiananmen* is a highly effective blend of family and archival still photos and Wang's own paintings, often brought to life with simple animation. The drawings and photos create a pastiche of fractured memories that perfectly conjures up the fantasies and fears of a young boy growing up amid the excitement and oppression of Mao's China. As the

9. The filmmakers also recruited several leading academics, journalists, and China scholars to collaborate on the film, including Geremie Barmé, who co-wrote the script and served as associate director; UC-Berkeley professor Orville Schell, who co-produced; and UC-Santa Cruz professor Gail Hershatter, who also served as associate director.

Painting by Shui-bo Wang used in the film *Sunrise Over Tiananmen.*

following illustration from the film indicates, the looming gaze of Mao was never far away.

In this painting of Shui-bo Wang's childhood home, two large portraits of Mao dwarf the tiny family photo suspended between them. The control of the state over the individual and the utter deification of Mao are all too clear. In addition, a Mao bust sits on the desk as a centerpiece, beside which is a four-volume set of Mao's collected works. Hanging above the bed is a quotation, "*hao bu li ji, zhuanmen li ren*" 毫不利己, 專門利人, or "with no thoughts of the self, completely devote oneself to others," a Mao saying often used to describe the selfless work of Canadian Dr. Henry Norman Bethune (1890–1939), Shui-bo Wang's childhood hero. But all around the room lurk remnants of violence. Besides the ideological violence implied by the omnipresence of Mao, we see the taped windows, a precaution in case of a bombing or air raid that would shatter the glass, and, of course, the goldfish flying through the air. The goldfish, which are animated in the film, represent the Maoist line that keeping pets is a petty bourgeoisie habit that needs to be eliminated. Here the fish (along with Shui-bo Wang and his family) swim through a sea of ideologically charged Maoism. In *Sunrise Over Tiananmen*, however, the ever-present gaze of Mao is subverted by the very form of the film, which configures the innumerable images of the chairman within a world more fantastic, surreal, and terrifying than he himself could have imagined.

In addition to the visualization of national history through repeated images of Mao, Tiananmen Square, and historical events like the War of Resistance, there is the even more riveting narrative of Shui-bo Wang's personal history. Born during the mass famine of the Great Leap Forward, Wang is only six

years old when the Cultural Revolution breaks out in 1966. The most forma-
tive memories and experiences of his childhood are haunted by violence and
death. At the age of eight, he sees a corpse for the first time, a victim of a vio-
lent struggle session whose dead body hangs from a tree. The following year,
Wang and his friends encounter a dead baby in a white box, abandoned in a
cornfield. Assuming it must be a "class enemy," they stone the dead baby. Even
Wang's imagination of the West is imbued with images of violence; the sole
Western children's tale he is taught is Hans Christian Andersen's *The Little
Match Girl*, wherein the protagonist freezes to death, and he hears stories of
children starving to death in New York on Christmas Eve. The link between
national and personal histories is, of course, Tiananmen Square 1989, where
Shui-bo Wang's fate, along with that of countless other Chinese, is forever
changed.

 Sunrise Over Tiananmen also traces the inner struggle and transformation
of Wang as an artist, from the PLA, where he painted propaganda posters of
Mao and espoused the benefits of socialism, through his tenure as an art
student in Beijing discovering the Western masters and a new form of apo-
litical artistic expression, to his eventual work as a freelance artist abroad.
Throughout, the conflict between art and ideology, creativity and propa-
ganda remains ever present. Years after his work as a propaganda artist for
the PLA, the image of Mao still dominates Wang's art, although it is now
portrayed in a highly subversive way. The great leader's gaze lingers—just as
his portrait still hangs over Tiananmen Square, even during the 1989 pro-
tests. Wang implies that Mao was actually a fundamental part of the inci-
dent. Throughout the film, he presents the struggle and inner turmoil that
mirrored the schizophrenic social transformation going on around him, well
demonstrated by the famous slogan "Socialism with Chinese Characteris-
tics." Wang's own powerful metaphor for China's predicament is a pop art
image of Marx invaded by an army of Coca-Cola bottles. Describing Shui-bo
Wang's inner conflict between loyalty to socialism and a newfound craving
for individuality and Western culture, it is a most succinct (and ironic) meta-
phor for June Fourth.

 Sunrise Over Tiananmen is most successful not in dissecting the historical
details of Tiananmen 1989 but in exploring the massive social, historical, and
philosophical dimensions of the incident. Even more startling is the way Shui-bo
Wang is able to address a complex combination of historical forces and ideo-
logical conflicts in a lucid and personal narrative. In just thirty minutes and
utilizing only still images, simple animation, and an understated voice-over,
Sunrise Over Tiananmen is able to breathe life into history.

Disappearing June Fourth: Remembering to Forget

A full decade after Kevin Feng Ke observed what a "great movie" Tiananmen would make, he released his own take on the event, *The Official Account*. One of the principal architects behind the famous Goddess of Democracy statue in Tiananmen Square, Kevin Ke is a graduate of Fudan University and NYU Film School and has directed *Song and Cry* and *When East Meets EAST*. Completed in 1999, ten years after the massacre, *The Official Account* won Ke the Directors Guild of America award for Best Asian-American Student Filmmaker. Despite the title, Ke's film was a dramatization of a Chinese newsman's personal turmoil over whether to report the truth about the massacre or follow the government line.

How to portray the events that played out in Tiananmen was a central question facing not only reporters and representatives of the media but also filmmakers, especially in China. But they faced a conundrum: *how* to portray that which it was forbidden to portray and, in the eyes of the government, never even happened. The task was to make the invisible visible—and in a way that would cloak the true intent of the representation. Many filmmakers were forced to turn to allegory and metaphor to release their angst. Unlike the documentaries previously discussed, which were all produced overseas, films in China representing Tiananmen brought a new set of challenges. Narrative filmmakers within China used two different strategies to deal with Tiananmen: directly portraying the incident and its aftermath, as in Stanley Kwan's *Lan Yu*, Emily Tang's *Conjugation*, and Lou Ye's *Summer Palace*; and rendering the incident through allegory, invisibility, and the politics of disappearance, as in Yu Benzheng's 於本正 *Fatal Decision*.

LAN YU: *COMMITTING TO VIOLENCE*

Perhaps the best-known narrative film about Tiananmen Square is Hong Kong director Stanley Kwan's 2001 film version of the previously discussed Internet novel *Lan Yu*. Born in 1957 to parents from Guangdong, who had immigrated to Hong Kong on the eve of the Communist victory on the mainland, Kwan entered the film industry as an assistant director in 1980 and made his directorial debut in 1984 with the box office hit *Women* (*Nüren xin* 女人心). Kwan's 1987 masterpiece, *Rouge* (*Yan zhikou* 胭脂扣), firmly established his place among the most important auteurs in contemporary Hong Kong cinema. A sensitive and poignant cinematic exploration of memory, nostalgia, broken promises, and love, *Rouge* is a powerful testament to Hong Kong's longing for its past and uncertainty about its future. Kwan continued with the

award-winning *Full Moon in New York* (*Ren zai niuyue* 人在紐約) (1990), a sensitive drama about three women—one from Taiwan, one from Hong Kong, and one from China—who form an unlikely bond in Manhattan, and two period pieces, 1992's *Centre Stage* (*Ruan Lingyu* 阮玲玉) and 1994's *Red Rose White Rose* (*Hong meigui, bai meigui* 紅玫瑰, 白玫瑰). After a 1996 documentary, *Yang ± Yin: Gender in Chinese Cinema*, Kwan further explored gender with 1997's *Hold You Tight* (*Yu kuaile yu duoluo* 愈快樂愈墮落), a meditation on identity structured around a complex web of relationships. After 2000's disappointing *The Island Tales* (*You shi tiaowu* 有時跳舞), Kwan made a major comeback with *Lan Yu*.

Winner of five major awards at the 2001 Golden Horse Awards, including best director, *Lan Yu* is a tragic and touching story about the relationship between two gay men in contemporary Beijing. Among Kwan's strongest works to date, the film subtly yet powerfully engages several of the key themes that have been so important to the director's oeuvre. Centered on a gay love story, *Lan Yu* very directly engages issues of gender and (homo)sexuality. The film also places a renewed emphasis on the politics of mourning, loss, and nostalgia, key elements in *Rouge*. And *Lan Yu* expresses the director's brilliantly understated political angst, which is doubled by the personal impact of death and loss.

Lan Yu was adapted from the controversial Internet novel *Beijing Story*. Kwan spoke extensively about the adaptation process during a 2002 interview. In this excerpt, he discusses his reservations about the work and the novel's handing of sexual identity.

> When my producer, Zhang Yongning 張永寧, brought me the hard copy, I thought, what's there here worthy of shooting? Number one, it was filled with all these bold and explicit descriptions of erotic scenes; moreover, there were all kinds of elements that came across as being very clichéd. . . . By the time I read the work a second time, it started to remind me of all kinds of things I had experienced with my boyfriend over the course of our eleven-year relationship. That became the sole motive for me to take on this film. The fact that the story took place in Beijing, a city foreign to me, didn't bother me . . . but the subject matter was so close to me. I might not be Lan Yu and my boyfriend may not be Chen Handong, but virtually everything they go through in the novel I've been through with my partner. This was what really made me finally want to take the project on. (Berry 2005:453–454)

Kwan's remarks speak to directly to the challenges of cinematic adaptation from literary (or, in this case, Internet) sources. But even more telling are

Kwan's comments on June Fourth. As a Chinese novelist writing in New York, Beijing Comrade had few, if any limitations in depicting the violence of the massacre. Shooting an underground film in Beijing, however, presented a very different set of problems when it came to re-creating the mass historical events of June Fourth. Kwan explains:

> In the novel there are extensive passages describing June 4, but for me it was just background. What I was interested in was how we could transform June 4 into the moment that Chen Handong commits to Lan Yu. These were the kinds of details that we spent a lot of time on during the adaptation. (454)

Although according to Kwan, the June Fourth Massacre is merely a narrative device to solidify the commitment between Chen Handong (played by Hu Jun 胡軍) and Lan Yu (played by Liu Ye), hints of the approaching disaster repeatedly appear. Striking workers are heard chanting in the background as Chen Handong works in his office . . . and it is mentioned that the failure to repair a faulty office air conditioner is due to the strike. The impending crackdown becomes implicit when Handong's well-connected brother-in-law visits him with the warning, "They're clearing the square tonight." This echoes an earlier cryptic message from the brother-in-law during a family gathering about bad times ahead.

After receiving word that the square is to be cleared on the afternoon of June 3, Chen Handong drives his Mercedes-Benz through the streets and alleys of Beijing, searching for Lan Yu. Along the way, he witnesses not the massacre, but the vestiges of violence it has left behind. Except for brief scenes of quickly cut images of bicycles chaotically fleeing down dark alleys and carts filled with bodies being pushed down the street, the film contains no direct portrayals of the violence. In the early morning hours of June 4, when Lan Yu discovers Chen asleep in his car, the lovers are finally reunited and share a passionate embrace. The subtext, of course, is that as they hold each other, showers of bullets and lines of tanks fill the nearby streets surrounding Tiananmen Square.[10] Even Lan Yu's detailed testimonial about what he witnessed, which is highlighted in the novel, is displaced by uncontrollable tears in the film. The massacre is left unaddressed to such a degree that viewers unfamiliar with June Fourth would be left

10. The level of dramatic license employed by Kwan is here also at its greatest. In *Lan Yu*, the narrative account of the Tiananmen reunion suffers from the sheer improbability, if not impossibility, of Chen Handong's being able to both freely drive through the barricaded streets of Beijing during martial law and actually find his lost lover.

Lan Yu awakening Chen Handong after the latter's long search on the morning of June Fourth (left). The lovers embrace after their reunion (right).

wondering what had actually happened. Ironically, the novel presents a much more visual and visceral depiction of violence than the film.

Although it devotes less than five minutes to the events surrounding the massacre, *Lan Yu* stands out as the first major Chinese-language feature film shot within China that dealt with the incident at all. Tiananmen plays an essential role in the film's narrative arc, not only as the catalyst bringing the protagonists back together but also as an integral part of their development, especially Lan Yu's. He is dually marginalized by society for his political (dissident) and sexual (homosexual) identities, both deemed equally "deviant" by the government. With the failure of the democracy movement, Lan Yu's political voice is silenced and the only way he can express his identity is through his sexuality. After a tumultuous beginning, the lovers finally commit to each other and assert the one thing they have left. However, Lan Yu's detachment and solemn melancholy silently bear witness to the ways the phantom of the violence lingers on, until his untimely death.

The portrayal of Lan Yu's death in the film also deviates from the original novel. Instead of perishing in a car accident, which adds another level of symbolism to the novel, even hinting at some culpability on the part of Chen Handong, Lan Yu dies during an accident at a construction site where he has been working as an architect. In Kwan's version, Lan Yu's death is more random, but not without a symbolic dimension. Perhaps Lan Yu is to be seen as a sacrifice for the construction of a new China, or a belated casualty of historical violence. The closing sequence of the film shows Chen Handong driving past the location of Lan Yu's accident and then on through the city. The camera's perspective shifts toward the window as Beijing's cityscape flashes past. Countless construction sites stretch out ahead, and the lovers' anthem "How Could You Allow Me to Be Sad?" by Taiwan singer Huang Pinyuan 黃品源 blares. The moving scene serves as a final

visual testament to the resilience of the city rising from the ashes while bearing the scars of those lost in its construction, including the victims of that unforgettable and unspeakable day in June 1989. At the same time, the movement away from the city and the epicenter of trauma represents a new departure.

CONJUGATION: THE GRAMMAR OF ATROCITY

Sixth Generation director Emily Tang's (b. 1970) *Conjugation* (*Dongci bianwei* 動詞變位) also visually configures Tiananmen amid a matrix of disappearance. The film is the first full-length feature helmed by Tang, a graduate of the department of Western Languages and Literatures at Beijing University who pursued graduate studies at the China Art Academy and the National Drama Academy. Tang was just completing her first year of undergraduate work when the tumultuous events of 1989, in which her alma mater played a crucial role, took place. Memories of Tiananmen continued to haunt Tang, and more than a decade later, she and a group of primarily twenty-something actors and crew members, most of whom had no experience in film, produced one of the darkest and most unforgettable meditations on what was actually lost in Tiananmen Square that spring.

Lan Yu had also been shot on location in Beijing, but the stakes were higher for Tang. Unlike Stanley Kwan, who had some degree of protection as a Hong Kong resident, Tang and her crew faced considerably greater risk since they were all PRC citizens. Furthermore, unlike *Lan Yu*, which according to the director was never meant to be primarily about June Fourth, *Conjunction* was conceived precisely as a cinematic exploration of the aftermath of the incident, a potentially dangerous subject for any artist in China. Produced by the director's own independent production company, Tang Film LTD, *Conjugation* is set during the winter of 1989, six months after the crackdown, and deals with the psychological impact of the incident on a group of recent college graduates. The film also serves as a cinematic homage to the prolific 1980s poet Haizi 海子.

In the film, Tian Yu 田雨, Big Jack 大貓, Little Fourth 小四, Guo Song 郭松, and Xiao Qing 曉青 are all college friends who took part in the Tiananmen Square protests. Guo Song and Xiao Qing are lovers who met in Tiananmen Square during the height of the student protests. In the repressive environment of post–Tiananmen Beijing, enduring the cold winter and the oppression of martial law, the characters battle disillusionment and desperation, struggling to come to terms with what they have experienced and the choices that lie before them. Tian Yu throws away his academic career to start a small business, Big Jack leaves the capital for Shanxi, Little Fourth prepares for study abroad, Xiao Qing takes a job as a waitress in a small privately owned café, and

Guo Song abandons a future in science to work at a government factory. But haunting them all is the unseen member of their group, Foot Finger 腳指, a fellow student and amateur singer who was a victim of the government crackdown.

The narrative focus of *Conjugation* is on the couple Guo Song and Xiao Qing, tracing their relationship after they move in together and struggle against the outside world—and each other. Their bond is further enhanced by Tang's brilliant use of cinematic language to visually link the characters. An understated parallel plot structure follows the lovers as they descend through society. Guo goes from science student to factory worker and ultimately to street peddler as Xiao simultaneously goes from French student to waitress to (implied) prostitute. The parallelism is developed through the use of different narrative voices and storytelling devices; the authoritarian voice of Guo's factory supervisor is juxtaposed against that of Xiao's French teacher, and later, Guo's recitation of poetry is mirrored by the macabre stories Xiao begins to tell customers at the café where she works. Guo's fascination with poetry and Xiao's violent fantasies about murder and dismemberment serve as their sole cathartic release, as they sublimate their unspeakable loss through a language of the unconscious.

The burden of Tiananmen proves especially traumatic for the lovers because it represents both the site where they bid their dreams farewell and, ironically, where they first met. As Tian Yu observes, "I'll say, Xiao Qing was fascinated by Guo Song's romantic and passionate performance in the square." But six months later, romance and passion have all but disappeared; the film opens with the two desperate lovers breaking into a parked public bus in the middle of the night in order to have sex. They choose what is, during the day, the most public of locations to engage in the most private of activities. The lovers are forced into a strict lifestyle of mandatory lessons and training and constantly admonished by authority figures, and their former passion and idealism as represented by that Beijing Spring have been all but erased; the only freedom they have left is their midnight sexual trysts in parked public buses—but even there, Xiao Qing and Guo Song seem anything but excited, happy, or free. Like the characters in *Summer of Betrayal* and *Lan Yu*, they have been stripped of everything but their physical identities. The lovers subsequently rent a small room in a traditional Beijing *hutong*, where they can begin to reconstruct a world around themselves.

But as Guo and Xiao begin their new life, it becomes increasingly clear how fundamentally the world around them has changed. Although their new apartment provides the semblance of stability and a new start, one night, soon after moving in, they are warned of a residence card inspection (it is illegal for an

Remnants of the "democracy wall" (left) and a close-up displaying the now depoliticized posting, "Café waitress urgently wanted" (right).

unmarried couple to cohabitate) and are forced back to the public bus—a sobering reminder of how trapped they truly are. All around them, signposts of the familiar have been transformed and subverted. A medium-long shot of a campus bulletin board, surrounded by captivated readers who get off their bicycles to read the notices, immediately conjures up memories of the democracy slogans and big-character posters that adorned Beijing University and other campuses during the 1989 movement. However, as the director cuts to the close-up, the former site of protest is consumed by the quotidian. Instead of slogans, protests, and impassioned political treatises, the wall is adorned with advertisements for rentals and part-time jobs, including one for a café waitress, which Xiao Qing will soon become.

Another example of the changes comes as the lovers drive past yet another site associated with the movement, Tiananmen Square. Another place that just six months earlier was filled with crowds and bustling with optimism, idealism, and dreams is now reduced to a cold, overcast landscape of desolation. The dejected and lifeless expression on Xiao Qing's face as they ride past (neither she nor Guo Song looks toward the square) reflects not only to the unspoken dreams that have been shattered but also the insurmountable loss the iconic space now represents. For Xiao Qing and Guo Song, the site of romance and passion is also the site of death. They drive past the square immediately after Xiao Qing leaves the hospital after having an abortion, adding yet another layer of death and mourning to a place already stained with blood. Her failed pregnancy echoes the aborted student democracy movement.

Death is configured most tangibly in the film through the absence of Foot Finger, a character who is never seen, but whose ghostly presence is constantly felt, especially through music. Because he was a singer, the Chinese folk songs intermittently performed serve as reminders of him, as does the ominous score, which, employed with the greatest restraint, hauntingly creeps back in with the

Riding out the storm: interior shot of the protagonists Xiao Qing and Guo Song driving past Tiananmen after Xiao's abortion (left); exterior shot of the Front Gate (right).

mention of his name. The characters try to understand and cope with his absence, but it is an invisible disappearance. The loss of Foot Finger is unrecognized by any public commemoration, acknowledgment, or even place in the larger reality. Instead, the survivors are forced to continue their everyday lives with only the most cryptic and usually admonitory references to what occurred in the square.[11] The shadow of Foot Finger represents another significant absence that drives the film's narrative, leading to a string of actions (or, more appropriately, nonactions) whereby his loss paralyzes other characters and prevents them from moving on.

In order to fully understand the death of Foot Finger and what it represents, we must turn to another tragedy that was also silently carried out during the spring of 1989. Just nine weeks before the crackdown, Haizi, one of the most imaginative and prolific poets of the 1980s, lay down on a desolate stretch of railroad tracks in Hebei province and ended his life. Haizi (1964–1989) was a 1983 graduate of Beijing University best known for eight volumes of poetry published between the time of his graduation and his death on March 26, 1989. Seven years later, in 1996, fellow poet Xi Chuan 西川 wrote, "Haizi has indeed become a mythic figure: his poems have been imitated, his suicide has been debated, there are those preparing to adapt his script *Patricide* (*Shi* 弑) into an opera, there are those who are planning on adapting his short poetry for television, and students in the square or at various literary readings recite Haizi's poems" (Haizi 919). Haizi partly inspired Tang's *Con-*

11. One example of the film's veiled references to Tiananmen is when Guo Song's factory leader admonishes him for not taking a more active part in preparations for the Asian Games, for which the factory is planning a highly choreographed celebratory dance. During her high-minded lecture, she tells Guo, "To participate in this activity is very important to the new college graduates like you. First, it can enhance your sense of organization. Second, your sense of discipline. That's what you youngsters nowadays lack."

jugation, wherein his work is central, sharing the stage with the Tiananmen Square massacre.

In *Conjugation,* the death of Foot Finger and the poetry and death of Haizi are inextricably intertwined. During a casual card game between Guo Dong and Tian Yu, Tian hands Guo an envelope and explains, "His girlfriend said that someone left this for Foot Finger." That night Guo Dong awakens and opens the envelope to discover a poem inside, which he reads by flashlight:

Sister, this time I am ready to go to that place called Delingha
Sister, I am ready now
I will leave in two days
Sister, in the past you always said that I was forever a child
Exhausting my life
Sister, when I arrive at Delingha
Everything will be fine
Sister, it's cold and there is no heat in this room
It rains and the emperor's new clothes got all wet
Sister, don't drink too much wine, eat more meat
Sister, I miss you

The poem is inspired by Haizi's "Diary" ("Riji" 日記) written on July 25, 1988 on a train passing Delingha 德令哈, which lies in Qinghai 青海 province.[12] Although it contains thinly veiled political references ("and the emperor's new clothes got all wet"), at its heart, "Diary" is a melancholy work written in anticipation of departure. Here departure is again inextricably linked with death. This poem is also written on a train, the very vehicle that would end Haizi's life less than a year later. And just a few scenes after reciting it, Guo Dong quits his factory job, where he is crushed by the oppressive atmosphere, and rides his bicycle to the railroad tracks. He parks his bicycle alongside the tracks and stands beside the oncoming train contemplating Foot Finger's (Haizi's?) death—and the possibility of his own. A few more scenes later, Guo Dong continues reciting the poem.

The poetry of Haizi, recited by Guo and appearing in intertitles, gradually becomes a primary component of the film's narrative structure, though its

12. I emphasize that the poem is only inspired by "Diary" because, although the original poem contains several lines used in the film, the poetry in *Conjugation* contains enough textual discrepancies to qualify as a different text. This may be a metafictional intervention on the part of the screenwriter/director or an uncorrupted version of a different poem by Haizi, which was not previously published in his "Complete Works."

meaning remains cryptically sealed from the characters. Several times Guo Song even discusses the poem in the envelope with Tian Yu, debating who the author might be, whether or not he really had a sister, and his relationship to Foot Finger. For Guo Song and Tian Yu, the questions remain largely unanswered, just as the details behind Foot Finger's disappearance (and probable death) continued to be shrouded in mystery. Haizi's poetic oeuvre is haunted and directly inscribed by violence, death, and suicide.[13] Haizi's poem is recited once more toward the end of the film in a climatic moment that combines different forms of narrative and visual violence. This is also where the post-traumatic journey of Guo and Xiao ends and the sublimated violence from six months earlier finally manifests itself through a dark dance of images and words.

The disturbing sequence comes after Xiao has slept with another man she met in the café in a cheap insect-infested hotel. In the aftermath of their passionless lovemaking, we hear Xiao's monotone voiceover, narrating the end of the macabre tale she began telling the man earlier in the café:

After the woman's husband died, her days passed by in relative peace.

She told others that her husband was missing.

At first the villagers didn't believe her, but as time went by people began to.

And as more time crept by, people stopped even mentioning her missing husband.

Many years passed by, and the woman herself began to forget what actually happened.

But then one day her sister-in-law came to visit her from far, far away.

As they were eating, the sister-in-law asked, "Just where did my brother go?"

The woman replied, "He has been lost for a long time now, everyone knows that."

She spoke with an easy conscience, because she believed no one would ever discover the truth.

Although her two-year-old son was present at the time, she was certain he would not remember—especially since he had been mute ever since the incident.

However, before dinner ended that night, her son suddenly began to speak.

He asked, "Mommy, can we eat Daddy's pickled meat in the jar now?"

13. Haizi's literary imagination is filled with countless examples of macabre imagery, as testified to in "Poem of Death" ("Siwang zhi shi" 死亡之詩), "Song of the Suicide Victim" ("Zishazhe zhi ge" 自殺者之歌), and "Sun: Decapitation" ("Taiyang: duantou" 太陽: 斷頭). Xi Chuan even described Haizi as having a "suicide complex."

The passage not only is an allegorical retelling of the Tiananmen massacre but also contains the mechanisms of post-traumatic memory. From the silence and forgetting of the crowd, which eventually allows even the murderer herself to forget her crimes, to the traumatized silence of the son, whose voice is only rediscovered through a terrifying cannibalistic twist, Xiao Qing's tale once again echoes the Lu Xunian model. There is also an implied connection between the silence of the villagers and that of society, the muteness of the child and that of the student protesters after the crackdown, and the final haunting question about finally eating the pickled meat, which is represented in the film by the characters' constant moral dilemma about when they can finally spend the money donated by the public to the student protesters in Tiananmen Square—which to them has become "blood money" closely associated with Foot Finger and his death. Xiao's dark tale is juxtaposed against Guo's narration of a final verse from Haizi, which immediately follows. The two are joined not only by the narrative continuity but also through the most disturbing visual sequence in the entire film—that of Guo Song shredding meat.

The mechanical motion of shredding the meat into a bowl, which is highlighted through extreme close-ups of the meat and multiple angles of Guo, presents another projected layer of allegorical violence, which up until this point has been sublimated and repressed. The multiple layers of violence in different forms merge. On the narrative level, Guo's final recitation of Haizi's poem collides with Xiao Qing's cannibalistic tale; on the physical level; Guo's violent slicing of the meat reflects Xiao Qing's violent betrayal of her own body through prostitution.

Through this key scene, which marks the belated release of Xiao Qing's and Guo Song's suppressed memories of atrocity, the couple finally emerges from this traumatic haunting to begin their voyage to a new place. The change begins in the narration of the final verse of Haizi's poetry, in a distinctly different tone from both Xiao Qing's violent tale and earlier verses of Haizi's poems cited in the film.

> Sister, starting tomorrow, I'll be a happy man
> Feeding the horses, chopping firewood, and traveling the world
> Sister, starting tomorrow, I'll start paying attention to food and vegetables
> Starting tomorrow, I'll write letters to all of our relatives
> To tell them of my happiness
> What that fleeting flash of happiness has told me
> I will share with all others
> Sister, give every river, every mountain a warm name

Stranger, to you too I send my blessings
Wishing you a bright future
Wishing those of you in love to be joined in marriage
Wishing everyone to find happiness in this world of dust
All I want is to face the sea during the warm spring with the flowers in bloom.

Throughout the film, Haizi's poems signify the suppression of the June Fourth crackdown and the mysterious disappearance of Foot Finger. In this final verse, they take on a more optimistic tone, pointing toward a future that requires leaving behind traumatic memory and the site of that memory—Beijing. In all the verses of poetry that have been cited, departure and death are intricately intertwined. Cathy Caruth has written about the connection between departure and trauma, describing the Freudian conception of traumatic experience (ironically also involving a train, the place of composition of Haizi's original poem and the vehicle of his death):

> Indeed, in Freud's own theoretical explanation of trauma, in the example
> of the accident, it is, finally, *the act of leaving* that constitutes its central and
> enigmatic core. . . . The trauma of the accident, in its very unconsciousness,
> is born by an act of departure. It is a departure that, in the full force of its
> historicity, remains at the same time in some sense absolutely opaque, both to
> the one who leaves and also to the theoretician, linked to the sufferer in his
> attempt to bring the experience to light. (Caruth 1996:22)

In *Conjugation,* departure and death also play a key role in the fate of the protagonists. Big Jack leaves for Shanxi and Little Fourth departs for the United States, but the act of leaving is most fully explored through Guo Song and Xiao Qing. As they feel their way through the shadows of atrocity, Guo and Xiao begin their journey by moving into the small apartment, an action depicted in the first scene after the title sequence. It quickly becomes clear that before they can move on, they must sort through their past, battling their demons and struggling to make sense of the pervasive loss that engulfs them. Six months after the atrocity, the protagonists come face to face with the trauma they have experienced, each taking a dark, self-destructive journey. Only at the end of the film, after each has revisited the violence of June Fourth in their own way, can Guo and Xiao finally embark on a second departure, leaving the city and the site of trauma for an uncertain future. The date they choose, January 11, 1990, corresponds to the lifting of martial law. Are they heading to Delingha, or at least the Delingha of their imagination—a place where they can "be engulfed

by the darkness of the night" and "concern themselves not with the rest of humanity"? Perhaps with the lifting of martial law, the dark shadows of their violent past have also been lifted. However, because departure is intricately intertwined with trauma, the voyage to Delingha may be yet another stage in their traumatic journey.

Emily Tang does not provide an answer to the fate of Guo Song and Xiao Qing, just as they are never provided an answer to the mystery of the Delingha poem or Foot Finger's disappearance. But *Conjugation* is a sensitive and thought-provoking exploration of survivors living after an "invisible massacre." By "conjugating" the violence of Tiananmen in the past tense and exploring its post-traumatic aftermath, the film reveals a much more powerful and nuanced vision of atrocity than immediate coverage would have. The psychological forces that so often render atrocity unspeakable are here reinforced by the political forces that ensure silence. Just as the characters in the film cannot face the reality of what happened and must bury it deep inside, the film itself cannot directly portray the massacre.[14] For the time being, an aesthetics of invisibility still dominates cinematic representations of June Fourth. All that *Lan Yu* and *Conjugation* can offer is the hope that, as they depart from Beijing, Chen Handong, Guo Song, and Xiao Qing will be able to leave behind their personal city of sadness and confront the trauma that silently runs so deep.

FROM BEIJING TO BERLIN: FILM MAPPING AND POLITICAL ERASURE IN *SUMMER PALACE*

In 2006, Sixth Generation filmmaker Lou Ye (b. 1965) completed his fifth feature film, *Summer Palace* (*Yiheyuan* 頤和園), a bold vision of China in transition from the 1980s to the 2000s that challenged the limits of censorship. An early version of the original screenplay was awarded a prize at the Pusan International Film Festival back in 2001, following the success of Lou's stylized Hitchcockian thriller *Suzhou River* (*Suzhou he* 蘇州河). Principal filming did not begin until September 2004, after completion of Lou's big-budget period film *Purple Butterfly* (*Zi hudie* 紫蝴蝶). No stranger to controversy, Lou Ye had seen two of his previous films banned in China

14. The failure to directly portray the Tiananmen Massacre was as much an issue of political censorship as of practical and budgetary considerations. As Tang writes in her director's statement, "Due to a lack of financing for a low-budget independent film like mine, we weren't able to re-create the past. . . . We avoided almost all exterior scenes and events."

(1995's *Weekend Lover* (*[Zhoumo qingren* 週末情人)*]* and 2000's *Suzhou River*); the latter even resulted in a two-year ban on filmmaking. *Summer Palace* proved to be more ambitious, masterful, and controversial than any of his previous films.

The film spans nearly two decades, but at the heart of *Summer Palace* lies the Tiananmen Square massacre. Lou Ye offers the single most extensive portrayal of the incident to yet appear (or disappear) on the Chinese screen. While *Lan Yu* included only a few blurry images of students running down the street and *Conjugation* was set entirely in the aftermath of Tiananmen, *Summer Palace* contains extensive sequences depicting the 1989 protests and the eventual military crackdown, even featuring disturbing images of PLA troops firing on students. At one point, the director goes so far as to borrow stock news footage of the actual incident, which is intercut into the film. Such frank depictions of the violence of 1989 are unheard of in Chinese cinema, and Lou Ye deserves credit for even attempting such a bold statement, let alone actually making it. However, the director is interested not in a crude re-creation of the event itself but in a deeper exploration of the pressures leading up to it, and especially the post-traumatic legacy it left behind.

Summer Palace begins several years earlier in a provincial town along the Chinese border with North Korea, and follows the story of a high school girl named Yu Hong 余虹 (Hao Lei 郝蕾). Upon her acceptance to Beiqing University 北清大學—a fictional school whose name is an amalgamation of Beijing University 北京大學 and Qinghua University 清華大學—Yu Hong travels to the capital, where she witnesses the cultural renaissance gripping the campus, including everything from rock and roll music and disco parties to casual sex and cultural debates. Yu Hong gets caught up in the lightning-fast transformation and eventually falls in love. The object of her affection and eventual obsession is her classmate Zhou Wei 周偉 (Guo Xiaodong), a handsome student athlete and friend of Li Ti 李緹 and Ruo Gu 若古, a couple who have also befriended Yu Hong. Yu Hong and Zhou Wei continue their dysfunctional on-again off-again relationship throughout college, until the eve of June Fourth, when Yu discovers her boyfriend has been sleeping with her best friend, Li Ti.

Unlike *Lan Yu,* where June Fourth signaled the moment of commitment between the lovers, in *Summer Palace* it marks the dissolution of the relationship. Tiananmen represents not only the state's ultimate betrayal of its people but also Yu Hong's betrayal by both her lover and her best friend. After the incident, Yu Hong drops out of school and returns home with her old hometown sweetheart. Zhou Wei remains in Beijing, taking part in mandatory military

Yu Hong (Hao Lei) and Zhou Wei (Guo Xiaodong) in *Summer Palace*.

reeducation outings after the massacre, and eventually travels to Germany, where he and Li Ti join Ruo Gu, who has been studying there since the late 1980s. In the ensuing years, Yu Hong seems to futilely attempt to relive the excitement of her youth and the passion of her affair with Zhou Wei as she travels from city to city and from man to man, working at a monotonous government office job and growing increasingly lost. The narrative continues up to the 2000s, when Zhou Wei returns from Berlin and he eventually reconnects with Yu Hong for a fleeting, heartbreaking reunion.

Besides a frank portrayal of the 1989 democracy movement, *Summer Palace* features equally forthright depictions of sexuality and desire. Spread throughout the two hour, twenty-minute film are more than half a dozen sex scenes, featuring full-frontal male and female nudity, masturbation, and allusions to homosexual relationships. The attention to sexuality can be read as mirroring the intense liberalization going on in all other realms of Chinese society, from culture and the arts to business and economics. But even more palpably, Yu Hong's sexual journey is a desperate way for her to communicate with the world and try to create meaning in her life. Often Yu Hong's sexual trysts with any number of men include nondiegetic voice-over readings of her diary entries, fragmented soliloquies that appear sporadically throughout the film. These diary entries reveal the dark inner world of Yu Hong, riddled with desperation and sadness and thus place the sexual acts that intersperse the narrative in a new context.

In one scene years after the massacre, when Yu Hong seeks out her married lover on a rainy afternoon, their passionate sex is mediated by the following diary entry:

Looking through my photo album, I came across a picture of Zhou Wei. My heart raced wildly. One look, and all the joy and pain flooded back. Staring at his image, I asked myself how it was that on this serene face, open, frank, and resolute, I saw no trace, no shadow, that could make me doubt? Why could nothing he'd said to me, or done to me, prevent my heart from going out to him? Apparently, I was the one pursuing him, yearning for him, but I never felt enslaved. At times, I was clearer than him. The memories brought tears, and the resolve to endure. Today is Saturday and I'm screwed again. Tonight, there was nothing to do but to go to him. He has a wife. She's away studying. We met at a karaoke bar. I really feel we're in the same boat. Alone . . . and without purpose. A colleague who knows the law told me that our affair isn't illegal, but immoral. What is morality? Two people together: I think that's morality. When he and I are like that, when our bodies merge, I trust him. I feel the will to succeed. Making love with him consumes me entirely. There's no room for anything else. But I know with a terrible certainty that my passion for him will not last. I know that I can kiss him but that I won't remain. Humans yearn to be alone. And they long for death. Why else do we fight with those we love most? Why this indifference to what is in front of us, our eyes fixed always on the unreachable?

Such narrative sequences serve a number of different functions in the film. Yu's frank longing for Zhou Wei serves to maintain the emotional (or at least narrative) connection between the two characters throughout the second half, long after they have parted, transforming each of Yu Hong's lovers into carnal substitutes for her true love. On a deeper level, the detached, matter-of-fact narration also de-eroticizes the sexual images on screen, making them seem mechanical and unfeeling, while adding a layer of hurt and sorrow to the act of lovemaking. The indescribable loss that Yu Hong repeatedly uses her body to replace, each time ending up only more alienated, is of course a longing not just for Zhou Wei but also for the joy and purpose that was taken on that early morning in June 1989. Yu Hong's breakup with Zhou Wei occurred on June Fourth, inextricably linking her lost lover with the violence, violation, and betrayal of the massacre. Thus, Yu Hong's subsequent downward spiral of sex and nihilistic self-destruction can be seen as the post-traumatic replaying of the lingering fantasies and nightmares of 1989.

This conflation of violence and sex, however, is not purely a symptom of June Fourth but also a product of a deep psychological scar in Yu Hong. At the beginning of the film, before she journeys to Beijing, she enacts a similar pattern with her first love, Xiao Jun 曉軍 (Cui Lin 崔林), when they make love after Xiao Jun gets in a bloody fight on the basketball court over her. A similar violent game of courtship is played later in Beijing when Zhou Wei fights with a classmate who tries to court her. Perhaps most telling, in the dorm room argument between Zhou and Yu during one of their many breakups, she repeatedly demands he hit her before she will leave . . . and after three vicious slaps across the face, they make love. Thus, the combination of sex and violence, both everyday and epic, is constant in Yu Hong's life, in self-destructive cycles of repetition.

One such cycle plays out in a most uncanny way through the character of Li Ti, Yu Hong's best friend during their student days at Beiqing University. In one early scene, Li Ti sees Yu Hong standing at the edge of a campus rooftop, seemingly contemplating suicide. Li Ti rushes to her, and the suicide is seemingly aborted. In the following sequence the girls are seen at a club wearing identical striped outfits, visually identifying them as doubles. But the true doubling does not occur until later, when Li Ti begins secretly sleeping with Zhou Wei. Their clandestine affair continues for years, even after they move to Berlin and Li Ti is reunited with her longtime partner, Ruo Gu. But as Zhou Wei prepares to return to China, leaving Li behind in Germany, Li Ti suddenly decides to take her own life—throwing herself from a Berlin rooftop. Li's enigmatic death may be read as a love suicide by some, but the darker meaning behind her departure can be found in one of her final conversations with Zhou, when she suddenly asks him: "What happened to us that summer?" Zhou's sardonic response, "What's going on with us now?" speaks to the present, but Li Ti is still haunted by the demons of the past—*that* summer is the summer of 1989. When Li Ti takes her life in 1998, almost a full decade after the Tiananmen Square massacre, she is not only belatedly carrying out Yu Hong's aborted suicide but also claiming a form of belated victimhood. The key to that victimhood and why it was transplanted from Beijing to Berlin can be found in the other set of doubling that Lou Ye employs in the film.

Just as Li Ti serves as Yu Hong's double, the cities in *Summer Palace* serve as an entry point for understanding the film's structure and philosophy of movement. In *Summer Palace,* politics is always intricately tied to place. The film opens not in Beijing, but in the Chinese border city of Tumen 圖們. This marginalized territory identifies Yu Hong's minority ethnicity as a Korean Chinese

and also signals the socialist cradle from which she came. By the mid-1980s, almost a decade after Deng's Open Door Policy was instituted, most of China was already opening up and well on the way to Western-style liberalization. Because of its close proximity to North Korea and large number of refugees and immigrants, Tumen represents one of the few locales still under the shadow of socialism, symbolized by the looming portrait of Kim Il-Sung in one of the opening shots. Such a background makes Yu Hong's journey to the capital of Beijing all the more dramatic. Lou Ye has also spoken extensively about the way geographic movement plays into the film's structure:

> We decided to use Yu Hong's origins when we were scouting locations for the film. We went to that region to find a place near the border with North Korea, where Russia, North Korea, and China meet. We felt that her geograghic origins could have some influence on her character. We originally wanted to start the story in the north and progress along a north-south axis, a parallel of overall development in China. The film was even supposed to end in Shenzhen. As it turned out, it begins in Beijing, stops briefly in Wuhan, and then continues slowly south, a progression linked to Yu Hong's story, as she heads toward more open cities, where development is happening faster. (Weber 5)

In the second half of the film, Yu Hong's physical journey seems to mimic her psychological instability: she first returns to Tumen before venturing to China's wild west city of Shenzhen and then to Wuhan and Chongqing before ending up back in Beijing, near Beidaihe. The journey of Zhou Wei with Li Ti and Ruo Gu is even more dramatic, from Beijing to Berlin and eventually back again. Berlin can be seen as a double, or at least alternate, identity for Beijing. Both historical capitals faced major international crises in 1989; the fall of the Berlin Wall succeeded in bringing about what the student demonstrators in Beijing had hoped for, a true democratic political revolution. From this perspective, the characters' journey to Berlin can be seen as a means of retroactively realizing their dreams of liberal democracy and seeing their idealistic revolution succeed . . . or is it?[15]

Just a few hours before Li Ti takes her own life, she walks the streets of Berlin with Zhou Wei and Ruo Gu, and they encounter a festive street fair and parade. As they stroll down the avenue, they see a group of protesters carrying a massive political banner sporting the iconic profiles of Marx, Lenin, and Mao,

15. Doubling is also a key theme in Lou Ye's 2000 film *Suzhou River*. For more on that film, see Jerome Silbergeld's *Hitchcock with a Chinese Face: Cinematic Doubles, Oedipal Triangles, and China's Moral Voice.*

the specters of the socialist world they tried to escape. And indeed, in the end, none of them does escape: Li Ti kills herself and both Zhou Wei and Ruo Gu return to China. Lou Ye's sophisticated use of space and urban doubling provides no easy answers for Beijing's future or the future of his characters, but it does reveal the deep anguish and contradictions haunting diasporic dreams after historical trauma.

Also fascinating in the film's construction of space is the way various cities and locals are identified in the narrative. Throughout the first section of the film, up until the Beijing Massacre of 1989, titles appear onscreen identifying the various cities where action transpires—but these titles appear only *after* characters leave the site. For instance, the film opens in Yu Hong's childhood home of Tumen, but only as she leaves Tumen for Beijing does the title "Tumen 1987" appear. During the second half of the film, in most cases, titles are used in a more traditional way, identifying each city just as the action turns there. This difference in the framing of sites and cities is a subtle but powerful tool for displaying how characters' movement is alternately driven by a forward-looking optimism pre–1989 and a reflexive philosophy that continually looks back after the stunning upheaval.

Two masterful cinematic montage sequences depict the fast-paced cultural melting of university life in the 1980s, cut to the pace of Lo Ta-yu's upbeat "Youth Dance" (*Qingchun wuqu* 青春舞曲), and the radical transformation of China from the Tiananmen Square massacre and Deng Xiaoping's Southern Tour in 1992 up to the 1997 Handover of Hong Kong, which is given Black Panther's 黑豹 rock anthem "Don't Break My Heart" as its soundtrack. Each sequence intercuts stock news footage of historical events with short scenes documenting the two protagonists' transformation over the course of nearly a decade. These sequences stand in stark contrast to the deliberate and gradual pacing of the rest of the film and attest to Lou's mastery of slick MTV-style editing to convey epic historical changes. They also carry a special meaning as narrative bookmarks tracing the massive cultural and historical metamorphosis that took place in China just before and immediately following the Tiananmen massacre. From this perspective, the pair of sequences contextualize Tiananmen as falling squarely between the high culture fever of the 1980s and the economic fever of the 1990s. Even the choice of music documents the changes in pop culture as China began to produce its own genre of Western-style pop rock. Such a placement also serves as an attempt to trace the historical roots of the massacre within deeper historical fissures. Tiananmen Square has been regarded as the central historical scar of the post–Cultural Revolution era; Lou Ye prods us to also consider the concealed traumatic nature of

the surrounding cultural and economic upheavals that helped define that historical moment.

Also framing the film are the two aforementioned images of the socialist icons Kim Il-Sung, whose portrait appears in Tumen at the beginning, and Mao Zedong, who reappears in Berlin just before Li Ti's death and Zhou Wei's departure. The spectral return of these socialist deities in the age of liberal economic reform and material prosperity is a reminder of the lingering power of the state to discipline, punish, and regulate. This power was exercised in 2006, upon Lou Ye's film. The international distributors of *Summer Palace* submitted the film to the Cannes Film Festival prior to its approval by the State Administration of Radio, Film, and Television (SARFT), and a major controversy began to brew. SARFT initially claimed the film could not be reviewed due to poor sound and picture quality, then ordered a full media blackout throughout China beginning May 21, 2006. Eventually SARFT banned the film and banned Lou Ye's filmmaking activities in China for five years. Such a punishment was not a first; in 2000, *Devils on the Doorstep* (*Guizi laile* 鬼子來了) was banned and its director, Jiang Wen 姜文, punished with a seven-year ban on directing. Given that *Summer Palace* boldly broke taboos concerning both politics and sex, it is not surprising that the authorities responded by politically erasing Lou Ye's film and, according to some reports, confiscating all international revenue that was generated. In the end, the film mimicked the characters' voyage from Beijing to Berlin, traveling from China to international screens, the only space where it can be rendered visible and the only forum where the trauma of Tiananmen is seemingly allowed to speak.

FATAL DECISION: TIANANMEN, PRIME TIME AND DISPLACED

In *Lan Yu, Conjugation,* and *Summer Palace,* Beijing 1989 serves as both the background and a key narrative device, if not the narrative hub. Numerous other filmmakers went to much greater lengths to shroud and displace their own visions of Tiananmen Square. One case in point is Zhang Yimou, the most famous filmmaker in China, whose 1990 film *Ju Dou* (菊豆) has been often interpreted as a veiled commentary on the events of June Fourth. As leading PRC cultural critic Dai Jinhua 戴錦華 has noted, "*Ju Dou,* after all, provides an allegorical text. In a certain way, it relates the heavy and painful emotions associated with the Tiananmen Square crackdown to the China of the nineties" (Dai Jinhua 56). Zhang's next film, *Raise the Red Lantern* (*Da hong denglong gaogao gua* 大紅燈籠高高掛) (1991) continued his covert exploration of the power relations behind Tiananmen, as did his 2002 blockbuster *Hero* (*Yingxiong* 英雄), which numerous critics have disparaged as an about-face in which he retroac-

tively condones the massacre.[16] In *Raise the Red Lantern,* Zhang's social critique is revealed not only through the oppressive imagery, hard symmetrical lines, and architectural structures dominating the film's framing but also, even more powerfully, in the faceless but omnipresent patriarchal power (Master Chen) who controls the desires, freedoms, and lives of his wives—a figure that can be read as a sublimated portrait of the CCP's stringent control of the Chinese people in the late 1980s. Like the student protesters who were massacred and erased, the women in the Chen compound who attempt resistance are summarily silenced: hanged in the rooftop tower, their voices forever silenced.[17] Although he has never gone so far as to detail the symbolism of *Raise the Red Lantern,* Zhang Yimou has openly spoken about the film's relation to June Fourth:

> The social symbolism ingrained into the fabric of *Raise the Red Lantern* is the most powerful of all my films. That was right after June Fourth, and I don't know why, but against that particular historical backdrop I suddenly found myself having all kinds of ideas about the inherent nature of the Chinese people. I shot the film very quickly, immediately after June Fourth, so it is inundated with symbolism. (Berry 2005:130)

Thus a tale set in Republican China about a girl student married into a feudal household where she is eventually crushed beneath its oppressive rules and codes, becomes a veiled retelling of the 1989 student movement where idealistic students rise up against an equally repressive system, only to be crushed beneath its weight. Zhang, of course, was not alone in offered allegorical critiques of Tiananmen. His former classmate Chen Kaige's *Life on a String (Bianzou bianchang* 邊走邊唱*)* has also been viewed as a platform for commenting on June Fourth.[18] Unbeknownst to most audiences, the muffled cries and blurry shadows of Tiananmen were actually creeping back into theaters—even into the works of two of China's most popular directors. Although *Lan Yu, Conjugation,* and *Summer Palace* are among the only narrative films openly addressing the incident, Tiananmen has played a much greater role in the Chinese cinematic imagination since the 1990s.

16. Among the stronger criticisms of *Hero* is filmmaker and critic Evan Chan's essay, "Zhang Yimou's *Hero*—The Temptations of Fascism," *Film International* 8 (March 2004).

17. Those not hanged in the dark rooftop tower (or drowned in the garden well, as in Su Tong's original story), are driven insane, like Songlian 頌蓮 (Gong Li 鞏俐), who goes mad after witnessing the murder of the Third Wife. Here the Lu Xunian connection between cannibalism and madness is again made clear. In "Diary of a Madman," only the "madman" is able to see the Chinese tradition of cannibalism and barbarism for what it truly is. A Lu Xianian reading of *Raise the Red Lantern* can be pushed even further if we take the entire Chen compound (where the film is set and from which the characters seem unable to escape) as a symbolic rendering of Lu Xun's famous parable of the "iron house."

18. See Chen's comments in Berry, *Speaking in Images,* 94.

One of the more interesting cases, and one that configures Tiananmen in a very different context, is that of *Fatal Decision* (*Shengsi jueze* 生死抉擇).

Based on Zhang Ping's (b. 1953) best-selling novel *Decision* (*Jueze* 抉擇), winner of the fifth Mao Dun Literary Prize, *Fatal Decision* was the single most popular film in the relatively new genre of "anticorruption cinema." Jeffrey C. Kinkley has described the adaptation as "one of the most influential and widely viewed films ever made in China, outgrossing all movies previously screened in the country with the exception of *Titanic* . . . 25 million people viewed it in theaters, and it was extensively pirated for home viewing" (Kinkley 79). Released in 2000, *Fatal Decision* was directed by Yu Benzheng and starred Wang Qingxiang 王慶祥, Liao Jingsheng 廖京生, Zuo Ling 左翎, and Wang Zhenrong 王振榮. The story revolves around an upright mayor, Li Gaocheng 李高成, who, after returning from a training session at the Central Cadre School, receives an emergency call from the local Zhongyang Garment Factory, where a major crisis is under way. Thousands of disgruntled factory workers, angry about loss of benefits, unfair compensation, and widespread corruption, have stormed the factory demanding a dialogue with officials. Li arrives in the middle of the night to quell the unrest, promising to take appropriate action. He institutes a new policy to "conduct small investigations into small cases, medium investigations into medium cases, and large investigations into major cases." Over the course of Li Gaocheng's investigation, he uncovers an intricate and far-reaching web of corruption and lies. The scandal extends from the heads of the factory to Li's subordinates, his superiors, and even his own wife. In the end, Li Gaocheng is faced with a "fatal decision" between truth and lies—and between his responsibility to his family and his duty to his country.

The popularity of the novel and film even led to a seventeen-episode prime-time television miniseries, *Select* (*Jueze* 抉擇), directed by Fifth Generation director Chen Guoxing 陳國星, a former educated youth who also directed such films as *Kong Fansen* 孔繁森 and *One Family Two Systems* (*Yi jia liangzhi* 一家兩制), and starring Li Xuejian 李雪健 in the role of Li Gaocheng. The popularity of the three representations of the story in fiction, film, and television served as a vivid reminder of propaganda's power, even in the post–Deng era, when communist ideals seemed superseded by capitalist individualism. The full-length film version, *Fatal Decision,* was obligatory viewing for party officials and cadres nationwide and won over working-class audiences with its sympathetic view of the plight facing so many affected by corruption and the dismantling of state enterprises. Though it is a work of thinly veiled entertainment propaganda, *Fatal Decision*'s realism and boldness struck a genuine chord.

One reason for the film's relevance was its series of indirect references to the Chen Xitong 陳希同 corruption case of 1995, which captured the imagination of the media throughout China. Chen was a prominent politician who served as

mayor of Beijing and was among the most powerful men in the nation. He won favor in the party for his tough stance during the uprising of 1989 and subsequently played a key role in the capital's modernization. But after being accused of demanding major bribes from construction companies, Chen was stripped of his posts and placed under house arrest in 1995, then sentenced to a sixteen-year prison term in 1998. The case was the most visible effort in China's war against corruption and is certainly one of the primary incidents informing Zhang Ping's original novel, which was published in 1997, at the height of the media sensation. *Fatal Decision* once again presents a city mayor surrounded by corruption and a system wherein bribery and lies seem to be the rule. But *Fatal Decision* goes further in rewriting an even larger historical injustice: June Fourth.

At no point in the film is the Tiananmen Incident of 1989 directly broached; however, it remains an implicit subtext behind the story. All of the major action, including the "decision" referred to in the title, is set in motion by the protests outside the Zhongyang Garment Factory. The film begins with images of thousands of disgruntled workers descending upon the factory in the middle of the night and being restrained by police and public security officials. The workers have not spontaneously organized themselves but have acted under the guidance of a group of "impassioned university students." The developing conflict, as graphically displayed in the film and television versions, bears a striking resemblance to the 1989 Beijing protests.

The dynamic between historical flashback and historical revision, however, begins to change with the arrival of Mayor Li Gaocheng. Disregarding pleas from his subordinates to keep a safe distance from the strikers, Li walks directly into the heart of the demonstration and addresses the factory workers, first through a megaphone and then through a microphone loudspeaker system. First Li Gaocheng dismisses all police and public security officers, along with all factory officials, from the scene. Then he proceeds to address the crowd:

> Brothers, sisters, and elders from Zhongyang Garment factory, your factory is amid such a major incident and I, Li Gaocheng, didn't even know. This is a dereliction of my duty. I am sure that you all must have your reasons for having complaints about your leaders. I understand everyone's feelings. So I rushed over the moment I got off the plane; that way you wouldn't have to travel miles away [to the county seat] and lose sleep. If there is anything bothering you, please feel free to speak your piece and share your thoughts with me. If there are any problems, you can report them to me!

Li then stays up all night with a group of worker representatives, listening patiently and sensitively to their grievances and complaints.

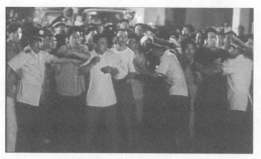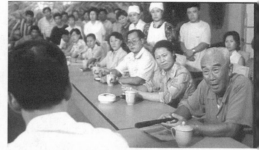

Police holding back disgruntled garment factory workers (left) and Li Gaocheng listening to the complaints of the disgruntled workers during an all-night session after the riot (right) in *Fatal Decision*.

The entire scene is reminiscent of June Fourth, and can also be seen as a conscious attempt to revisit the incident and belatedly reconfigure that past. Whereas Tiananmen Square saw the use of military force and a policy of non-cooperation with demonstrators (barring, of course, the now-infamous confrontation between Li Peng and hunger-striking students), *Fatal Decision* has the leader dismissing the soldiers and directly engaging the protesters through dialogue. And in contrast to Tiananmen, for which no one has ever taken responsibility, Li Gaocheng immediately accepts responsibility for his "dereliction of duty." Just over a decade after the suppression of the student movement, as overseas dissidents and human rights groups lobbied for a reevaluation of the historical place of June Fourth, the government offered its own startling fictional attempt to reevaluate that history. *Fatal Decision* presents a concerted effort to address—and redress—June Fourth without ever actually having to mention the subject. In the context of popular culture, the CCP reinvents itself as a regime that does not slaughter students in the middle of the night, but instead labors the night through to maintain peace with the people. Leaders are not dismissive but sensitive, and social unrest is not violently quelled but gently pacified.

Belated Tragedies and the Transnational Imagination: Terrence Chang and Gu Zhaosen

The Chinese diaspora has played an important role in the imagination of June Fourth. Under a system of censorship in China that strictly prohibits the publication or dissemination of any printed material about the massacre,

whether fact or fiction, looking abroad seems to be the only option for approaching the Tiananmen Massacre. Writing in England and America, respectively, Hong Ying and Beijing Comrade reconfigured the Beijing Spring of 1989 years later and far, far away, publishing their work outside China—in the case of Beijing Comrade, in the borderless virtual world. Although they are among the few writers working in Chinese who have directly depicted the incident, they are part of a much larger transnational phenomenon. In the years since the crackdown, Beijing 1989 has become one of the most popular time-space coordinates onto which overseas Chinese writers project their fictional worlds, making the portrayal of the Tiananmen Square Massacre one of the central themes in contemporary Chinese American and transnational Chinese fiction.

Many Western readers are intimately familiar with the memoirs, diaries, and reminiscences that flooded the international publishing market in the wake of the incident, including Shen Tong's *Almost a Revolution*, Michael Duke's *The Iron House: A Memoir of the Chinese Democracy Movement and the Tiananmen Massacre*, Li Lu's *Moving the Mountain*, and Zhang Boli's *Escape from China: The Long Journey from Tiananmen to Freedom*. One of the most powerful such accounts was by Su Xiaokang 蘇曉康, a writer, intellectual, and activist best known as co-creator of the enormously influential television series *River Elegy* (*He sheng* 河傷). *A Memoir of Misfortune* deals less with the incident itself than with the dark shadow it cast. More nuanced and reflective than many of his contemporaries' explorations of Tiananmen, it is a gripping testament to Su's years in exile and the terrible trials experienced by his family, especially after his wife's debilitating car accident. Su's memoir is a springboard from which he probes the plight of contemporary Chinese intellectuals and the recurring traumas they face. The notion of belated tragedy, so evident in this work, is also a constant theme in the growing body of fictional representations of Tiananmen.

Tiananmen is an equally important place in the work of both veteran writers and first-time authors. Best-selling Hong Kong writer Lillian Lee was one of the first novelists to approach the incident with her 1990 collection, *Stories from Tiananmen* (*Tiananmen jiupo xinhun* 天安門舊魄新魂). It was quickly followed in 1991 by *Gate of Rage,* the first full-length English novel about the massacre, by veteran novelist C. Y. Lee (b. 1917), author of the classic *Flower Drum Song*. *Gate of Rage* follows a Chinese American businessman who left China in the late 1940s as he returns to be reunited with his son on the eve of the 1989 crackdown. Other novels include *Lili: A Novel of Tiananmen* (2001) by Annie Wang, the story of a woman's life from her sexual victimization during the

Cultural Revolution to her romance with an American reporter just before the Tiananmen incident—and *The Crazed* (2002), by National Book Award and PEN/Faulkner recipient Ha Jin 哈金. Set on the eve of the 1989 crackdown, Ha Jin's brilliant novel tells of a "crazed" bedridden Professor Yang and his student and future son-in-law, Jian. Although it fails to highlight (or exploit?) the massacre in the way that many other works have, the June Fourth tragedy remains very much the center of its fictional universe.

June Fourth has already been firmly established as one of the most important themes of transnational Chinese and Chinese American literature since the nineties. This section focuses on how two Chinese American writers have imagined the incident, examining the startling ways atrocity has been projected, violence has been displaced, and tragedy has been belatedly revisited.

Reimagining a Nameless Hero: Terrence Cheng's Sons of Heaven

One of the most critically praised reexaminations of Tiananmen Square, *Sons of Heaven* (2002), took a new approach to the topic with a three-pronged structure that went to the very heart of the incident. Born in 1972 in Taiwan and raised in suburban New York, author Terrence Cheng is twice removed from the political center of Beijing, where his novel takes place. Cheng was a junior in high school at the time of the Tiananmen Square massacre, but something about the startling and disturbing images led him on a journey that came full circle more than a decade later. *Sons of Heaven* is as much an exploration of violence as a search for cultural identity and roots.

The novel's balanced structure, which attempts to look at the incident alternately from different angles, is compromised by layers of cultural stereotypes woven into the narrative. From the beautiful, servile peasant girl to the almost epiphanic appearance of the Great Wall, which is described as "the blade-scale back of a dragon, curling to the bend of the earth" (Cheng 2002:242), these clichés taint the novel with an almost orientalist dimension that highlights the fears and fantasies the West holds about China. Other, more pronounced examples include conspicuous mention of orphaned girls and the way Christianity is presented: "Preaching a reactionary religion with crosses and Bibles. . . . We can take you away just for that" (256). This quote is followed by the overtly symbolic burning of a church and the near-fatal beating of its pastor by a PLA soldier. Such imagery works to simultaneously build up the mysterious, mystical image of an exotic cultural China and reinforce Western stereotypes of religious oppression, child abandonment, and

other human rights abuses. The abuses relayed in *Sons of Heaven* go far beyond Tiananmen Square and are represented by a variety of icons, symbols, and images that are powerful but threaten to break the spell of Cheng's carefully constructed fictional world. But the novel still deserves attention for its nuanced prose, daring narrative approach, and fascinating (thought not always believable) fictional probe into the minds of some of the key participants in the events of 1989.

The novel explores the incident through the perspective of three players on the historical stage: Lu, a People's Liberation Army soldier called in to suppress the "chaos"; Xiao-di, a recent graduate of Cornell who gets caught up in the Tiananmen protests; and Deng Xiaoping, the powerful leader who is often condemned for ordering the June Fourth crackdown. Divided into chapters alternately labeled, "Soldier," "Dissident," and "Comrade," the novel attempts a daring leap into the psychology of each character, probing the motivations that drive them and the demons that haunt them. Taking a radically different approach from both the PRC line, which has demonized the protesters, and the liberal overseas line, which has praised them as heroic freedom fighters, Cheng paints a relatively even-handed portrait of the students, the leaders, and even the soldiers in a more human light. However, as the chapters alternate among Lu, Xiao-di, and Deng, the author's objectivity is betrayed by his narrative strategy: the stories of Lu and Deng are told in a slightly more detached third-person voice, while the more direct first-person narrative is reserved for Xiao-di—the "hero" is still the dissident.

Cheng's dissident protagonist is not a fictionalized Wang Dan, Wuer Kaixi, Chai Ling, or other high-profile student leader. Instead, Xiao-di or "Little Brother," whose name also hints at a kind of universality, is a Cornell graduate who, after four years in America, returns to China in 1989 heartbroken, unemployed, frustrated, and disaffected by the society around him. When the Tiananmen Square rallies break out in the spring, he and his friend, Wong, join in. They take part in the hunger strike, make impassioned statements to foreign media, and eventually become enemies of the state—Wong is killed during the crackdown and Xiao-di becomes a fugitive. What makes Xiao-di such a threat to the state is not necessarily the derogatory comments that he makes in English to the international media about his country and Deng Xiaoping but rather what he symbolizes through his second media appearance, made in concert with a battalion of four armored tanks.

One of the most powerful, enduring, and symbolic moments of the 1989 Tiananmen Square Incident occurred in the immediate aftermath of June

Fourth when a lone young man (some think it could have been a woman) stood in the middle of an avenue, blocking a line of tanks with nothing but sheer courage. The image of a small, unarmed individual single-handedly stopping an army was so powerful it came to embody much of what the Tiananmen Square incident stood for in the minds of millions. After being transmitted across the globe on television sets and with newspaper headlines, the iconic image quickly came to adorn posters, postcards, and even T-shirts. *Frontline* produced a documentary entitled *Tank Man* (2006) probing the possible identity of the individual. And in *Tiananmen 1989,* one of the most comprehensive Chinese-language publications on the incident, the photo is given a full two-page spread and accompanied by the caption, "Twenty centuries, just one single image: One man stops a tank, the entire world pays its respect!" Terrence Cheng also remembers that moment when a skinny young man held back an army of tanks:

> But the image that continues to haunt me is of a young man, who, in broad daylight, walked in front of a line of tanks and stopped. The tanks, I thought, would run him over, but they didn't. They tried to go around him, but he kept jumping in the way. He just would not move until people from the side of the street came and dragged him away. No one knew who he was, or what happened to him. To this day, no one does.
>
> He amazed me: his power, his pride, and his fear. Even from a distance and only being able to see his back, I knew he was afraid. He was afraid and he was angry and he was proud and willing to die for his beliefs. What could make a man do what he had done? What had pushed him to the point, what kind of emotions make you so stupid and so brave and able to transcend in such a miraculous yet mortal way? The whole world was fascinated, but as the years went by, that image and the cries over the Tiananmen Massacre (as it is known in the West; it is the Tiananmen "Incident" in China) dissipated.
>
> But the young man and those tanks never left me, the wonder about how and what and why. (Cheng, "The Story Behind the Book")

Xiao-di is modeled after this iconic, nameless figure, and *Sons of Heaven* is an attempt to create a fictional history for this man who put a human face on the events of that spring.

Like T. F. Mou's controversial film *Black Sun,* which created a fictional narrative of the Nanjing Massacre by reconstructing detailed stories and complex episodes around a series of black-and-white photographs, Terrence Cheng's novel is a more detailed and challenging meditation on history and violence

that also begins with a single photograph and a short video clip that was re-played countless times. Gradually Cheng creates an identity for the unknown hero, tracing his journey to America and back; his romance with the blond-haired, blue-eyed California girl Elsie; his breakup with his fiancée, Xiao-An; and his transition from frustration to demonstration. Rejected by both of the women in his life, berated by his grandparents, and with his future sabotaged by his would-be father-in-law, Xiao-di is near the breaking point. The rupture comes during the June Fourth crackdown, when Xiao-di witnesses the death of his best friend, Wong, as they flee the square. The utter destruction of the world around him drives Xiao-di to stand up for himself in a highly sym-bolic gesture that comes at the narrative center of *Sons of Heaven:*

As I continued I heard the sound of metal treads on the concrete, shots ringing in the background. I saw tanks in a line down the avenue, the long guns pointing forward. They were moving fast. I was close to the square and felt something inside me burst. The tanks came closer. I could see at least three, maybe four. I stopped walking, caught in the sound of the treads, the roar and rumble of the engines, their procession a spectacle in itself.

I walked into the avenue and they did not slow down. When I was in the middle of the street I wondered if they could see me. I heard voices around me: "What are you doing? Get out of the way . . . they're going to run you over!" I felt the vibration of the earth. I started waving my arms. People were shouting.

I thought of Wong, my grandparents, and all they had gone through and done for me; I thought of Elsie, Xiao-An, the promises I'd made to everyone and broken, the promises her father had made to me and broken as well; the life I'd adopted and left behind, and I hated myself because it had all been my fault. I felt this electric, boiling anger, this frantic rage. I stood there and did nothing, waiting. I wanted them to kill me the way they had killed Wong and how many others, without reason, in cold blood. The tanks had slowed and were creeping forward. I felt cool, though I was sweating. The lead tank stopped no more than fifteen feet away. It was trying to maneuver around me. I slid along with it, could hear the treads and coils screeching and grinding. It tried to turn to the other side and I hopped in its way. I thought I might be shot in the back or from the side. I stayed aligned with the nose of the tank's cannon, told myself this was not a humiliating way to die. My arms were pressed to my sides. I shuffled my feet to stay dead center to their guns.

Everything stopped. I stared into the green metal and waited. The people were still shouting for me to get out of the way. I was frozen, could feel Wong

watching. I wanted to show him that I had not left him because I was selfish, only because I was scared.

"GO BACK! TURN AROUND! STOP KILLING MY PEOPLE!" I stepped forward, climbed the side of the tank, reached the top door. I pounded on it and screamed until a soldier's face popped through. He had on a white helmet and plastic goggles, red pimples on his chin. I could see his eyes through the clear goggles. He stared at me as if we knew each other. (Cheng 2002:136–138)

Interestingly, among the thoughts, desires, and memories expressed by Xiao-di during that critical moment is the implied desire to suffer the same fate as Wong and the other victims who perished in the square, rooted in the knowledge that the only way to truly understand the process of victimization is to suffer and endure the same fate. But Xiao-di is destined to become not a martyr but a symbol of hope. He escapes death twice, first while fleeing the square in the immediate aftermath of the crackdown and again as he blocks the advancing tanks. However, he cannot escape his fate. In the end, the hand of death extends ironically from his very flesh and blood.

At the end of the passage, when Xiao-di confronts the PLA officer who emerges from the cockpit, the momentary connection between the two characters shows they are not so far apart after all, hinting at a deeper bond between the soldier and the dissident. Xiao-di's own brother is a PLA soldier and, although they have not spoken for several years and seem worlds apart, the two brothers mirror each other. In their early childhood during the Cultural Revolution, Xiao-di and especially Lu emulated the Red Guards. Twenty years later, they finally make it to where the Red Guards had rallied in the heart of Tiananmen, but by then Xiao-di is fighting for revolution and Lu is fighting for the government. Lu plays the most critical role in the search and capture of the dissident fugitive. The cannibalistic symbolism embedded within the conflict between the brothers is only moderated by the fact that ultimately, they *both* become victims of the state.

Through the generic prefix *"xiao"* or "little" attached to their names, Cheng seems to want to establish a common denominator among most of the characters: Xiao-di, the dissident protagonist; Xiao-An, his wealthy fiancée with a powerful cadre father; Xiao-mei, a peasant girl who helps him while on the run;[19] Lu, who, we later learn, was once called "Xiao Lu" by his parents; and of course, China's top leader, Xiaoping. Through the novel's structure, Lu, Xiao-di,

19. After failed relationships with Xiao-An and Elsie, Xiao-mei or "Little Sister" is imagined as the true mirror of Xiao-di, "Little Brother."

and Deng Xiaoping become reflections of one another, connected by blood bonds and similar experiences. Like Xiao-di, Deng Xiaoping was once a young foreign student. He took part in his own dissident and underground movements, and their families both suffered during the Cultural Revolution. They are all brothers and all "sons of heaven."

The Cultural Revolution plays a key role in Cheng's conception of June Fourth. Although it may or may not have weighed as heavily on Deng Xiaoping's conscience as Cheng imagines, Mao's legacy casts a long, dark shadow on modern Chinese history, including the events of 1989. Purged from his posts and sent to labor during the Cultural Revolution, Deng Xiaoping certainly felt its effects. Although there is a long tradition of popular student protest in modern China, especially in Tiananmen Square, it was Mao who first told his Red Guards in 1966 that "It's Right to Rebel," condoning popular protest on an unprecedented scale and fanning the flames of revolution to new heights. Cheng effectively links the crackdown with that larger historical tradition of protest and revolution. He also links the events to Deng's very personal experiences, including the crippling of his son, Pufang 鄧樸方, during the Cultural Revolution. Thus, Cheng implies not only the circular nature of history but also the ghosts and deep-rooted nightmares that haunt it. Just as the brothers' actions are intricately connected with their experiences during the Cultural Revolution, so too are Deng's motivations for ordering the crackdown. The question that Cheng leaves us with is: Was the 1989 massacre of the students truly to repress a dangerous social movement that threatened the stability of the party? Or was it a twenty-years-belated act of vengeance against an earlier generation of student rebels?

Although Xiao-di escapes death twice, he must face the consequences of his actions, within days of his very public demonstration. In other cases, the hand of fate may not strike as quickly—but it does strike. In his short story "Plain Moon," Gu Zhaosen further explores the long shadow of atrocity cast from Tiananmen Square.

Destroying Heroes and Breaking Hearts: Gu Zhaosen's "Plain Moon"

Born in 1954 and raised in Taipei, Gu Zhaosen 顧肇森 was educated at Donghai University in Taiwan and New York University Medical School. Unlike Lu Xun, Gu never gave up medicine, instead finding the rare balance between the body and the soul. While maintaining an active medical practice in New York, Dr. Gu has managed to publish four collections of short stories: *The Dismantled Boat* (*Chai chuan* 拆船) (1977), *Cat Face Days* (*Maolian de suiyue* 貓臉的歲月)

(1986), *The Sound of the Moon Rising* (*Yuesheng de shengyin* 月升的聲音) (1986), and *The Face of the Seasons* (*Jijie de rongyan* 季節的容顏) (1991). Although he has received several major literary prizes for short fiction in Taiwan, he is not the most prolific writer and has never won the wide readership that many of his contemporaries enjoy. However, his subtly spun stories and skillfully crafted prose make him one of the finest short story stylists of his generation—and he is certainly among the most underrated writers to emerge from the Chinese diaspora. Gu Zhaosen's fiction is mostly composed of portraits of Chinese immigrants from various social backgrounds struggling to get a foothold in a foreign land. Gu's adopted home of New York is the site where his literary universe unfolds, although the heart of his fiction is often somewhere else, as in his elegiac short story "Plain Moon" ("Su Yue" 素月), which puts a new twist on the memory of Tiananmen Square.

First published in 1991,[20] "Plain Moon" is the tale of a lonely young New York garment factory worker in her mid-twenties, living between the ceaseless hum of the sewing machines and the incessant raids by immigration inspectors. Born in Kowloon, Hong Kong, Plain Moon immigrated to Manhattan years ago after the death of her parents, a detail that only accentuates her loneliness—and rootlessness. But everything changes on her twenty-fifth birthday during a celebratory lunch at Phoenix, a local Chinatown restaurant, when she first sees Li Ping:

> He had a fair complexion, slender eyebrows like two gladiolas, a pair of big, clear eyes. His lips were ruby red, his hair dark and full, hanging low on his forehead—he probably cut it himself. He was lean, maybe four inches taller than she. Not really tall, but tall enough. (Wang and Tai 1994:140)

Li Ping is a mainland Chinese student from Shanghai working part-time at the restaurant to help support his "family" back home. But after the 1989 Tiananmen Incident, Li's government fellowship is revoked for his participation in overseas democracy protests, forcing the young student to pursue new avenues to achieve his dreams. After a short, unorthodox romance, Plain Moon and Li Ping decide on a marriage of convenience—Li is awarded legal status and Plain Moon is awarded the man she desires. The couple's happy days, however, are destined not to last, as it is revealed that the money Li has

20. "Su yue" was first serialized between January 1 and 7, 1991 in the *United Daily*. It was later widely reprinted, including in Gu's 1994 collection *Journey on a Wintry Day*. An English translation by Michelle Yeh appeared in *The Chinese Pen* Taipei (Autumn 1992):145–175 and was reprinted in *Running Wild: New Chinese Writers*, 137–157.

been sending to his "family" has actually gone to his childhood sweetheart and fiancée back in Shanghai. When the fiancée comes to New York, the old lovers are reunited and Li's relationship with Plain Moon dissolves, although Moon agrees to stay married to him long enough for him to finalize his legal residency.

On the surface, "Plain Moon" seems to have little to do with the bloodshed half a world away in Beijing, but the ghost of Tiananmen Square haunts the story and Plain Moon's fate. The connection with atrocity is first drawn in the author's introductory paragraph with an understated description of Moon's workplace. The satirically named Chinatown sweathouse Rich Garment Manufacturer resembles "Berlin after Allied bombing in World War II" (137). The space Plain Moon occupies is metaphorically positioned as the place of former terror. The shadow of the nightmarish past is further revealed in a phantasmagoric dimension of the Rich Garment Manufacturer: "An overseas student's wife slipped and fell from the fire escape on the sixth floor. She was dead on impact. Afterward, a rumor that the storage room was haunted lasted for two or three years" (139–140). The eerie imagery used to describe the "haunted" factory reinforces Gu's conception of this place of atrocity and also foreshadows Moon's own victimization at the hands of another foreign student.

Although the relationship between Plain Moon and Li Ping begins innocently enough, with Moon admiring Li from afar during her daily lunchtime visits to Phoenix, it unfolds and develops against the backdrop of violence. The first time they speak to each other is after Li nearly runs her over on his bicycle one night after work. As his bicycle screeches to a halt, the near collision serves as a telling signpost of the nature of their relationship and the tragedy to come. The awkwardness of their initial face-to-face meeting is extended by their inability to communicate in each other's native language—instead, the Cantonese and the Mandarin speaker are forced to use the common language of English. Their romance unfolds against the student protests taking place across the globe in Beijing; for their first "date," the young couple choose the "romantic destination" of a democracy demonstration outside the Chinese consulate in New York. Their second date is canceled because of another act of random violence—Li Ping's roommate is shot during a mugging. It is only during their third date, which corresponds to the actual June Fourth massacre in Beijing, that they finally begin to take their relationship to a more intimate stage, holding hands.

The consummation of the relationship occurs as Li Ping and Plain Moon sit in the latter's apartment watching television coverage of the terrifying events unfolding in China. The footage is the same iconic moment that inspired Terrence Cheng's novel *Sons of Heaven*:

On the screen, a man wearing a short-sleeved white shirt and carrying a bag in his hand stood in front of the troop of tanks. He climbed on the one at the head. You couldn't tell what he was saying. Then he climbed down. The tank steered to the left, he moved to the left; the tank steered to the right, he moved to the right, refusing to retreat. (148)

Here, the nameless hero of Tiananmen inspires *not* revolution, but love between the unlikely pair. But the forces attracting Plain Moon to Li Ping seem to owe as much to pop culture as political culture.

Early in the story, we learn of Plain Moon's attraction to Cantonese popular culture, including the romance novels of Yi Shu 亦舒, Hong Kong's answer to Danielle Steele, and the Canto-pop of Hong Kong crooner Leslie Cheung 張國榮.[21] Moon not only sings Leslie's songs, attends his Atlantic City concerts, and hangs a poster of the pop icon on her wall, she even takes him as the model for her "ideal lover." An average working-class girl, Moon has no hope of ever meeting her idol. At his concert she does not even have the nerve to approach him: "Those who were bolder rushed up to the stage at the end of the show and hugged and kissed him. The timid ones, such as Plain Moon, only huddled under the stage with their arms crossed in front of their chests and screamed like a bunch of startled monkeys" (143). It is only during the Tiananmen Massacre and its aftermath, as the student leaders are transformed into international celebrities, that Plain Moon finally has her opportunity to get close to one of these pop icons—the student dissident Li Ping. And it is only during a demonstration outside the United Nations, amid a "surging sea of people and banners," that she is finally able to partake in the excitement denied by her timidity during the Atlantic City concert.

And so, Plain Moon projects her fantasy of the tall, dark, and handsome pop celebrity onto Li Ping. Suddenly there is a transition from popular culture to political culture as she shifts her fixation from Leslie Cheung to the heroic student leaders in Tiananmen Square. The malleable identity of the faceless, nameless hero who held back the tanks in the square makes Moon's job of projecting his heroic deeds onto her own student leader, Li Ping, ever so easy. The shift is completed when, after their wedding, Little Moon symbolically takes

21. Leslie Cheung (1956–2003) was one of contemporary Chinese cinema's premier dramatic actors and a superstar in Cantonese and Mandarin popular music. He began acting in the early 1980s and was launched into fame with the success of John Woo's *A Better Tomorrow* series. Cheung went on to star in numerous films, among them Stanley Kwan's *Rouge*; Chen Kaige's *Farewell My Concubine* and *Temptress Moon*; Wong Kar-wai's *Days of Being Wild, Ashes of Time,* and *Happy Together*; and Ronny Yu's *The Bride with White Hair*. Cheung took his own life on April 1, 2003.

down the poster of Leslie Cheung hanging in her apartment. The scene of the unknown man holding back the tanks is also a pivotal moment for Li Ping. However, it is not so much the image of the young man stopping a tank on the television but the television set itself, as well as the size of Plain Moon's apartment, that fascinate Li—not to mention Plain Moon's U.S. citizenship. Whereas her fantasies are based on romantic dreams of heroism, Li Ping's are of a more pragmatic pedigree. Through these two levels of deception (by Li Ping) and self-deception (by Plain Moon), a new tragedy arises from the ashes of Tiananmen Square.

"Plain Moon" documents not only how a lonely woman's heart is broken and how she becomes, as critic David Der-wei Wang has noted, "a belated victim of the incident" (256), but also the deconstruction of the heroic image of the Tiananmen student leaders. Just as the Goddess of Democracy statue was crushed by tanks in the early hours of June Fourth, for many, the heroic mystique that surrounded many of the democracy leaders was destroyed in the aftermath of the incident. Leaders like Chai Ling, Li Lu, and Wuer Kaixi became favorite targets for the international Chinese press as attempts to organize a legitimate overseas Chinese democracy movement were plagued by disorganization, disagreement, and internal strife. The trivialization of the movement is here referenced by Li Ping's use of a Wuer Kaixi lecture as a pretext for getting out of the house to cheat on his wife. In addition to following the journeys of Li Ping and Plain Moon, the story subtly traces the transformation of Wuer Kaixi from the student icon on television during the demonstrations to the fugitive escaping to Hong Kong to the famous lecturer in New York. His identity and journey echo those of Li Ping, and Gu Zhaosen suggests a degree of culpability on the part of both. And what of the true victim of the story, Plain Moon? Like those who fell in Tiananmen Square, she is deprived of a voice. In the end, all she can do is hang her poster of Leslie Cheung back up on the wall and return to her old life at the sewing machine, forever haunted by the memory of Tiananmen Square.

Two Chinese American writers born in Taiwan, both writing from the common ground of New York, have revisited the bloodshed in Tiananmen Square in 1989, both taking as the point of departure the iconic image of the nameless student who stopped the tanks. More significantly, both visions signal an attempt to unimagine China in different ways. Terrence Cheng offers a probing fictionalization of Xiao-di that delves into that unforgettable moment and teases out the tragic consequences of his bravery, silently enacted during the crackdown. Centrifugal trauma manifests itself in a different manner for Gu Zhaosen; half a world away and months after the massacre, belated atrocities

are still playing out and claiming new victims. The internal strife in Beijing sets in motion a series of events that inspire a new heroic dissident identity for Li Ping and a new form of transnational victimization for Plain Moon. In the end, both writers describe the pain of tragedies both spatially and temporally removed from the site of Beijing 1989, yet inextricably linked to that bloody moment.

Coda: Hong Kong 1997

> Time and place do not define [Hong Kong], although
> moments of its history do. We do not experience
> history chronicled by historians. Rather, we know where
> we were when the buses stopped in 1967 amid the riots
> on Nathan Road, or to whom we turned
> when midnight struck on June 30, 1997.
>
> —XU XI (2001:11)

Anticipatory Trauma

As China approached the end of the twentieth century, a period of violence, war, and political purges, it seemed that memories of the brutal past stained not only the nation's collective memory but also its future. Suddenly, writers and filmmakers' "obsession with China" and the past seemed even more concerned with China's future—and their predictions were most disturbing. In 1991, Wang Lixiong 王力雄 (b. 1953), writing under the pen name Bao Mi 保密, or "Kept Secret," published a massive three-volume novel entitled *Yellow Peril* (*Huang huo* 黃禍). It revealed a disturbing vision of the future, including political assassination, a full-scale Chinese civil war, and the utter annihilation of Taipei. Although banned in China, Wang's dark portrait of turmoil was a best-seller in Taiwan, Hong Kong, and overseas Chinese communities and was eventually listed by *Asia Weekly* (*Yazhou zhoukan* 亞洲週刊) among the most influential 100 Chinese novels of the century, ranked in the top half. In 1996 Qiao Liang喬良 published another voluminous novel that predicted a millennial breakdown filled with international espionage, presidential assassinations, rampant Internet viruses, and a new world war between China and the West. *Door of Doomsday* (*Mori zhi men* 末日之門) extended the literary malaise of *Yellow Peril;* it was marketed by the publisher as "The first book by a Chinese writer of 'prediction fiction.'" But Wang and Qiao were only two of many artists and writers projecting their fears and anxieties about a violent future into their creative work. And the majority had their sights set on Hong Kong.

During the summer of 1997, terrible atrocities were committed in Hong Kong. It was a time of disease, massive riots, army tanks crushing protesters, murders, suicides, accidents, and unspeakable acts of violence. The difference between these events and the historical atrocities described in the preceding chapters is that they occurred only in written pages and celluloid frames. They were atrocities of the imagination. After much anticipation, dread, and trepidation, the fateful date of July 1, 1997 came and went with little fanfare, other than the brilliant fireworks display over Victoria Harbor. There were protests, of course, but they were not violently suppressed as had been predicted; when the PRC tanks rolled across the Tsing Ma Bridge, they came with the utmost discipline and restraint. The orderly transition to Chinese rule after well over a century as a British colony seemed to belie the pathos and fear that so many had felt. Much of the widespread anticipation of violence was related to what had occurred eight years earlier in Beijing. The Tiananmen Square Massacre, which fell squarely between the 1984 signing of the Joint Declaration and the 1997 Handover of the colony to mainland China, had a profound effect upon Hong Kong's society and psyche. One of the most direct consequences was the massive wave of emigration it spawned.

> Surveys conducted in the months following the Beijing massacre revealed that the emigration problem could spiral out of control: sixty percent of lawyers, seventy-five percent of pharmacists, eighty percent of accountants, eighty-five percent of property surveyors, and ninety-nine percent of government doctors intended to leave before the transfer of sovereignty. Many had applied to leave even before the upheaval and said they would not stay in Hong Kong even if China became more democratic. It looked as though Hong Kong might become a ghost town by 1997. (Roberti 1994:167)

> Previously, people were interested in leaving Hong Kong only if they could go to the United States, Canada, or Australia. In the panic that followed the crackdown in Beijing, people looked for an exit. The tiny Central American nation of Belize (formerly British Honduras), which offered passports for $23,800 with no residency requirement, saw a surge in inquiries. It was later revealed that the Panamanian consulate, which was run by a relative of General Manuel Noriega, had sold some 3,000 passports illegally to panicked residents. Countries such as Jamaica, Tonga, and Gambia were now being considered in the desperate scramble for foreign passports. . . . Everyone was talking emigration, at work, over *yum cha*, and between games of squash. Executives who once traded investment tips now prided themselves on being up on the latest escape route—from the Marshall Islands (which was freely

associated with the United States and could lead to residency there) to American Indian reservations. (265–266)

This interest in emigration was but one symptom of a much larger angst, deeply rooted in a complex historical shadow of violence and atrocity, that had enveloped society on the eve of the Handover. The population of Hong Kong was largely composed of immigrants from the mainland; many older immigrants were still haunted by memories of the Chinese Civil War, the Sino-Japanese War, and the multitude of purges and violent political movements carried out under the Communists, while older local residents still remembered the 1941 Japanese invasion of Hong Kong. For them—and even for younger generations of Hong Kong residents who had grown up in a relatively peaceful era seemingly impervious to history—a brutal wake-up call came as the tanks rolled into Tiananmen Square on June 4, 1989. It seemed that the historical pendulum was swinging back toward Hong Kong.

While countless Hong Kong residents responded to the perceived threat to their lifestyle, livelihood, and possibly lives with a mass movement to leave, many artists, writers, and filmmakers projected the coming cataclysm into their work. The widespread phenomenon of predicting, projecting, and pre-conceiving the expected horrors of 1997 and Hong Kong's subsequent reality constitute what I term "anticipatory trauma": a complex whereby angst and trepidation about the future are projected into catastrophic visions of what is to come, reinforced by historical or psychological scars from past traumas. Anticipatory trauma is just as much about fear for the future as about memories of the past. The anticipation directly (or symbolically) associated with the Handover dominated Hong Kong's cultural imagination from the mid-1980s to 1997. After a century of violence, much of which was indigenous violence committed by Chinese upon their compatriots, it seemed natural and inevitable that the next page in Hong Kong's history would also be written in blood.

In literature, anticipatory trauma was widespread. In 1999, author, filmmaker, and cultural critic John Chan 陳冠中 published his short novel *Nothing Happened* (*Shenme dou meiyou fasheng* 甚麼都沒有發生), which reflected upon the Handover one year later. If "nothing happened," the question implicit in the title seemed to be, "What was *supposed* to have happened?" For many local writers, such as Wong Bik Wan, Xi Xi 西西, Dung Kai Cheung (Dong Qizhang) 董啟章, and Xu Xi, the answer was not terribly optimistic. Veteran writer Liu Yichang's 劉以鬯 short story "1997" ("Yi jiu jiu qi" 一九九七), which appeared in 1983, told of a small-time factory owner haunted by an unsure future who schemes to sell off all his stocks and his factory and emigrate, only to be

run over by a car before he can even leave Hong Kong. As critic Yan Jiayan 嚴
家炎 observed, the projected horrors of 1997 could even be seen in martial arts
fiction, such as Ye Si's 也斯 *The Magic Fighter* (*Shenda* 神打). After practic-
ing his martial arts skills, "the protagonist believes, 'By the time '97 comes
around, no bullets or knives will be able to hurt me and I will have nothing to
fear.' But the absurd content hints at the uneasiness and worry" (Yan 213). Ye Si
would later offer a more serious literary meditation on Hong Kong's status after
the Handover in his 1993 novel *Cities of Memory, Cities of Fabrication* (*Jiyi de
changshi, xugou de changshi* 記憶的城市, 虛構的城市). Combining fiction
with essay and elements of autobiography, Ye Si reconstructs Hong Kong
through the lens of other cultures and the other cities the narrator has lived in
and visited. Another attempt to re-create a Hong Kong of memory and imagi-
nation was Dung Kai Cheung's ingenious 1997 novel *The Atlas: The Archeology
of an Imaginary City* (*Ditu ji: yige xiangxiang de chengshi de kaoguxue* 地圖集:
一個想像的城市的考古學). Written from the vantage point of an archeologist
from the next millennium, *The Atlas* attempts to imagine the former colony's
culture and history circa 1841–1997 through a collection of ancient maps. After
the 1984 Joint Declaration, there was an unprecedented search for cultural iden-
tity in Hong Kong. These works and others, such as Xi Xi's *Marvels of a Float-
ing City* (*Fuzheng zhiyi* 浮城誌異), demonstrate a creative urge to map out and
reimagine a city alternately positioned as fabricated, imaginary, or floating.
This vision of Hong Kong erased is what Ackbar Abbas (1997) has described as
the city's "culture of disappearance, whose appearance is posited on the immi-
nence of its disappearance" (7).

Another example of this "culture of disappearance" can be seen in the
equally powerful and disturbing fiction of Wong Bik Wan (b. 1961). Often
compared to PRC writers Yu Hu and Can Xue 殘雪 for her avant-garde prose
and violent imagination, Wong projected her angst concerning 1997 in numer-
ous stories and novels, such as her 1999 award-winning novel *Portrait of a
Chaste Lady,* which traced a century of loneliness and emptiness through three
generations of women. But nowhere is the anticipation of apocalypse in 1997
more palpable than in her work of short fiction "Lost City." At the heart of the
story is the relationship between an architect and his nurse wife, starting with
their brisk union in the shadow of the signing of the Joint Declaration: "We
can't stay here. Let's get married and get out of Hong Kong" (199). They even-
tually immigrate to Canada and have four children. They are forced to settle
for odd jobs in foreign cities just to make ends meet, and the husband, Chen
Luyuan 陳路遠, begins fanaticizing about murdering his wife, who is losing
her sanity under the strain. Their journey eventually takes them to San Fran-
cisco, where Chen, unable to "carry the cross of love any longer," abandons his

family after seeing his wife force their children to eat raw chicken hearts, ox spleen, and pig liver. He travels to Europe before returning alone to Hong Kong on the eve of the Handover. His wife, Zhao Mei 趙眉, however, tracks him down, but she and the children become the victims of his bizarre murder fantasy. As Chen later recalls:

> So the human body really does contain a lot of blood. Zhao Mei didn't even recognize me; just before she died she cried out, "Burglar!" Mingming's drawing was dyed red, Little Four was so little she didn't even know what was happening, she thought I was just playing a game with her, even called out to me, "Daddy!" Little Two was deep in dreamland and didn't even wake up; Xiao Yuan just came out of his sleep for a split second before falling back into the eternal silence of darkness beyond consciousness. (206)

Chen Luyuan's nonchalant murders mark the climax of this Handover tale of a family that tried to escape the violence of 1997 by fleeing, only to return and be victimized by themselves. This is not only anticipatory trauma but also the internalization of that violence. A thrust away from the epicenter of the coming trauma inspires their diasporic dreams, but after they arrive in Canada, it becomes clear that the true demon lies within. The "lost city" of the title carries multiple meanings: lost to the colonial powers (an attitude that also figures prominently in the story), who are losing *their* city, and lost to Chen Luyuan and Zhao Mei, whose transnational journey results in the loss of their home and their identity as well. If anything is gained, it is the realization that the projected nightmare of 1997 was there all along, part of themselves. Here is the ultimate conflation of the traumatic forces at work, from the centripetal to the centrifugal.

The possibility of a coming tragedy even captured the imagination of overseas writers, such as New York-based novelist Justin Scott, whose *The Nine Dragons: A Novel of Hong Kong 1997*, published in 1991, was touted as "a whirlwind novel of gripping suspense set against the teeming backdrop of the richest Chinese city in the world, a city on the brink of chaos." In 2001, Gillian Bickley published a historical study of an 1871 novel predicting a Franco-Russian assault on Hong Kong, titled *Hong Kong Invaded! A '97 Nightmare*. Although the reference was to 1897, the subtext was all too clear. For British writers, however, 1997 did not represent an anticipatory trauma as much as a form of postcolonial mourning, a testament to the receding power and reach of the Crown.

Atrocity was projected in much greater detail and abundance in the Hong Kong film industry. As early as 1984, the year of the Joint Declaration in which Deng Xiaoping and Margaret Thatcher decided the parameters of the

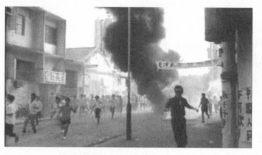

Projecting violence in John Woo's *Bullet in the Head:* street riots in 1960s Hong Kong (left); fighting each other in Vietnam (right).

Handover, visions of a dark future had already begun to appear onscreen. However, they were often only realized and contextualized through the past. New Wave pioneer Ann Hui's 許鞍華 lavish adaptation of Eileen Chang's classic story "Love in a Fallen City" was set during the Japanese World War II–era occupation of the colony and starred Chow Yun-fat 周潤發. Although Hui has repeatedly downplayed the allegorical dimensions of the film, critics seemed unable to avoid drawing parallels between the occupation of the city five decades earlier and the current events that announced another coming "occupation." Fellow New Wave director Leung Po-chih's 梁普智 *Hong Kong 1941* (*Dengdai liming* 等待黎明), which was also released in 1984 and also starred Chow Yun-fat in the lead role, used the same backdrop. This story of three friends who struggle to persevere amid the chaos and violence of Japanese rule was written and conceived by John Chan, author of *Nothing Happened,* proving that fifteen years earlier, he was already pondering the question of 1997. Perhaps it was only by imagining the past of Hong Kong 1941 that Chan could answer the question of what was "supposed" to happen in 1997.

In 1990, John Woo (b. 1946), veteran Hong Kong–Hollywood director of such films as *A Better Tomorrow* (*Yingxiong bense* 英雄本色) and *Face/Off,* also turned to the past to express his vision of the potential consequences of Hong Kong's return to China. In *Bullet in the Head* (*Diexue shuangxiong*), Woo creates a dark world reigned alternately by bloody street protests, gang violence, and war. Although set in the 1960s, the film was a direct attempt to address the violence that had occurred in Beijing less than a year earlier *and* the fears of people in Hong Kong about the impending Handover. Lisa Odham Stokes and Michael Hoover make the film's implied subtext clear through interviews with director John Woo and producer Terrence Chang:

Street scenes featuring lone young men standing against large tanks repeat as obvious references to Tiananmen. Ironically, producer and partner Terrence Chang relates, "John Woo attempted to put his personal feelings towards 1997 in *Bullet in the Head,* but unfortunately most Hong Kong people identified with the Waise Lee character and thought he was the real hero of the movie." Woo adds, "I think the movie was too painful for the audience, reminding them of the recent Tiananmen Square massacre, and that is why it did badly." (Stokes and Hoover 1999:184)

One of the more fantastic conceptions of Hong Kong's post–1997 nightmare came in the form of Tsui Hark's science-fiction fantasy *The Wicked City* (*Yaoshou dushi* 妖兽都市). Starring Jacky Cheung 張學友and Leon Lai 黎明 and based on a popular Japanese anime, the 1992 film imagines a future where Hong Kong is on the verge of being taken over by Reptoids—terrible monsters disguised as humans. Although Britain symbolically replaces China as the enemy, the outcome of the Handover is no less catastrophic.

Hong Kong is already a city in which humans (read: Chinese) and monsters (indeed, the key monster assassin is a Caucasian woman) are fighting for control; even though the Commander mentions that "the Handover will be a good time for the monsters," the intent is clearly to drive the monsters/ Caucasians/British from Hong Kong. The battleground becomes Hong Kong's most famous architectural wonder, the Bank of China building; at the film's end the Anti-Monster Squad seem as intent on saving the building as their own men. (Morton 2001:191–192)

Long known for the national (and often nationalistic) allegories in his films, such as *Once Upon a Time in China* (*Huang Feihong* 黃飛鴻), Tsui Hark here offers a sumptuous visual feast that projects the Handover onto a futuristic dystopian nightmare.

Although he had worked in the Hong Kong film industry for more than a decade as a planner and assistant director, it was not until his 1997 small-budget independent masterpiece, *Made in Hong Kong,* that Fruit Chan (b. 1959) established himself as a director. A powerful and disturbing vision of personal apocalypse on the eve of the long-awaited Handover, *Made in Hong Kong* tells of Autumn Moon 屠中秋 (Sam Lee 李璨琛), a disaffected high school dropout mixed up in a circle of loan sharks and gangs, and his two friends, Sylvester 阿龍 (Wenbers Li Tung-Chuen 李棟泉), a mentally challenged teenager who is the frequent target of local bullies, and Ping 林玉屏 (Neiky Yim Hui-Chi 嚴栩慈),

Fruit Chan's independent Handover masterpiece *Made in Hong Kong* features the breakout star Sam Lee going ballistic (left) before taking his own life beside the tomb of his girlfriend (right), who has just died of cancer.

a young girl suffering from a terminal illness. Together they navigate a world of violence, inequality, desperation, and uncertainty as the curtain of colonialism falls over the Pearl River. Shot with leftover film stock and on a shoestring budget, with a crew of five and a cast of nonprofessional actors, *Made in Hong Kong* seemed an unlikely candidate to redefine Hong Kong cinema, but that is precisely what it did. With a stirring voice-over monologue, nonlinear narrative devices, jarring handheld camera work, and unconventional editing, including freeze frames and slow motion, *Made in Hong Kong* created a bold new vision for independent cinema in the ruthlessly fast-paced and commercial Hong Kong industry.

Made in Hong Kong was the first film in what would be Chan's trilogy of tales centering on the 1997 Handover, including *The Longest Summer* (*Qunian yanhua tebie duo* 去年煙花特別多) (1998) and *Little Cheung* (*Xiluxiang* 細路祥) (2000). Amid the fireworks and celebrations marking Hong Kong's return to Chinese rule, *The Longest Summer* explores the impact of the Handover on a group of middle-aged soldiers who face an uncertain future. Beginning with the disbanding of the corps on March 31, 1997, the film traces the soldiers' increasing desperation, culminating in their plot to rob a British bank under cover of the Handover celebrations. The film mixed drama and comedy in a complex hybrid of commercial and art cinema. When discussing the origins of *The Longest Summer,* Chan also revealed the implicit connection between violence and the Handover:

As it happened, April 1997 marked the grand opening of the Tsing Ma Bridge. They were going to have a big celebration with fireworks and all the rest. Since we had so much film stock left over that wasn't being used, I figured that we

should go and shoot the grand opening. But then I heard that several other directors had the same idea; Mabel Cheung 張婉婷 was going to use the opening for *City of Glass* (*Boli zhi cheng* 玻璃之城) and Tsui Hark was going to be there shooting footage for *Knock Off*. I thought it was strange that so many people were going to be there shooting. Finally I said to Sam Lee, "Okay, they're going to shoot the fireworks, we'll shoot someone getting shot!" So we rented two cameras and showed up there on the waterside first thing in the morning to get a good place for our cameras. So we shot across from the bridge, getting a lot of footage of the fireworks. I told Sam to walk into frame about two minutes into the fireworks display for the murder scene [which was eventually used in *The Longest Summer*]. (Berry 2005:574)

Chan completed his trilogy at the turn of the millennium with *Little Cheung*, a lyrical and moving depiction of the friendship between a Hong Kong boy named Little Cheung and Fan, a little girl whose entire family are illegal immigrants from the mainland. The trilogy earned Chan more than two dozen major awards at film festivals in Pusan, Gijon, Nantes, Taipei, and Hong Kong.

As Fruit Chan wrapped up his Handover trilogy, he was already beginning production on a second trilogy, this time focusing on mainland Chinese prostitutes' voyage to Hong Kong. *Durian Durian* (*Liulian piaopiao* 榴蓮飄飄) (2000), the first installment of Chan's self-described Prostitute Trilogy, marked another breakthrough. Qin Hailu 秦海璐 stars as a prostitute named Yan 阿燕 who comes to Hong Kong on a tourist visa to work in the sex industry and befriends a young illegal immigrant from Guangdong (who turns out to be Fan 阿芬 from *Little Cheung*). The film features a startlingly frank and, at times, comic portrayal of sex workers in Hong Kong. Equally startling is the film's innovative structure, which features two distinct segments set in Hong Kong and northern China focusing on the two very different sides of Yan's life and identity, portrayed in an inspired performance by newcomer Qin Hailu. *Hollywood Hong Kong* (*Xianggang youge helihuo* 香港有個荷里活) (2002), a dark comedy, continued the trilogy with a twisted tale of sex, violence, deceit, and betrayal in which a deceptively naïve-looking girl from China (Zhou Xun 周迅) turns a poor Hong Kong neighborhood upside down. From its opening shots of fat, sweaty, half-naked men and pig carcasses, *Hollywood Hong Kong* displayed a new, comically vulgar aesthetic in Fruit Chan's work. It also presented a new form of post–Handover angst, wherein a fear of China is projected onto the terrifying powers of a castrating mainland prostitute, a complex also prominently featured in such films as Tsang Kan-cheung's 曾謹昌 1997 *Intruder* (*Kongbu ji* 恐怖雞), about a murderous mainland prostitute who terrorizes Hong Kong.

Death of the lovers at midnight on January 1, 1997 in London in Mabel Cheung's *City of Glass*.

In his discussion of *The Longest Summer*, Fruit Chan mentioned that among the other filmmakers shooting the historic fireworks display was Mabel Cheung. The film that would emerge from the fireworks was Cheung's 1997 feature *City of Glass*, starring Leon Lai and Shu Qi as lovers carrying on a lifelong affair, unknown to their respective spouses—until they die together in a car accident in London as the clock strikes midnight on January 1, 1997. Their death brings their two children together as they try to trace the mysterious double life that his father and her mother led. The symbolic death on New Year's Eve, just months before the Handover, effectively ends their secret and "illegitimate" life and offers another sumptuous dose of allegory, as does the actual site of the accident. When their car flips over and the lovers die, Cheung gives us an inverted view of the New Year fireworks, once again challenging the celebratory fervor of the Handover and signaling a much more ominous future.

The inversion of Hong Kong—and history—is also present in Wong Kar-wai's brilliant meditation on "starting over," *Happy Together*, which won Wong honors for Best Director at Cannes in 1997. The film begins as a road movie of sorts about a gay couple (Leslie Cheung and Tony Leung) setting out to see the Iguazu Falls in Argentina, then deconstructs into a case study about the demise of their relationship and how they cope with the aftermath. *City of Glass* flirted with the transnational imagination and its relation to the Handover, but *Happy Together* goes even further in its cinematic conception of a spatially displaced Hong Kong. Though it directly addresses the Handover, *Happy Together* is set almost exclusively in Buenos Aires, Argentina, with only a short cinematic coda set in Taipei, Taiwan. In fact, the sole images of Hong Kong presented onscreen are in a short montage sequence of the city's skyline shot upside down and from a slowly moving vehicle.

As in *City of Glass*, the inversion of Hong Kong in *Happy Together* is intended as a subversion of the Handover, just as the positioning of the two protagonists

Two images from Wong Kar-wai's *Happy Together:* the sole image of Hong Kong, inverted (left) and images of desolation in Buenos Aires (right).

outside the city signals another layer of estrangement.[1] The fleeting image of an inverted Hong Kong also represents the perspective of the characters as they "gaze" at their home from the other side of the world. The choice of Buenos Aires as their vantage point is also instructive in terms of Argentina's own colonial past. Once considered the most cosmopolitan, prosperous, and "European" city of the Americas, Buenos Aires parallels Hong Kong's own identity as a colonial city that has often been called the cosmopolitan center of Asian commerce, finance, and trade. In *Happy Together,* however, that glory has been all but lost under a cloud of desolation and darkness. The art design of the film instead presents a world caught in the past and engulfed in dilapidation and decadence. The antiquated vision of Buenos Aires is expressed by (often broken-down) 1960s automobiles, retro architecture in disrepair, and outdated fashions in concert with desolate views, and even through the cinematographer's use of grainy stock that enhances the film's dark qualities. In *Happy Together* Wong Kar-wai travels across the globe to see how Hong Kong's double, the city of Buenos Aires, has fared in its own bout with decolonization . . . and the results are not promising.

Another key to both *City of Glass* and *Happy Together* is the movement of Chinese out of Hong Kong on the eve of the Handover. The diaspora proved to be a key motif of much of the colony's cinema leading up to 1997, from Allen Fong's 方育平 1986 New Wave classic *Just Like Weather* (*Meiguo xin* 美國心), a sophisticated exploration of the emigration dilemma, to Peter Chan's 陳可辛 1996 blockbuster *Comrades: Almost a Love Story* (*Tianmimi* 甜蜜蜜), which traces a group of protagonists' journey from China to Hong Kong to New York.

1. This tenuous relationship with the "fatherland" is further signaled by the highly symbolic estrangement of Tony Leung's character from his own father, as evidenced in the multiple scenes where he telephones home.

During the decade between *Just Like Weather* and *Comrades,* numerous other films examined the emigration craze, including Evans Chan's 陳耀成 *To Liv(e)* (*Fushi lianqu* 浮世戀曲) and *Crossings* (*Cuo ai* 錯愛). Inspired by a true story, *Crossings* is the tragic tale of a young Hong Kong woman who immigrates to America after the horrific events of 1989, only to be murdered in a New York subway. Yet another tragedy of Cantonese immigrants in New York was played out in Clara Law's disturbing 1990 film *Farewell China*.

In *Farewell China,* Hong 李紅 (Maggie Cheung 張曼玉) goes to New York on a student visa and suddenly disappears. Her husband, Nansheng 周南生 (Tony Leung Ka Fai), makes the journey to America as an illegal immigrant to search for her, launching on an adventure through the dark side of New York, where he meets a "prostitute with a heart of gold" who helps him navigate the city. At the very end of the film, Nansheng finally locates his wife; now insane and suffering from memory loss, she not only fails to recognize him but even ends up stabbing him during a struggle in a Chinatown park. The violent reunion between Hong and Nansheng serves as an ironic parallel to Hong Kong's own reunion with China. After undergoing untold hardships to be reunited with his wife, Nansheng must face the cruel reality that the reunion also represents his demise. The allegorical dimension is heightened further by the setting, at the base of a Chinatown replica of the famed Goddess of Democracy statue—the symbol of the 1989 Beijing massacre. As Nansheng falls to the ground, dying, the shadow of Tiananmen looms over him, tainting his reunion with Hong as well as Hong Kong's reunion with China.

Hong's memory loss in *Farewell China* is yet another recurring trope in Hong Kong cinema's visual anticipation of the Handover. In his study of post–1997 and Hong Kong cinema, film critic Lang Tian 朗天 writes,

> Memory itself is history; a person's history is decided by his/her memory. People with memory loss are perceived as abnormal or sick because they have lost their history and since it is history that constructs their identity and subjectivity, they find that they have lost themselves. On one level, they no longer exist.
>
> Around the time of the 1997 Handover there was a time of cultural unrest in Hong Kong as people attempted to search for/establish their own unique identity as Hong Kong people. It was also at this time that a seemingly unending flurry of postcolonial and cultural criticism began to emerge. Under the impending loss of Hong Kong's subjective identity, everyone was scrambling to find their own memory, establish their own history, confirm their own

故鄉是真正好
The land, my motherland

The climactic ending of Clara Law's *Farewell China,* where Nansheng (Tony Leung) is murdered by his wife Li Hong (Maggie Cheung) in a New York Chinatown park, in the shadow of a replica of the Goddess of Democracy statue.

frontier culture vis-à-vis the domination of Greater China, and contend with the possibility of post–Handover assimilation and destruction—no one wanted to let themselves disappear. (Lang Tian 2003:89–90)

Among the numerous Handover-era films exploring memory loss and the matrix of forgetting, Wong Kar-wai's 1994 postmodern martial arts epic *Ashes of Time* (*Dongxie xidu* 東邪西毒) is a primary example.[2] Indeed, perhaps the greatest and most terrifying atrocity that Hong Kong filmmakers were projecting into their work was not the ghostly return of the 1941 Japanese invasion, the 1967 riots, or even the 1989 Tiananmen Massacre but instead a destruction of history, memory, and identity.

Just as so many Hong Kong filmmakers were looking to outside, examining the Handover through the prism of diaspora and the transnational imagination, there were some on the outside looking in. In 1997, Wayne Wang (b. 1949), award-winning Chinese American director of such films as *Smoke* and *The Joy Luck Club,* produced his own Handover film, *Chinese Box.* The allegorical dimensions of this Sino–British love story, set during the months leading up to the Handover, seems clear even from the casting, with China's most recognizable actress, Gong Li, opposite one of the UK's most bankable stars, Jeremy Irons. The film is about John (Jeremy Irons), a British journalist stationed in

2. In his chapter "Memory Loss Game" ("Shiyi youxi" 失憶遊戲) (89–116) in *Hong Kong Cinema Post–1997*, Lang Tian discusses memory loss in relation to the Handover–era films *Once Upon a Time in China and America* (*Huang Feihong zhi xiyu xiongshi* 黃飛鴻之西域雄獅) (1997), *Inner Senses* (*Yidu kongjian* 異度空間) (2002), and even Jackie Chan's *Who Am I?* (*Wo shi shei?* 我是誰?) (1998).

Stills from Wayne Wang's *Chinese Box:* Gong Li just days before the Handover, "I want to leave Hong Kong" (left); news footage of a student who burned himself in protest of the impending Handover, which is featured in the film (right).

Hong Kong for more than a decade, and his relationship with two women, Vivian (Gong Li), a former prostitute from the mainland whom he loves (but can never be with), and Jean (Maggie Cheung), a Hong Kong local with a troubled past whom he takes as the subject of a video documentary.

Like *City of Glass, Chinese Box* begins on January 1, 1997 and spans the six months leading up to the Handover. Once again, symbolic parallelism between characters and the locals they represent is central to the film's structure and story. In one of the main narrative strains, John is struggling to understand Jean's past as part of a final effort to capture a vestige of pre–Handover Hong Kong. The climax comes, however, when it is revealed that this British man, with whom Jean has been in love her entire life, doesn't even know her. The parable is a visible signpost of Britain's "abandonment" of Hong Kong, as well as a symptom of Hong Kong's crisis of memory and identity.

The allegorical dimensions of *Chinese Box*, however, are most evident in the character of John, who, shortly after the New Year, is diagnosed with a rare form of leukemia and given only months to live. His death in the immediate aftermath of the Handover, left floating aimlessly on a junk in Hong Kong's harbor, is simultaneous with the death of Britain's colonial empire in Asia.

John is situated, quite literally, between the democracy protests and the encroaching hegemonic power of China, and he remains impotent to affect Hong Kong's future one way or another. His death further heightens the director's allegorical statement on Britain's disempowerment in their former colony. Although *Chinese Box* highlights a series of neat ideological parallels, the metaphoric symbolism betrays the fact that, at its heart, the film is about a crisis of identity equally devastating for both the colonized and the colonizer.

爭取民主！
Fight for democracy!

香港是國際都會、金融重鎮…

John (Jeremy Irons), on the eve of the Handover, begins to lose his battle with leukemia in *Chinese Box*. His illness is situated between democracy protests (left) and the encroaching hegemonic power of China (right), here represented by the PRC's mouthpiece, *The People's Daily*.

Conclusion

Hong Kong 1997 represents a unique chronotopic space that simultaneously revisits and reframes many of the central concerns of this study: history and fiction, atrocity and diaspora, trauma and memory. From the personal apocalypse of "Lost City" to the fantastic war between humankind and monsters in *The Wicked City*, the Handover is the site of endless mutations of projected violence, both real and imaginary. This anticipatory trauma, while intricately connected to the Tiananmen complex, is also part of a larger historical continuum that reaches much further back into the past—and the popular imagination of that past. The Musha Incident, the Rape of Nanjing, the February 28th Incident, the Cultural Revolution, and the Tiananmen Square Massacre represent five crucial entry points for examining how historical pain has been reconceived, reconceptualized, and revisited. After a century full of acts of historical violence and their continual resurrection through literary, visual, and historical reconstructions, atrocity had become a fundamental part of the modern Chinese historical experience and the Chinese imagination of the future.

Examining the loss of memory so deeply ingrained in the Hong Kong imagination of 1997, we should also recall the fracture of memory and identity central to the protagonist of Lu Xun's dark parable, "Diary of a Madman." Of the five historical calamities addressed in this study, three—the February 28th Incident, the Cultural Revolution and the Tiananmen Massacre—were dominated by indigenous Chinese-on-Chinese violence, and even representations of the Musha Incident and the Rape of Nanjing are haunted by the Lu Xunian

ghost. But as the specter of China's cannibalistic past prepared to descend once more, history proved the imagination wrong. Indeed, "nothing happened" in Hong Kong in 1997—at least, no massive political purges or restaging of the Tiananmen Square Massacre. However, something *did* happen to the Hong Kong people's psyche and imagination, something not only very real and tangible but also very horrific.

One place where history seems to have proved the imagination correct is in the popular imagination of diaspora. The works analyzed in this "history of pain" provide new ways of approaching the past (or, in the case of Hong Kong 1997, approaching the present and future), a key aspect of which is the ways violence has been inextricably intertwined with massive population movement, from the large-scale dispersal of people to escape (or create) calamities in wartime to the use of relocation as a tool of violence during the Cultural Revolution. In 1989, in the immediate aftermath of Tiananmen, intellectuals began a exodus and violence began to play a fundamental role in population dispersal, as well as in the ongoing creation of China's diaspora. This international focus extended through Hong Kong 1997, when the intricate connections between atrocity and emigration, violence and diaspora were at their strongest and most prominent. In works like *Farewell China* and *Crossings,* where transnational tragedies await the immigrant who flees a trauma that never arrives, the artistic imagination seems to indicate that sometimes the medicine is worse than the disease.

Hong Kong 1997 also marks the ultimate deconstruction of the historical site of atrocity. Although our starting point has been a series of specific time-space coordinates of violence, the underlying historical events have become increasingly contentious, until the sites themselves have become illusory. This genealogy of violence challenges the very tangibility—or intangibility—of the historical loci involved. Musha, a "savage land" on the periphery, was subsequently erased through genocidal tactics and the forced exile of the Atayal survivors. The Musha Incident stands out not just for the disturbing events that occurred but also for the disturbing history of exploitation that followed, resulting in a colonization of historical memory, carried out alternately by the Japanese, Chinese, and Taiwanese. Musha is also unique for its conflation of so many of the themes central to this study: traumatic memory and representation, ethnicity and nationalism, colonial resistance and self-mutilating violence. While the history of Chinese representation has firmly positioned the Musha Incident as a centripetal trauma, a shock from the outside triggering a powerful internal, nationalistic response, the complexity of the event (especially the Second Musha Incident) points to hidden centrifugal forces lurking within, making simplistic readings nearly impossible. Thus while the new century has seen

a reimagination of Musha as the cradle of native Taiwan history and national consciousness, it is projected under a shadow of complexity, exploitation, and unspoken pain.

The massive scale and horrific nature of the Nanjing Massacre, documented by photos, documentary video, and numerous eyewitness accounts, not only seemed irrefutable but even replaced Musha as the symbol of all Japanese wartime aggression in China. However, even in the case of the Nanjing Massacre, decades of Japanese denial and Chinese avoidance of the issue have transformed the location into a contested site. Just what really did happen in Nanjing in 1937? Since the 1980s, the thrust to prove what occurred during the Rape of Nanjing has become a powerful component of a new Chinese national imagination.

Taipei 1947 marks the epicenter of what was to become one of the most important historical moments in the formation of modern Taiwan's identity. In the case of 2/28, the conflict in the capital quickly gave rise to insurrections throughout the island. The result was that most of the works considered here are ironically set outside of Taipei, with the notable exception of *March of Happiness,* in which Lin Cheng-sheng attempts to belatedly reinstate Taipei as the traumatic epicenter and primal scene of atrocity. The case of the February 28th Uprising is also unique in the temporal malleability of its literary and visual representations. Chapter 3 examined the belated effects of 2/28 as evidenced by the White Terror and psychological stigmatization of its victims and also the phenomenon of "prewriting" or anticipating atrocity, with the examples of authors like Lü Heruo and Bo Zi.

In the case of the educated youths in Yunnan during the Cultural Revolution, the spatial and temporal parameters of experiencing and remembering violence extended beyond a singular "city of sadness," dispersed throughout an entire province (not to mention the numerous other locations where educated youth were sent, such as Inner Mongolia, Tibet, and Anhui province). And although the timeline begins in 1968, the modes of violence and the atrocities faced by the educated youths took many forms for more than a decade. However, in such works as Tsui Hark and Yim Ho's *The King of Chess,* where the topological mapping of 1960s Xishuangbanna is layered over 1980s Taipei, and Ye Xin's *The Wages of Sin,* where the tragedy of the educated youths makes a belated and duplicitous return in 1990s Shanghai, the temporal and spatial boundaries of historical violence seem unlimited. More than thirty years after the last educated youths returned home, the shadow of Yunnan's tragedy continues to extend into the future.

Like the Nanjing Massacre, the 1989 Tiananmen Square Massacre seems to offer a more concrete epicenter at which violence is rooted—June 4, 1989, Tiananmen Square, Beijing. Looks, however, can be deceiving. Just as Nanjing

became a contested site in the wake of Japanese denial, fifty-two years later, so did Beijing in the wake of Chinese denial. The ultimate paradox is that just as Beijing was denying the existence of a so-called "massacre," denying the very place of violence, thanks to the proliferation of global media, the massacre was simultaneously playing out in coffee shops and living rooms across the globe. Beijing 1989 was transformed into a series of "phantom images" made ubiquitous through cable television broadcasts and magazine spreads while being denied a physical site—the first "virtual massacre." It would, however, carry very real consequences, triggering a large wave of immigration to the West and a series of belated tragedies, such as that of Plain Moon, the Chinatown worker in New York.[3] The ultimate irony, however, is the case of Hong Kong 1997, where the time-space coordinates and the atrocity etched onto them completely disappear—nothing ever happens.[4] This spatial and temporal disappearance does not undermine the respective atrocities or different types of traumatic experience examined in this study; it signals the ubiquitous way historical violence haunts different sites, surreptitiously moving from the past into the present and projecting into the future.

The contested nature of many of the historical sites revisited here is manifested in the conflicting ways the events have been referred to over time—Musha Incident, Wushe Anti-Japanese Uprising; Nanjing Incident, Rape of Nanjing; 2/28 incident, 2/28 uprising; Tiananmen Incident, Tiananmen Massacre. The renaming of these events highlights the struggle among different ideologies, political agendas, and nations to control historical memory. In my discussions of these historical events, I have alternated among the different names to reflect these multiple identities in contemporary historiography and cultural memory. There is never a precise equivalence in any two forms of traumatic experience, but there are fundamental historical and often psychological links that allow, for example, Zhang Shenqie's account of the Musha Incident to reflect upon the 2/28 incident or Hou Hsiao-hsien's *City of Sadness* to serve as a reference point for June Fourth (even through principal shooting was completed well before the Tiananmen Incident).

3. Another example of the spatial mutability of Tiananmen is one of the massacre's key icons, the Goddess of Democracy statue, modeled on the Statue of Liberty. After the statue's erasure from Beijing, it was temporarily reconstructed in Hong Kong (as documented in *Sunless Days*) and New York (as documented in *Farewell China*).

4. In this context, Hong Kong's matrix of disappearance can also be read as part of a larger cultural discourse on the former colony's fate, which has been explored in the theoretical realm by Ackbar Abbas in *Hong Kong: Culture and the Politics of Disappearance* and in the literary world by Dung Kai Cheung in *The Atlas: The Archaeology of an Imaginary City*, among others.

Numerous historians have observed the role that wars and mass violence play in the creation of nations. National victimization perpetrated by an outside force is often transformed through popular culture into the ideological building blocks of nationalism, a process I here refer to as centripetal trauma. However, turmoil and violence unleashed by a state upon its own people can have an equally powerful effect on dismantling traditional conceptions of "the nation." This centrifugal trauma also plays an important role in the creation of a new transnational imagination, wherein the global replaces the local after the failure of a nationalistic vision. This is not a clean-cut binary; elements of the centripetal and the centrifugal always exist within each other. Keeping this in mind suggests alternate ways of thinking about the complex relationships among trauma, nation, and the imagination.

Elaine Scarry has discussed the power of pain to destroy mental and language capabilities in not only the victims of physical trauma but also the observers (1985:279). This breakdown is clearly highlighted in the first section, especially in the discussion of Chen Chieh-jen's *Lingchi: Echoes of a Historical Photograph* and the relationship between the "body in pain" and the crowd of witnesses. At this juncture, we the readers and consumers of the texts discussed here have become that audience, the latest witnesses in the evolving chain of events and representations. But have we been witnesses to trauma, vicarious trauma, or a performative attempt to re-create an *imaginary* trauma?

Readers and viewers of trauma fiction and film tend to unconsciously confound the text with "what actually happened."[5] In many cases, these texts do contextualize and conceptualize the most horrific and "unimaginable" moments of the past. But in our attempts to revisit—and sometimes rewrite—those darkest pages of history, it becomes clear that the traumatic imagination is always temporally, spatially, and often psychologically convoluted. However, in mapping that past, it should not be forgotten that beyond the "history that historians call history" lies a rich, multifaceted, and ever-growing matrix of words and images that help us reconstitute stories what once seemed forever lost. Although these works may have their roots in historical reality, their narrative structure and artistic vision branch out into a world of the imagination. With the case of Hong Kong 1997, we seem to finally make the leap from history to the imaginary . . . but isn't that where we have been all along?

5. In cinema, this tendency is often further confounded by filmmakers' use of black-and-white and archival documentary footage, which further heightens the legitimacy and reality of the work for many lay viewers. (It can be argued that, although this process is not always necessarily conscious, it can operate on a more subtle level with a large spectrum of audiences.)

A Cheng. *Selected Stories by A Cheng.* Beijing: Chinese Literature Press, 1999.

Abbas, Ackbar. *Hong Kong: Culture and the Politics of Disappearance.* Minneapolis: University of Minnesota Press, 1997.

Adorno, Theodor. *Negative Dialectics.* Trans. E. B. Ashton. New York: Continuum, 1973.

Ah Cheng 阿城. *Biandi fengliu* 遍地風流 (*A Land for Life, A Land for Love*). Taipei: Rye Field, 2001.

——. *Qiwang, shuwang, haiziwang* 棋王, 樹王, 孩子王 (*King of Chess, King of the Trees, King of the Children*). Taipei: Haifeng chubanshe, 1996.

——. *Three Kings: Three Stories from Today's China.* Trans. Bonnie S. McDougall. London: Collins Harvill, 1990.

Ah Long 阿壠. *Nanjing xueji* 南京血祭 (*Nanjing Bloody Sacrifice*). Beijing: People's Literature Publishing House, 1987.

Ahwei Hebaha 阿威赫拔哈 (oral dictation), Xu Jielin 許介鱗 (writer and editor), Lin Daosheng 林道生 (translator). *Ahwei Hebaha de Wushe shijian zhengyan* 阿威赫拔哈的霧社事件證言 (*Ahwei Hebaha's Testimony on the Musha Incident*). Taipei: Taiyuan chuban she, 2000.

Ai Xiaoming 艾曉明 and Li Yinhe 李銀河, eds. *Langman qishi: jiyi Wang Xiaobo* 浪漫騎士: 記憶王小波 (*Romantic Warrior: Remembering Wang Xiaobo*). Beijing: Zhongguo qingnian chubanshe, 1997.

Aijmer, Göran and Jon Abbink, eds. *Meanings of Violence: A Cross-Cultural Perspective.* Oxford: Berg, 2000.

An Lianxing 安劍星. *Wo shi Mao zhuxi de hong xiao bing* 我是毛主席的紅小兵 (*I Was Chairman Mao's Little Red Soldier*).Taipei: Ritai, 1996.

Bakhtin, M. M. *Rabelais and His World*. Trans. Helene Iswolsky. Bloomington: Indiana University Press, 1984.

——. *The Dialogic Imagination: Four Essays*. Ed. Michael Holquist. Trans. Caryl Emerson and Michael Holquist. Austin: University of Texas Press, 1981.

Balcom, John and Yingtsih Balcom, eds. *Indigenous Writers of Taiwan: An Anthology of Stories, Essays, and Poems*. New York: Columbia University Press, 2005.

Barclay, Paul D. "Cultural Brokerage and Interethnic Marriage in Colonial Taiwan: Japanese Subalterns and Their Aborigine Wives, 1895–1930." *The Journal of Asian Studies* 64, no. 2 (May 2005): 323–360.

——. "'Gaining Confidence and Friendship' in Aborigine Country: Diplomacy, Drinking, and Debauchery on Japan's Southern Frontier." *Social Science Japan Journal* 6, no. 1 (2003): 77–96.

Bartov, Omer. *Mirrors of Destruction: War, Genocide, and Modern Identity*. Oxford: Oxford University Press, 2000.

Bataille, Georges. *The Tears of Eros*. San Francisco: City Lights Books, 1989.

Baudrillard, Jean. *Simulacra and Simulation*. Trans. Sheila Faria Glaser. Ann Arbor: University of Michigan Press, 1994.

Beijing tongzhi 北京同志 (Beijing Comrade). *Lan Yu* 藍宇. Hong Kong: Dongfan chuban, 2001.

Berry, Michael. *Speaking in Images: Interviews with Contemporary Chinese Filmmakers*. New York: Columbia University Press, 2005.

——. "Words and Images: A Conversation with Hou Hsiao-hsien and Chu T'ienwen." *positions: east asia cultures critique* 11, no. 3 (Winter 2003).

Bennett, Jill. *Empathic Vision: Affect, Trauma, and Contemporary Art*. Stanford: Stanford University Press, 2005.

Bhabha, Homi K. *Nation and Narration*. London: Routledge, 1990.

Bickley, Gillian. *Hong Kong Invaded! A '97 Nightmare*. Hong Kong: Hong Kong University Press, 2001.

Binstock, R. C. *Tree of Heaven*. New York: Soho Press, 1995.

Black, George and Robin Munro. *Black Hands of Beijing: Lives of Defiance in China's Democracy Movement*. New York: Wiley, 1993.

Boyers, Robert. *Atrocity and Amnesia: The Political Novel Since 1945*. Oxford: Oxford University Press, 1985.

Braester, Yomi. *Witness Against History: Literature, Film, and Public Discourse in Twentieth-Century China*. Stanford: Stanford University Press, 2003.

Brink, Andre. *The Novel: Language and Narrative from Cervantes to Calvino*. New York: New York University Press, 1998.

Brook, Timothy, ed. *Documents on the Nanjing Massacre*. Ann Arbor: University of Michigan Press, 1999.

——. *Quelling the People: The Military Suppression of the Beijing Democracy Movement*. Stanford: Stanford University Press, 1998.

Brook, Timothy, Jérôme Bourgon, and Gregory Blue. *Death by a Thousand Cuts*. Cambridge: Harvard University Press, 2008.

Brown, Melissa J. *Is Taiwan Chinese? The Impact of Culture, Power, and Migration on Changing Identities*. Berkeley: University of California Press, 2004.

Buruma, Ian. *The Wages of Guilt: Memories of War in Germany and Japan*. New York: Farrar, Straus & Giroux, 1994.

Cai Yuxi 蔡玉洗, ed. *Nanjing qingdiao* 南京情調 (*Nanjing Mood*). Wuhan: Changjiang wenyi chuban she, 2000.

Cao, Zuoya. *Out of the Crucible: Literary Works About the Rusticated Youth*. Lanham, MD: Lexington Books, 2003.

Caruth, Cathy, ed. *Unclaimed Experience: Trauma, Narrative, and History*. Baltimore: Johns Hopkins University Press, 1996.

——. *Trauma: Explorations in Memory*. Baltimore: Johns Hopkins University Press, 1995.

Chang, Carrie. "Forgotten Holocaust: The Rape of Nanking Still Looms in the Minds of Many" and "Interview with Iris Chang: Remembering Nanking with Rage." *Monolid* 2, no. 2 (Summer/Fall 2001): 12–14.

Chang, Iris. *The Rape of Nanking: The Forgotten Holocaust of World War II*. New York: Basic Books, 1997.

Chang, Sung-sheng Yvonne. *Modernism and the Nativist Resistance: Contemporary Chinese Fiction from Taiwan*. Durham: Duke University Press, 1993.

Chang, Tony H. *China During the Cultural Revolution, 1966–1976: A Selected Bibliography of English-Language Works*. Westport, CT: Greenwood Press, 1999.

Che Muqi. *Beijing Turmoil: More Than Meets the Eye*. Beijing: Foreign Languages Press, 1990.

Chen Anji 陳安吉, ed. Qinhua rijun nanjing datusha shi guoji xueshu yantaohui lunwenji 侵華日軍南京大屠殺史國際學術研討會論文集 (Collection of Essays from the International Academic Conference on the History of the Rape of Nanjing Committed by the Invading Japanese Army). Hefei: Anhui daxue chubanshe, 1997.

Chen Chieh-jen. "'Lingchi: Echoes of a Historical Photo' Artist's Statement." Taipei: Chen Studio, 2002.

Chen Fangming 陳方明. *In Search of a Canon* (*Dianfan de zhuiqiu* 典範的追求), 305–339. Taipei: Unitas, 1994.

Chen Fangming 陳方明, ed. *Er er ba shijian xueshu lunwen ji* 二二八事件學術論文集 (*Collection of Academic Conference Papers on the February 28th Incident*). Taipei: Qianwei chuban she, 1988.

Chen Guanzhong 陳冠中 (John Chan). *Shenme dou meiyou fasheng* 甚麼都沒有發生 (*Nothing Happened*). Hong Kong: Youth Literary Book Store, 1999.

Chen Kaige 陳凱歌. *Shaonian Kaige* 少年凱歌 (*Young Kaige*). Taipei: Yuanliu, 1991.

Chen Kaige and Tony Rayns. *King of the Children and the New Chinese Cinema*. London: Faber & Faber, 1989.

Chen, Ming K. and Gerard A. Postiglione, eds. *The Hong Kong Reader: Passage to Chinese Sovereignty*. Armonk, NY: M. E. Sharpe, 1996.

Chen Mo 陳墨. *Chen Kaige dianying lun* 陳凱歌電影論 (*On the Films of Chen Kaige*). Beijing: Wenhua yishu chubanshe, 1998.

Chen Quchuan 陳渠川. *Wushe shijian* 霧社事件 (*The Musha Incident*). Taipei: Diqiu chuban she, 1977.

Chen Sihe 陳思和. *Tan hu tan tu* 談虎談兔 (*On Tigers and Rabbits*). Guilin: Guangxi Normal University Press, 2001.

Chen Ye 陳曄. *Lieai zhenhua* 烈愛真華.Taipei: Lianjing, 2002.

——. *Banlian nüer* 半臉女兒 (*The Girl with Half a Face*). Taipei: Pingan congshu, 2001.

——. *Ni he* 泥河 (*Muddy River*). Taipei: Zili baoxi chuban, 1989.

Chen Yingzhen 陳映真. *Chen Yingzhen xiaoshuo ji* 陳映真小說集 (*Collected Fiction of Chen Yingzhen*), 6 vols. Taipei: Hongfan, 2001.

Cheng, Amy Huei-Hua. "On Lingchi: Echoes of a Historical Photograph." *Yishu: Journal of Contemporary Chinese Art* (March 2003):77–81.

Cheng Jiang 成江. *Lao zhiqing: Tuwen zhuiyi Zhongguo sandai zhiqing* 老知青: 圖文追憶中國撒三代知青 (*Old Educated Youths: Remembering Three Generations of Chinese Educated Youths Through Photos and Text*). Beijing: Shiyou gongye chubanshe, 1998.

Cheng Shuan 程樹安, ed. *Zhongguo dianying mingpian jianshang cidian* 中國電影名片鑑賞辭典 (*Encyclopedia of Appreciation of Chinese Films*). Beijing: Long March Publishing House, 1997.

Cheng, Sung-sheng Yvonne Chang. *Modernism and the Nativist Resistance: Contemporary Chinese Fiction from Taiwan*. Durham: Duke University Press, 1993.

Cheng, Terrence. *Sons of Heaven: A Novel*. New York: William Morrow, 2002.

——. "A Conversation with Terrence Cheng." 2002. http://www.harpercollins.com/catalog/book_interview_xml.asp?isbn=0060002441.

——. "*Sons of Heaven:* The Story Behind the Book." 2002. http://www.bookreporter.com/authors/talk-cheng-terrence.asp.

Chi, Robert Yee-sin. *Picture Perfect: Narrating Public Memory in Twentieth-Century China*. Ph.D. diss., Harvard University, 2001.

Chiang Kai-shek, Generalissimo. *Resistance and Reconstruction: Messages During China's Six Years of War 1937–1943*. New York: Harper & Brothers, 1943.

Chinese Ministry of Information, comp. *China Handbook 1937–1943: A Comprehensive Survey of Major Developments in China in Six Years of War*. New York: Macmillan, 1943.

Ching, Leo T.S. *Becoming "Japanese": Colonial Taiwan and the Politics of Identity Formation*. Berkeley: University of California Press, 2001.

Chow, Rey. *Primitive Passions:Visuality, Sexuality, Ethnography, and Contemporary Chinese Cinema*. New York: Columbia University Press, 1995.

——. *Woman and Chinese Modernity: The Politics of Reading Between West and East*. Minneapolis: University of Minnesota Press, 1991.

Clark, Katerina and Michael Holquist. *Mikhail Bakhtin.* Cambridge: The Belknap Press of Harvard University Press, 1984.

Clendinnen, Inga. *Reading the Holocaust.* Cambridge: Cambridge University Press, 1999.

Cuddon, J. A. *Penguin Dictionary of Literary Terms and Literary Theory.* London: Penguin, 1992.

Dai Guohui 戴國煇 and Ye Yunyun 葉芸芸. *Ai zeng 2,28: Shenhua yu shishi, jiekai lishi zhi mi* 愛憎二二八:神話與事實, 揭開歷史之謎 (*Love Hate 2,28: Myths and Historical Record, Revealing the Riddle of History*). Taipei: Yuanliu, 1992.

Dai Jinhua. *Cinema and Desire: Feminist Marxism and Cultural Politics in the Work of Dai Jinhua.* Ed. Jing Wang and Tani E. Barlow. London: Verso, 2002.

Davis, General Raymond and Judge Dan Winn. *The Super Holocaust* (*in China*). Bloomington, IN: Authorhouse, 2005.

Dellamora, Richard, ed. *Postmodern Apocalypse: Theory and Cultural Practice at the End.* Philadelphia: University of Pennsylvania Press, 1995.

Deng Xian 鄧賢. *Zhongguo zhiqing zongjie* 中國知情總結 (*The End of the Chinese Urban Youth*). Beijing: Renmin wenxue chubanshe, 2003.

——. *Zhongguo zhiqing meng* 中國知情夢 (*Dream of the Chinese Urban Youth*). Beijing: Renmin wenxue chubanshe, 1993.

Deng Xiangyang 鄧相揚. *Fengzhong feiying: Wushe shijian zhenxiang ji Huagangchuzi de gushi* 風中非櫻: 霧社事件真相及花岡初子的故事 (*Dana Sakura: The True Musha Incident and the Story of Hanaoka Hatsuko*). Taipei: Yushan she, 2000.

——. *Wucong yunshen: Wushe shijian hou, yige taiya jiating* 霧重雲深: 霧社事件後, 一個泰雅家庭 (*Layers of Mist, Heavy Clouds: One Atayal Family After the Musha Incident*). Taipei: Yushan she, 1998.

——. *Wushe shijian* 霧社事件 (*The Musha Incident*). Taipei: Yushan she, 1998.

Deng Xiangyang and Qiu Ruolong. *Mono Ludao* 莫那 魯道 (*Mona Rudao*). Taipei: National Taiwan Museum of Fine Arts, 2006.

Deng Xiangyang 鄧相揚 (original author) and Wan Ren 萬仁 (director). *Fengzhong feiying: Wushe shijian: juben yingxiang shu* 風中緋櫻: 霧社事件: 劇本 影像書 (*Dana Sakura: The Musha Incident: Teleplay and Production Stills*). Taipei: Yushan she, 2004.

Des Forges, Roger V., Luo Ning, and Wu Yen-bo. *Chinese Democracy and the Crisis of 1989: Chinese and American Reflections.* Albany: SUNY Press, 1993.

Ding Yizhuang 定宜莊. *Zhongguo zhiqing shi: chulan 1953–1968* 中國知青史: 初瀾 1953–1968 (*A History of Educated Youth in China: The First Billows 1953–1968*). Beijing: Zhongguo shehui kexue chubanshe, 1998.

Dissanayake, Wimal. *Wong Kar-wai's Ashes of Time.* Hong Kong: Hong Kong University Press, 2003.

——. *Melodrama and Asian Cinema.* London: Cambridge University Press, 1993.

Eagleton, Terry. *Sweet Violence: The Idea of the Tragic.* Oxford: Blackwell Publishing, 2003.

Edgerton, Robert B. *Warriors of the Rising Sun: A History of the Japanese Military.* New York: Norton, 1997.

Elkins, James. *The Domain of Images.* Ithaca, NY: Cornell University Press, 1999.

——. *Pictures of the Body: Pain and Metamorphosis*. Stanford: Stanford University Press, 1999.

Fabe, Marilyn. *Closely Watched Films: An Introduction to the Art*. Berkeley: University of California Press, 2004.

Feldman, Allen. "Violence and Vision: The Prosthetics and Aesthetics of Terror." In Fernando Coronil and Julie Skurski, eds., *States of Violence*, 425–468. Ann Arbor: University of Michigan Press, 2006.

Felman, Shoshana and Dori Laub, M.D. *Testimony: Crises of Witnessing in Literature, Psychoanalysis, and History*. New York: Routledge, 1992.

Feng Jicai. *Voices from the Whirlwind: An Oral History of the Chinese Cultural Revolution*. New York: Pantheon, 1991.

Film Archives Oral Film History Committee 電影資料館口述電影史小組. *Taiyu pian shidai* 台語片時代 (*The Age of Taiwanese Films*). Taipei: Guojia dianying ziliaoguan, 1994.

Fogel, Joshua A., ed. *The Nanjing Massacre in History and Historiography*. Berkeley: University of California Press, 2000.

Fonoroff, Paul. *At the Hong Kong Movies: 600 Reviews from 1988 Till the Handover*. Hong Kong: Film Biweekly Publishing House, 1988.

Foucault, Michel. *Language, Counter-Memory, Practice: Selected Essays and Interviews*. Ed. D. F. Bouchard. Ithaca, NY: Cornell University Press, 1997.

Friedman, Saul S. *Holocaust Literature: A Handbook of Critical, Historical, and Literary Writings*. Westport, CT: Greenwood Press, 1993.

Fujitani, T., Geoffrey M. White, and Lisa Yoneyame, eds. *Perilous Memories: The Asia-Pacific War(s)*. Durham: Duke University Press, 2001.

Gao Yuandong 高遠東, ed. *Zuojin Lu Xun shijie: Xiaoshuo juan* 走進魯迅世界·小說卷 (*Enter the World of Lu Xun: Literature Volume*). Beijing: Beijing gongye daxue chubanshe, 1995.

George, Kenneth M. *Showing Signs of Violence: The Cultural Politics of a Twentieth-Century Headhunting Ritual*. Berkeley: University of California Press, 1996

Goodwin, Sarah Webster and Elisabeth Bronfen, eds. *Death and Representation*. Baltimore: Johns Hopkins University Press, 1993.

Gu Shengying and Chen Limin, eds. *Shanghen* 傷痕 (*Scar*). Beijing: Zhongguo wenxue chubanshe, 1993.

Gu Zhaosen 顧肇森. *Dongri zhi lü* 冬日之旅 (*Journey on a Wintry Day*). Taipei: Hongfan, 1994.

——. *Maolian de suiyue* 貓臉的歲月 (*Cat Face Years*). Taipei: Jiuge, 1986.

Guo Songfen 郭松棻. *Benpao de muqin* 奔跑的母親 (*Mother Running*). Taipei: Rye Field, 2002.

Ha Jin. *The Crazed: A Novel*. New York: Pantheon, 2002.

Haggith, Toby and Joanna Newman, eds. *Holocaust and the Moving Image: Representations in Film and Television Since 1933*. London: Wallflower, 2005.

Han Minzhu, ed. *Cries for Democracy: Writings and Speeches from the 1989 Chinese Democracy Movement*. Princeton: Princeton University Press, 1990.

Hanan, Patrick. *Chinese Fiction of the Nineteenth and Early Twentieth Centuries: Essays by Patrick Hanan*. New York: Columbia University Press, 2004.

Harrison, Henrietta. "Clothing and Power on the Periphery of Empire: The Costumes of the Indigenous People of Taiwan." *positions: east asia cultures critique* 11, no. 2 (2003).

Hayder, Mo. *The Devil of Nanking*. New York: Grove Press, 2005.

He, Zhou. *Mass Media and Tiananmen Square*. New York: Nova Science Publishers, 1996.

Heng Digang 橫地剛. *Nantian zhi qiao: Ba er er ba shijian ke zai banhua shang de ren* 南天之橋: 把二二八事件刻在版畫上的人 (*Bridge of the Southern Sky: The Man Who Carved the February 28 Incident in Woodblocks*) (Biography of Huang Rongcan 黃榮燦). Trans. Lu Pingdan 陸平舟. Taipei: Lianjing (Renjian), 2002.

Hicks, George, ed. *The Broken Mirror: China After Tiananmen*. Essex, England: Longman Current Affairs, 1990.

Hillenbrand, Margaret. "Trauma and the Politics of Identity: Form and Function in Narratives of the February 28th Incident." *Modern Chinese Literature and Culture* 17, no. 2 (Fall 2005).

Hinton, Carma and Richard Gordon. *The Gate of Heavenly Peace*. Hong Kong: Mirror Company, 1997.

Hirsch, Joshua. *Afterimage: Film, Trauma, and the Holocaust*. Philadelphia: Temple University Press, 2004.

Hirsch, Marianne. *Family Frames: Photography, Narrative, and Postmemory*. Cambridge: Harvard University Press, 1997.

Hitchcock, Peter. *Dialogics of the Oppressed*. Minneapolis: University of Minnesota Press, 1993.

Honda Katsuichi. *The Nanjing Massacre: A Japanese Journalist Confronts Japan's National Shame*. Armonk, NY: M. E. Sharpe, 1999.

Hong Ying. *Summer of Betrayal*. Trans. Martha Avery. New York: Farrar, Straus & Giroux, 1997.

Hoskins, Janet, ed. *Headhunting and the Social Imagination in Southeast Asia*. Stanford: Stanford University Press, 1996.

Hsia, C. T. *A History of Modern Chinese Fiction*. 3rd ed. Bloomington: Indiana University Press, 1999.

Hsia, Tsi-an. *The Gate of Darkness: Studies on the Leftist Literary Movement in China*. Seattle: University of Washington Press, 1968.

Hsiau, A-chin. *Contemporary Taiwanese Cultural Nationalism*. London: Routledge, 2000.

Hsieh, Tung-shan. *Contemporary Art in Taiwan*. Taipei: Yishujia chubanshe, 2003.

Hsu, Mutsu. *Culture, Self, and Adaptation: The Psychological Anthopology of Two Malayo-Polynesian Groups in Taiwan*. Taipei: Institute of Ethnology, Academia Sinica, 1991.

Hu, Hua-ling. *American Goddess at the Rape of Nanjing: The Courage of Minnie Vautrin*. Carbondale: Southern Illinois University Press, 2000.

Huang Biyun 黃碧雲. *Shier nuse* 十二女色 (*12 Colors of Women*). Taipei: Rye Field, 2000.

Huang Ren 黃仁. *Beiqing taiyu pian* 悲情台語片 (*Tragic Taiwanese Films*). Taipei: Wanxiang tushu, 1994.

——. *Dianying yu zhengzhi xuanchuan* 電影與政治宣傳 (*Film and Political Propaganda*). Taipei: Wanxiang tushu, 1994.

Huang Yao 黃堯. *No Introduction* 無序 (*Wu xu*). Beijing: Zuojia chubanshe, 2000.

Huang Yuling 黃于玲. *Taiwan Hua 3: Jinian er er ba zhuanji* 台灣畫 3: 紀念二二八專輯 (*Taiwan School 3: February 28 Commemorative Issue*). Taipei: Nan Gallery, 1993.

Huot, Claire. *China's New Cultural Scene: A Handbook of Changes*. Durham: Duke University Press, 2000.

Idema, Wilt L., Wai-yee Li, and Ellen Widmer. *Trauma and Transcendence in Early Qing Literature*. Cambridge: Harvard University Press, 2006.

Insdorf, Annette. *Indelible Shadows: Film and the Holocaust*. 2nd ed. Cambridge: Cambridge University Press, 1989.

Jay, Martin. *Refractions of Violence*. London: Routledge, 2003.

Jen Yu-wen. *The Taiping Revolutionary Movement*. New Haven: Yale University Press, 1973.

Ji Chenggui 黎澄貴, Hu Huiling 胡慧玲, and Zhang Yanxian 張炎憲, eds. *Danshui he yu er er ba* 淡水河域二二八 (*Danshui River February 28th 1947*). Taipei: Taiwan shiliao zhongxin, 1996.

Jiang, Yarong and David Ashley. *Mao's Children in the New China: Voices from the Red Guard Generation*. London: Routledge, 2000.

Jiao Xiongping 焦雄屏 (Peggy Chiao). *Taiwan dianying 90 xin xin langchao* 台灣電影 90 新新浪潮 (*New New Wave of Taiwan Cinema 90s*). Taipei: Rye Field, 2002.

——. *Fengyun jihui: Yu dangdai Zhongguo dianying duihua* 風雲際會:與當代中國電影對話 (*Dialogues with Contemporary Chinese Directors*). Taipei: Yuanliu Publishing House, 1998.

——. *Taigang dianying zhong de zuozhe yu leixing* 台港電影中的作家與類型 (*Auteurs and Genres in Taiwan and Hong Kong Cinema*). Taipei: Yuanliu, 1991.

——. *Taiwan xin dianying* 台灣新電影 (*New Taiwan Cinema*). Taipei: China Times, 1988.

Jin Yucheng 金宇澄, ed. *Wo de da chuanlian: Piaobo zai hong haiyang* 我的大串聯:漂泊在紅海洋 (*My Great Linking Up: Floating in the Red Sea*). Taipei: China Times, 1996.

Jintian Daofu 津田道夫. *Nanjing datusha he ribenren de jingsheng gouzao* 南京大屠殺和日本人的精神構造 (*The Nanjing Massacre and the Spiritual Makeup of the Japanese People*). Trans. Cheng Zhaoqi and Liu Yan. Hong Kong: Shangwu yinshu guan, 2000.

Kaplan, E. Ann. *Trauma Culture: The Politics of Terror and Loss in Media and Literature.* New Brunswick: Rutgers University Press, 2005.

Katz, Paul. *When the Valleys Turned Blood Red: The Ta-pa-ni Incident in Colonial Taiwan.* Honolulu: University of Hawai'i Press, 2005.

King, Richard, guest ed. *Renditions* Special Issue: "There and Back Again: The Chinese 'Urban Youth' Generation." Hong Kong: Chinese University of Hong Kong, 1998.

Kinkley, Jeffrey C. *Corruption and Realism in Late Socialist China: The Return of the Political Novel.* Stanford: Stanford University Press, 2007.

Kong Shangren 孔尚任. *Tao hua shan* 桃花扇 (*The Peach Blossom Fan*). Beijing: Renmin wenxue chubanshe, 1997.

Kono, Kimberly Tae. "Writing Colonial Lineage in Sakaguchi Reiko's 'Tokeiso.'" *The Journal of Japanese Studies* 32, no. 1 (Winter 2006): 83–117.

Kracier, Shelly. Review of *March of Happiness* (at the 1999 Toronto Film Festival). http://www.chinesecinemas.org/marchofhappiness.html.

Kumu Tapas 姑目 荅芭絲. *Buluo jiyi: Wushe shijian de koushu lishi* 部落記憶: 霧社事件的口述歷史 (*Tribal Memories: An Oral History of the Musha Incident*). 2 vols. Taipei: Hanlu, 2004.

K'ung Shang-jen. *The Peach Blossom Fan.* Trans. Chen Shih-hsiang and Harold Action with Cyril Birch. Berkeley: University of California Press, 1976.

LaCapra, Dominick. *Writing History, Writing Trauma.* Baltimore: John Hopkins University Press, 2001.

———. *Representing the Holocaust: History, Theory, Trauma.* Ithaca, NY: Cornell University Press, 1994.

Lai Tse-Han, Ramon H. Myers, and Wei Wou. *A Tragic Beginning: The Taiwan Uprising of February 28, 1947.* Stanford: Stanford University Press, 1991. (Chinese edition: *Beiju xing de kaiduan: Taiwan er er ba shibian.* Taipei: China Times, 1993.)

Lamb, H. K. *A Date with Fate: Hong Kong 1997.* Hong Kong: Lincoln Green, YEAR.

Landy, Maricia, ed. *The Historical Film: History and Memory in Media.* New Brunswick: Rutgers University Press, 2001.

Lang, Miriam. "Taiwanese Romance: San Mao and Qiong Yao." In *The Columbia Companion to Modern East Asian Literature,* ed. Joshua Mostow, 515–519. New York: Columbia University Press, 2003.

Lang Tian. *Hong Kong Cinema Post–1997 (Hou jiuqi yu Xianggang dianying).* Hong Kong: Hong Kong Film Critics Society, 2003.

Langer, Lawrence L. *Art from the Ashes: A Holocaust Anthology.* Oxford: Oxford University Press, 1995.

———. *The Holocaust and the Literary Imagination.* New Haven: Yale University Press, 1975.

Lao Gui 老鬼. *Xue yu tie* 血與鐵 (*Blood and Iron*). Beijing: Zhongguo shehui kexue chubanshe, 1998.

———. *Neimeng caoyuan* 內蒙草原 (*Inner Mongolian Grasslands*). Taipei: Fengyun shidai chuban gongsi, 1989.

———. *Xuese huanghun* 血色黃昏 (*Blood Red Sunset*). Taipei: Fengyun shidai chuban gongsi, 1989.

———. *Zaijian nüshen* 再見女神 (*Farewell Goddess*). Taipei: Fengyun shidai chuban gongsi, 1989.

Lao She. *Rickshaw: The Novel Lo-t'o Hsiang Tzu*. Trans. Jean M. James. Honolulu: University of Hawai'i Press, 1979.

Lee, C. Y. *Gate of Rage*. New York: William Morrow, 1991.

Lee, Hong Yung. *Politics of the Chinese Cultural Revolution: A Case Study*. Los Angeles: University of California Press, 1978.

Lee, Leo Ou-fan. *Shanghai Modern: The Flowering of a New Urban Culture in China 1930–1945*. Cambridge: Harvard University Press, 1999.

———. *Voices from the Iron House: A Study of Lu Xun*. Bloomington: Indiana University Press, 1987.

Lee Wenju 李文茹. "*Wenxue, lishi, xingbie: yi xingbie jiaodu tantao wusheshijian wenxue* 文學,歷史, 性別: 以性別角度探討霧社事件文學" ("Literature, History, and Gender: On Narrative of the Wushe Event Through a Gender Viewpoint"). In *Shanhai de wenxue shijie* 山海的文學世界(*The International Conference on Taiwan Indigenous Literature*). Taipei: Shanhai wenhua, 2005.

Lee, Yungchuan 李泳泉. *Taiwan dianying yuelan* 台灣電影閱覽 (*Taiwanese Cinema: An Illustrated History*). Taipei: Yushan Press, 1998.

Leung, Laifong. *Morning Sun: Interviews with Chinese Writers of the Lost Generation*. Armonk, NY: M.E. Sharpe, 1994.

Levi, Primo. *Survival in Auschwitz*. New York: Touchstone, 1996.

Leys, Ruth. *Trauma: A Genealogy*. Chicago: University of Chicago Press, 2000.

Li Ang 李昂. *Piaoliu zhilu* 漂流之旅 (*A Floating Journey*). Taipei: Crown Books, 2000.

———. *Zizhuan no xiaoshuo* 自傳の小說 (*Autobiography: A Novel*). Taipei: Crown Books, 2000.

Li Ao and Chen Jingchuan. *Ni buzhidao de er er ba: er er ba shijian* 你不知道的二二八: 二二八事件 (*What You Don't Know About 2/28*). Taipei: Xin xinwen wenhua, 1997.

Li Bihua 李碧華 (Lillian Lee). *Yanhua sanyue* 煙華三月 (*The Red String*). Hong Kong: Cosmos Books, 2000.

———. *Tiananmen jiupo xinhun* 天安門舊魄新魂 (*Stories from Tiananmen*). Hong Kong: Cosmos Books, 1990.

Li, Fei Fei, Robert Sabella, and David Liu, eds. *Nanking 1937: Memory and Healing*. Armonk, NY: M. E. Sharpe, 2002.

Li Hanwei 李漢偉. *Taiwan xiaoshuo de sanzhong beiqing* 台灣小說的三種悲情 (*Three Forms of the Tragic in Taiwan Literature*). Banqiao: Luotuo chuban, 1997.

Li Jiang 李江. *Beijing fengbo jishi* 北京風波記實 (*The Truth About the Beijing Turmoil*). Beijing: Beijing Publishing House, 1993.

Li Qiao 李喬. *Wintry Night*. Trans. Taotao Liu and John Balcom. New York: Columbia University Press, 2001.

——. *Maiyuan: 1947: Maiyuan* 埋冤: 1947: 埋冤 (*Burying Injustice: 1947: Burying Injustice*). 2 vols. Jilong: Haiyang Taiwan chubanshe, 1995.

Li Qiao 李喬 and Zheng Qingwen 鄭清文, eds. *Taiwan dangdai xiaoshuo jingxuan:1945–1988* 台灣當代小說精選 (*Selected Works of Contemporary Taiwan Literature: 1945–1988*). 4 vols. Taipei: Xindi, 1989.

Li Ruiteng 李瑞騰, ed. *Kuhan ziyou: Tiananmen yundong yuanshi wenjian shilu* 哭喊自由: 天安門運動原始文件實錄 (*Cries for Freedom: Original Documents from the Tiananmen Movement*). Taipei: Wenxun zazhi she, 1989.

Li Tianze李天鐸, ed. *Dangdai huayu dianying lunshu* 當代華語電影論述 (*Critical Essays on Contemporary Chinese Cinema*). Taipei: China Times, 1996.

Li Yongchi 李永熾. *Buqudeshanyue: Wushe shijian*不屈的山嶽: 霧社事件 (*The Unyielding Mounatins: The Musha Incident*). Taipei: Jindai zhongguo, 1977.

Li Yu 李渝 (Stella Lee). *Stories from Wenzhou Street* 溫州街的故事 (*Wenzhou jie de gushi*). Taipei: Hongfan, 1991.

Lin, Jing. *The Red Guards' Path to Violence: Political, Educational, and Psychological Factors*. New York: Praeger, 1991.

Lin Mushun 林木順, ed. *Taiwan eryue geming*台灣二月革命 (*Taiwan's February Revolution*). Taipei: Qianwei chuban she, 1990.

Lin Nan. *The Struggle for Tiananmen: Anatomy of the 1989 Mass Movement*. London: Praeger, 1992.

Lin Ruiming 林瑞明. "Lun Zhong Zhaozheng de 'Gaoshan zuqu': Chuanzhongdao de zhanhuo "論鐘肇政的'高山組曲': 川中島的戰火" ("On Zhong Zhaozheng's 'Mountain Suite': Flames of War in Chuanzhongdao"). Tainan: National Cheng Kung University. http://email.ncku.edu.tw/~z6908003/art_misc_05.htm.

Lin Shuangbu 林雙不. *The Works of Lin Shuangbu* 林雙不集 (*Lin Shuangbu ji*). Taipei: Qianwei, 1992.

——, ed. *Ere r ba Taiwan xiaoshuo xuan* 二二八台灣小說選 (*A Collection of February 28th Fiction*). Taipei: Zili wanbao she wenhua chuban bu, 1989.

Lin Shuifu 林水福, ed. *Lin Yaode yu xin shidai zuojia wenxue lun* 林燿德與新時代作家文學論(*Critical Essays on Lin Yaode and the New Generation of Taiwanese Writers*). Taipei: Xingzheng Yuan wenhua jianshe weiyuanhui, 1997.

Lin, Sylvia Li-chun. "Two Texts to a Story: White Terror in Taiwan." *Modern Chinese Literature and Culture* 16, no. 1 (Spring 2004).

Lin, Wenchi 林文淇, Shiao-ying Shen 沈曉茵, and Jerome Chenya Li 李振亞. *Xilian rensheng: Hou Xiaoxian dianying yanjiu* 戲戀人生:侯孝賢電影研究 (*Passionate Detachment: Films of Hou Hsiao-hsien*). Taipei: Rye Field, 2000.

Lin Xi 林希. *Baise huajie: Hu Feng fan geming jituan yuanan da jishi* 白色花劫:胡風反革命集團冤案大紀實 (*Record of the Injustices Done to the Hu Feng Counter-Revolutionary Clique*). Wuhan: Changjiang wenyi chuban she, 1999.

Lin Xiaoyun 林小雲, ed. *Ningshi Taiwan: Qidong Taiwan meishu zhong de er er ba yuansu* 凝視台灣:啓動台灣美術中的二二八元素 (*Gazing at Taiwan: Firing up the February 28th Element in Taiwan Art*). Jilong: Haiyang Taiwan chuban, 2002.

Lin Yaode 林燿德. *Yi jiu si qi gaosha baihe* 一九四七高砂百合 (*1947 Lilium formosanum*). Taipei: Unitas, 1990.

Lin Zhengsheng 林正盛. *Weilai, yizhilai yizhilai* 未來, 一直來一直來 (*The Future Keeps Coming and Coming*). Taipei: Unitas, 2001.

Lingmu Zhiyuan 鈴木質原. *Taiwan fanren fengsu zhi* 台灣蕃人風俗誌 (*Record of the Customs and Habits of the Taiwan Savages*). Ed. Lin Chuanfu 林川夫. Taipei: Wuling, 1991.

Link, Perry. *Mandarin Ducks and Butterflies: Popular Fiction in Early Twentieth-Century Chinese Cities.* Berkeley: University of California Press, 1981.

Lipman, Jonathan N. and Steven Harrell, eds. *Violence in China: Essays in Culture and Counterculture.* Albany: SUNY Press, 1990.

Liu Guokai 劉國凱, ed. *Fengsha buliao de lishi* 封殺不了的歷史 (*A History That Cannot Be Silenced*). New York: RERUN, 1996.

Liu, Joyce C. H. "The Gaze of Revolt: Chen Chieh-Jen's Historical Images and His Aesthetic of Horror." 2000. www.srcs.nctu.edu.tw/joyceliu/mworks/mwinterart/GazeOfRevolt/GazeOfRevolt.htm.

Liu, Leo Xi Rang. *Oz Tale Sweet and Sour.* Victoria, Australia: Papyrus Publishing, 2002.

Liu Xiaomeng 劉小萌. *Zhongguo zhiqing koushu shi* 中國知青口述史 (*An Oral History of the Educated Youth in China*). Beijing: Zhongguo shehui kexue chubanshe, 2004.

——. *Zhongguo zhiqing shi: dachao 1966–1980* 中國知青史: 大潮 1966–1980 (*A History of Educated Youth in China: The Great Flood 1966–1980*). Beijing: Zhongguo shehui kexue chubanshe, 1998.

Liu Xiaomeng 劉小萌, Ding Yizhuang 定宜莊, Shi Weimin 史衛民, and He Feng 何嵐. *Zhongguo zhiqing shidian* 中國知青事典 (*Encyclopedia of the Chinese Educated Youth*). Chengdu: Sichuan renmin chubanshe, 1995.

Liu Yichang 劉以鬯. *Yijiujiuqi* 一九九七 (*1997*). Taipei: Yuanjing, 1984.

Long Shong 龍祥國際 International Co. Ltd., ed. *Nanking 1937.* Taipei: Wanxiang tushu, 1995.

Lu Feiyi 盧非易. *Taiwan dianying shehui yu guojia* 台灣電影:政治, 經濟, 美學 1949–1994 (*Taiwan Cinema: Politics, Economics, Aesthetics 1949–1994*). Taipei: Yuanliu, 1998.

Lu Hong 呂紅 and Jiang Xue 姜雪. "Jiedu Lou Ye daoyan de Yiheyuan" 解讀婁燁導演的頤和園("Reading Director Lou Ye's *Summer Palace*"). *Shijie ribao* 世界日報 (*World Journal*), October 29, 2006, 38–40.

Lu Hsun. *Selected Stories of Lu Hsun.* New York: Norton, 1977.

Lu Xun 魯迅. *Lu Xun quanji* 魯迅全集 (*The Complete Works of Lu Xun*). Beijing: Renmin wenxue chubanshe, 2005.

Lu Xinhua, Liu Xinwu, et al. *The Wounded: New Stories of the Cultural Revolution 77–78.* Trans. Geremie Barmé and Bennett Lee. Hong Kong: Joint Publishing, 1979.

Luo Feng 洛楓. *Shengshi bianyuan: Xianggang dianying de xingbie, teji yu jiuqi zhengzhi* 盛世邊緣: 香港電影的性別, 特技與九七政治 (*City on the Edge of Time: Gender, Special Effects, and Handover Politics in Hong Kong Cinema*). Hong Kong: Oxford University Press, 2002.

Ma Bo. *Blood Red Sunset: A Memoir of the Chinese Cultural Revolution.* Trans. Howard Goldblatt. New York: Penguin, 1995.

Ma, Laurence J.C. and Carolyn Carier. *The Chinese Diaspora: Space, Place, Mobility, and Identity.* Lanham, MD: Rowman and Littlefield, 2003.

MacFarquhar, Roderick. *The Origins of the Cultural Revolution.* 3 vols. New York: Columbia University Press, 1997.

Masato Kajimoto. *Online Documentary: The Nanking Atrocities.* M.A. thesis, University of Missouri-Columbia, 2000. http://web,missouri.edu/~jschool/nanking.

Masaaki, Tanaka. *What Really Happened in Nanking: The Refutation of a Common Myth.* Tokyo: Sekai Shuppan, 2000.

McDougall, Bonnie S. and Kam Louie. *The Literature of China in the Twentieth Century.* New York: Columbia University Press, 1997.

McNally, Richard J. *Remembering Trauma.* Cambridge: The Belknap Press of Harvard University Press, 2003.

Mi Zou 迷走 and Liang Xinhua 梁新華. *Xin dianying zhi wai/hou: cong zhongmeiti dao dianying pinglun tizhi* 新電影之外/後: 從眾媒體到電影評論體制 (*Outside/After New Taiwan Cinema*). Taipei: Tonsan Books, 1994.

——. *Xin dianying zhi si: Cong "Yi qie wei mingtian" dao "Beiqing chengshi"* 新電影之死: 從 "一切爲明天" 到 "悲情城市" (*The Death of New Taiwan Film: From Everything Is for Tomorrow to City of Sadness*). Taipei: Tonsan Books, 1991.

Miller, Lucien. *South of the Clouds: Tales from Yunnan.* Seattle: University of Washington Press, 1994.

——. *Exiles at Home: Short Stories by Ch'en Ying-chen.* Ann Arbor: The Center for Chinese Studies, University of Michigan, 1986.

Ming Liguo 明立國. *Taiwan yuanzhuminzu de jili* 台灣原住民族的祭禮 (*Sacrficial Rites Among the Taiwan Aborigine Tribes*). Taipei: Taiyuan chuban, 1989.

Mintz, Alan. *Popular Culture and the Shaping of Holocaust Memory in America.* Seattle: University of Washington Press, 2001.

Morris, David B. *The Culture of Pain.* Berkeley: University of California Press, 1991.

Morrison, Donald, ed. *Massacre in Beijing: China's Struggle for Democracy.* New York: Time Books, 1989.

Morson, Gary Saul and Caryl Emerson. *Mikhail Bakhtin: Creation of a Prosaics.* Stanford: Stanford University Press, 1990.

Morton, Lisa. *The Cinema of Tsui Hark.* Jefferson, NC: McFarland & Co., 2001.

Nishikawa Mitsuru. "Eiren's Fan—An Elegy on the February 28 Incident." *Taiwan Literature: English Translation Series* 13 (July 2003): 59–82.

Oksenberg, Michel, Lawrence R. Sullivan, and Marc Lambert, eds. *Beijing Spring, 1989: Confrontation and Conflict, the Basic Documents.* Armonk, NY: M. E. Sharpe, 1990.

Ong, Aihwa. *Flexible Citizenship: The Cultural Logics of Transnationality*. Durham: Duke University Press, 1999.

Pierce, Steven and Anupama Rao, eds. *Discipline and the Other Body: Correction, Corporeality, Colonialism*. Durham: Duke University Press, 2006.

Ping Lu 平路. *Jinshu qishilu* 禁書啓示錄 (*Revelations on Banned Books*). Taipei: Rye Field, 1997.

Phillips, Steven E. *Between Assimilation and Independence: The Taiwanese Encounter Nationalist China, 1945–1950*. Stanford: Stanford University Press, 2003.

Qian Zhongshu 錢鐘書 (Ch'ien Chung-shu). *Weicheng* 圍城. Beijing: Renmin wenxue chubanshe, 1993.

——. *Fortress Besieged*. Trans. Jeanne Kelly and Nathan K. Mao. Bloomington: Indiana University Press, 1979.

Qiao Liang 喬良. *Mori zhi men* 末日之門 (*The Door of Doomsday*). 2 vols. Taipei: Fengyun shidai chuban, 1996.

Qiu Guifen 邱貴芬. (*Bu*) *tong guo Nüren guocao* (不)同國女人聒噪 (*Interviews with Taiwan Women Writers*). Taipei: Yuanzun wenhua, 1998.

Qiu Ruolong 邱若龍. *Wushe shijian: Taiwan diyibu yuanzhumin diaocha baogao manhua* 霧社事件: 台灣第一部原住民調查報告漫畫 (*Oda mspais alang paran*). Taipei: Yushan she, 2004.

——. *Wushe shijian* 霧社事件: 台灣原住民歷史漫畫 (*The Musha Incident: A Manga History of Taiwan Aborigine History*). Taipei: Caituan faren Taiwan yuanzhumin wenjiao jijinhui, 2001.

Ragland, Ellie. *Essays on the Pleasures of Death: From Freud to Lacan*. London: Routledge, 1995.

Reynaud, Berenice. *A City of Sadness*. London: British Film Institute, 2002.

Riches, David. "Aggression, War, Violence: Space/Time and Paradigm." *Man* 26 (1991): 281–298.

Roberti, Mark. *The Fall of Hong Kong: China's Triumph and Britain's Betrayal*. New York: Wiley, 1994.

Rosebaum, Alan S. *Is the Holocaust Unique? Perspectives on Comparative Genocide*. Boulder: Westview Press, 2001.

Rosenstone, Robert A. *Visions of the Past: The Challenge of Film to Our Idea of History*. Cambridge: Harvard University Press, 1995.

Rothberg, Michael. *Traumatic Realism: The Demands of Holocaust Representation*. Minneapolis: University of Minnesota Press, 2000.

Roy, Denny. *Taiwan: A Political History*. Ithaca, NY: Cornell University Press, 2003.

Ruan Changrui 阮昌銳, Li Zining 李子寧, Wu Bailu 吳佰祿, and Ma Tengyu 馬騰嶽. *Wenmian, guoshou, taiya wenhua* 文面, 馘首,泰雅文化 (*Facial Tattoos, Headhunting, Atayal Culture*). Taipei: Guoli Taiwan bowuguan, 1999.

Ruan Meizhu 阮美姝. *Youan jiaoluo de qisheng: Xunfang er er ba sanluo de yizu* 幽暗角落的泣聲尋訪二二八散落的遺族 (*Cries from a Dark Corner: Interviews with Survivors of the 2/28 Incident*). Taipei: Qianwei chubanshe, 1992.

Ruan Taoyuan 阮桃園. "When the Native Meets Ah Q" ("Dang yuanxiangren yush-ang Ah Q" 當原鄉人遇上阿 Q). In Chinese Department of Donghai University, ed., *Historical Experience in Taiwan Literature* (*Taiwan wenxue zhong de lishi jingyan* 台灣文學中的歷史經驗), 97–153. Taipei: Wenjin chubanshe, 1997.

Salisbury, Harrison E. *Tiananmen Diary: Thirteen Days in June.* Boston: Little, Brown, 1989.

Scarry, Elaine. *Resisting Representation.* Oxford: Oxford University Press, 1994.

——. *The Body in Pain: The Making and Unmaking of the World.* Oxford: Oxford University Press, 1987.

Schaefer, Eric. *"Bold! Daring! Shocking! True!" A History of Exploitation Films, 1919–1959.* Durham: Duke University Press, 1999.

Schwartz, Vera. *Bridge Across Broken Time: Chinese and Jewish Cultural Memory.* New Haven: Yale University Press, 1998.

Scott, Justin. *The Nine Dragons: A Novel of Hong Kong 1997.* New York: Bantam, 1991.

Sekine, Ken. "A Verbose Silence in 1939 Chongqing: Why Ah Long's *Nanjing* Could Not Be Published." Modern Chinese Literature and Culture Resource Center, 2004. http://mclc.osu.edu/rc/pubs/sekine.htm.

Sharrett, Christopher, ed. *Mythologies of Violence in Postmodern Media.* Detroit: Wayne State University Press, 1999.

Shen Tong with Marianne Yen. *Almost a Revolution: The Story of a Chinese Student's Journey from Boyhood to Leadership in Tiananmen Square.* New York: Houghton Mifflin, 1990.

Shen Ts'ung-wen (Shen Congwen). *The Chinese Earth.* Trans. Ching Ti and Robert Payne. New York: Columbia University Press, 1982.

Shi Donglang 史東朗 (Shiro, Azuma). *Shidong Lang riji* 史東朗日記 (*The Diary of Azuma Shiro*). Nanjing: Jiangsu jiaoyu chubanshe, 1999.

Si Fu 斯夫, et al. *1937–1938 Nanjing zhengfu da chetui 1937–1938* 南京政府大撤退 (*1937–1938 The Nanjing Government's Great Retreat*). Beijing: Tuanjie chuban she, 1998.

Silbergeld, Jerome. *Hitchcock with a Chinese Face: Cinematic Doubles, Oedipal Triangles, and China's Moral Voice.* Seattle: University of Washington Press, 2004.

——. *China Into Film: Frames of Reference in Contemporary Chinese Cinema.* London: Reaktion Books, 1999.

Singer, Martin. *Educated Youth and the Cultural Revolution in China.* Ann Arbor: University of Michigan Press, 1971.

Slocum, J. David. *Violence and American Cinema.* New York: Routledge, 2001.

Song Guanghui 宋廣輝 and Huai Nan 淮南, eds. *Wang Xiaobo menxia zougou* 王小波門下走狗 (*Running Dogs Outside Wang Xiaobo's Door*). Beijing: Wenhua yishu chubanshe, 2002.

Song Zelai 宋澤萊. *The Works of Song Zelai* 宋澤萊集 (*Song Zelai ji*). Taipei: Qianwei, 1992.

Sontag, Susan. *Regarding the Pain of Others.* New York: Picador, 2004.

——. *On Photography*. New York: Dell, 1973.

Spence, Jonathan D. *God's Chinese Son: The Taiping Heavenly Kingdom of Hong Xiuquan*. New York: Norton, 1996.

——. *The Gate of Heavenly Peace: The Chinese and Their Revolution 1895–1980*. New York: Penguin, 1982.

Stokes, Lisa Odham and Michael Hoover. *City on Fire: Hong Kong Cinema*. London: Verso, 1999.

Struve, Lynn A., ed. and trans. *Voices from the Ming-Qing Cataclysm: China in Tigers' Jaws*. New Haven: Yale University Press, 1993.

Su Xiaokang 蘇曉康. *A Memoir of Misfortune* (English translation of *Lihun lijie zixu*). Trans. Zhu Hong. New York: Knopf, 2001.

——. *Lihun lijie zixu* 離魂歷劫自序. Taipei: China Times, 1997.

Sullivan, Lawrence R., ed. *China Since Tiananmen: Political, Economic, and Social Conflicts*. Armonk, NY: M. E. Sharpe, 1995.

Sun Zhaiwei 孫宅魏. *Yijiusanqi nanjing beige: rijun tusha lu* 一九三七南京悲歌: 日軍屠殺錄 (*1937 Nanjing Elegy: Record of Atrocities Committed by the Japanese Army*). Taipei: Taiwan xianzhi chuban shiye gufen youxiangongsi, 1995.

Syat, Tabu, Xu Shijie 許世楷, and Shi Zhengfeng 施正鋒, eds. *Wushe shijian: Taiwanren de jiti jiyi* 霧社事件: 台灣人的集體記憶 (*The Musha Incident: The Collective Memory of the Taiwan People*). Taipei: Qianwei, 2001.

Tahuda, Michael. *Hong Kong: China's Challenge*. London: Routledge, 1996.

Tal, Kalí. *Worlds of Hurt: Reading the Literatures of Trauma*. Cambridge: Cambridge University Press, 1996.

Tanaka, Yuki. *Hidden Horrors: Japanese War Crimes in World War II*. Foreword by John W. Dower. Boulder: Westview Press, 1996.

Tang Meiru 湯美如, ed. *Nanjing yijiusanqi nian shier yue zhi yijiusanba nian wu yue* 南京一九三七年十二月至一九三八年五月 (*Nanjing December 1937–May 1938*). Hong Kong: Joint Publishing, 1995.

Thomas, Gordon. *Chaos Under Heaven: The Shocking Story Behind China's Search for Democracy*. New York: Birch Lane Press, 1991.

Till, Barry, with the assistance of Paula Swart. *In Search of Old Nanking*. Hong Kong: Joint Publishing, 1984.

Various authors. *Taiwan xin dianying ershi nian* 台灣新電影二十年 (*20th Anniversary of Taiwanese New Cinema*). Taipei: Taipei Golden Horse Special Programs Publication, 2002.

——. *Hou Hsiao-hsien* 侯孝賢. Taipei: Chinese Taipei Film Archive, 2000.

——. *"Labei riji" faxian shimo* "拉貝日記" 發現始末 (*The Full Story About the Discovery of the* Diary of John Rabe). Nanjing: Qinhua rijun Nanjing datusha yunan tongbao jinian guan, 1997.

——. *Nanjing bainian fengyun 1840–1949* 南京百年風雲 1840–1949 (*Nanjing, a Hundred Years of Change 1840–1949*). Nanjing: Nanjing chubanshe, 1997.

——. *Riben diguozhuyi qinhua dang'an ziliao xuanbian: Nanjing datusha* 日本帝國主義侵華檔案資料選編: 南京大屠殺 (*A Selection of Archival Materials Relating to the Japanese Imperialists' Invasion of China: Nanjing Massacre*). Vol. 12. Beijing: Zhonghua shuju, 1995.

——. *Xunzhao dianying zhong de Taibei 1950–1990* 尋找電影中的台北 *1950–1990* (*Focus on Taipei Through Cinema 1950–1990*). Taipei: Golden Horse Special Programs Publication, 1995.

——. *Zhiqing dangan 1962–1979: zhishi qingnian shangshan xiaxiang jishi* 知青檔案 *1962–1979:* 知識青年上山下鄉紀實 (*Educated Youth Files 1962–1979: Record of the Educated Youth Rustification Movement*). Chengdu: Sichuan wenyi chubanshe, 1992.

——. *Tiananmen yijiubajiu* 天安門一九八九 (*Tiananmen 1989*). Taipei: Lianjing, 1989.

——. *Xuechao, dongluan, baoluan* 學潮, 動亂, 暴亂 (*Student Demonstrations, Disturbances, Riots*). Chengdu: Sichuan renmin chubanshe, 1989.

——. *Yuanzhumin: Bei yabozhe de nahan* 原住民: 被壓迫者的吶喊 (*Aborigines: Cry of the Oppressed*). Taipei: Taiwan yuanzhuminzu quanli cujin hui, 1987.

——. *Gaoshan zu jianshi* 高山族簡史 (*A Short History of the Mountain People*). Fujian: Fujian renmin chubanshe, 1982.

——. *Qinhua rijun nanjing datusha baoxing zhaopian ji* 侵華日軍南京大屠殺暴行照片集 (*A Photo Group Reflecting the Japanese Army's Massacre of Nanjing People*). No. 2 History Archives of China, Nanjing Archives. Nanjing: The Editorial Board of Historical Data of Nanjing Massacre. 1992.

Vickroy, Laurie. *Trauma and Survival in Contemporary Fiction*. Charlottesville: University of Virginia Press, 2002.

Walker, Janet. *Trauma Cinema: Documenting Incest and the Holocaust*. Berkeley: University of California Press, 2005.

Wang, Annie. *Lili: A Novel of Tiananmen*. New York: Pantheon, 2001.

Wang Dan 王丹 et al. *Recollections of June 4 Participants* 六四參與者回憶錄 (*Liu si canyu zhe huiyilu*). New York: Mirror Books, 2004.

Wang, David Der-wei. *The Monster That Is History: History, Violence, and Fictional Writing in Twentieth-Century China*. Berkeley: University of California Press, 2004.

——. *Fin-de-Siècle Splendor: Repressed Modernities of Late Qing Fiction, 1848–1911*. Stanford: Stanford University Press, 1997.

——. *Fictional Realism in Twentieth-Century China: Mao Dun, Lao She, Shen Congwen*. New York: Columbia University Press, 1993.

Wang, David Der-wei and Carlos Rojas, eds. *Writing Taiwan: A New Literary History*. Durham: Duke University Press, 2007.

Wang, David Der-wei and Jeanne Tai, eds. *Running Wild: New Chinese Writers*. New York: Columbia University Press, 1994.

Wang Dewei 王德威 (Wang, David Der-wei). "Xuyan: Yange xing: Ye Zhaoyan de

xinpai renqing xiaoshuo." "序言:艷歌行:葉兆言的新派人情小說" ("Introduction: YE Zhao's New Humanistic Fiction"). In Ye Zhaoyan, *Huasha* 花煞. Taipei: Maitian chuban, 1998.

Wang Huo 王火. *Zhanzheng he ren* 戰爭和人 (*People and War*). 3 vols. Beijing: Renmin wenxue chubanshe, 1993.

Wang, Jing. *High Culture Fever: Politics, Aesthetics, and Ideology in Deng's China*. Los Angeles: University of California Press, 1996.

Wang Mingjian 王鳴劍. *Shangshan xiaxiang* 上山下鄉 (*Up to the Mountains, Down to the Countryside*). Beijing: Guangming ribao chubanshe, 1998.

Wang Xiaobo 王小波. *The Golden Age*. Trans. Hongling Zhang. Unpublished manuscript, 2004.

——. *Huangjin shidai* 黃金時代 (*The Golden Age*). Guangzhou: Huacheng chubanshe, 1997.

——. *Huangjin niandai* 黃金年代 (*The Golden Years*). Taipei: Lianjing, 1992.

Wang Yi 王毅, ed. *Bu zai chenmo: Renwenxuezhe lun Wang Xiaobo* 不再沉默:人文學者論王小波 (*No Longer Silent: Humanities Scholars on Wang Xiaobo*). Beijing: Guangming ribao chubanshe, 1998.

Wang Youqin 王友琴. *Victims of the Cultural Revolution: An Investigative Account of Persecution, Imprisonment, and Murder* (*Wenge shounanzhe: Guanyu pohai, jianjinyushalu de xunfang shilu* 文革受難者:關於迫害, 監禁與殺戮的尋訪實錄). Hong Kong: Kaifang zazhi she, 2004.

Weber, Olivier. "Interview: Lou Ye." In *Summer Palace Press Kit* prepared by Wild Bunch, 2006.

Wei Desheng 魏德聖 (original screenplay), Yan Yunnong 嚴云農 (novel). *Saideke Balai* 賽德克巴萊 (*Seediq Bale*). Taipei: Crown, 2004.

Wei Shaochang 魏紹昌, ed. *Yuanyang hudie pai yanjiu ziliao* 鴛鴦蝴蝶派研究資料 (*Research Materials on the Mandarin Duck and Butterfly School*). Hong Kong: Sanlian shudian, 1980.

Weissman, Gary. *Fantasies of Witnessing: Postwar Efforts to Experience the Holocaust*. Ithaca, NY: Cornell University Press, 2004.

Weller, Robert P. *Resistance, Chaos, and Control in China: Taiping Rebels, Taiwanese Ghosts, and Tiananmen*. Seattle: University of Washington Press, 1994.

West, Paul. *The Tent of Orange Mist: A Novel*. New York: Scribner, 1995.

Wickery, Erwin, ed. *The Good German of Nanking: The Diaries of John Rabe*. Trans. John E. Woods. London: Little, Brown, 1999.

Wong, Edward. "An Indelible Massacre, Unrolling Like a Movie." *The New York Times*, June 3, 2000.

Wood, Miles. *Cine East: Hong Kong Cinema Through the Looking Glass*. Surrey, England: FAB Press, 1998.

Wu Guangyi 吳廣義. *Dong Shilang sugongan yu Nanjing datusha zhenxiang* 東史郎訴公訟案與南京大屠殺真相 (*The Case of Azuma Shiro and the Truth Behind the Rape of Nanjing*). Beijing: Renmin chuban she, 1998.

Wu He 舞鶴. *Remains of Life* (excerpt). *Taiwan Literature: English Translation Series* 13 (July 2003): 85–102.

——. *Sadness* 悲傷 (*Beishang*). Taipei: Rye Field, 2001.

——. *Guier yu Ayao* 鬼兒與阿妖 (*Ghost and Goblin*). Taipei: Rye Field, 2000.

——`. *Yu sheng* 餘生 (*Remains of Life*). Taipei: Rye Field, 1999.

——. *Sisuo Abang Kalusi* 思索阿邦·卡露斯 (*Meditations on Ah Bang and Kalusi*). 1997; reprint, Taipei: Rye Field, 2002.

——. *Shi gu* 拾骨(*Excavating Bones*). Gaoxiong: Chunye chubanshe, 1995.

Wu Hung. *Remaking Beijing: Tiananmen Square and the Creation of a Political Space.* Chicago: University of Chicago Press, 2005.

Wu Hung and Christopher Phillips. *Between Past and Future: New Photography and Video from China.* Gottingen: Steiddl Publishers, 2004.

Wu Jianren 吳趼人. *Wu Jianren xiaoshuo sizhong* 吳趼人小說四種 (*Four Novels by Wu Jianren*). 2 vols. Changchun: Jilin wenshi chubanshe, 1986.

——. *Tong shi* 痛史 (*A History of Pain*). Hong Kong: Zhonghua shuju, 1959.

Wu Jinfa 吳錦發, ed. *Beiqing de shanlin: Taiwan shandi xiaoshuo xuan* 悲情的山林: 台灣山地小說選 (*The Forest of Sadness: A Selection of Aborigine Fiction from Taiwan*). Taizhong: Chenxing chuban, 1987.

Wu Nianzhen 吳念真 and Zhu Tianwen 朱天文. *A City of Sadness* 悲情城市 (*Beiqing chengshi*). Taipei: San san shufang, 1989.

Wu, Wo-yao. *Vignettes from the Late Ch'ing: Bizarre Happenings Eyewitnessed Over Two Decades.* Trans. with an introduction by Shih Shun Liu. Hong Kong: Chinese University Press, 1975.

Wu Yongfu 巫永福. *Wushe feiying* 霧社緋櫻 (*Sakura of Musha*). Taipei: Lishi kanwu, 1990.

Wu Zhuoliu 吳濁流. *The Fig Tree: Memoirs of a Taiwanese Patriot.* Trans. Duncan Hunter, with commentaries by Helmut Martin and Jean-Pierre Cabestan. Bloomington: 1st Books Library, 2002.

——. *Wu huaguo* 無花果 (*The Fig Tree*). Taipei: Caogen chuban shiye youxian gongsi, 1995.

——. *Yaxiya de guer* 亞西亞的孤兒 (*The Orphan of Asia*). Taipei: Caogen chuban shiye youxian gongsi, 1995.

Xi Xi. *Flying Carpet: A Tale of Fertillia.* Trans. Diana Yue. Hong Kong: Hong Kong University Press, 2000.

——. *Marvels of a Floating City and Other Stories.* Ed. Eva Hung. Hong Kong: Renditions Paperbacks, 1997.

Xiao Jian 曉劍. *Zhongguo zhiqing zai haiwai* 中國知青在海外 (*Chinese Educated Youths Abroad*). Beijing: Zuojia chubanshe, 1993.

Xie Bizhen 謝肇禎. *Qunyu luanwu: Wu He xiaoshuo zhong de xing zhengzhi* 群慾亂舞: 舞鶴小說中的性政治 (*The Chaotic Dance of Myriad Desires: Sexual Politics in the Fiction of Dancing Crane*). Taipei: Rye Field, 2003.

Xin Ping 忻平. *1937: Shenzhong de zainan yu lishi de zhuanzhe 1937:* 深重的災難與歷

史的轉折 (*1937: Terrible Atrocities and Historical Turns*). Shanghai: Shanghai ren-
min chubanshe, 1999.

Xu Junya 許俊雅, ed. *Wuyu de chuntian: Er er ba xiaoshuo xuan* 無語的春天: 二二八
小說選 (*A Spring of Silence: A Selection of February 28 Fiction*). Taipei: Yushan she,
2003.

Xu Xi (Sussy Komala). *History's Fiction: Stories from the City of Hong Kong*. Hong
Kong: Chameleon Press, 2001.

——. *The Unwalled City: A Novel of Hong Kong*. Hong Kong: Chameleon Press,
2001.

Xu Xiuzhen 許琇禎. *Taiwan dangdai xiaoshuo zonglun: jieyan qianhou 1977–1997* 台灣
當代小說總論: 解嚴前後 *1977–1997* (*Study of Contemporary Taiwan Literature:
Before and After the Lifting of Martial Law 1977–1997*). Taipei: Wunan tushu, 2001.

Xu Zhigeng 徐志耕. *Nanjing datusha* 南京大屠殺 (*The Nanjing Massacre*). Beijing:
Jiefangjun wenyi chubanshe, 1997.

——. *Lest We Forget: Nanjing Massacre, 1937*. Beijing: Chinese Literature Press (Panda
Books), 1995.

Xu Zidong 許子東. *Wei le wangque de jiti jiyi: Jiedu 50 pian wenge xiaoshuo* 爲了忘卻
的集體記憶: 解讀 50 篇文革小說 (*In Order to Forget the Collective Memory: Read-
ing Fifty Works of Cultural Revolution Fiction*). Beijing: Sanlian, 2000.

Xue Bing 薛冰. *Jia zhu liuchao yanshui jian: Nanjing* 家住六朝煙水間: 南京 (*Home Is
Between the Smoke and Water of the Six Dynasties: Nanjing*). Shanghai: Shanghai
guji chubanshe, 2000.

Yamamoto, Masahiro. *Nanking: Anatomy of an Atrocity*. Westport, CT: Praeger, 2000.

Yan Jiaqi and Gao Gao. *Turbulent Decade: A History of the Cultural Revolution*. Trans.
and ed. D. Y. Kwok. Honolulu: University of Hawai'i Press, 1996.

Yan Jiayan 嚴家炎. *Shiji de zuyin* 世紀的足音 (*The Last Sounds of the Century*). Hong
Kong: Tiandi tushu, 1995.

Yang Jian 楊建. *Zhongguo zhiqing wenxue shi* 中國知青文學史 (*A Literary History of
China's Educated Youths*). Beijing: Zhongguo gongren chubanshe, 2002.

Yang Kelin 楊克林. *Wenhua da geming bowuguan 1966–1976* 文革大革命博物館
1966–1976 (*Cultural Revolution Museum 1966–1976*). Hong Kong: Tiandi tushu
youxian gongsi, 2003.

Yang, Lan. *Chinese Fiction of the Cultural Revolution*. Hong Kong: Hong Kong Univer-
sity Press, 1998.

Yang, Xiaobin. *The Chinese Postmodern: Trauma and Irony in Chinese Avant-Garde Fic-
tion*. Ann Arbor: University of Michigan Press, 2002.

Yang Yidan 楊逸舟. *Er er ba minbian: Taiwan yu Jiang Jieshi* 二二八民變: 台灣與蔣
介石 (*The February 28th People's Uprising: Taiwan and Chiang Kai-shek*). Trans.
Zhang Liangze. Taipei: Qianwei chuban she, 1991.

Yang Zhao 楊照. "Yi jiu ba jiu" "一九八九" ("1989"). *Ink Literary Monthly* (September
2003):216–233.

——. *An hun* 暗魂 (*Dark Souls*). Taipei: Crown, 1993.

Yao Biyang. *China's Secrets and Hong Kong's Future.* New York: Vantage Press, 1995.

Yao Jiawen 姚嘉文. *Wushe renzhiguan* 霧社人止關 (*The Limits and the Gate*). Taipei: Qianwei, 2006.

Yao Xinyong 姚新勇. *Zhuti de suzao yu bianqian: Zhongguo zhiqing wenxue xin lun (1977–1995 nian)* 主題的塑造與變遷: 中國知青文學新論 (*1977–1995* 年) (*The Formation and Transformation of the Subject: New Discourse on Chinese Educated Youth Literature [1977–1995]*). Guangdong: Jinan daxue chubanshe, 2000.

Ye Longyan 葉龍彥. *Chunhua menglu: Zhengzong taiyu dianying xingshuai lu* 春花夢露:正宗台語電影興衰錄 (*History of Taiwanese Movies During the Japanese Colonial Period*). Taipei: Boyang wenhua, 1999.

Ye Shitao 葉石濤. *Jian Ahtao, A Taiwan Man* 台灣男子簡阿淘 (*Taiwan nanzi jian ahtao*). Taipei: Caogen, 1994.

——. *Taiwan wenxue de beiqing* 台灣文學的悲情 (*The Tragic in Taiwan Literature*). Gaoxiong: Baise wenhua chubanshe, 1990.

Ye Si 也斯. *Jiyi de changshi, xugou de changshi* 記憶的城市, 虛構的城市 (*Cities of Memory, Cities of Fabrication*). Oxford: Oxford University Press, 1993.

Ye Shengtao 葉聖陶. *Schoolmaster Ni Huan-chih.* Trans. A. C. Barnes. Peking: Foreign Languages Press, 1958.

Ye Xin 葉辛. *Ye Xin wenji* 葉辛文集 (*The Collected Works of Ye Xin*). 10 vols. Nanjing: Jiangsu wenyi chubanshe, 1996.

Ye Zhaoyan 葉兆言. *Nanjing 1937: A Love Story.* Trans. with an introduction by Michael Berry. New York: Columbia University Press, 2002.

——. "Weicheng li de xiaosheng" "圍城裡的笑聲" ("Laughter in the Fortress Besieged"). *Shouhuo* (*Harvest*) 4 (2000).

——. *Lao Nanjing* 老南京 (*Old Nanjing*). Nanjing: Jiangsu wenyi chubanshe, 1998.

——. *Nanjing ren* 南京人 (*Nanjing People*). Hangzhou: Zhejiang renmin chubanshe, 1997.

——. *Yijiusanqinian de aiqing* 一九三七年的愛情 (*Nanjing 1937: A Love Story*). Nanjing: Jiangsu wenyi chubanshe, 1996.

——. *Yebo Qinhuai* 夜泊秦淮 (*Evening Moor on the Qinhuai*). Taipei: Yuanliu chuban gongsi, 1992.

Yi Mu and Mark V. Thompson. *Crisis at Tiananmen: Reform and Reality in Modern China.* San Francisco: China Books and Periodicals, 1989.

Yin Jijun 尹集鈞. *1937, Nanjing da jiuhuan: Xifang renshi he guoji anquanqu* 1937, 南京大救緩: 西方人士和國際安全區 (*1937, The Great Rescue of Nanjing: Westerners and the International Safety Zone*). Shanghai: Wenhui chubanshe, 1997.

Yin, James (Yin Jijun) and Shi Young. *The Rape of Nanjing: An Undeniable History in Photographs.* Chicago: Innovative Publishing Group, 1996.

Yoshida, Takashi. *The Making of the "Rape of Nanking": History and Memory in Japan, China, and the United States.* Oxford: Oxford University Press, 2006.

Young, James E. *At Memory's Edge: After-Images of the Holocaust in Contemporary Art and Architecture.* New Haven: Yale University Press, 2000.

——. *Writing and Rewriting the Holocaust: Narrative and the Consequences of Interpretation*. Bloomington: Indiana University Press, 1988.

Yu Guangyuan 於光遠. *Wenge zhong de wo* 文革中的我 (*Me During the Cultural Revolution*). Shanghai: Shanghai yuandong chuban, 1995.

Yu Yingshi 余英時, Bao Zunxin 包遵信, et al. *Cong wusi dao xin wusi* 從五四到新五四 (*From May Fourth to the New May Fourth*). Ed. Zhou Yangshan. Taipei: China Times, 1989.

Yue, Gang. *The Mouth That Begs: Hunger, Cannibalism, and the Politics of Eating in Modern China*. Durham: Duke University Press, 1999.

Zelizer, Barbie. *Remembering to Forget: Holocaust Memory Through the Camera's Eye*. Chicago: University of Chicago Press, 1998.

Zeng Jianmin 曾健民, ed. *Xin er er ba shixiang: zuixin chutu shijian xiaoshuo, shi, baodao, pinglun* 新二二八史像: 最新出土事件,詩,報導,評論 (*New Historical Portrait of 2/28: Newly Unearthed Fiction, Poetry, Reports and Criticism of the Incident*). Taipei: Taiwan shehui kexue chubanshe, 2003.

Zeng Jianmin 曾健民, Heng Digang 橫地剛, Lan Bozhou 藍博洲, eds. *Wenxue er er ba* 文學二二八 (*Literature 2/28*). Taipei: Taiwan shehui kexue chubanshe, 2004.

Zeng Zhizhong and You Dechan, eds. *Huang Shang shuo Nanjing* (*Huang Shang Speaks About Nanjing*). Chengdu: Sichuan wenyi chubanshe, 2001.

Zhang Henshui 張恨水. *Shanghai Express*. Trans. William A. Lyell. Honolulu: University of Hawai'i Press, 1997.

——. *Shenye chen* 深夜沉 (*Deep in the Night*). Shanxi: Beiyao wenyi chubanshe, 1994.

Zhang Kaiyuan. *Eyewitnesses to Massacre: American Missionaries Bear Witness to Japanese Atrocities in Nanjing*. Armonk, NY: M. E. Sharpe, 2001.

Zhang Junxiang 張駿祥 and Cheng Jihua 程季華, eds. *Zhongguo dianying da cidian* 中國電影大辭典 (*China Cinema Encyclopedia*). Shanghai: Shanghai Cishu Publishing House, 1997.

Zhang Kai 張凱 and Ji Yuan 紀元. *You shuo "lao san jie"* 又說"老三屆" (*More on the Three Graduating Classes*). Beijing: Zhongguo qingnian chubanshe, 1997.

Zhang Liang, comp., Andrew J. Nathan and Perry Link, eds. *The Tiananmen Papers*. New York: Public Affairs, 2001.

Zhang Ping 張平. *Jueze* 抉擇 (*Decision*). Beijing: Qunzhong chubanshe, 2001.

Zhang Shenqie 張深切. *Zhang Shenqie quanji juan 8: Biandi hong: Wushe shijian (yingju xiaoshuo) Hunbian (yingju jiaoben)* 張深切全集卷 8: 遍地紅 – 霧社事件 (影劇小說) 婚變 (影劇腳本) (*The Complete Works of Zhang Shenqie, Vol. 8*). Taipei: Wenjing chubanshe, 1998.

Zhang Suzhen 張素貞. "Saomiao erer ba de jiti jiyi: Wu He de 'Diaocha: Xushu'" "掃描二二八的集體記憶: 舞鶴的 '調查:敘述'" ("Scanning the Collective Memory of the February 28th Incident: Wu He's 'Investigation: A Narrative'"). *Zhongyang ribao*, March 16, 2002.

Zhang Wenjiang 張文江. *Suzao babi ta de zhizhe: Qian Zhongshu zhuan* 塑造巴比塔的智者:錢鐘書傳 (*A Biography of Qian Zhongshu*). Shanghai: Shanghai wenyi chubanshe, 1993.

Zhang Xiguo 張系國. *Qi wang* 棋王 (*Chess King*). Taipei: Hongfan, 1978.

Zhang Xuan 張煊, ed. *Wan zhong wei shei er ming: Wu Ziniu* 晚鐘爲誰而鳴: 吳子牛 (*For Whom the Evening Bell Tolls: Wu Ziniu*). Changsha: Hunan Arts and Literature Publishing House, 1996.

Zhang, Xudong. *Chinese Modernism in the Era of Reforms: Cultural Fever, Avant-Garde Fiction, and the New Chinese Cinema*. Durham: Duke University Press, 1997.

Zhang, Yingjin and Xiao, Zhiwei. *Encyclopedia of Chinese Film*. New York: Routledge, 1998.

Zhao, Dingxin. *The Power of Tiananmen: State-Society Relations and the 1989 Beijing Student Movement*. Chicago: University of Chicago Press, 2001.

Zhao Lihong 趙麗宏. *Daoren biji: Wenge shehui shitai lu* 島人筆記: 文革社會世態錄 (*Islander's Notebook: Record of Social Attitudes During the Cultural Revolution*). Shanghai: Zhishi chubanshe, 1993.

Zheng Mingli 鄭明娳 (Cheng Ming-lee). *Dangdai Taiwan zhengzhi wenxue lun* 當代台灣政治文學論 (*Politics and Contemporary Taiwanese Literature*). Taipei: China Times, 1994.

Zhongchuan Haoyi 中川浩一 (Nakagawa Kóichi) and Gesen Minnan 和歌森民男 (Wakamori Tamio), eds. *Wushe shijian: Tufa de da beiju* 霧社事件: 突發的大悲劇 (*The Musha Incident: A Great Tragedy Out of Nowhere*). Taipei: Wuling, 1997.

Zhongdao Lilang, ed. *New Taiwan Literature and Lu Xun* (*Taiwan xin wenxue yu Lu Xun* 台灣新文學與魯迅). Taipei: Qianwei, 1999.

Zhongyang yanjiuyuan jindaishi yanjiu suo 中央研究院近代史研究所 (Academia Sinica Institute of Modern History), eds. *Er er ba shijian ziliao xuanji* 二二八事件資料選集 (*Selection of Historical Documents on the February 28th Incident*). Taipei: Zhongyang yanjiuyuan jindaishi yanjiu suo, 1992.

Zhong Zhaozheng 鐘肇政. *Zhong Zhaozheng quanji 7* 鐘肇政全集 7 (*The Complete Works of Zhong Zhaozheng, Vol. 7*). Taoyuan: Taoyuan xianli wenhua zhongxin, 2000.

——. *Zhong Zhaozheng quanji 9* 鐘肇政全集 9 (*The Complete Works of Zhong Zhaozheng, Vol. 9*). Taoyuan: Taoyuan xianli wenhua zhongxin, 2000.

——. *Zhong Zhaozheng quanji 30* 鐘肇政全集 30 (*The Complete Works of Zhong Zhaozheng, Vol. 30*). Taoyuan: Taoyuan xianli wenhua zhongxin, 2000.

——. *Zhong Zhaozheng quanji 31* 鐘肇政全集 31 (*The Complete Works of Zhong Zhaozheng, Vol. 31*). Taoyuan: Taoyuan xianli wenhua zhongxin, 2000.

Zhou Erfu 周而復. *Zhou Erfu: Liushi nian wenyi manbi* 周而復:六十年文藝漫筆 (*Zhou Erfu: Sixty Years of Random Essays on Art and Literature*). Beijing: Zhongguo gongren chubanshe, 1997.

——. *Langtao sha* 浪濤沙. Beijing: Dangan chubanshe, 1991.

——. *Nanjing de xianluo* 南京的陷落 (*The Fall of Nanjing*). Beijing: People's Literature Publishing House, 1988.

——. *Wenxue de tansuo* 文學的探索 (*Literary Exploration*). Changsha: Hunan renmin chubanshe, 1984.

——. *Huainian ji* 懷念集 (*Collection of Reminiscences*). Beijing: Renmin wenxue chubanshe, 1983.

Zhu Chengshan 朱成山, ed. *Qinhua rijun nanjing datusha yanjiu chengguo jiaoliu hui lunwenji* 侵華日軍南京大屠殺研究成果交流會論文集 (*A Collection of Essays from the Research Conference on the History of the Rape of Nanjing Committed by the Invading Japanese Army*). Hefei: Anhui daxue chubanshe, 1999.

——. *Qinhua rijun nanjing datusha waiji renshi zhengyan ji* 侵華日軍南京大屠殺外籍人士證言集 (*A Collection of Testimonies by Foreigners About the Rape of Nanjing Committed by the Invading Japanese Army*). Nanjing: Jiangsu renmin chubanshe, 1998.

——. *Jinling Xuelei* 金陵血淚 (*Jinling Blood and Tears*). Nanjing: Nanjing chubanshe, 1997.

——. *Qinhua rijun nanjing datusha xingcunzhe zhengyan ji* 侵華日軍南京大屠殺倖存者證言集 (*A Collection of Testimonies by Survivors of the Rape of Nanjing Committed by the Invading Japanese Army*). Nanjing: Nanjing daxue chubanshe, 1994.

Zhu Shuangyi 朱雙一. *Zhanhou taiwan xin shidai wenxue lun* 戰後台灣新時代文學論 (*Critical Survey of Post-War Taiwan Literature*). Taipei: Yangzhi wenhua, 2002.

Zhu Tianwen 朱天文 (Chu Tien-wen). *Beiqing chengshi* 悲情城市 (*A City of Sadness*). Shanghai: Shanghai wenyi chuban she, 2001.

Cai Chonglong 蔡崇隆 and Lu Kaisheng 陸凱聲 (directors). *Qiji beihou* 奇蹟背後 (*Behind the Miracle*). Taipei: Gongshi, 2002.

Chan, Evans 陳耀成 (director). *Cuo ai* 錯愛 (*Crossings*). New York: Riverdrive Productions, 1994.

——. *Fushi lianqu* 浮世戀曲 (*To Liv[e]*). New York: Riverdrive Productions, 1992.

Chan, Fruit 陳果 (director). *Xianggang zhizao* 香港製造 (*Made in Hong Kong*). Hong Kong: Nicetop Independent/Teamwork Production House, 1997.

Chan, Peter 陳可辛 (director). *Tian mimi* 甜蜜蜜 (*Comrades, Almost a Love Story*). Hong Kong: Golden Harvest/United Filmmakers Organization/Golden Movies International, 1996.

Chen Chieh-jen 陳界仁 (director). *Jiagong chang* 加工廠 (*Factory*). Taipei: Chen Studio, 2003.

——. *Lingchi kao* 凌遲考 (*Lingchi: Echoes of a Historical Photograph*). Taipei: Chen Studio, 2002.

Chen Guoxing 陳國星 (director). *Jueze* 抉擇 (*Decision*). Beijing: Beijing Jinyingma yingshi wenhua, Beijing Film Studio, Liaoning dianshi tai, and Zhongguo jiancha ribao shitianzheng yingshi, 1998.

Chen Kaige 陳凱歌 (director). *Haizi wang* 孩子王 (*King of the Children*). Xi'an: Xi'an Film Studio, 1987.

——. *Menghuan buluo* 夢幻部落 (*Somewhere Over the Dreamland*). Taipei, 2002.

Choy, Christine 崔明慧 and Nancy Tong 湯美如 (directors). *In the Name of the Emperor* (奉天皇之命). New York: Film News Now Foundation, AMVNM, 1995.

Dai Sijie 戴思杰 (director). *Xiao cai feng* 小裁縫 (*The Little Chinese Seamstress*). Paris: TFI International/China Films, 2003.

——. *China, My Sorrow*. Paris: Flach Film, 1989.

Fong, Allen 方育平 (director). *Meiguo xin* 美國心 (*Just Like Weather*). Hong Kong: Sil-Metropole Organization, 1986.

Gao Qunshu 高群書 (director). *Dongjing shenpan* 東京審判 (*The Tokyo Trial*). Shanghai: Shanghai dianying jituan gongsi, 2006.

Gordon, Richard, and Carma Hinton (producers and directors). *The Gate of Heavenly Peace*. Brookline, MA/Hong Kong: Long Bow and Shu Kei's Creative Workshop, 1995.

Guo Daqun 郭大群 (director). *Zhiming de chengnuo* 致命的承諾 (*Fatal Promise*). Hubei: Hubei dianying zhipianchang and Hubei taiyue yingshi, 2002.

Hou Hsiao-hsien 侯孝賢 (Hou Xiaoxian) (director). *Beiqing chengshi* 悲青城市 (*A City of Sadness*). Taipei: Era International presentation of a 3-H production, 1989.

Huang Shuqin 黃蜀芹 (director). *Nie zhai* 孽債 (*The Wages of Sin*). Shanghai: Shanghai dianshi tai qiu suo dianshi zhizuo she, 1993.

Hui, Ann 許鞍華 (director). *Qingcheng zhi lian* 傾城之戀 (*Love in a Fallen City*). Hong Kong: Shaw Brothers, 1984.

Kwan, Stanley 關錦鵬 (director). *Lan Yu* 藍宇. Hong Kong: Golden Scene, 2002.

Law, Clara 羅卓瑤 (director). *Ai zai biexiang de jijie* 愛在別鄉的季節 (*Farewell China*). Hong Kong: Golden Harvest, 1990.

Leung Po-chih 梁普智 (director). *Dengdai liming* 等待黎明 (*Hong Kong 1941*). Hong Kong: D & B Films/Bo Ho Films, 1984.

Lin Cheng-sheng 林正盛 (Lin Zhengsheng) (director). *Tianma chafang* 天馬茶坊 (*March of Happiness*). Taipei: Minjian quanmin dianshi gongsi & Qing pingguo zhizuo gongsi, 1999.

Lü Yue 呂樂 (director). *Mei ren cao* 美人草 (*The Foliage*). Beijing: Wenzhou Teleplay/Beijing 21 Century Bona Film Company, 2004.

Luo Guanqun 羅冠群 (director). *Tuchang xuezheng* 屠城血証 (*Massacre in Nanjing*). Fuzhou/Nanjing: Fujian Film Studio, Nanjing Film Studio, 1987.

Lou Ye 婁燁 (director). *Yiheyuan* 頤和園 (*Summer Palace*). Fantasy Films, 2006.

Mak, Peter Tai-kit 麥大杰 (director). *Yaoshou dushi* 妖獸都市 (*The Wicked City*). Hong Kong: Golden Princess/Film Workshop/Edko Films, 1992.

Mou, T. F. 牟敦芾 (Mou Dunfei) (producer and director). *Hei taiyang: Nanjing da tusha* 黑太陽: 南京大屠殺 (*Black Sun: The Nanking Massacre*). Hong Kong: T. F. Films, 1995.

Shen Tao 沈涛 (director). *Toudu* 偷渡 (*Dangerous Trip*).Beijing: Beijing dianshitai, 2003.

Shu Kei 舒琪 (director). *Meiyou taiyang de rizi* 沒有太陽的日子 (*Sunless Days*). Tokyo: NHK Enterprises, 1998.

Su Zilong 蘇子龍. *Nanjing datusha—Xingcunzhe de jianzheng* 南京大屠殺: 倖存者 的見證 (*The Massacre of Nanjing—The Surviving Witnesses*). Nanjing: Jiangsu Television Station.

Sun Zhaohui 孫照輝, Yang Li 楊理, and Zhu Weimin 朱衛民 (writers and directors). *Gungun hongchen: Zhongguo zhiqing minjian jiyi jishi* 滾滾紅塵:中國知青民間記憶紀實 (*Red Dust: Memories of the Chinese Educated Youth*). Guangzhou: Pheonix TV, 2005.

Tang, Emily 唐曉白(Tang Xiaobai) (director/script). *Dongci bianwei* 動詞變位 (*Conjugation*). Beijing: Tang Film LTD, 2002.

Teng Wenji 騰文驥 (writer and director). *Qi wang* 棋王 (*King of Chess*). Xi'an: Xi'an Film Studio, 1988.

Thomas, Antony (writer, director, producer). *The Tank Man*. Arlington, VA: PBS (*Frontline*), 2006.

Tsang, Sammy Kan-cheung 曾謹昌 (writer and director). *Kongbu ji* 恐怖雞 (*Intruder*). Hong Kong: China Star Entertainment/Win's Entertainment/Milkyway Image, 1997.

Tu, Raymond 杜國威 (Du Guowei) (writer and director). *Wu Yue he Ba Yue* 五月和八月 (*May & August*). Nanjing: Nanjing Film Studio (PRC), Huanyu yule (HK), and Hsu Hsiao-ming Production Co. (Taiwan), 2002.

Various. *Can Japan Say No to the Truth?* Boxed set. Flushing, NY: The Alliance in Memory of Victims of the Nanjing Massacre (AMVNM), 1997.

Wan Jen 萬仁. *Fengzhong feiying: Wushe shijian* 風中緋櫻: 霧社事件 (*Dana Sakura: The Musha Incident*). Taipei: Taiwan Public Television, 2002.

Wang Lili 王犁犁 (director). *Nanjing datusha shizheng* 南京大屠殺實証 (*Actual Record of the Nanjing Massacre*). Beijing: Beijing Film Academy Publishing House.

Wang, Peter (director). *Magee's Testament*. New York: The Alliance in Memory of Victims of the Nanjing Massacre, 1991.

Wang Yulin 王育麟 (director). *Xunzhao ererba chenmo muqin: Lin Jiangmai* 尋找二二八沉默母親: 林 江邁(*In Search of the Silent Mother of 2/28: Lin Jiangmai*). Taipei: Nanfang jiayuan wenhua, 2006.

Wei Desheng 魏德聖. *Saideke balai* 賽德克 巴萊 (*Seediq Bale*). Taipei, 2004.

Williams, Sue (writer, producer, director). *China: A Century of Revolution*. New York: Ambrica Productions, 1997.

Wong Kar-wai 王家衛 (director). *Chunguang zhaxie* 春光乍洩 (*Happy Together*). Hong Kong: Times Productions, 1997.

——. *Dongxie Xidu* 東邪西毒 (*Ashes of Time*). Hong Kong: Scholar Films/Jet Tone Productions/Beijing Film Studio/Tsui Siu Ming Productions/Pony Canyon, 1994.

Woo, John 吳宇森 (writer and director). *Diexue jietou* 喋血街頭 (*Bullet in the Head*). Hong Kong: John Woo Productions, 1990.

Wu Ziniu 吳子牛 (director). *Nanjing 1937* 南京一九三七 (*Don't Cry, Nanking*). Taipei: China Film Co-production Corporation, Long Shong Production Co. Ltd., 1995.

Yim Ho 嚴浩 and Tsui Hark 徐克 (directors). *Qi wang* 棋王 (*King of Chess*). Hong Kong: Media Asia & Film Workshop, 1992.

Yu Benzheng 於本正 (director). *Shengsi jueze* 生死抉擇 (*Fatal Decision*). Shanghai: Shanghai Film Studio, 2000.

Yuan Jun 袁軍 (director). *Zhongguo zhiqing buluo* 中國知情部落 (*The Zhiqing Tribe of China*). Guangzhou: Guangzhou TV/Station TV Video, 1998.

Zhai Heping 翟和平 (writer and director). *Lao san jie* 老三屆 (*The Three Old Graduating Classes*). Nanjing: Huawen yingshi zhongxin and Jiangsu haiwai jituan xinye wenhua, 2005.

Zhang Nuanxin 張暖忻 (director). *Qingchun ji* 青春祭 (*Sacrificed Youth*). Beijing: BFA Youth Film, 1985.

Zhang Xiaoguang 張曉光 (director). *Wuye yangguang* 午夜陽光 (*Midnight Sunlight*). Beijing: Hairun yingshi zhizuo and Beijing changsheng gaoke xinxi zixun, 2005.